The Manual of Photography
Eighth Edition

The Manual of Photography

Eighth Edition

Ralph E Jacobson MSc, PhD, CChem, FRSC, FRPS (Editor)
Sidney F Ray BSc, MSc, FBIPP, FMPA, FRPS
Geoffrey G Attridge BSc, PhD, FRPS

Focal Press
London and Boston

Focal Press
is an imprint of the Butterworth Scientific

 PART OF REED INTERNATIONAL P.L.C.

The Ilford Manual of Photography
First published 1890
Fifth edition 1958
 Reprinted eight times

The Manual of Photography
Sixth edition 1971
 Reprinted 1971, 1972, 1973, 1975
Seventh edition 1978
 Reprinted 1978, 1981, 1983, 1987
Eighth edition 1988
 Reprinted 1990

© Butterworth & Co. (Publishers) Ltd, 1988

British Library Cataloguing in Publication Data

The manual of photography — 8th ed.
 1. Photography
 I. Jacobson, Ralph E. (Ralph Eric)
 II. Ray, Sidney F., *1939–* III. Attridge, G.G.
 (Geoffrey G.) *1938–*
770

 ISBN 0-240-51268-5

Library of Congress Cataloging-in-Publication Data

The Manual of photography.—8th ed./revised by Ralph E.
 Jacobson, Sidney F. Ray, Geoffrey G. Attridge.
 p. cm.
 Bibliography: p.
 Includes index.
 ISBN 0-240-51268-5 :
 1. Photography. I. Jacobson, R. E. II. Ray, Sidney F.
III. Attridge, G. G.
TR145.M315 1988
770—dc19 88-10545

Laserset by Scribe Design, Gillingham, Kent
Printed and Bound in Great Britain by Courier International Ltd, Tiptree, Esse

Preface to the eighth edition

There have been many innovations in photographic equipment and materials in the last decade, since the publication of the previous edition. Amongst these has been the move towards more automation in cameras, flash equipment and processing and printing equipment. This has been made possible by the extended applications of the microchip and modern optoelectronic technology. Photography has been simplified by the provision of autofocus cameras, sophisticated in-camera metering systems and zoom lenses, all of which are now widely available. These features are also provided in many of the more modestly priced compact cameras. It has never been easier for the unskilled photographer to take correctly exposed and sharply focused photographs.

Parallel with the evolution of equipment there have been many subtle and significant advances made in photographic emulsions, accelerated by a trend towards smaller-format films. Image quality is extremely high; although much of the advanced chemical technology that all modern materials make use of was originally designed for colour materials, it is also now applied to black-and-white materials.

Processing of photographic materials has become simpler and more reliable, as has the printing of films, due to the application of electronics in processing and printing equipment, and there is a general trend towards daylight operation of equipment that has normally been associated with darkroom use. However, many of the traditional practices survive, aided by modern technology.

Although electronic still video cameras have been introduced since the publication of the previous edition, their use has yet to make an impact on photography. However, they are finding application in some specialist areas, where the advantages of rapidity of access to images, and ease of manipulation and transmission, outweigh the limitations of cost and inferior image quality when compared with photographic materials and systems.

Electronic cameras are now included in the book, which has been thoroughly revised to take into account the advances in virtually all areas of photography. Many chapters have been completely rewritten so as to provide an up-to-date account of the principles and practices of photography needed by those involved in the diverse areas of imaging.

Because of the diverse nature of photography it has been necessary to draw on the expertise of those experienced in the appropriate specialist areas, as it was for the previous edition. My task of editing *The Manual of Photography* has been greatly lightened by my colleagues at The Polytechnic of Central London who possess specialized knowledge in areas other than my own. I gratefully acknowledge the able contributions made by Mr S.F. Ray, Dr G.G. Attridge and Mr N.R. Axford, indicated by their names appearing alongside the appropriate chapters.

R.E.J.

Contents

ix *Contents*

16 The reproduction of colour 195

Geoffrey G. Attridge

17 Developers and development 211

Ralph E. Jacobson

18 Processing following development 239

Ralph E. Jacobson

26 Faults in negatives and prints 354

Ralph E. Jacobson

Appendix 366

Index 383

1 The photographic process

The photographic process involves the use of light-sensitive silver compounds called silver halides as the means of recording images. It has been in use for more than a hundred years and, despite the introduction of electronic systems for image recording, is likely to remain an important means of imaging. The advantages of the silver-based photographic process may be summarized as follows:

(1) *Sensitivity* Silver materials are available with very high sensitivity, and are able to record images in low levels of illumination. For example a modern high-speed colour-negative film can record images by candle-light with an exposure of 1/30 s at *f*/2.8.

(2) *Spectral sensitivity* The natural sensitivity of silver halides extends from cosmic radiation to the blue region of the spectrum. It can be extended to cover the entire visible spectrum and into the infrared region. Silver halides can also be selectively sensitized to specific regions of the visible spectrum, thus making the reproduction of colour possible.

(3) *Resolution* Silver materials are able to resolve very fine detail. For example, special materials are available which can resolve in excess of 1000 cycles/mm and most general-purpose films can resolve detail of around 100-200 cycles/mm.

(4) *Continuous tone* Can record tones or intermediate grey levels between black and white.

(5) *Versatility* May be manufactured and/or processed in a variety of different ways to cover most imaging tasks, from holography to electron beam recording.

(6) *Information capacity* Very high. For example, photographic materials have maximum capacities from around 10^6 to 10^8 bits/cm^2.

(7) *Archival aspects* If correctly processed and stored, black-and-white images are of archival permanence.

(8) *Shelf-life* For most materials this is of the order of several years before exposure, and with appropriate storage can be as long as 10 years after exposure, though it is recommended that exposed materials should be processed as soon after exposure as practicable.

(9) *Silver re-use* Silver is recoverable from materials and certain processing solutions and is recycled.

The silver-based photographic system suffers from one major limitation from the user's point of view, namely the involvement of a wet chemical process to amplify and stabilize the image. This results in long access times between recording the image and viewing the final result. However, this limitation has been largely overcome by the provision of instant-print and instant-slide systems.

Electronic means of recording and displaying images are likely to become increasingly important because of their rapidity of access and ease of transmission and manipulation of images in a digital form. But at present they suffer from high cost and limitations in the quality of results for the production of images in the form of hard copy (prints). Their application is mainly for scientific and technical purposes and certain types of press photography where their advantages outweigh their limitations.

Although today the photographic process finds many other applications, photography is primarily a method of making pictures. It is a means of making pictures by the agency of light, the word photography having its origin in two Greek words meaning light and writing. When a photograph is taken with a camera, light passes through a lens to form an image on a light-sensitive film. The film records an impression of the image. This impression, which is invisible, is termed a *latent* (hidden) *image*.

Photographs are obtained from an exposed film by *processing*. The processing of a film comprises several chemical operations, the purpose of which is to convert the invisible image on the film into a permanent visible image. The most characteristic operation in processing is *development*. The essential steps of the photographic process in its simplest (black-and-white, negative–positive) form are summarized in Table 1.1.

The image formed when a film is processed in this way is a negative, and to obtain positive prints the negative is printed. This involves a repetition of the photographic process using a further light-sensitive material, this time usually a sheet of paper, on which an image of the negative is formed by passing light through the negative. This paper is processed in a similar manner to the film to produce a black-and-white print of the familiar kind.

Table 1.1 The photographic process

Exposure	Latent image formed
Processing:	
Development	Visible image formed
Rinsing	Development checked
Fixing	Unused sensitive material converted into soluble chemicals
Washing	Soluble chemicals removed
Drying	

The production of photographs

For success in the production of a photograph consideration must be given to each of the following four essential factors.

Composition

Composition means the choice and arrangement of the subject matter within the confines of the finished picture. The camera can only record what is imaged on the sensitive material, and the photographer must control this, for example, by choice of viewpoint: its angle and distance from the subject; by controlling the placing of the subject within the picture space; or by suitable arrangement of the elements of the picture.

Illumination

Photographs originate with light travelling from the subject towards the camera lens. Although some objects, e.g. firework displays, are self-luminous, most objects are viewed and photographed by diffusely-reflected light. The appearance of an object, both visually and photographically, thus depends not only on the object itself but also upon the light that illuminates it.

The main sources of illumination in the day are sun, clear sky and clouds. Control of lighting of subject matter in daylight consists largely in selecting (or waiting for) the time of day or season of the year when natural lighting produces the effect the photographer desires. Sources of artifical light share in varying degree the advantage that, unlike daylight, they can be controlled at will. With artificial light, therefore, a wide variety of effects is possible. However, it is good practice with most subjects to aim at producing a lighting effect similar to natural lighting on a sunny day: to use a main light in the role of the sun, i.e. casting shadows, and subsidiary lighting to lighten these shadows as required.

Image formation

To produce a photograph, light from the subject must be collected by a light-sensitive material, and must illuminate it as an optical image which is a two-dimensional replica of the subject. The faithfulness of the resemblance will depend upon the optical system employed; in particular upon the lens used and the relation of the lens to the sensitive surface.

Image perpetuation

Finally, the image-forming light must produce changes in the light-sensitive material in the camera so that in this material an impression of the image is retained; this impression must be rendered permanent. This fourth factor is the one generally recognized as the defining characteristic of photography.

Each of the above factors plays an important role in the production of the finished picture, and the photographer should be familiar with the part played by each, and the rules governing it. The first factor, composition, is much less amenable to rules than the others, and it is primarily in the control of this – coupled with the second factor, illumination – that the personality of the individual photographer has greatest room for expression. For this reason, the most successful photographer is frequently one whose mastery of camera technique is such that his or her whole attention can be given to the subject.

Features characteristic of the photographic process

Photography is only one of a number of methods of making images. Others include pencil sketching, water-colour painting, oil painting, etching, charcoal drawing, etc. Each method has certain advantages and limitations both as regards its technique and its results.

An outstanding characteristic peculiar to the photographic method of making images is that the photographer usually has to wait for an appreciable period after taking the photograph before seeing the result. The delay between exposure and the production of the actual print means that great care must be taken in the selection of the subject and in choosing the right moment for exposure. The successful photographer works very quickly when necessary, and forms a mental picture of the subject at the moment of exposure which usually enables an immediate decision on whether a retake is required. The ability to do this is indispensable to the professional photographer, for with many subjects there is no opportunity for a retake at a later date.

Among other features characteristic of the photographic process are the following:

(1) A real subject is necessary.
(2) Perspective is governed by optical laws.
(3) Colour may be recorded in colour, or in black-and-white, according to the type of film used.
(4) Gradation of tone is usually very fully recorded.
(5) Detail is recorded quickly and with comparative ease.

Perspective in photographs

The term *perspective* is applied to the apparent relationship between the position and size of objects when seen from a specific viewpoint, in a scene examined visually. The same principle applies when a scene is photographed, the only difference being that the camera lens takes the place of the eye. Control of perspective in photography is therefore achieved by control of viewpoint.

A painter is not limited in this way; he can place objects in his picture anywhere he pleases, and alter their relative sizes at will. If, for example, he is depicting a building, and is forced by the presence of other buildings to work close up to it, he can nevertheless produce a picture which, as far as perspective is concerned, appears to have been painted at a distance. The photographer cannot do this. Selection of viewpoint is thus of great importance to the photographer, if a given perspective is to be achieved.

Reproduction of colour

Colour photography did not become a practicable proposition for the average photographer until nearly 100 years after the invention of photography, but in recent years its use has gained rapidly over that of black-and-white photography, and in many fields it now predominates. However, a great deal of photographic work, especially photojournalism and fine-art photography is still in monochrome. Colour photography is essentially a development from black-and-white photography, so that a study of the principles of this will provide a sound basis for a consideration of colour photography.

Monochrome reproduction is not peculiar to black-and-white photography, but is shared by processes such as pencil sketching, charcoal drawing and etching. In all these processes attempts are made to reproduce in two dimensions and one colour an original subject which is in three dimensions and in many colours. This is a task to which the photographer must bring all the help provided by the nature of the particular process that is being used. For example, in a photographic print a fair impression of solidity may be obtained by intelligent use of perspective, differential focusing, haze and receding planes, and, although only shades of grey from white to black are available, by reproducing colours as greys similar in tone to the original colours an acceptable rendering of colours in monochrome may be achieved. Fortunately, in the representation both of solidity and of colour the forces of convention and habit are on our side.

To reproduce an original subject of many different colours in an acceptable manner, colour photographic materials are used either in the form of prints for viewing by reflected light, or in the form of transparencies for viewing by transmitted light. The fact that colours can be reproduced photographically in an acceptable way is surprising when we consider that the colours of the image are formed by combinations of three synthetic dyes. However, no photographic reproduction of colour is identical with the original. Indeed, certain preferred colour renderings differ from the original. However, acceptable colour reproduction is achieved if the *consistency principle* is obeyed. This principle may be summarized as follows:

(1) Identical colours in the original must appear identical in the reproduction.
(2) Colours that differ one from another in the original must differ in the reproduction.
(3) Any differences in colour between the original and the reproduction must be consistent throughout.

The entire area of colour reproduction is very complex and involves considerations of both objective and complex subjective effects. Apart from the reproduction of hues or colours the *saturation* and *luminosity* are important. The saturation of a colour decreases with the addition of grey. Luminosity is associated with the amount of light emitted, transmitted or reflected by the sample under consideration. These factors depend very much on the nature of the surface and the viewing conditions. At best, colour reproductions are only representations of the original scene, but, as we all know, colour photographic materials carry out their task of reproducing colours and tone remarkably well, despite differences in colour and viewing conditions between the original scene and the reproduction.

Reproduction of tone

Various ways of achieving gradation of tone are employed in the graphic arts. In etchings and drawings in pen and ink, which consist of lines varying principally in width rather than in density, effects of light and shade are obtained largely by controlling

the width or the spacing of the lines. For example, several lines placed close together, in what is termed *hatching*, produce an area of shade. Such pictures are referred to as *line reproductions*. In photographs, on the other hand, the effects of light and shade are obtained by variation of the tone of the print. Thus, a highlight of uniform brightness in the subject appears as a uniform area of very light grey in the print. A shadow of uniform depth appears as a uniform area of dark grey, or black, in the print. Between these extremes all shades of grey may be present. Photographs are therefore referred to as *continuous-tone reproductions*. (When photography is used to record originals which are themselves confined to two tones, as for instance when an engineering drawing is copied, the photographic process is then employed to produce a line, not a continous-tone, copy.)

It should be noted that in black-and-white photography there is only one variant in the print, that of tone, which has to reproduce all variations in the subject, whether of luminance or of colour.

Reproduction of detail

For the reproduction of detail the photographic process is without equal. Whereas a detailed drawing demands far more in time and energy from an artist than a simple sketch, the camera can record a wealth of detail just as easily and quickly as it can a simple object. Thus the reproduction of texture by the camera – essentially fine detail – is the envy of the graphics artist.

Negatives and positives

Most photographs are produced by exposing a film, following this by a further exposure to produce a print on paper. This procedure is followed because the lighter the subject matter the darker the photographic image. The film record therefore has the tones of the subject in reverse: black where the original is light, clear where the original is dark, with the intermediate tones similarly reversed. The original film is therefore referred to as a *negative*, while a print, in which by a further use of the photographic process the tones of the original are re-reversed, is termed a *positive*. Commercial technology designates colour films of this type as *colour negative*

films (popularly termed *colour print films*). Any photographic process by which a negative is made first and employed for the subsequent preparation of prints is referred to as a *negative-positive process*. Although the eye accepts a two-dimensional monochrome print as a fair representation of a three-dimensional coloured object, it does not accept a negative as an objective picture. Negative records are thus not acceptable for pictorial purposes (except for deliberate effects), although they are acceptable in certain technical applications of photography.

It is possible to obtain positive photographs directly on the material exposed in the camera, but the procedure for doing this is more complex than the preparation of negatives. The first widely-used photographic process, due to Daguerre, did produce positives directly. The first negative-positive process, due to Talbot, although announced at about the same time as that of Daguerre, gained ground rather more slowly, though today negative-positive processes are used for the majority of black-and-white and colour photographs. Although processes giving positive photographs in a single operation appear attractive, in practice negative-positive processes are useful because two stages are required. In the first place, the negative provides a master which can be filed for safe keeping. Then, it is easier to make copies from a transparent master than from a positive photograph, which is usually required to be on an opaque paper base. Again, the printing stage of a two-stage process gives an additional valuable opportunity for control of the finished picture. However, in professional work, especially colour, it has been the practice to produce *transparencies*, or direct positives, from which blocks can be made for subsequent *photomechanical printing*.

Negatives are usually made on a transparent base and positives on paper, though there are important exceptions to this. For example, positives are sometimes made on film for projection purposes, as in the case of filmstrips and motion-picture films. Such positives are termed, *slides, diapositives* or *transparencies*. So-called colour-slide films (e.g. Kodachrome, Fujichrome and other films with names ending in '-chrome') are intended to produce colour positive transparencies for projection as slides or for direct viewing. The action of light in producing an image on negative materials and positive materials is essentially the same in the two cases.

2 The nature of light

As far as the photographer is concerned, photography starts with light. Light radiated by the sun – or whatever other source is employed – travels through space and falls on the surface of the subject. According to the way in which it is received or rejected, a complex pattern of light, shade and colour results. This is interpreted by us from past experience in terms of three-dimensional solidity. The picture made by the camera is a more-or-less faithful representation of what a single eye sees, and, from the light and shade in the positive photographic print, the process of visual perception can arrive at a reasonably accurate interpretation of the form and nature of the objects portrayed. Thus, light makes it possible for us to be well-informed about the shapes, sizes, and textures of things, whether we can handle them or not.

The true nature of light has been the subject of much speculation. In Newton's view light was *corpuscular*, i.e. consisted of particles, but this theory could not be made to fit all the known facts, and the *wave theory* of Huygens and Young took its place. Later still, Planck found that many facts could be explained only on the assumption that energy is always emitted in discrete amounts, or *quanta*. Planck's *quantum theory* might appear at first sight to be a revival of Newton's corpuscular theory, but there is only a superficial similarity. Nowadays, physicists make their interpretations of light phenomena in terms of both the wave and quantum models. The quantum of light is called the *photon*.

Optics

The study of the behaviour of light is termed *optics*. It is customary to group the problems that confront us in this study in three different classes, and to formulate for each a different set of rules as to how light behaves. The science of optics is thus divided into three branches:

Physical optics

This is the study of light on the assumption that it behaves as waves. A stone dropped into a pond of still water causes a train of waves to spread out in all directions on the surface of the water. Such waves are almost completely confined to the surface of the water, the advancing wavefront being *circular* in form. A point source of light, however, is assumed to emit energy in the form of waves which spread out in all directions, and hence, with light, the wavefront forms a *spherical* surface of ever-increasing size. This wavefront may be deviated from its original direction by obstacles in its path, the form of the deviation depending on the shape and nature of the obstacle.

Geometrical optics

The path of any single point on the wavefront referred to above is a straight line with direction perpendicular to the wavefront. Hence we say that light travels in straight lines. In geometrical optics we postulate the existence of *light rays* represented by such straight lines along which light energy flows. By means of these lines, change of direction of travel of a wavefront can be shown easily. The concept of light rays is helpful in studying the formation of an image by a lens.

Quantum optics

This branch of modern physics, which assumes that light consists essentially of quanta of energy, is employed when studying in detail the effects that take place when light is absorbed by matter, e.g. a photographic emulsion or other light-sensitive material.

Light waves

Many of the properties of light can be readily predicted if we suppose that it takes the form of waves. Unlike sound waves, which require for their propagation air or some other material medium, light waves travel freely in empty space at almost exactly 3×10^8 metres per second (300000 kilometres per second). In air, its velocity is very nearly as great, but in water it is reduced to three-quarters and in glass to about two-thirds of its value in empty space.

Many forms of wave besides light travel in space at the same speed as light; they are termed the family of *electromagnetic waves*. Electromagnetic

waves are considered as vibrating at right angles to their direction of travel. As such, they are described as *transverse* waves, as opposed to *longitudinal* waves such as sound waves, in which the direction of vibration is along the line of travel.

The distance in the direction of travel from one wavecrest to the corresponding point on the next is called the *wavelength* of the radiation. Wavelenth is usually denoted by the Greek letter λ (lambda). The number of waves passing any given point per second is termed the *frequency* of vibration. Different kinds of electromagnetic waves are distinguished by their wavelength or frequency. The amount of displacement of a light wave in a lateral direction is termed its *amplitude*. Amplitude is a measure of the intensity of the light, but is a term rarely needed in photography.

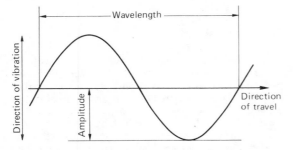

Figure 2.1 A light wave shown diagrammatically

Figure 2.1 shows a light wave diagrammatically, and illustrates the terms wavelength and amplitude. In the figure, the ray of light is shown as vibrating in one plane only, namely the plane of the paper. It should however, be considered as vibrating in all directions simultaneously, i.e. at right-angles to the paper as well as in its plane. The product of wavelength and frequency equals the velocity of propagation of the radiation.

The electromagnetic spectrum

Of the other waves besides light travelling in space, some have shorter wavelengths than that of light and others have longer wavelengths. The complete series of waves, arranged in order of wavelengths, is referred to as the *electromagnetic spectrum*. This is illustrated in Figure 2.2. There is no clear-cut line between one wave and another, or between one type of radiation and another – the series of waves is continuous.

The various types forming the family of electromagnetic radiation differ widely in their effect. Waves of very long wavelength such as radio waves, for example, have no effect on the body, i.e. they cannot be seen or felt, although they can readily be

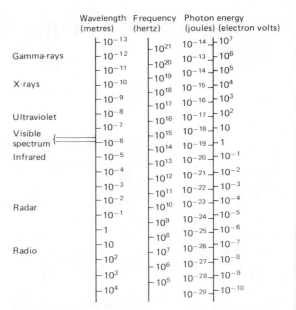

Figure 2.2 Electromagnetic spectrum. relationship between wavelength, frequency and energy

detected by radio receivers. Moving along the spectrum to shorter wavelengths, we reach infrared radiation, which we feel as heat, and then come to waves that the eye sees as light; these form the visible spectrum. Even shorter wavelengths provide radiation such as ultraviolet, which causes sunburn, X-radiation, which can penetrate the human body, and gamma-radiation, which can penetrate several inches of steel. Both X-radiation and gamma-radiation, unless properly controlled, are dangerous to human beings.

The visible spectrum

Photography is mainly concerned with visible radiation, although other electromagnetic radiation has important applications in specialized branches of photography. The visible spectrum occupies only a minute part of the total range of electromagnetic radiation, comprising wavelengths within the limits of approximately 400 and 700 nanometres.* Within these limits, the human eye sees change of wavelength as a change of hue. The change from one hue to another is not a sharp one, but the spectrum may be divided up roughly as shown in Figure 2.3.(See also Chapter 16.)

The eye has a slight sensitivity beyond this region, to 390 nm at the short-wave end and 760 nm at the long-wave end, but for most photographic purposes

*1 nanometre (nm) = 10^{-9} metre (m).

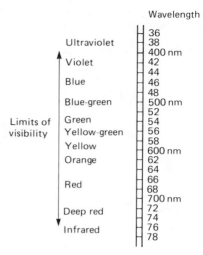

Wavelength

Ultraviolet — 36
— 38
— 400 nm
Violet — 42
— 44
Blue — 46
— 48
Blue-green — 500 nm
— 52
Green — 54
Yellow-green — 56
— 58
Yellow — 600 nm
Orange — 62
— 64
— 66
Red — 68
— 700 nm
— 72
Deep red — 74
— 76
Infrared — 78

Limits of visibility

Figure 2.3 The visible spectrum expanded

this can be ignored. Shorter wavelengths than 390 nm, invisible to the eye, are referred to as *ultraviolet* (UV), and longer wavelengths than 760 nm, also invisible to the eye, are referred to as *infrared* (IR).

Figure 2.3 shows that the visible spectrum contains the hues of the rainbow in their familiar order, from violet at the short-wavelength end to red at the long-wavelength end. For many photographic purposes we can usefully consider the visible spectrum to consist of three bands only: blue-violet from 400 to 500 nm, green from 500 to 600 nm and red from 600 to 700 nm. This division is only an approach to the truth, but it is sufficiently accurate to be of help in solving many practical problems, and is readily memorized.

White light and colour mixtures

More than three hundred yeas ago Newton discovered that sunlight could be made to yield a variety of hues by allowing it to pass through a triangular glass prism. A narrow beam of sunlight was *dispersed* into a band showing the hues of the rainbow. These represent the visible spectrum, and the experiment is shown diagrammatically in Figure 2.4. It

was later found that recombination of the dispersed light by means of a second prism gave white light once more.

Later experiments showed that by masking off parts of the spectrum before recombination a range of colours could be produced. Young showed that if small parts of the spectrum were selected in the blue, green and red regions, a mixture of appropriate amounts of blue, green and red light appeared white. Fifty years after Young's original experiements (in 1802), Helmholtz was successful in quantifying these phenomena. Variation of the blue, green and red contents of the mixture resulted in a wide range of colours. Almost any colour could be produced, including magenta, or purple, which did not appear in the visible spectrum. The results of mixing blue, green and red light are listed in Table 2.1 and illustrated in Figure 2.5.

Table 2.1 Mixing blue, green and red light

Colours of light mixed	Visual appearance
Blue + green	Blue-green, or *cyan*
Blue + red	Red-purple, or *magenta*
Green + red	Yellow
Blue + green + red	White

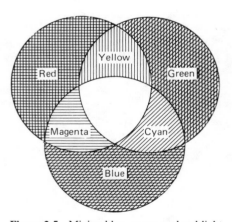

Figure 2.5 Mixing blue, green and red light

The results of mixing blue, green and red light, suggested that the human eye might possess three types of colour sensitivity, to blue, green and red light respectively. This triple-sensitivity theory is called the *Young-Helmholtz theory of colour vision*. It provides a fairly simple explanation for the production of any colour from an appropriate proportions of these primaries.

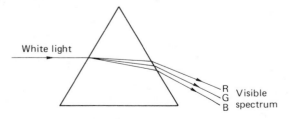

White light

R
G Visible
B spectrum

Figure 2.4 Dispersion of white light by a prism

Use of the word 'light' in photography

The various forms of waves comprising the electromagnetic spectrum are referred to generally as *radiation* or *radiant flux*. Strictly speaking, only radiation capable of stimulating the eye to produce visual sensation should be referred to as 'light'. For the purposes of photography it is, however, frequently convenient to use the term 'light' to include both visible and near-visible radiation, namely ultraviolet and infrared, which can affect photographic materials. However, the terms *ultraviolet radiation* and *infrared radiation* are to be preferred.

3 Photographic light sources

Photographs are taken by the agency of light travelling from the subject to the camera. This light usually originates at a source outside the picture and is reflected by the subject. Light comes from both natural and artificial sources. Natural sources include the sun, clear sky and clouds. Artificial sources are classified by the method used to produce the light (see Table 3.1).

Characteristics of light sources

Light sources differ in many ways, and the selection of suitable sources for various purposes is based on the order of importance of a number of characteristics that are significant from a photographic point of view. A summary of some of the properties of the most common sources used in a range of photographic tasks is given in Table 3.2. The more important characteristics are discussed in more detail below.

Spectral quality

The radiation from most sources comprises a mixture of light of various wavelengths. The *hue* of the light from a source, or its *spectral quality*, may vary widely depending on the distribution of energy at each wavelength in the spectrum. Most of the sources used for photography give what is usually termed *white light*. This is a loose term, describing light that is not visibly deficient in any particular band of wavelengths, but not implying any very definite colour quality. Most white-light sources vary considerably among themselves and from daylight. Because of the perceptual phenomenon of

colour constancy these differences matter little in everyday life, but they can be very important in photography, especially when using colour materials. It is therefore desirable that light quality should be described in precise terms. Light is a particular region of the electromagnetic spectrum and is a form of radiant energy. The colour quality may be defined in terms of the *spectral power distribution* (SPD) throughout the spectrum. There are several ways this can be expressed, with varying degrees of precision. Each method has its own advantages, but not all methods are applicable to every light source.

Spectral power distribution curve

With a suitable instrument such as a *spectroradiometer*, the spectral distribution of light energy can be measured and shown as the SPD curve. Curves of this type are shown in Figure 3.1 for the sun and in Figure 3.2 for some other sources. Such data show clearly small differences between various forms of light. For example, the light sources in Figure 3.1 seen separately would, owing to colour constancy effects, probably be described as white, yet the curves are different. Light from a clear blue sky has a high blue content, while light from a tungsten lamp has a high red content. Although not obvious to the eye such differences can be clearly shown on a colour slide. Each film type has to be balanced for a particular form of lighting.

Analysis of SPD curves show that there are three main types of spectrum emitted by light sources. The sources in Figure 3.1 have *continuous spectra*, with energy present at all wavelengths in the region

Table 3.1 Methods of producing light

Method	Source of light	Examples
Burning	Flame from oil, fat, wax, wood or metals	Candles, oil lamps, matches, magnesium ribbon, flash powder and flash-bulbs
Heating	Carbon or tungsten filament	Incandescent electric lamps, e.g. domestic lamps, studio lamps, tungsten-halogen lamps
Electric spark or arc	Crater or flame of arc	Carbon arcs, spark gaps
Electrical discharge	Gas or metallic vapour Phosphors	Electronic flash, fluorescent lighting, metal halide lamps, sodium and mercury vapour lamps

Table 3.2 The properties of some light sources used in photography

Source	Type of spectrum: C. continuous L. line B. line plus continuum	Colour temperature (kelvins)	Efficacy (lumens per watt)	Average lamp life (hours)	Light output H. high M. moderate L. low	Constancy of output P. poor G. good E. excellent V. variable	Costs: L. low M. moderate H. high Initial	Running	Size of unit: S. small M. medium L. large	Ease of operation: D. difficult M. moderate S. simple
Daylight	C	2000–20000			H–L	P	L	L	S	S
Tungsten filament lamps:										
General service	C	2760–2960	†13	1000	L	P	L	L	M	S
Photographic	C	3200	†20	100	L	G	M	M	M	S
Photoflood	C	3400	†40	3–10	M	P	L	M	S	S
Projector	C	3200	†20	25–100	M	G	M	M	S	S
Tungsten halogen lamps	C	2700–3400	15–35	25–200	M	E	M	H	S,M	S
Carbon arc lamps:										
Low intensity	C	3800–10000		1–2	H	P	H	L	L	D
High intensity	C	6000		1–2	H	P	H	L	L	D
White flame	C	5000		1–2	H	P	H	L	L	D
Mercury vapour discharge lamps:										
Low pressure	L		6		M	G	H	L	M	S
High pressure	L		35–55	1000–2000	H	G	H	L	M	S
Fluorescent lamps	B	*3000–6500	†62	7000–8000	M	P	M	L	L	M
Sodium vapour discharge lamps:										
Low pressure	L		170	10–16000	H	E	M	L	M	M
High pressure	L		100		H	E	H	L	M	M
Metal halide lamps	B	5600–6000	85–100	200–1000	H	E,V	H	H	M	M
Pulsed xenon lamps	B	5600	25–50	300–1000	H	G	H	L	M,S	M
Flash bulbs	C	3800 or 5500		used once only	H	E	L	H	S	S
Electronic flash	B	*6000	40		M	G	H,M,L	L	L,M,S	M

*correlated value
†typical value

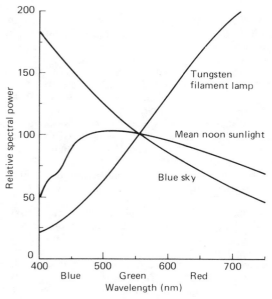

Figure 3.1 Spectral power distribution curves of sunlight, light from a blue sky and light from a tungsten lamp

measured. Many sources, including all incandescent-filament lamps, have this type of spectrum. In other sources the energy is confined to a few narrow spectral regions. At these wavelengths the energy is high, but it is elsewhere almost nil. This spectrum is called a *discontinuous* or *line spectrum*, and is emitted typically by low-pressure discharge lamps such as sodium- and mercury-vapour lamps.

A third type of spectrum possesses broad bands of energy accompanied by a continuous background spectrum of varying magnitude, and may be obtained from discharge-tube sources in various ways. One way is to increase the internal pressure of the discharge tube, as in the case of the high-pressure mercury-vapour lamp. Alternatively, the inside of the discharge tube may be coated with 'phosphors' which fluoresce, i.e. emit light at longer wavelengths than the spectral lines which stimulate them. Yet another method is to include in the tubes gases such as xenon or argon, and metal halide vapour.

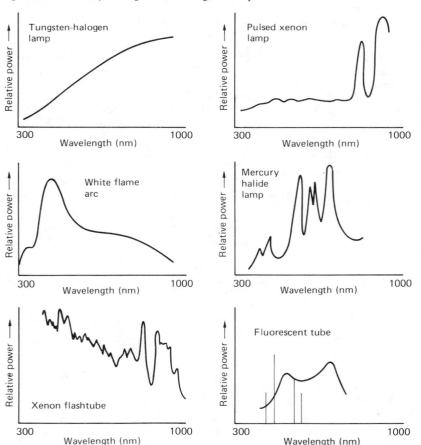

Figure 3.2 Spectral power distribution curves typical of some of the artificial light sources used in photography

Colour temperature

For photographic purposes a more common method of describing the light quality of an incandescent source is by means of its *colour temperature*. This is defined in terms of what is called a *Planckian radiator*, a *full radiator* or simply a *black body*. This is a light source emitting radiation in which the SPD depends only on its temperature and not on the material or nature of the source.

The colour temperature of a light source is the temperature of a full radiator that would emit radiation of substantially the same spectral distribution in the visible region as the radiation from the light source. Colour temperatures are measured on the *thermodynamic* or *Kelvin* scale, which has a unit of temperature interval identical to that of the Celsius scale, but with its zero at −273.15°C.

The idea of colour temperature can be appreciated by considering the progressive change in colour of the light emitted by a piece of metal as its temperature is raised, going from dull black through red and orange to white heat. The quality of the light emitted is thus a function of the temperature of the metal. Luminous sources of low colour temperature are characterised by a SPD relatively rich in red radiation. With progression up the colour scale the emission of energy is more balanced and the light becomes whiter. At high values the SPD is rich in blue radiation. It is perhaps unfortunate that reddish light has been traditionally known as 'warm' and bluish light as 'cold', as the actual temperatures associated with these colours are the other way round.

The concept of colour temperature is strictly applicable only to sources that are full radiators, but in practice it is extended to those that have a SPD approximating to that of a full radiator, such as a tungsten filament lamp. The term is, however often applied incorrectly to fluorescent lamps, whose spectra and photographic effects can be very different from those of full radiators. The preferred term describing such sources is *correlated colour temperature*, which indicates a visual similarity to a value on the colour-temperature scale (but with an unpredictable photographic effect).

The approximate colour temperatures of some light sources encountered in photography are given in Table 3.3.

In black-and-white photography, the colour quality of light is of limited practical importance. In colour photography, however, it is vitally important, because colour materials are balanced to give correct rendering with an illuminant of a particular colour temperature. Consequently, the measurement and control of colour temperature must be considered for such work.

Colour rendering

In the particular case of fluorescent lamps, which vary greatly in spectral energy distribution, covering a wide range of correlated colour temperatures, the results given by two lamps of nominally the same properties may be quite different if used for visual colour matching or for colour photography. Various objective methods have been devised to give a

Table 3.3 Colour temperatures of some common light sources

Light source	Approximate colour temperature	Mired value
Standard candle	1930 K	518
Dawn sunlight	2000 K	500
Vacuum tungsten lamp	2400 K	417
Acetylene lamp (used in early sensitometric work)	2415 K	414
Gas-filled tungsten lamp (general service)	2760 to 2960 K	362 to 338
Warm-white fluorescent lamp	3000 K	333
Photographic lamp	3200 K	312
Photoflood lamp	3400 K	294
Clear flashbulb	3800 K	263
Plain carbon arc	3800 K	263
Daylight fluorescent lamp	4500 K	222
White-flame arc	5000 K	200
Mean noon sunlight	5400 K	185
Photographic daylight	5500 K	182
Blue flashbulb	6000 K	167
H.I. carbon arc (sun arc)	6000 K	167
Electronic flash tube	6000 K	167
Average daylight (sunlight and skylight combined)	6500 K	154
Colour-matching fluorescent lamp	6500 K	154
Enclosed arc	10000 K	100
Blue sky	12000 to 18000 K	83 to 56

numerical value to the colour rendering given by such sources as compared with a corresponding full radiator, or with visual perception. Based on the measurement of luminance in some 6 or 8 spectral bands and compared with the total luminance, coupled with weighting factors, a *colour-rendering index* or *value* of 100 indicates ideal performance. Typical values vary from 50 for a 'warm-white' type to greater than 90 for a 'colour-matching' version.

Percentage content of primary hues

For many photographic purposes, the spectrum can be considered as consisting of three main bands: blue, green and red. The quality of light from a source with a continuous spectrum can be approximately expressed in terms of the percentages in which light of these three hues are present. The method is imprecise; but it is the basis of some *colour temperature meters*, where the ratios of blue-green and red-green content are compared. (The same principles are used to specify the colour rendering given by a lens, as absorption of light is often found in optical glass at the blue end of the spectrum.)

Measurement and control of colour temperature

In colour photography, the colour temperature of the light emitted by all the separate sources used on a subject must agree with that for which the process being used is balanced. The tolerance permissible depends on the process and to some extent on the subject. A departure of 100 K from the specified value by all the sources (which may arise from a 10 per cent variation in supply voltage) is probably the maximum tolerable for colour reversal material balanced for a colour temperature of around 3200 K. Colour negative material (depending on how it is sensitized) may allow a greater departure than this, because a certain amount of correction can be introduced at the printing stage.

One problem arising on location photography is that of *mixed lighting*, where part of the subject may be unavoidably illuminated by a light source of markedly different colour quality from the rest. A localized colour cast may then appear in the photograph. Another example is the use of tungsten lamps fitted with blue filters to match daylight for fill-in purposes, where some mismatch can occur. Note that both blue flashbulbs and electronic flash may be used successfully as fill-in sources when daylight is the main illuminant. A visual comparison of the colour quality of two light sources may be obtained by viewing the independently-illuminated halves of

a folded sheet of white paper with its apex pointing towards the observer. Any visually-observable difference in colour would be recorded in a photograph, so must be corrected (see below).

In general, instrumental methods are more convenient, for example, colour temperature meters. Most such instruments incorporate filtered photocells which sample specific regions of the spectrum, such as red, green and blue. A direct readout of colour temperature may be given, together with recommendations as to the type of light-balancing or colour-correction filters needed for a particular type of film.

The colour balance of colour films and illuminants are specified by their manufacturers. The colour temperature of a lamp may be affected by the reflector and optics used; it also changes with variations in the power supply and with the age of the lamp. To obtain light of the correct quality, various precautions should be observed. The lamps must be operated at the specified voltage, and any reflectors, diffusers and lenses must be as near to neutral in colour as possible. Voltage control can be by a constant-voltage transformer. The life of filament lamps can be extended by switching on and arranging the subject lighting at reduced voltage, and using the correct full voltage only for the actual exposure. Variable resistances or solid-state dimmer devices may also be used with individual lamps for trim control. To raise or lower the colour temperature by small amounts, light-balancing filters may be used over the lamps. Pale blue filters raise the colour temperature while pale amber ones lower it.

As tungsten filament lamps age, the inner side of the envelope darkens from a deposit of tungsten evaporated from the filament. Both light output and colour temperature decrease as a result. Bulb replacement is the only remedy; in general, all bulbs of a particular set should be replaced at the same time. Tungsten-halogen lamps maintain a constant output throughout an extended life, as compared with ordinary filament lamps.

To compensate for the wide variations encountered in daylight conditions for colour photography, camera filtration is sometimes necessary by means of light balancing filters of known *mired shift value* as defined below. To use colour film in lighting conditions for which it is not balanced, *colour conversion (CC) filters* with large mired shift values are available (see Chapter 11).

The mired scale

An alternative method of specifying the colour balance of an incandescent source is by the *mired scale*, the name of which is an acronym derived from *micro reciprocal degree* (the unit now known as the

'kelvin' used to be the 'degree Kelvin'). The relationship between mired value and colour temperature is:

$$\text{mired value} = \frac{10^6}{\text{colour temperature in kelvins}}$$

Figure 3.3 can be used for conversion from one scale to the other. Note that as colour temperature increases the mired value decreases and vice versa.

The main advantage of the mired scale, apart from the smaller numbers involved, is that equal variations correspond to approximately equal visual variations in colour. Consequently, light-balancing filters can be given mired shift values which indicate the change in colour quality that the filter will give, regardless of the source being used. Salmon-pink filters, for raising the mired value of the light, i.e. lowering its colour temperature in kelvins, are given positive mired shift values; bluish filters, for lowering the mired value, i.e. raising the colour temperature in kelvins, are given negative values. Thus a bluish light-balancing filter with a mired shift value of -18 is suitable for converting tungsten light at 3000 K (333 mireds) to approximately 3200 K (312 mireds). It is also suitable for converting daylight at 5000 K (200 mireds) to 5500 K (182 mireds). Most filters of this type are given values in decamireds, i.e. mired shift value \div 10. Thus a blue daylight-to-tungsten filter of value -120 mireds is designated B12.

Light output

The output power of a source is an important characteristic. A source can emit energy in a wide spectral band from the ultraviolet to the infrared regions; indeed, most of the output of incandescent sources is in the infrared. For most photography only the visible region is of importance. Three related photometric units are used to define light output: *luminous intensity, luminance* and *luminous flux*.

Luminous intensity is expressed numerically in terms of the fundamental SI unit, the *candela* (cd). One candela is the luminous intensity in the direction of the normal to the surface of a full radiator of surface area 1/600 000 square metre, at the temperature of solidification of platinum. It should be noted that luminous intensity of a source is not necessarily uniform in all directions, so a mean spherical value, i.e. the mean value of luminous intensity in all directions, is sometimes used. Luminous intensity was at one time known as 'candle-power'.

Luminance is defined as luminous intensity per square metre. The unit of luminance is the candela per square metre (cd/m^2). An obsolescent unit sometimes encountered is the *apostilb* (asb) which is one lumen per square metre (lm/m^2), and refers specifically to light reflected from a surface rather than emitted by it. The luminance of a source, like its luminous intensity, is not necessarily the same in all directions. The term luminance is applicable equally to light sources and illuminated surfaces. In photography, luminances are recorded by a film as optical densities of silver or coloured dyes.

Luminous flux is a measure of the amount of light emitted into space, defined in terms of unit solid angle or *steradian*, which is the angle subtended at the centre of a sphere of unit radius by a surface of unit area on the sphere. Thus, an area of 1 square metre on the surface of a sphere of 1 metre radius subtends at its centre a solid angle of 1 steradian. The luminous flux emitted into unit solid angle by a point source having a luminous intensity of one candela in all directions within the angle is 1 *lumen* (lm). Since a sphere subtends 4π steradians at its centre (the area of the surface of a sphere is $4\pi r^2$), a light source of luminous intensity of 1 candela radiating uniformly in all directions emits a total of 4π lumens, approximately 12.5 lm (this conversion is only approximately applicable to practical light sources, which do not radiate uniformly in all directions). The lumen provides a useful measure when considering the output of a source in a reflector or other housing or the amount of light passing through an optical system.

Illumination and reflectors

The design of the reflector and housing of a light source are important for uniformity and distribution of illumination over the area of coverage of the lamp. The term 'illumination' refers to light falling on a surface and depends on the luminous flux falling on a surface and its area. The quantitative term is *illuminance* or incident *luminous flux* per unit area of surface. The unit is the *lux* (lx); 1 lux is

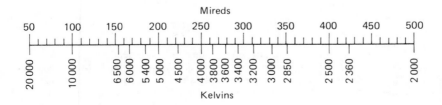

Figure 3.3 The mired and kelvin scales

Source of uniform luminous intensity 1 candela (cd)

Quantity of luminous flux (light) in this cone = 1 lumen

1 metre

Illuminance on this surface = 1 lux (1 lumen per square metre)

1 metre

1 metre

Figure 3.4 Relation between luminous intensity of a source, luminous flux and illumination on a surface.

an illuminance of 1 lumen per square metre. The relationship between the various photometric units of luminous intensity, luminous flux and illumination is shown in Figure 3.4. The illumination E on a surface at a distance d from a point source of light depends on the output of the source, its distance and the inclination of the surface to the source. The relationship between illumination and distance from the source is known as the *inverse square law of illumination* and is illustrated in Figure 3.5. Light emitted into the cone to illuminate base area A at distance d_1 with illumination E_1 is dispersed over area B at distance d_2 to give illumination E_2. It is readily shown by geometry that if d_2 is twice d_1, then B is four times A, i.e. illumination is inversely proportional to the square of the distance d. Hence

$$\frac{E_1}{E_2} = \frac{d_2^2}{d_1^2}$$

Also, from the definition of the lumen, the illumination in luxes may be found as given by a source at any distance from it, by dividing the luminous

intensity of the lamp by the square of the distance in metres. Thus the illumination on a surface 5 metres from a source of 100 candelas is $100/5^2 = 4\,\text{lx}$. Recommended values of illumination for different areas range from 100 lx for a domestic lounge to at least 400 lx for a working office.

The effect of a tilted surface is given by Lambert's *cosine law of illumination*, which states that the illumination on an inclined surface is proportional to the cosine of the angle of incidence of the light rays falling on the surface (Figure 3.6). For a source of luminous intensity I at a distance d from a surface inclined at an angle θ, the illuminance E on the surface is given by

$$E = \frac{I \cos \theta}{d^2}$$

The inverse square law applies strictly only to point sources. It is approximately true for any source that is small in proportion to its distance from the subject. The law is generally applicable to lamps used in shallow reflectors, but not deep reflectors. It is not applicable to the illumination provided by a spotlight due to the optical system used to direct the light beam. Most light sources are used with reflectors, which may be an integral part of the lamp or a

Figure 3.5 Demonstration of the inverse square law of illumination

Figure 3.6 Lambert's cosine law of illumination. The illuminance E at point A distant d_1 from source S of intensity I is given by $E = I/d_1^2$, but at point B on the same surface receiving light obliquely the reduced illuminance is given by $E = I \cos \theta/d_2^2$

separate item. A reflector has a considerable influence on the properties of the lighting unit as regards distribution of illumination or evenness and colour of the light.

Reflectors vary in size, shape and nature of surface. Some are flat or very shallow, others deeply curved in spherical or paraboloidal form. The surface finishes vary from highly polished to smooth matt. Some intermediate arrangement is usually favoured to give a mixture of direct and diffuse illumination. An effective way of showing the light distribution of a source plus reflector or optical system is to plot the luminous intensity in each direction in a given horizontal plane through the source as a curve in polar coordinates, termed a *polar distribution curve* (Figure 3.7). In this figure the source is at the origin and the length of the radius from the centre to any point on the curve gives the luminous intensity in candelas in that particular direction.

The effect of a reflector is given in terms of the *reflector factor* which is the ratio of the illuminance on the subject by a light source in a reflector to that provided by the bare source. Depending on design, a flashgun reflector may have a reflector factor from 2 to 6 in order to make efficient use of the light output, which is directed into a shaped beam with very little illumination outside the primary area.

In many instances flashguns are used with a large reflector of shallow box- or umbrella-like design and construction. A variety of surface finishes and diameters are available, serving to convert the flashgun from a small source giving hard shadows on the subject when used direct, to a large, diffuse source offering softer lighting when used as the sole illuminant, albeit with considerable loss of efficiency. Bare-bulb technique, where the flash source is used without reflector or diffuser, is sometimes used for its particular lighting quality.

By way of contrast, the *spotlight* provides a high level of illumination over a relatively small area, and as a rule gives shadows with hard edges. The illumination at the edges of the illuminated area falls off quite steeply.

The use of diffusers serves to give softer shadows, and the use of 'snoots' gives well-defined edges. A spotlight consists of a small incandescent or flash source with a filament or flashtube at the centre of curvature of a concave reflector, together with a condenser lens, usually of *Fresnel lens* construction to reduce weight. (Figure 3.8). By varying the distance between source and condenser the diameter of the beam of light may be varied. For a near-parallel beam, the source is positioned at the focus of the condenser lens. With compact light sources, such as tungsten-halogen lamps,where it is possible to reduce the physical size of spotlights and floodlights, the optical quality of reflectors and condensers used in such designs needs to be high to ensure even illumination.

Many small electronic flash units allow the distance of the flashtube from the Fresnel lens to be varied to provide a narrower beam that will concentrate the light output into the field of view of lenses of differing focal lengths. This action may even be motorized and under control of a central processing

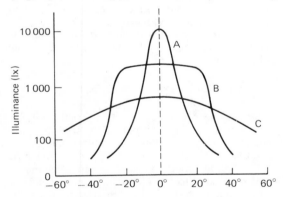

Figure 3.7 Distribution of illumination. Illumination levels at 5 m distance from a light source. A, a 2 kW spotlight in 'spot' mode; B, in 'flood' mode; C, a 2.5 kW 'fill-in' light

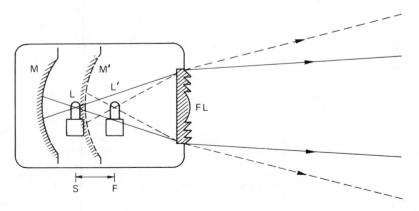

Figure 3.8 Principle of spotlight. When light source L is in 'spot' position S at the focus of spherical mirror M and Fresnel lens FL, a narrow beam of some 40° results. At 'flood' position F, a broader beam of some 85° results

unit (CPU) in a camera and change automatically when a lens of the appropriate focal length is attached to the camera.

The housing, reflector, diffuser and electrical supply arrangements of a lighting unit or fitting for photography are often referred to collectively as the *luminaire*.

Constancy of output

A constant light output and quality are necessary characteristics of photographic light sources, especially for colour work. Daylight, although an intense and cheap form of lighting, is by no means constant: its intensity and quality vary with the season, time of day and weather. Artificial light sources are much more reliable, but much effort can go into arranging lighting set-ups to simulate the desirable directional qualities of sunlight and diffuse daylight. Electric light sources are more reliable than daylight but need a reliable power supply in order to maintain a constant output. If the frequency and/or voltage of the mains supply fluctuates, appreciable variation in light intensity and quality may result (Figure 3.9). Incandescent lamps give a more reliable output if used with some form of constant voltage control; but inevitably as they age they darken, resulting in a lowering of both output and colour temperature. Sources using the tungsten-halogen cycle largely

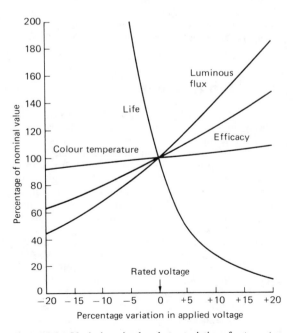

Figure 3.9 Variations in the characteristics of a tungsten lamp with applied voltage

circumvent these problems. Fluorescent lamps have a long life, but gradually decline in light output as they age.

An advantage of flashbulbs and electronic flash is the reliability of light output and quality that can be obtained. Flashbulbs in particular have a output which is dependent only on manufacturing tolerances. Electronic flash also gives an acceptably constant output provided adequate recharging time is allowed between successive flashes. The neon red-light indicators fitted to many units glow when only about 80 per cent of the charging voltage is reached; at this point the energy available for the flash is only some two-thirds of full charge. A further time must be allowed to elapse before discharge, to ensure full capacity is available.

Efficiency

The efficiency of a light source for photographic use is given by various factors determining its usefulness and economy in particular circumstances. Such factors include control circuitry utilizing design techniques to give a low power consumption and choice of reflector to concentrate light output in a particular direction. Electronic flash units are examples of efficient reflector design, with little of the luminous output wasted.

The photographic effectiveness of a light source relative to a reference source is called its *actinity*, and takes into account the SPD of the source and the spectral response of the sensitized material. Obviously it is inefficient to use a source poor in ultraviolet radiation with materials whose sensitization is predominantly in the blue and ultraviolet spectral regions. A commonly-expressed measure of the efficiency of a light source is *efficacy*. This is the ratio of luminous flux emitted to the power consumed by the source and is expressed in lumens per watt. A theoretically perfect light source emitting white light of daylight quality would have an efficacy of about 220 lumens per watt. Values obtained in practice for some common light sources are given in Table 3.2 The obsolete term 'half-watt' was formerly applied to general-purpose filament lamps, which were presumed to have an efficacy of 1 candle-power per half-watt, corresponding roughly to 25 lumens per watt. This value was optimistic.

Operation and maintenance

Reliability is one of the most desirable attributes of a photographic light source. Incandescent sources may fail when initially switched on, owing to power surges and physical changes in the filament. Power control devices such as dimmers and series-parallel

switching arrangements serve to reduce such occurrences. Extensive switching operations and vibration in use should be avoided. Electronic flash units may be very reliable in operation but cannot readily be repaired if they fail on the job. In view of the high voltages and currents involved, electronic flash apparatus should be treated with respect. Most flash units have some form of automatic 'dump' circuit to dispose of redundant charge when output is altered or the unit switched off. Modern lighting units of compact dimensions, light weight, ease of portability and incorporating devices such as automatic control of output in electronic flashguns certainly ease the task of operation, but the disposition of the lighting arrangements on the subject is still a matter of skill on the part of the user.

Some maintenance is necessary for every light source, varying with the particular unit. It may be as simple as ensuring reflectors are cleaned regularly or batteries are replaced or recharged as recommended. The ability of a light source to operate on a variety of alternative power sources such as batteries, mains or a portable generator may be a decisive factor in its choice. Other convenience factors relate to the comfort of the operator and subject, such as the amount of heat generated and the intensity of the light. Undoubtedly, electronic flash lighting is superior in these aspects.

Daylight

A great deal of photographic work is done out of doors in ordinary daylight. Daylight typically includes light from the sun, from the sky and from clouds. It has a continuous spectrum, although it may not be represented exactly by any single colour temperature. However, in the visible region (though not beyond it) colour temperature does give a close approximation of its quality. The quality of daylight varies through the day. Its colour temperature is low at dawn, in the region of 2000 K if the sun is unobscured. It then rises to a maximum, and remains fairly constant through the middle of the day, to tail off slowly through the afternoon and finally fall rapidly at sunset to a value which is again below that of a tungsten filament lamp. The quality of daylight also varies from place to place according to whether the sun is shining in a clear sky or is obscured by cloud. The reddening of daylight at sunrise and at sunset is due to the absorption and scattering of sunlight by the atmosphere. These are greatest when the sun is low, because the path of the light through the earth's atmosphere is then longest. As the degree of scattering is more marked at short wavelengths, the unscattered light which is transmitted contains a preponderance of longer wavelengths, and appears reddish, while the scattered light (skylight) becomes more blue towards sunrise and sunset.

Fluctuations such as have been described prohibit the use of ordinary daylight for sensitometric evaluation of photographic materials. Light sources of fixed colour quality are essential. For many photographic purposes, especially in sensitometry, the average quality of sunlight is used as the standard (skylight is excluded). This is referred to as *mean noon sunlight*, and approximates to light at a colour temperature of 5400 K. Mean noon sunlight was obtained by averaging readings taken in Washington by the (then) US National Bureau of Standards at the summer and winter solstices 21 June and 21 December in 1926. Light of similar quality, but with a colour temperature of 5500 K, is sometimes referred to as 'photographic daylight'. It is achieved in the laboratory by operating a tungsten lamp under controlled conditions so that it emits light of the required colour temperature, by modifying its output with a *Davis-Gibson liquid filter*. Sunlight SPD is of importance in sensitometry, not so much because it may approximately represent a standard white, but because it represents, perhaps better than any other single energy distribution, the average conditions under which the great majority of camera photographic materials are exposed.

The combination of light from the sun, sky and clouds near noon usually has a colour temperature in the region of 6000–6500 K. An overcast (cloudy) sky has a somewhat higher colour temperature, while that of a blue sky may become as high as 12 000–18 000 K. The colour temperature of the light from the sky and the clouds is of interest independently of that of sunlight, because it is *skylight* alone which illuminates shadows and may give them a colour balance that differs from that of a sunlit area.

Tungsten filament lamps

In an incandescent lamp, light is produced by the heating action of electric current through a filament of tungsten metal, with melting point 3650 K. The envelope is filled with a mixture of argon and nitrogen gas and can operate at temperatures up to 3200 K. A further increase, to 3400 K, gives increased efficacy but a decrease in lamp life. 'Photoflood' lamps are deliberately overrun at the latter temperature, to give a high light output, at the expense of a short life.

A tungsten filament lamp is designed to operate at a specific voltage, and its performance is affected by deviation from this condition, as by fluctuations in supply voltage. Figure 3.9 shows the way the characteristics of a filament lamp are affected by departure from normal voltage: for example, a 1 per cent excess voltage causes a 4 per cent increase in luminous flux, a 2 per cent increase in efficacy, a 12 per cent decrease in life and a 10 K increase in

colour temperature for a lamp operating in the range 3200–3400 K.

Tungsten lamps are manufactured with a variety of different types of cap, designated by recognized abbreviations such as BC (bayonet cap), ES (Edison screw) and SCC (small centre contact). Certain types of lamp are designed to operate in one position only. Reference to manufacturers' catalogues will furnish details as to burning position as well as cap types and wattages available.

There are several types of photographic tungsten lamp:

General-service lamps

These are the type used for normal domestic purposes and are available in sizes from 15 W to 200 W with clear, pearl or opal envelopes. The colour temperature of the larger lamps ranges from about 2760 K to 2960 K, with a life of about 1000 hours.

Photographic lamps

Series of lamps are made specially for photographic use, usually as reflector spotlights and floodlights. The colour temperature is 3200 K, which is obtained at the expense of a life of approximately 100 hours only. The usual power rating is 500 W. Such lamps have largely been superseded by more efficient, smaller tungsten-halogen lamps with greater output and longer life.

Photoflood lamps

These lamps produce higher luminous output and more actinic light by operating at 3400 K; they have an efficacy of about 2.5 times that of general service lamps of the same wattage. Two ratings are available. The smaller No 1 type is rated at 275 W, with a life of 2–3 h. The larger No 2 type is rated at 500 W, with a life of 6–20 h. Photoflood lamps are also available with internal silvering in a shaped bulb, and these do not need to be used with an external reflector.

Projector lamps

A bewildering variety of projector lamps are manufactured, with wide variations in cap design, filament shape, and size. They may include reflectors and lenses within the envelope. operation is at mains voltage or reduced voltage by step-down transformer. Wattages from 50 W to 1000 W are available. Colour temperature is in the region of 3200 K and lamp life is given as 25, 50 or 100 h. Once again,

the compact size of the tungsten-halogen lamp has great advantages in such applications; and operation at low voltages such as 12 or 24 V allows use of a particularly robust filament. Many colour enlargers use projector lamps as their light source.

Tungsten-halogen lamps.

The *tungsten-halogen lamp* is a special form of tungsten lamp in which a quantity of a halogen is added to the filling gas. During operation a regenerative cycle is set up whereby evaporated tungsten combines with the halogen in the cooler region of the vicinity of the envelope wall, and when returned by convection currents to the much hotter filament region the compound decomposes, returning tungsten to the filament and freeing the halogen for further reaction. There are various consequences of this cycle. Evaporated tungsten is prevented from depositing on the bulb wall which thus remains free from blackening through age. Filament life is also considerably extended owing to the returned tungsten, but eventually the filament breaks as the redeposition is not uniform. The complex tungsten-halogen cycle functions only when the temperature of the envelope exceeds 250°C, achieved by using a small-diameter envelope of borosilicate glass or quartz. The increased mechanical strength of such a construction permits the gas filling to be used at several atmospheres pressure. This pressure inhibits the evaporation of tungsten from the filament and is a major factor in the significantly-increased life of such lamps as compared with that of conventional tungsten lamps of equivalent rating. The small size of tungsten-halogen lamps has resulted in lighter, more efficient luminaires and lighting units as well as improved performance from projection optics.

Early lamps of this type used iodine as the halogen and the lamps were commonly known as 'quartz-iodine' lamps. Other halogens and their derivatives are also used. Tungsten-halogen lamps are available as small bulbs and in tubular form, supplied in a range of sizes from 50 to 5000 W with colour temperatures ranging from 2700 to 3400 K. Special designs can replace conventional 500 W tungsten lamps in spotlights and other luminaires with the added advantage of some 200 h life and near-constant colour temperature. Replacement costs are higher, however. Most tungsten-halogen lamps operate at low voltages (12 or 24 V), which means that a much more compact filament can be used than with conventional filament lamps.

Fluorescent lamps

A *fluorescent lamp* consists of a low-pressure mercury-vapour discharge lamp with a cylindrical

envelope coated internally with a mixture of fluorescent powders or *phosphors*. These substances have the property of converting short-wave radiation into radiation of longer wavelength. The phosphors used in the lamps absorb ultraviolet radiation and emit visible light, the colour of which depends on the phosphors used. The resultant light quality can be made a close visual match to continuous-spectrum lighting. Fluorescent lamps emit a line spectrum with a strong continuous background; their light quality can be expressed approximately as a *correlated colour* temperature. A measure of *colour rendering* may also be quoted. There are many subjective descriptive names for fluorescent lamps such as 'daylight', 'warm white' and 'natural', but there is little agreement between manufacturers as to the precise SPD of a named variety. Lamps are also classified into two main groups, 'high-efficiency' and 'de-luxe'. The former group have approximately twice the light output of the latter for a given wattage, but are deficient in red. They include 'daylight' lamps of approximately 4000 K and 'warm white' lamps of approximately 3000 K, a rough match to domestic tungsten lighting. The de-luxe group gives good colour rendering by virtue of the use of lanthanide (rare-earth element) phosphors, and includes colour matching at equivalent colour temperatures of 3000, 4000, 5000 and 6000 kelvins.

Colour photography undertaken in the presence of fluorescent light sources, even when they are only present as background lighting, may result in unpleasant green or blue colour casts, especially on colour-reversal film, necessitating corrective filtration by means of colour-compensating filters over the camera lens.

Fluorescent lamps are supplied in the form of tubes of various lengths for use in a variety of domestic and industrial fittings. Domestic lamps operate at mains voltage and use a hot cathode, to maintain the discharge, which is usually initiated by a switch starter which produces a pulse of high voltage sufficient to ionize the gas. Cold-cathode fluorescent lamps use an emissive cathode at much higher voltages, and have instant-start characteristics. Such lamps, in grid or spiral form, were at one time widely used in large-format enlargers. However, such light sources are unsuitable for colour printing purposes. The life of a fluorescent tube is usually of the order of 7000 to 8000 h, and the output is insensitive to small voltage fluctuations.

Metal-halide lamps

At one time the only metals used in discharge lamps were mercury and sodium, as the vapour pressures of other metals tend to be too low to give adequate working pressure. However the halides of most metals have higher vapour pressures than the metals themselves. In particular the halides of lanthanide elements readily dissociate into metals and halides within the arc of a discharge tube. The ionised metal vapour emits light with a multi-line spectrum and a strong continuous background, giving what is virtually a continuous spectrum. The metals and halides recombine in cooler parts of the envelope. Compounds used include mixtures of the iodides of sodium, thallium and gallium, and halides of dysprosium, thulium and holmium in trace amounts. The discharge lamp is a very small ellipsoidal quartz envelope with tungsten electrodes and molybdenum seals. Oxidation of these seals limits lamp life to about 200 h, but by enclosing the tube in an outer casing and reflector with an inert gas filling, life can be increased to 1000 h.

The small size of this lamp has given rise to the term *compact-source iodide lamp* (CSI). Light output is very high, with an efficacy of 85–100 lumens per watt. A short warm-up time is needed. When operated on an AC supply the light output fluctuates at twice the supply frequency. Whereas the resulting variation in intensity is about 7 per cent for conventional tungsten lamps it is some 60 to 80 per cent for metal halide lamps. This can cause problems when used for short exposure durations in photography. Ratings of up to 5 kW are available.

Pulsed xenon lamps

Pulsed xenon lamps are a continuously-operating form of electronic flash device. By suitable circuit design a quartz tube filled with xenon gas at low pressure discharges at twice the mains frequency, i.e. 100 Hz for a 50 Hz supply, so that although pulsed the light output appears continuous to the eye. The spectral emission is virtually continuous, with a colour temperature of approximately 5600 K (plus significant amounts of ultraviolet and infrared radiation). Forced cooling may be needed. The physical dimensions of such lamps are small, and they are an excellent replacement for traditional carbon-arc lamps and for film projection. Power ratings up to 8 kW are available, and lamp life is 300 to 1000 h depending on type.

Flashbulbs

Most flashbulbs contain fine metal ribbon in an atmosphere of oxygen at low pressure, enclosed in a glass envelope with a lacquer coating to prevent shattering when fired. The metal ribbon in the smaller bulbs is hafnium or zirconium; larger bulbs use an aluminium-magnesium alloy. On ignition by the passage of electric current through a filament, a

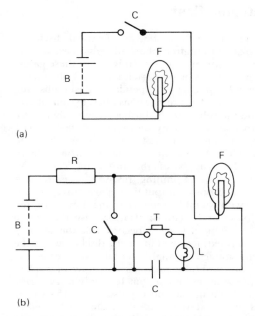

(a)

(b)

Figure 3.10 Flashbulb firing circuits. (a) Direct ignition from battery B (3–45 volts DC) to flashbulb F using shutter synchronization or 'open flash' contacts C: (b) Capacitor ignition where B is 15 or 22.5 volts, resistor R is 3–5 kilohms and capacitor C is 100–250 microfarads. Push-button switch T is for charge test lamp L

bright flash of light is emitted, of a duration ranging from about 0.01 s to 0.02 s, the larger bulbs emitting the longer flash. The spectrum of a flashbulb is continuous, with a colour temperature of about 3800 K. A transparent blue lacquer coating converts the colour temperature to 5500 K. Blue flashbulbs were originally intended for use with colour film, but they are equally suitable for black-and-white materials. In the case of *flashbulb arrays* such as 'flashcubes', four small clear flashbulbs, are each housed with their individual reflectors in an outer enclosure of transparent blue plastic material which acts as a colour conversion filter.

Flashbulbs, which are available in a limited range of sizes and types, are in most cases designed to be operated from dry batteries with a voltage range from about 3 to 30 volts. Although a circuit which connects a 3 V or 4.5 V battery directly across the bulb will fire the bulb, for greater reliability a battery-capacitor circuit is used (Figure 3.10). A battery is used to charge a capacitor through a high resistance. The discharge of the capacitor fires the bulb. A small 15 V or 22.5 V battery is commonly used in such a circuit; these cannot be used on their own to fire the flashbulb because of their high internal resistance. In the circuit shown in Figure 3.10 the capacitor is charged only when a bulb is inserted into a socket, so that battery life is con-

served if the flashgun is stored without a bulb in place. The resistor is of a value sufficiently high to ensure that the capacitor-charging current will not fire the flashbulb, but is low enough to give a short charging time. A test lamp is used to check on the state of charge. Such a circuit may be used to fire several flashbulbs simultaneously in a multiple-flash set-up. The limitations to this arrangement are the resistances of the connecting wires, which may be quite long. A better arrangement is to use slave units connected to the individual extension heads. In this system, one flashbulb is triggered from the camera shutter contacts, and the light emitted by it operates photocell switches installed in the slave units to give near-simultaneous firing.

Alternative methods are used for firing flashcubes and other arrays of bulbs in units intended primarily for simple cameras, to avoid the necessity for batteries. The 'Magicube' type uses mechanical firing of a special bulb containing a tube loaded with a priming chemical. Each bulb has its own external torsion spring. On releasing the shutter the primer tube is struck by the spring. The primer ignites and fires the filling. The time from firing to peak output intensity is a usefully short 7 milliseconds.

Alternatively, a piezo-electric crystal in the camera body produces the firing pulse when struck by a striker mechanism coupled to the camera shutter release. Bulbs in a spatial array are fired sequentially by current-steering thermal switches which in turn close circuit paths to the next bulb. Both of these arrangements require cameras with the firing arrangements included in their construction.

Flashbulb performance is usually depicted in the form of a graph of luminous flux emitted by the bulb plotted against time, as shown in Figure 3.11.

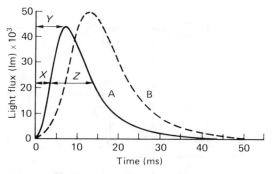

Figure 3.11 Flashbulb characteristics. The characteristics are shown on a graph of light output in lumens against time in milliseconds for a Magicube A and a Flip-Flash B. The time to half-peak is X, time to peak is Y and effective flash duration is Z, measured between half-peaks. For bulb A, X, Y and Z have values of 4, 7 and 9.5 ms respectively. For bulb B, X, Y and Z have values of 7, 13 and 14.5 ms respectively

Various parameters may be determined from such a graph. The *effective flash duration* is a measure of the motion-stopping power of the flash and is the time interval between half-peaks. The camera shutter must be fully open at the point of peak output. The total light output (in lumen seconds) is given by the area under the curve.

The *guide numbers* supplied by the manufacturer of the bulb are used to calculate camera exposure. A guide number is the product of the *f*-number N of the camera lens and the subject distance d in metres.

Guide numbers are quoted for a range of film speeds and exposure times for leaf shutters. They are subject to modification to suit the particular conditions of use, being influenced by the reflective properties of the surroundings of the subject. Guide numbers are calculated from the following formula:

$$\text{Guide number} = \sqrt{(0.004\ LtRS)}$$

where L is the maximum light flux in lumens, t is the exposure duration in seconds, R is the reflector factor and S is the arithmetic film speed.

A modification is necessary for units with built-in reflectors such as flashcubes, when it becomes

$$\text{Guide number} = \sqrt{(0.05\ EtS)}$$

where E is the *effective beam intensity* of the bulb. This quantity is measured by an integrating light meter across the entire angle of coverage of the reflector and is therefore not influenced by hot spots. It replaces the earlier measure of *beam candle power*, which was measured at the centre of the beam only, and could be misleading.

The problems of flash synchronization are discussed in Chapter 9.

Electronic flash

In an electronic flashtube, an electrical discharge takes place in an atmosphere of noble gas, usually xenon, krypton or argon or a mixture of these gases, resulting in emission of a brief, intense flash of light. Unlike the contents of expendable flashbulbs, the active components are not consumed by this operation and the tube may be flashed repeatedly, with a life expectancy of many thousands of flashes. The essentials of an electronic flash circuit are shown in Figure 3.12. A capacitor is charged from a high-voltage DC supply of the order of 350–500 V, through a current-limiting resistor. This resistor allows a high-power output from a low-current-rated supply with suitably long charging times, of the order of several seconds; also, because the charge current is limited the gas becomes de-ionized and the flash is extinguished after the discharge. At the charging voltage the high internal resistance of the gas in the flashtube prevents any flow of current from the main capacitor; but by apply a triggering voltage (typically a short pulse of 5–15 kV) by means of an external electrode, the gas is ionized and becomes conducting, allowing the capacitor to discharge rapidly through it, resulting in a brief flash of light. The triggering voltage is obtained from a spark coil arrangement using a triggering capacitor and transformer, and is activated by a switch, usually the shutter contacts in the camera. The voltage is limited to less than 150 V and 500 μA by positioning it on the low-voltage side of the spark coil, so that this voltage appears only on the contacts, preventing possible accidental injury to the user and damage to the shutter contacts. The trigger electrode may be in the form of fine wire around the flashtube or a transparent conductive coating.

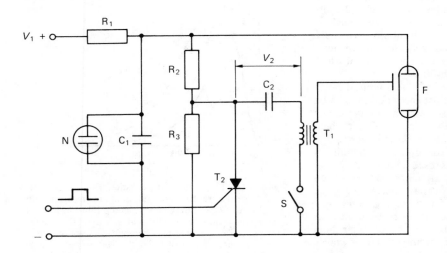

Figure 3.12 Basic electrical circuit for an electronic flashgun. The input voltage V_1 charges the main capacitor C_1 via limiting resistor R_1. The neon light N shows the state of charge reached. The trigger capacitor C_2 is charged by a primary trigger voltage V_2. R_2 and R_3 are limiting resistors. Closure of shutter contacts S and receipt of a pulse by the triggering thyristor T_2 causes C_2 to discharge through primary of trigger transformer T_1 to give a high voltage pulse to the external electrode of the flashtube F. The tube becomes conducting and C_1 discharges through it to produce a brief flash of light

The power output may be altered by switching additional capacitors in or out of circuit, or the current may be divided between two tubes or separate heads or by thyristor control etc. Low-power settings typically offer alternative outputs from ½ to 1/32 of full power in halving steps. Extension heads may be used for multiple flash arrangements and each head may have its own capacitor. If the extension head shares the main capacitor output the connecting lead must be substantial, to reduce resistance losses. For greatest efficiency the connection between capacitor and flashtube must be as short and of as low resistance as possible. One-piece or 'monobloc' studio flash units are examples of this type. The use of slave units facilitates multiple-flash operation.

Battery units

There are various alternatives for the power supply to charge up the capacitor of portable units. The simplest is a high-voltage dry battery, but this is heavy and expensive. The preferred alternative is a low-voltage battery giving 6–9 V with suitable circuitry to convert this into high voltage. Usually this consists of a transistorized oscillator to convert DC into AC (producing a characteristic whining noise); the voltage is increased by a step-up transformer and then rectified to DC once more. Additional circuitry may allow for operation directly from the mains supply, used for most studio flash units.

Batteries may be of the zinc-carbon variety, or alkaline-manganese for improved performance. Alternatively, rechargeable nickel-cadmium (NiCd) or lead-acid cells may be used. Additional circuitry may be incorporated for the recharging cycle, inside the unit. A visual state-of-charge indicator in the forms of floating coloured balls is used with lead-acid cells, as the relative density of the acid varies with the level of discharge. No such indication is possible with NiCd batteries, which typically have a lower capacity, only enough for about 40 full-power flashes (enough for a 36 exposure film) in the absence of energy-saving circuitry (see below). Such cells, however, are completely sealed and need no maintenance other than an occasional full discharge to prevent loss of capacity due to 'memory' effect if they are frequently recharged before being fully exhausted.

The energy input J in joules per flash (not all available as output) is given by the formula

$$J = \frac{CV^2}{2}$$

where C is the capacitance in microfarads and V is the voltage in kilovolts. Hand-held units for on-camera or in-camera use are rated at 20–200 joules. Large studio flash units are available with ratings of some 200–5000 joules. The state of charge of the capacitor, i.e. readiness for discharge, is indicated by a neon light or beeping sound circuit which is usually set to strike at about 80 per cent of maximum voltage, i.e. at about two-thirds full charge. Several seconds must be allowed to elapse after this to ensure full charge. If the flash is not then discharged, various forms of monitoring circuitry may be used to switch the charging circuitry on and off to maintain full charge with minimum use of the power supply while conserving battery power. Some units may be equipped with an arrangement that switches off the circuit if it is not used within a set period.

Flash duration and exposure

The characteristics of an electronic flash discharge are shown in Figure 3.13. The *effective flash duration* is generally measured between one-third-peak power points, and the area under the curve between these points represents approximately 90 per cent of the light emitted, measured in lumen-seconds or effective beam-candela-seconds. The flash duration t, as defined above, in a unit whose total tube and circuit resistance is R with a capacitor of capacitance C is given approximately by

$$t = \frac{RC}{2}$$

Consequently for a 1 ms duration flash, the requirements are for high capacitance, low voltage and a tube of high internal resistance. The flash duration is usually in the range 2 ms to 0.02 ms to effect a compromise between ability to stop motion and avoidance of the possible effects of high-intensity reciprocity law failure. Units may have a variable output, controlled either by switching in or out of additional capacitors or by automatic 'quenching' controlled by monitoring of scene or image luminance (see below), giving a suitable variation in either intensity or flash duration. For example, a studio flash unit on full power may have a flash duration of 2 ms, changing to 1 ms and 0.5 ms when half- and quarter-power respectively are selected. Some special flash units for scientific applications may have outputs whose duration is of the order of 1 microsecond but with only of the order of 1 joule of energy. The efficacy E of a flashtube is defined slightly differently from other sources as being

$$E = \frac{Lt}{J}$$

where L is the peak output (in lumens) during effective flash duration t and J is the input energy in joules.

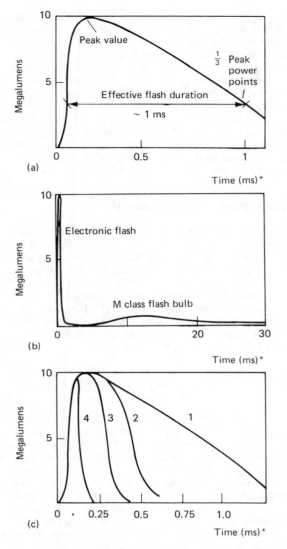

(a)

(b)

Electronic flash

M class flash bulb

(c)

*as measured from point where shutter is fully open

Figure 3.13 Characteristics of electronic flash: (a) Conventional graph of light output in megalumens against time in milliseconds; (b) comparison of electronic flash and a typical flashbulb; (c) variation of effective flash duration, curves 1 to 4, as the discharge is quenched for automatic exposure by a thyristor circuit

Subsequently, from the above characteristics, the guide number of a flash unit with reflector factor R used with a film of arithmetic speed rating S is given by

Guide number $= \sqrt{(0.005\ RSJE)}$

A useful practical point is that for a given flash unit the flash guide number for distance in metres for

ISO 100/21° film is usually incorporated in the designation number of the unit.

The usual practical restrictions apply to guide number values. The reflectors used with electronic flashguns are highly efficient and direct the emitted light into a well defined rectangular area with sharp cut-off, approximating to the coverage of a semi-wide-angle lens on a camera. Coverage may be altered to greater or lesser areas to correspond with the coverage of other lenses or a zoom lens by the addition of clip-on diffusers or by moving a Fresnel-type condenser lens in front of the flashtube to an alternative position. This 'zoom' feature may be controlled automatically by the camera itself.

The use of 'bounce' or indirect flash severely reduces the illumination on the subject and often needs corrective filtration with colour materials owing to the nature and colour of the reflective surface. This can be used to advantage, as when a golden-surfaced umbrella reflector is used to modify the slight blue cast given by some flash units, which may have colour temperatures of 6000 K or more. The main result of 'bounce' lighting is to produce softer, more even illumination. An umbrella-type reflector of roughly paraboloidal shape, made of translucent or opaque material, with white or metallic silver or gold finish, is a widely-used accessory item.

Modern studio units have the convenience of a 'modelling lamp' positioned within the usual helical discharge tube to give a preview of the proposed lighting. The modelling lamp may be a Photoflood or tungsten-halogen lamp, often with fan-assisted cooling, and its output may be variable, with the flash output selected so as to facilitate visual judgement of lighting balance. The flash output of a studio unit may be selected manually by switches or by remote control, using a cordless infrared programming unit used in the hand from the camera position. The flash output may be set within limits as precisely as one-tenth of a stop.

The calculation of the appropriate lens aperture setting may be arrived at from guide numbers, practical experience, exposure meter readings using modelling light illumination, or the use of an integrating flash meter. Automatic methods include the use of photocells to monitor the scene luminance or the image luminance on the film surface by reflected light to a photocell in the camera body during the flash discharge. This is termed *off-the-film (OTF) flash metering*. As a confirmation, a sheet of Polaroid instant film may be exposed to evaluate exposure and lighting, as well as to check that everything is operating satisfactorily.

The SPD of the flash discharge is basically the line spectrum characteristic of xenon, superimposed on a very strong continuous background. The light emitted has a correlated colour temperature of about 6000 K. The characteristic bluish cast given by elec-

tronic flash with some colour reversal materials may be corrected by a light-balancing filter with a low positive mired shift value, or by a pale yellow colour-compensating filter. Often the flashtube or reflector is tinted yellow or yellow-green as a means of compensation. The flashtube may be of glass or quartz, the former giving a cut-off at 300 nm, the latter at 180 nm. Both give an output up to 1500 nm in the infrared region. Consequently, an electronic flashgun can be a useful source of ultraviolet and infrared radiation as well as of visible light. A significant development in flashgun design has been the automation of camera exposure determination and consequent power saving advantages. This has been made possible by advances in opto-electronics and the use of solid-state rapid switching devices called *thyristors*.

A rapid-acting photosensor such as a phototransistor or silicon photodiode can monitor the subject luminance when it is illuminated by the flash discharge, and the resultant signal can be integrated until it reaches a preset level. The flash discharge can then be abruptly cut off at the correct exposure. The switch-off level is determined by the film speed and aperture in use. Typically, the integrating circuit is a capacitor which charges up to a preset voltage level, the time taken being a function of the intensity and duration of light reaching the photocell (Figure 3.14).

The discharge is switched off by the action of the thyristor. There are two design possibilities. First, the discharging capacitor may have its energy diverted into an alternative 'quench' tube, which is a low-resistance discharge tube connected in parallel

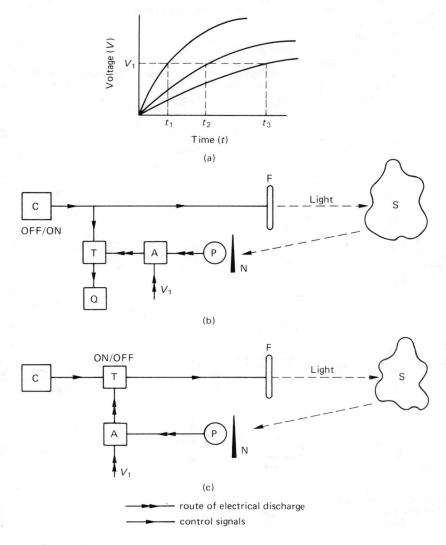

Figure 3.14 The operation of automatic electronic flash units: (a) Charging characteristics of the integrating capacitor shown as voltage against time. Voltage V_1 is the preset triggering level; (b) Arrangement of the quench tube and thyristor switch; (c) preferred power-saving arrangement
Key: C main capacitor, F flash tube, S subject, P photocell, T thyristor switch, Q quench tube, N neutral density wedge, A integrating amplifier preset to give a pulse to the thyristor at voltage V_1 of the charging curve of the timing capacitor as shown in (a). t_1, t_2 and t_3 are various flash durations determined by the operating conditions

with the main tube. The quench circuit is activated only when the main tube has ignited so as to prevent effects from other flashguns in use in the vicinity. There is no light output from the quench tube and there is a loss of energy. The effective flash duration, dependent on subject distance, reflectance and film speed, may be as short as 0.02 ms, with concomitant motion-stopping ability.

The second, preferred switching arrangement saves the residual charge in the capacitor and thereby reduces recharging time per successive flash and also increases the total number of flashes available from a set of batteries or charged cells. This energy-saving circuitry has the thyristor switch positioned between the main capacitor and the flashtube. The characteristic of the thyristor is that it may be closed on command, i.e. when the flash is initiated, and then opened almost instantaneously on receiving a pulse from the light-monitoring circuit to terminate the flow of current sustaining the flash. Obviously a high current-handling ability is needed. An added advantage is that full flash discharge is possible in manual mode simply by taking the monitoring photocell out of circuit or covering it over so that the 'open' pulse is never given. To allow for the use of different film speeds and lens apertures the photo-

cell may be biased electrically or mechanically. The former method would cause alterations in the firing voltage of the timing capacitor, so the latter is usually preferred and is also much easier, requiring only a vane-type mask or a turret of neutral-density filters over the photocell. The two types of circuit arrangement are shown in Figure 3.14. The small shoe-mounted housing of the photocell is attached to the flash unit by a flying lead, which allows monitoring of scene luminance irrespective of the flash-head position, and, in particular, allows for the use of bounce flash. It is desirable with flashguns having an integral photocell that this is positioned to face the subject irrespective of the direction in which a rotatable or swivelling flashtube may be pointed. Often a supplementary flashtube is integrated into the gun, giving a small direct flash towards the subject to offset some of the less desirable effects of the bounce lighting from the main tube.

Integral flash units

Many cameras have an integral flash unit of modest output. In the case of compact cameras this flash is automatically activated when the light level is too

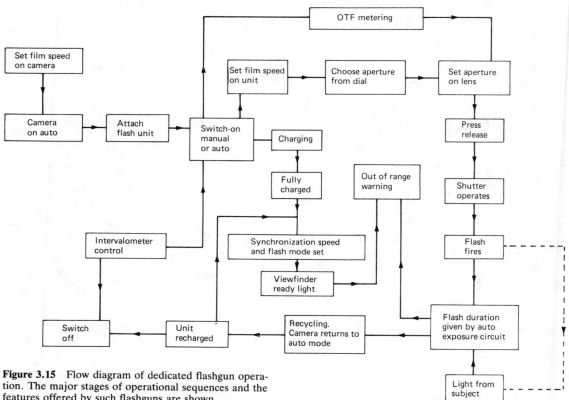

Figure 3.15 Flow diagram of dedicated flashgun operation. The major stages of operational sequences and the features offered by such flashguns are shown

low for an ambient-light exposure. The flash output may be just a single full discharge, the necessary lens aperture being set to the required value according to the guide number for the unit by using subject distance information from the autofocus system used in the camera. This has been referred to as a 'flashmatic' system. In more complex cameras, particularly the SLR type, the flashgun is often fully dedicated, i.e. its attachment may set various camera controls such as shutter speed and aperture. In addition, the flashtube may be used to emit a pre-flash pulse of light, possibly filtered to pass only the near infrared component, which is used to focus the camera in poor light conditions by an autofocus system, or to determine the necessary value of the aperture and other functions. The mode and state of the flash unit and suggested operating conditions may be given by a *liquid-crystal display (LCD)* on the unit itself, or by a *light-emitting diode (LED) (alphanumeric) display* in the camera viewfinder. A typical block diagram for dedicated-flash operation is shown in Figure 3.15. Synchronization of electronic flash is via the usual connections to the camera shutter or by hot-shoe arrangements whereby connection is made automatically on insertion of the flash unit into the camera accessory shoe. Additional electrical connections in the hot shoe provide the necessary interface for the additional features and functions of a dedicated flashgun. Such flashguns cannot be used with different makes of cameras unless there is provision for interchangeable modules to provide correct interfacing with the camera. The problems of flash synchronization to the camera shutter are dealt with in chapter 9.

4 The geometry of image formation

Interaction of light with matter

The results of the interaction of light with matter are fourfold: *absorption, reflection, transmission,* and *chemical change*. The first two of these always occur to some extent: transmission occurs in the case of translucent or transparent matter; and chemical change occurs under special circumstances which are described in Chapter 12. When light energy is absorbed it is not destroyed, but converted into some other form of energy, usually heat, but sometimes electrical or chemical energy. This chapter is concerned with the behaviour of light that is reflected or transmitted by matter, and in particular with the formation of an optical image.

Transmission

Some transparent and translucent materials allow light to pass completely through them apart from absorption losses. Such light is said to be *transmitted* and the *transmittance* of the material is the ratio of emergent luminous flux to incident luminous flux. *Direct transmission* (sometimes miscalled 'specular transmission') refers to light transmitted without scatter, as for example by clear glass. If scattering occurs as in a translucent medium, the light undergoes *diffuse transmission*, which may be uniform or preferential. The transmittance of such a medium may be defined as either general or in a specific direction. If *selective absorption* takes place for particular wavelengths of incident white light, then the material is seen as coloured, as in the case of a camera filter (see Chapter 11).

Reflection

Depending on the nature of the surface, particularly its smoothness, the reflection of light may be *direct* or *diffuse*. *Direct* or *specular reflection* is the type of reflection produced by a highly-polished surface such as a mirror, and is subject to the *laws of reflection* (Figure 4.1). Light incident on the surface is reflected at an angle equal to the angle of incidence. (The angles of incidence and reflection are both measured from the *normal*, i.e. the line perpendicular to the surface at the point of incidence.) The surface brightness of a directly-reflecting surface is highly dependent on viewpoint. A perfectly diffuse surface, on the other hand, reflects the incident light equally in all directions; thus its brightness or *luminance* is seen as constant irrespective of viewpoint. Few surfaces may have such extreme properties; shiny surfaces usually produce some scattered light, and matt surfaces may show a sheen. Reflection from most surfaces combines both direct and diffuse reflection and is known

Figure 4.1 Light ray reflected by a plane mirror; $i = r$

as *mixed reflection*. Depending on the properties of the incident light, the nature of the material and angle of incidence, the reflected light may also be partially or completely polarized (page 140). Objects in the world around us are seen mainly by diffusely reflected light which permits the perception of detail and texture, qualities not found in specular surfaces such as mirrors.

Figure 4.2 Light ray reflected by a matt surface

Reflectance is defined as the ratio of the reflected luminous flux to the incident luminous flux, and (as with transmittance) this may be defined as either general or in a specific direction. Surfaces commonly encountered have reflectances in the range 0.02 (2%) (matt black paint) to 0.9 (90%).

Refraction

When a ray of light being transmitted by one medium passes into another of different optical properties its direction is changed at the interface except in the case when it enters normally, i.e. perpendicular to the interface. The deviation, or refraction of the ray, results from a change in the velocity of light in passing from one medium to the next (Figure 4.3). Lenses utilize the refraction of glass to form *images*. Light travels more slowly in a denser medium, and a decrease (increase) in velocity causes the ray to be bent towards (away from) the normal. The ratio of the velocity in empty space to that within the medium is known as the *refractive index* of the medium. For two media of refractive indices n_1 and n_2 where the angles of incidence and refraction are respectively i and r, then the amount of refraction is given by Snell's Law:

$n_1 \sin i = n_2 \sin r$

Taking n_1 as air of refractive index approximately equal to 1, then the refractive index of the medium n_2 is given by

$n_2 = \sin i / \sin r$

Refractive index varies in a non-linear manner with wavelength, being greater for blue light than for red light, as the velocity of light in an optical medium depends on its wavelength. Thus any quoted value for refractive index applies only to one particular wavelength. The one usually quoted (n_d) refers to the refractive index at the wavelength of the *d* line in the helium spectrum (587 nm).

When light is transmitted by clear optical glass solids or prisms, refraction gives rise to other important effects such as *deviation, dispersion* and *total internal reflection* (figure 4.4). Deviation is the change of direction of the emergent ray with respect to the direction of the incident ray. In the case of a parallel-sided glass block, the emergent ray is not deviated with respect to the original incident ray;

but it is *displaced*, the amount depending on the angle of incidence and the thickness of the block and its refractive index. A non-parallel-sided prism deviates the ray by two refractions, the deviation D depending on the refracting angle A of the prism, and on its refractive index. But when white light is deviated by a prism it is also dispersed to form a spectrum. The dispersive power of the prism is not directly related to its refractive index, so it is possible to neutralize dispersion by using two different types of glass together, whilst retaining some deviation. In the case of lenses this allows rays of different wavelengths to be brought to a common focus (see Chapter 6).

For a ray of light emerging from a dense medium of refractive index n_2 into a less dense medium of refractive index n_1, the angle of refraction is greater than the angle of incidence, and increases as the angle of incidence increases until a critical value i_c is reached. At this angle of incidence the ray will not emerge at all: it will undergo total internal reflection (TIR).

At this *critical angle* of incidence, $i_c = \sin^{-1}(n_1/n_2)$. For air ($n_1 \cong 1$), and glass with $n_2 = 1.66$, i_c is 37°. TIR is used in reflector prisms to give almost 100 per cent reflection as compared with 95 per cent at best for uncoated front-surface mirrors. A 45° prism will deviate a collimated (i.e. parallel) beam through 90° by TIR; but for a widely-diverging beam the angle of incidence may not exceed the critical angle for the whole beam, and it may be necessary to metallize the reflecting surface.

Image formation

When light from an object has passed through some kind of optical system, the object may appear to the viewer as being in a different place (and probably of a different size). This phenomenon is described as the formation of an *optical image*. An optical system may be as simple as a plane mirror or as complex as

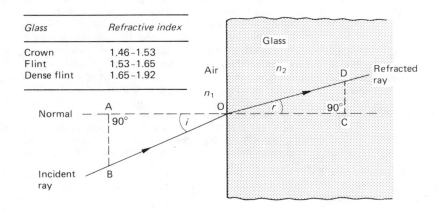

Glass	Refractive index
Crown	1.46–1.53
Flint	1.53–1.65
Dense flint	1.65–1.92

Figure 4.3 Light ray passing obliquely from air to glass

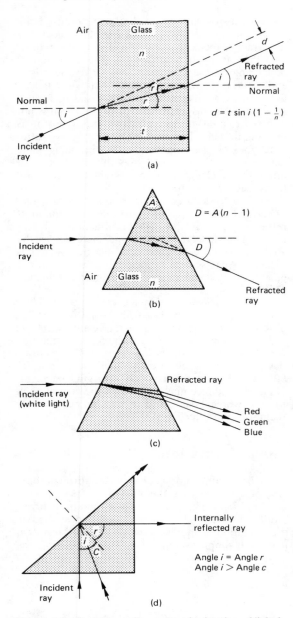

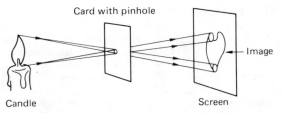

Figure 4.5 Formation of an image by a pinhole

rays from the object actually pass through it, and that, as light travels in straight lines, the image is *inverted*, and *laterally reversed* as viewed from behind the screen.* The ground-glass focusing screen of a technical camera shows such an image when used with a pinhole.

A pinhole is somewhat limited as a producer of real images, as the sharpness of the image depends on the size of the pinhole. There is an optimum diameter K for the pinhole, given by the approximate formula.

$$K = \frac{\sqrt{v}}{25}$$

where v is the distance from pinhole to screen. A larger hole gives a brighter but less sharp image. A smaller hole gives a less bright image, but this is also less sharp owing to diffraction (see Chapter 6). Although a pinhole image does not suffer from distortion, as images produced by lenses sometimes do, its poor light transmittance and low resolution limit its use to a few specialized applications.

The simple lens

A lens is a system of one or more pieces of glass bounded by (usually) spherical surfaces, all of whose centres are on a common axis, the *optical (or principal) axis*. A *simple* or *thin lens* is a single piece of glass whose axial thickness is small compared with its diameter, whereas a *compound* or *thick lens* consists of several *components*, or groups of components, some of which may comprise several *elements* cemented together. The need for such complexity is discussed in Chapter 6. A simple lens may be considered, at an elementary level, to be formed from a number of prisms, as shown in Figure 4.6. Light diverging from a point source P_1 and incident on the front surface of the positive lens is redirected by refraction to form a real image at point P_2. These rays are said to come to a *focus*. Alternatively, by using a negative lens, the incident rays may be further diverged by the refraction of the lens, and

Figure 4.4 Various consequences of refraction of light by glass prisms. (A) Light ray passing obliquely through a parallel-sided glass block, and resultant displacement d; (b) refraction of light caused by its passage through a prism, and resultant deviation D; (c) dispersion of white light by a prism; (d) total internal reflection in a right-angled prism, critical angle C

a well-corrected camera lens. A simple method of image formation is via a *pinhole* in an opaque screen (Figure 4.5). Two important properties of this image are that it is *real*, i.e. it can be seen on a screen as

*That is to say, it is as though the image had been rotated 180° *in its own plane.*

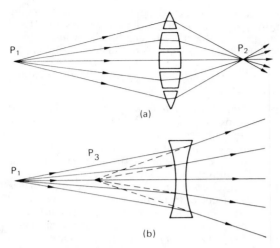

Figure 4.6 Negative and positive lenses: (a) A simple positive lens considered as a series of prisms: (b) formation of a virtual image of a point object by a negative lens

thus appear to have originated from a *virtual focus* at point P_3.

The front and rear surfaces of the lens may be convex, concave or plane; the six possible configurations of a simple lens are shown in cross-section in Figure 4.7. A meniscus lens is one in which the *centres of curvature* of the surfaces are both on the same side of the lens. Simple positive meniscus lenses are used as *close-up lenses* for many cameras.

Positive lenses

Double convex Plano-convex Positive meniscus

Negative lenses

Double concave Plano-concave Negative meniscus

Figure 4.7 Types of simple lenses

While the same refracting power in *dioptres* is possible with various pairs of curvatures, the shape of a close-up lens is important in determining its effect on the quality of the image given by the lens on the camera.

The relationships between the various parameters of a single-element lens of refractive index n_d, axial thickness q and radii of curvature of the surfaces R_1 and R_2 required to give a focal length f or *(refractive) power K* are given by the 'lensmakers' formula'

$$K = \frac{1}{f} = (n_d - 1)\left(\frac{1}{R_1} - \frac{1}{R_2} + \frac{(n_d - 1)q}{n_d R_1 R_2}\right)$$

For f measured in millimetres, $K = 1000/f$ in dioptres.

Image formation by a positive lens

Irrespective of the details of their construction, camera lenses are essentially similar to simple lenses in their image-forming properties. In particular, a camera lens always forms a real image if the object is a distance from it of more than one focal length. So far, only the formation of the image from a point source has been considered. It is more useful to consider the formation of the image of an extended object.

If the object is near the lens, the position and size of the optical image can be determined by considering the refraction of light diverging to the lens from two points at opposite ends of the object. Figure 4.8 shows this for a simple lens. The image is inverted, laterally reversed, behind the lens and real.

A distant object can to a first approximation be considered as being situated at infinity. All the rays from any point on the object that reach the lens are effectively parallel. The image is formed closer to the lens, inverted, laterally reversed and real as before. The plane in which the image of a distant object is formed is termed the *principal focal plane*. For a flat distant object and an 'ideal' lens, every point of the image lies in this plane. The point of intersection of the focal plane and the optical axis is termed the *rear principal focus* (or simply the *focus*) of the lens, and the distance from this point to the lens is termed the *focal length* (*f*) of the lens. Only for an object at infinity does the image distance *v* from the lens correspond to the focal length. As the object approaches the lens (i.e. object distance *u* decreases), the value of *v* increases (for a positive lens). If the lens is turned round, a second focal point is obtained; the focal length remains the same. The focal lengths of thick lenses are measured from different points in the lens configuration (see below). Finally, the distance of the focus from the rear surface of a lens is known as the *back focus* or *back focal distance*.

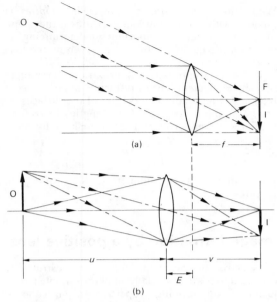

Figure 4.8 Image formation by a positive lens. (a) For a distant subject; F is the rear principal focal plane; (b) for a near subject; focusing extension $E = v - f$; I is an inverted real image

Formation of images by a compound lens

A lens is considered as 'thin' if its axial thickness is small compared to the object and image distances and its focal length, so that measurements can be made from the plane passing through its centre without significant error (Figure 4.9(a)). With a compound lens of axial thickness that is a significant fraction of its focal length, these measurements plainly cannot be made simply from the front or back surface of the lens or some point in between. However, it was demonstrated by Gauss that a thick or compound lens could be treated as a whole, and thin-lens formulae used to describe image formation, provided that the object and image distances were measured from two theoretical planes fixed with reference to the lens. This treatment of lenses is referred to as *Gaussian optics*, and holds for *paraxial* conditions, i.e. for rays the angle of which to the optical axis does not exceed about 10°.

Gaussian optics defines six *cardinal* or *Gauss points* for any lens or system of lenses. These are two *principal focal points*, two *principal points* and two *nodal points*. The corresponding planes through these points perpendicular to the optical axis are called the *focal planes, principal planes* and *nodal planes* respectively (Figure 4.9(b)). The focal length of a lens is defined in Gaussian optics as the distance

from a given principal point to the corresponding principal focal point. A lens thus has two focal lengths, an object focal length and an image focal length; these are, however, usually equal (see below).

The definitions and properties of the cardinal points are as follows:

(1) *Object principal focal point* (F_1) The point whose image is on the axis at infinity in the image space.

(2) *Image principal focal point* (F_2) The point occupied by the image of an object on the axis at infinity in the object space.

(3) *Object principal point* (P_1) The point that is a distance from the object principal focal point equal to the object focal length F_1. All object distances are measured from this point.

(4) *Image principal point* (P_2) The point that is a distance from the image principal focal point equal to the image focal length F_2. All image distances are measured from this point. The principal planes through these points are important, as the thick lens system can be treated (as it was by Gauss) as if the refraction of the light rays by the lens takes place at these planes only. An important additional property is that they are planes of unit magnification for conjugate rays.

(5) *Object nodal point* (N_1) and

(6) *Image nodal point* (N_2) These are a pair of planes such that rays entering the lens in the direction of the object nodal point leave the lens travelling parallel to their original direction as if they came from the image nodal point. Any such ray is displaced but not deviated. If a lens is rotated about its rear nodal point the image of a distant object will remain stationary. This property is used to locate the nodal points, and is the optical principle underlying one form of panoramic camera.

If the lens lies wholly in air, the object and image focal length (known as the *effective* or *equivalent focal length*) are equal, and the positions of the principal and nodal points coincide. This considerably simplifies calculations for the determination of image properties. The great value of Gaussian optics is that provided the positions of the object and cardinal points are known, the image position and magnification can be calculated with no other knowledge of the optical system. Knowledge of the positions of the cardinal points and planes can also be used for graphical construction of images.

In most lens systems the nodal points lie within the lens, but in some lenses, either or both the nodal points may be outside the lens, either in front of it or behind it. In a few cases the nodal points may actually be crossed. The distance between the nodal

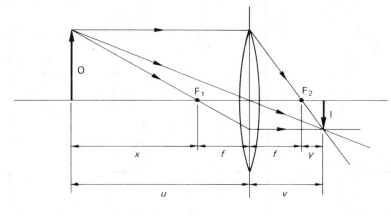

(a) Simple lens

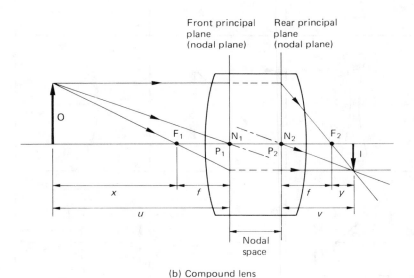

(b) Compound lens

Figure 4.9 Image formation by simple and compound lenses: (a) For a simple lens, distances are measured from the centre of the lens; distance y is the focusing extension; (b) for a compound lens, distances are measured from the principal or nodal planes (the principal planes coincide with the nodal planes when the lens is wholly in air)

points is called the *nodal space* or *hiatus*; in the case of crossed nodal points this distance is negative.

Graphical construction of images

The refractive action of a lens may perhaps be understood more easily if the paths of some of the image-forming rays are traced by graphical means. For a positive lens a few simple rules can be given, based on the definitions of lens properties.

(1) A ray passing through the centre of a thin lens is undeviated.

(2) A ray entering a lens parallel to the optical axis, after refraction, passes through the focal point of the lens on the opposite side.

(3) A ray passing through the focal point of a lens, after refraction, emerges from the lens parallel to the optical axis.

(4) A meridional ray (one in a plane containing the optical axis), entering the front nodal plane at a height X above the axis, emerges from the rear nodal plane at the same height X above the axis on the same side and undeviated (see Figure 4.9(b)).

These rules (except the last) are illustrated in Figure 4.10, together with their modification to deal with image formation by negative lenses and concave and convex spherical mirrors. Figure 4.10 shows how each type of lens and mirror actually forms an image.

34

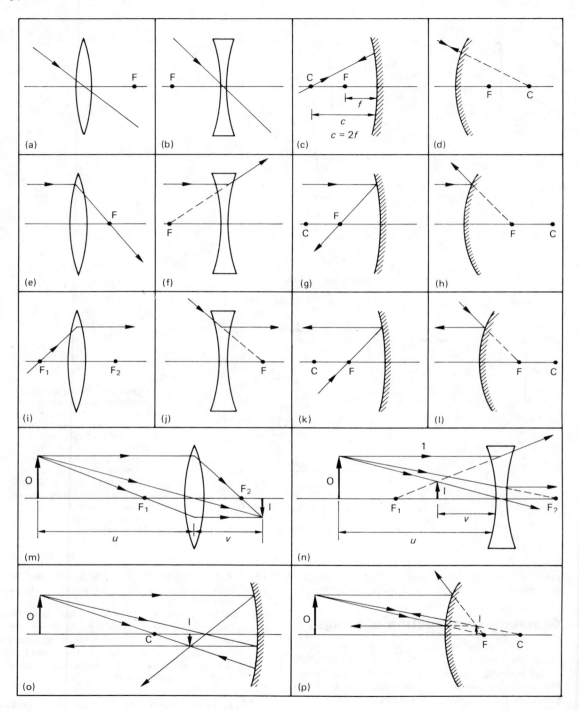

(a)

(b)

(c)
$c = 2f$

(d)

(e)

(f)

(g)

(h)

(i)

(j)

(k)

(l)

(m)

(n)

(o)

(p)

Figure 4.10 The graphical construction of images formed by simple lenses and spherical mirrors.

(a) A ray passing through the centre of a positive (i.e. convex) lens is undeviated

(b) A ray passing through the centre of a negative (i.e. concave) lens is undeviated

(c) A ray passing through the centre of curvature of a concave mirror is directed back upon itself

(d) A ray directed towards the centre of curvature of a convex mirror is directed back upon itself

(e) A ray travelling parallel to the optical axis of a positive lens, after refraction passes through the far focal point of the lens

(f) A ray travelling parallel to the optical axis of a negative lens, after refraction appears as if it had originated at the near focal point of the lens

(g) A ray travelling parallel to the optical axis of a concave mirror, after reflection passes through the focus of the mirror

(h) A ray travelling parallel to the optical axis of a convex mirror, after reflection appears as if it had originated from the focus of the mirror

(i) A ray passing through the near focal point of a positive lens, after refraction emerges from the lens parallel to the optical axis

(j) A ray travelling towards the far focal point of a negative lens, after refraction emerges from the lens parallel to the optical axis

(k) A ray passing through the focus of a concave mirror, after reflection travels parallel to the optical axis

(l) A ray directed towards the focus of a convex mirror, after reflection travels parallel to the optical axis

(m) An example of image construction for a positive lens using the three rules illustrated above

(n) An example of image construction for a negative lens

(o) An example of image construction for a concave mirror

(p) An example of image construction for a convex mirror

The lens equation

It is possible to derive a relationship between the conjugate distances and the focal length of a lens. With reference to Figure 4.11, a positive lens of focal length f with an object distance u forms an image at distance v.

From similar triangles ABC and XYC,

$$\frac{AB}{XY} = \frac{BC}{YC} = \frac{u}{v} \tag{1}$$

From the figure,

$$BF_1 = u - f \tag{2}$$

Also from similar triangles ABF and QCF

$$\frac{BF_1}{CF_1} = \frac{AB}{QC} = \frac{AB}{XY} \tag{3}$$

By substituting equations 1 and 2 in 3 we obtain

$$\frac{u - f}{f} = \frac{u}{v}$$

Rearranging and dividing by uf we obtain the *lens conjugate equation*

$$\frac{1}{u} + \frac{1}{v} = \frac{1}{f} \tag{4}$$

This equation may be applied to thick lenses if u and v are measured from the appropriate cardinal points.

The equation is not very suitable for practical photographic use as it does not make use of object size AB or image size XY, one or both of which are usually known. Defining *magnification (m)* or *ratio of reproduction or image scale* as $XY/AB = v/u$, and substituting into the lens equation and solving for u and v we obtain

$$u = f(1 + 1/m) \tag{5}$$

and

$$v = f(1 + m) \tag{6}$$

Because of the conjugate relationship between u and v as given by the lens equation above, these distances are often called the *object conjugate distance* and *image conjugate distance* respectively. These terms are usually abbreviated to 'conjugates'.

A summary of useful lens formulae is given in Figure 4.12, including formulae for calculating the combined focal length of two thin lenses in contact or separated by a small distance. A suitable sign convention must be used. For most elementary photographic purposes the 'real is positive' convention is usually adopted. By this convention, all distances to real objects and real images are considered to be positive. All distances to virtual images are considered as negative. The magnification of a virtual image is also negative. Some textbooks use a

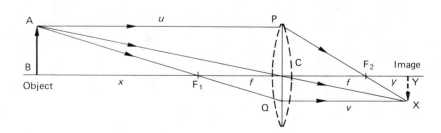

Figure 4.11 Derivation of the lens equation

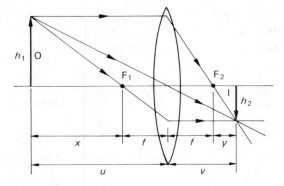

(a) Simple lens

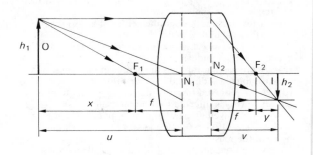

(b) Compound lens

1. $\dfrac{1}{u} + \dfrac{1}{v} = \dfrac{1}{f}$ $\left.\right\}$ $u = f\left(1 + \dfrac{1}{m}\right)$

2. $\dfrac{h_2}{h_1} = \dfrac{I}{O} = \dfrac{v}{u} = m$ $v = f(1 + m)$

3. For $u = \infty$, or for $u \gg v$, $v = f$ so that $m = \dfrac{f}{u}$

4. $xy = f^2$

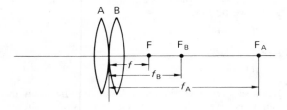

(c) Thin lenses in contact

$\dfrac{1}{f} = \dfrac{1}{f_A} + \dfrac{1}{f_B}$ or,

$\dfrac{1}{f} = P = P_A + P_B$

P is the 'power' (expressed in dioptres)

(d) Thin lenses separated by a small distance

$\dfrac{1}{f} = \dfrac{1}{f_A} + \dfrac{1}{f_B} - \dfrac{d}{f_A f_B}$

Figure 4.12 Some useful lens formulae

Cartesian convention in which the lens is at the origin; distances measured to the right are positive, and distances to the left are negative.

It is useful to note that when the object conjugate u is very large, as for a distant subject, the corresponding value of the image conjugate v may be taken as f, the focal length. Consequently, the magnification is given by $m = f/u$. Thus, magnification or image scale depends directly on the focal length of the camera lens for a subject at a fixed distance. From a fixed viewpoint, to maintain a constant image size as subject distance varies a lens with variable focal length is required, i.e. a *zoom lens* (see Chapter 7).

Field of view

The focal length of a lens also determines the angle of the *field of view* (FOV) as used in conjunctiuon with a given film format. The FOV is defined as the angle subtended at the (distortion-free) lens by the diagonal (K) of the film format when the lens is focused on infinity (Figure 4.13).

Given that the FOV angle A is twice the semi-angle of view θ, then:

$$A = 2\theta = 2\tan^{-1}\left(\dfrac{K}{2f}\right)$$

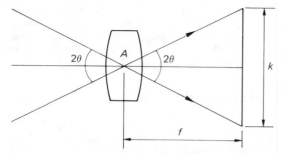

Figure 4.13 Field (angle) of view (FOV)

The field of view for a particular combination of focal length and film format may be obtained from Table 4.1. To use this table, the diagonal of the negative should be divided by the focal length of the lens; the FOV can then be read off against the quotient obtained.

As the subject becomes closer, the lens to film distance is increased, and the FOV decreases from its infinity-focus value. At unit magnification the FOV has approximately half the value obtained as compared with the FOV when the lens is focused on infinity.

Photographic lenses can be classified according to the field of view for the particular film format for which they are designed. There are sound reasons for taking as 'standard' a lens that has a field of view equal to the diagonal of the film format. For the most common formats this angle will be around 52°–53°. Wide-angle lenses can have FOVs up to 120° or more, and long-focus lenses down to 1° or

less. Table 4.2 gives a classification of lenses for various formats based on FOV.

Occasionally confusion may arise as to the FOV of a lens as quoted, because a convention exists in many textbooks on optics to quote the semi-angle θ, in which cases values given must be doubled for photographic purposes. It should also be noted that the FOV for the *sides* of a rectangular film format is always less than the value quoted for the diagonal.

The term 'field of view' becomes ambiguous when describing lenses that produce distortion, such as fish-eye and anamorphic objectives. In such cases it may be preferable to describe the angle subtended by the diagonal of the format at the lens as the 'angle of field' and the corresponding angle in the object space as the 'angle of view'.

Table 4.1 Table for deriving field of view of a lens

Diagonal/focal length	Field of view*
0.35	20°
0.44	25°
0.54	30°
0.63	35°
0.73	40°
0.83	45°
0.93	50°
1.04	55°
1.15	60°
1.27	65°
1.40	70°
1.53	75°
1.68	80°
1.83	85°
2.00	90°
2.38	100°
2.86	110°
3.46	120°

*These values are for a lens which produces geometrically correct perspective

Table 4.2 Lens type related to focal length and format coverage

Focal length (mm)	Nominal format (mm)	Angle of view (degrees on diagonal)	Lens type
15	24 × 36	110	EWA
20	24 × 36	94	EWA
24	24 × 36	84	WA
35	24 × 36	63	SWA
40	24 × 36	57	S
40	60 × 60	94	EWA
50	24 × 36	47	S
50	60 × 60	81	WA
50	60 × 70	85	WA
65	24 × 36	37	MLF
65	60 × 60	66	SWA
65	4 × 5 in	103	EWA
80	60 × 60	56	S
90	24 × 36	27	MLF
90	4 × 5 in	84	WA
135	24 × 36	18	LF
135	60 × 60	35	MLF
135	4 × 5 in	62	S
150	60 × 60	32	LF
150	4 × 5 in	57	S
200	24 × 36	12	LF
200	8 × 10 in	78	WA
250	60 × 60	19	LF
300	24 × 36	8	VLF
300	8 × 10 in	57	S
500	24 × 36	5	VLF
500	60 × 60	10	LF
500	4 × 5 in	19	LF
1000	24 × 36	2.5	ELF
1000	60 × 60	5	VLF
1000	4 × 5 in	9	LF
1000	8 × 10 in	19	LF

EWA extreme wide-angle
WA wide-angle
SWA semi wide-angle
S standard
MLF medium long-focus
LF long-focus
VLF very long-focus
ELF extreme long-focus

Covering power of a lens

Every lens projects a disc of light, the base of a right circular cone whose apex is at the centre of the exit pupil of the lens (page 48). The illumination of this disc falls off towards the edges, at first gradually and then very rapidly. The limit to this *circle of illumination* is set by the rapid fall-off due to *natural vignetting* (page 52) as distinct from any concomitant mechanical vignetting. Also, owing to the presence of residual lens aberrations, the definition of the image within this disc deteriorates from the centre of the field outwards, at first gradually and them more rapidly. By defining an acceptable standard of image quality, it is possible to locate an outer boundary defining a *circle of acceptable definition* within this circle of illumination. The negative format should be located within this circle (Figure 4.14). The extent of the circle of acceptable definition also determines the practical performance of the lens as regards the covering power relative to a given format. The covering power is usually expressed as an angle of view which may be the same as or greater than that given by the format in use. A greater FOV than set by the format is called *extra covering power* and is essential for a lens fitted to a technical camera or a *perspective-control (PC)* or 'shift' lens when lens displacement movements are to be used. The extra covering power permits displacement of the lens within the large circle of good definition until vignetting occurs, indicated by a marked decrease in luminance at the periphery of the format.

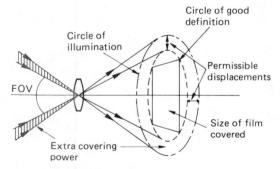

Figure 4.14 The covering power of a lens

Covering power is increased by closing down the iris diaphragm of a camera lens, because mechanical vignetting is reduced, and off-axis lens aberrations (see pages 59–64) are decreased by this action. The covering power of lenses for technical cameras is quoted for use at f/22 and with the lens focused on infinity. Covering power increases as the lens is focused closer; for close-up work a lens intended for

a smaller format may serve to cover a larger format, with the advantage of a shorter bellows extension giving the same magnification as a longer focal length which would normally cover the format in use.

Geometric distortion

A wide-angle lens, i.e. a lens with an angle of view of not less than 75°, is invaluable in many situations, such as under cramped conditions, and where exploitation of the steep perspective associated with the use of such lenses at close viewpoints is indicated. The large angle of view combined with a flat film plane (rather than the saucer-shaped surface that would intuitively be thought preferable), makes distortion of three-dimensional objects near the edge of the field of view very noticeable. The geometry of image formation by such a lens is shown in Figure 4.15. This form of geometrical distortion must not be confused with the curvilinear distortion caused by lens aberrations. Flat objects are of course not distorted in this way; a wide-angle lens can thus be used for the copying of flat originals. As an example of the distortion occuring with a subject such as a sphere of diameter $2r$, the image is an ellipse of minor diameter $2r$ and major diameter W, where $W = 2r \sec \theta$, given unit magnification and that r is small relative to the object distance. The term $\sec \theta$ is the *elongation factor* of the image.

Depth of field

Image sharpness

Any subject can be considered as made up of a large number of points. An ideal lens would image each of these as a point image (strictly, an Airy diffraction pattern) by refracting and converging the cone of light from the subject point to a focus. The purpose of focusing the camera is to adjust the image conjugate to satisfy the lens equation. The image plane is strictly correct for all object points in a conjugate plane, provided all points of the objects *do* lie in a plane. Unfortunately, objects in practice do not lie in a plane, and thus the image also does not lie in a single plane. Let us consider just two of the planes containing the object (Figure 4.16). For an axial point in both planes, each point can be focused in turn but both cannot be rendered sharp simultaneously. When the image of one is in focus the other is represented by an image patch, called more formally a *blur circle*. These circles of confusion are cross-sections of the cone of light coming to a focus behind or in front of the surface of the film.

This purely geometrical approach suggests that when photographing an object with depth, only one

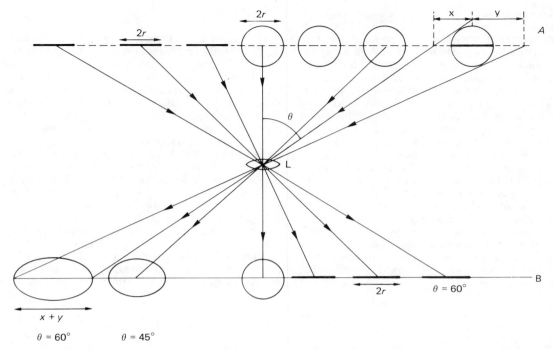

Figure 4.15 Geometric distortion. An array of spheres of radius *r* and lines of length 2*r* in the subject plane A are imaged by lens L in image plane B at unit magnification.

The lines retain their length independent of field angle θ, but the spheres are progressively distorted into ellipses with increase in θ

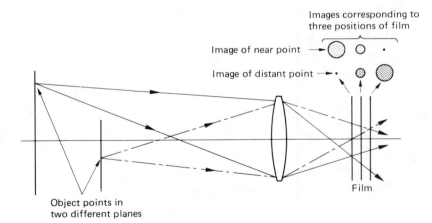

Figure 4.16 Object and image points

plane can be in sharp focus and all other planes are out of focus. yet in practice we do obtain pictures of objects with considerable depth that appear sharp all over. The reason is that the eye is satisfied with something less than pin-point sharpness. In the absence of other image-degrading factors such as lens aberrations or camera shake, a subjective measure of image quality is its perceived sharpness, which may be defined as the adequate provision of resolved detail in the image. If you inspect a photograph containing subject matter covering a considerable depth you will see that the sharpness of the image does vary with depth. Detail both in front of and behind the point of optimum focus may, however, be rendered adequately sharp, giving a zone of acceptably sharp focus; this zone is termed the *depth of field*. (The term applies only to the object space and should not be confused with the related *depth of*

focus which applies to the conjugate region near the focal plane in the image space.) Depth of field is of great importance in most types of photography, the manipulation of its positioning and extent being an important creative control. Knowledge of the means of extending, restricting or simply achieving depth of field is a vital skill in practical photography.

Manipulation of a camera and lens will demonstrate the control of depth of field possible by a choice of the focal length and aperture of the lens together with the focused subject distance (Figure 4.17). The various movements of a technical camera, described in Chapter 10, can also be used.

Depth of field can be quantified and calculated in terms of these three variables, but first it is necessary to consider what exactly 'an acceptable standard of sharpness' means in terms of a photographic record such as a print viewed in the hand. The depth-of-field boundaries are not as a rule sharply defined; usually there is a blending of acceptably sharp into less sharp detail. Much depends on the viewing conditions.

Visual acuity

Perception of detail, judgement of its sharpness, and depth of field in a photograph depend largely upon viewing distance and visual acuity, though other factors such as image contrast and ambient illumination are also significant. Normal vision requires muscular action to alter the refractive state of the eye in order to focus. This internal focusing is called *accommodation*, and physiological limitations set a comfortable 'near distance of distinct vision' (D_v) of some 250 mm. The resolving power of the eye, or visual acuity, is the ability to discriminate fine details of objects in the visual field of view, and it decreases radially. It may be specified as the width of an object at a specific distance or as the angle subtended by this object or even as the width of its retinal image, that is just resolved by the eye. For example, in ideal conditions a high-contrast line of width 0.075 mm can be perceived at D_v, subtending an angle of approximately 1 minute of arc, and representing an image on the retina of the eye of

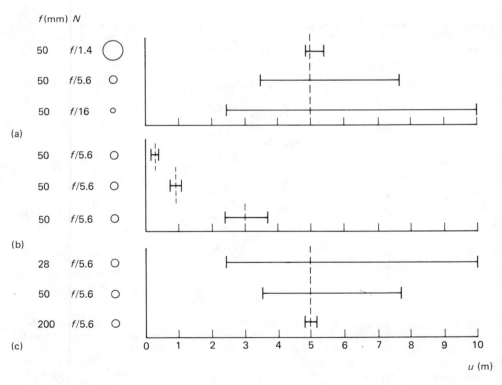

Figure 4.17 Depth of field. Three variables in general determine depth of field T at a constant value for the circle of confusion. (a) Lens aperture N, varying from $f/1.4$ to $f/16$ with a 50 mm lens focused at 5 m. (b) Focused distance u, varying from 0.5 to 3 m with a 50 mm lens at $f/5.6$. (c) Focal length f varying from 28 to 200 mm at $f/5.6$ focused on 5 m

some 5 micrometres in width. The performance is limited by the structure of the retina, which consists of light receptors of finite size. This limiting performance is seldom achieved, and a lower value of 0.1 mm line width at D_v is commonly adopted. Converted into resolving power, an acuity of 0.1 mm corresponds to a spatial cycle of 0.2 mm, being the width of the line plus an adjacent identical space such as is used on a bar-type resolution test target, giving a value of 5 cycles per mm for the average eye.

Circle of confusion

It follows that for a photograph viewed at D_v, any subject detail resolved and recorded optically, that is smaller than 0.2 mm in general dimensions may not be perceptible to the unaided eye. Thus any detail finer than this size is not required. This leads to a practical definition of resolving power. A limit is set to the size of an image blur that is not distinguishable from a point (by the unaided eye), and this is called the (minimum permissible) circle of confusion. This is arrived at by empirical means. A photograph is viewed in a *cone of vision* where acceptable visual acuity is given over a FOV of some 50 to 60 degrees. The *comfortable viewing area* has a diameter of some 290mm at D_v. The acceptable circle of confusion is derived from what is accepted as satisfactory definition within this area.

The obsolete 'whole-plate' size of 6½ × 8½ inches (165 × 216 mm, with a diagonal of some 270 mm), fitted neatly into the cone of vision at a distance of about 10 inches, and indeed for early photography was the usual size for contact prints for hand viewing. The standard lens for this format had a focal length of 10 inches (250 mm), and a contact print

viewed at D_v gave correct perspective (page 46). A value of 0.2 mm or so could be used for C to determine the required lens performance and depth of field.

The advent of smaller formats, especially 24 × 36 mm, necessitated enlargement to give a print for viewing at D_v with correct perspective (Figure 4.18). According to the rules of perspective, a satisfactory visual rendering is given of an image corresponding spatially to the original scene when viewed at a distance equal to the focal length of the taking lens. Strictly a 24 × 36 mm image taken with a 50 mm lens should be viewed as a contact print at 50 mm, which is less than D_v. In practice an enlargement is viewed at 250 mm, but correct perspective is retained providing the proportional increase in viewing distance corresponds numerically to the degree of enlargement or print magnification M. Obviously the value of C in the camera image must be related to subsequent enlargement and correspondingly reduced as enlargement increases. A linear enlargement of × 8 from a 24 × 36 mm negative is common practice: it gives a resultant print of 192 × 288 mm, suited to 8 × 10 inch (203 × 254 mm) print material, a size readily viewable within the cone of vision. This implies a minimum resolving power of 40 cycles/mm for the camera lens, the product of × 8 enlargement and visual performance of 5 cycles/mm. The latter value also relates usefully to the resolving power of photographic printing paper which is approximately 6 cycles/mm.

To summarize, the permissible diameter of the circle of confusion must be reduced if subsequent enlargement is to take place. In practice values of C from 0.025 to 0.033 mm are used for the 24 × 36 mm format to allow × 8 enlargement. Values of 0.06 mm and 0.1 mm are used for medium and large formats respectively.

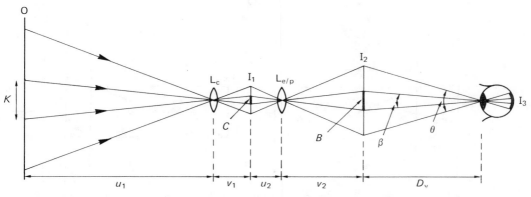

Figure 4.18 Geometry of the blur circle. Subject plane O with detail K is imaged by camera lens L_C at I_1, then re-imaged by enlarger or projector lens $L_{e/p}$ at I_2 and finally imaged on the retina at I_3. The circle of confusion C is seen as blur circle B in the cone of vision angle θ. Visual acuity is $1/\beta$. Relationships are: $m = v_1/u_1$, $M = v_2/u_2$, $K = C/m$, $B = CM$, $\beta = B/D_V$

It is worth noting that in the early days of small-format photography a criterion of 1/1000 of the focal length of the lens was used for C, giving 0.05 mm for the 50 mm lens, which was for a long time the standard lens used for the 24 × 36 mm format, and correspondingly different values for different focal lengths. This criterion was in use for many years and is still quoted by some sources. It gives values for depth of field which imply different degrees of enlargement for different focal lengths. Some confusion has arisen on depth-of-field matters, especially in the provision of tables and scales, as well as comparisons between equivalent lenses from different sources. The idea of $C = f/1000$ is now deprecated, and instead the value of C is taken as constant for a given format, for the whole range of lenses.

Depth of field equations

Useful equations for the calculation of depth of field (and depth of focus) are derived from the geometry of image formation as shown in Figure 4.19. A lens of focal length f is focused on subject plane O, distant L from the front principal plane P_1, with conjugate image plane I distant L' from P_2. Image magnification is m. The entrance and exit pupils E_N and E_X have diameters D and d respectively. Plane O is also distant u from E_N. There are two other planes, 1 and 2, at distances R and S from E_N, rays from which to E_N intersect plane O in small circles of diameter K to be imaged in plane I as circles of confusion, diameter C, where $C = mK$.

In the object space, from similar triangles,

$$S = \frac{uD}{D - K} \tag{7}$$

$$R = \frac{uD}{D + K} \tag{8}$$

Now $m = L'/L = v/u$, and the effective aperture $N' = v/D$, so that $D = um/N'$. Taking $D = uL'/N'L$ and also $K = CL/L'$, then, substituting for D and K in equations 7 and 8,

$$S = \frac{u(uL'/N'L)}{(uL'/N'L)-(CL/L')} \text{ and } R = \frac{u(uL'/N'L)}{(uL'/N'L)+(CL/L')}$$

So that

$$S = \frac{u^2(L')^2}{u(L')^2 - N'CL} \text{ and } R = \frac{u^2(L')^2}{u(L')^2 + N'CL}$$

Considering the general photographic case, for distant subjects where m is less than unity, the object plane is near infinity, so we may put $L' \cong f$. Likewise, N', the effective aperture, may be replaced by N, the relative aperture. For simple and symmetrical lenses, the pupils are located in the principal planes, so we may take $L = u$. Hence

$$S = \frac{uf^2}{f^2 - NCu} \tag{9}$$

$$R = \frac{uf^2}{f^2 + NCu} \tag{10}$$

The values of S and R define the *far* and *near limits* respectively of the depth of field, when the lens is focused on distance u. The values may be tabulated in various ways, displayed in graphical form or as depth-of-field scales on the focusing mounts of lenses (Figure 4.20).

If depth of field (T) is defined as $T = S - R$ then

$$T = \frac{2f^2u^2NC}{f^4 - N^2C^2u^2} \tag{11}$$

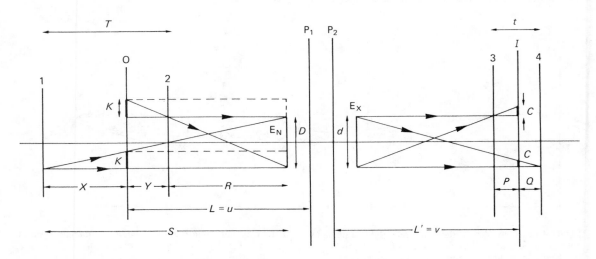

Figure 4.19 Geometry of image formation for depth of field

(a)

(b)

Figure 4.20 (a) Depth of field indicator scale; (b) coupled indicator

For practical purposes the $N^2C^2u^2$ term in the denominator may be disregarded, so to a first approximation

$$T = \frac{2u^2NC}{f^2} \tag{12}$$

This equation 12 finds many useful applications.

Depth of field is directly proportional to the diameter of the circle of confusion, the f-number and the square of the focused distance, and inversely proportional to the square of the focal length of the lens. Subject distance and focal length have the greatest influence; doubling the value of u increases T fourfold, while doubling focal length reduces T (at a fixed distance) by a factor of four.

It is of interest to note that equation 10 shows that a short-focus lens yields more depth of field than one of longer focus, provided that both are used to give the same magnification of a particular subject, in which case the two values of u differ. For example, using $C = 0.025$ mm, a lens of focal length 100 mm focused at 5 m and with an aperture of $f/4$ gives a magnification of 0.0204 and depth of field 501 mm. If a lens of focal length 25 mm is used, with u reduced to 1.25 m to give the same magnification, the depth of field at $f/4$ is now 521 mm, a little greater. However, subjective effects regarding the changed viewpoint for the subject and different performances from the two lenses can give a further subjective impression of a greater depth of field, as there is no fixed boundary that separates 'sharp' from 'unsharp'.

When the subject is closer, say 2 m for the 100 mm lens and a corresponding 0.5 m for the 25 mm lens,

the depth of field at $f/4$ is 80 mm for both lenses, so that, in theory, there should be no difference.

The differences in practice are due to the approximations and assumptions made in deriving the formulae. Use of the simplified equation 11 gives identical results in both examples. In the alternative case of a fixed viewpoint and constant u, with the value of f altered by use of a zoom lens (or interchangeable lens) followed by different degrees of enlargement to give the same final print magnification, then when viewed at D_v the depth of field will be seen to reamin essentially constant when the actual diameter of the aperture of the lens remains unaltered. Thus combinations of 100 mm at $f/11$, 50 mm at $f/5.6$ and 25 mm at $f/2.8$, all have the same depth of field for a fixed viewpoint.

Note that the use of the criterion of $C = f/1000$ gives different values for both lenses in the example above and would indicate that depth of field is greater for the longer focal length in such circumstances, which is incorrect.

Departures from theory

The theory developed above assumes a truly circular circle of confusion; but this is not always so and marked departures from circular are found in anamorphic lenses, lenses with uncorrected aberrations and catadioptric (mirror) lenses. The 'circle of confusion' for the last of these is an annulus (caused by the central opaque disc inside the lens), and its effect can clearly be seen in out-of-focus detail. In the special case of a soft-focus lens, where undercorrected spherical aberration is used to give the desired soft effect with a core of sharpness, the diameter of the blur circle cannot be defined and calculations are meaningless. The so-called deep-field lens is often incorrectly taken to mean a lens possessing enhanced depth of field, but the effect is due to anti-reflection coatings which provide increased light transmittance, so that a reduced aperture may be used for a given exposure level compared with a lens of lower transmittance. It is the smaller aperture that gives the increased depth of field, not any special correction of aberrations. In practice, for an ordinary aberration-limited lens, progressive stopping down brings the depth of field closer to predicted values until diffraction effects occur.

Hyperfocal distance

Maximum depth of field in any situation is obtained by use of the hyperfocal distance. The value of S, the far limit of T, is given by equation 9. The *hyperfocal distance h* is defined as the value of a particular focus setting u of the lens, which makes S equal to infinity. The necessary condition is

$f^2 = NCu;$

then, as $u = h$,

$$h = \frac{f^2}{NC} \tag{13}$$

The concept of h allows simplification of equations 9 and 10 to

$$S = \frac{hu}{h - u} \tag{14}$$

$$R = \frac{hu}{h + u} \tag{15}$$

And likewise

$$T = \frac{2hu^2}{h^2 - u^2} \tag{16}$$

From equation 15, if u equals h, then R is $h/2$; when u is infinity, then R equals h. So if the lens is focused at a distance u so that u equals h, then the near limit of the depth of field is $h/2$. This gives the maximum depth of field, from infinity to $h/2$, for a given aperture N.

Simple cameras with fixed-focus lenses are constructed with the focus set on the hyperfocal distance (for the maximum aperture if this is variable) so as to give maximum depth of field.

Close-up depth of field

Close-up photography is defined as photography where the distance from the subject to the lens is such that magnification m is in the range 0.1 to 1.0. Referring again to Figure 4.19, the close-up depth of field T may be taken as the sum of distances X and Y, the respective distances of planes 1 and 2 from the plane of focus O, where

$$X = \frac{uK}{D - K}$$

$$Y = \frac{uK}{D + K}$$

As these planes are close to the entrance pupil, the value of K is much smaller than D and so can be neglected in the denominators, giving

$$X = Y = \frac{uK}{D}$$

Now u/D can be replaced by N'/m, and also $C = mK$, therefore

$$X = Y = \frac{CN'}{m^2}$$

The effective aperture N' may be replaced by $N(1 + m)$, where N is the marked f-number. As $T = X + Y$, we have

$$T = \frac{2CN(1 + m)}{m^2} \tag{17}$$

Equation 17 does not involve focal length directly, so for a given magnification a long focal length is preferably to a short focal length, as it gives a longer working distance and better perspective by virtue of its more distant viewpoint, without any difference in depth of field for a given f-number. Unlike general photography, the final magnification Z in the print of the subject is usually stated. So for a print enlargement of M, $Z = mM$.

Depth of focus

The term *depth of focus* applies only to the image space (Figure 4.21) and is the tolerance in the position of the film plane I, which depends on the acceptable diameter C of the circle of confusion (Figure 4.19). Alternatively, it may be regarded as the distance between the conjugate planes 3 and 4 either side of image plane I, corresponding to planes 1 and 2 respectively, which define depth of field. Planes 3 and 4 are distant P and Q respectively from plane I, and the cones of light from the exit pupil E_x of diameter d coming to a focus on planes 3 and 4 form blur circles of diameter C on plane I, which is distant v from P_2, the rear principal plane.

From similar triangles,

$$P = \frac{vC}{d + C}$$

$$Q = \frac{vC}{d - C}$$

But C is small compared with d and may be removed from the denominators, so

$$P = Q = \frac{vC}{d}$$

Remembering $N' = v/d$ and also $N' = N(1 + m)$, the depth of focus t is the sum of P and Q, so

$$t = 2CN(1 + m) \tag{18}$$

$$t = \frac{2CNv}{f} \tag{19}$$

For general photography where m is small, equations 18 and 19 reduce to

$$t = 2CN \tag{20}$$

It can be seen that for a large-aperture lens the depth of focus is small and the film gate must be accurately perpendicular to the optical axis. The necessary tolerances can be relaxed for large formats where C is greater and small apertures are used; but even so, a 75 mm $f/4.5$ wide-angle lens used on a 4×5 inch format has only 0.9 mm depth

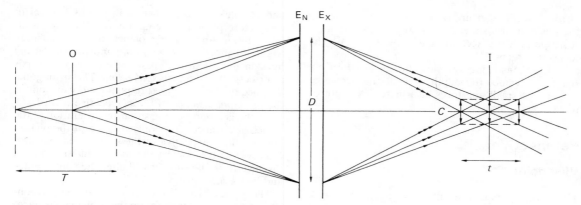

Figure 4.21 Conjugate relationship between depth of field and depth of focus

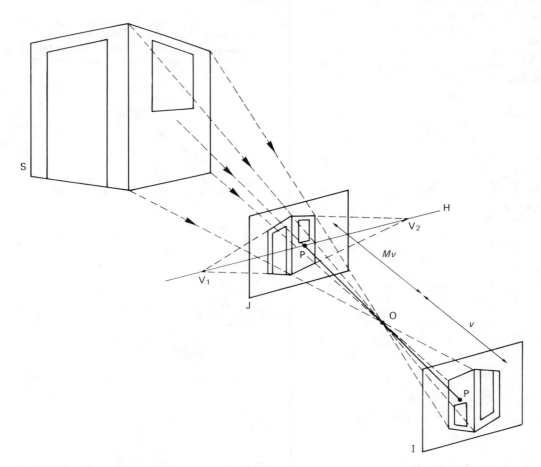

Figure 4.22 Elements of central perspective. In the diagram S represents the subject, I the optical image, O the centre of perspective, P the principal point, OP the principal distance, J the perspective of the subject or picture plane, V_1 and V_2 the vanishing points, H the horizon line

of focus at full aperture (assuming *C* is 0.1 mm), so the position of a sheet of film in a dark-slide must correspond very accurately to the plane of the focusing screen.

When a lens is focused close up, so that *m* has a significant value, the depth of focus is increased. The use of small apertures also increases depth of focus.

Perspective

Viewpoint

The term 'perspective' literally means 'to look through', and an accurate record of the spatial relationships of objects in a scene can be obtained by placing a glass plate, 'the picture plane', in the observer's FOV, and tracing the necessary outlines on it. The reduced-size facsimile records the intersection of the projection of each subject point, converging to the *centre of perspective* or *viewpoint* (Figure 4.22).

The viewpoint is the pupil of the eye of the observer. Conventionally the picture plane is vertical, so that vertical lines in the subject remain vertical and parallel. Horizontal lines in planes parallel to the picture plane also remain horizontal and parallel, but in inclined subject planes they will converge to one or more *vanishing points*, positioned on the horizon line of the facsimile where the visual axis intersects it at the *principal point*. The orthogonal distance between the picture plane and viewpoint is the *principal distance* of the perspective record.

By the geometry of the situation, alteration of the principal distance alters only the size of the picture and not the perspective of the spatial relationships. However, alteration of the viewpoint in terms of distance from the subject will alter the convergence and hence alter perspective.

The perspective of the scene is correctly reconstructed only by viewing from the principal distance, which is then termed the *viewing distance* (*D*).

Camera viewpoint

A camera records a three-dimensional scene as a two-dimensional planar image in the print. By placing the camera lens at the viewpoint, familiar photographic parameters replace the terminology of perspective as defined above.

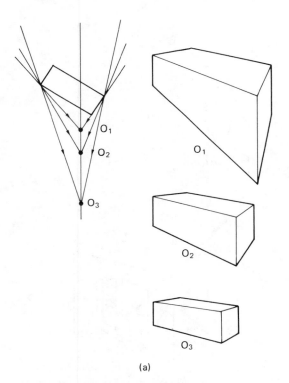

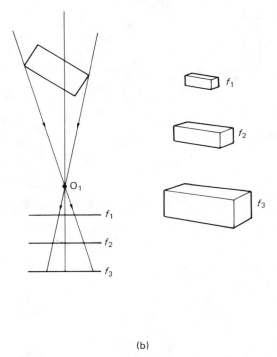

(a) (b)

Figure 4.23 Perspective in relation to viewpoint and focal length. (a) Subject appearance due to reducing viewpoint distance and increasing the field of view of the lens;

(b) from a fixed viewpoint, an increase in principal distance or focal length leaves the perspective unchanged

The convergent rays form a *central perspective* by passing through the lens, and continue diverging beyond the viewpoint to an image plane conjugate to the subject plane. The principal distance is now the image conjugate v, commonly taken as the focal length f for distant scenes. The facsimile or photographic record is now inverted and laterally reversed but can be contact printed and 'flopped' to position in the picture plane for viewing at correct distance $D = v$.

Various points need clarification. By altering the lens to one of longer focal length v is increased and the image enlarged; but it retains identical perspective. So a charge of focal length for a given viewpoint does not alter perspective but only image size. By altering viewpoint by changing the object conjugate u, the perspective *does* change, the more obviously since a lens of large FOV may be used to include the same area of the subject from a closer viewpoint, (Figure 4.23). Such 'steep' perspective can be used to dramatic effect.

The centre of perspective of a camera lens is the centre of the entrance pupil for object space and the centre of the exit pupil for projection into image space. The correct viewing distance is then given by

$$D = v = f(1 + m)$$

This theoretical value of D cannot usually be used, especially if it is less than D_v. Small images need to be enlarged by magnification M for comfortable viewing and the viewing distance is then given by

$$D = Mv$$

For distant scenes, v is replaced by f as usual.

The correct-viewing-distance criterion is seldom observed for photographic images, prints being viewed at a convenient distance, irrespective of the values of f and M used (usually these are not known to the observer). Incorrect viewing gives rise to perspective distortions. In pictorial terms, a near viewpoint gives a steep perspective with large changes of scale in a subject, while a distant viewpoint gives a flattened perspective with only small changes of scale even in a subject of considerable depth. The perspective of a print viewed from too great a distance tends to appear steep, while that of a print viewed from too short a distance tends to appear flat. This is the reverse of the perspective effects achieved on taking the picture.

5 The photometry of image formation

The light-transmitting ability of a photographic lens, which determines the illuminance of the image at the film plane, is usually referred to as the *speed* of the lens. Together with the effective emulsion speed and the subject luminance, it determines the exposure duration necessary to give a correctly-exposed result. The separate problem of the determination of camera exposure is dealt with in Chapter 20. In the sections below the factors influencing image illuminance are examined in detail.

Stops and pupils

An optical system such as a camera and lens normally has two *stops* located within its configuration. The term 'stop' originates from its original construction of a hole in an opaque plate perpendicular to the optical axis. One of these is the *field stop* or film gate; this determines the extent of the image in the focal plane.

The *aperture stop* is located within the lens or close to it, and determines the light transmittance of the lens. It also controls depth of field (Chapter 4) and lens performance, in terms of the accuracy and resolution of the image.

In a simple lens the aperture stop may be fixed, or it may have one or two alternative settings. A compound lens is usually fitted with a variable-aperture stop called an *iris diaphragm* because of its similar function to the iris in the human eye. The iris diaphragm is continuously adjustable between its maximum and minimum apertures. The usual construction is five or more movable blades, providing a more or less circular opening. The blade adjustment control or aperture ring may have click settings at whole and intermediate values. In practical photography the maximum aperture as well as the aperture range is important, as it is one of the main controls in picture making.

In a compound lens with an iris diaphragm located within its elements, the apparent diameter of the iris diaphragm when viewed from the object point is called the *entrance pupil* (E_N). Similarly, the apparent diameter of the iris diaphragm when viewed from the image point is called the *exit pupil* (E_X) (Figure 5.1). These are virtual images of the iris diaphragm, and their diameter is seldom equal to its actual diameter. To indicate this difference the term

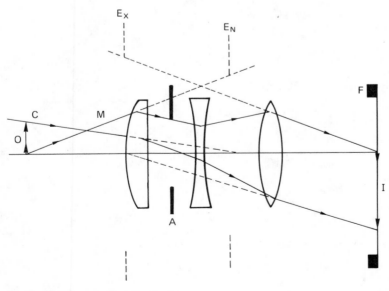

Figure 5.1 Stops and pupils of a lens

pupil factor or *pupil magnification* is used; this is defined as the ratio of the diameter of the exit pupil to that of the entrance pupil. Symmetrical lenses have a pupil factor of approximately one; on the other hand, telephoto and retrofocus lenses (page 76) have values that are respectively less than and greater than unity. Pupil magnification affects image illuminance, as will be seen later. Note that the pupils are not in general coincident with the principal planes of a lens.

Aperture

The light-transmitting ability of a lens, usually referred to loosely as *aperture* (in deference to the control exercised by the iris diaphragm) may be defined and quantified in various ways. Lenses are usually fitted with iris diaphragms calibrated in units of *relative aperture*. This is represented by a number N, which is defined as the equivalent focal length f of the lens divided by the diameter d of the entrance pupil. This diameter is sometimes referred to erroneously as the effective aperture of the lens in contrast to the actual aperture of the lens, which is the mean diameter of the actual aperture formed by the diaphragm opening (this is not necessarily circular). The term *effective aperture* properly refers to the relative aperture as corrected for a lens that is not focused on infinity.

Relative aperture, expressed mathematically, is

$N = f/d$ (for infinity focus).

Thus a lens with an entrance pupil 25 mm in diameter and a focal length of 50 mm has a relative aperture of 50/25, i.e. 2. The numerical value of relative aperture is usually prefixed by the italic letter f and an oblique stroke, e.g. $f/2$, which serves as a reminder of its derivation. The denominator of the expression used alone is usually referred to as the f-number of the lens. However, the lens aperture engraved on most lens mounts appears as a simple ratio. Thus the aperture of an $f/2$ lens appears on the lens mount as '1:2'.

The relative aperture of a lens is commonly referred to simply as its 'aperture'. The maximum aperture of a lens is the relative aperture corresponding to the largest diaphragm opening that can be used with it. For simple lenses the lens diameter itself, or the stop diameter close to the lens, is substituted for the entrance pupil: thus the f-number of a simple lens is its focal length divided by its diameter.

To simplify exposure calculations, the f-numbers engraved on a lens are usually selected from a standard series of numbers, each of which is related to the next in the series by a constant factor calculated so that the amount of light passed by the lens when set to one number is half that passed by the lens when set to the previous number, as the iris diaphragm is progressively closed. As the amount of light passed by a lens is inversely proportional to the *square* of the f-number, the numbers in the series increase by a factor of $\sqrt{2}$, i.e. 1.4 (to 2 figures). The standard series of f-numbers is $f/1$, 1.4, 2, 2.8, 4, 5.6, 8, 11, 16, 22, 32, 45, 64.

The maximum aperture of a lens may, and frequently does, lie between two of the standard f-numbers, and in this case will be marked with a number not in the standard series.

A variety of other series of numbers have been used in the past, using a similar ratio, but with different starting points. Such figures may be encountered on older lenses and exposure meters. In the case of automatic exposure in cameras offering shutter priority and program modes, the user may have no idea whatsoever of the aperture setting of the camera lens. An alteration in relative aperture corresponding to a change in exposure by a factor of 2 is referred to as a change of 'one stop'. Alteration by 'one-third of a stop', 'half a stop' and 'two stops' refer to exposure factors of 1.26, 1.4 and 4 respectively. When the lens opening is made smaller, i.e. the f-number is made numerically larger, the operation is referred to as 'stopping down'. The converse is called 'opening up'. The exposure control actions of altering shutter speeds and alteration of the effective exposure index of a film by adjusted processing are often also referred to by their action on effective exposure in 'stops'.

Vignetting

The aperture of a lens is defined in terms of a distant axial object point. Lenses are used to produce images of extended objects however, so that any point on the object may be well away from the optical axis of the lens, depending on its field of view. If the diameter of a pencil of rays is considered from an off-axis point passing through a lens, a certain amount of obstruction may occur because of the type and design of the lens, its axial length and position of the aperture stop, and the mechanical construction of the lens barrel (Figure 5.2). The effect is to reduce the diameter of the pencil of rays that can pass unobstructed through the lens. This is termed '(mechanical) vignetting', and the image plane receives progressively less light as the field angle increases. This darkening at the edges of images is one factor determining image illuminance as a function of field angle and hence the circle of illumination. Mechanical vignetting must not be confused with the *natural* fall-off of light due to the geometry of image formation (page 38). Vignetting may be reduced by designing lenses with oversize front and rear elements, and by careful engineering of the lens barrel.

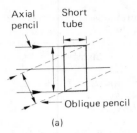

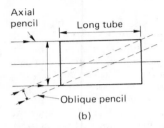

Figure 5.2 Cause of vignetting: (a) With a short tube, the area of cross-section of the oblique beam is only a little less than that of the axial beam; (b) with a long tube, the area of the cross-section of the oblique beam is much smaller than thatof the axial beam

Illuminance of the image formed by a camera lens

It is possible to deduce from first principles an expression for the illuminance at any point of an image formed by a camera lens of a distant, extended object. To do this however, it is necessary to make use of two relationships, (the derivations of which are beyond the scope of this book), concerning the light flux emitted by a surface and the luminance of the image given by the lens.

Luminous flux emitted by a surface

In Figure 5.3, the flux F emitted by a small area S of a uniformly-diffusing surface (i.e. one that appears

Figure 5.3 The light flux F emitted by a small area S of a surface of luminance L into a cone of semi-angle ω is given by $F = \pi LS \sin^2 \omega$

equally bright in all directions) of luminance L into a cone of semi-angle ω is given by the equation

$$F = \pi LS \sin^2\omega \qquad (1)$$

Note that the flux emitted is independent of the distance of the source. This equation is used to calculate the flux entering a lens.

Luminance of an image formed by a lens

For an object and an image that are both uniformly diffuse, whose luminances are L and L' respectively, it may be shown using equation 1 that for an 'ideal' lens of transmittance T

$$L' = TL \qquad (2)$$

In other words, the image luminance is the same as the object luminance apart from a factor due to the transmittance of the lens, within the cone of semi-angle ω.

Image illuminance

Consider the case shown in Figure 5.4, where a thin lens of diameter d, cross-sectional area A and transmittance T is forming an image S' at a distance v from the lens, of a small area S of an extended subject at a distance u from the lens. The subject luminance is L and the small area S is displaced from the optical axis such that a principal ray (i.e. one through the centre of the lens) from object to image is inclined at angle θ to the axis. The solid angle subtended by the lens at S is ω. The apparent area of the lens seen from S is $A \cos \theta$. The distance between the lens and S is $u/\cos \theta$.

The solid angle of a cone is defined as its base area divided by the square of its height. Consequently,

$$\omega = \frac{A \cos \theta}{(u/\cos \theta)^2} = \frac{A \cos^3 \theta}{u^2}$$

The flux leaving S at the normal is LS, so the flux leaving S at an angle θ into the cone subtended by the lens is $LS \cos \theta$. Thus the flux K entering the lens is given by:

$$K = (LS \cos \theta)\frac{A \cos^3 \theta}{u^2} = \frac{LSA \cos^4 \theta}{u^2}$$

Hence from equation 2, the flux K' leaving the lens is given by

$$K' = \frac{TLSA \cos^4 \theta}{u^2}$$

Now, illuminance is defined as flux per unit area, so image illuminance E is

$$E = \frac{K'}{S'} = \frac{TLA \cos^4 \theta \, S}{u^2 S'}$$

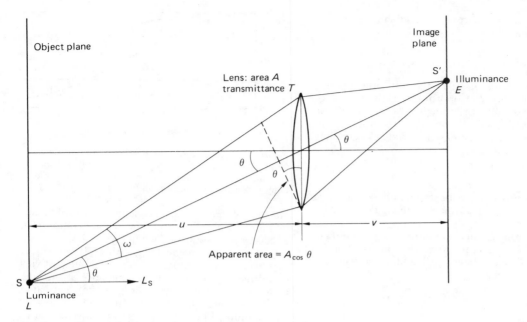

Figure 5.4 The factors determing image illuminance

From geometry, by the ratio of the solid angles involved,

$$\frac{S}{S'} = \frac{u^2}{v^2}$$

Hence

$$E = \frac{TLA\ \cos^4\theta}{v^2} \qquad (3)$$

The evaluation of equation 3 gives a number of useful results and an insight into the factors influencing image illuminance:

The value of E is independent of u, the subject distance, although the value of v is related to u by the lens equation.

The axial value of illuminance is given when $\theta = 0$, then $\cos\theta = 1$ and $\cos^4\theta = 1$. Hence

$$E = \frac{TLA}{v^2} \qquad (4)$$

Now lens area A is given by

$$A = \frac{\pi d^2}{4}$$

so that

$$E = \frac{\pi LTd^2}{4v^2} \qquad (5)$$

For the subject at infinity, $v = f$. By definition, the relative aperture N is given by $N = f/d$. By substitution into equation 5 we thus have:

$$E = \frac{\pi TL}{4N^2} \qquad (6)$$

Equation 6 gives us the important result that, for a distant subject, on the optical axis in the focal plane

$$E \propto \frac{1}{N^2}$$

Hence image illuminance is inversely proportional to the square of the f-number. For two different f-numbers N_1 and N_2, the ratio of corresponding image illuminances is given by

$$\frac{E_1}{E_2} = \frac{N_2^2}{N_1^2} \qquad (7)$$

Thus, for example, it is possible to calculate that the image illuminance at $f/4$ is one-quarter of the value at $f/2$.

The *exposure H* received by a film during exposure duration t is given by

$$H = Et \qquad (8)$$

Consequently, for a fixed exposure time, as $H \propto E$, then from equation 7

$$\frac{H_1}{H_2} = \frac{N_2^2}{N_1^2} \qquad (9)$$

Also, from equation 8

$$E \propto \frac{1}{t}$$

Hence the exposure time t_1 and t_2 required to

produce equal exposures at *f*-numbers N_1 and N_2 respectively are given by

$$\frac{t_1}{t_2} = \frac{N_1^2}{N_2^2} \qquad (10)$$

Also from equation 7, $E \propto d^2$. In other words, image illuminance is proportional to the square of the lens diameter, or effective diameter of the entrance pupil. Thus by doubling the value of d, image illuminance is increased fourfold. Values may be calculated from

$$\frac{E_1}{E_2} = \frac{d_1^2}{d_2^2} \qquad (11)$$

To give a doubling series of stop numbers, the value of d is altered by a factor of $\sqrt{2}$, giving the standard *f*-number series.

An interesting result also follows from equation 6. By suitable choice of photometric units, such as by taking E in luxes (lumen/m^2) and L in apostilbs ($1/\pi$ cd/m^2), we have

$$E = \frac{TL}{4N^2}$$

For a lens with perfect transmittance, i.e. $T = 1$, the maximum value of the relative aperture N is $f/0.5$, so that $E = L$ (values close to $f/0.5$ have been achieved in special lens designs).

When the object distance u is not large, we cannot take $v = f$ in equation 5, but instead use $v = f(1 + m)$ from the lens equation. Consequently,

$$E = \frac{\pi TL}{4N^2(1 + m)^2} \qquad (12)$$

In addition, for non-symmetrical lenses, the pupil magnification P must also be incorporated, since

$$v = f\left(1 + \frac{m}{p}\right)$$

So that

$$E = \frac{\pi TL}{4N^2\left(1 + m/p\right)^2} \qquad (13)$$

When we consider image illumination off-axis, θ is not equal to 0. Then $\cos^4 \theta$ has a value less than unity, rapidly tending to zero as θ approaches 90°. In addition, we have to introduce a vignetting factor V into the equation to allow for vignetting effects by the lens with increase in field angle. So our equation for image illuminance, allowing for all factors, is now:

$$E = \frac{V\pi TL\cos^4 \theta}{4N^2\left(1 + m/p\right)^2} \qquad (14)$$

From equation 14 we see that $E \propto \cos^4\theta$. This is the embodiment of the so-called *cos⁴ law* of illumination, or 'natural vignetting' as it is sometimes called, which may be derived from the geometry of the

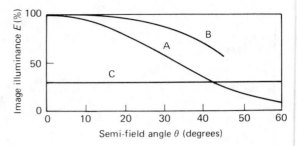

Figure 5.5 The effect of the cos⁴θ law of illumination. (A) Natural light losses due to the law; (B) improvements possible by utilizing the Slussarev effects; (C) use of a neutral-density 'anti-vignetting' filter

imaging system, the inverse square law of illumination and Lambert's cosine law of illumination. The effects of this law are shown in Figure 5.5, (ignoring the effects of 'mechanical' vignetting). It can be seen that even a standard lens with a semi-angle of view of 26° has a level of image illuminance at the edge of the image of only two-thirds of the axial value. For a wide-angle lens with a semi-angle of view of 60°, peripheral illuminance is reduced to 0.06 of its axial value. For wide-angle lens designs, corrective measures are necessary to obtain more uniform illumination over the image area.

Image illuminance in wide-angle lenses

There are several approaches open to designers wishing to achieve uniform illumination in the image plane; these are usually dictated by the design of a lens and its particular applications.

Mechanical methods

An early method of reducing illumination fall-off was a revolving star-shaped device in front of the lens, used on the unique Goerz Hypergon lens, which at *f*/16 had an angle of field of 120°. A more modern remedy is a *graduated neutral density filter*, in which density decreases non-linearly from a maximum value at the optical centre to near-zero at the periphery; this can provide a fairly precise match for illumination fall-off. Such filters are widely used with aerial survey lenses. Oversize front and rear elements are also employed, to minimize mechanical vignetting (page 49).

Negative outer elements

As we have seen, one of the main factors in illumination fall-off is that the projected area of the

aperture stop is smaller for rays that pass through it at an angle. This angle can be greatly reduced if the lens is designed so that its outermost elements are negative. Lens designs such as quasi-symmetrical lenses with short back foci, and retrofocus lenses, both benefit from this technique. The overall effect is to reduce the 'cos$^4\theta$' effect to roughly cos$^3\theta$.

Slussarev effect

Named after its discoverer, this approach relies on the deliberate introduction of coma (page 60) into the pencils of rays at the entrance and exit pupils of the lens. Their cross-sectional areas are thereby increased, so that illuminance is increased at the periphery, but the positive and negative coma effects cancel out.

Uncorrected distortion

The theoretical consideration of image illuminance applies only to well-corrected lenses that are free from distortion. If distortion correction (which becomes increasingly difficult to achieve as angle of field increases) is abandoned, and the lens design deliberately introduces barrel distortion (page 63) so that the light flux is distributed over proportionally smaller areas towards the periphery, then fairly uniform illuminance is possible even up to the angles of view of 180° or more. 'Fisheye' lenses are examples of the application of this principle.

Exposure compensation for close-up photography

The definition of relative aperture assumes that the object is at infinity, so that the image conjugate v can be considered as equal to the focal length f. When the object is closer this assumption no longer applies, and instead of f in the equation $N = f/d$, we need to use v, the lens extension. We must then define N' as equal to v/d where N' is the *effective f-number* or *effective aperture*.

Camera exposure compensation may be necessary when the object is within about ten focal lengths from the lens. Various methods are possible, using the values of f and v (if known), or magnification m, if this can be measured. Mathematically, it is easier to use a known magnification in the determination of the correction factor for either the effective f-number N' or the corrected exposure duration t'. The required relationships are, respectively:

$$\frac{t'}{t} = \left(\frac{N'}{N}\right)^2 \tag{15}$$

or

$$t' = t(1 + m)^2 \tag{16}$$

and

$$N' = N\frac{v}{f} \tag{17}$$

i.e. $N' = N(1 - m)$ (18)

These expressions are readily derived from the lens equation and equation (10). The exposure correction factor increases rapidly as magnification increases. For example, at unit magnification the exposure factor is ×4, so that the original estimated exposure time must be multiplied by four or the lens aperture opened up by two whole stops.

For copying, where allowance for bellows extension must always be made, it may be more convenient to calculate correction factors based on an exposure time that gives correct exposure at unit magnification. Table 5.1 gives a list of exposure factors.

The use of cameras with through-the-lens (TTL)

Table 5.1 Exposure factors for different scales of reproduction (magnification)

1 *Object distance*	*2* *Bellows extension*	*3* *Linear scale of reproduction*	*4* *Marked f-number must be multiplied by:*	*5* *Exposure indicated for object at ∞ must be multiplied by:**	*6* *Exposure indicated for same-size reproduction must be multiplied by:**
u	*v*	$m = v/f - 1$	$1 + m$	$(1 + m)^2$	$(1 + m)^2/4$
∞	f	0	×1	×1	×¼
	$1\frac{1}{8}f$	⅛	×1⅛	×1¼	×⁵⁄₁₆
	$1\frac{1}{4}f$	¼	×1¼	×1½	×⅜
	$1\frac{1}{2}f$	½	×1½	×2¼	×½
	$1\frac{3}{4}f$	¾	×1¾	×3	×¾
2f	2f	1 (same-size)	×2	×4	×1
	$2\frac{1}{2}f$	1½	×2½	×6	×1½
	3f	2	×3	×9	×2¼
	4f	3	×4	×16	×4
	5f	4	×5	×25	×6

*The exposure factors in columns 5 and 6 are practical approximations.

metering systems is often a great convenience in close-up photography, as compensation for bellows extension is automatically taken into account. TTL metering is also essential with lenses using internal focusing and for zoom lenses with variable aperture due to mechanical compensation, as the effective aperture may not vary strictly according to theory. Similarly, due to the pupil magnification effect, the use of telephoto and retrofocus design lenses with a reversing ring (page 110) may demand an exposure correction factor differing from that calculated by equations 16 and 18. The variable m must be replaced by m/p, where p is the pupil magnification.

Light losses and lens transmittance

Part of the light incident on a lens is lost by reflection at the air-glass interfaces and somewhat less is lost by absorption. The remainder is transmitted, to form the image. Thus the value of T in equation 2 and subsequent equations is always less than unity. For any given lens the light losses depend on the number and composition of the glasses employed. An average figure for the loss due to reflection might be 5 per cent for each air-glass interface. If k ($= 0.95$) is the transmittance at such an interface, then as the losses at successive interfaces are multiplied, for n interfaces with identical transmittance, the total transmittance $T = k^n$. This means that an uncoated four-element lens with eight air-glass interfaces would have reflection losses amounting to some $(0.95)^8 = 35$ per cent of the incident light, i.e. a transmittance of 0.65.

Flare, flare spots, ghost images

Some of the light reflected at the lens surfaces passes out of the front of the lens and causes no trouble other than loss to the system; but a proportion is re-reflected from other surfaces and may ultimately reach the film. Some of this reflected non-image-forming light is spread uniformly over the surface of the film, and is referred to as *lens flare* or *veiling glare*. The effect of flare is to compress the tones in the shadow areas of the image and to reduce the image illuminance range. Not all the flare light may be spread uniformly; some of it may form out-of-focus images of the iris diaphragm ('flare spots') or of bright objects in the subject field ('ghost images'). Such flare effects can be minimized by anti-reflection coatings and use of a lens hood. Light reflected from the inside of the camera body, e.g. from the bellows and the film surface itself, produces what is known as 'camera flare'. This effect can be especially noticeable in a technical camera when the field covered by the lens is appreciably greater than the film format. Such flare can

often be considerably reduced by use of an efficient lens hood.

The number obtained by dividing the subject luminance range by the image illuminance range is termed the *flare factor*. This is a somewhat indeterminate quantity, since it depends not only on the lens and camera but also on the distribution of light within and around the subject area. The flare factor for an average lens and camera considered together may vary from about 2 to 10 for average subject matter. The usual value is from 2 to 4 depending on the age of the camera and lens design. A high flare factor is characteristic of subjects having high luminance range, such as back-lit subjects.

In the camera, flare affects shadow detail in a negative more than highlight detail; in the enlarger (i.e. in the print), flare affects highlight detail more than shadow detail. In practice, provided the negative edges are properly masked in the enlarger, flare is seldom serious. This is partly because the density range of the average negative is lower than the log-luminance range of the average subject, and partly because the negative is not surrounded by bright objects, as may happen in the subject matter. In colour photography, flare is likely to lead to a desaturation of colours, as flare light is usually a mixture approximating to white. Flare may also lead to colour casts resulting from coloured objects outside the subject area.

T-numbers

Because lens transmittance is never 100 per cent, relative aperture or f-number (as defined by the geometry of the system) does not completely indicate the light-transmitting performance of a lens in practice. Two lenses of the same f-number may have different transmittances, and thus different speeds, depending on the type of construction, number of components, and type of lens coatings. The use of lens coatings to reduce reflection losses markedly improves transmittance, and there is a need in some fields of application for a more accurate measure of the transmittance of a lens. *T*-numbers, which are photometrically-determined values taking into account both imaging geometry and transmittance, may be used instead of f-numbers where such accuracy is necessary. The *T*-number of any aperture of a lens is defined as the f-number of a perfectly-transmitting lens which gives the same axial image illuminance as the actual lens at this aperture. For a lens of transmittance τ and a circular aperture,

$$T\text{-number} = \frac{f\text{-number}}{\sqrt{\tau}} = N\tau^{-1/2}$$

Thus a $T/8$ lens is one which passes as much light as a theoretically-perfect $f/8$ lens. The relative aperture of the $T/8$ lens may be about $f/6.3$. The concept of

T-numbers is of chief interest in cinematography and television, and where exposure latitude is small. It is implicit in the *T*-number system that every lens should be individually calibrated.

If depth-of-field calculations are made using *T*-numbers instead of *f*-numbers, the results will theoretically be affected, through the practical effects may be small enough to be ignored.

Lens coatings

Single coatings

A very effective practical method of increasing the transmittance of a lens by reducing surface reflection losses is by applying thin coatings of refractive material to the air-glass interfaces. The transmittance at an interface may in this manner be increased from about 0.95 to 0.99 or more. For a lens with, say, eight such interfaces of average transmittance 0.95, the lens transmittance increases from $(0.95)^8$ to $(0.99)^8$, representing an increase in transmittance from 0.65 to 0.92, or approximately one-third of a stop, for a given *f*-number. In the case of a zoom lens, which may have 20 such surfaces, the transmittance may be increased from 0.36 to 0.82, i.e. more than doubled. Equally important is the accompanying reduction in lens flare, giving an image of useful contrast where, without the use of such coatings, such a lens design would be impraticable.

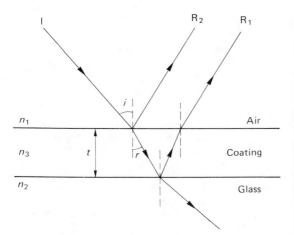

Figure 5.6 An anti-reflection coating on glass using the principle of destructive interference of light

The effect of surface coating of a lens depends on two principles. First, the surface reflectance *R* depends on the refractive indexes n_1 and n_2 of the two media forming the interface; in simplified form (from Fresnel's equations) this is given by

$$R = \frac{(n_2 - n_1)^2}{(n_2 + n_1)^2} \tag{20}$$

In the case of a lens surface, n_1 is the refractive index of air and is approximately equal to 1, and n_2 is the refractive index of the glass. From equation 20 it can be seen that reflectance increases rapidly with increase in the value of n_2. In modern lenses, using glasses of high refractive index (typically 1.7 to 1.9), such losses would be severe without coating.

Secondly, when the coating is very thin there is interference between the light wavefronts reflected from the first and second surfaces of the coating. Let us consider the interaction of the two reflected beams R_1 and R_2 from the surface of the lens and from the surface of a thin coating, of thickness *t* and refractive index n_3, applied to the lens surface (Figure 5.6). The condition for R_1 and R_2 to interfere destructively and cancel out is given by

$$2n_3 t \cos r = \lambda/2 \tag{21}$$

where *r* is the angle of refraction and λ the wavelength of the light. For light at normal incidence this expression simplifies to:

$$2n_3 t \cos r = \lambda/2 \tag{21}$$

From equation 22 we see that to satisfy this condition the 'optical thickness' of the coating, which is the product of refractive index and thickness, must be $\lambda/4$, i.e. one quarter of the wavelength of the incident light.* This type of coating is termed 'quarter-wave coating'. As the thickness of such a coating can be correct for only one wavelength it is usually optimized for the middle of the spectrum (green) and hence looks magenta (white minus green) in appearance. By applying similar coatings on other lens surfaces, but matched to other wavelengths, it is possible to balance lens transmission for the whole visible spectrum and ensure that the range of lenses available for a given camera produce similar colour renderings on colour reversal film, irrespective of their type of construction.

We have not so far discussed the choice of a material of suitable refractive index for the lens coating. The optimum value is also obtained from the conditions for the two reflected wavefronts to interfere destructively and cancel. For this to happen the magnitudes of R_1 and R_2 need to be the same.

From equation (20) we can obtain expressions for R_1 and R_2:

$$R_1 = \frac{(n_2 - n_3)^2}{(n_2 + n_3)^2}$$

*The wavelength within the coating, of course, not in air.

$$R_2 = \frac{(n_3 - n_1)^2}{(n_3 + n_1)^2}$$

By equating $R_1 = R_2$ and taking $n_1 = 1$,

$$n_3 = \sqrt{n_2}$$

In other words, the optimum refractive index of the coating should have a value corresponding to the square root of the refractive index of the glass.

For a glass of refractive index 1.51, the coating should ideally have a value of about 1.23. In practice the material nearest to meeting the requirements is magnesium fluoride, which has a refractive index of 1.38. A quarter-wave coating of this material results in an increase in transmittance at an air-glass interface from about 0.95 to about 0.98 as the light energy involved in the destructive interference process is not lost but is transmitted.

Evaporative coating

The usual method of applying a coating to a lens surface is by placing the lens in a vacuum chamber in which is a small container of the coating material. This is electrically heated, and evaporates, being deposited on the lens surface. The deposition is continued until the coating thickness is the required value. This technique is, of course, limited to materials which will evaporate at sufficiently low temperatures.

Electron beam coating

An alternative technique is to direct an electron beam at the coating substance in a vacuum chamber. This high-intensity beam evaporates even materials with very high melting points which are unsuitable for the evaporation technique. Typical materials used in this manner are silicon dioxide ($n = 1.46$) and aluminium oxide ($n = 1.62$). The chief merit of these materials is their extreme hardness. They are used to protect aluminized and soft optical glass surfaces as the refractive indexes are too high for use as interference coatings.

Multiple coating

Controlled surface treatment is now widely applied to a range of other optical products. With the advent

of improved coating machinery and a wider range of coating materials, together with the aid of digital computers to carry out the necessary calculations, it has proved economically feasible to extend coating techniques by using several separate coatings on each air-glass interface. A stack of 25 or more coatings may be used to give the necessary spectral transmittance properties to *interference filters*, as used in colour enlargers and specialized applications such as spectroscopy and microscopy. By suitable choice of the number, order, thicknesses and refractive indexes of individual coatings the spectral transmittance of an optical component may be selectively enhanced to a value greater than 0.99 for any selected portion of the visible spectrum (Figure 5.7).

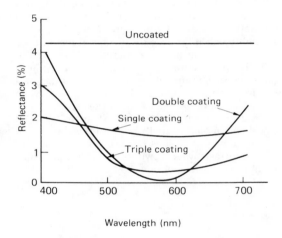

Figure 5.7 The effects of various types of anti-reflection coatings compared with uncoated glass for a single lens surface at normal incidence

The use of double and triple coatings in modern photographic lenses is now almost universal, and numbers of coatings between 7 and 11 are claimed by some manufacturers. Occasionally the interfaces between cemented glass elements may also be coated. The practice of lens coating has made practicable a number of advanced lens designs that would otherwise have been unusable because of flare and low transmittance.

6 Lens aberrations

In previous chapters lenses have been considered as 'ideal', forming accurate images of subjects before them. In practice actual lenses, especially simple lenses, only approximate to the ideal. There are three main reasons for this:

(1) The refractive index of glass varies with wavelength
(2) Lens surfaces are generally spherical in shape
(3) Light behaves as if it were a wave motion

The ways in which the image departs from the ideal as a result of these are referred to as lens errors or *aberrations*. Effects due to (1) are called *chromatic effects*, those due to (2) are *spherical effects* and those due to (3) are *diffraction effects*. In general, the effects of aberrations increase with aperture and angle of field.

The primary chromatic and spherical errors from which an image may suffer are seven in number. The two *direct errors* or *axial aberrations* affect all parts of the image field including the centre, and are called respectively *axial chromatic aberration* and *spherical aberration*. The other five errors affect only rays passing obliquely through the lens and do not affect the centre of the image. The effects of these *oblique errors, or off-axis aberrations*, increase with distance from the lens axis. They are called *transverse* (or *lateral*) *chromatic aberration* (formerly called 'lateral colour'), *coma, curvature of field, astigmatism*, and *(curvilinear) distortion*, and their effects appear in roughly that order as the angle of field increases. Axial and lateral chromatic aberration are chromatic effects; spherical aberration, coma, curvature of field, astigmatism and distortion are spherical effects. The latter are also called *Seidel aberrations* after L Seidel, who first described their mathematics in 1856. They are also known as *third-order aberrations*, from their mathematical form. Although lens aberrations are to a large extent interconnected in practice, it is convenient to consider each aberration separately. Modern highly-corrected lenses have only residual traces of these primary aberrations. The presence of less easily-corrected higher orders of aberration (known as *fifth-order aberrations*) sets practical performance limits.

Chromatic aberration (axial)

The refractive index of all transparent media varies with the wavelength of the light passing through,

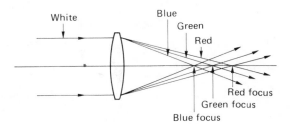

Figure 6.1 Chromatic aberration in a simple lens

shorter wavelengths being refracted more than longer wavelengths. The focus of a simple lens therefore varies with the wavelength of the light transmitted. This separation of focus along the optical axis of a positive lens is shown in Figure 6.1; the focus for blue light is closer to the lens than the focus for red light. The image is said to suffer from *axial chromtic aberration*. Early photographic lenses were of simple design, and the non-coincidence of the visual (yellow-green) focus with the 'chemical' or 'actinic' (blue) focus for the blue-sensitive materials then available presented a serious problem. It was therefore necessary to make an allowance for the shift in focus either by altering the lens position or by using a small aperture to increase the depth of focus. The latter technique allows such lenses to be used in inexpensive cameras, with reasonable results.

It was shown by Dollond in 1757 that if a lens is made of two elements, the chromatic aberrations in one can be made to cancel out those in the other. Typically, a combination of positive 'crown' glass and negative 'flint' glass lenses was used. The convergent crown element had a low refractive index and a low dispersive power, while the divergent flint element had a somewhat higher refractive index and a much higher dispersive power. The crown element was given a greater refractive power than the flint element, resulting in a combination that was positive overall, but with its positive and megative dispersions equal and cancelling out. A *cemented achromatic doublet* lens made in this way is shown in Figure 6.2.

The chromatic performance of a lens is usually shown by a graph of wavelength against focal length, as shown in Figure 6.3. The variation of focus with wavelength for an uncorrected lens is a more-or-less straight line; that of an achromatic lens is approximately a parabola. The latter curve indicates the

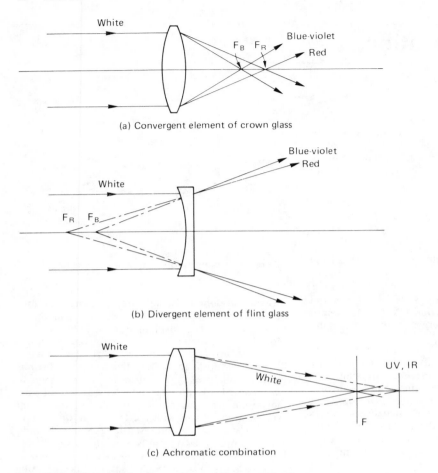

(a) Convergent element of crown glass

(b) Divergent element of flint glass

(c) Achromatic combination

Figure 6.2 The principle of an achromatic lens combination

presence of an uncorrected *secondary spectrum*. The two wavelengths with the same focus positions are usually chosen in the red and blue regions of the spectrum, for example the C and F Fraunhöfer lines (other pairs were chosen in early lenses for use with non-panchromatic materials). For some applications such as colour-separation work, a lens may be corrected to bring three foci into coincidence, giving three coincident images when red, green and blue colour-separation filters are used. A lens possessing this higher degree of correction is said to be *apochromatic*. Note that this term is often used nowadays to describe lenses that are corrected fully for only two wavelengths, but use special low-dispersion glasses to give a much-reduced secondary spectrum. It is also possible, using modern glasses, to obtain an even higher degree of correction and to

bring four wavelengths to a common focus. Such a lens is termed a *superachromat*. The wavelengths chosen are typically in the blue, green, red and infrared regions, so that no focus correction is needed between 400 and 1000 nm.

Optical materials other than glass also require chromatic correction. Plastics are increasingly being used for photographic lenses; it is possible to make an achromatic combination out of plastics materials, given the wide choice of optical-quality plastics materials available.

The use of reflecting surfaces which do not disperse light, in the form of 'mirror lenses', offers another solution; but most mirror designs are for long-focus lenses only. Most of these, too, are *catadioptric lenses* (page 76), and these still require some colour correction.

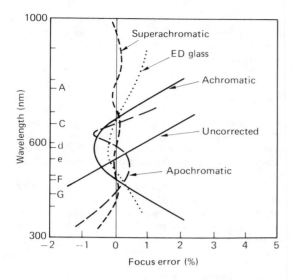

Figure 6.3 Types of correction for lenses. The letters on the vertical axis represent the wavelengths of the spectral lines used for standardization purposes

Chromatic aberration (lateral)

Lateral or *transverse chromatic aberration*, formerly called *lateral colour* and still sometimes called *chromatic difference of magnification*, is a particularly troublesome error which appears in the form of colour fringes at the edges of the image (Figure 6.4). It is an off-axis aberration, i.e. it is zero at the optical centre of the focal plane but increases as the angle of field increases. Whereas axial chromatic aberration concerns the distance from the lens at which the image is formed, lateral chromatic aberration concerns the size of the image. It is not easy to correct: its effects worsen with increase in focal length, and are not reduced by closing down the lens aperture. It effectively sets a limit on the performance of long-focus lenses, especially those used for photomechanical colour-separation work. 'Mirror' lenses may offer an alternative in some cases, but they have their own limitations. Lateral chromatic aberration can be minimized by a symmetrical lens construction and the use of not less than three different types of glass; almost full correction is possible by use of special optical materials. These include optical glass of anomalous or *extra-low dispersion (ED)* which may be used in lenses, giving few problems other than increased cost. One material which shows exceptionally low dispersion characteristics is *fluorite* (calcium fluoride). It has been used in its natural form, where it is found in small pieces of optical quality, for use in microscope objectives; more recently, it has become possible to grow large flawless crystals for use in photographic lenses. Fluorite is attacked by the atmosphere, so it must be protected by outer elements in the lens construction. The focal length of fluorite lenses varies with temperature, and this presents problems with the focusing calibration. The cost of lenses incorporating fluorite elements is significantly higher than that of equivalent conventional designs.

Spherical aberration

The angle of refraction of a ray of light depends on the angles of incidence made with the surfaces of the lenses in its path. These surfaces are almost always

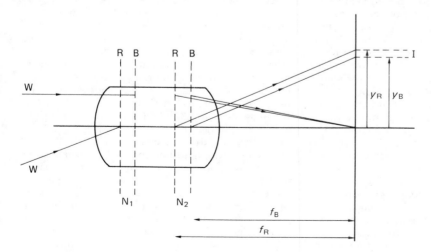

Figure 6.4 Lateral (or transverse) chromatic aberration for off-axis points in a lens that has been corrected for longitudinal chromatic aberration only. The effect is a variation in image height *y* for red and blue light

spherical, because spherical surfaces are easy to manufacture. However, a lens with a spherical surface does not bring all paraxial rays to a focus at the same point. The exact point of focus depends on the circular zone of the lens under consideration. A zone is an annular region of the lens centred on the optical axis. Rays passing through the outer zones come to a focus nearer to the lens than the rays through the central zone (Figure 6.5). Consequently, a point source does not produce a point image. The resultant unsharpness is called *spherical aberration*. In a simple lens, spherical aberration is reduced by stopping down. As the lens aperture is reduced the plane of best focus may shift, a phenomenon characteristic of the aberration. Spherical aberration in a simple lens is minimized by a suitable choice of radii of curvature of the two surfaces of the lens.

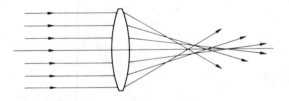

Figure 6.5 Spherical aberration in a simple lens

Correction of spherical aberration is by the choice of a suitable combination of positive and negative lenses such that their spherical aberrations are equal and opposite. This correction may be combined with that necessary for chromatic aberration and for coma (see below); such a corrected combination is termed *aplanatic*. It is difficult to provide complete correction for spherical aberration, one of the reasons being that, like chromatic aberration, it has both axial and lateral components. This sets a limit on the maximum useful aperture of some otherwise excellent lens designs, for example *f*/5.6 for some symmetrical designs. More elaborate designs such as those derived from the double-Gauss principle (see page 72), with six or more elements, allow apertures of *f*/2 and greater, with adequate correction. The cost of production is also greater.

The use of an *aspheric surface* in a lens design can give a larger useful aperture, or permit a reduction in the number of elements necessary for a given aperture. Modern optical technology can now produce such surfaces at high (though not impossible) cost. Another alternative is to use new, computer-designed glasses of very high refractive index which allow the use of low curvatures for a given refractive power, with a consequent reduction in spherical aberration.

One of the more important problems in lens design is the variation in spherical aberration with focused distance. A lens computed to give full correction of spherical aberration when focused on infinity may perform poorly when focused close up. One solution used in multi-element lenses is to have one group of elements move axially for correction purposes as the lens is focused. This movement may be coupled to the focusing control, or be set manually after focusing. This arrangement is termed a *floating element*, and is a result of experience gained in zoom lens design. Most 'macro' lenses incorporate such a system.

Certain lenses have been designed with a controllable amount of residual uncorrected spherical aberration to give a 'soft-focus' effect, particularly for portraiture. The Rodenstock Imagon is perhaps the best-known example. The degree of softness may be controlled either by specially-shaped and perforated aperture stops or by progressive separation of two of the elements of the lens.

Coma

In an uncorrected lens, oblique rays passing through different annular zones of the lens fall on the film at different distances from the axis, instead of being superimposed. The central zone forms a point image that is in the correct geometrical position. The next zone forms an image that is not a point but a small circle that is displaced radially outwards from the geometric image. Successive zones form larger circles that are further displaced, the whole adding together to give a V-shaped patch known as a *coma patch*, from its resemblance to a comet. A lens exhibiting this defect is said to suffer from *coma* (Figure 6.6(a)). Coma should not be confused with the lateral component of spherical aberration; it is a different term in the Seidel equations, and a lens may be corrected for lateral spherical aberration and coma independently. In a lens system coma may be either outward (away from the lens axis, as in Figure 6.6), or inward, with the tail pointing towards the lens axis. Coma, like spherical aberration, is reduced by stopping down. This, however, may cause the image to shift laterally (just as the image shifts axially if spherical aberration is present), and this may reveal a further aberration called 'distortion' (see below). Coma can be reduced in a simple lens by employing a stop in such a position that it restricts the area of the lens over which oblique rays strike it. This method is used to minimize coma in simple box camera lenses (Figure 6.6(b)). In compound lenses coma is reduced by balancing the error in one element by an equal and opposite error in another. In particular, symmetrical construction is beneficial. Coma is particularly troublesome in wide-aperture lenses.

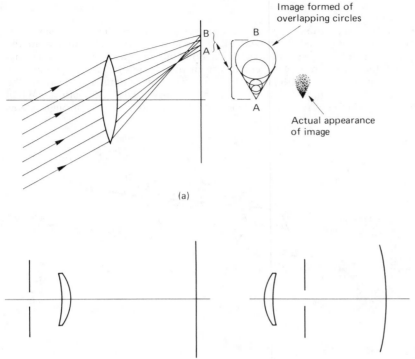

Image formed of
overlapping circles

Actual appearance
of image

(a)

(b)

Figure 6.6 (a) Coma in a
simple lens. (b) Use of
meniscus lenses in simple
cameras

Curvature of field

In the basic lens formula, the locus of sharp focus
for an object is the so-called *Gaussian plane*. In a
simple lens, however, this focal surface is in practice
not a plane at all, but a spherical surface, called the
Petzval surface, centred roughly on the rear nodal
point of the lens (Figure 6.7).

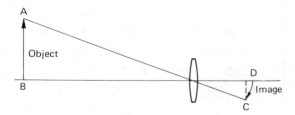

A

Object

B

D

Image

C

Figure 6.7 Curvature of field in a simple lens

With a lens suffering from this aberration it is
impossible to obtain a sharp image all over the field:
when the centre is sharp the image is blurred, and
vice versa. This is to be expected, as points in the
object plane that are away from the optical axis are
farther from the centre of the lens than points that

are near the axis, and accordingly form image points
that are nearer to the lens than points near the axis.
Petzval was the first person to design a lens (in 1840)
by mathematical computation, and he devised a
formula, known as the *Petzval sum*, describing the
curvature of field of a lens system in terms of the
refractive indexes and surface curvatures of its com-
ponents. By choosing these variables appropriately,
the Petzval sum can be reduced to zero, giving a
completely flat field. Unfortunately, this cannot be
done without leaving other aberrations only partly
corrected, and in some scientific instruments where
curvature of field is unavoidable it may be necessary
to use very thin glass plates that can be bent to the
required curvature. Some large-aperture camera
lenses are designed with sufficient residual curvature
of field to match the field of sharp focus to the
natural curvature of the film in the gate; a number of
slide-projector lenses have been designed in this
way. Lens designs derived from the double-Gauss
configuration are capable of giving a particularly flat
image surface.

Astigmatism

The situation is complicated further by the fact that
the Petzval surface represents the locus of true point

images only in the absence of a further aberration called *astigmatism*. This gives two additional curved surfaces close to the Petzval surface, which may also be thought of as surfaces of sharp focus, but in a different way. They are called *astigmatic surfaces*. The term 'astigmatic' comes from a Greek expression meaning 'not a point', and the two surfaces are

the loci of images of points in the object plane that appear in one case as short lines radial from the optical axis, and in the other as short lines tangential to circles drawn round the optical axis. Figure 6.8 shows the geometry of the system, and illustrates the reason for the occurrence of astigmatism. When light from an off-axis point passes through a lens

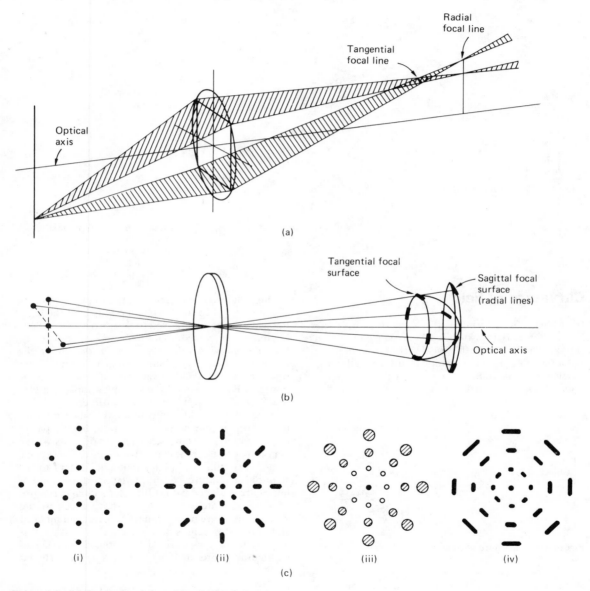

Figure 6.8 (a)Geometry of an astigmatic image-forming system; (b) astigmatic surfaces for radial and tangential foci; (c) appearance of images of point objects on the astigmatic surfaces. (i) object plane, (ii) sagittal focal surface, (iii) surface containing discs of least confusion, (iv) tangential focal surface

obliquely, a plane sheet of rays parallel to a line joining the point to the optical axis passes through the lens making angles of incidence and emergence that differ from the minimum-deviation conditions; they are therefore brought to a focus closer to the lens than are axial rays. At the same time, sheets of rays perpendicular to this line pass through the lens obliquely, so that the lens appears thicker and its curvature higher; these are also brought to a focus closer to the lens than are axial rays. *But this 'tangential' focus is in a different position from the other, 'radial' (or 'sagittal') focus* (it is, typically, nearer to the lens, as shown in Figure 6.8(a)). The result is that on one of these surfaces all images of off-axis points appear as short lines radial from the optical axis, and on the other they appear as tangential lines. The surface which approximately bisects the space between the two astigmatic surfaces contains images which are minimum discs of confusion and may represent the best focus compromise (Figure 6.8(b) and (c)). Astigmatism mainly affects the margins of the field, and is therefore a more serious problem with lenses that have a large angle of view.

The effects of both astigmatism and curvature of field are reduced by closing down the lens aperture. Although curvature of field can be completely corrected, as explained earlier, astigmatism cannot, and it remained a problem in camera lenses until the 1880s, when new types of glass were made available from Schott based on work by Abbé, in which low refractive index was combined with high dispersion and vice versa. This made it possible to reduce astigmatism to low values without prejudicing the correction of chromatic and spherical aberration and coma. Such lenses were called *anastigmats*. Early anastigmat lenses were usually based on symmetrical designs, which gave a substantially flat field with limited distortion (see below).

Distortion

When an iris diaphragm is used to limit the diameter of a camera lens in order to reduce aberrations, it is desirable that it should be situated in such a position that it transmits the bundle of rays that surround the primary ray (i.e. the ray that passes through the centre of the lens undeviated). Distortion occurs when a stop is used to control aberrations such as coma. If the stop is positioned in front of the lens or behind it, the bundle of rays selected does not pass through the centre of the lens (as is assumed in theory based on thin lenses), but through a more peripheral region, where it is deviated either inwards, for a stop on the object side of the lens ('barrel distortion'), or outwards, for a stop on the image side of the lens ('pincushion distortion'). These names represent the shapes into which the

images of rectangles centred on the optical axis are distorted; because the aberration produces curved images of straight lines it is sometimes known as *curvilinear distortion*, to distinguish it from the perceptual distortion consequent on viewing photographs taken with a wide-angle lens from an inappropriate distance (see page 47). The principle of distortion is shown in Figure 6.9.

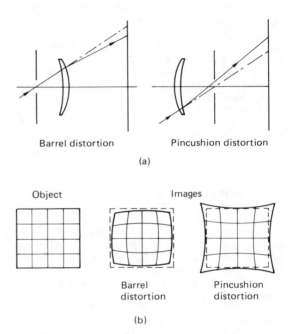

Figure 6.9 The effects of distortion. (a) The effects of selection of a geometrically-incorrect ray bundle; (b) barrel and pincushion distortion

As distortion is a consequence of employing a stop, it cannot be reduced by stopping down. Indeed, the fact that this action sharpens up the distorted image means that the use of a small aperture makes the distortion more noticeable. Distortion can be minimized by making the lens symmetrical in configuration, or nearly symmetrical ('quasi-symmetrical'): the first symmetrical lens, the 'Rapid Rectilinear', took its name from the fact that it produced distortion-free images. A truly distortion-free lens is termed *orthoscopic*. The accuracy of imaging of a lens is sometimes referred to as its 'drawing'.

Some symmetrical lenses have separately-removable front and rear components. Used alone, the front component of such a lens introduces pincushion distortion and the rear component barrel distortion; when the two components are used together the two defects cancel one another. The use of a symmetrical construction eliminates not

only distortion but also coma and lateral chromatic aberration. Unfortunately, residual higher orders of spherical aberration limit the maximum aperture of such lenses to about $f/4$.

Lenses of highly asymmetrical construction, such as telephoto and retrofocus lenses, are prone to residual distortions: telephoto lenses show pin-cushion distortion and retrofocus lenses barrel distortion. The effect is more serious in the latter case, as retrofocus lenses are used chiefly for wide-angle work, where distortion is more noticeable. Zoom lenses tend to show pincushion distortion at long-focus settings and barrel distortion at short-focus settings. General-purpose lenses usually have about 1 per cent distortion, with little effect in practice. Wide-angle lenses for architectural work must have less than this, while lenses for aerial survey work and photogrammetry must be essentially distortion-free, with residual image displacements measurable in micrometres.

Diffraction

Even when all primary and higher-order aberrations in a lens have been corrected and residuals reduced to a minimum, imaging errors due to diffraction remain. Diffraction is a phenomenon characteristic of the behaviour of light at all times, and is characterized in particular by the deviation of parts of a light beam when it passes through a narrow aperture or close to the edge of an opaque obstacle. Diffraction is described by the wave model for the behaviour of light, and its effects can be quantified by fairly simple mathematics.

The most important effect of diffraction is at the aperture of a lens. The image of a point source formed by an 'ideal' (i.e. aberration-free) lens is not a point but a patch of light having a small but quite specific pattern. Its nature was first described by Airy in 1835, and it is referred to as the *Airy diffraction pattern*. It consists of a bright disc (the *Airy disc*) surrounded by a set of concentric rings of much lower brightness (Figure 6.10). It can be shown that the diameter D of the Airy disc (to the first zero of luminance) is given by

$$D = 2.44\lambda \frac{v}{d}$$

where λ is the wavelength of the light, v is the distance of the image from the lens, and d is the diameter of the lens aperture. For a lens focused at or near infinity, this can be rewritten as

$$D = 2.44\,\lambda N$$

where N is the f-number of the lens (N is replaced by N', the effective aperture, for close-ups).

With blue-violet light of wavelength 400 nm, the

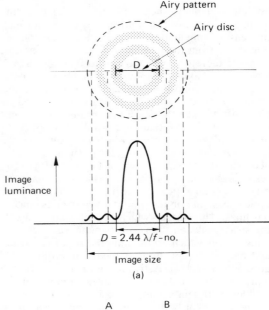

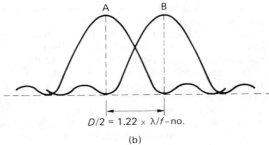

Figure 6.10 Resolving power of a lens. (a) A point source is imaged by a lens in the form of an Airy diffraction pattern; (b) Rayleigh criterion for resolving power of a lens using the overlap of two adjacent Airy patterns, with peaks at A and B corresponding to adjacent minima

diameter of the Airy disc is approximately $0.001\,N$ mm. Thus it is 0.008 mm for a lens at an aperture of $f/8$. This theoretical value may be compared with typical values of 0.03–0.1 mm taken for the diameter of the circle of confusion in aberration-limited lenses.

Notice that the shorter the wavelength of light the less the diffraction, the smaller the diameter of the Airy disc and therefore the higher the resolving power theoretically possible (see below). This is why ultraviolet and electron microscopy can give much higher resolution than visible light microscopy. Notice also that diffraction increases on stopping down the lens. The practical effects of this are considered below.

Resolving power of a lens

The ability of a lens to resolve fine detail is usually termed its *resolving power*, and is determined by the extent of residual aberrations of the lens, by diffraction, and by the contrast of the subject. In practical photography the concern is with the resolving power of the entire photographic system rather than just the lens, and this depends on the resolving power of the film used as well as the lens, together with other system factors such as vibration, subject movement, air turbulence and haze. Various test targets have been devised in order to obtain some objective measure of lens/film resolving power, based on photographing the target at a known magnification and a visual estimation (with the aid of a microscope) of the target details that are just resolved in the final photographic image. While such methods have the advantage of being easily carried out, and can give useful information on a comparative basis, they do not give a full picture of the performance of the system. Such information is vital for lens design and quality control procedures.

Modern methods of lens evaluation make use of the *optical spread function*, which is the light-intensity profile of the optical image of a point or line object, and of the *optical transfer function*, which is a graph of the relative contrast in the image of a sinusoidal intensity profile test target plotted against the spatial frequency of the image of the target. The transfer function may be derived mathematically from the spread function.

For many purposes a practical test target for resolving-power measurements consists of an array of patterns of the three-bar type. Each pattern consists of two orthogonal sets of three black bars of length five times their width, separated by white spaces of equal width (Figure 6.11). The spatial frequency of such a target is measured in line pairs per millimetre (lp/mm).

Successive targets proportionally reduce in size, a

usual factor being $2^{1/6}$. The resolution limit is taken as the spatial frequency at which the orientation of the bars can no longer be distinguished.

Rayleigh criterion

It was proposed by Rayleigh in 1879 (in connection with spectroscopy) that two components of equal intensity should be considered to be just resolved when the principal intensity maximum of one coincides with the first intensity minimum of the other. If this criterion is adopted for two Airy diffraction patterns, the resolving power RP of a diffraction-limited optical system is given by the expression

$$RP = \frac{1}{1.22\lambda N}$$

where N is the *f*-number of the system and λ the wavelength of the light. An Airy disc with a diameter of 0.008 mm thus corresponds to a resolving power of about 250 lp/mm at *f*/8 for an aberration-free lens. In practice, the presence of residual lens aberrations reduces lens performance, and so-called *spurious resolution* severely reduces theoretical values of resolving power. If the (arithmetic) contrast of the test target is reduced from a value of about 1000:1 for the ratio of the reflectance or luminance of the white areas to the black, to values more typical of those found in practical subjects, which may be as low as 5:1, the effect is even greater. A series of test targets of differing contrasts are needed to give useful data.

Lens aperture and performance

If the aperture of a photographic lens is closed down progressively, starting from maximum aperture, the residual aberrations (except lateral chromatic aberration and distortion) are reduced, but the effects of diffraction are increased. At large apertures the effects of diffraction are small, but uncorrected aberrations reduce the theoretical performance. The balance between the decreasing aberrations and the increasing diffraction effects on stopping down the lens means that aberration-limited lenses have an optimum aperture for best results, often about three stops down from maximum aperture. Many lenses, especially those of wide aperture, do not stop down very far, *f*/16 or *f*/22 being usual values, and diffraction effects may not be noticed: the only practical effect observed may be the increase in depth of field. However, with wide-angle lenses a variation in performance at different apertures is to be expected, owing to the effect of residual oblique aberrations. Here it may be an advantage to use a small stop. For

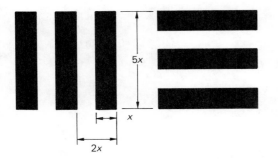

Figure 6.11 An element of a lens test target. A line plus its adjacent space gives a line pair with a spatial frequency of $\frac{1}{2}x$

close-up photography, photomacrography and en-larging, the value of v/d is much greater than the f-number of the lens, and the effects of diffraction are correspondingly greater than when the same lens is used for ordinary photography. In these circum-stances the lens should therefore be used at the largest aperture that will give an overall sharp image.

7 The camera lens

A *simple lens*, i.e. a lens made from a single piece of glass, exhibits all of the primary aberrations to a greater or lesser extent. Chromatic aberrations, spherical aberration, coma, astigmatism and curvature of field all combine to give poor image quality, while distortion leads to misshapen images. Thus the *image quality* of a simple lens is poor. But even in such a lens aberrations can be controlled to a certain degree, by choice of suitable curvatures for the two surfaces and by careful positioning of an appropriate stop, as suggested in the previous chapter. If, in addition, the field covered is restricted, it is possible even with a simple lens to obtain image quality that is acceptable for some purposes. However, the best simple lens produced is still limited not only in image quality but also in relative aperture and covering power. Early in the days of photography it was realised that for the photographic process to be exploited to the full, improved performance was required of the lens in all three of these properties. In view of the lack of sensitivity to light of the early sensitised materials, the primary requirement was an increase in relative aperture, to allow pictures, particularly portraits, to be taken without inconveniently long exposures.

Possible ways of improving the performance of a simple positive, biconvex lens are shown in Figure 7.1. The principles of compounding and splitting a lens element to allow the use of different glasses and distribution of the refracting power between the elements were found to be powerful tools of lens design.

Compound lenses

The reason the performance of a single-element lens cannot be improved beyond a certain point is that the number of optical variables or *degrees of freedom* which the designer can use is limited: in particular, there are only two surfaces. By using two elements instead of one to give a *doublet lens*, the number of degrees of freedom available is increased: there are four surfaces instead of two over which to spread the desired refraction of light; different types of glass can be used for the elements; and their spacing can be varied. The introduction of further elements increase the possibilities. Indeed, a *triplet lens* of three air-spaced elements can satisfactorily be corrected for the seven primary aberrations

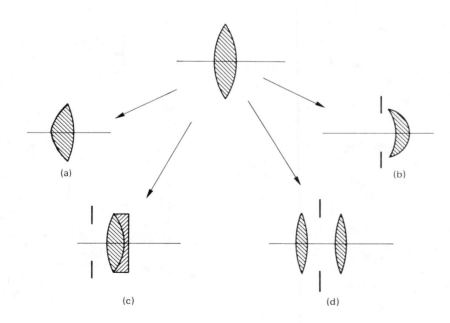

Figure 7.1 Methods of making simple derivatives for improved performance from a simple biconvex lens: (a) Aspheric front surface; (b) changing to meniscus shape and positioning a stop; (c) compounding with another lens into an achromatic doublet; (d) splitting to give a symmetrical lens

for a modest aperture and field of view. Six to eight elements are adequate for highly corrected, large aperture lenses. The optical constraints of modern extreme-ratio zoom lenses, however, may demand from fifteen to thirty elements.

To design a compound lens for a specific purpose, the lens designer has the following degrees of freedom and variables to work with:

(1) Radii of curvature of lens surfaces
(2) Limited use of aspheric surfaces

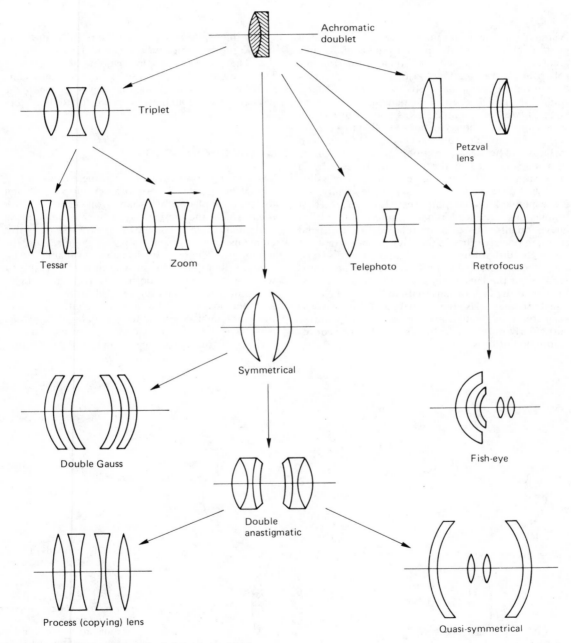

Figure 7.2 Relationships of basic lens designs to the simple achromatic doublet

(3) Maximum aperture as set by the stop
(4) Position of the aperture stop
(5) Number of separate elements
(6) Spacings of the elements
(7) Thicknesses of individual elements
(8) Use of types of glass differing in refractive index and/or dispersive power
(9) Limited possibilities of graded refractive index (GRIN) materials

Compound lenses were progressively developed as a means of reducing lens aberrations to acceptable levels to give better image quality, larger apertures and greater covering power than those of simple lenses. The way in which each aberration can be controlled has been indicated in Chapter 6. The general principle is to balance an error in one element by an equal but opposite error in another element in the configuration. It is not usually possible to eliminate an error entirely, merely to reduce it to an acceptable level in terms of its effects on image contrast, or shape or size of the spread function (see page 65). Frequently the correction of one error affects another, and a compromise has to be made with a lens intended for general-purpose use. If, however, maximum correction is desired in a lens designed with one particular use in mind, and which will therefore be employed only under a narrow range of conditions (say, always at full aperture, or at one scale of reproduction, or with monochromatic light), then improved performance is possible under these conditions at the expense of performance under other conditions for which the lens is not intended. Lenses of the highest correction are usually designed to give their best performance at or about one specific reproduction ratio, at one aperture and with light of a given quality. An apochromatic copying lens for example may be suitable for reproduction ratios from 1:5 to 1:1. An enlarging lens may be designed for a similar range of ratios, but scaling up rather than down. In general the requirements of high resolving power, large aperture and extra covering power are mutually opposed. When the very highest performance in any one of these is needed, the other two must be sacrificed to some degree.

There are only a very few basic types of lens, in terms of configurations or arrangements of individual elements; most practical photographic lenses are derived from these few types. The relationships of these types to each other and to the basic simple achromatic doublet lens are shown in Figure 7.2. Only the simplest form of each is shown. Practical designs usually have many more elements for the control of aberrations, but the principles remain the same.

Development of the photographic lens

In order to meet the demands of photographers for lenses of ever larger aperture, wider field angle and extended performance, many thousands of lens designs have been produced. Most of these when

Figure 7.3 Configurations of early lenses: (a) Landscape lens of Wollaston; (b) achromatic landscape lens of Chevalier; (c) Grubb's lanscape lens; (d) Petzval portrait lens; (e) Steinheil's Periskop lens: (f) Rapid Rectilinear lens: (g) Zeiss Double Protar lens; (h) Goerz Dagor lens; (i) Cooke triplet lens: (j) Zeiss Tessar lens

Table 7.1 Some outstanding steps in the development of the photographic objective

Type of lens	Degree of correction of aberrations							Maximum aperture on introduction	Approx. field covered at maximum aperture (degrees)
	Chromatic aberration	Spherical aberration	Lateral chromatic aberration	Coma	Distortion	Curvature of field	Astigmatism		
Simple lenses									
Wollaston landscape (stop in front) 1812	Poor	Satisfactory	Very poor	Satisfactory	Satisfactory	Satisfactory	Poor	$f/14$	53
Landscape with stop behind	Poor	Satisfactory	Very poor	Satisfactory	Poor	Satisfactory (if film is curved)	Poor	$f/14$	53
Chevalier landscape (achromatized) 1828	Good	Good	Poor	Satisfactory	Poor	Satisfactory	Poor	$f/12$	28
Petzval lens 1840	Good	Good	Poor	Satisfactory	Poor	Satisfactory	Poor	$f/3.7$	20
Doublets									
Steinheil Periskop (not achromatized) 1865	Poor	Good	Very much reduced	Very much reduced	Very much reduced	Satisfactory	Poor	$f/10$	90
Rapid Rectilinear ('old' achromat) 1866	Good	Good	Good	Good	Good	Satisfactory	Poor	$f/8$	44
Anastigmats (Jena glasses)									
Ross Concentric ('new' achromat) 1888	Good	Satisfactory	Good	Good	Good	Good	Good	$f/16$	53
Zeiss Anastigmat (Protar) (= half 'old' achromat, half 'new' achromat) 1890	Good	Good	Good	Good	Good	Good	Good	$f/8$	60
Triplet									
Cooke 1893	Good	Good	Good	Good	Good	Good	Good	$f/4.5$	53
Tessar 1902	Good	Good	Good	Good	Good	Good	Good	$f/5.5$	53

introduced represented state-of-the-art solutions to the problems involved, and ranged from simple to very complex designs, the number of elements not necessarily being related to performance.

It is possible to group photographic lenses into several categories based on the progress of nineteenth-century lens design; these give a fair indication of the limits to performance figures. By the beginning of the twentieth century lenses were available (albeit of modest aperture and field angle) which were virtually fully corrected for all the primary lens aberrations. Since that time, progress in lens design has largely been dependent on the availability of improved optical materials, lens-coating techniques, computer-assisted calculations, advances in lens production methods and more appropriate means of lens testing and evaluation (see page 65).

It is instructive to examine briefly the development of the photographic lens, the outstanding early advances of which are detailed in Table 7.1. The configurations of some of these lenses are shown in Figure 7.3.

Simple lenses and achromats

The year 1839 is taken as marking the beginning of practical photography. The use of lenses prior to this had been mainly for spectacles, telescopes, microscopes and the camera obscura. The *landscape lens* as used in the camera obscura was initially adapted for use in cameras in meniscus form with a front stop; Wollaston had shown in 1812 that a flatter field and reduced coma were given by this arrangement. Such lenses remained in use until comparatively recently in simple box cameras. In 1757 Dollond had produced an achromatic doublet telescope lens and this form of doublet was adopted for landscape lenses for photography. Because of uncorrected oblique errors, such lenses had to be used at small apertures and fields. Maximum apertures seldom exceeded $f/14$.

The Petzval lens

The simple lens was inconveniently slow for portraiture with the insensitive plates of the period, and active efforts were made to design a lens of large aperture; the principles were already well understood, but lack of suitable optical glasses hampered their realization. In 1840 J. Petzval designed a lens of aperture $f/3.7$. It consisted of two separated, dissimilar achromatic doublets; this was the first lens to be computed mathematically specifically for photography. It had roughly fifteen times the transmittance of other contemporary designs. The inevitable uncorrected aberrations, particularly astigmatism, gave poor peripheral definition, but this was found particularly pleasing for portraiture, as it gave a characteristic softness. Its restricted field of good central definition demanded a longer focal length than normal to cover a given plate size; the consequent need for a fairly distant viewpoint was a factor contributing to improved perspective in portraiture. The design is still the basis of many long-focus large-aperture systems.

Symmetrical doublets

There were few improvements in landscape lenses until the 1860s, when lenses of good definition, flat field and moderate aperture became available. The Steinheil Periskop lens of 1865 used two meniscus components placed symmetrically about a central stop. The importance of symmetrical or near-symmetrical construction is that it permits almost complete correction of the oblique errors, i.e. coma, lateral chromatic aberration and distortion. This non-achromatic lens was superseded in 1866 by the simultaneous introduction of two independent designs: the Rapid Rectilinear by Dallmeyer and the Aplanat of Steinheil, in which the meniscus lenses were replaced by achromatic combinations. Maximum aperture was around $f/8$, and astigmatism was still uncorrected.

Anastigmats

Astigmatism and field curvature could not at this time be corrected together with the other errors, as the dispersion of available glasses increased more or less proportionally with refractive index. However, pioneer work by Abbé and Schott in the 1880s (see page 63) produced new types of optical glass. Use of these resulted in the first *anastigmatic lenses*. Early examples of such lenses include the Ross Concentric (1888), Zeiss Protar (1890), Goerz Dagor (1892) and Zeiss Double Protar (1894). Lenses became increasingly complex: although the principle of symmetrical construction was followed, each component became a multiple cemented combination of old and new glass types, with maximum apertures up to about $f/6.8$.

Triplets

The increasing complexity of anastigmat lenses led to high manufacturing costs. In 1893 the Cooke Triplet lens, designed by H. Dennis Taylor and made by Taylor, Taylor and Hobson, was introduced. This was a departure from contemporary symmetrical designs as it consisted of only three single separated lenses, two crown-glass convex lenses of high refractive index and low dispersion, separated by a biconcave lens of light flint glass of high dispersion which served to flatten the field. The

outstanding feature of the triplet design is its simplicity of construction, while leaving sufficient degrees of freedom for full correction. The original aperture was $f/4.5$, but this was soon increased to $f/2.8$. Subsequent development by splitting and/or compounding the elements produced a wide variety of triplet derivatives. The Zeiss Tessar lens, designed independently in 1902 by Rudolph and in production ever since, is one of the best-known designs derived from the triplet configuration.

Double-Gauss lenses

Although lenses of symmetrical construction have considerable advantages, a major disadvantage of this configuration is the inability to correct higher-order aberrations, particularly higher-order spherical aberration; this limits maximum apertures to about $f/5.6$. Triplet construction, on the other hand, has a limit of about $f/2.8$. In order to obtain useful maximum apertures of $f/2$ or better with symmetrical configurations, a derivative of a symmetrical design based on a telescope doublet due to Gauss came into use. This doublet was air-spaced, with deeply curved surfaces concave to the subject. Two such doublets both concave to a central stop, are the basis of the *double-Gauss* form of lens. Derivatives with up to seven elements have useful apertures up to $f/1.2$.

Modern camera lenses

The highly-corrected camera lenses in use today are usually based on triplet designs for the lower priced, moderate-aperture varieties and double-Gauss designs for larger-aperture constructions. Symmetrical design is used for lenses for large-format cameras, for copying lenses and for some types of wide-angle lens. Highly asymmetric designs are used for zoom, telephoto, retrofocus and 'fish-eye' lenses.

Different in concept, and used only for long-focus lenses, the 'mirror lens' employs reflecting surfaces as the primary means of image formation, and to fold the light path for compactness. The relationship of these lenses (except for mirror systems) is shown in figure 7.2, and Table 7.2 lists some of their features. A selection of typical configurations is shown in Figure 7.4.

Standard lenses for most film formats have reached a high level of development, with large usable apertures and uniform performance over their angle of field. However, the standard lens does not fulfil all requirements, particularly where photographs of large angular field in cramped surroundings, or long-distance shots of inaccessible subjects, are required. In such instances, the use of wide-angle or long-focus lenses is necessary. In addition, where there is a need for a big close-up of a subject, a 'macro' lens is preferable. These lenses exist in a number of distinct design types, the results of intensive development work in recent years, aided by a number of interrelated innovations. These include:

Lens coatings

The widespread adoption of single or multiple anti-reflection coatings of various properties has enabled lens designers to incorporate many more elements than before. The contrast, colour balance and performance at extremes of aperture and field angle have all been improved.

Optical glass

New types of glass with higher refractive index and lower dispersions as well as lower weight per unit

(a) (b) (c)

(d) (e) (f)

Figure 7.4 Modern lens configurations: (a) 8 mm fisheye; (b) 24 mm retrofocus wide-angle; (c) 50 mm $f/1.4$ double-Gauss derivative; (d) 105 mm $f/1.8$ double-Gauss derivative; (e) 200 mm telephoto; (f) 400 mm super telephoto with ED glass element (hatched)

Table 7.2 Modern lens types

Name or type	Basic optical construction	Exceptional for	Poor for	Special features or advantages of this design or construction	Uses
Meniscus			A,D,F	Cheap, low flare	Simple cameras, close-up lenses
Landscape		CA	A,F	Achromatic	Simple cameras, close-up lenses
Soft-focus portrait			Deliberate spherical aberration	Controllable residual aberrations	Portraiture
Petzval		S	A,F	Large aperture, good correction	Portraiture, projection
Symmetrical		D	F	Distortion-free	General
Double anastigmat		D	S	Distortion-free, components usable separately	General
Double Gauss		S,C	D	Large apertures possible	Low light level work
Triplet				Good correction for all aberrations, cheap	General
Quasi-symmetrical		D		Wide-angle lens, distortion-free	Aerial survey work, rangefinder cameras
Process		All		Highly corrected	Copying and close-up work
Telephoto			D	Short back focus, compact	Long-focus lens
Retrofocus			D	Long back focus, reflex focusing	Wide-angle lens for SLR cameras
Fisheye			Deliberate distortion	Field angle exceeding 180°, reflex focusing	Cloud studies, special effects
Zoom			D	Variable focal length with constant f/number	General
Mirror		S,CA,L	A,F	Compact construction, lightweight	Long focus lens

S, spherical aberration. CA, chromatic aberration. L, lateral colour. C, coma. A, astigmatism. D, distortion. F, field curvature.

volume have become available. Chemical elements such as lanthanum and tantalum are used in some newer glasses, and materials such as fluorite and fused silica (quartz) are used for some applications requiring chromatic correction extending into the ultraviolet and infrared regions.

Aspheric surfaces

The use of aspheric surfaces for small production runs of lenses (made possible by advances in manufacturing techniques) allows lenses to be made with very large useful apertures in both long-focus and

wide-angle designs. In traditional designs fewer elements are needed.

Floating elements

Experience with groups of moving elements as used in zoom lenses has enabled designers to introduce 'floating elements' that move axially to correct for spherical aberration, and retain performance at close object distances. Such techniques are particularly useful in macro lenses and wide-angle lenses of large aperture. The technique is also used for 'internal focusing' of a range of lenses from autofocus (AF) types to super-telephotos, giving a means of rapid focus change with little mechanical movement and allowing the lens barrel to be sealed.

Computer aided design

The tedious task of calculating ray paths through optical systems, an essential design procedure, has been greatly speeded up by the use of digital computers and optical design packages. Usually such programs will optimize a design as far as possible given practical restraints, after which human judgement determines the final configuration. The design of increasingly complex lens-barrel and focusing-mount assemblies is also dependent on such assistance.

Evaluation of results

The use of complex image-evaluation techniques to provide means for the objective evaluation of lens performance has contributed to improvements in design and to the essential quality control in manufacture. Few lens users have access to such equipment for the measurement of image contrast and the production of modulation transfer function figures (see page 65). A direct result has been a considerable increase in the range of focal lengths available for the various formats; also larger usable apertures, closer focusing, unusual designs for specific functions and overall improved performance. The range of modern lenses offered by a manufacturer for given formats may typically be:

(1) 6.5 to 2000 mm focal length for the 24 × 36 mm format
(2) 30 to 1000 mm focal length for the 60 × 60 mm format
(3) 65 to 1000 mm focal length for the 4 × 5 in (102 × 127 mm) format

An example of the improvements that have been made in just one class of lens is illustrated by the case of the wide-angle lens. The old problems of poor covering power, low marginal resolution, small usable apertures and flare have largely been overcome. Typically, for the 24 × 36 mm format, 15 mm $f/3.5$, 24 mm $f/2$, 28 mm $f/3.5$ perspective-control and 35 mm $f/1.4$ lenses are commonly available, all in retrofocus configurations. The 60 × 60 mm format has available lenses of 30 to 50 mm focal length and aperture $f/4$ to $f/2.8$. Large formats also have wide-angle lenses with usable apertures of $f/5.6$ to $f/4$ and sufficient covering power to permit limited use of camera movements. At the extreme ends of the available range of focal lengths, ultrashort-focus fisheye lenses and ultralong-focus mirror-lens designs are now common.

Another type of lens, the *zoom lens*, has undergone very substantial improvement in recent years with many interesting design variants, but this lens has not yet reached the end of its design potential; indeed there is already a trend for zoom lenses to become the standard lens for a general-purpose camera.

The so-called macro lens, which is specifically designed and corrected for close-up work, is now available with an excellent all-round performance and a maximum aperture of $f/2$, its versatility making it also a contender with the traditional standard lens usually supplied with a camera.

Finally, the standard lens itself has undergone several changes. Contrast, resolution and freedom from flare have all been improved. Maximum apertures of $f/2$ or $f/1.4$ are commonplace for lenses used with the 24 × 36 mm format, and $f/1.2$ is not uncommon; $f/2$ lenses are now standard for the 60 × 60 mm format in some cases.

Wide-angle lenses

Wide-angle lenses, i.e. lenses where the focal length is less than the diagonal of the film format, have been in use since the earliest symmetrical versions were produced in the middle of the nineteenth century. They were limited in practice by severely-restricted covering power, owing to the \cos^4 law (see page 52), fall-off in marginal resolution, and small useful apertures (typically about $f/22$).

Symmetrical-derivative designs

Forms of quasi-symmetrical construction have been found to give improved evenness of illumination and better image quality, as well as the use of larger apertures up to about $f/2.8$. The symmetry means that correction for distortion is particularly good. These symmetrical derivatives use very large negative meniscus lenses either side of the small central positive groups, giving the lens a characteristic wasp-waisted appearance and increasing its bulk.

Such lenses, when used on technical cameras, allow use of the camera movements, depending on their focal length and covering power. The ability to employ the rising-front movement is particularly useful. Unfortunately, in common with the simpler symmetrical form, such lenses have a very short back focal distance so that the rear element is close to the film plane. Consequently, any form of reflex viewing and focusing is impossible; when this is necessary, lenses of retrofocus construction must be used instead.

Retrofocus designs

Departure from the symmetrical form of construction by using a front divergent (negative) group with a rear convergent (positive) group of elements gives a lens that has a short focal length in relation to its back focal distance, owing to a shift in the positions of the nodal planes (Figure 7.5). As this arrangement is the opposite of the telephoto construction it is often described as a reverse or inverted telephoto configuration.

The asymmetry of the design can give rise to barrel distortion, especially in earlier designs. However the long back focal distance permits devices such as shutters, beamsplitters and reflex mirrors to be inserted between the lens and film

plane. The disadvantages are increased complexity of construction and the associated extra cost, bulk and weight.

Fish-eye lenses

As discussed on pages 49–54, the geometry of image formation and illuminance limit the field of view of a distortion-free lens to about 120°. However, if the occurrence of barrel distortion is permissible, a lens covering angles of view of 180° and even more is not ruled out. Retrofocus configuration is used to permit the installation of such lens systems in single-lens reflex cameras. Such lenses are called *fish-eye lenses*, and they come in two versions. The *quasi-fish-eye lens* has a circle of illumination that circumscribes the film format and gives 180° angle of view across the diagonal. The *true fish-eye lens* has its circular image wholly within the film frame, thus recording more of the scene. The diameter of the image circle depends on the focal length of the lens.

A different form of image projection is used for image formation. A conventional photographic lens of focal length f and semi-field angle θ forms images by *central projection*, where the image height Y as measured from the optical axis of the lens is given by the relationship $Y = f \tan \theta$. Most fish-eye lenses use *equidistant projection*, where $Y = f\theta$ when θ is measured in radians. Such lenses have many technical applications.

Long-focus lenses

A long-focus lens is a lens possessing a focal length markedly greater than the diagonal of the format in use. As image height is proportional to focal length, an increase in focal length gives a bigger image. The usual achromat lens configurations—Petzval, symmetrical and double-Gauss—have all been used, depending on the maximum aperture and focal length required. Very-long-focus lenses of small aperture can be of simple construction, even merely achromatic doublets. However, there are practical problems in the use of such designs. The use of refracting lenses is limited by the diameter of available glass blanks (some 150 mm) and by the effects of lateral chromatic aberration as focal length is increased. Also, the length and weight of such lens systems pose problems in design and handling. There is also a danger of internal reflections from the long lens mount. The use of telephoto construction and mirror optics removes some of the problems of excessive length and lateral chromatic aberration. Refracting elements made from fluorite or special extra-low-dispersion glass can greatly improve colour correction.

(a)

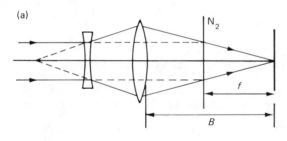

(b)

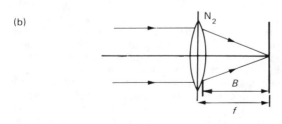

Figure 7.5 Retrofocus construction: (a) A retrofocus combination of front negative lens and rear positive lens giving back focal distance B much greater than focal length f; (b) an equivalent short-focus lens where B and f are similar

Telephoto lenses

By placing a negative component behind a positive component, the transmitted beam of rays is made less convergent, as though it had been formed by a lens of much greater focal length; the nodal planes are in front of the lens (figure 7.6). Thus the length of the lens barrel is very much less than would be needed for a conventional lens of such long focal length.

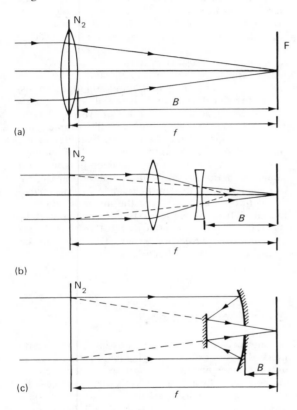

(a)

(b)

(c)

Figure 7.6 Telephoto construction: (a) A long-focus lens where the back focal distance *B* is similar to the focal length *f* measured from rear nodal point N$_2$ to film plane F; (b) An equivalent design using a front positive lens and a rear negative lens in a telephoto combination so that *B* is much less than *f*; (c) another equivalent design using two optical reflecting surfaces to give a mirror lens, where *B* is very much less than *f*

On this principle, early *telephoto attachments*, the precursors of the modern *teleconverter*, were formerly used in conjunction with normal lenses for obtaining a variety of focal lengths with relatively short camera extensions. The resultant combinations had small apertures, and performance was poor. Such devices have now been replaced by complete *telephoto lenses*, the components of which are fully corrected. The ratio of the focal length of a telephoto lens to the distance from the front element to the film plane is known as the *telephoto power*.

Telephoto lenses are generally well-corrected, and have fairly large apertures. They tend to suffer from pincushion distortion due to the asymmetric construction, but this is not usually a serious problem. Cameras equipped with telephoto lenses are easier to handle, and less prone to camera shake, than those equipped with a long-focus lens of conventional design, as the camera is better balanced and lighter. The introduction of materials such as extra-low-dispersion glass and fluorite has given rise to a class of lens called *super-telephoto*. These are lenses predominantly for 24 × 36 mm and 45 × 60 mm formats, and have focal lengths of 200 to 800 mm with the exceptionally large apertures of *f*/2 to *f*/2.8 in the shorter focal lengths and *f*/4 to *f*/5.6 in the longer focal lengths. Such lenses are state-of-the-art designs using multi-coatings, internal focusing and anti-flare construction. They are costly but are exceptionally easy to use hand-held; and they find extensive applications in sport, natural history and surveillance work. Apart from the ease of focusing and the capability of use of the slower colour films or short exposure times, an advantage of the large aperture is that the use of suitably designed teleconverters (see page 80) gives very long focus lenses that nevertheless have a usefully large aperture. For example, a 300 mm *f*/2.8 camera lens can be converted into a 450 mm *f*/4 or a 600 mm *f*/5.6 lens by the use of × 1.5 and × 2 teleconverters respectively.

Catadioptric lenses ('mirror lenses')

The advantage of using a concave mirror rather than a convex lens is that it does not produce any chromatic dispersion. Such an approach was used by Newton for a reflecting telescope. Newton's telescope, however, had an eyepiece that was at right angles to the incident light. For photographic purposes there must be convenient access to the image, and the lens is best pointed at the subject, so the Cassegrainian system is preferred. This system requires a secondary reflector to project the image through a hole in the primary mirror. For astronomical telescopes a paraboloidal mirror is employed, but for photographic purposes such a mirror is not suitable; not only is it expensive to produce, but it can cope with only small field angles owing to off-axis aberrations. If a spherical mirror is used instead, the field angle can be larger, but the image suffers from both spherical aberration and curvature of field.

Residual spherical aberration may be corrected in various ways (Figure 7.7). An aspheric *Schmidt*

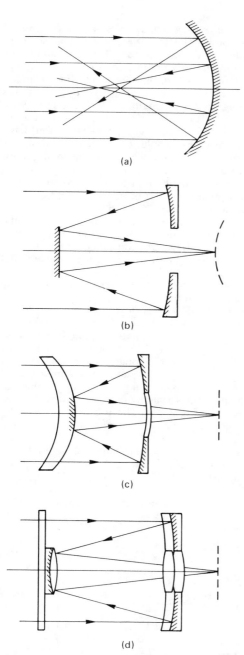

Figure 7.7 Mirror lens designs: (a) Simple spherical mirror with spherical aberration; (b) Cassegrainian construction with secondary reflector; (c) Bouwers-Maksutov design; (d) Mangin mirror design

surface coated onto the rear surface of a thin refracting element; or, alternatively, large thick refracting elements that are concentric with the spherical prime mirror. This latter approach was pioneered independently by Bouwers in Holland and Maksutov in Russia during World War II. The introduction of refracting elements constitutes a *catadioptric* design. (A *dioptric system* is a system consisting of transmitting elements, i.e. lenses, whereas a *catoptric system* consists of reflective elements, i.e. optical mirrors. A *catadioptric system* is a hybrid optical system containing both lenses and mirrors.)

The refracting elements need to be achromatized; but their power may be chosen so as to give a flat field. They may also be positioned so as to seal the barrel and at the same time to provide a support for the secondary reflector. In all designs flare is a serious problem, and baffling and other anti-flare construction are essential.

Because of the central obstruction of the secondary mirror, the transmittance of such a lens cannot be controlled by an iris diaphragm. Instead, a turret of neutral-density filters is used; this may also contain colour filters. Mirror lenses are available with focal lengths in the range of 300 to more than 2000 mm and with apertures from $f/5.6$ to $f/11$. The compact design with its short length and large diameter compares favourably with equivalent long-focus or telephoto constructions. Solid glass construction has been used to further reduce optical path length and provide optical path stability.

A useful feature of mirror lenses is their ability to focus close up. An axial movement of only a few millimetres of the secondary mirror will serve to focus a 500 mm lens from infinity to an image scale of some 0.25.

Zoom and varifocal lenses

A *zoom lens* is a lens with a focal length that can be varied continuously between fixed limits while the image stays in acceptably sharp focus. The visual effect in the viewfinder is that of a smaller or a larger image as the focal length is decreased or increased respectively. The *zoom ratio* is the ratio of the longest to the shortest focal length: for example, a 70–210 mm zoom lens has a zoom ratio of 3:1. For 35 mm still photography, zoom ratios of about 2:1–6:1 are available, but for cinematography and video, where formats are much smaller, zoom ratios of 10:1 or 20:1 are not uncommon.

The optical theory of a zoom lens is simple (through the practical designs tend to be complex): the equivalent focal length of a multi-element lens depends on the focal lengths of individual elements and their axial separations. An axial movement of one element will therefore change the focal length of

corrector plate at the centre of curvature of the spherical mirror is used for large aperture, wide-field astronomical cameras, but is very expensive to manufacture. Cheaper alternatives used for photography are a *Mangin mirror*, which has a reflecting

the combination. Such a movement coupled to a hand control would give a primitive zoom lens. The simplest possible arrangement would be a front negative lens plus rear positive lens; reducing their separation would increase the equivalent focal length.

Such a simple lens would suffer from two major defects: the image would be severely aberrated; more important, it would not remain in focus while being 'zoomed'. Both defects demand extra lens elements; in practice any number between six and twenty may be needed. A sharply-focused image is retained by a process of compensation, as provided, for example, by another element moving in conjunction with the zoom element. Two types of compensation are used; optical, where the two moving elements or groups are coupled and move together, and mechanical, where the two groups move at different rates, sometimes in different directions. Optical compensation was preferred originally, as the lens unit and internal controls were easier to make, but with the advent of numerically-controlled machine tools complex control cams can be cut, and mechanical compensation is now preferred as higher levels of correction as possible. The moving groups may follow non-linear paths, so that as the zoom control is operated the elements may first advance and then recede again. Some modern optically-compensated zoom lenses use three or even four moving groups, with some degree of mechanical compensation.

The classic design of zoom lens is an arrangement of four groups of elements. Normally the two linked movable zoom groups are located between a movable front group which is used to focus the lens and a fixed rear group which also contains the iris diaphragm. This rear group is positive and acts as a relay lens to produce an image in the film plane via the zoom groups, which act as an afocal telescope of variable power (Figure 7.8). This system also keeps the *f*-number constant as focal length is altered, by controlling the size and location of the exit pupil of the system. This 'fixed-group' feature means that a separate mechanical control to adjust the iris according to focal length is not required. With computer-assisted design techniques, innovations such as close focusing (i.e. nearer than 1–2 m) have recently become possible. In another new design, a separate *macro-zoom control* used the zoom groups so that for a certain focal length one group is moved to give a form of internal focusing over a limited close-up range with the prime focus control set at infinity focus. (There may in practice be a gap between normal close focus and the far point of the close-up range). One advantage of this system is that the *f*-number stays almost constant over the close-up range, which is not the case with a conventional macro lens.

As few present-day 'macro' lenses offer a genuine 1:1 scale, the term 'macro' has become to some extent devalued. The performance of zoom lenses for close-up work has been poor owing to problems of spherical aberration, curvature of field and distortion. However, zoom lenses are now entering a new generation of design, and many of the drawbacks of earlier designs have been reduced or eliminated. A modern zoom lens may now be no larger than an equivalent fixed-focal-length lens of the longest focal length it replaces. The use of ED glass elements permits even more correction and compactness.

Recent additions to the range of zoom lenses include wide-angle-to-standard lenses for 35 mm cameras such as 21–35 mm, 24–35 mm and 24–50 mm. Continuous close focusing is possible with a single focus control, by movement of all or

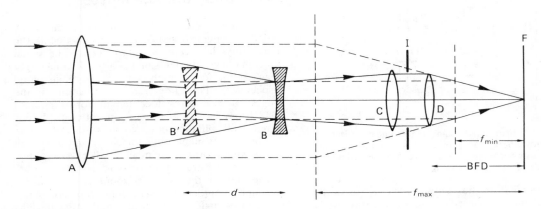

Figure 7.8 Basic zoom lens system: Elements A, B and C form the zoom variator system; D is the relay lens and I is the iris diaphragm

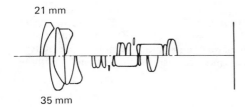

21 mm

35 mm

(a)

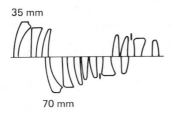

35 mm

70 mm

(b)

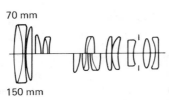

70 mm

150 mm

(c)

Figure 7.9 Zoom lens configurations; the various groups of elements alter their relative positions in various ways to change focal length: (a) All the elements in three groups move between the extremes shown to give 21–35 mm. The iris also shifts; (b) all the elements move in two groups with the iris to give 35–70 mm; (c) two groups move to give 70–150 mm, the iris remaining static; in focusing, the whole lens is moved axially

part of the lens groups in some of the newer lenses, making separate macro modes obsolescent. The internal focusing may be under the control of an in-camera autofocus system, and the lens will contain suitable electronics to relay data back into the central processing unit of the camera.

A penalty of mechanical compensation is that the *f*-number changes with focal length, giving a loss of one-half to one full stop from minimum to maximum focal length. This penalty may also be accepted in order to keep the size of a zoom lens to within reasonable limits. Some lenses do have additional mechanical control of the iris to keep the *f*-number approximately constant while zooming. However, almost all cameras now have TTL metering, which will correct for changes in effective *f*-number. The modern zoom lens is very much a viewfinder-oriented lens in that it carries little information on its controls as to focus setting, focal length and depth of field. The distortion correction of zoom lenses is now also much improved, and image quality may approach that of a fixed-focal-length lens.

Varifocal lens

In a varifocal lens there is no attempt to hold the focal plane constant when the focal length is changed. This makes for a simpler and cheaper design where a constant focal plane has little or no advantage, as in slide and ciné projectors. To offset the slight inconvenience of having to refocus the lens when the focal length (i.e. the projected image size) is changed, it is possible to produce very good correction with comparatively few glass elements.

For general-purpose photography, the zoom lens can be a very useful tool. One lens, say of 28–85 mm specification with close-focus capability to an image magnification of 0.25, can perform adequately for many purposes, especially if moderate apertures can be used. At the time of writing, zoom lenses are still of modest maximum aperture, and the double-Gauss type of lens with aperture *f*/1.4 is still needed for some low-light photographic tasks.

Macro lenses

The design of a lens with good aberration correction requires the object conjugate distance to be specified. As most amateur photography is of subject matter that is at least 200 focal lengths away, the object conjugate is taken as infinity. General-purpose lenses are therefore designed to give their best performance for infinity, or at least for a large distance. The performance of such a lens is likely to be much less satisfactory when focused on a short distance, as in close-up work or photomacrography. Measures such as floating elements and lens reversal rings may help in some cases, but it is clearly better to have a lens that is designed from the start to produce a high-quality result when used for close-up work. Such a lens is known as a *macro lens*.

A macro lens of the type that is available as an alternative to the standard lens for SLR cameras usually features an extended focusing mount using a double helicoid arrangement. This gives enough additional extension to provide a magnification of 0.5, though a few do give actual-size reproduction. A range from infinity to half-life-size is usually sufficient in practice, at least in the 24 × 36 mm format, and this keeps the focusing mount to a reasonable size. For the magnification range from 0.5 to 1.0 an extension tube can be added. Such a

lens has full automation of the iris, and full aperture metering. Correction is optimized for a magnification of 0.1 and the corrections hold well down through the close-up range to unit magnification. Thereafter the lens is best used reversed, with consequent loss of the automatic features. The lens barrel is engraved with scales of magnification and exposure correction factors: these are more useful when using manual electronic flash, as TTL metering systems automatically correct exposure at long extensions.

Macro lenses use triplet-derivative or double-Gauss designs computed to give the flat fields and distortion-free images essential for copying work. The maximum aperture is commonly $f/2.8$. For optimum results with subjects at infinity it is advisable to close down about two stops from maximum. Macro lenses often have focal lengths that are longer than normal; they are typically in the range 55 to 200 mm for a 24 × 36 mm format. Some are obtainable as just a *lens head*, an optical unit for attachment directly to an extension bellows so as to give an extended focusing range.

Teleconverters

Although they are not strictly camera lenses, as they do not form a real image on their own, these optical devices are in common use with camera lenses, and a discussion of their features is therefore appropriate here. The astronomer Barlow reported in 1834 that placing a secondary negative lens behind a primary positive lens would increase the effective focal length; indeed, this is the principle of the telephoto lens discussed earlier. (Galileo had noted this two hundred years previously.) Today such lenses are sold as *teleconverter lenses* which contain typically four to eight elements with a net negative effect, housed in a short extension tube. The teleconverter is usually fitted between the camera lens and body (Figure 7.10); linkages transmit the functions of automatic iris and focus and metering information. The effect of a teleconverter is typically to double or triple the focal length of the camera lens, forming a telephoto combination of short physical length. As the size of the entrance pupil is unaffected, this doubling or tripling means that the maximum aperture is reduced by two or three whole stops, turning for example a 100 mm $f/2.8$ lens into a 200 mm $f/5.6$ or a 300 mm $f/8.4$. Where these losses are unacceptable, a × 1.4 converter with only 1 stop loss may be preferred, especially where a long-focus lens is already in use.

The change of marked apertures is usually automatically corrected for by the TTL metering system used in most cameras, but must be remembered for use with manual, automatic and non-OTF electronic flash. The modest cost, small size and reasonable

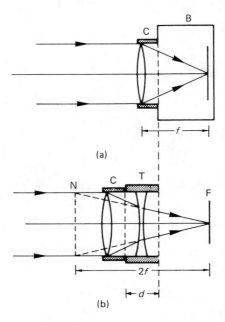

Figure 7.10 The teleconverter principle: (a) Camera lens C of focal length f in body B focuses light onto film F; (b) addition of teleconverter T of thickness d gives rear nodal plane N and combined focal length $2f$

results make teleconverters useful accessories. The minimum focusing distance of the camera lens is retained, with image magnification increased. Thus a 90 mm $f/2.8$ macro lens focusing unaided to give 0.5 magnification, when used with a specially designed converter, often called a *matched multiplier*, will give a combination 180 mm $f/5.6$ lens focusing to give unit magnification. Some manufacturers produce highly-corrected converters designed especially for a particular lens or range of focal lengths; in such cases the performance is excellent. In general teleconverters do not perform well with wide-angle lenses, as aberration correction may be affected adversely. Thus it is pointless to convert a 24 mm lens into a 48 mm lens of mediocre performance when a good 50 mm standard lens may be available; on the other hand it is useful to be able to convert a 200 mm lens to 400 mm to save buying a heavy and expensive lens that will seldom be needed.

8 Types of camera

A camera is essentially a light-tight box with a lens at one end and a fixture to hold light-sensitive material at the other. In all but the simplest cameras there is provision for variation of the distance between the lens and the film in order to focus on subjects at various distances from the lens. Light is prevented from reaching the sensitive material by a shutter, which controls the duration of the exposure. During the exposure the illuminance on the film is controlled by an iris diaphragm, the aperture diameter of which can be varied. The settings of the shutter and iris diaphragm may be determined by an exposure measuring system that is part of the camera, possibly measuring through the lens. Finally, the camera must have a viewfinder system by which the subject area to be included on the film may be determined. An essential feature is some means of advancing the exposed film in the gate to the next frame, and an additional feature is a flash synchronization device coupled to the shutter.

Survey of development

A prominent feature in the development of camera design since the primitive cameras used in the early nineteenth century is the way the weight, size and shape have varied with innovations and improvements in design. Such changes have been due to parallel developments in emulsion technology, optical design, construction materials and manufacturing techniques, as well as being related to the popular appeal of certain formats and the demand for versatility of function.

Camera format

During the last decades of the nineteenth century, and continuing well into the twentieth, the majority of photographs were taken on glass plates. Contact printing was normal practice and plate sizes up to 305 × 381 mm were not uncommon. Indeed 'quarter plate' (82 × 108 mm or 3¼ × 4¼ inches) was long regarded as the minimum useful size. Apart from the commonly-adopted plate sizes there were some unusual ones for specific cameras. Steady improvements in lenses, emulsions and illuminants made projection printing a feasibility and started the steady decrease in negative size. the advent of roll film hastened this process and the 60 × 90 mm

format (8 pictures on 120 size material) became very popular shortly before the Second World War, though by this time the 24 × 36 mm format on 35 mm perforated film had begun to be less of a novelty than it had been in the late 1920s when it was introduced. The 24 × 36 mm format has emerged as the most enduringly popular size, in spite of sporadic efforts on the part of manufacturers to introduce variations such as 24 × 32 mm and 28 × 40 mm. For a few years the 'half-frame' format of 18 × 24 mm proved popular on account of film economy and the range of compact cameras available. However, the advent of cameras using the conventional format of 24 × 36 mm but equally small in size ousted the smaller format.

The demand for a truly pocket-size camera was in part met by the introduction in the early 1970s of yet another format, that of 11 × 17 mm on film 16 mm wide in pre-loaded cartridges, designated 110 size. Similarly, another format of very small dimensions of some 8 × 10 mm, giving 15 exposures spaced

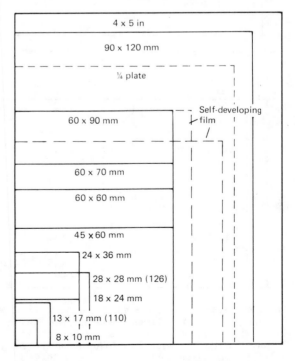

Figure 8.1 Relataive area of nominal film formats

radially round a single circular piece of film ('disc' format) was introduced in the early 1980s. This, too, gave very compact camera dimensions but required a high-technology approach in respect of both lens design and automation of functions. The relative areas of various film formats are shown in Figure 8.1.

Roll films have been manufactured in very many sizes, most now obsolete. Currently-available sizes are coded 110, 126, 127, 120 and 220. Perforated films of gauge 16 mm, 35 mm and 70 mm are also used. 110 and 126 films are in the form of drop-in cartridges with pre-fogged film rebates. The 126 format is 28 × 28 mm on film 35 mm wide. Both of these formats and the disc format are widely used in simple or automatic cameras intended primarily for the casual user. The 127 size is virtually obsolete, no new camera for this size having been produced for many years. Cameras with formats of 30 × 40 mm, 40 × 40 mm ('Superslide') and 40 × 65 mm were at one time available, using 127 roll film and giving 16, 12 and 8 exposures respectively per roll.

The most commonly-used roll film at present is the 120 size, using film of 62 mm gauge. This gives a wide choice of formats such as 45 × 60 mm, 60 ×

60 mm, 60 × 70 mm, 60 × 80 mm and 60 × 90 mm, giving 16 or 15, 12, 10, 9 and 8 exposures respectively per roll. These numbers are doubled for the 220 size, which is the same width as 120, but twice as long and supplied with leaders but no backing paper. The same formats are used with 70 mm perforated film, but the choice of emulsion types is limited. A small number of specialist cameras use 120 film to give formats of high aspect ratio such as 60 × 120 mm and 60 × 170 mm. Various formats are shown in Figure 8.2.

Sheet films were at one time considered an inferior alternative to plates. The introduction of plastics base materials such as polyester, with improved dimensional stability, has meant the end of plate use for most purposes other than specialist applications such as holography, astrophotography, spectroscopy and photogrammetry. Professional work has tended to become standardized on 102 × 127 mm (4 × 5 inch) and 203 × 254 mm (8 × 10 inch) sizes, while 60 × 90 mm is used occasionally. The formats of quarter-plate (3¼ × 4¼ inch), half-plate (4¾ × 6½ inch) and wholeplate (6½ × 8½ inch) are almost obsolete, while 5 × 7 inch is becoming rare.

A large format does not necessarily mean bulk;

Figure 8.2 Formats on roll film: (a) 35 mm film (perforations omitted), all dimensions in millimetres: A, 18 × 24 (half-frame); B, 23 × 24 (stereo, Robot); C, 24 × 32 (rare); D, 24 × 36 (135); E, 24 × 56 (panoramic); F, 28 × 28 (126); (b) 120 roll film (62 mm wide): A, 45 × 60; B, 60 × 60 (2¼ inches square); C, 60 × 70 (ideal format); D, 60 × 90; E, 40 × 40 (super slide); F, 23 × 23 (stereo); G, 28 × 40 (828 size, 24 on 120); not shown are 60 × 80 mm, 60 × 120 mm and 60 × 170 mm

ingenious construction methods have been used to reduce the size of such cameras for transportation purposes. Technical cameras, even the monorail type, may be collapsed to moderate dimensions. Cameras using 35 mm film began as very compact pieces of apparatus, but have tended to increase in bulk as their versatility has been extended. Cameras using 120 size film, on the other hand, began as bulky 'box' cameras, where superseded by compact folding models, and then became enlarged again into modern twin-lens and single-lens reflex cameras. Many cameras can be provided with adaptors to take a smaller format, e.g. roll-film backs for technical cameras and 35 mm film adaptors for 120 size roll-film cameras.

The true pocket-size or 'sub-miniature' camera has existed in various forms for many years and generally uses 16 mm or 9.5 mm perforated film with a format of 11 × 17 mm or less. The 110 cartridge camera has generally replaced these. The disc-format camera could be classified as sub-miniature as far as format is concerned, but the camera itself is comparatively large as it usually features an integral electronic flash unit. Disc camera cassettes are particularly easy to load.

Versatility of function

On early cameras, features such as triple-extension bellows, extensive range of camera movements and interchangeable lenses and backs were taken for granted. As cameras developed, many of these features were lost. For example, restricted focusing movements often allowed lenses to be focused no closer than 1 metre; for closer work special attachments were needed. This trend has now reversed, and the standard lens on most cameras will focus continuously down to 0.5 m or less without attachments.

Large-aperture lenses require precision-built camera bodies; this means the loss of camera movements, though the limited covering power of such lenses would in any case not permit their use. Interchangeable lenses were uncommon until the advent of modern small-format cameras, particularly the single-lens reflex camera. The facility of interchangeable backs is still limited to a few cameras. Technical cameras have retained all of these useful features, and have been much improved by innovations such as modular and 'optical-bench' construction, 'international' backs, electronic shutters and through-the-lens exposure metering. In small-format cameras the continuing trend is to incorporate more features such as power-wind and integral flash units to increase versatility; accordingly, 24 × 36 mm and medium-format cameras are produced as the basic unit in a 'system' of interchangeable lenses, viewfinders and backs, remote control, motor drives and close-up accessories. Such a system increases versatility enormously in comparison to haphazardly-produced accessories.

The materials of construction used are an important feature. Early plate cameras were of wood with brass fittings and leather bellows, which gave low weight and reasonable precision. Modern technical cameras made of die-cast alloys have greater weight but their bulk is much the same. Bellows of square, taper or bag construction are still used. The advent of small-format cameras demanded a precision given only by all-metal construction and small manufacturing tolerances. This resulted in a camera that was heavy for its size. The judicious use of modern engineering plastics such as carbon-filled polycarbonates for many control surfaces, exteriors and less critical components, coupled with a precision die-cast alloy core forming the camera body, has successfully combined moderate weight with the necessary accuracy. Such plastics materials give a pleasant surface finish to the camera body and allow shaping of the body to provide anatomical grips. Camera bodies may occasionally be made from titanium metal for exceptional durability and strength with low weight.

Increasingly, ergonomics are being seriously considered in camera design: cameras are now being designed to be more easily operated when hand-held. Improvements include positioning and legibility of scales, direction and amount of movement in focusing controls, larger and better-sited controls, large eyepieces in viewfinders, easy loading of film and the use of a comprehensive LED type display in the viewfinder, or of a large LCD type display using various pictograms on top of the camera body to give a read-out of the status of the camera in its alternative modes of use. Modular design of sub-units such as the shutter assembly or electronics wiring harness greatly facilitates servicing or repair. Modern solid-state devices are very reliable, and the extensive adoption of electronics in cameras has not led to any significant increase in camera malfunctions. Simple maintenance such as changing camera batteries that operate shutters and metering systems is the responsibility of the user, but long-life lithium batteries are increasingly being used for functions and require less frequent replacement.

Camera types

Many types of camera have been manufactured both for general applications and for specialized purposes in conjunction with a range of accessories. Most cameras can be categorized into one of several well-defined types, though of course there are unique exceptions. The major types of camera in production may be listed as simple, compact, range-finder, twin-lens reflex, single-lens reflex, technical,

miscellaneous specialized designs and still video cameras. The last offers most of the features of a conventional camera, but uses an opto-electronic form of imaging sensor rather than the silver-halide materials of traditional usage. A variety of types of camera are shown in Figure 8.3.

Simple cameras

The term 'simple camera' is now taken to mean one made for ease of operation, with little choice of control settings. The archetypal simple camera was the early primitive box camera equipped with a

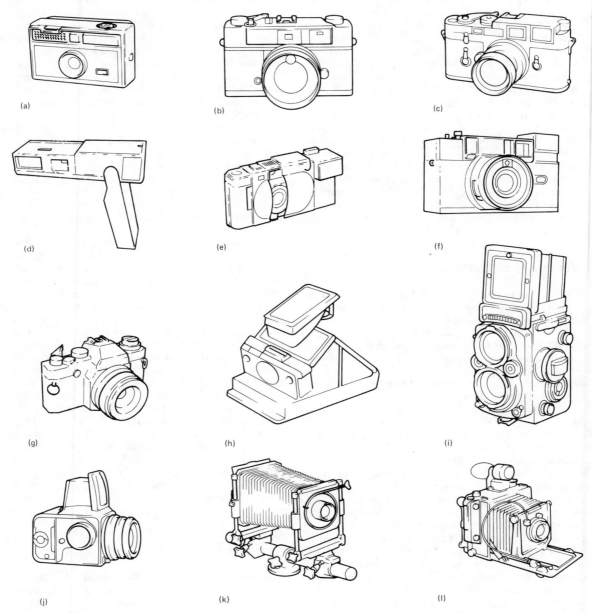

Figure 8.3 Camera types. (a) Simple camera using 126 film; (b) rangefinder camera with fixed lens; (c) rangefinder camera with interchangeable lens; (d) 110 format camera with case/handle and integral flash; (e) compact camera with attachable flash; (f) compact autofocus camera with integral flash; (g) single-lens reflex camera for 35 mm film; (h) camera for self-developing film; (i) twin-lens reflex with fixed lenses; (j) single-lens reflex for 120 films; (k) technical camera of the monorail type; (l) technical camera of the folding baseboard type

single meniscus or doublet lens with an aperture of about $f/11$. Smaller apertures of $f/16$ and $f/22$ might be indicated by 'weather' symbols on the aperture control. The lens was usually fixed-focus, set at the hyperfocal distance to give reasonably sharp focus from 2 m to infinity. A 'portrait' supplementary lens, if attached, brought the focus down to about 1 metre. An alternative focusing arrangement used an elementary *three-point symbol* focusing system to indicate the sharpness zones of 1–2 m (portrait), 2–8 m (group) and 3 m–infinity (landscape). A simple 'everset' shutter offered two settings of 'I' for 'instantaneous' (about 1/40 s) and 'B' for time exposures. Flash synchronization was for flashbulbs. The viewfinder was either a direct optical one or a brilliant (reflex) type without focusing function. The choice of format has varied widely, from 60 × 90 mm (eight exposures on 120 film) down to 30 × 40 mm (16 on 127 film), but is now more likely to be the 28 × 28 mm format of the 126 cartridge, the 11 × 17 mm of the 110 cartridge, or the 8 × 10 mm of the disc film cassette.

Simple camera design was revolutionized by the success of the 126 size drop-in loading technique. The later 110 cartridge allowed even smaller dimensions, with some cameras only 25 mm thick. Notwithstanding such small volumes, many such pocket cameras are available in a range of progressively more comprehensive specifications. In particular, exposure automation using an electronic shutter is common, even if the lens is of fixed focus and modest specification. The prevalent use of flash with such cameras to supplement the modest aperture of the lens, and the proximity of the flash reflector to the optical axis, is a cause of the 'red-eye' effect found in many portraits taken with such cameras.

The accompanying improvements in sensitized materials which make such small formats practicable, especially colour-negative emulsions, and which allow useful enlargement, have also been of great benefit to the larger formats.

Compact cameras

Originally introduced to fill a gap in technology between the simple camera and the more complex single-lens reflex type, the 'compact' camera provided a non-interchangeable lens together with reasonable specifications and limited automation, in a body of modest dimensions, and using standard 35 mm cassettes the 24 × 36 mm format. Typical early versions provided a coupled rangefinder, large-aperture lens, bright-line finder and choice of shutter- or aperture-priority automation; since then there has been a rapid evolution into a distinct design type with increasingly comprehensive specifications. Significant developments were, first, the

introduction of an integral electronic flash unit which added little to dimensions but extended operating capabilities, and, secondly, an 'auto-focusing' facility for the camera lens, using initially an image-processing comparison system, but later an active infrared ranging system or phase detection system (see pages 114–117 for details).

To perform well within economic operating parameters, the lens has a typical maximum aperture of $f/2.8$ and a focal length of 35 to 40 mm. A photosensor, usually of the cadmium sulphide (CdS) type, monitors subject luminance and operates an exposure program with a between-lens shutter offering a range of some 1/20 to 1/500 s and an aperture range of $f/2.8$ to $f/16$. If the subject luminance is inadequate, the shutter release may lock until the integral flash unit is charged for use instead. Flash exposure automation is by alteration of lens aperture in accordance with distance data from the autofocus system. The film speed may be set manually or by the *DX coding system* (see Chapter 12) on the film cassette. A *backlight control* may provide 1–2 stops exposure increase for high-contrast scenes. The flash may be used for fill-in purposes too, or a sophisticated exposure metering system may combine flash with the ambient light exposure.

Now considered essential are a self-timer and a 'prefocus' system to allow focusing at a chosen distance. A separate close-focus capability may be provided. The original fixed focal length lens has been replaced by a choice of two focal lengths, usually by the switch-operated insertion of an integral teleconverter behind the prime lens, typically giving a choice of 38 mm $f/2.8$ or 70 mm $f/5.6$. The viewfinder frame alters appropriately. Motorized zoom lens alternatives give a continuously variable lens of typically 35 to 70 mm focal length with the viewfinder frame altering to match. Additional or alternative features are a *data back* for date or time imprinting, a soft-focus device, multiple-exposure facilities and a weatherproof or waterproof body. Camera dimensions are increased accordingly. Film loading is semi-automatic with advancement to frame 1 on closing the camera back. Film advance is motorized, as is rewind of the exposed film.

The specifications of the compact camera ensure a very high success rate in terms of correctly-exposed, sharply-focused pictures made with a minimum of fuss or expertise, and with no accessories required other than perhaps a spare set of the essential batteries. Such cameras provide a very acceptable introduction to photography and a useful decision-free instrument for leisure pursuits.

Rangefinder cameras

This type of camera utilizes a coincidence-type rangefinder system (see Chapter 9), coupled to the

focusing mechanism of the lens to enable the lens to be accurately focused at the subject distance. This method of focusing appeared with the introduction of the early 35 mm cameras such as the Leica, being essential for the focusing of large-aperture lenses. Rangefinder focusing was adopted in cameras of format up to half-plate. Design advanced rapidly in conjunction with improvements in viewfinders, and soon combined rangefinder-viewfinders with bright-line frames were common. Small- and medium-format cameras using folding bellows construction required ingenious solutions for the coupling of rangefinder optics and lens focusing control. Interchangeable lenses were an additional problem, as the fixed base-length of the rangefinder meant that focusing accuracy decreased with increase in focal length. In technical cameras, changing lenses also meant changing the focusing cam for the feeler arm which was coupled to the rangefinder mechanism. Each lens required its own individually-calibrated cam. In 35 mm cameras the feeler arm operated on a cam on the rear of the lens barrel. Close-focusing devices for rangefinder cameras were clumsy

arrangements in general. The use of a rangefinder does, however, permit a camera of compact dimensions. There are several distinct categories (see Figure 8.4). Most cameras use 35 mm film and are of modest specification, with non-interchangeable lens and some form of exposure automation; but there are a few high-specification varieties such as the Leica M6. A number of medium-format cameras of folding construction use coupled rangefinders, as do large-format technical cameras of the folding baseboard type. The latter also have normal ground-glass screen focusing facilities.

Twin-lens reflex cameras

This type of camera has been popular since the introduction of the first Rolleiflex camera. Much is due to simplicity in use and versatility. Such a camera consists essentially of two cameras mounted one above the other, the upper for viewing and focusing, the lower for exposing the film (Figure 8.5). The two lenses must have the same focal

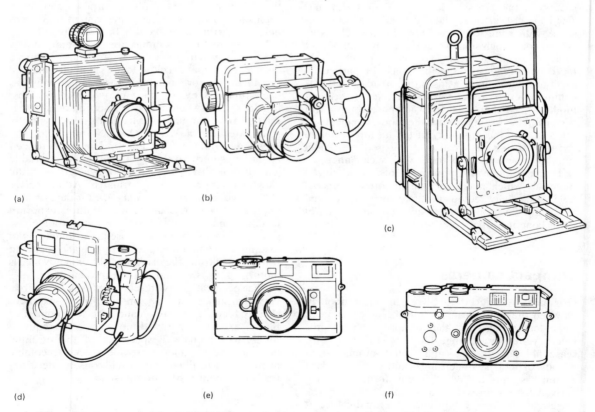

(a) (b) (c) (d) (e) (f)

Figure 8.4 Rangefinder cameras, a selection of typical designs of camera with coupled rangefinders: (a) Folding baseboard type with a separate optical finder; (b) rigid type with bright-line multi-frame finder; (c) folding type with collapsible frame finder; (d) rigid type; (e) automatic-exposure type with interchangeable lenses; (f) the classic rangefinder

length, but the one used for focusing may be of simpler construction and have a larger aperture, to facilitate focusing in dim light. The two lenses are mounted on the same panel, which is moved bodily to provide continuous viewing and focusing. The reflex mirror gives an upright, laterally reversed image on a ground-glass screen. The screen is shielded for focusing by a collapsible hood with a flip-up magnifier. The hood may be interchangeable with a pentaprism for eye-level viewing and focusing. The focusing screen may incorporate a Fresnel lens, split-image rangefinder or microprism array to assist focusing. The viewing lens is always used at full aperture. The operation of film transport and shutter setting is normally by means of a folding crank device. Current designs are for the 60 ×

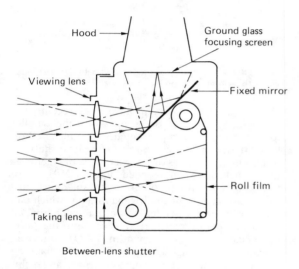

Figure 8.5　Principle of the twin-lens reflex camera

60 mm format using 120/220 film. The square format was originally chosen so that the camera could always be held in the same orientation for viewing and focusing, the negative being cropped during enlargement to give the final composition. Alternative formats such as 35 mm were obtained in some models by means of adaptors.

Most twin-lens reflex cameras do not have interchangeable lenses, a considerable disadvantage. Some models were fitted with fixed lenses of 55 or 135 mm focal length instead of the usual 75 or 80 mm. The Mamiyaflex, introduced in the late 1950s, has pairs of interchangeable lenses on panels, and an integral bellows caters for differing focusing extensions and permits close focusing. A full range of accessories makes this a true system camera.

A problem associated with all TLR cameras is the *parallax error* in the viewfinder screen image due to

the separation between viewing and taking lenses. Attempts at solving this problem have included the use of a viewing screen of reduced area, a swivelling viewing lens, moving masks and moving pointers to delineate the top of the field of view. The problem becomes more serious in close-up photography; a wedge-shaped prism fitted to the viewing lens when supplementary lenses are used is a partial answer, but a lifting device to raise the camera bodily on a tripod by the distance between optical axes is needed for accurate work.

Single-lens reflex cameras

This type of camera (usually abbreviated to SLR) has been popular since its introduction in the late nineteenth century, apart from a temporary fall from favour when the twin-lens reflex design was introduced. Now, following a period of intensive development in 35 mm and medium format, it is the leading design. Most innovations in camera design have first appeared in SLR cameras. The principle of the camera is illustrated in Figure 8.6. A plane

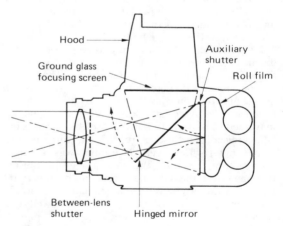

Figure 8.6　Principle of the single-lens reflex camera (Hasselblad)

front-surface mirror at 45° to the optical axis is used to form the image from the camera lens on a screen where it may be focused and composed. For exposure the mirror is lifted out of the way before the camera shutter operates. Immediately the exposure is completed the mirror returns to the viewing position. The need for speed and reliability in this basically simple operation has led to the development of electromechanical operations of some complexity. Details are given in Chapter 9. The great advantages of this design are the ease of viewing and

focusing, and the freedom from parallax error, especially important for close-up work. The depth of field at the preselected aperture can also be judged.

The earliest designs of SLR camera had large rectangular formats, in which a rotating back was an essential part of the design so that upright or horizontal pictures could be composed. The interchangeable lenses had only an iris diaphragm and were focused using a bellows arrangement on a rack-and-pinion drive. The counterbalanced pivoted mirror was raised by pressure on the release lever which lifted the mirror out of the way and then released a focal-plane shutter.

After a decline in usage due to the advent of the TLR camera, the design reappeared in 35 mm, 127 and 120 sizes important early models being the Kiné-Exakta (35 mm) and Reflex-Korelle (6 × 6 cm). Such cameras were popular because of their small size. Such cameras were fitted with focal-plane shutters having an extended range of speeds and a spring-operated mirror which returned to the viewing position upon advancing the film. The loss of the viewfinder image at the moment of exposure and afterwards was always regarded as a disadvantage of the design. The *instant return mirror*, which permitted uninterrupted viewing (except during the brief time the shutter was open) followed in the 1950s, and is now standard on all smaller SLR cameras. The depth of the mirror box in the camera compelled the design of lenses with a long back focal distance; in particular, the retrofocus type of wide-angle lens was extensively developed. The reflex mirror needs to be made sufficiently large to avoid image cut-off in the viewfinder area, and in order to retain a suitably compact camera body the mirror may need to move backwards as well as upwards on being raised. The use of rectangular formats was inconvenient when a vertical framing was required for a picture, as turning the camera sideways caused the image on the viewing screen to be inverted. Usually a direct-vision viewfinder had to be used. The square format of 60 × 60 mm allowed the camera to be held in the same way for all photographs, the picture shape being determined by masking off at the printing stage.

Shortly after World War II, the *pentaprism viewfinder* was introduced, and this boosted the popularity of SLR cameras enormously. Eye-level viewing and focusing were now possible, with the viewfinder image erect and laterally correct for both horizontal and vertical formats. The principle of the pentaprism viewfinder is illustrated in Figure 8.7. Note that the laterally-reversed but erect image on the focusing screen undergoes three further reflections inside the roof prism in order to appear correctly oriented. The necessary precision of the angles of the prism requires it to be made from a solid block of glass, and accordingly it is weighty and expensive. Design improvements were initially all in the 35 mm format,

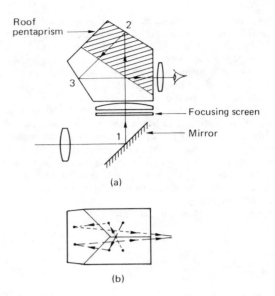

Figure 8.7 Action of a pentaprism viewfinder. (a) Side view; (b) top view, showing cross-over

but medium-format designs have more recently developed, to become on a par with the smaller format. Significant improvements have included reliable flash synchronization of focal-plane shutters, so that many cameras are now capable of electronic flash synchronization at speeds up to 1/250 s. Also, following the introduction of the instant-return mirror, the operation of the iris diaphragm, which had previously always needed to be manually stopped down just before exposure, evolved into the *fully-automatic diaphragm* mechanism (FAD). Improved viewfinder focusing screens with *passive focusing aids* in the form of microprism arrays and split-image rangefinders became standard fittings, usually with a choice of alternative screens for specialized purposes. A vast range of lenses (many from independent manufacturers) is now available to fit SLR cameras, ranging from fish-eye to extreme long-focus types. A feature formerly confined to medium-format cameras is the facility of fully *interchangeable magazine backs* for changing film type in mid-roll, or for rapid reloading. A further design advance introduced in the mid-1960's was *through-the-lens* (TTL) *metering*. The availability of reliable photoelectronic devices of the necessary sensitivity and spectral response, coupled with the ease of showing the measurement area in the viewfinder, ensured rapid development (see Chapter 9). The operational advantages of the SLR design have meant that it has become probably the most highly-developed system camera, and the basic unit for a wide range of accessories. In particular, owing to the electronic 'enrichment' of its functions it has steadily-widening applications. The medium-format SLR

camera is replacing the technical camera for many of those roles which do not require a large format or extensive camera movements.

Technical cameras

The term *technical camera* is used to cover two types of camera. The first is the *monorail* type. This is based on the optical-bench principle, and offers the widest possible range of camera movements (see Chapter 10). All focusing and composition is done on the ground-glass screen, and the camera must therefore be used on a rigid support such as a tripod or pillar stand. The second type is the *folding-baseboard* variety, and is normally equipped with a coupled range-finder and optical finder as well as a ground-glass screen. It may therefore be used in the hand as well as mounted on a tripod.

The rationalization of the technical camera is another example of continuing improvements in design, manufacture, functional capabilities and automation of operation. The early wood and brass *studio* and *field cameras* were adequate for large-format work but were very slow in operation. Improvements in lenses and a preference for smaller formats called for greater precision in manufacture. In order to achieve this, metal was substituted for wood, achieving rigidity at the expense of weight. A measure of standardization was achieved in the sizes of items such as lens panels, darkslides and camera backs. Technical cameras are made in medium formats such as 60×70 mm and 60×90 mm, but monorail cameras in these formats are still uncommon. The term 'large format' covers film sizes of 102 \times 127 mm (4 \times 5 in) and 203 \times 254 mm (8 \times 10 in); intermediate sizes are obsolescent. Most cameras in this range feature *reducing backs* and *format changing* to allow the use of smaller or larger formats with the same basic camera components when required for reasons of convenience or economy. As with other camera types, the modern technical camera is a 'system' camera. The basic body may be fitted with or adapted to a host of accessories, covering alternatives to almost every component. This is especially true for monorail designs produced on modular principles so that rails, front and rear standards, bellows, focusing screens, lenses and shutters are interchangeable to adapt for a range of formats or types of work.

The folding-baseboard camera uses a high-precision rangefinder normally coupled to three alternative lenses. Viewing is by means of a multiple-frame, bright-line viewfinder. Sheet film, roll film, Polaroid material and even plates can be used. To offset its merit of being able to be used in the hand, it has a more limited range of movements than the monorail type. The ground-glass screen must be used for close-up work or camera movements because the rangefinder is not then operative. The bellows is usually of triple-extension type, allowing a magnification of $\times 2$ with the standard lens.

Recent developments in technical camera design include forms of through-the-lens exposure measurement, preset mechanisms for shutter speeds and aperture settings, electronic shutters, extreme wide-angle lenses of large useful aperture, and binocular viewing and focusing aids.

Cameras for self-developing materials

A number of cameras are available especially to utilize the range of self-developing (instant print) materials manufactured by the Polaroid Corporation. These materials are available in roll-film, sheet-film and film-pack forms and the formats used currently range from 60×90 mm to 102×127 mm. Both colour and black-and-white materials are available, together with a range of materials that can be used in any 35 mm camera. These cameras range from simple types with minimal control of functions to sophisticated models equipped with electronic shutters, TTL exposure metering, autofocusing by means of a sonar pulse ranging system and automatic ejection of the exposed film. The geometry of image formation, and the sequence of the layers in the particular film type, may require use of a mirror system in the camera body in order to obtain a laterally-correct image in the print. This requirement can lead to a bulky, inconvenient shape or to considerable design ingenuity to permit folding to a compact size for carrying. Conventional types of film cannot be used in these cameras, although adaptor backs are available to permit the use of self-developing materials in conventional cameras.

Such camera and film combinations are often very convenient to use, and find a large number of useful applications outside amateur photography. A range of accessories is available to extend their capabilities.

Aerial cameras

Most aerial cameras are rigid, remotely-controlled fixtures in an aircraft, but for hand-held oblique aerial photography a few special cameras may be obtained. These are simplified versions of technical cameras without movements and with rigid bodies and lenses focused permanently on infinity. A fixture for filters, a simple direct-vision metal viewfinder and ample hand-grips with incorporated shutter release complete the requirements. If roll film is

used (normally 70 mm), film advance may be by lever wind or may be electrically driven. In order to obtain the short exposure durations necessary to offset vibration and subject movement, a *sector shutter* may be used. This is a form of focal-plane shutter in which an opaque wheel with a cut-out radial sector is rotated at high speed in front of the film gate to make the exposure. Various forms of data imprinting may be used to record positional and other information at the moment of exposure. These data may be taken directly from the navigational system of the aircraft.

Underwater cameras

Many types of camera can be housed in a pressure-resistant container with an optically flat window or a spherical 'dome port' to enable them to be used underwater. This housing may be part of the accessory range for the camera. Unfortunately these casings are cumbersome. However, a few cameras have been designed with a pressure-resistant, water-tight body and lens to make them usable down to specific depths for underwater work. They are also useful in adverse conditions on land where water, mud or sand would ruin an unprotected camera mechanism. These cameras have a simple direct-vision or optical finder and manually-set focusing controls. The lenses are interchangeable and have suitable seals, but changing must be done out of the water. A short-focus lens may be fitted as standard to compensate for the optical magnification that occurs due to the change in apparent subject distance caused by the refractive index of the water in the object space. A field of view equivalent to that of a standard lens on a conventional camera is then obtained. Special lenses corrected for underwater use, i.e. with water actually in contact with the front element, are also available. Such lenses cannot be used in air as aberrations would then not be adequately corrected. Some compact cameras are specially sealed to allow underwater use to depths such as 3 metres.

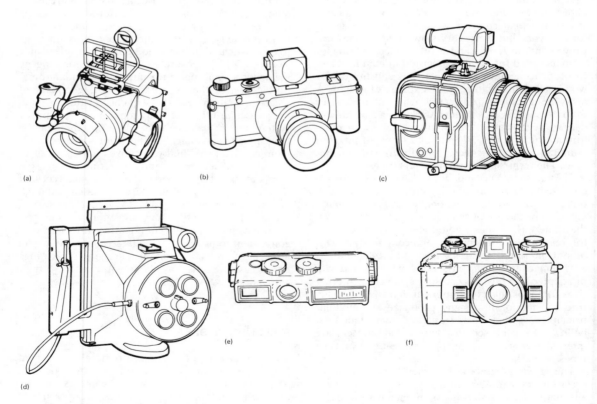

Figure 8.8 Special purpose cameras; (a) Electrically-operated hand-held aerial camera for 4 × 5 in format; (b) wide-angle panoramic camera for a format of 60 × 170 mm on 120 film; (c) Superwide-angle camera for a 60 × 60 mm format, the 38 mm lens giving a picture angle of 90°; (d) a multiple-image camera giving four exposures on 4 × 5 in self-developing film; (e) environment-protected camera using 110 film; (f) underwater camera for 24 × 36 mm format

Ultrawide-angle cameras

When a sufficiently large angle of view cannot be obtained from the normal range of lenses available for a camera, and when perspective and distortion considerations rule out the use of a fish-eye lens, then one of two types of camera embracing a large angle of view may be used. First, a camera body of shallow depth with a lens (usually non-interchangeable) with a large angle of view, e.g. some 110° on the diagonal, may be obtained by the use of a 65 mm lens with a 4 × 5 in format. Focusing of such a lens is usually by focusing scale, and the viewfinder may be a simple direct-vision or optical type, often incorporating a spirit level as a useful aid for aligning the camera. Limited shift movements may be possible. Other features of the camera are as normal. Secondly, a *panoramic camera* may be used. Typically, 140° horizontally and 50° vertically may be covered by rotating a normal lens design about its rear nodal point and imaging the scene through a slit in the focal plane which exposes the film sequentially during the exposure time. Exposure duration is controlled by varying the width of the slit. A high-aspect-ratio format is employed in such cameras. Other cameras may use similar high-aspect-ratio formats without the characteristic *cylindrical perspective* of the panoramic camera by using formats such as 60 × 120 mm and 60 × 170 mm in the form of alternative roll-film backs on large-format cameras.

A variety of special-purpose camera types is shown in Figure 8.8.

Still video cameras

Following advances in electronic imaging systems, particularly in magnetic recording of video imagery, in the late 1980s still video (SV) cameras were introduced to supplement and complement existing varieties of conventional cameras designed for silver halide materials. SV camera designs are predominantly SLR and compact types incorporating autofocus, or alternatively take the form of an interchangeable special back for an existing SLR camera system. Features such as remote control, intervalometer, self-timer and LCD data display panel are provided. Automatic exposure by ambient light or synchronized electronic flash is controlled by SPD sensors using selectable programs. The SLR design may use a beamsplitter behind the lens or a reflex mirror integral with the focal-plane shutter. A speed range of from several seconds to 1/2000 s is available, and flash synchronization can be at 1/250 s. The principal differences in camera design and image recording relate to the photosensor array used and the magnetic disc system used to record the image data.

Quite early on, a degree of standardization was achieved. The photosensor array generally has a format of 6.6 × 8.8 mm, i.e. a 3:4 aspect ratio, with a format diagonal of 11 mm (and total area one-quarter that of a 24 × 36 mm film frame) allowing considerable scope for the design of large-aperture lenses, in particular of high-ratio zoom lenses.

The sequential read-out of photosensor data is recorded on an encapsulated magnetic disc of diameter 47 mm, formated into 52 tracks. By rotating the disc at 60 or 50 rev/s for the NTSC or PAL video systems respectively, one TV field per track or one TV frame per two tracks can be recorded, giving a choice of 50 or 25 images per disc. Each track is separately recordable, accessible and erasable. Exposure data and sound may also be recorded. Exposure sequences of 2 to 15 fields per second are possible. The stored information can be accessed either from the camera disc mechanism itself or by a separate player for viewing the images on a TV set or monitor. The data can be transmitted via various links or used in different forms of printer to produce a 'hard-copy' print output. Provided the sensor array is on the optical axis of the lens, the disc assembly can be elsewhere in the camera, allowing a more ergonomic design.

It is useful to consider the image quality and resolving power of the system. The rectangular photosensor device is an array of discrete photocells either of the metal-oxide semiconductor (MOS) or charge-coupled device (CCD) type. Initially arrays of some 600 vertical × 500 horizontal elements were used. This gives a vertical resolution of some 500 TV lines in the *frame mode*. Only half this value is given in the *field mode* where the TV interlace (even) lines are not used, but the number of images per 50-track disc is doubled. Little visual difference is seen between the two modes at usual viewing distances.

The image data are obtained either by the *interline* method, where each photo-element charge is transferred to an adjacent element in vertical columns for read-out line by line via a serial register between exposures, or by the alternative *frame transfer* method, which uses half the sensor area to store each frame before readout and thus has only half the resolution of the interline method. The CCD or MOS arrays for colour reproduction have associated filter mosaics of various configurations, for example vertical stripes of red, green and blue filters which associate several CCD elements into one active picture element or *pixel*. Thus an expected horizontal resolution of (say) 800 TV lines is thereby reduced by a factor of three to approximately 250 TV lines. A claimed 'resolution' of 300 000 elements (600 × 500) gives a colour frame of only some 50 000 pixels. As designs progress, more densely-packed arrays offer higher resolution. By comparison, a 24 × 36 mm colour negative can resolve at least ten times as many pixel equivalents.

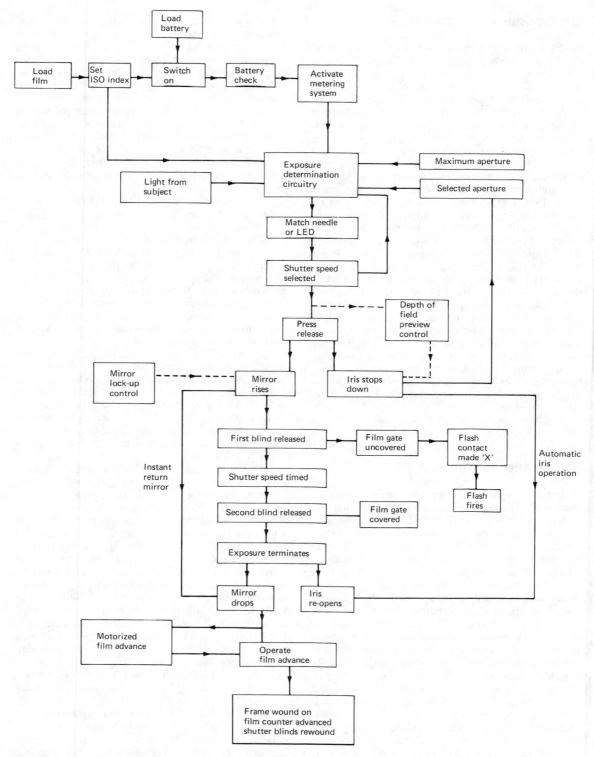

Figure 8.9 Flow diagram of exposure sequence with a semi-automatic SLR camera using analogue systems

Note that fine detail rendering may be deliberately restricted by an optical low-pass (frequency) filter immediately in front of the sensor array chip. This selective diffuser can be an etched diffraction pattern on a quartz plate, the interference effects suppressing detail so as to avoid the appearance of artefacts in the video image.

The sensor has a typical sensitivity to light (after filtration) equivalent to between ISO 100/21° and ISO 200/24°, but additional gain increases the effective exposure index. Spectral sensitivity is panchromatic, with noticeable infrared sensitivity. A choice of several illuminants may be provided by a switchable white balance.

Automatic cameras

Most types of camera have benefited from the progress made in solid-state micro-electronics: many functions previously operated by a mechanical, electrical or electromagnetic devices are now initiated and controlled by electronic circuitry. This replacement of gears, rods and levers varies from primitive controls, through electronic 'enrichment' to full electronic control. Contemporary cameras exhibit most stages of this progress, and most are also known generally as 'electronic cameras'. Strictly speaking, this term means a camera in which functions such as shutter operation and metering are controlled by commands from a *central processing unit* which makes logical decisions based on the

information *input* from various sources. The subsequent control commands or *output* can be carried out by the camera to give *full automation*, or with the aid of the user to change settings as appropriate, to give *semi-automatic* operation. A flow diagram to show the operational sequence of a semi-automatic camera is shown in Figure 8.9.

Analogue systems

The chronology of the incorporation of electronic systems into cameras illustrates the major advances in design, beginning with the all-mechanical camera where operation depended on the film advance mechanism to cock and set actuating springs and where shutter timing depended on escapement devices and gear trains.

The first introduction of electronics was in the form of the selenium cell light meter (see page 117); and primitive forms of semi-automation were the manual alteration of shutter speed or aperture settings to match a movable pointer to the meter needle. This is still called a 'match needle' operation even if LEDs are used. Full automation became possible when it was realized that the meter needle itself could be used to set the camera exposure with the aid of trapping devices to lock it. Such arrangements used levers, pneumatic bellows and chain drives.

The electronically-controlled shutter using a resistor-capacitor circuit for timing was introduced

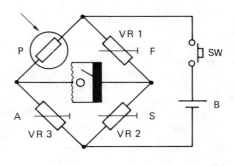

(a) (b)

Figure 8.10 Circuits and displays for semi-automatic metering in cameras. (a) Simple series circuit with the photoresistor P and battery B in series with potentiometers VR1 and VR2. VR1 is coupled to the film-speed setting control F and VR2 to the shutter-speed setting control S. Light falling on P gives a deflection of the meter needle seen in the viewfinder, or causes an LED or arrow symbols to light up. Alteration by hand of the aperture control to match a pointer to the needle or bring the needle to an index mark will set the correct exposure. Five typical viewfinder read-outs are shown, 1 by lit LED, 2 by two lit

arrows, 3 by centring needle, 4 needle and index, 5 match pointer. This form of circuit is sensitive to battery voltage; (b) An improved circuit is one of the Wheatstone bridge type with the photoresistor and three potentiometers forming the arms of the bridge, which balances the meter needle when the products of resistance on opposite sides of the bridge are equal. This arrangement is independent of battery voltage. The additional potentiometer VR3 is coupled to the aperture setting control A. The meter can be zeroed, i.e. correct aperture set, by alteration of either VR2 or VR3 or both together

almost simultaneously with the replacement of the selenium cells by smaller CdS cells which allowed TTL metering. Total automation came when the photocell output was used to control the shutter timing circuitry. Electronically, the exposure-determining circuitry of the camera solves the usual exposure equation relating shutter speed (t), aperture (N), subject luminance (L) and the film speed (S), involving the meter constant (K) where:

$$LSt = KN^2$$

This can be done by an analogue circuit such as a Wheatstone bridge arrangement (see Figure 8.10), where electrical resistance, voltage or current represent the physical quantities involved (all of which are usually measured in different units). Resistance is most commonly used.

To set the appropriate resistance values into a primitive computing device such as a Wheatstone bridge analogue converter devices are needed. The shutter-speed setting control, film-speed setting and exposure-compensation controls all use forms of fixed and variable resistors. Aperture value setting is more difficult, as the analogue device is in the camera body and the iris diaphragm is some distance away in the lens. Some form of mechanical linkage is needed to engage a variable resistor, usually located inside the throat of the lens mount. In addition there is a need for a *maximum-aperture indicator* to correct the calculations for the preset aperture when full-aperture metering is used, or to control a dedicated flashgun. Bayonet mounts are needed to ensure precise location and mating of these linkages. The next stage is to arrange that the aperture control ring in the lens selects resistance values according to aperture, and that these values are transmitted to the control unit in the camera body by electrical contacts such as pins (thus increasing reliability).

For shutter-priority operation in earlier designs, the output of the control unit was used to arrest the iris diaphragm unit at a value predetermined by the metering system. For aperture-priority operation the photocell output controlled exposure duration via the shutter. Such simple control circuitry required only a few components such as transistors, resistors and capacitors on a printed circuit board. Introduction of the silicon photodiode (SPD) with its very fast reaction time and freedom from unwanted 'memory' allowed metering to be carried out in 'real time', that is in the short interval between depression of the release button and the mirror rising or the shutter operating, or, better, during the shutter operation itself by metering from the actual film surface. Previous CdS systems took a reading which was held or memorized by crude circuitry, and used to set the controls before the shutter was operated. *Real-time metering* was also possible with electronic flash using suitably thyristor-operated

switching circuitry; additional forms of analogue devices were needed for interfacing with the dedicated flashgun, such as provision of the *hot shoe* with several electrical contacts for the purpose of data transmission and the transfer of command pulses. The SPD required additional circuitry such as operational amplifiers, and drew current from the battery, which also provided power for the shutter and viewfinder display. The slow-acting and delicate meter needle was replaced by the LED, still as an analogue arrangement. Apart from the possibility of a choice of colours, the LED could code information in several other ways, such as being 'on' or 'off', by its intensity, by flashing at different rates, or by being lit continuously. Some very complex viewfinder data displays were devised.

A *power winder* or *motor drive* became part of every camera system and required electronic linking to the central control in order to forestall any tendency for it to operate during an exposure. The insides of cameras thus became packed with circuitry and wiring. Increasing demands were made on the simple analogue circuitry, especially with the advent of multi-mode metering systems. In the short time available to carry out the necessary operations for each exposure especially with a motor drive operating at several frames per second and with the complexity of viewfinder displays the possibility of overload became real. The answer was to convert the control system to digital circuitry.

Digital control

A viewfinder display that uses alphanumeric characters formed from seven-segment LEDs is commonly called a *digital display*; letters and symbols are formed as well as numbers. The power-consuming LED displays can be replaced or complemented by large LCD panels which give a comprehensive readout of the current status of the camera (such as exposure mode, film frame number, film speed in use), as shown in Figure 8.11. Such displays require more complex control circuitry than a simple LED display, where the LED is either lit up or not. Activation is from the central control unit or central processing unit (CPU) via devices called *decoders* and *multiplexers*. A multiplexer is a circuit which selects one at a time from a number of inputs and outputs automatically in turn, with the aid of a *clock circuit*.

The real problem, however, was to increase computing speed and the capacity to handle more and more calculations. The need was for a *microprocessor* to be used in the camera. Now, a computer consists of only a few sub-units: a CPU to do the calculations, input and output devices for the flow of

data and commands, and memory devices to store the data and programs of operations. An external clock circuit monitors the sequence of operations and all are connected by buses for data flow.

Some solid-state devices require a 6-volt supply; others need only 3 volts, thus dictating battery needs, and space for them. Most devices are sensitive to voltage changes, so a constant-voltage supply circuit is needed. Some devices are sensitive to temperature, so another compensating circuit is needed for this.

Various types of CPU can be used, depending on needs. All of them have large numbers of circuit elements per unit area, and are known as *large-scale integrated circuits (LSIs)*. The highest packing density is given by *metal oxide semiconductor (MOS)* types of circuitry. These are sensitive to voltage and temperature, and are not easy to interface with other devices in the camera. The alternative *transistor-transistor logic* (or *TTL*) (not to be confused with 'TTL' metering) costs more, and uses more power, but needs less precise control. Processing

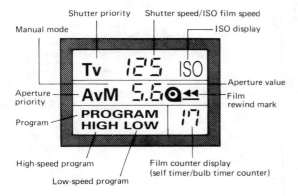

Shutter priority Shutter speed/ISO film speed

Manual mode

ISO display

Tv 125 ISO

Aperture priority

Aperture value

AvM 5.6 ◐◄◄

Film rewind mark

Program

PROGRAM HIGH LOW

High-speed program

Film counter display (self timer/bulb timer counter)

Low-speed program

Figure 8.11 Example of an external LCD panel display on a camera

speed is higher than with the simple MOS type. An intermediate choice is *integrated-injection logic* or I^2L type, which has the packing density of the MOS type but is slower than the TTL type. It requires a *read-only memory* or ROM device to give a fixed program of operational steps in the correct sequence to guide the CPU through its calculations in the correct order. This program may be many hundreds of lines long. The ROM is static, and does not disappear when the camera is switched off; its program cannot be added to or modified subsequently.

The whole microcomputer system described so far depends on a clock circuit as a reference for the order of events. This may be provided by a *quartz oscillator* giving 32 768 beats per second. These

pulses are counted by appropriate circuitry, and can also be used to control shutter speeds, self-timer delays, meter 'on' timing controls and intervalometers. An exposure of 1/1000 s is timed as 33 pulses, an error of less than one per cent. The counting circuit delays travel of the second blind until sufficient pulses have elapsed. An alternative *ceramic oscillator* device gives 4 194 000 Hz for even greater accuracy and for control of complex data displays.

The term 'digital control' means that the data and calculations are handled in discrete form and not as an infinitely-variable electrical quantity (as in analogue form). The electronic circuitry as described is basically a huge array of transistor switches, each of which can be in only one of two states, either 'off' or 'on', to shunt the current flow through logic gates of the 'if/then' and 'and/or' configurations. The decimal system of 10 digits from 0 to 9 is replaced by the binary system using the two digits 0 and 1, corresponding to the two alternative states of a switch. The sheer 'number-crunching' power of a digital processing unit, plus its speed and error-free operation, more than offsets the additional circuitry needed compared with analogue systems.

All data must of course be coded into binary form and then the output commands decoded for implementation. The analogue data from *transducers* such as potentiometers in the film speed setting control is changed into binary data by another special circuit called an *analogue-to-digital converter*, termed A/D, and the reverse operation by a *digital-to-analogue* circuit, termed D/A. This conversion is doubly difficult in the case of the data from the SPD photocell. This can give subject luminance data only in analogue form, and covers an enormous dynamic range: a 20 EV metering range corresponds to a light level range of 1 048 576:1. The only way to compress this range is to convert the values to their logarithmic equivalents before conversion to digital form, by another special circuit called a *logarithmic compression circuit*. Encoding may be by movement of a wiper arm over a patterned resistor or an optical device, the output being a string of pulses corresponding to the required 0 and 1 values. To guard against encoding inaccuracies, the strict binary code may be replaced by, for example, the *Gray Code*, which permits the checking of values by arrangements of what are called 'truth tables', so that impossible values cannot be entered into the CPU. Other components of the camera such as flash units, power drives and multifunction backs may also transduce and transform their data as necessary. By means of the *DX film coding* system in binary form on a 35 mm film cassette, the film speed, exposure latitude and number of exposures may be encoded directly into the CPU by means of an array of contact pins in the cassette compartment.

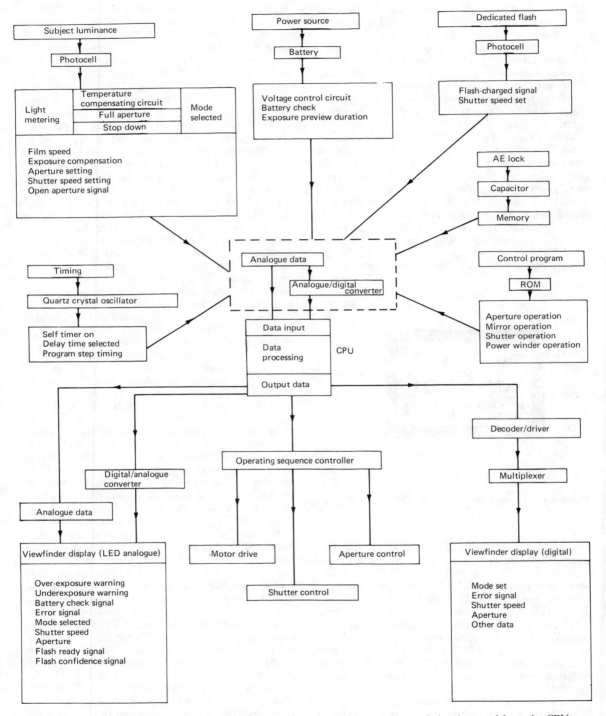

Figure 8.12 The electronic camera: generalized picture of the flow of data and control signals to and from the CPU

The CPU also carries out useful actions on its output. It rounds off values for the viewfinder display to conventional values or to two decimal places. It can update the display every half second or alter its intensity in accordance with the photocell output by the simple means of altering the pulsing rate of each segment (the intensity of a LED cannot be varied by other means). It can operate a 'bleeper' to warn of camera shake or inadequate light, generate an error signal, and so on.

An additional CPU may be used for the complex *signal-processing operations* required in using the data from arrays of sequentially-scanned CCD devices (as used for autofocus systems). Accessories such as flashguns may also have complex LCD digital displays to supplement the main display on the camera body or in the viewfinder.

Additional *interfaces* in the form of arrays of electrical contacts are used in the lens mount, film gate, viewfinder well and hot shoe to allow the flow of data and commands from an autofocus lens with its own ROM and transducers, with a multi-function back, an accessory automatic metering viewfinder system and various forms of dedicated flashgun respectively. A generalized picture of the flow of data and control signals in an automatic camera under digital control is shown in Figure 8.12.

The operation of the main CPU may be further expanded or updated by means such as interchangeable ROM expansion cards or cartridges, which can provide a range of additional and specialist operational modes.

9 The elements of the camera

As indicated in Chapter 8, many of the advances in camera design are due to the developing of specific elements in the mechanism of the camera. These advances have led to the emergence of certain types of camera that have become particularly popular. Owing to the complexity of each of these elements, many of which are interdependent, it is worth examining the various design elements in detail. In particular, the following are considered in this chapter: shutter systems, iris diaphragms, viewfinder systems, flash synchronization, focusing mechanisms and exposure metering systems. The camera lens has already been dealt with in detail in Chapter 7.

The shutter

The type and operational range of the camera shutter contribute significantly to the performance of a camera. The function of a shutter is to expose the sensitized material to the action of light for a predetermined time, as chosen by the user or by an automatic exposure-metering system. An ideal shutter would expose each part of the film equally and simultaneously, i.e. it would allow the cone of light from the lens aperture to any point in the focal plane to fall upon the film for the entire duration of the exposure. It should be silent in operation; there should be no jarring or vibration; and it should require little effort to set in motion. Its effective exposure duration should be accurately repeatable. The perfect shutter has yet to be achieved.

There are two main types of shutter in general use, namely the *leaf* or *between-lens shutter* and the *focal-plane shutter*; both may be purely mechanical, or may combine both mechanical and electronic features.

Between-lens shutters

The ideal position to intercept the light transmitted by a lens is in the plane of the iris diaphragm, where the beam of light is at its narrowest, and thus the minimum amount of shutter travel is required to allow the beam through. The sensitive material is also uniformly exposed at all stages in the operation of the shutter.

Figure 9.1 The between-lens leaf-type shutter. Principles of operation of a 5-bladed shutter, shown here in the closed position and with two adjacent blades only, for clarity. Note the considerable overlap of the blades. A specially shaped blade (1) has a slot fitting over a fixed pin (2) to give a hinge for rotary motion. Another hole (3) fits over a pin (4) in the actuating ring (5). This ring moves anti clockwise to move the blades apart and then, after a timed delay, moves clockwise to close them again

Simple cameras often use single- or double-bladed between-lens shutters, but the majority of cameras so equipped use multi-bladed shutters (see Figure 9.1). Usually five blades or sectors are used, and these open somewhat like the leaves of an iris diaphragm. In certain cameras, an 'everset' or 'self-setting' type of shutter mechanism is used. In this, a single control is depressed to compress the operating spring mechanism and then release the shutter in one movement. The speed range available may be limited to only a few settings.

As a rule, between-lens shutters are of the 'preset' type. In these, two movements are required: one for tensioning (cocking) the operating spring and one for releasing the shutter. In most cameras the cocking operation is performed by the film advance

Figure 9.2 The timing circuit of an electronic shutter

mechanism. Preset shutters of the traditional Compur, Copal and Prontor types commonly provide for exposure times ranging from 1 to 1/500 s plus a 'B' setting, where the shutter remains open while the release button is held depressed thus permitting time exposures. Occasionally a 'T' setting is available, where the shutter stays open when the button is released, and remains open until the button is again depressed to close it. The shutter blades pivot about their ends (or, rarely, centre) and, for all but the shortest durations, open with a constant velocity. An additional spring mechanism increases operating velocity at the highest speeds, while the slower speeds are usually controlled by engaging a gear train to retard the blade closure mechanism.

On older shutters, the conventional series of shutter speeds was 1, 1/2, 1/5, 1/10, 1/25, 1/50, 1/100, 1/250 and 1/500 second. In modern shutters it is 1, 1/2, 1/4, 1/8, 1/15, 1/30, 1/60, 1/125, 1/250 and 1/500 second, to give a progression of exposure increments similar to that provided by the standard series of lens aperture numbers, i.e. with each step double that of the previous one. This latter arrangement was originally designed to permit the introduction of an optional mechanical interlock between the aperture and shutter speed controls, in order to keep the two in reciprocal relationship with reference to an EV number. This ensured that as the shutter speed was adjusted, so the iris diaphragm was automatically opened or closed to keep the exposure the same.

The effective duration of a particular shutter-speed setting depends upon a number of variables, including the age and state of the shutter, the particular speed selected and the aperture in use. Calibration is necessary for critical work. Shutter speeds are usually set by click stops on the selector control although the design of the shutter may in some (but not all) cases permit intermediate values to be set. For reasons of economy many shutters do not have speeds longer than 1/30 s. Large-diameter lenses as used in large-format cameras require larger, heavier shutter blades, and the top speed for such assemblies is usually 1/250 s.

The mechanism of most between-lens shutters includes electronic as well as mechanical operation. *Electronic shutters* may have the blades opened by a spring mechanism, but the closing mechanism is retarded by an electromagnet controlled by timing circuitry to give a range of shutter speeds. A typical resistor-capacitor circuit element is shown in Figure 9.2. Switch S is closed by the shutter blades opening, and battery B begins to charge capacitor C through a variable resistor R. The time taken to reach a critical voltage depends on the value of R, but when it is reached the capacitor discharges to operate a transistorized trigger circuit T which releases the electromagnet holding the shutter blades open. Changing the shutter speed is accomplished by switching in a different value of R. In automatic cameras the control unit may be a CdS photoresistor or silicon photodiode arrangement which monitors the subject luminance and gives a continuously-variable shutter speed range within the range available. Thus more accurate exposures may be given, rather than just the discrete values on the setting control. A visible or audible signal gives a warning when the required exposure time is longer than 1/30 s indicating the need for use of a tripod, or a change to electronic flash.

As the blades and drive of an electronic shutter are still largely mechanical, it does not improve on earlier designs in terms of performance at higher speeds or greater efficiency. It does however lend itself to automation and remote control. The camera body may carry the shutter speed control for a range of interchangeable lenses, each fitted with its own shutter and with means for interfacing with an accessory exposure-metering prism finder. A control box for selecting shutter speeds and apertures may be used on a long cable for linking to electronic shutters, in lenses for technical cameras. Such shutters all require battery power for operation, and in the absence of electrical power a single mechanical shutter speed may be available for emergency use. This is usually the lowest shutter speed that requires no electronically-controlled retardation.

The conventional shutter mechanism may have some further items incorporated in the shutter housing. Besides the usual shutter speed and aperture scales, an interlocked shutter bears a third scale of exposure values (see page 266). The numbers on this scale usually range from 2 to 18 or so, a change from one number to the next corresponding to an alteration in the luminance of the subject matter by a factor of 2. This scale is often used with a specially-graduated exposure meter. Also, a 'self-timer' or delayed-action device is often fitted; by means of this the release of the shutter can be delayed for perhaps 5–15 s. On many shutters for technical cameras there is a 'press-focus' button which opens the shutter on a time setting irrespective of the shutter speed preselected. This feature facilitates

focusing on the ground-glass screen and eliminates the necessity for constant resetting of shutter speed to T or B for this operation.

One of the great practical advantages of between-lens shutters is the simplicity of flash synchronization at all shutter speeds. This enables the use of electronic flash for fill-in purposes which is discussed fully in Chapter 20.

Focal-plane shutters

This type of shutter is located in the camera body and travels close to the film plane. In earlier forms, the focal-plane shutter consisted of an opaque blind with a variable slit, or several fixed slits of various widths; the slit chosen was driven past the front surface of the film at a constant speed, exposing the film as it passed across. With a focal-plane shutter the film area is exposed sequentially, unlike the action of a between-lens shutter. The *effective exposure time* to any portion of the film frame is given by the slit width divided by the slit velocity.

Figure 9.3 The focal-plane shutter. The classic two-blind design of horizontally running focal plane shutter. A slit of width W is formed between two blinds 1 and 2 to travel at velocity *v*. The blinds travel from a common drum D to separate tensioned take-up drums of slightly different diameters

Modern shutters of this type use two opaque blinds pulled across the film gate by spring action, (see Figure 9.3). The leading blind starts to uncover the film when the shutter release is pressed and the trailing blind follows to cover up the film, with a greater or a smaller gap according to the delay set and timed by the shutter speed selected. The separation between the rear edge of the leading blind and the front edge of the trailing blind thus constitutes a slit of adjustable width which allows a range of exposure durations. The slit may vary in width during its travel to compensate for the acceleration

of the slit during the exposure. Such a shutter is also 'self-capping': the slit is closed by overlap of the blinds when they are reset by operation of the film advance mechanism.

Many focal-plane shutters use rubberized cloth blinds, but materials such as aluminium and titanium can be used. Polymers and plastics are popular for designs where the slit is formed by a vertically-travelling fan of interlocked blades, as they can be readily manufactured with the right combination of lightness and strength. The slit may travel either sideways or vertically with respect to the film gate. When photographing rapidly-moving subjects with a focal-plane shutter, the sequential exposure of the optical image can result in distortion, the direction of the distortion depending on the direction of movement of the slit relative to the direction of movement of the optical image.

The major problems associated with focal-plane shutter design have been those of uniform exposure, avoidance of shutter bounce, and flash synchronization. The slit width and velocity must be maintained over the whole film area, with the adjustments discussed above. For instance, an exposure of 1/2000 s demands an accurately maintained slit width of 1.5 mm between leading and trailing blinds travelling at some 3.6 metres per second, remembering the necessity for acceleration from and deceleration to rest positions. This action may be necessary up to five times or more per second during motorized operation. Problems increase with larger formats and this, together with flash synchronization difficulties, has resulted in their abandonment in many medium- and large-format cameras, in favour of between-lens shutters. Shutter bounce is indicated by a narrow strip of over-exposure at the edge of the film frame where the trailing blind has recoiled momentarily on cessation of its forward travel.

The typical exposure time range available is from several seconds to 1/8000 s (0.125 ms), but the transit time of the shutter may be from 1/250 s to as much as 1/30 s even at its minimum effective exposure duration. Flash synchronization for flash bulbs used to pose problems, as special (FP) bulbs with a long burning time (now unobtainable) were needed for the higher shutter speeds. A more recent electronic flash equivalent is a special 'strobed' flash unit which gives an effective flash duration of some 20–40 ms, allowing electronic flash synchronization even at shutter speeds of 1/2000 s.

Conventional electronic flash with its negligible delay time and short duration poses other problems. The film frame must be fully uncovered at the instant the flash fires, i.e. when the leading blind has uncovered the film frame but before the trailing blind starts its travel. The flash is fired by the leading blind when it has completed its run (see Figure 9.4). Depending on the shutter design and

the format, the minimum shutter speed for synchronization is at a setting (usually marked X) of between 1/40 and 1/250 s. Shorter exposure durations cannot be used because the frame would only be partly exposed, the shutter aperture being narrower than the film gate. At suitable synchronization speeds, subject movement may be effectively arrested by the short flash duration, but double images or over-exposure may occur at high ambient light levels. Synchro-sun techniques are therefore restricted. Between-lens shutters are therefore preferred for more sophisticated flash work.

Alternative designs of focal-plane shutter do not use the double blind system; instead, the travelling aperture is provided by an elaborate system of pairs of blades in a guillotine action, or by end-pivoted arrays of fan-shaped blades. The use of a vertically travelling slit with a 24 × 36 mm format can give a 50 per cent reduction in travel time compared with horizontal travel, so flash synchronization is possible at higher shutter speeds.

Figure 9.4 Operating sequence of a focal-plane shutter in an SLR camera. Key: A lens, B iris, C reflex mirror, D focusing screen, E shutter-blind drums, F blinds, G film. (a) Focusing with the iris open; (b) on pressing the release, the mirror rises and the iris closes down; (c) leading blind starts its travel; (d) film gate is fully open, flash will fire if connected (1/30–1/250 s); (e) trailing blind begins its travel; (f) at higher speeds both blinds operate to form a slit; (g) blinds almost fully home; (h) shutter closed, mirror drops and iris opens to restore viewing; (i) film is wound on, blinds are capped and return to 'start' position

A focal-plane shutter allows easy interchange of lenses on a camera body; the lenses do not need individual costly between-lens shutters; and a wide range of shutter speeds is available. Cameras that have interchangeable lenses equipped with their own between-lens shutters require a separate capping shutter within the camera body, to act as a light-tight baffle when focusing the camera or changing lenses.

Modular design of shutters allows easy replacement or repair when necessary. For many years mechanically-operated shutters did not permit the automation of exposure; the user manually set the shutter speed at a pre-selected aperture in accordance with a separate or built-in (but uncoupled) light meter. The advent of electromechanically-operated shutters equipped with electronic timing systems for release of the shutter blinds allowed integration of the shutter mechanism with the light-metering circuitry. Continuously-variable exposure durations from many seconds to 0.25 ms could be given (though even mechanical shutters can have continuously-variable exposure times). *Hybrid shutters* may use electronic timing for speeds longer than about 1/60 s and mechanical timing for shorter times, thus allowing the shutter to be used with electronic flash and a limited range of speeds in the event of battery failure.

Camera shutters are usually operated by a *body release* situated in an ergonomically-designed position that reduces the possibility of camera shake and gives fingertip operation. The body release may also operate a reflex mirror, automatic diaphragm or exposure metering system by first pressure, before the shutter is actually released. Electronic shutters are operated by a release which is simply an electrical switch. Such devices readily lend themselves to remote control by electrical or radio impulses or from special command camera backs which incorporate intervalometers or automatic exposure-bracketing systems.

When used in conjuction with an aperture-priority automatic exposure mode, a camera body equipped with an electronically-controlled focal-plane shutter may be attached to all manner of optical imaging devices, for which the effective aperture may not be known.

The iris diaphragm

The intensity of the light passing through a photographic lens is limited by the iris diaphragm. In some simple cameras the aperture is fixed in size; in others the diaphragm consists of a rotatable disc bearing several circular apertures so that any of them may be brought in line with the lens. Such fixed apertures are known as *Waterhouse stops* and are used, for

Figure 9.5 The iris diaphragm. (a) Principle of the iris diaphragm. Ring A contains a number of slots. An iris leaf D has a fixed hinge C at one end and a pin B at the other which moves in a slot in the rotating ring A. As ring A is rotated, pin B moves so that the leaf moves in an arc. The action of several overlapping leaves is to give larger or a smaller central aperture. (b) Multi-bladed iris using a simple radiused shape for each leaf. This gives a circular aperture but an unevenly spaced aperture scale. (c) Another multi-blade design, where the more complex blade shape gives an aperture scale with equidistant spacings suitable for automation or servo control

example, in some fish-eye lenses. This arrangement is limited in scope. The majority of lenses are fitted with an iris diaphragm, the leaves of which may be moved so as to form an approximately circular aperture of continuously-variable diameter. When the camera shutter is of the between-lens type the diaphragm is part of the shutter assembly. It is operated by a rotating ring, usually with click settings at half-stop intervals, and calibrated in the standard series of f-numbers. The interval between marked values will be constant if the diaphragm blades are designed to give such a scale; in older lenses with multi-bladed diaphragms the scale may be non-linear, and the smaller apertures cramped together (Figure 9.5).

The maximum aperture of a lens does not necessarily belong in the conventional f-number series, but may be an intermediate value, e.g. f/3.5. The minimum aperture for lenses for small-format cameras is seldom less than f/16 or f/22, but for lenses on large-format cameras, minimum values of f/32 to f/64 are not uncommon. With the growing dominance of the SLR camera, a demand for automatic selection of the chosen aperture immediately before exposure arose, in order to permit viewing and focusing at full aperture up to the moment the shutter was released.

On the earliest forms of these cameras, the lens had to be stopped down by reference to the aperture scale. The introduction of click settings assisted in this process. Next a pre-setting device was introduced which, by means of a twist on the aperture ring, stopped the lens down to the preset value and no further. This arrangement is still used, for example, on perspective control (PC) lenses. The next step was to introduce a spring mechanism into this type of diaphragm, triggered by the shutter release. The sequence was thus speeded up, but the spring needed resetting after each exposure and the diaphragm then re-opened to its maximum value. This was known as the *semi-automatic diaphragm*. Finally with the advent of the instant-return mirror came the *fully automatic diaphragm*. In this system an actuating lever or similar device in the camera, operated by the shutter release, closes the diaphragm down during the shutter operation. On completion of the exposure the diaphragm re-opens and the mirror returns to permit full-aperture viewing again (Figure 9.6). A manual override may be fitted to allow depth-of-field estimation with the lens stopped down. Many cameras with early forms of through-the-lens (TTL) metering required the lens to be stopped down to the preset aperture for exposure measurement. Modern cameras offering a shutter-priority mode have an additional setting on the lens aperture scale, usually marked 'A', where the necessary f-number is determined by the camera and set just before exposure, the user having selected an appropriate shutter speed. The aperture

set may be in smaller increments than the usual half-stop increments.

The design of TTL metering systems in most cameras requires the maximum aperture of the lens in use in most modes to be set into the metering system. A variety of linkages between lens and body have been devised for this purpose.

As the focal length of the lens increases, the problems of fitting a mechanically-actuated automatic diaphragm increase, so electrical systems are favoured. Some ultralong-focus lenses cannot be connected electrically and require manual setting of

(d)

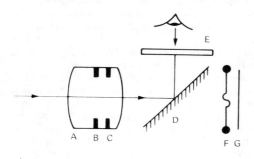

(a)

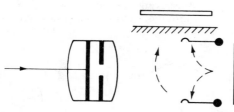

(b)

(c)

(e)

Figure 9.6 Operating sequence of a leaf shutter in a SLR camera. Key: A lens, B shutter, C iris, D reflex mirror, E focusing screen, F rear shutter or baffle flaps, G film. (a) Viewing position, shutter and iris open. (b) After pressing release, shutter closes, iris stops down, mirror rises and baffles open. (c) Shutter operates, flash fires (if attached). (d) Shutter closes, baffles close.(e) Film is wound on, mirror drops, iris and shutter reopen. Note: operations (a) and (b) may be carried out separately by a pre-release button

the aperture. Extension tubes usually transmit the actuation for diaphragm operation via pushrods or electrical connections, but extension bellows may not do so, and manual operation, or use of a *double cable release*, may be necessary.

Lenses fitted to large-format technical cameras are usually manually operated, although some pre-setting devices are available.

Viewfinder systems

The function of the viewfinder is to indicate the limits of the field of view of the camera lens in use and to enable the user to select and compose the picture. Except for those fitted to simple cameras, viewfinders also incorporate a method of focus indication, such as a rangefinder or ground-glass screen. The type of viewfinder used often determines the shape and size of the camera, as with the TLR type, and the purchase of a particular type of camera may even be related to the ease of use of the

viewfinder, especially if the user wears spectacles. The viewfinder also acts as a 'control centre' and has a data display system primarily for the exposure measurement system, with a variety of indices, needles, icons, alphanumerics, lights and camera settings visible around or within the focusing screen area.

Simple viewfinders

The simplest finders, as fitted to early box cameras and as supplementary finders for large-format cameras, employed a positive lens of about 25mm focal length, a reflex mirror inclined at 45° and a ground glass by which the image was viewed. This finder was used at waist level; the image illumination was poor. This early type was superseded by the 'brilliant' finder which employed a second positive lens in place of the screen; this imaged the first lens in the plane of the viewer's eyes, giving greatly improved luminance. Such finders are still occasionally found on simple cameras, and as viewfinders on exposure meters.

The need for a simple finder for use at eye level produced the *wire frame finder*. A wire or metal open frame, in the same proportions as the film format, was viewed through a small peep-sight to define the subject area. This type of finder is still available as an accessory and is compact when collapsed. Refinements to the basic design give exact delineation of the subject area and parallax

compensation. Use is now mainly confined to technical, aerial and underwater cameras. Various simple viewfinders are shown in Figure 9.7.

Direct-vision optical finders

At one time most small- and medium-format cameras employed a direct-vision optical finder for use at eye level. In the simplest type a strongly-diverging lens is used to form an erect virtual image which is viewed through a weak positive eyepiece lens. This type of finder, usually called a *Newtonian finder*, is in effect a reversed Galilean telescope, the two lenses combining to produce a bright erect virtual image.

A great improvement on this type, the *van Albada finder*, has a mask bearing a white frame line in front of the positive lens: the negative lens has a partially-reflecting rear surface. As a result, the white line is seen superimposed on the virtual image (Figure 9.8). The view through the finder extends beyond the frame line so that objects outside the scene can be seen through it. This is a great aid in composing, especially if the subject is moving. The eye may be moved laterally without altering the boundary of the scene. This finder is prone to flare and loss of the frame line in adverse lighting conditions; an improved version is the *suspended frame finder*, where a separate mask carrying one or several selectable frame lines for different lenses is superimposed on the field of view by a beamsplitter in the optical

(a)

(b)

(c)

(d)

(e)

Figure 9.7 Direct-vision optical viewfinders: (a) Frame finder; (b) Newton finder; (c) reversed Galilean telescope; (d) simple van Albada; (e) Galilean van Albada

Figure 9.8 The van Albada finder. A frame of semi-dimension *j* on plate P around eyepiece E is reflected in the metallized rear surface of objective lens O and seen at distance f_E. (a) Simple spherical semi-silvered mirror type. M, mirror. (b) Reversed Galilean type

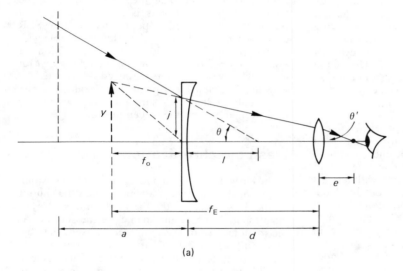

Figure 9.9 Reversed Galilean finder. (a) Distance *a* is usually zero, as the lens edge acts as the entrance window. Distance *d* corresponds to camera body thickness. *e*, eye relief. (b) Reflected mask frame version: F, separately illuminated frame. M, mirror. B, beamsplitter

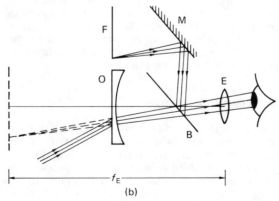

finder. The frame lines are separately illuminated by a frosted glass window adjacent to the finder objective lens (Figure 9.9). This type of finder has been considerably refined, and usually incorporates the rangefinder image of a coupled rangefinder. Other refinements are compensation for viewfinder parallax error by movement of the frame line with the focusing mechanism, and a reduction in the frame area when focusing at closer distances. As seen in such finders, the image size is usually around ×0.7 to × 0.9 life-size. Simpler cameras with non-interchangeable lenses may have a finder giving a life-size image so that both eyes may remain open, giving the impression of a frame superimposed on the scene.

For technical cameras, a zoom-type Albada finder for use with a range of lenses is often used for hand-held camera applications. Compact cameras with integral zoom lenses use similar viewfinders coupled to the zoom control.

Ground-glass screen viewfinders

Many of the earliest types of camera used a plain *ground-glass screen* upon which the image from the lens was composed and focused, and which was then replaced by a plate-holder or film-holder in order to make the exposure. This system is still in use in technical cameras. The advantages of exact assessment of the subject area covered by the lens, accurate focusing and appraisal of the effects of camera movements offset any inconvenience in viewing an image that is inverted and reversed.

Most small- and medium-format cameras use a reflex system, with a front-surface mirror inclined at 45° to the optical axis giving an image on a ground-glass screen in an *equivalent focal plane*. The image is the same size as it will be recorded on film, and erect but laterally reversed. In the twin-lens reflex camera, viewing and taking are by separate lenses; in the single-lens reflex camera, viewing and taking are by the same lens. Focusing and viewing are carried out at chest level using the unaided eye or a flip-up magnifier in the viewfinder hood. Unlike the SLR camera, the TLR camera suffers from parallax error, and a mask or indicator in the viewfinder may be coupled to the focusing mechanism, to compensate for this defect.

The presence of the mirror in the viewfinder system of a SLR camera has led to a number of refinements in camera design. The most common refinement is *instant return* (with a damping system to minimize camera shake). Cameras without this facility have the viewfinder blanked out until the mirror is returned to the viewing position when the film is advanced to the next frame. The mirror may have a lock-up facility for shake-free release in telephotography and photomicrography.

SLR cameras for amateur use have a viewfinder that is roughly 5 per cent pessimistic in each direction, i.e. more appears in the picture than in the viewfinder. The reason usually quoted for this is to overcome differences in aperture size in transparency mounts. Professional SLR cameras, however, do indicate the actual area included on the negative. Although a plain ground-glass screen indicates whether focusing is correct, it gives a rather dim image, with a rapid fall-off in illumination towards the corners. Evenness of illumination is improved if the screen is etched on the flat base of a plano-convex lens, or if an accessory Fresnel screen is used as a field-brightening element.

Small-format cameras usually have a supplementary focusing aid incorporated in the centre of the screen. This is a passive device, i.e. it has no moving parts. It is usually in the form of a *split-image rangefinder* or a *microprism array* (described later). Professional cameras have interchangeable viewing screens for different applications. Many screens incorporate two or more focusing methods, and are termed *mixed screens*. With all these screens, however, if the reflex mirror is too small there will be a progressive loss of illumination towards the top of the screen with increase in focal length of the camera lens. This cut-off (viewfinder vignetting) is not seen on the film image. The reflex mirror may be multi-coated to improve reflectance and give a brighter viewfinder image. In order to transmit a portion of the incident light to a photocell for exposure metering or to a photosensor array for autofocusing, the mirror may have a partially-transmitting zone or a pattern of fine perforations, and a supplementary or 'piggy-back' mirror hinged to its reverse side.

Lateral reversal of the viewfinder image is troublesome, especially in action photography. Fortunately, the pentaprism viewfinder allows an erect, laterally-correct and magnified screen image to be focused (Figure 8.7); this is no doubt the main reason for the present popularity of the SLR camera. These finders may be interchangeable with other types of finder, and most have provision for *eyepiece correction lenses* or *dioptric adjustment* for users who would otherwise need spectacles for viewing. The viewfinder prism may also incorporate a through-the-lens exposure metering system for measurements from the screen image.

Flash synchronization

In the early days of flash photography it was customary to set the camera on a tripod, open the shutter on the 'B' setting, fire the flash (which was a tray of magnesium powder) and then close the shutter. As the manufacture of flashbulbs progressed, they became sufficiently reliable to be synchronized with the opening of the camera shutter. This made it possible for flash to be used with the shutter set to give an 'instantaneous' exposure, and the camera could be hand-held for flash exposures. At first, a separate synchronizer device was attached to the camera; in modern shutters flash contacts are incorporated in the shutter mechanism.

Between-lens shutters

Synchronization of between-lens and focal-plane shutters presents different problems. With a between-lens shutter, the aim is to arrange for the peak of the flash to coincide with the period over which the shutter blades are fully open. In all shutters there is a short delay between the moment of release and the time when the blades start to open (approximately 2–5 ms), and a further slight delay before the blades are fully open. With flashbulbs there is also a delay after firing while the igniter wire becomes heated, before combustion occurs and light

is produced. By comparison electronic flash reaches full output virtually instantaneously.

To cope with both types of flash, a between-lens shutter may be fitted with two types of synchronization, called respectively *X- and M-synchronization*. With X-synchronization, electrical contact is made at the instant the shutter blades become fully open so this type can be used with electronic flash at all shutter speeds (Figure 9.10). It is also suitable for use with small flashbulbs at shutter speeds up to 1/30 s. Compact cameras with an integral electronic flash unit are X-synchronized only, as are hot-shoe connections. With M-synchronization the shutter blades are timed to be fully open approximately 17 milliseconds after electrical contact is made. This was originally to allow large flashbulbs time to reach full luminous output when the shutter was fully open. This requires a delay mechanism in the shutter, and one similar to that used for the slower speeds in preset shutters is commonly employed. M-synchronization allows synchronization of type M (medium-output) flashbulbs at all shutter speeds. It is not suitable for small flashbulbs (type MF) and certainly not for electronic flash, which would be over before the shutter even began to open. This form of synchronization is now becoming rare in modern cameras, where as a rule only X-synchronization is provided. The exceptions are lenses with leaf shutters intended for large-format and some medium-format cameras. Some shutters manufactured in the early days of internal flash-synchronization have a lever marked 'V-X-M'. The 'V' in this case is a delayed-action ('self-timer') setting, which is synchronized to electronic flash only.

Focal-plane shutters

Synchronization of focal-plane shutters presents a special problem. Exposures with electronic flash and most ordinary types of flashbulb can be made only at the slower shutter speeds, where the shutter blind is fully open during part of the exposure, so that the whole film frame in the gate can be exposed simultaneously by the flash. At one time, when large flashbulbs were required to be synchronized with fast shutter speeds up to 1/1000 s, a special slow-burning bulb (class FP), now obsolete, was available. This bulb gave a near-constant output for the whole transit time of the shutter blind,. There is a modern electronic flash counterpart which has a rapidly pulsed or 'strobed' output; this permits the use of flash even at 1/2000 s.

Unlike a fully-synchronized between-lens shutter, which has only one flash connection and a two-position switch to select 'X' or 'M' synchronization, some focal-plane shutters may have one, two or even three flash connections in the form of PC (coaxial) sockets, hot shoes and special-fitting sockets. If only one, unmarked, outlet is fitted to the camera, such as a simple hot-shoe or PC cable socket, the shutter is X-synchronized only. Some older cameras have a separate control with this sole outlet, able to select different forms of delay, but this is now obsolete. A pair of outlets may be X and M, or perhaps X and FP. Use of the appropriate one of these with a suitable shutter speed automatically gives correct synchronization. The extension of exposure automation to the use of electronic flash has resulted in many cameras offering automatic setting of the electronically-controlled shutter to the correct X-synchronization speed, on attachment of a suitable electronic flashgun, reverting to an alternative setting for ambient light exposure while the *dedicated flash* is recharging.

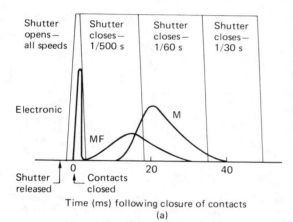

Time (ms) following closure of contacts
(a)

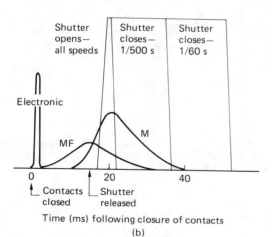

Time (ms) following closure of contacts
(b)

Figure 9.10 Flashbulb and electronic flash light output curves shown in relation to shutter performance curves for different types of synchronization: (a) X-synchronization; (b) M-synchronization

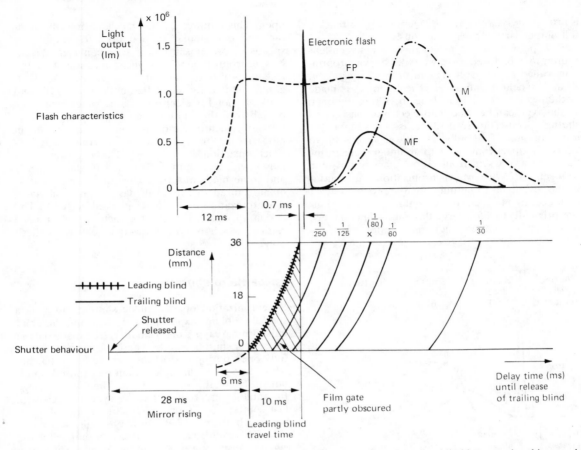

Figure 9.11 Flash synchronization of a focal-plane shutter. The lower part of the diagram shows the horizontal movement of the leading and trailing blinds across the film gate. The leading blind is released some 6 ms before the end of the 28 ms taken for the reflex mirror to rise, and it takes some 10 ms to open fully. The trailing blind is released after a suitable delay time, also taking some 10 ms for its full travel. At exposure durations of less than 1/80 s (the X-synchronization value here), the film gate is still partially obscured, as the trailing blind is released before the leading blind has completed its travel. The leading blind fires the electronic flash after a delay of less than 1 ms and the flash discharge time is 1 ms or less. The full flash output of a small flashbulb of the MF type is obtained with X-synchronization and a shutter speed of 1/30 s or more, likewise for the larger 'M' type of bulb. To use the shorter shutter speeds of 1/80 to 1/2000 s, the long-burning 'FP' bulb (now obsolete) was triggered some 12 ms before the leading blind started to move. The upper part of the diagram shows the flash characteristics

In X-type synchronization, the electrical contact is made when the leading shutter blind has fully uncovered the film gate, and before the trailing blind has begun to move. Depending on the design of shutter, X-synchronization may be possible up to a shutter speed of 1/250 s. Medium-format cameras have synchronization restricted to a maximum shutter speed of 1/30 to 1/90. In view of these comparatively long shutter-open times in relation to the brief duration of an electronic flash unit, the effect of the ambient light can be a problem, and an electronic flash exposure meter which also takes into account the shutter speed in use is helpful. A comparison of shutter operation and light source properties is shown in Figure 9.11.

Focusing systems

Although lenses can be used satisfactorily as fixed-focus objectives, relying upon small apertures, depth of field and distant subjects to give adequate sharpness, this simplification is not possible with

Figure 9.12 Focusing a lens. There are four principal methods of focusing: (a) by extending the whole lens by a distance *x*; (b) by front-cell focusing, smaller extension needed; (c) by adding a close-up lens L, no extension needed; (d) by internal focusing; no extension needed

lenses of large aperture or long focal length, nor for close-up work. To ensure the subject is in sharp focus it is necessary to have some form of focusing mechanism, as well as visual indication of the state of focus. Current focusing systems use a variety of mechanical, optical and opto-electronic arrangements (Figure 9.12).

Front-cell focusing

In simple cameras fitted with between-lens shutters, focusing is often accomplished by varying the focal length of the lens and not by varying the lens-to-film distance. This is achieved by mounting the front element in a cell with a coarse-pitch screw thread. Rotation of this cell alters the separation of the front element from the other groups. A slight increase in this separation causes an appreciable decrease in focal length, giving a useful focusing range. Close focusing is not possible because the lens aberrations

introduced adversely affect performance. A distance scale is engraved on the movable cell. Many modern zoom lenses also use a (well-corrected) movable front group for focusing.

Internal focusing

A recent development has been the introduction of *internal focusing*. In this system, rotation of the focus control moves an internal element or group of the lens system along the optical axis, thereby changing the position of the rear nodal point. By this means an extensive focusing range is possible with only a small movement involving few mechanical parts. The lens is not extended physically, and the whole unit can be sealed against the ingress of dust and water. The focusing movement may be non-linear, and incorporate the correction of those lens aberrations which increase as the focused distance is decreased. The small masses and mechanical forces involved mean that internal focusing is particularly suitable for autofocus lenses with the drive motor located either in the camera body or in the lens housing. Internal focusing is used for zoom lenses, macro lenses and super-telephoto lenses.

Unit focusing

The traditional method of focusing is by movement of the entire lens or optical unit. This is called 'unit focusing'. The lens elements are held in a fixed configuration. Movement is achieved in various ways. Technical cameras of the baseboard type employ a rack-and-pinion or friction device to move the lens on a panel for focusing by coupled range-finder or ground-glass screen. The monorail type is focused by moving either the lens or the back of the camera; this can be useful in applications such as copying, because rear focusing alters the focus only, whereas front focusing alters the size of the image as well as the focus.

Small-format cameras have the lens unit installed in a focusing mount. Rotation of a ring on the lens barrel moves the lens in an axial direction. A *helical* focusing mount causes the lens to rotate during focusing, whereas a *rectilinear mount* does not. Rotation is generally undesirable, as the various scales may not be visible at all times and optical attachments such as polarizing filters, which are sensitive to orientation, may need continuous adjustment. A special *double helicoid* arrangement is used to provide macro lenses with the extended movement necessary to allow continuous focus to magnifications of 0.5 or more. The focusing action may be coupled to a rangefinder or to an autofocus system, or it may be viewed on a screen. The

focusing distance may also be set by a scale on the baseboard.

Extension tubes and bellows

The focusing arrangement of many lenses allows focusing close enough to provide a magnification of only about 0.1. Most standard lenses have a minimum focusing distance of 0.75 to 1.0 metres. If the lens is removable, the use of *extension tubes* and *bellows extensions* between the lens and camera body provide the additional lens-to-image distance needed to give greater magnification. (Non-interchangeable lenses are limited to use of a supplementary close-up lens (page 144).) The basic extension tube has a diameter similar to that of the lens mount, with fittings for attaching the lens to one end and the camera body to the other. Tubes of various lengths are available for use singly or in combination. Variable-length tubes are also available. For SLR cameras, automatic extension tubes which have the necessary mechanical and/or electrical linkages to retain the operation of the iris diaphragm and TTL metering systems are preferred.

In conjunction with the focusing movement on the lens mount, an extension tube has a limited focusing range. Also, at long extensions, a narrow-diameter tube may cause vignetting. For these reasons, extension bellows are preferable as they permit a full and continuous focusing range, and allow lenses of long focal length to be used. Certain lenses may be separately demountable, to allow use with a bellows unit; others are produced in a short-mount bellows-unit-only version. A 135 mm focal length lens for the 24 × 36 mm format with bellows may typically have a focusing range from infinity down to same-size reproduction. True macro lenses, i.e. lenses capable of full correction at magnifications greater than unity are available specifically for bellows use.

The automatic diaphragm and other operations of a lens are retained with most designs of bellows by means of mechanical or electrical linkages, but where this is not so, a double cable release arrangement is needed to operate the iris diaphragm and shutter together (or the lens may need to be stopped down manually). Where magnification is greater than 1.0, the optical performance of a lens mounted in the usual way may be impaired, as corrections are normally computed for work at infinity, and macro settings reverse the usual proportions of conjugate distances (i.e. $v \geqslant u$). *A lens reversing ring*, to mount the lens with its rear element facing the subject, avoids this problem. Extension tubes and bellows are most useful with SLR cameras, owing to the ease of focusing. A table of increases in exposure required for the various magnifications is usually provided by the manufacturer, but TTL metering, being self-compensating, avoids the necessity for this.

Focusing scales

In practice most lenses are focused without reference to the distance scales engraved on the focusing control if a rangefinder, focusing screen or auto-focus system is provided. It is useful to retain these scales, however, for two reasons: first, for reference when electronic flash is being used, so that the aperture may be set according to a flash guide number, or to check if the subject is within the operating distance range of an automatic flash exposure system, as described in Chapter 3; secondly, because the distance figures give the depth of field by reference to the appropriate scales on the mount, or to tables.

As the focal length of a lens determines the amount of extension necessary for focusing on a nearby object, the closest marked distance on a focusing scale varies with the particular lens in use. The small extension required with wide-angle, short-focus lenses means that many have provision for focusing down to a few centimetres. The standard lenses fitted to 24 × 36 mm format cameras commonly focus down to approximately 0.5 m, while macro lenses have provision for magnification of 0.5 to 1.0, and additional scales of exposure increase factors and reproduction ratios. Long-focus lenses may focus no nearer than 2–10 m, depending on their focal length, without recourse to extension tubes, bellows or close-up lens attachments. The long bellows extension of a technical camera and the possibility of increasing the extension by adding another section, makes for a very versatile focusing system. The usual triple-extension bellows allows a magnification of 2.0 with a standard lens, but may need replacement by a bag-bellows for use with short-focus lenses, as the pleated type will not close sufficiently to allow the lens to be focused on infinity.

Focusing mechanisms vary in their ease of use. Focusing rings, knobs and levers vary in size and width. The amount of friction, ease of gripping and direction of rotation for focusing differ from one mechanism to another, and this can cause confusion when several lenses are in use. A locking control is often desirable to allow focus to be preset in several positions or to prevent accidental alteration during use (such as when copying). A zoom lens may have three raised rings on the lens barrel for the alteration of focus, aperture and focal lengths; careful design is needed to avoid confusion of function. Most zoom lenses use a *one touch* operation: a

control that rotates to change focus and slides to change focal length is now almost universal; systems using separate controls are less common.

Ground-glass focusing screen

Various optical devices can be incorporated into the camera viewfinder to assist rapid, accurate focusing with a range of lenses over a wide range of subject distances. Of these, the traditional *ground-glass screen* is undoubtedly the most adaptable and versatile. It has the great advantages of giving a positive indication of sharp focus and allowing the depth of field to be estimated. No linkages between lens and viewfinder are necessary, apart from a mirror (if reflex focusing is used). The screen may be used to focus any lens or optical system, but focusing accuracy depends on screen image luminance, subject contrast and the visual acuity of the individual. Supplementary aids such as a screen magnifier and a focusing hood or cloth are essential, especially when trying to focus systems at a small effective aperture in poor light. The plain screen has evolved into a complex optical subsystem, incorporating passive focusing aids (see below) and Fresnel lenses to improve screen luminance. In some types of camera the screen is a plate of fused optical fibres; alternatively, the glass may have a laser-etched finish to provide a detailed, contrasty, bright image. No one type of screen is suitable for all focusing tasks and most cameras offer interchangeable focusing screens with different properties.

Coincidence-type rangefinder

Coincidence-type rangefinders usually employ two windows a short distance apart, through each of which an image of the subject is seen. The two images are viewed superimposed, one directly and the other after deviation by an optical system (Figure 9.13(a)). For a subject at infinity the beamsplitter M_1 and rotatable mirror M_2 are parallel, and the two images coincide. For a subject at a finite distance u the two images coincide only when mirror M_2 has been rotated through an angle $x/2$. The angle x is therefore a measure of u by the geometry of the system, and may be calibrated in terms of subject distance. By coupling the mirror rotation to the focusing mount of the lens in use, the lens is automatically in focus on the subject when the rangefinder images coincide. The accuracy of this *coupled rangefinder* system is a function of subject distance u, the baselength b between the two mirrors and the angle x subtended at the subject by the base-length. Mechanical and optical limitations make this system of focusing unsuitable for lenses of

Figure 9.13 Coincidence rangefinder: (a) Rotating mirror type; (b) sliding-lens type incorporated into a viewfinder. S and T are viewfinder elements, K a beamsplitter and L a sliding lens moving a distance d coupled to lens focusing

more than about two-and-a-half times the standard focal length for the film format, e.g. 135 mm for the 24 × 36 mm format. The method is unsurpassed in accuracy for the focusing of wide-angle lenses, particularly with a long-base rangefinder and in poor light conditions.

As the distance to be focused on changes from infinity to about 1 metre, the required rotation of the mirror is only some 3°, so that high mechanical accuracy and manufacturing skill are required to produce a reliable rangefinder. Alternative systems involving much greater movements have been devised. One of these employs a fixed mirror and beamsplitter, obtaining the necessary deviation by a lens element which slides across the light path between them (Figure 9.13(b)).

The rangefinder images are usually incorporated into a bright-line frame viewfinder, one of the images being in contrasting colour for differentiation. Rangefinders add little to the bulk or weight of a camera and were incorporated into folding cameras such as the classic Zeiss-Ikon Super Ikonta series of cameras of the 1930s.

Split-image rangefinder

A *split-image rangefinder* (strictly focus finder) is a passive focusing aid, i.e. it has no moving parts,

unlike the coincidence type rangefinder. It is a small device, consisting basically of two semi-circular glass prisms inserted in opposite senses in the plane of the focusing screen. As shown in Figure 9.14, any image that is not exactly in focus on the central area of the screen appears as two displaced halves. These move together to join up as the image is brought into focus, in a similar way to the two images of the field in a coincidence-type rangefinder. The image is always bright and in focus, even in poor light conditions. Because focusing accuracy by the user depends on the ability of the eye to recognize the displacement of a line, rather than on the resolving power of the eye, which is of a lower order, the device is very sensitive, especially with wide-angle lenses at larger or moderate apertures. The inherent accuracy of this rangefinder depends on the diameter of the entrance pupil of the lens in use, so large apertures improve the performance. Unfortunately, the geometry of the system is such that for effective apertures of less than about *f*/5.6 the diameter of its exit pupil is very small, and the user's eye needs to be very accurately located. Slight

Out of focus (1)

In focus

Out of focus (2)

Figure 9.14 Principle of the split-image rangefinder

movements of the eye from this critical position cause one or other half of the split field to black out. Consequently, the use of long-focus lenses or close-up photography can result in a loss of function of the rangefinder facility and produce an irritating blemish in the viewfinder image. Since this obscuration is related to the prism angle, alternative prisms with refracting angles more suited to the lens aperture in use, or even of variable, stepped angle design, can retain useful rangefinder images even at small apertures.

The field-splitting arrangements may be vertical, horizontal, at 45°, or a more complex arrangement intended to cope with subjects without definite linear structures. An additional focusing aid such as an annular fine ground-glass ring around the rangefinder prisms is often provided. The split-image rangefinder finds popularity with wearers of spectacles and others with refraction errors of vision, who may find it difficult to focus a screen image.

Microprism grids and screens

The principle of the split-image rangefinder (or focus finder) is also used in the *microprism grid* array, which is also located in the centre of the viewfinder focusing screen. A large number of small facets in the shape of triangular or square base pyramids are embossed into the focusing screen surface (Figure 9.15). An image from the camera lens that is not precisely in focus on the screen

(a) (b)

(c)

Figure 9.15 The microprism focus finder: (a) Typical location in focusing screen; (b) enlarged plan view of prisms with square base of side of about 0.05 mm; (c) perspective view of microprisms

undergoes multiple refraction by these facets so that the image appears broken up into minute fragmentary areas with a characteristic shimmering effect. At correct focus this image snaps back into its correct appearance, giving a very positive indication of the point of focus. The pyramids are small enough (<0.1 mm side) to be beyond the resolving power of the eye. This system is easy to use and very popular. Again, no moving parts are used. The disadvantage of the microprism is the same as that of the split-image rangefinder, the microprism array blacking out at effective apertures less than about *f*/5.6. Interchangeable viewfinder screens that consist entirely of microprisms are available. These give a very bright image for focusing; they can be obtained with prisms with angles suitable for lenses of a particular focal length. Microprism arrays are generally used in conjunction with one or more of the other focusing aids; thus a central split-image rangefinder may be surrounded by annual rings of microprisms and ground glass, with the rest of the screen area occupied by a Fresnel lens.

Autofocus systems

For many purposes a lens that is focused visually, or even a fixed-focus lens, is adequate; the various optical aids described above simply improve accuracy of focusing. But visual focusing can be slow, inaccurate and tiring, especially if continuous adjustments are necessary. Some means of obtaining or retaining focus automatically is helpful, especially when using long-focus lenses and following subjects moving obliquely across the field of view in poor light; also for unattended cameras operated by an intervalometer. Various forms of *autofocus system* have been devised; these can operate in various modes. An 'active' autofocus system will not only focus the lens upon the subject, but will constantly search for optimum focus as the distance changes. A 'passive' system will operate only on demand, and will lock the focus at the chosen distance as determined by the area of the subject selected. This is useful as a prefocus feature as the sensor area may be much smaller than the field of view of the lens; also, the composition may be such that an active system would give sharp focus on an area other than the main subject feature (for example, the background seen between the two heads, in a double portrait).

A *focus indication mode* or *assisted focusing mode* is an electronic analogue of an optical rangefinder or focusing screen. An LED display lights up in the viewfinder to indicate correct focus when the lens is focused manually; the direction of focusing movement required is indicated if the focus is incorrect.

A *focus maintenance mode* retains sharp focus once this has been set visually; this is the system commonly used in 'autofocus' slide projectors.

Ideally, autofocus systems should be rapid-acting, should not 'hunt', should continue to function at low light levels, be economical with batteries, contribute little volume or weight to the camera, be reliable, and give accuracy comparable to or better than visual methods. Systems embodying several different principles are in use.

Ranging systems

One obvious autofocus method is direct measurement of the subject distance. A ranging method using pulses of ultrasound was introduced by Polaroid for use in certain of their range of cameras for self-developing film. A *piezo-electric ceramic vibrator* (PECV) emits a 'chirp' of ultrasonic frequencies while the lens moves to focus from its near distance to infinity. The elapsed time for the return journey to the subject is proportional to subject distance. The return echo is used to stop this focusing action. Alternatively, a turret of supplementary lenses or a single elongated aspheric element may be rotated behind the main camera lens to vary the focus. This system operates even in the dark, but cannot penetrate glass.

Other optoelectronic systems involve some means of scanning the subject area (see Figure 9.16). An *electronic distance measurement* (EDM) system uses an infrared-emitting diode moving behind an aspheric projection lens to scan its narrow beam across the scene. Its reflectance from a small well-defined subject area is detected as a maximum response from a photodiode, and the scan action is halted, as is the synchronous focusing movement of the camera lens. The Honeywell Visitronic module also uses a subject-scanning system, where a rotating mirror synchronized to the motorized focusing movement images a zone of the subject onto a photodetector array; this response is compared to the static response of the subject area as seen by a fixed mirror and second detector array. The subsequent correlation signal is a maximum when both mirrors image the same zone. This signal then locks the focusing travel. This is an electronic analogue of an optical rangefinder. The system works best at high light levels and is dependent on specialized signal-processing circuitry. Another system (due to Canon) hs no moving parts, and has two fixed mirrors imaging zones of the scene cross a linear CCD array of some 240 elements. The focused image area is compared with adajcent image areas along the array, and maximum correlation gives a 'base' or distance between the two correlated regions which relates to the subject distance and an angular subtense. This continuous self-scanning triangulation system may be incorporated to operate through the lenses of video cameras.

Systems using infrared beams can operate in darkness and through glass, but can be fooled by unusual reflectances of the radiation from various materials such as dark cloth.

(a)

(b)

(c)

Figure 9.16 Ranging systems for autofocus cameras: (a) Scanning IR-emitting diode K with aspheric lenses L_1 and L_2 and photocell P; (b) static system with linear CCD array A. The correlated images at separations d_1 and d_2 correspond to distances u and D respectively; (c) scanning mirror R to correlate images on twin photocells P_1 and P_2

Image contrast measurement

A simple estimation of image contrast by through-focus observation on a ground-glass focusing screen shows that contrast is a maximum at optimum focus and decreases either side of this point. Visual focusing is essentially a contrast-judging process, and it is possible to automate this routine by measurements from the image itself where the image illumination gradient is converted into digital data for analysis. A linear CCD array is suitable, and comparison of the outputs of adjacent elements gives precise indication of the focus of edge details (Figure 9.17). No moving parts are involved, and two adjacent arrays, plus all the signal processing circuitry, can be integrated onto a small chip located in an *equivalent image plane* in the camera. Usually this is in the base of the mirror compartment of a SLR camera; a partially-transmitting mirror plus a piggy-back mirror image a zone of the subject matter onto the array. A small two- or three-way beamsplitter above the array provides information to the focus drive motor as to the direction of travel of the lens needed. Another system uses two CCD arrays to monitor the luminance of the two halves of the exit pupil of the lens. A micromotor in the camera or lens operates a unit

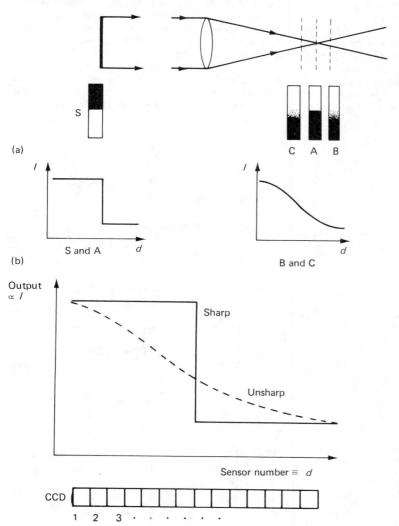

Figure 9.17 Focus detection by a linear CCD array: (a) a lens imaging a subject S gives a sharp image at focus A and unsharp images at B and C which have less contrast; (b) graphs of intensity *I* against distance *d* along the subject and its images give a step or a curve shape: (c) the intensity profile, as a measure of focus, can be determined from a linear array of charge-coupled devices (CCD 1, 2, 3 etc) whose output is proportional to intensity, and the sensor number corresponds to distance. Signal processing techniques detect the sharp or unsharp characteristic

focusing or floating-element system. These systems operate well in bright light, and in dim light (with ISO 100/21° film) to a level corresponding to an exposure of some 2EV.

Phase detection focusing

An alternative, more recent system, also using a linear CCD array allows operation at lower light levels than does image contrast measurement. The CCD array is located beyond an equivalent focal plane and behind a pair of small lenses which act in a similar manner to a prismatic split-image range-finder, as in Figure 9.18. Divergent pencils of rays beyond the correct focus position are refracted to refocus upon the array, and the separation (or 'phase') of these focus positions relative to a reference signal is a measure of the focus condition of the camera lens. The phase information operates a motorized focus control (Figure 9.19), which may be in the lens itself, so that each motor is suited to the torque requirements of individual lenses. Very rapid focusing is possible, even in continuous-focus mode. The system will even focus in the dark, using the emission of infrared radiation from a suitably-filtered source in a dedicated flashgun.

Various other useful features may include an automatic *depth-of-field mode* where the lens is focused automatically on the near and far points of the scene to be rendered in focus, and the automatic exposure determination system in the camera then chooses the appropriate aperture to give the correct depth of field, given an input of data from the lens as to its focal length even when using a zoom lens. Another feature is a *motion-detection mode*, where the camera is autofocused at a suitable distance; when a moving subject enters this zone, the camera automatically fires the shutter. One operational disadvantage is that, as the optical design of the autofocus system involves a beamsplitter mirror, the operation of which is affected by linearly-polarized light, the system may not work correctly if a linear polarizing filter is used over the camera lens.

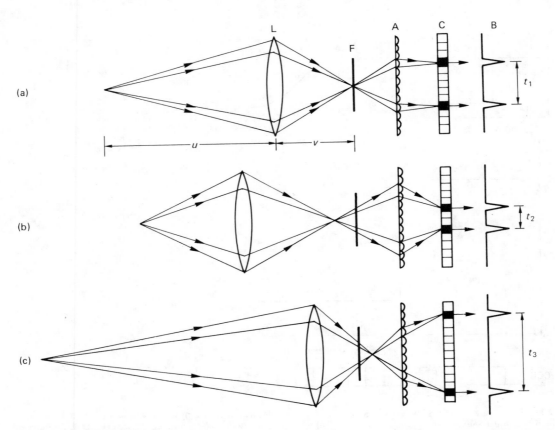

Figure 9.18 Principles of autofocus by phase detection: (a) Subject in focus; (b) focus in front of subject; (c) focus beyond subject. Key: L camera lens, F equivalent focal plane, A lenslet array, C CCD linear array, B output signals with time delay t_1 etc

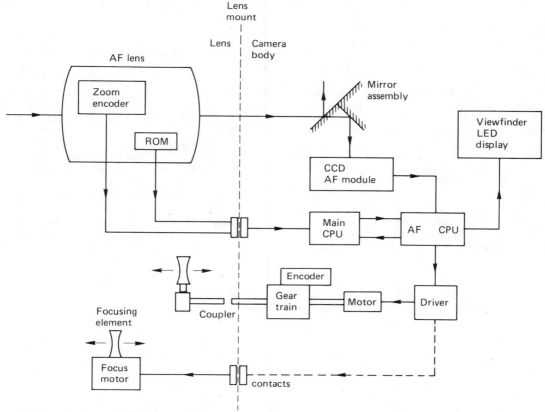

Figure 9.19 Schematic diagram of in-camera autofocus control systems with various circuit elements and interfaces with the lens

Exposure metering systems

The topic of camera exposure determination is dealt with fully in Chapter 20. The incorporation of an exposure metering system into a camera body is more than simply a question of convenience for the user: it is a crucial element in the design. There is a large range of different types available, each with its own advantages and limitations. With the increased use of colour, the need for accurate exposure has become steadily more important. Separate exposure meters have been used for many years, but the business of transferring the indicated values of shutter speed and aperture from meter to camera is time-consuming. An *integral meter* coupled to the camera controls gives more rapid operation; and there are numerous possibilities of exposure automation. The evolution of the built-in meter has gone through several stages, each of increasing complexity; but before considering these it is useful to review the properties of the various types of *photoelectronic device* ('photocell') in use in light-metering systems.

Selenium cells

Light-sensitive selenium (Se) is the active element in a *photovoltaic cell*. Exposure to light generates an electric potential across the cell. A sensitive galvanometer in the circuit gives a deflection that is proportional to the amount of light incident on the cell, and the necessary camera exposure may be derived from the meter reading, usually via a calculator disc mounted on the meter. Sensitivity of the system is somewhat limited, depending on the area of the cell exposed to light. A baffle limits the acceptance angle of the cell to approximately that of the camera with standard lens.

Cadmium sulphide cells

The action of light on a *cadmium sulphide (CdS) photocell* is to lower its electrical resistance, and

hence increase the current from a d.c. power source connected across the cell. A sensitive galvanometer in the circuit is calibrated accordingly. A small, long-life power cell of constant voltage is connected in series in the meter circuit. The CdS device is called a *photoresistor*, and is very small; but it has a much greater sensitivity than a selenium cell. Its spectral response is adjusted so that it approximately matches that of the selenium cell. The three main disadvantages of the CdS cell are its temperature-dependence, its 'memory' and its low speed of response. The ambient temperature can affect the response of the cell and its calibration. The response also depends on the previous history of illumination so that a reading taken in a low light level after exposure of the cell to a much higher light level, tends to be an exaggerated response due to its 'memory' of the previous light level. A significant time is required before response is back to normal. Finally, the speed of response in low lighting is slow,

the meter needle usually taking several seconds to reach its final reading.

Silicon and gallium arsenide phosphide photodiodes

Light incident upon a solid-state device known as a *silicon (Si) photodiode (SPD)* generates a very small current. The effect is similar with another device called a *gallium arsenide phosphide (GaAsP) photodiode (GPD)*. These devices may be thought of as photovoltaic cells in a similar way to the selenium cell. But their output is too low to be used in the same way, and for a practical photocell for use in cameras an amplifier is used in conjunction with the photodiode to produce a useful output. An operational amplifier acts as a current-to-voltage converter, and with a suitable feedback resistance gives a high output voltage, linearly proportional to the

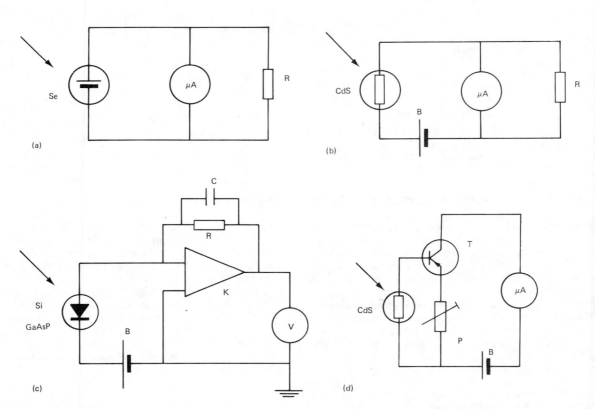

Figure 9.20 Basic electrical circuits for the different types of photocell used for exposure determination: (a) selenium (Se) photocell with microammeter μA and resistor R; (b) cadmium sulphide (CdS) photocell needs a d.c. power source B; (c) SPD (Si) or GPD (GaAsP) photocells: K is an operational amplifier and R is a

feedback resistor acting as a sensitivity control, C is a damping capacitor and V a voltmeter; (d) for a CdS cell a compensating-zero method circuit using a potentiometer P and an emitter-follower transistor T compensates for the non-linearity between the incident light input and photocell output

incident light. The response is significant even at very low light levels, and the linearity of response is maintained over a wide range of illuminance levels. The response of both types of photodiode is almost instantaneous, of the order of microseconds with the GPD, a most useful property for switching functions. The cell area need be only very small while retaining adequate sensitivity (a useful property for incorporation into a camera body). The advent of suitable solid-state amplifier modules has provided a photocell device possessing properties much superior to those of CdS cells.

Like the CdS cell, and in contrast to the Se cell the spectral sensitivity of the Si cell extends from about 300 nm to about 1200 nm, with a peak around 900 nm. For photometric use in a camera or light meter, filtration of this natural sensitivity is required to give a suitable response. Such filtered varieties for use in the visible spectrum are often termed 'silicon blue' cells. Comparative electrical circuits for the operation of Se, CdS, Si and GaAsP photocells are shown in Figure 9.20.

Integral exposure meters

Most modern cameras are fitted with integral light meters, and even those that are sold without them have provision for accessory clip-on meters which in some cases can be coupled to the camera controls. The three types of photocell may be used with the cells external to the camera body, positioned in a variety of locations and ways. Because of their large size, selenium cells are generally located in the front plate of the camera or in a ring round the lens. The acceptance angle usually matches that of the non-interchangeable standard lens. On the other hand CdS or SPD cells, being much smaller, have greater freedom of positioning, but are generally located behind a small lens aperture in the front plate or in the lens surround. The acceptance angle is usually smaller than that of the standard lens. Provision for a small battery and on-off switch for the meter cell must be made.

The majority of cameras with integral meters have the photocells positioned within the camera body so that light measurement is made through the camera lens itself.

Through-the-lens exposure measurement

A direct result of the small size and high sensitivity of CdS and SPD photosensors has been the possibility of taking reflected-light measurements from the subject through the camera lens by a photocell installed in the camera body. In theory, this should automatically compensate for the transmission losses of the lens in use, for any lens extension used for close focusing and for the use of filters, perhaps with limitations in the last case. Measurement may be from all or only part of the subject covered by the lens in use. Such a system is easily incorporated in a SLR camera. Many cameras of this type are available with a variety of *through-the-lens (TTL) metering* systems either fixed in the camera or as an option, by means of an alternative viewfinder housing incorporating the meter system.

Several problems are encountered in the design of a TTL metering system and current camera models reflect the variety of solutions possible.

Position of the meter cell

The cell or cells employed can assume a variety of shapes or sizes without much effect on sensitivity; this allows great flexibility in the choice of location within the camera body (Figure 9.21). Ideally, the cell should be located close to the film plane, but the presence of a focal-plane shutter hinders this. A cell on a hinged or retractable arm which locates it just in front of the shutter blinds has been used, but measurements are more commonly made with the cell in an equivalent focal plane. This is a plane located at the same distance from the exit pupil of the camera lens as the film plane. One such plane is that of the ground-glass screen used for focusing, and can be monitored by photocells in the viewfinder housing. A beamsplitter system may be used to divert light from part of the screen to a cell located outside the screen area. The area used for measurement purposes can be delineated on the screen to show clearly the part of the subject being metered.

Another equivalent focal plane is located in the base of the dark chamber or mirror housing of the camera body. A partially-transparent or perforated area of the main reflex mirror transmits light via a small subsidiary mirror, termed a piggy-back mirror, down into the well of the dark chamber where a complex photocell arrangement is located. The cell may be a segmented type or have a supplementary aspheric lens which can be selected to give a different form of metering pattern.

A simple but seldom-used solution to cell location is to place the cell or cells behind all or parts of the reflex mirror, allowing light to reach it by an arrangement of slits in the mirror or by making the mirror partially transparent. An additional cell reading in opposition may be need to cancel out the error effects of light reaching the cells from the viewfinder system. Such an arrangement is unsatisfactory with interchangeable lenses if there is a change in position of the lens exit pupil. Different lenses may have exit pupils that are at different distances from the mirror along the optical axis. The measurement area of the reflex mirror then intersects the cone of light

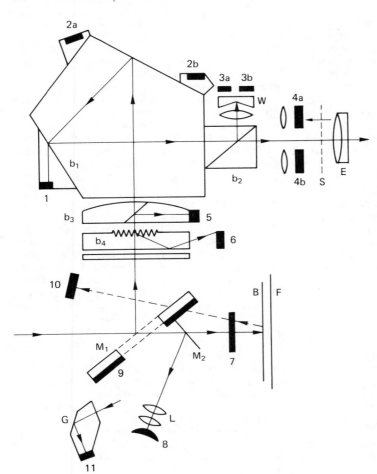

Figure 9.21 Photocell positions for in-camera TTL metering systems; a selection of systems and associated optics. (a) Screen luminance measurements: 1 integrated reading via beamsplitter b_1; 2a, 2b photocells in series for weighted reading; 3a, 3b segmented photocells reading via double wedge W and beamsplitter b_2; 4a, 4b cells near eyepiece for integrated readings. Supplementary lenses give central bias. One cell may read stray light through the eyepiece for correction. E eyepiece, S eyepiece shutter. (b) Equivalent focal plane measurements: 5 small area reading via beamsplitter b_3; 6 small-area reading via diffraction type beamsplitter b_4; 7 removable photocell on pivot; 8 photocell reading via semi-reflecting or perforated mirror M_1 and piggy-back mirror M_2, supplementary lens L added for bias; 9 photocell behind perforated mirror. (c) Measurement 'off the film' (OTF) or shutter blind B: 10 photocell for integrated reading; 11 photocell and light guide G. Cell 8 may also be used. The shutter blind may have a reflective zone

from the lens exit pupil in different positions, and samples different cross-sectional areas of the cone.

A popular solution to the problem of cell location is to position cells in the housing of the pentaprism and use them to measure the luminance of the image on the focusing screen, remembering that a change of focusing screen type may need a correction applied to the metering system, owing to changes in screen image luminance. Such arrangements also allow an interchangeable pentaprism housing with TTL metering to be offered as part of a camera system. This alternative is favoured for medium-format cameras of both the TLR and SLR types. The cell or cells are located either behind a pentaprism face or around the eyepiece lens. A single cell monitoring the whole of the screen area may be used, but generally two cells are employed to give a weighted reading to favour the central zone of the screen. This can also offset uneven illumination of the screen caused by lenses of a variety of focal lengths. A choice of weighted or small-area readings may be possible. Use of a segmented photocell

allows different modes of use by comparison of scene luminances in different regions. Another ingenious solution is to position a fast-reacting SPD to respond to light reflected from the film surface itself, i.e. to the image luminance, and to terminate the exposure duration by controlling the shutter operation or by terminating an electronic flash emission. This is referred to as *off-the-film (OTF) metering*. Such an arrangement may also monitor changes in the subject luminance during the exposure duration, when the mirror is raised and when other metering systems would not be operating. It has a sufficiently rapid response to monitor the output of a dedicated electronic flashgun with the necessary thyristor control circuitry (page 25). To allow for the incomplete uncovering of the film gate by the slit in the blinds of the focal plane shutter when giving short exposure durations, the shutter blinds may be printed with randomized arrays of light and dark patches to simulate the reflectance of the film surface and provide a form of weighted reading if required.

Type of reading

The TTL metering system is based on measurement of the light reflected from the subject as transmitted by the optical system in use. The meter cell does not, however, always measure all the light from the subject area covered by the lens. Several different systems are in use (Figure 9.22). A 'fully-integrated' reading is a measure of all the light from the subject area, and the exposure indicated or given is liable to all the usual variations caused by tonal distribution and luminance range of the subject matter. An alternative is a 'spot' reading, where a very small area of the subject is measured; but unlike the case where a true photometer is used, a mid-tone grey region of the subject must usually be selected for measurement. Some cameras do offer the choice of a shadow or highlight spot reading and may even provide facilities for taking several such readings from chosen parts of the scene, when the metering system will give an average reading based on these.

The 'small area' type of reading is an integrated measurement of an area of the subject too large to be considered a spot reading, but it is not a fully-integrated one. This system can provide a useful compromise. The 'weighted' reading is also a compromise where the whole subject area is measured, but the central portion of the subject as viewed contributes most towards the result given. Various weighting patterns are in use, favouring different regions of the scene.

The use of a segmented photocell, which takes several discrete or overlapping measurements simultaneously from different zones of the scene, permits rapid changeover between different metering patterns, but in combination with a memory programmed with a large range of optimum exposures for various scene luminance ranges and luminance distributions, the automatic metering system may select the optimum exposure in the circumstances.

In circumstances where the metering system in use may give an erroneous result due to non-typical tone distribution or luminance ratio, the use of an *exposure memory lock* control can be useful. The

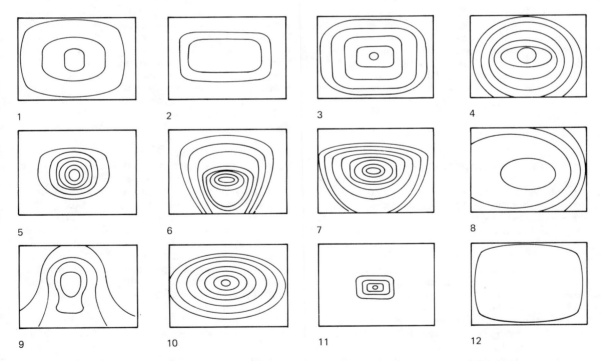

1 2 3 4

5 6 7 8

9 10 11 12

Figure 9.22 TTL metering sensitivity patterns. It is possible to plot a form of contour map of the field of view of the metering system where the lines enclose regions of decreasing sensitivity measured outwards from the centre of the format area. Twelve patterns are shown. 1 and 2: approximate integrated readings with slight central bias; 3 and 10: centre-weighted readings of differing patterns; 4, 6, 7 and 9: centre-weighted with pronounced bias to the base of the picture; 8: an asymmetric centre-weighted reading with bias to the left of the scene as is given by a reading at a medium shutter speed from a patterned blind in OTF metering; 5 and 6: pronounced centre-weighting approximating to a small area reading; 11: small area reading as given by a beam-splitter system; 12: fully integrated reading with usual slight reduction at the periphery

camera is directed at a part of the subject (or at an alternative subject) and the indicated exposure settings are stored in a memory. The camera is then pointed at the subject again as composed and an exposure made with the predetermined values. The memory may be self-cancelling, or the data locked in until erased.

The multiplicity of methods of readings, combined with the different locations possible for the meter cell, give rise to the large number of variations in TTL-metering cameras currently available.

Sensitivity

The *metering sensitivity* obtained in a TTL system is generally only of the same order as a good selenium-cell meter for hand-held use. This is due to the considerable absorption of light by the optical and viewing system of the camera. Use of a lens of large maximum aperture improves metering sensitivity, unless a stop-down measurement system is being used. The use of a SPD with amplification circuitry can increase metering sensitivity by a useful amount owing to the greater inherent response of such a circuit. In order to be able to compare sensitivities, it is usual to quote the sensitivity as the minimum EV number that the system can provide as an exposure when ISO 100/21° film is in use. For example, a sensitivity of EV 1 is typical of an SLR TTL system. A hand-held light meter, by comparison, can have an equivalent sensitivity of -4 to -6 EV, factors respectively of 32 and 128 times the sensitivity.

Operation of the metering system

An integral metering system is of great practical assistance, but the method used to set the camera at the necessary exposure varies to some extent. There are a number of steps involved. First, the battery to power the system must be switched on, often by first pressure on the shutter release button. This may then initiate a *battery check function* and a *timing circuit* to limit battery use and conserve electrical energy. Then the subject must be sharply focused and the appropriate area selected for measurement if applicable. In semi-automatic exposure modes either the shutter speed or lens aperture is selected first, and then the other variable set as indicated by the meter. This may be done by match-needle operation, i.e. by altering the appropriate control until a moving needle in the viewfinder readout is brought into coincidence with a fixed needle or

cursor. Other cameras using a LED display may indicate the necessary setting by a flashing symbol or by a simple plus, zero and minus signs which light up as the settings are changed. Stop-down metering, where the operation is done at the chosen aperture, is now rare except for instances such as close-up photography, or for use with lenses lacking a fully-automatic iris diaphragm. In fully-automatic cameras there is usually a choice of one or several alternative metering modes, and the user may simply have to select one setting of aperture or shutter speed or just a letter such as S, A or P on a control dial or LCD display.

Automatic exposure modes

In the *aperture-priority mode* the user selects the lens aperture most suitable for purposes such as depth of field or optimum lens performance. Sometimes the effective aperture of the optical system in use, such as a microscope, may not be known. The metering system then gives the appropriate exposure duration by control of the shutter mechanism. The exposure could be of many seconds duration, when reciprocity-law failure might be anticipated, but the duration also depends on metering sensitivity. An indication is given when the exposure duration is out of range of the shutter.

In the *shutter-priority mode* the user selects the shutter speed most appropriate to avoid camera shake or to stop a moving subject or to allow the use of electronic flash fill-in lighting. The metering system then determines the appropriate aperture. The lens requires a separate 'A' setting on the aperture control ring. Various mechanisms set the aperture to the required fractional setting, including motorized operation within the lens mount.

In the *programmed mode* the camera metering system selects a suitable combination of shutter speed and lens aperture from a program of combinations related to the subject luminance. More details are given in Chapter 20. The program may be selectable from several on offer, set by the user, and may also receive an input from the lens in use to determine the appropriate shutter speed. Programs which favour small apertures for maximum depth of field are also used.

When using TTL flash metering, the usual arrangement is for the user to select an aperture; the flash is quenched appropriately, giving a measured exposure duration. But *programmed flash* is also possible where the subject distance, as focused first, will determine the lens aperture for a given flash output. Other alternatives are possible.

10 Camera movements

Much professional photography is carried out using large-format cameras. These offer high image quality and the kind of versatility, that comes from modular design and from *camera movements* for precise control of focus, distribution of image sharpness and shape of the image. A direct-viewing focusing screen is mandatory.

Large-format studio cameras are sometimes called *view cameras* or *technical cameras*. They are usually of folding baseboard or monorail construction, the latter giving unsurpassed versatility. The monorail design uses the principle of the optical bench. The principal components are the front and rear standards, which carry the lens panel and film holder respectively, and which are connected by a flexible or pleated bellows. The standards may be of U or L shape, and the movements usually have click-set neutral positions and are lockable in other positions. Rotational movements are usually calibrated in degrees and translational movements in millimetres. A rotational movement may be about an axis through the standard, termed *centre tilt*, or about an axis located near the monorail, termed *base tilt*; or the axis may be movable to various positions. Each has advantages and limitations. Some of the various camera movements may also be used with smaller-format cameras and lenses.

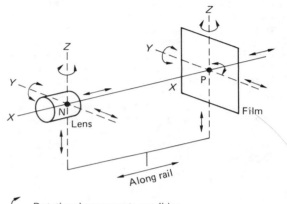

Rotational movements possible
Translational movements possible

Figure 10.1 Monorail camera with its movements neutral. The optical axis and the camera axis are coincident in this neutral position

View camera movements are shown in Figure 10.1, and are listed in Table 10.1. These movements are the 'degrees of freedom' of the imaging system.

Table 10.1 A summary of camera movements using the notation of Figure 10.1

Type of movement: D displacement R rotational	Axis used: L lens C camera	Usual name of movement	Prime function or use
D	X_L	Front focusing	Focusing, with change in magnification
D	Y_L	Cross front	Position image on film
D	Z_L	Rising front Drop front	Position image on film Correction of verticals
R	Y_L	Tilting front	Depth of field zone
R	Z_L	Swing front	Depth of field zone
D	X_C	Rear focusing	Focusing, no change in magnification
D	Y_C	Cross back	Position image on film
D	Z_C	Rising back Drop back	Position image on film
R	X_C	Rotating back	Alter aspect ratio of image on film
R	Y_C	Tilting back	Depth of field and image shape
R	Z_C	Swing back	Depth of field and image shape

Translational movements

The first group of movements are those of displacement or translation along the mutually orthogonal XYZ axes, which are centred either at the rear nodal point of the lens (so that the X-axis is by convention the optical axis when horizontal) or at the principal point P where the optical axis intersects the film plane orthogonally at the centre of the format (Figure 10.1). For the purpose of this chapter the rear X-axis is called the *camera axis* and the front X-axis the *lens axis*. Initially a view camera may be set up with both lens and camera axes coincident and horizontal, the so-called neutral position, after which camera movements can be applied, including the tilting of the combined axes from their horizontal orientation.

Movements along the X-axis give *front focus* or *rear focus* with reference to the lens panel and film holder respectively. The former movement alters focus and magnification together, the latter alters focus at a fixed magnification. Alternatively both

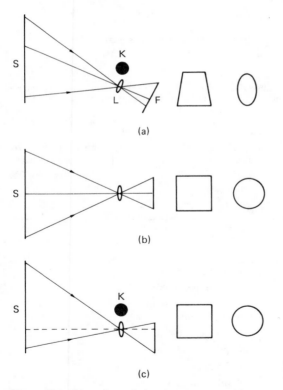

(a)

(b)

(c)

Figure 10.2 Use of translational movements. (a) An enforced oblique view of subject S, due to obstruction K. Square and circular subjects are imaged as trapezoidal and elliptical respectively. L camera lens. F film plane. (b) Ideal square-on view without movements; (c) an oblique view using cross-front movements to simulate a square-on view. All views are from above

standards may be moved together at a fixed separation to provide focus on the subject by moving the whole camera. Front and rear movements along the Y (transverse) and Z (vertical) axes are useful to centre the subject on the format without small adjustments of the camera on its stand. These rising, falling and cross movements are also useful in retaining parallel lines or features in the image where a centralized viewpoint is not possible. The film plane needs to be kept vertical or parallel to the subject (Figure 10.2).

An important consideration is the covering power of the lens, which determines the permissible extent of translational movements.

Rotational movements

In theory, both the lens and the film plane may be rotated about each of the XYZ axes, the three rotational and three translational (displacement) movements giving a total of six degrees of freedom for each. In practice the lens is not rotated about its X axis (optical axis) as it is axially symmetrical. For a helical focusing mount, the focusing action gives X-translation and rotation combined. Occasionally an eccentric lens panel allows translation movements as a rotation of the optical axis about the camera axis. The film plane, however, may have X-rotation, in the form of a rotating back which revolves the film-holder continuously from a vertical to a horizontal position. The most important rotations are those about the Y and Z axes, referred to as *tilt* and *swing* respectively. Front and rear tilt and swing may be used individually or in combination, or in conjunction with displacement movements. For some purposes, front or rear tilt or swing may be used interchangeably; but in general those of the lens are used to control the distribution of sharpness in the image, and those of the film holder to determine the shape or perspective of the image (details are given below). The allowable amount of lens movement is dependent on the covering power of the lens used.

Lens covering power

The covering power of a lens is the diameter of the circle of good definition in the focal plane, which is less than or (rarely) equal to that of the circle of illumination from the lens. Covering power is a minimum at maximum aperture and infinity focus, but increases as the lens is progressively stopped down, or focused closer (Figure 10.3).

A lens designed for use with camera movements usually has *extra covering power* to give a circle of good definition significantly larger than the format

Figure 10.3 Lens covering power and camera movements: the format $x \times y$ related to image circles of various radii R. Key: R_1 format semi-diagonal, as covered by a large aperture or telephoto lens at infinity focus, R_2 lens with extra covering power of 70°, infinity focus, full aperture, R_3 lens used at f/22, R_4 lens used at $m = 1$, Y possible vertical shift, X possible horizontal shift; $\sqrt{(X^2 + Y^2)}$ is the maximum displacement movement.

in use. This allows the film area to remain within the circle of good definition when translational movements are used or when the lens is tilted or swung. It is common practice to provide a covering power corresponding to a field of view (FOV) of some 70–80° for a standard lens, for a given format which can accommodate some 50°, hence allowing some 10–15° of lens rotation or tilt. Wide-angle lenses have less covering power. Where the FOV on the format is not of prime concern but extensive movements are needed, then a 'long-focus wide-angle' technique may be used. This means that a wide-angle or standard lens for a larger format is used, so that the extra covering power for that format gives adequate covering power for the smaller format. Thus a 210 mm wide-angle lens for an 8 × 10 inch format used with a 4 × 5 inch format offers a slightly long-focus lens with a circle of good definition of diameter some 500 mm relative to the format diagonal of 164 mm.

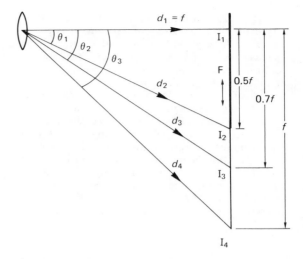

Figure 10.4 Displacement movements and image illumination. Geometry of image formation at infinity focus for a standard lens with normal (θ_1), extra (θ_2) and exceptional (θ_3) covering power. See also Table 10.2. F is the film format

The extent of the translational movements may be limited not only by covering power available, but also by the type of film used. This is because the exposure latitutde of the film has to take care of the $\cos^4 \theta$ variation in image illumination. At extremes, one side of the film format may be on axis, the other side at the image periphery. Figure 10.4 shows the situation with a lens of focal length f allowing a displacement of up to $0.5f$ within an image circle of diameter $2f$. The natural vignetting gives illumination values and losses as detailed in Table 10.2. Given a change in exposure level of not more than 0.5 EV across the format, then a FOV of 70° for a standard lens, allowing a maximum displacement movement of $0.2f$, is a reasonable limit for infinity focus. Individual lenses need to be tested for their capabilities.

Control of image sharpness

Image sharpness in a photographic record is usually controlled by suitable choice of focused distance,

Table 10.2 Exposure variation limits to displacement movements

Lateral displacement of format in terms of lens focal length f	Necessary semi-FOV of lens (θ)	Distance of edge detail from lens in terms of f (d)	Illumination (I)	Exposure change (EV)
–	–	$d_1 = f$	$I_1 = 1$	0
0	26.6	$d_2 = f/0.894$	$I_2 = 0.8$	$-1/5$
0.2f	35	$d_3 = f/0.819$	$I_3 = 0.67$	$-1/3$
0.5f	45	$d_4 = f/0.707$	$I_4 = 0.5$	-1

lens aperture and focal length to ensure the necessary depth of field. Large-format camera work uses lenses of long focal length; and even with the increase in diameter of the acceptable circle of confusion and the small apertures available, depth of field may be inadequate, especially for an extended subject inclined to the optical axis. Figure 10.5 shows the geometry of such a situation, with the lens focused on a subject point on axis, and near and far subject points focused behind and in front of the film plane respectively, giving large circles of confusion and consequent out-of-focus images on the film. It is plain that rotation of the film plane to coincide with the other foci will give a sharp image overall. It maybe less obvious that a similar effect can be produced by keeping the film plane static and

rotating instead the lens. Theoretically the two solutions are equivalent, and lead to *Scheimpflug's Rule* that an inclined subject plane is rendered sharp when the plane of the subject, the rear nodal (principal) plane of the lens and the film plane, all extended into space as necessary, meet in a single line. Figure 10.6 shows the subject plane S, rear nodal plane L and film plane F extended to meet in a common line R. If the lens conjugate equation is satisfied for all points on plane S then all the plane will be in focus.

For a point A at infinity and a point B on S whose image points are a and b respectively, both rays Aa and Bb pass through the optical centre O. Let Aa be parallel to BR. Construct perpendiculars from B, b and a to the plane L, so that the distances aQ, BD

Figure 10.5 Rotational movements and Scheimpflug's rule. Points A, B and C on subject plane S give image points a, b and c and circles of confusion K on film plane F. Rotating F through angle *p* to intersect with S and lens

plane L at R_1 gives sharp focus and satisfies Scheimpflug's rule. But leaving F and instead rotating L through angle *q* to give intersection at R_2 will also give overall sharp focus on S

Figure 10.6 Derivation of Scheimpflug's rule

and bC represent *f, u* and *v* in turn. Then

$$\frac{1}{u} + \frac{1}{v} = \frac{1}{RB \sin \beta} + \frac{1}{Rb \sin \alpha}$$

$$= \frac{1}{RB \left(\dfrac{f}{aO}\right)} + \frac{1}{Rb \left(\dfrac{f}{Ra}\right)}$$

$$= \frac{1}{f \left(\dfrac{aO}{RB} + \dfrac{Ra}{Rb}\right)}$$

From similar triangles $\triangle baO$ and $\triangle bRB$,

$$\frac{aO}{RB} = \frac{ab}{Rb}$$

Substituting

$$\frac{1}{u} + \frac{1}{v} = \frac{1}{f \left(\dfrac{ab}{Rb} + \dfrac{Ra}{Rb}\right)}$$

$$= \frac{1}{f \left(\dfrac{ab + Ra}{Rb}\right)}$$

but since ab + Ra = Rb, then the quantity in brackets is unity. So the relationship $1/u + 1/v = 1/f$ hold true for the condition that the three planes meet in a common line.

The Scheimpflug geometry is usually set up by eye, and fine-tuned using the focusing screen; but it is possible to arrive at optimum settings by calculation. Special enlargers called *rectifying enlargers*, which use movements to correct for the effects of tilt in aerial photographs, are equipped with mechanical linkages which retain automatic setting of the Scheimpflug relationships.

Limits to lens tilt

When camera movements, and in particular lens tilt movements, are used to control perspective and image sharpness according to the rules given above, the optical axis of the lens will not in general pass through the centre of the film frame. This means that extra covering power will almost always be needed. A lens with a useful angle of field of 70°, used as a standard lens for a format of 50° FOV, allows a tilt of no more than about 15°, bearing in mind the limitations imposed by $\cos^4 \theta$ fall-off. The limits are increased a little for close-up work, and with the use of small apertures.

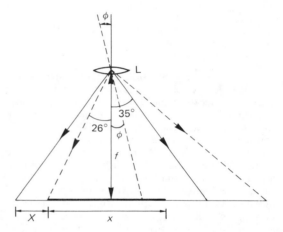

Figure 10.7 Limits to front movements. A standard lens L set at infinity focus with FOV 70° covers a format with a dimension *x* to allow a maximum lateral displacement of *X*. A maximum tilt of ϕ is possible, where $\phi = (35 - 26) = 9°$

In theory, the camera back may be swung to almost any extent, provided that the format remains within the cone of illumination from the lens. In practice there are two limitations, the variations in image illumination and in image shape. The limit to rear tilt movements, and the associated exposure variation across the format, is shown in Figure 10.8. It can be seen that a tilt of no more than 15° results in an illuminance ratio of some 0.6 (approximately 0.5 EV) at the rear and far edges of the tilted film plane. The change in image shape with application of rear tilt is even more important. There is a change in magnification *m* as image conjugate *v* varies with tilt, while subject conjugate *u* is unaltered in the relationship $m = v/u$.

The choice of a lens and of a camera with an appropriate range of movements should be considered on the grounds of optical limitations.

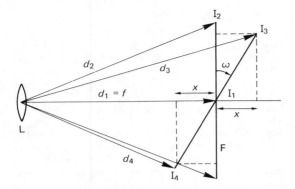

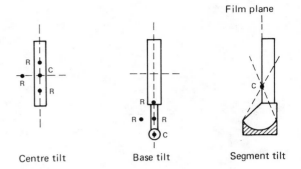

Figure 10.10 Tilts and mechanical designs. C is the centre of rotation, which does not usually coincide with the rear nodal point of the lens or the film plane. The segment tilt is the exception. C may be located elsewhere, denoted by R

Figure 10.8 Limits to rear rotational movements. With lens L set to infinity focus, $d_1 = f$. Film plane F is swung through angle ω. To a first approximation, $d_3 = d_1 + x$ and $d_4 = d_1 - x$. For a typical value of ω of 15°, $d_3 = 1.13f$ and $d_4 = 0.87f$. So ratio I_3/I_4 is $(0.87)^2/(1.13)^2 = 0.6$

In practice a combination of front and rear tilts may be used to obtain the necessary sharpness, if the subject allows for some distortion. Tilt in an opposite direction may be used to *reduce* the zone of sharpness for a specific purpose. Tilts are used in conjunction with the aperture setting to obtain a volume of sharply-rendered subject space of wedge shape which is judiciously positioned to encompass all of the subject matter that is required to be in focus (see Figure 10.9). Careful use of rotational movements allows minimal use of the iris diaphragm, so allowing a lens to be used at larger apertures, giving better optical performance and allowing shorter exposure times and reduced light-

ing levels. The main limitation on the use of combined swing and tilt movements is that of mechanical design and the fact that the image framing shifts when movements are used. A patented design in the Sinar range of cameras uses a 'segment tilt' which avoids this problem by allowing the rotational axis to be positioned precisely in the film plane and to correspond to the part of the subject focused upon (Figure 10.10). The (theoretically) simple camera movements of displacement and rotation may only be realizable in some camera designs by the simultaneous use of several movements to give the equivalent of one simple movement (Figure 10.11).

The efficient use of swing and tilt movements is hampered in practice by uncertainty concerning the exact position of the axis of rotation. Lenses

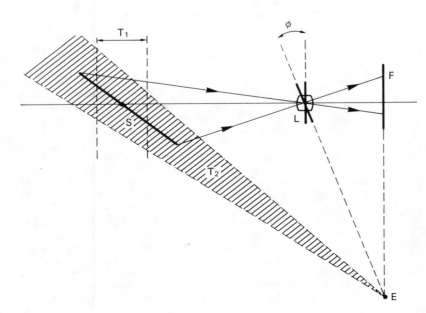

Figure 10.9 Depth of field and camera movements. The inclined subject S is not fully within the depth of field T_1 until lens is rotated through angle ϕ to satisfy Scheimpflug's rule, locating S within depth-of-field zone T_2

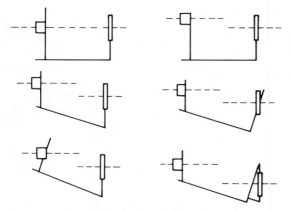

Figure 10.11 Equivalent movements. Dependent on mechanical design limitations, a particular camera movement may be given in various ways, as shown here for rising front, using base and centre tilts on front and rear

mounted in a panel seldom have the rear nodal plane corresponding to the axis of rotation. In the case of telephoto lenses, the rear nodal plane is in front of the lens barrel itself and any angular movement needs to be greater than might be expected. Such lens designs, however seldom have extra covering power, and do not lend themselves to use of camera movements. Centre tilt would appear to be advantageous, as little or no refocusing is required after use, in contrast to the application of base tilt, but film holders can be inserted unobstructed with the latter design. Some cameras provide both base and centre tilts.

Control of image shape

A view camera with all movements at neutral, imaging a planar subject perpendicular to the optical axis, will give (within the usual practical limits) an undistorted image which is a true perspective rendering of the subject. If the film plane is swung (or tilted) and the lens is also swung to satisfy the Scheimpflug condition, then the image shape will also alter (Figure 10.12). Lines formerly perpendicular to the rotation axis will now converge to a 'vanishing point' of perspective. This is due to the alteration in the image conjugate v while the subject conjugate u remains constant, resulting in a change in magnification. This change in image shape can be used to produce deliberate changes in perspective, for example to make lines inclined to the film plane parallel, and to make parallel lines converge towards a vanishing point. By making the film plane more parallel or less parallel to the plane of the subject, linear detail can be made to converge respectively to a lesser or greater extent. The result is a flattening or steepening of perspective (Figure

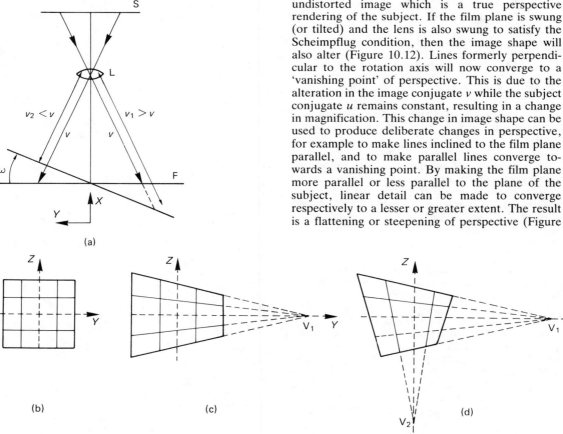

Figure 10.12 Effect of film plane rotation on image shape: (a) rotation of film plane F through angle ω alters v to v_1 and v_2 and changes magnifications; (b) appearance of subject with all movements neutral; (c) with rear swing

about Z axis to give vanishing point V_1; (d) with combined rear swing and tilt about Z and Y axes respectively to give vanishing points V_1 and V_2

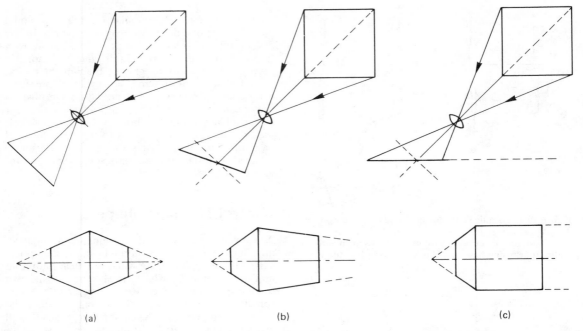

Figure 10.13 Perspective control by alteration of image shape. As an example, an oblique view of a cube with progressive swing of the film plane to be parallel to the front face gives image shape and vanishing points as shown from (a) to (c)

10.13). The term 'perspective control' is often used to describe this type of manipulation of the optical image.

A common application of perspective control is in the photography of buildings, where an oblique viewpoint with a camera in neutral mode gives a true perspective rendering with converging verticals in the picture. The preferred 'drawing', (i.e. with the vertical lines remaining parallel) is obtained by restoring the film plane to the vertical. In practice the photographer usually uses the rising front (Figure 10.14).

An anomalous effect may sometimes arise in such 'corrected' photographic images: it is a purely subjective keystone effect. Although the verticals in the print are indeed parallel, they nevertheless appear to be diverging, for example at the top of a building, resulting in a top-heavy appearance. The reverse effect arises when a high oblique viewpoint is used with drop front to retain parallel linear features: the subject then appears wider at the base. The best way of avoiding this is to apply somewhat less of the camera movements than would be suggested by theory. The cause of this anomalous effect is not simply an optical illusion: it is that the outermost part of the field of view actually becomes elongated owing to geometrical distortion in the image when it is subjected to this type of 'correction'. The precise extent of this distortion belongs in the realm of photogrammetry.

(a)

(b)

Figure 10.14 The use of rising front. This is in effect a rear tilt movement to remove the convergence of vertical lines. (a) Conventional oblique view; (b) film back parallel to vertical subject

Perspective control lenses

The majority of small- and medium-format cameras lack movements other than focusing; but lenses which incorporate a limited range of translational and rotational movement as part of the construction of the lens barrel and mount are now available. They are known as *perspective-control* or 'shift' lenses. They are usually of semi-wide-angle or wide-angle design with the necessary extra covering power to allow up to 11 mm of lateral displacement or 10° of tilt relative to the 24 mm side of the 24 × 36 mm format. Usually the lens can be displaced in only one direction by mechanical movement, but the whole lens may be rotated to allow the equivalent of rising and drop front or cross front. Even with full movement applied, hand-held exposures are possible, provided moderate apertures are used. Although such lenses cannot give a 35 mm camera the perspective control available with a view camera equipped with a full range of movements, they do make it possible to produce satisfactory record photographs of (for example) architecture, under circumstances where large-format equipment would be unacceptably cumbersome.

11 Optical filters and attachments

A wide range of optical filters and other attachments is available for use with cameras. Filters are used to modify the spectral characteristics of the image-forming light by selective absorption. Other attachments used in front of the lens are spectrally non-selective, but alter the nature of the image.

General characteristics of optical filters

Spectral absorption

A *colour filter* consists of a transparent flat sheet of coloured material, usually placed over the camera lens. It acts by selective absorption of the light incident upon it, as shown in Figure 11.1. As we have seen, a coloured opaque object – say a yellow

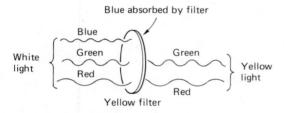

Figure 11.1 How a colour filter works

sheet of paper – reflects green and red light and absorbs blue, so a yellow transparent object transmits green and red light and absorbs blue. Such a filter is called an *absorption filter*, and achieves its effect in a different manner from an *interference filter*. Colour filters permit full control of colour rendering with panchromatic and colour films; however, with orthochromatic (blue-and-green-sensitive) materials, only yellow filters can be usefully employed, and colour filters have no applications with materials sensitive only to blue light.

Absorption curves

The spectral transmission characteristics of a filter can be expressed by a curve in which spectral transmission is plotted against wavelength. Transmittance may be normalized, or expressed as a percentage. Both arithmetic and logarithmic scales are used. A common method is to plot optical transmission density (see page 170) against wavelength, giving spectral absorption curves (Figure 11.2). These curves are produced by an instrument such as a recording spectrophotometer.

Filter factors

To obtain correctly-exposed results when using a filter, a somewhat greater camera exposure must be

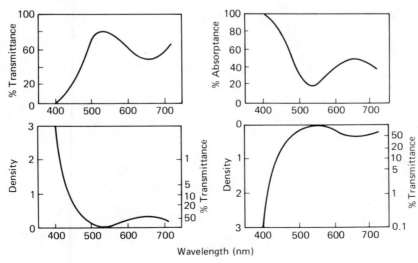

Figure 11.2 Some methods of illustrating spectral absorption data for a colour filter. The four graphs show the same data for a pale green filter plotted in different ways to show the variations in curve shape given

given, to compensate for the absorption of light by the filter. This increase may be obtained either by increasing the exposure time or by using a larger aperture. The ratio of the filtered exposure to the corresponding unfiltered exposure is termed the *exposure factor* or *filter factor*. The value of the filter factor for any given filter depends on the spectral absorption of the filter, the spectral quality of the light source used, the spectral sensitivity of the photographic material used, and the exposure duration (if reciprocity-law failure effects are significant). Often a filter may be described as '2× yellow' or '4× orange', implying filter factors of 2 and 4 respectively, regardless of the particular conditions and photographic material inuse. Alternatively, the effect on exposure may be given as a negative EV (exposure value) number. Although such general filter factors may be incorrect under some particular exposure conditions, these numbers do give an idea of approximate values, at least for filters with relatively low filter factors, used with panchromatic film.

Filter factors may be determined in a number of ways. One practical method is to photograph a neutral subject such as a neutral grey scale, first without a filter, then with the filter, under the same conditions of illumination, giving a range of exposures in the latter case. The filtered negative having the same range of densities as the unfiltered negative is selected, and the exposures compared; the filter factor is the ratio of the two exposures. Dense filters (such as those used in colour separation work), which require large increases in exposure, are best measured in terms of *intensity filter factors*, using a fixed exposure time such as 10 s and altering the lens aperture accordingly. Cameras incorporating through-the-lens exposure metering may give the correct compensation for certain filters such as neutral density, polarizing and pale light-balancing types, but with others anomalies may arise owing to the differing spectral sensitivities of the measuring photocell and the sensitized material in use. Beam-splitter devices in the camera may cause also incorrect indication of exposure when polarizing filters are used, depending on the orientation of the polarizing axis to the optical axis. In such cases special circular polarizing filters must be used instead of the usual linear varieties.

Commercial forms of colour filters

When a filter is required, it is important to use one specially designed for photographic use, with appropriate spectral and optical properties, rather than any convenient coloured piece of glass or plastics material, with unknown spectral absorption properties and inadequate optical quality.

Optical filters should be free from surface defects, and should have faces that are accurately parallel, otherwise the performance of the camera lens may be degraded. If they are to be used for photomacrography or other close-up work they should be as thin as possible to avoid possible displacement of the optical image if they are inserted after focusing. So important are the possible effects on image quality that some lens designs such as fish-eye and mirror types are computed to be used with a suitable filter permanently in place among the lens elements. Such lenses have a selection of filters for monochrome photography in a turret as an integral part of the lens casing, usually including a colourless filter for normal colour photography. Filters can be made of various materials such as gelatin, cellulose acetate, polyester, solid glass, gelatin cemented in glass, gelatin coated on glass, optical resin, and dielectric-coated glass for interference filters. A convenient and permanent form is a sheet of coloured glass, termed 'dyed in the mass', but only a restricted range of spectral transmittances is available. Some filters, such as heat-absorbing and ultraviolet transmitting filters, are available only in glass form. When filters of special transmission characteristics are required (as for example in technical, scientific and colour photography), dyed-gelatin filters are usually employed. These are made either by surface absorption of suitable dyes into gelatin layers or by mixing organic dyes in gelatin and coating this on glass. When dry, the coated film (which is about 0.1 mm thick) is stripped from the glass. It is supplied lacquered on both sides for protection. Light filters intended for use in an illumination system rather than in the image-forming space may be of lower optical quality and lower cost. Darkroom safelight screens may be of plastics or coated glass, protected by a cover glass.

Gelatin filters can be of excellent optical quality, equal to that of the best optical-quality glass filters, and with virtually no effect on image location. They are available in a range of spectral absorption properties. Because of their susceptibility to surface damage and to warping under conditions of high humidity and/or temperature, gelatin filters can often be obtained cemented between two pieces of glass of appropriate optical quality.

Where constant handling is unavoidable or where high temperatures may be encountered or where large sizes are required, dyed cellulose acetate or acetate-butyrate sheet provides a useful filter material. Being thicker and of lower optical quality than gelatin sheet, the use of such materials is limited to non-optical purposes such as colour filtration of illumination systems. Such filters should be non-flammable. The low cost of non-photographic filters and their availability in large sizes and rolls means that filtration of large areas such as windows may be carried out, in order to give safelight conditions or

to balance exterior lighting such as daylight to a subject lit by tungsten studio lamps. By using plastics materials such as methacrylate, polycarbonate or CR39 optical resin, which are either dyed in the mass during manufacture or coloured by imbibition of colorant, light-weight and unbreakable filters of acceptable optical quality can be made in a thickness of about 2 mm.

Filter sizes

Conventional colour filters and other optical filters are available in a variety of sizes and forms. Gelatin filters come in sizes from 50 × 50 mm upwards, and most camera systems have special filter holders for these. Acetate filters are available in sizes ranging from small squares to large rolls, suitable for covering large areas or light fittings. Cemented filters are restricted to a few square or circular sizes. Glass filters dyed in the mass are available in a range of standard mounted diameters such as 49, 52, 58, 67 and 100 mm. It is desirable to have anti-reflection coatings on both glass surfaces to reduce reflection losses and the possibility of lens flare. Multi-layer coatings are used on some of the more expensive filters.

Optical filters may be positioned in front of, behind or even within a lens. Rear fitting allows filters of smaller diameter to be used. Lenses with filter turrets usually have the filters positioned between lens elements. A variety of fittings including push-on, screw and bayonet attachments are used. Often a single filter size is common to a range of lenses, allowing economy. Compendium-type lens hoods using extensible bellows allow filter discs or squares to be fitted to the rear. Other systems allow the use of several filters and attachments in tandem, each being capable of independent rotation or shifting for variation of effect.

Being part of the image-forming system, filters should be treated with care, handled as little as possible and kept scrupulously clean. Gelatin filters in particular must be kept cool and dry when not in use. Filter mounts should not stress or distort the filters when in position, otherwise image quality may suffer.

A colourless 'haze' or UV-absorbing filter is often used as an 'optical lens cap' to protect the front element of the lens from damage on the grounds that it is cheaper to replace even a high-quality filter than to pay for repair to a lens. There is, of course, little optical justification for this, as modern optical glasses are almost completely opaque to UV radiation.

Filters and focusing

When using filters in conjunction with a camera, problems may arise with respect to the accuracy of focusing the filtered image. Glass filters (especially the cemented variety) may be thick enough to cause a significant displacement of the image plane of the lens (by approximately one-third of the filter thickness). Visual focusing on a screen with the filter in place is thus essential, at least in close-up work. If a filter is very dense or even visually opaque, as in the case of certain ultraviolet and infrared transmitting filters, then substitution of a clear glass blank of identical thickness is necessary. Correction for the appropriate UV or IR focus is then applied. This problem does not arise with thin gelatin filters. For infrared photography, when a visually-opaque filter is to be used, focusing may be carried out through a substitute tricolour red filter.

In colour-separation work, where exposures are to be made through dense tricolour filters, the original should be focused using the tricolour green filter, as the wavelength of peak transmission of this filter approximates to the peak sensitivity of the eye.

With the increasing use of SLR cameras, the presence of a colour filter permanently tinting the viewfinder image may be found irksome, especially with deeper colours such as orange, green or red. There may be difficulty in visualization of the picture or in focusing the image in poor light conditions.

Colour filters for black-and-white photography

In black-and-white photography colour filters are employed primarily as a means of controlling the rendering of colours in terms of greys. They may be divided into two main groups according to their use.

Correction Filters

Sensitized materials for black-and-white photography may be blue-sensitive, orthochromatic or panchromatic. The first two are used almost exclusively for special purposes such as copying and tone-separation work, and almost all general photography is carried out using panchromatic material. However, panchromatic sensitization is not in fact uniform throughout the spectrum, most materials being more sensitive to blue than green, while some materials have enhanced red sensitivity. Some tonal distortion of colours is thus inevitable in a monochrome reproduction. *Correction filters* are employed with the aim of recording the colours of the subject in their true luminosity. Full or partial correction is possible, but full correction demands a considerable increase in camera exposure. It is worth noting that although such procedures may be technically 'correct', the result obtained may be disappointingly dull and flat from the pictorial point of view.

Table 11.1 Correction filters for black-and-white photography

Light source	Film sensitization	Rendering of colours		Correction filter needed	
		Too dark	*Too light*	*Partial correction*	*Full correction*
Daylight	pan	green	blue	pale yellow	yellow-green
Daylight	ortho	red	blue	pale yellow	not possible
Tungsten	pan	blue	red	pale greenish blue	blue-green
Electronic flash	pan	–	blue	–	pale yellow

A more effective interpretation of subject matter is frequently obtained by retaining the colour contrasts existing in the original and modifying them as necessary, using *contrast filters* to produce the desired effect in each case.

Correction filters are available in various densities of yellow and yellow-green; their use is summarized in Table 11.1. It should be remembered that with panchromatic films in daylight blues are rendered too light and greens too dark, while in tungsten illumination reds are too light and blues too dark. Thus white clouds and blue sky may be recorded

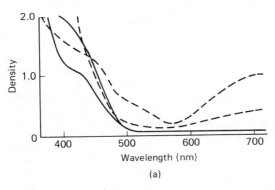

(a)

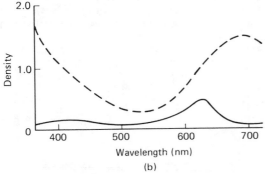

(b)

Figure 11.3 Spectral absorption curves for correction filters for black-and-white film materials; (a) filters for partial or full correction in daylight; (b) filters for correction in tungsten light. Solid lines = partial correction, broken lines = full correction

with similar densities, i.e. lacking in contrast, while the subject of a portrait in tungsten light may appear to have skin that is too pale and eyes that are too dark. Typical spectral absorption curves for correction filters are shown in Figure 11.3.

Contrast filters

Differences of colour and luminance in the subject are both represented in the print as differences in tone. Contrast filters are used to control the tonal contrast in the print arising from colour contrast in the subject. They may be used to make a colour appear lighter, to make it appear darker, or to make one colour darker and another lighter simultaneously. For example, a subject may have areas of green and orange which, whilst having considerable colour contrast, may have little difference in luminance. A 'correct' rendering would show them as similar shades of grey with little or no contrast. A contrast filter is required to produce the necessary tone separation that is essential if the photograph is to show the distinction between the coloured areas. The fundamental property of a colour filter is that it transmits light of its own hue and absorbs light of the complementary hue (i.e. all other wavelengths). Depending on filter density, various amounts of the 'transmission' band may also be absorbed. The basic rule for the selection of contrast filters is that to lighten a colour a filter which transmits that particular spectral region should be used; conversely, to

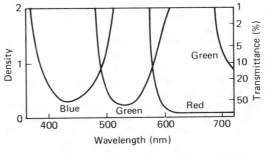

Figure 11.4 Spectral absorption curves of standard tricolour filters

Table 11.2 Contrast filters for black-and-white photography

Filter	Colour	Absorbs	Lightens	Typical uses
Tricolour blue	blue	red, green	blue	copying, emphasis of haze
Tricolour green	green	blue, red	green	landscape photography
Tricolour red	red	blue, green	red	cloud photography, haze penetration
Narrow-band blue	deep blue	red, green, some blue	blue	copying and colour separation
Narrow-band green	deep green	blue, red, some green	green	copying and colour separation
Narrow-band red	deep red	blue, green, some red	red	copying and colour separation
Minus-blue	yellow	blue	yellow	cloud photography
Minus-green	magenta	green	magenta	copying
Minus-red	cyan	red	cyan	copying
Orange ('furniture red')	deep orange	blue, some green	red	emphasis of wood grain

darken a colour, a filter which has a low transmittance in that particular spectral region should be used. Some colours such as reds and yellows are easily controlled in this way, but greens and browns may prove more difficult because of their low saturation (i.e. they contain a significant proportion of white light). A contrast filter of the same colour as a self-coloured object is often termed a *detail filter*, because it lowers the contrast between an object and its surroundings so that contrast in the object itself can be increased by photographic means. Detail filters find uses in photomicrography, and are used in general photography to obtain improved rendering of texture.

A summary of the more important contrast filters for photography is given in Table 11.2, and typical spectral absorption properties of contrast filters are shown in Figures 11.4, 11.5 and 11.6. Narrow-band filters have a spectral transmission bandwidth less than that of standard tricolour filters.

Haze penetration

Distant objects frequently exhibit low contrast because the light reaching the observer has become scattered by gas molecules in the air (*Rayleigh scatter*) and by suspended droplets of water (*Mie-scatter*). The molecular scattering is wavelength-dependent, being inversely proportional to the fourth power of the wavelength. Consequently it is a maximum for ultraviolet radiation, and decreases with increase in wavelength to a minimum for infrared radiation. Thus direct light has a higher red content, while the scattered light has a correspondingly higher blue content.

In pictorial photography it may be desirable to retain the effects of haze, or in telephotography to eliminate it. Owing to their inherent UV- and blue-sensitivity, photographic materials exposed without a filter may give a stronger impression of haze than the eye. To prevent the recording of the

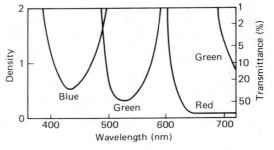

Figure 11.5 Spectral absorption curves of narrow-band tricolour filters

scattered radiation and hence reduce the impression of haze, thereby increasing subject contrast, a filter is required which absorbs in the blue and transmits in the red of the spectrum. A pale yellow filter allows panchromatic film to give a result approximating closely to the visual impression of haze. Greater penetration is achieved by using an orange or red filter. Maximum penetration is given using infrared-sensitive materials with an IR-transmitting filter. Even infrared photography, however, cannot penetrate haze caused by large droplets, such as fog or sea mist, because scattering by such particles is almost independent of wavelength.

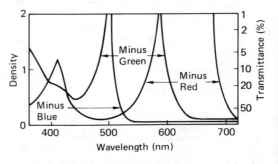

Figure 11.6 Spectral absorption curves of complementary filters

To absorb ultraviolet radiation only without affecting the visible spectrum, a UV-absorbing flter may be used. This is often called a *haze filter* or *skylight filter*. This may be useful in colour photography, reducing the blue cast associated with distance. Such filters require no increase in exposure. However, as pointed out earlier, the use of UV-absorbing filters has much less effect with modern equipment than in former times, as the glasses used in modern lenses are themselves almost opaque to UV radiation.

Colour filters for colour photography

The problems associated with colour films are quite different from those associated with monochrome materials. In colour photography the main problem is the securing of an acceptable colour balance. Principal among the factors involved are the colour temperature of the illuminant used, (colour film is balanced for use with a specific colour temperature, usually 3200 K, 3400 K or 5500 K), and the exposure duration, which for correct colour balance is usually restricted to a specified range to avoid the effects of reciprocity law failure. Accordingly, there are many pale filters in various colours to adjust the colour balance at the camera exposure stage. In addition, colour negatives are printed with the aid of colour print filters, to obtain correct colour balance in the print.

Light-balancing filters

These are a form of *photometric filter* designed to raise or lower the colour temperature of the image-forming light by small increments. They may be used over the camera lens or over individual light sources so as to bring these to a common value suitable for the colour film in use. Two series of filters are available, one bluish, to raise colour temperature, the other pale amber, to lower colour temperature. They are suitable only for use with incandescent sources, which have a continuous spectrum. Their effect is best described using the mired scale (see page 13), as on this scale equal intervals correspond to equal variations in colour of the source. The mired shift value S of the filter required is given by the formula

$$S = \left(\frac{1}{T_2} - \frac{1}{T_1}\right) \times 10^6$$

where T_1 is the colour temperature of the illuminant (in kelvins) and T_2 is the colour temperature balance of the material in use. The value of the shift may be positive or negative. The pale blue filter series,

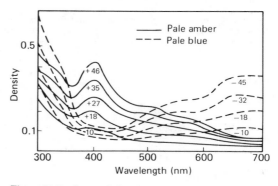

Figure 11.7 Spectral absorption curves for light-balancing filters. The number adjacent to each curve refers to its mired shift value

which produces an increase in effective temperature, carries negative mired values, and the pale amber (pink) series, which produces a decrease in colour temperature, carries positive mired values. These comparatively pale filters have low filter factors, though their effect on colour rendering is quite marked. An 18-mired (1.8 decamired) shift, for example, removes the strong blue cast due to skylight, when photographing subjects in open shade. Table 11.3 gives a summary of the properties and availability of colour filters for colour films, while Figure 11.7 illustrates their spectral properties.

Colour-conversion filters

Occasions often arise when it is unavoidable to expose colour film that is balanced for a particular colour temperature in conditions where the illuminant has a different colour temperature, for example, daylight-type film intended for 5500 K exposed in artificial light of 3200 K. To prevent the colour cast such mismatching would cause, *colour-conversion filters* are available in two series, blue and salmon-pink in hue respectively (see Figure 11.8). The mired shift values of such filters is high, typically 130, being the difference between the mired values for 3200 K and 5500 K. The blue series for exposing daylight-type film in artificial light have large filter factors (about 3½), and with some films may give incomplete correction. The salmon-pink series, for exposing artificial-light-type film in daylight, have small filter factors (about 1⅔), and usually give complete correction. Most films intended for motion-picture work are balanced only for artificial light, and the camera has a colour conversion filter permanently installed in the optical system. Insertion of movie lights on a bar or a different type of film cartridge automatically removes the filter.

Table 11.3 Light-balancing and colour-conversion filters for use with colour films. Type A is balanced for artificial light of 3400 K (photoflood); Type B is balanced for artificial light of 3200 K (studio lamp); Type D is balanced for daylight of 5500 K.

Filter colour	Mired shift value	Exposure increase in stops	Typical use
Pale blue	−81	1	Type D film with aluminium flashbulbs
	−56	⅔	Type D film with zirconium flashbulbs
	−45	⅔	Type B film with GS lamps
	−32	⅓	Type B film with GS lamps
	−18	⅓	Type A film with 3200 K lighting
	−10	⅓	
Pale amber	+10	⅓	With electronic flash
	+18	⅓	Type B film with photofloods
	+27	⅓	
	+35	⅓	Type A or B film with clear flashbulbs
	+53	⅔	
Salmon-pink	+112	⅔	Type A films in daylight
	+130	⅔	Type B films in daylight
Blue	−130	2	Type D films in 3200 K lighting

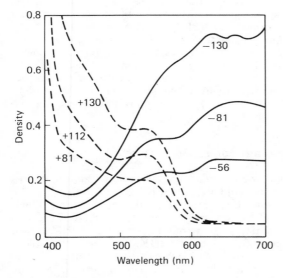

Figure 11.8 Spectral absorption curves for colour conversion filters. The numbers adjacent to the curves refer to their mired shift values

reflection from a coloured surface, variations in emulsion batch, the effects of reciprocity law failure and light absorption in underwater photography. For example, colour photography using fluorescent lighting as the sole illuminant may show colour casts in the photographs, owing to the anomalous spectral quality of such light sources. In particular a green cast is caused by the strong emission line at 546 nm in the mercury spectrum. However by using a variety of colour-compensating filters such effects can be reduced. Two varieties of filter are available, one for use with film balanced for 5500 K, the other with film balanced for 3200 K. Such filters can, of course, be used to introduce deliberate colour casts for mood or effect. It is also possible to use them to remove colour casts in colour printing, but this is clumsy.

CC filters, as they are commonly abbreviated, are available in six hues: red, green, blue, cyan, magenta and yellow, indicated by their initial letters R, G, B, C, M and Y. The number of the filter (divided by 100) represents the density of the filter at its peak absorption wavelength. Thus a designation such as CC20R indicates a pale red filter whose optical density at its peak absorption is 0.2. A range of densities is available. Even the higher values have only moderate filter factors.

Colour-compensating filters

These filters are used to adjust the overall colour balance of results obtained from colour films, especially slide films. Without such filtration colour casts could result. Common causes of errors in colour balance include deficiencies in the spectral quality of the illuminant used, 'bounce' light coloured by

Special filters

In addition to the ranges of colour filters described above, there are others that have special or distinct functions. Some of them may have no visible hue, because their absorption lies outside the visible spectrum, or may be visually opaque, because their transmittance lies outside the visible spectrum.

Ultraviolet (UV)-absorbing filters

The sensitivity of photographic materials to scattered UV radiation and blue light has already been discussed above. The effects are a loss of contrast, and a blue cast with colour materials, increasing with increasing subject distance. In addition the spectral transmission of different lenses, especially older designs, may vary for the UV region and give

Figure 11.9 Absorption curve of an ultraviolet (UV)-transmitting filter (solid line); and of an UV-absorbing filter (broken line)

different colour balances in terms of 'warmth' of image. Consequently, it may be desirable to use UV-absorbing or haze filters to obtain a better match between lenses. An additional use is as a 'skylight filter' to reduce the effect of excessive scattered light from a blue sky. Such filters are usually colourless or a very pale pink or straw colour, depending on their cut-off wavelength (Figure 11.9). Often the digits in a filter code number indicates this point, e.g. 39 denotes 390 nm.

UV transmission filters

For some applications of photography, ultraviolet radiation is used as illuminant. However, UV sources also emit visible light. Special opaque glass filters which transmit only in the near UV region are used to block all visible radiation (Figure 11.9). A focus correction is usually essential for the camera lens unless a specially-computed lens made with quartz and fluorite elements is used.

Infrared (IR)-absorbing filters

As well as visible light, all thermal sources emit much of their energy in the form of infrared radiation, which is readily converted to heat energy. In an enclosed optical system such as an enlarger or slide projector, the negative or transparency in the gate must be protected from this unwanted radiation. Colour-print materials are sensitive to IR radiation,

and its elimination from the image-forming light is therefore essential for correct colour reproduction. Colourless glass filters ('heat-absorbing glasses') which transmit visible radiation but block IR radiation, are used for these purposes (Figure 11.10). As a rule they do not need to be of optical quality if they are mounted adjacent to the light source in an enlarger or projector. A loose mounting is needed to avoid cracking due to thermal expansion.

Interference-type filters may also be used. Usually such a filter transmits IR radiation and reflects visible light. Termed a *cold mirror*, the filter may usefully form an integral reflector of ellipsoidal shape for a tungsten-halogen light source.

IR transmission filters

Emulsions sensitive to IR radiation have a spectral sensitivity extended to about 900 nm, but they remain sensitive to visible and UV radiation. Consequently, their use demands a special filter opaque to UV and visible radiation but transmitting in the IR region (Figure 11.10). Such filters have a high filter

Figure 11.10 Absorption curve of an infrared (IR)-transmitting filter, (solid line), and of an IR-absorbing filter (heat-absorbing filter) (broken line)

factor which is not always reliable, as the sensitivity of the various types of exposure meter to IR radiation varies. These filters, which are almost opaque to visible light, are available in either gelatin or glass.

Neutral-density filters

Neutral-density (ND) filters absorb all visible wavelengths to a more or less equal extent. They may be scattering or non-scattering. A filter for use in front of the camera lens must be non-scattering, but for other applications such as the attenuation of a beam of light, the scattering type can be used. Optical quality ND filters are made by dispersing

colloidal carbon in gelatin. The addition of dyes with the necessary spectral absorption properties, combined with the brown colour due to the carbon, give the necessary neutral characteristics. It should be noted that the neutrality is confined to the visible spectrum, (Figure 11.11). The use of carbon particles of a size approximating to the wavelength of light gives improved non-selective neutral density filters, but the associated scattering of light makes them unsuitable for camera use. Photographically-formed silver can produce a good non-selective neutral density for the visible and infrared regions, but the scattering properties limit its use to non-image forming beams.

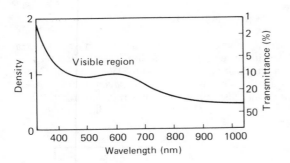

Figure 11.11 Absorption curve of a neutral density filter (non-scattering type, density 1.0)

The alloy *inconel*, evaporated in thin layers onto glass, gives an excellent non-selective, non-scattering, neutral-density filter, but as the attenuation is both by absorption and reflection the specular reflection may be a nuisance. Perforated metal sheets or mesh serve as excellent non-selective light attenuators, used for example in colour enlargers where they have no effect on the colour temperature of the light source. Their scattering properties do not permit use in front of a camera lens (unless they are to be used as effects filters).

Neutral-density filters are also available in graduated form, to give continuous light control over a given range of attenuation, or to give attenuation to part of the scene only, e.g. the sky region but not the foreground. A method of providing uniform controllable attentuation is by a pair of contra-rotating polarizing filters, which give almost complete cut-off when in the crossed position.

Neutral-density filters for camera use are calibrated in terms of their optical density and filter factor, e.g. a 0.3 ND filter with filter factor ×4. They can be used with both monochrome and colour films, as they have no effect on colour balance. Their uses range from a means of avoiding over-exposure with a fast film in very bright conditions to a way of using large apertures for selective focus in

well-lit conditions. Mirror lenses use ND filters in lieu of aperture stops.

Polarizing filters

As discussed in Chapter 2, light can be considered as a transverse wave motion, ie with vibrations orthogonal to the direction of propagation. The direction of vibration is completely randomized. This type of light is said to be 'unpolarized' (Figure 11.12).

Figure 11.12 Polarized light: (a) Unpolarized light; (b) partially polarized; (c) plane polarized (along Z-axis)

Under certain conditions, however, the vibrations can be restricted to one particular plane. This is called the *plane of polarization* and the light is said to be *linearly polarized*, or *plane polarized* (or simply *polarized*). Such light can be controlled and attenuated by a special type of filter termed a *polarizing filter*.

A polarizing filter for use over the camera lens is a sheet of plastics material containing a layer of transparent polymer molecules which have had their axes all aligned in one direction during manufacture. By a straining technique they are made *optically active*, so that light waves vibrating in one plane are transmitted, but light waves vibrating at right angles to this plane are blocked. Light waves vibrating in intermediate directions are partially transmitted. Such a linearly-polarizing filter may therefore be used to select light for transmission if some of it is polarized. The light coming from different parts of a scene may be in various states of complete or incomplete polarization. Polarizing filters have several distinct applications.

The light from any point in a clear blue sky is partially polarized, the direction of polarization being at right angles to the line joining it to the sun. The polarization is strongest over the arc of the sky that is 90° from the sun, and is weakest at 0° (ie close to the sun itself) and 180° (opposite the sun). Clear sky can thus be rendered darker by use of a polarizing filter over the camera lens; the sky rendering can be controlled by rotation of the filter. When used for this purpose, a polarizing filter does not otherwise affect colour rendering, and it may therefore be used in colour photography to control the depth of colour of a blue sky.

Unwanted reflections may also be controlled and under certain circumstances eliminated. Light that is specularly reflected from the surface of a non-metal at a certain angle is almost totally polarized in a plane perpendicular to the plane in which the incident and reflected rays lie. This is called *s-polarization**, and total *s*-polarization occurs when the angle of incidence is such that the reflected and refracted rays are orthogonal, i.e. the tangent of the angle of incidence is equal to the refractive index (*Brewster's law*). For material with a refractive index ca 1.5 (i.e. most polishes, gloss paints, plastics and glass) the angle of maximum polarization (the *Brewster angle*) is about 56°. For water (RI > 1.33) it is about 53°. Light reflected from a wide range of substances at approximately this angle is largely polarized. Polarizing filters may, therefore, be used for the control of reflections from non-metallic materials, for example glass, wood, paint, oil, polish, varnish, paper and any wet surface. Practical applications include removal of *glare spots* from painted walls, wood panelling, furniture and glass, provided a suitable viewpoint can be used. In colour photography, the presence of surface reflections reduces colour saturation, degrading the picture quality. Use of a polarizing filter to eliminate or subdue such reflections increases saturation.

When using a polarizing filter, the effect can be assessed by slowly rotating the filter until the optimum effect is found. For subjects that show reflection at only one surface or group of similarly placed surfaces, it is usually possible to select a suitable viewpoint for suppression. But where the reflections are at various angles, a polarising filter over the lens cannot suppress them all at the same time, and a compromise position must be found.

In copying applications, a polarizing filter over the lens offers little control of reflections, because the unwanted light is not reflected at anything approaching the Brewster angle. Only in the case of oil paintings, where individual brush marks may cause reflections at the Brewster angle, is any control achieved, and this is very limited. However, full control may be obtained if the light source itself is plane polarized, the method being to place polarizing filters both over the lens and the lamps, the direction of polarization of the lens filter being orthogonal to that of the lamp filters. In this technique, the diffusely-reflected light forming the image is depolarized, whereas the unwanted directly-reflected light remains polarized, and does not pass through the filter on the lens. In the same way, reflections from metal objects can be controlled by placing polarizing filters over the light sources as well as over the camera lens. Large sheets of

polarizing material are needed for use over light sources, and they must not be permitted to overheat.

The ideal polarizing filter works equally well for all wavelengths and has no effect on colour. In practice, polarizing filters need to be carefully selected and tested for neutrality of rendering for use in colour photography. Due to the absorption of both polarized light and transmitted light by the materials of the filters, the filter factor is usually about 3½ rather than the theoretical 2; but a TTL metering system will usually take such variations into consideration (with the qualification below). The filter factor is independent of the sensitive material and illuminant.

A practical problem arises when a linear polarising filter is used with a camera that has an optical system employing a beamsplitter device to sample the incoming light for exposure determination, or to direct part of the image to an array of photosensors in an autofocusing module set in the well of the camera. The beamsplitter analyses the incident light into two beams that are orthogonally polarized. Consequently, when a plane polarizing filter is

Figure 11.13 Polarized light and beamsplitters. (a) With natural light N, beamsplitter B reflects light to viewfinder V and transmits to photocell or autofocus module C in ratio 3 : 1. (b) With linear polarizing filter L in 45° position, ratio is 62:38. (c) With linear polarizing filter in 135° position, ratio is 88:12. (d) With circular polarizing filter made by addition of quarter-wave plate Q, the ratio is constant at 3:1 for all positions

*Polarization at right angles to this plane, i.e. in the plane containing the incident and reflected rays, is known as *p-polarization*. The light that is transmitted is partly *p*-polarized.

rotated over the camera lens, the beamsplitter does not divide this partially-polarized beam in the correct proportions for viewing and light measurement, nor transmit enough light to the autofocus module for this to operate satisfactorily. The effects are dependent on the orientation of the filter over the lens, (Figure 11.13). If, however, a *circularly-polarizing filter* is used instead of a linear type, the properties of the beamsplitter are unaffected and light measurement errors and inoperative autofocus systems are avoided. A circularly-polarizing filter uses in its construction an additional thin layer of optically-active material behind the polarizing material. This is known as a *quarter-wave plate*, and its effect is to displace the relative phases of the electric and magnetic components of the propagated wave so that the plane of polarization rotates through a complete circle with every wavecrest.

Filters for use in photographic laboratories

Safelight filters

The filters used in darkroom safelights are a special application of colour filters. Their function is to transmit light of only a restricted range of wavelengths, so that photographic laboratories may have as high a level of illumination as is consistent with the safe handling of photographic materials. Specific recommendations are usually given as to the wattage of the lamp to be used and the minimum safe distance of the material from the safelight, as well as the maximum duration of exposure, but the user is invariably recommended to carry out appropriate tests of conditions.

For blue-sensitive and orthochromatic materials the filter transmission range is chosen to fall outside the range of wavelengths to which the material is sensitive. Thus a yellow, orange or yellow-green safelight may be used with the former, and a red safelight with the latter. With panchromatic materials the problem is more serious because the emulsion is sensitive to the whole of the visible spectrum. Processing should therefore be carried out in complete darkness if possible. In emergency a very low level of illumination may be used, at a range of wavelengths to which the dark-adapted eye has its maximum sensitivity. This is in the mid-green region of the spectrum (the bluish-green appearance is an anomaly in visual perception resulting from the dark-adaptation of the eye). For colour-print materials a dim amber is preferred, corresponding to the minimum sensitivity of the material. This safelight is also suitable for panchromatic print paper (see Figure 11.14). It takes several minutes of dark-adaptation before visual assessment is possible with

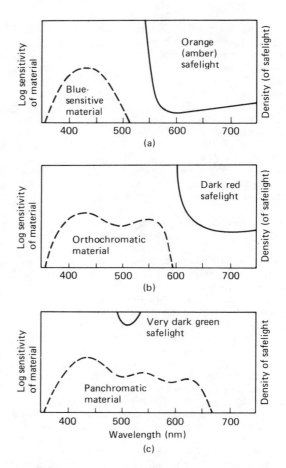

Figure 11.14 Spectral absorption curves for darkroom safelight filters. (a) For blue-sensitive materials; (b) for orthochromatic materials; (c) for panchromatic materials

these safelights. Also, as the material is not totally insensitive to the wavelengths emitted by these sources they should be used with caution, and preferably only in emergency.

Filters for colour printing

Various types of colour filters are used to obtain satisfactory colour balance in the final print, depending on the printing technique in use (see Figure 22.12).

A *tricolour set* comprising red, green and blue filters is used for the triple-exposure printing method. Alternatively, colour-compensating filters can be used in front of the enlarger lens with a single exposure, but the difficulties raised by calculations necessary to keep the number of filters to a minimum, and the need to avoid damage through handling, are such that this method is now seldom used.

A preferred method for single-exposure white-light (or subtractive) colour printing is to use sturdy cellulose acetate filters in the enlarger illumination system, where their optical quality is unimportant. These *CP filters* are available in yellow, magenta, cyan and red, in a range of density values. The numbering system is similar to that of CC filters, e.g. the designation CP40M denotes a magenta filter of density 0.40 in its region of maximum spectral absorption.

Dichroic filters

A drawback of filters using organic dyes is that they are prone to fading. Furthermore, a mixture of dyes may not be able to provide precisely the necessary spectral absorption characteristics. Fortunately, advances in thin-layer coating technology have resulted in the introduction of multi-layer interference filters into photographic use as a substitute for dye-based printing filters.

Dichroic or *interference filters*, yellow, magenta or cyan in hue, are used routinely in a 'colour head' equipped with a suitable illumination system. Such filters are calibrated either in arbitrary numbers or actual optical densities related to their effect when inserted to a greater or lesser extent into a collimated beam of light. UV- and IR- absorbing filters are also needed in a colour enlarger.

Instead of the selective absorption of light by coloured glass or gelatin, interference filters make use of the principle of constructive and destructive interference of light to give a selective transmission of any hue in the visible spectrum within narrow limits of wavelength, so that spectral transmission characteristics approach very closely to the ideal, with few losses. The portions of the spectrum that are not transmitted are reflected, not absorbed. Thus such filters appear one hue (.e.g. yellow) by transmitted light, and the complementary hue (blue) by reflected light, hence the alternative popular name of *dichroic 'two-colour') filters*. Interference filters consist of glass or quartz substrates, on which is deposited (by evaporation or electron bombardment in a high vacuum) a series of very thin layers of dielectric materials. As many as 25 individual layers are not unusual. A careful choice of refractive indexes and thicknesses of alternating layers restricts transmission to the desired spectral regions. Such filters should be used in a fairly well-collimated beam of light, as spectral transmission varies with angle of incidence. Dichroic filters are available in small sizes only, owing to the difficulties of coating large filters uniformly. The cost is high but not unreasonable, considering the long life and reliable performance of such filters.

Optical attachments

A wide range of optical attachments is available for use in front of the camera lens. Like filters, these are produced in a range of fittings and sizes, and are attached in a similar manner. Materials used range from high quality anti-reflection coated optical glass to moulded plastics. Dependent on its function, the device may be transparent and non-selective, or it may absorb some wavelengths selectively. Brief descriptions of some of the more common attachments follow.

Afocal converter lenses

These multiple-element lens units are generally used with non-interchangeable lenses. The term 'afocal' indicates that they have no focal length of their own, i.e. parallel light incident on the unit emerges parallel. Structurally, they are related to the Galilean telescope. However, when such a converter is used with a camera lens, the effective focal length of the combination may be greater or less than that of the camera lens alone, depending on the construction of the converter (Figure 11.15). The telephoto converter increases the focal length of the camera lens by factors of from ×1.5 to ×3, and the wide-angle converter decreases it by a factor of about ×2. These converters are commonly used with twin-lens

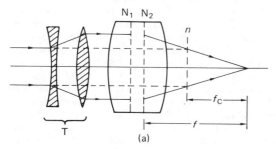

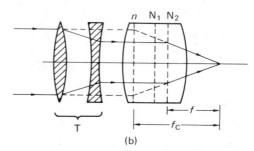

Figure 11.15 Afocal attachments: (a) Wide-angle attachment W; (b) telephoto attachment T. Key: *n* rear nodal plane of combination of focal length f_c, N_1 and N_2 nodal planes of prime lens of focal length f

reflex cameras and with compact cameras that lack interchangeable lenses. Unless the converters are of high optical quality the results can be disappointing. Large apertures give poor resolution and small apertures produce vignetting. No change in the marked apertures of the camera lens is necessary. Reflex focusing is mandatory for good results. With the telephoto converter the near focusing range is lost.

Close-up (supplementary) lenses

Single-element lenses were once added to a camera lens as a means of altering its focal length, a positive supplementary lens serving to reduce focal length and a negative lens serving to increase it. The most valuable use of such lenses is for close focusing with cameras having a limited focusing movement. Focusing on a subject at a given (close) distance is achieved by using a positive supplementary lens of focal length equal to the subject distance, irrespective of the focal length of the camera lens. The camera lens is then focused for infinity and the path of the rays is as shown in Figure 11.16. This is the basis of *close-up* or *portrait attachments*. Supplementary lenses are specified according to their power in

dioptres rather than by their focal length. The relationship between power and focal length is given by

Focal length in millimetres
= 1000 ÷ power in dioptres

The power of a convergent supplementary lens is positive and that of a divergent lens negative. Specification of lenses by their power is convenient because in a combination of lenses we can simply add the powers of the lenses to obtain the power of the combination.

It is possible to purchase close-up lenses in a range of +0.25 to +10 dioptres. The weaker powers of 0.25 and 0.5 dioptres are used chiefly with long-focus lenses to improve their close-focusing capability. They do not seriously affect the corrections of the camera lens. Supplementary lenses are usually meniscus singlets; this shape introduces only a minimal amount of oblique aberrations and thus has only a small detrimental effect on the performance of the camera lens. Some supplementary lenses are coated achromatic doublets, designed for use with a specific camera lens.

Lens hood

The use of a properly-designed *lens hood* with any lens will under most circumstances contribute significantly to the quality of the results. It will shield the lens from light outside the subject area, and reduce flare, especially in back-lit and side-lit conditions. The most common type of lens hood is a truncated cone, allowing maximum depth without resulting in vignetting. The internal finish is ridged and painted matt black. The front aperture is circular or, in more expensive models, rectangular and of the same aspect ratio as the film format. Owing to the danger of vignetting by a lens hood, especially if a filter is also in use, many wide-angle lenses are not expected to be fitted with them; many such lenses are built with a recessed front component so that the mount acts as a vestigial type of lens hood. As focal length increases the need for an efficient hood becomes greater. Many long-focus lenses are supplied with an integral retractable hood, to encourage the user to employ it. In the case of zoom lenses, the hood can only be of depth sufficient to avoid vignetting at the minimum focal length setting, even though the greatest need for a lens hood is at the maximum setting. One solution is to use a 'compendium' or bellows type of lens hood. This is unsurpassed in its efficiency, and is adjustable for a wide range of focal lengths. It can also take various filters, including vignetting and effects devices. Optimum adjustment is easy with a single-lens reflex camera.

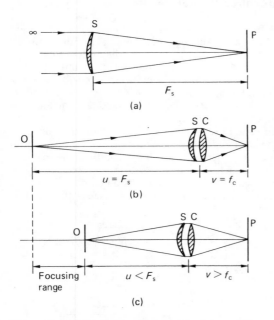

Figure 11.16 The close-up lens: (a) Positive meniscus close-up lens of focal length F_S; (b) used with a camera lens C of focal length f_C, nearest close focus is at distance F_S; (c) using the focusing extension of the camera lens to give a close-up focusing range

Miscellaneous devices and effects filters

Soft-focus attachments

A recurrent vogue in certain types of photography, such as portraiture, is for a *soft-focus effect* given by the spreading of the highlights of a subject into adjacent areas. Special portrait lenses using controllable residual spherical aberration to give this effect (such as the Rodenstock Imagon) are available; but these are expensive, and limited in application. A *soft-focus attachment* is a cheap alternative for use with any lens. Two basic types of attachment are available, one having a number of concentric grooves in plain glass, and the other having small regular or irregular deposits of refractive material about 1 μm thick, randomly scattered over a flat glass disc. The former type gives diffusion effects that depend on the aperture in use: the larger the aperture the greater the diffusion. The latter type operates independently of lens aperture. The softening of the image results from the effects of scattering and refraction due to the presence of the attachment. Various degrees of diffusion are available.

The use of soft-focus attachments at the negative printing stage gives results different from those given at the camera exposure stage; in particular, the effect of diffusion at the enlarging stage is to spread the dark areas, whereas diffusion at the taking stage spreads the light areas. Also available are devices termed 'haze effect' and 'fog effect' filters, which find particular application in landscape photography. This type of 'haze' filter is not to be confused with the UV-absorbing variety.

Multiple-image prisms

These are prismatic attachments, made of glass or moulded plastics material, which give an array of repeated images of a single subject. These additional images are typically in horizontal, vertical, slanting (echelon) or symmetrical arrangements (such as a central image with some three to seven repeat images distributed round it). The central image is, however, generally of poor quality and the remaining images may be severely degraded.

Split-field close-up

This uses half of a close-up lens in a semi-circular shape in front of the lower part of the camera lens, so allowing simultaneous focus on both near and far objects with an indistinct region between them.

Centre-focus lens

This is a glass disc with a clear central region and the outer annular region lightly ground so as to give an image with normal central definition and blurred peripheral detail.

Star-burst and twinkle devices

These are produced by a filter bearing closely-spaced engraved lines, which by scattering and diffraction cause the directional spreading of small intense highlights to give a 'star burst' effect to these regions, without seriously affecting overall definition. Occasionally, *diffraction gratings* are used alone or in tandem to produce small spectra from every small highlight or light source in the picture area.

Graduated colour filters

These are tinted over about half the filter area, with a gradual transition between the coloured and clear areas, so as to give selective filtration of parts of the subject. For example, a graduated yellow filter may be used to filter the sky in a landscape picture, leaving the foreground unfiltered, the horizon approximately coinciding with the transition zone. Pairs of differently coloured filters can be used in tandem in opposition to give selective filtration to different zones of the scene. Filter holders to allow both sliding and rotational movement are necessary.

12 The sensitive material

Many light-sensitive substances, varying widely in their sensitivity, are known. In the manufacture of conventional photographic materials, reliance is placed almost entirely upon the light sensitivity of the *silver halides*, the salts formed by the combination of silver with members of the group of elements known as the *halogens*: bromine, chlorine and iodine.

Photographic materials are coated with suspensions of minute crystals (with diameters from 0.03 μm for high-resolution film to 1.5 μm for a fast medical X-ray film) of silver halide in a binding agent, nowadays almost invariably gelatin. These photographic suspensions are called *emulsions*, although they are not emulsions but solid suspensions, strictly speaking. The crystals are commonly termed grains. In materials designed for the production of negatives, the halide is usually silver bromide, in which small quantities of iodide are also normally present. With papers and other positive materials the halide may be silver bromide or silver chloride or a mixture of the two. The use of two silver halides in one emulsion results not in two kinds of crystal but in crystals in which both halides are present, although not necessarily in the same proportion in all crystals. Photographic materials containing both silver bromide and silver iodide are referred to as iodobromide materials, and materials containing both silver chloride and silver bromide as chlorobromide materials.

Silver halides are particularly useful in photography because they are *developable*, which means that the effect of light in producing an image can be amplified by using a developing solution. The gain in sensitivity achieved in this way is of the order of a thousand million times. The image produced when photographic materials are exposed to light is normally invisible, the visible image not being produced until development. The invisible image is termed a *latent* (hidden) *image*. Photographic materials in which the image is produced in this way are sometimes termed *development*, or *developing-out*, *materials*.

For special purposes, silver halide emulsions are sometimes produced in which the action of light alone is relied upon to produce the visible image. These are referred to as *printing-out materials*. They are very much slower than development materials, and their use is nowadays confined to the preparation of certain types of contact-printing and chart-recording papers.

Latent image formation

The latent image is any exposure-induced change occurring within a silver halide crystal that increases the probability of development from a very low figure to a very high figure. Although all crystals will eventually be reduced to metallic silver if developed for a sufficient time, the rate of reduction is very much greater for those crystals that bear a latent image.

It is generally believed that this change is the addition at a site or sites on or within the crystal of an aggregate of silver atoms. The latent image sites are probably imperfections and impurities (e.g. silver sulphide specks) existing on the surface and within the bulk of the silver halide crystal. Light quanta are absorbed, releasing photoelectrons which combine with interstitial silver ions to produce the atoms of silver. Interstitial silver ions are mobile ions displaced from their normal positions in the silver halide lattice and are present in silver halide crystals of an emulsion prior to exposure. The general reaction can be represented by the equations.

$$Br^- \xrightarrow{h\nu} Br^{\cdot} + e^- \quad \text{and} \quad Ag^+ + e^- \rightarrow Ag$$

where $h\nu$ is a light quantum and e^- is an electron.

The energy levels relevant to latent image formation are shown schematically for a silver bromide crystal in Figure 12.1. Discounting thermal fluctuations, absorption of a quantum of energy greater than 2.5 eV (electron volts) is necessary in order that an electron may be raised from the valence to the conduction band. In this state it may contribute to the formation and growth of the latent image. An energy of 2.5 eV is equivalent to a wavelength of approximately 495 nm, and corresponds to the longest wavelength of the spectral sensitivity band of ordinary silver bromide. Also indicated in Figure 12.1 are the relevant energy levels of an adsorbed dye molecule suitable for sensitizing silver bromide to longer wavelengths. It can be seen that a photon of energy much less than 2.5 eV may, upon absorption by the dye, promote the molecule from its ground energy state to its first excited state. If the excited electron can pass from the dye to the crystal, latent image formation may proceed. In this way it is possible to sensitize silver halides to green and red light and even infrared radiation, although it should be noted that in the last case electron transitions

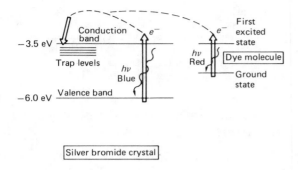

Figure 12.1 Schematic representation of the energy levels relevant in latent image formation

arising from thermal effects may cause crystals to become developable without exposure. Excessive fogging can result and careful storage and usage of such materials is necessary.

Although a number of different mechanisms have been suggested to account for the details of latent image formation, there is considerable experimental evidence supporting the basic principle suggested by Gurney and Mott in 1938. The essential feature of this treatment is that the latent image is formed as a result of the alternate arrival of photoelectrons and interstitial silver ions at particular sites in the crystal. Figure 12.2 shows the important steps. Here the process is considered as occurring in two stages:

(1) The nucleation of stable but subdevelopable specks
(2) Their subsequent growth to just-developable size and beyond.

The broken arrows indicate the decay of unstable species, an important characteristic of the process. The first stable species in the chain is the two-atom

centre, although it is generally believed that the size of a just developable speck is 3 to 4 atoms. This implies that a crystal must absorb at least 3 to 4 quanta in order to become developable, but throughout the sequence there are various opportunities for inefficiency, and as a general rule far more than this number will be required. During most of the nucleation stage the species are able to decay, and liberated electrons can recombine with halogen atoms formed during exposure. If this occurs, the photographic effect is lost. The halogen atoms may also attack the photolytically formed silver atoms and reform halide ions and silver ions. Although gelatin is a halogen acceptor and as such should remove the species before such reactions can occur, its capacity is limited and its efficiency drops with increasing exposure.

These considerations lead to possible explanations for low-intensity and high-intensity reciprocity-law failure. During low-intensity exposures, photoelectrons are produced at a low rate and the nucleation stage is prolonged. As a result the probability of decay and recombination is relatively high. During high-intensity exposures large numbers of electrons and bromine atoms are simultaneously present in the crystals. Such conditions can be expected to yield high recombination losses. Also, nucleation may occur at many sites in a single crystal, producing large numbers of very small silver specks.

The emulsion binder

For the proper working of a photographic material, the silver halide crystals must be uniformly distributed and each crystal should preferably be kept from touching its neighbour, the sensitive layer must be moderately robust so that it may be able to resist slight abrasion and the crystals in the layer must be accessible to processing solutions. There are few emulsion binders which meet all these requirements.

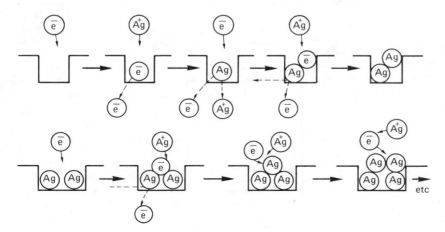

Figure 12.2 Latent image nucleation (top row). Initial growth (bottom row)

One of the first binding agents to be used was collodion, a syrupy transparent fluid prepared by dissolving pyroxyline (gun-cotton) in a mixture of ether and alcohol. Although of historical interest as an emulsion binder, collodion was replaced by gelatin over 100 years ago. Gelatin is a protein derived from collagen, the major protein component of the skin and bones of animals. It is a *lyophilic* or *hydrophilic colloid* made up of long chain molecules which are soluble in water. It possesses a number of unique properties which make it particularly suitable as a binder for silver halide microcrystals. The combination of many different physical and chemical properties in one type of chemical compound explains why it hs not so far been possible to replace gelatin by a synthetic polymer as a binder for silver halides. Certain synthetic polymers may be used in conjunction with gelatin as *gelatin extenders*, but not as a substitute.

Gelatin has remarkable properties as a binding agent:

(1) Dispersed with water, it forms a convenient medium in which solutions of silver nitrate and alkali halides can be brought together to form crystals of insoluble silver halides. These crystals remain suspended in the gelatin in a fine state of division, i.e. acts on a protective colloid.)

(2) Warmed in water, it forms a solution which will flow, and further, by cooling an aqueous solution of gelatin it can be set to a firm gel. Thus it is possible to cause an emulsion to set firmly almost immediately after it has been coated on the base, aided by cooling. Thereafter, all that remains to be done is to remove the bulk of the water in a current of warm air; the resulting emulsion surface is reasonably strong and resistant to abrasion.

(3) When wetted, gelatin swells and allows processing solutions to penetrate it.

(4) Gelatin is an active binding agent, containing traces of sodium thiosulphate and nucleic acid degradation products which profoundly influence the speed of emulsions made from it. By reason of certain of its constituents, such as sodium thiosulphate, gelatin acts as a sensitizer and thus influences the speed of an emulsion.

(5) It acts as a halogen acceptor, as described earlier.

(6) The properties of gelatin can be modified, by chemical reactions such as hardening or cross-linking of the gelatin chains, to make it tougher, and reduce its tendency to swell. This is done during manufacture, or in certain processing solutions such as *acid-hardening fixers*.

(7) It enables developer solutions to distinguish between exposed and unexposed silver halide crystals. In the absence of gelatin, silver halides are reduced to metallic silver by a developer solution regardless of whether they bear a latent image or not.

(8) Gelatin confers stability on the latent image.

Manufacture of photographic materials

Over the years great progress has been made in the production of emulsions a result of the policy adopted by the leading photographic manufacturers of maintaining their own research establishments, working in close association with the production units. Each firm has developed its own particular methods, many of which are confidential; but the general principles on which emulsion-making rests are well established, and these serve to illustrate the complexity of the whole process.

The principal materials used in the preparation of the emulsion are silver nitrate, alkali-metal halides and gelatin, and all these must satisfy stringent purity tests. The gelatin must be carefully chosen, since it is a complex mixture of substances obtained from the hides and bones of animals, and, although silver salts form the actual sensitive material, gelatin plays a very important part both physically and chemically, as already explained. Gelatins vary greatly in their photographic properties. The 'blending' of gelatins originating from different sources helps in producing a binder with the required properties and in obtaining consistency. The general way to test a blend of gelatin for performance is to use some of it to make an emulsion and to test this to see whether it possesses the desired photographic properties.

Nowadays 'inert' gelatin is generally used, i.e. gelatin containing less than five parts per million of sulphur sensitizers and nucleic-acid-type restrainers. A recent development by gelatin manufacturers is to provide gelatins which are substantially free of all sensitizers and restrainers ('empty' gelatin). These gelatins may then be 'doped' to the required degree by the addition of very small amounts of the appropriate chemicals by the emulsion manufacturer.

The emulsion-making process, reduced to its essentials, consists of the following stages:

(1) Solutions of silver nitrate and soluble halides are added to gelatin under carefully controlled conditions, where they react to form silver halide and a soluble nitrate. This stage is called *emulsification*.

(2) The emulsion thus formed is subjected to heat treatment in the presence of the gelatin in a solution in which the silver halide is slightly soluble. During this treatment the crystals of

silver halide grow to the size and distribution which will determine the characteristics of the final material, in particular, in terms of speed, contrast and graininess. This stage is known as the *first (physical* or *Ostwald) ripening.*

(3) The emulsion is then *washed* to remove the by-products of emulsification. In the earliest method of doing this the emulsion was chilled and set to a jelly, shredded or cut to a small size and then washed in water. In modern practice, washing is achieved by causing the emulsion to settle to the bottom of the vessel by the addition of a coagulant to the warm solution. The liquid can then be removed by decanting etc.

(4) The emulsion is subjected to a second heat treatment in the presence of a sulphur sensitizer. No grain growth occurs (or should occur) during this stage, but sensitivity specks of silver sulphide are formed on the grain surface and maximum sensitivity (speed) is reached. This stage is known as the *second ripening, digestion* or *chemical sensitization*

(5) Sensitizing dyes, stabilizing reagents, hardeners, wetting agents, etc, are now added.

All these operations are capable of wide variation, and it is in the modification of these steps that much progress has been made in recent years, so that emulsions of extremely diverse characteristics have been produced.

In a given photographic emulsion the silver halide crystals vary both in size and in the distribution of their sizes. They are said to be polydisperse unless special conditions are used in their preparation such that they are all of the same size ('monodisperse'). Not only does the crystal size and distribution of crystal sizes affect the photographic emulsion, but the shape of the crystals, the nature of the halides used, their relative amounts and even the distribution of the halides within a single crystal have pronounced effects.

Manufacturers of sensitive materials are able to control all these and many other factors, and to tailor-make emulsions so that the material is optimized with respect to speed and granularity (see Chapter 25) for a specific application, as well as having the appropriate characteristics of tone and colour reproduction. In the last decade much of the research and development work has led to the manufacture of colour-negative films and papers of high sensitivity, low granularity and high image quality. For optimizing the sensitivity, resolution and granularity of colour negative films the individual manufacturers adopt their own individual methods.

Some examples of the various sophisticated ways of employing specific types of silver halide crystal in colour negative films are illustrated in Figure 12.3.

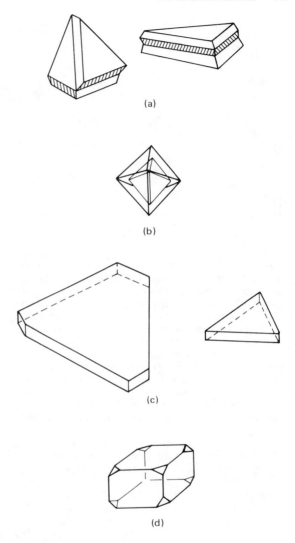

Figure 12.3 Examples of types of emulsion 'grains' (crystals). (a) Twin grains (Agfa), (b) double structure (Fuji); (c) tabular or T-grains (Kodak); (d) cubic (Konica)

Agfa-Gevaert use both flat and compact 'twin grains' (twinned crystals). Kodak use T-grains (flat tabular crystals). The latter allow maximum sensitizing dye to be adsorbed to the grain surface, and encourage very efficient absorption of light, as well as possessing other useful optical and chemical properties that give higher resolution and lower graininess than might be expected from crystals of large surface area. Fuji employ double-structure crystals which optimize both absorption of light and graininess. Konica make use of monodisperse crystals of appropriate size, which minimize light scatter within the layer, and so improve image resolution.

Figure 12.4 Aims for a colour photographic system

The aims of a colour photographic system are shown in a semi-quantitative way in Figure 12.4, in which the lengths of the arrows give an indication of the current position. The broad aims are to reduce the heights of the vertical lines representing access time and graininess, whilst increasing the lengths of the lines directed towards the corners of a rectangle, so making the diagram more nearly resemble a two-dimensional rectangle of large area. All the features indicated in the diagram are being improved with the introduction of new films, papers and processes. In addition, all these improvements have to be balanced by considerations of cost, so that the materials do not become uneconomically expensive.

Much of this sophisticated emulsion technology, originally devised for colour materials, has also been applied to the modern generation of black-and-white materials. Examples include Ilford's XP-1, a monochrome film that yields a dye image and is processed in colour-processing chemicals, Kodak's 'T max' films using Kodak's 'T-grain' technology, and Fuji's Neopan films which use their self-styled 'high-efficiency light-absorption grain technology'.

The support

The finished emulsion is coated on to a support, usually referred to as the base, most commonly film or paper. Negative emulsions are normally coated on film or sometimes on glass (plates); paper base is usually reserved for positive emulsions. There are, however, important exceptions.

Film base

The base used in the manufacture of films is usually a cellulose ester, commonly triacetate or acetate-butyrate. Cellulose nitrate (celluloid) was at one time widely used, but its use has now been discontinued on account of its flammability. Cellulose triacetate and acetate-butyrate are not, strictly speaking, non-flammable, but they are slow-burning. These 'safety' bases have the additional advantage that they keep well, whereas nitrate base disintegrates on prolonged storage. Early acetate film bases would not stand up to wear and tear or the effect of processing solutions as well as nitrate base, but the modern bases do not suffer from these disadvantages.

Until World War II, film bases were made almost exclusively from cellulose derivatives. Since then, new synthetic polymers have appeared offering important advantages in properties, particularly dimensional stability. This makes them of special value in the fields of graphic arts and aerial survey.

The first of these new materials to be used widely was polystyrene; but the most outstanding dimensionally stable base material to date is *polyethylene terephthalate*, a polyester, and the raw material of Terylene fabric. As a film, polyethylene terephthalate has exceptionally high strength, much less sensitivity to moisture than cellulose-derivative films, and an unusually small variation in size with temperature (see Table 12.1). Being insoluble in all common solvents, it cannot be fabricated by the traditional method of 'casting' (spreading a thick solution of the film-former on a moving polished band or drum, evaporating off the solvent, and stripping off the dry skin). Instead, the melted resin is extruded, i.e. forced through a die, to form a ribbon which is then stretched while heated to several times its initial length and width. A heat-setting treatment locks the structure in the stretched condition, and the film is then stable throughout the range of temperatures encountered by photographic film. Polystyrene is extruded in a somewhat similar manner.

Table 12.1 Properties of supports

	Glass	Paper	Cellulose triacetate	Polyethylene terephthalate
Thermal coefficient of expansion per °C	0.001%	–	0.0055%	<0.002%
Humidity coefficient of expansion per % RH	0.000	0.003 to 0.014%	0.005 to 0.010%	0.002 to 0.004%
Water absorbed at 50% RH, 21°C	0.0%	7.0%	1.5%	0.5%
Processing size change	0.00%	−0.2 to −0.8%	<−0.1%	±0.03%
Tensile strength at break, N cm^{-2}	13730	690	9650	17240

Bisphenol, a polycarbonate, another polyster, is of interest, as although it can be compared with polyethylene terephthalate in several of its physical properties, it is soluble in some solvents and can be made by the same casting technique as cellulose-derivative bases. However, neither polystyrene nor polycarbonate are in current use other than for a few specialized purposes.

Film base differs in thickness according to the particular product and type of base, most bases in general use coming within the range of 0.08 mm to 0.25 mm. Roll films are generally coated on 0.08 mm base, miniature and ciné films on 0.13 mm base, and sheet films on 0.10 mm to 0.25 mm base. Polyethylene terephthalate base can usually be somewhat thinner than the corresponding cellulosic base because of its higher strength.

Glass plates

Plates came before films, and, although they have now almost entirely been replaced by films, they are still used in a few specialized branches such as astronomy, holography and spectroscopy, because of their dimensional stability and rigidity. During processing, glass plates undergo no significant changes in dimensions, a feature that is particularly valuable in scientific work when accurate evaluation of image size is important. Similar conditions apply in photogrammetry and in many graphic arts processes, although the dimensional stability of modern safety film bases is such that the use of plates is now rarely *essential* in these fields. A further advantage of using plates is that no pains need be taken to ensure that the sensitive material lies flat in the camera; there is no possibility of cockling. Plates are at a disadvantage as regards their fragility, weight, storage space requirements and loading difficulties.

Paper base

The paper used for the base of photographic papers must be particularly pure. Photographic base paper is, therefore, manufactured at special mills where the greatest care is taken to ensure its purity. Before it is coated with emulsion, the base is usually coated with a paste of gelatin and a white pigment known as baryta (barium sulphate), the purpose of which is to provide a pure white foundation for the emulsion, giving maximum reflection. Baryta is chosen because it is a pure white pigment which is highly insoluble and is without any harmful action on the emulsion.

Some modern paper bases are not coated with baryta but are coated on both sides with a layer of polyethylene and are known as *PE* or *RC* (*polyethylene* or *resin-coated*) *papers* (Figure 12.5).

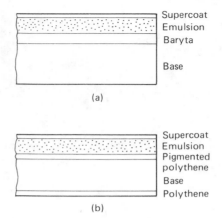

Figure 12.5 Construction of photographic papers. (a) Baryta paper; (b) polythene or resin-coated paper

The polyethylene backing is generally matt so that it has the appearance of traditional paper and can be written on. It is impermeable to water, which prevents the paper base from absorbing water and processing chemicals. This results in substantially shorter washing and drying times than are required by traditional baryta-coated fibre-based papers.

Coating the emulsion on the base

Before coating, the base must be suitably prepared to ensure good adhesion of the emulsion. Glass for photographic plates is prepared by coating it with a very thin substrate or 'subbing' of strongly hardened gelatin; film base is coated with a substrate of a somewhat different formulation. The film base is also usually coated with an anticurl and antihalation backing layer before being coated with emulsion (Figure 12.6). Plates are usually backed after the emulsion has been coated.

The coating of modern materials is a complex task and the coating methods in current use are the subject of commercial secrecy. One of the earliest

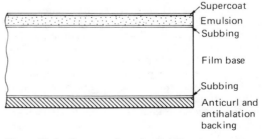

Figure 12.6 Cross-section of a flat film

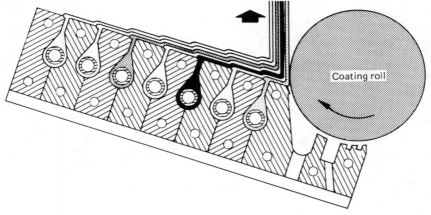

Figure 12.7 Cross-section of a multiple cascade coating head (Agfa)

forms of coating flexible supports was 'dip' or 'trough' coating (see Figure 12.8) but this method has been replaced by one or other of the coating techniques outlined below. Dip coating is a slow method because the faster coating results in thicker emulsion layers which are difficult to dry, and may have undesirable photographic properties.

In order to increase the coating speed this method has been modified by the use of an *air-knife*, which is an accurately machined slot directing a flow of air downwards onto the coated layer and increases the amount of emulsion running back into the coating trough. Coating by this method results in the use of more concentrated emulsions, faster coating speed and thinner coated layers.

Other coating methods employ accurately machined slots through which emulsion is pumped directly onto the support (slot applicator or extrusions coating) or after flowing down a slab or over a weir onto the support (cascade coating) (Figure 12.7). Such coating methods allow coating speeds to be far higher than were possible with the more traditional methods. It is thought that coating speeds approaching 60 metres per minute are now being used to coat base material approximately 1.4 metres wide. Modern monochrome materials have more than one layer coated; colour materials may have as many as fourteen layers, while instant self-developing colour-print films have an even more complex structure (Chapter 24). In modern coating technology, many layers are coated in a single pass of the base through the coating machine, either by using multiple slots or by using a number of coating stations, or by a combination of both. The coated material is chilled to set the emulsion, after which (with films and papers) a protective layer, termed a *nonstress supercoat*, is applied to reduce the effects of abrasion. The emulsion is then dried. With papers, the supercoat also serves to give added sheen or lustre, and, in the case of fibre-based papers, assists in glazing.

Plates are coated on glass of various sizes, not usually smaller in size than about 140 × 150 mm. Small plates are prepared by coating larger sheets of glass and cutting them up. Film base is coated as large rolls, commonly a little over 1 metre wide by approximately 300 metres long, and when dry is cut up in the required sizes. Papers are coated as large rolls which may be up to 1000 metres long for single-weight papers and 500 metres long for double-weight papers. Festoon drying was one of the methods formerly adopted for the drying of films and papers, the coated material being passed through a drying tunnel in a series of festoons supported on crossbars travelling on an endless chain. Flat-bed dryers are now in common use: in these air at the appropriate temperature and relative humidity is blown onto the surface of the coated material as it passes horizontally through a long drying tunnel (Figure 12.8). The coated material passes through graded zones of temperature, and chilling may not be required if the first zone is sufficiently low in temperature and relative humidity to set the emulsion.

With fast negative materials it is usually impossible to obtain the desired properties in any *single* emulsion. Two emulsions may then be prepared which together exhibit the desired characteristics.

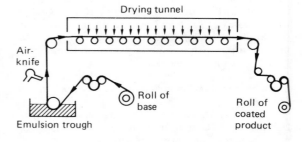

Figure 12.8 Schematic diagram of a coating machine

These may be mixed and coated as a single emulsion, or they may be applied as two separate layers, an undercoat and a top-coat. For the highest speeds the top-coat consists of the fastest component emulsion while the undercoat comprises a slower layer. This arrangement gives the required combination of speed, contrast and exposure latitude.

Sizes of films and papers

Sheet films and papers are supplied in a great many sizes. The nominal sizes in most common use are as follows:

89 × 140 mm (3½ × 5½ inches)
89 × 120 mm (3½ × 4½ inches)
102 × 127 mm (4 × 5 inches)†
105 × 148 mm (A6)
121 × 165 mm (4¾ × 6½ inches)*
148 × 210 mm (A5)
165 × 216 mm (6½ × 8½ inches)*
203 × 254 mm (8 × 10 inches)
210 × 297 mm (A4)

*Obsolescent sizes.
†Although non-standard, likely to be used for many years.

Roll and miniature films are made in several sizes, identified by code numbers. The most popular sizes are given in Table 12.2

Where more than one format is given in Table 12.2 the size achieved in any given instance depends upon the design of the camera used.

Films 35 mm wide, perforated at each edge, are normally employed to yield images measuring 24 × 36 mm, a 1.64 metre length of film yielding 36 exposures. Shorter lengths giving 12, 20 or 24 exposures are also available. Cameras are also available

yielding 18 × 24 mm images on perforated 35 mm film. These are usually referred to as *half-frame cameras*.

Roll films 16 mm wide with perforations along one edge, loaded in cartridges (110 size) are now being used extensively by amateurs in the modern generation of pocket cameras (see page 85).

Papers are supplied in packets for amateur use, in boxes for professionals, and in continuous rolls for photofinishers. As with films, a wide range of sizes is available.

Film identification and coding

Film manufacturers include means of identifying films when they are removed from their packings. Sheet film is notched in order to identify the emulsion side and the type of film. When a notch can be felt on the edge of top right-hand side, with the film in 'portrait' orientation, ie with the long side vertical, the emulsion side is towards you. The notches are coded according to the type of material; there are different numbers and shapes of notches. Roll films and 35 mm films have frame numbers and film emulsion identification numbers, which appear on the edges when the film has been processed. In addition a system of *DX coding* has been introduced for 35 mm films which provides coded information for the photographer and the processing laboratory. This system of coding is shown in Figure 12.9. The cassette has printed on it an auto-sensing code which enables certain cameras to set the film speed on the camera to that of the film automatically by making appropriate electrical contact with the pattern on the cassette. Also printed on the cassette is a

Table 12.2 Film sizes

Size coding	Film width	Nominal image size	Number of images	Notes
Disc	–	8 × 10 mm	15	Circular, images radially around central core
110	16 mm	13 × 17 mm	12/20	Single perforations, cartridge loaded
120	62 mm	45 × 60 mm	16/15	Unperforated, rolled in backing paper
		60 × 60 mm	12	
		60 × 70 mm	10	
		60 × 90 mm	8	
126	35 mm	26 × 26 mm	12/20	Single perforations, cartridge loaded
127*	45 mm	30 × 40 mm	16	As for 120
		40 × 40 mm	12	
		40 × 65 mm	8	
135	35 mm	18 × 24 mm	24–72	Double perforations, cassette loaded
		24 × 36 mm	12–36	
220	62 mm	As for 120 but double number of images		Unperforated film with leader and trailer
70 mm	70 mm			Double perforations, cassette loaded

*Obsolescent size

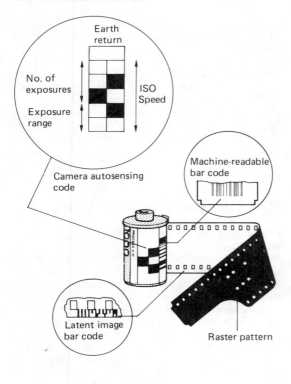

Figure 12.9 DX coding of 35 mm film

machine-readable bar code. A raster pattern punched into the film leader and a bar code along the edge of the film provide data about the film for the processing laboratory.

Packing and storage of films and papers

Sheet films are normally packed facing one way, usually interleaved with paper to minimize the risk of abrasion of films in contact, and to prevent possible interaction of the backing of one film with the emulsion of the next. Most types of sheet film are notched in manufacture to facilitate identification of the emulsion side in the darkroom. When such films are held with the notch at the right-hand end of the top (short) side the emulsion is facing the user.

Sheets of paper are usually packed with the emulsion surfaces of all sheets except the top one facing the same way. The top sheet faces the rest.

Roll films are packed in sealed foil wrappers in boxes; 35 mm cassettes are usually sealed in rigid metal or plastic containers.

If films are badly stored the quality of the results will be inferior. Bad storage causes a loss in speed and contrast accompanied by high fog levels. Multilayer materials suffer more than single layer materials. In multilayer colour materials the individual layers deteriorate at different rates, resulting in imbalances in speed and contrast between the layers, and hence poor colour reproduction. Also the more sensitive the material the more rapidly it deteriorates. Exposed film suffers more than unexposed film; so film should be removed from the camera and processed as soon as possible after it has been exposed. As many amateurs leave colour films in their cameras for long periods of time allowance is made for this in their manufacture.

It is generally, but not always, recommended that photographic materials should be stored in a refrigerator or a freezer in order to prolong their life, provided that they are contained in sealed packets or containers to protect them from humidity. Unprocessed material requires protection from (a) high temperature, (b) high relative humidity, (c) harmful gases and vapours, (d) ionizing or penetrating radiation such as X-rays or radiation emanating from radioactive materials, and (e) physical damage. The bulk of these conditions are met if photographic materials are stored in sealed packets in a refrigerator at a temperature below about 10°C. The shelf-life of colour materials can be prolonged by storage in a freezer at temperatures down to −18°C. When removing films from cold storage they must be allowed to warm to ambient temperature *before* opening the sealed packet. If this is not done, warm moist air may condense on the film and form moisture or water droplets. At least one hour should be allowed after removal from cold storage of a 35 mm cassette in its sealed container.

If there is likely to be an appreciable delay after exposure and before processing and ambient temperatures are high, storage in a refrigerator is also recommended. However *before* placing in the refrigerator the films must be dried by sealing in a container with a desiccant such as silica gel. This is especially important in conditions of high relative humidity.

13 Spectral sensitivity of photographic materials

The inherent sensitivity to light of the silver halides is confined to the limited range of wavelengths absorbed by them. This range includes the blue and violet regions of the visible spectrum, the ultraviolet region and shorter wavelengths extending to the limit of the known spectrum, including X-radiation and gamma-radiation (Figure 2.2). This applies, in general terms, to all types of emulsion – chloride, bromide, iodobromide, etc. – though the position of

the long-wave cut-off of sensitivity varies with the type of emulsion, as shown in Figure 13.1. The amount of light absorbed in the sensitive region, and hence the useful speed of an emulsion, depends on the volumes of the individual silver halide crystals present in the emulsion. Fast emulsions therefore usually give coarser-grained images than slower emulsions.

(a) Chloride

(b) Chlorobromide

(c) Bromide

(d) Iodobromide

Figure 13.1 Wedge spectrograms of unsensitized chloride, chlorobromide and iodobromide emulsions (to tungsten light at 2850 K)

Response of photographic materials to short-wave radiation

Despite the fact that the silver halides have an inherent sensitivity to all radiation of shorter wavelengths than the visible, the recording of such radiation involves special problems. In the first place, the crystals of silver halide in the emulsion significantly absorb radiation of wavelength shorter than about 400 nm. The result is that images produced by ultraviolet radiation lie near the surface of the emulsion, because the radiation is unable to penetrate very far. Also, at wavelengths shorter than about 330 nm, the radiation is absorbed by glass. To record beyond this region, quartz, or fluorite optics have to be employed. At about 230 nm, absorption of radiation by the gelatin of the emulsion becomes serious. To record beyond this region, *Schumann* or *Ilford Q emulsions* have been employed. Schumann emulsions have an extremely low gelatin content, and in Q emulsions, by the adoption of a particular manufacturing technique, the concentration of the silver halide grains is much higher at the surface than deeper in the emulsion layer. Particular care must be taken not to abrade the surface of either type of emulsion or stress marks will result. As an alternative to the use of such special emulsions, fluorescence can be employed to obtain records in this region. Ordinary photographic films can be used, the emulsion being coated with petroleum jelly or mineral oil, which fluoresces during the exposure to form a visible image to which the emulsion is sensitive. The jelly is removed before processing, by bathing the film in a suitable solvent.

The region 230 to 360 nm, sometimes referred to as the *quartz UV region*, is of particular importance in spectrography, because many elements display characteristic lines here. By a fortunate coincidence

155

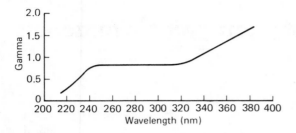

Figure 13.2 Relationship between gamma and wavelength in the ultraviolet for a typical emulsion

the *gamma* of many emulsions (see page 174), which in general varies considerably with wavelength, is comparatively constant throughout this region. This is illustrated in Figure 13.2.

Below about 180 nm UV radiation is absorbed by air, and recording has to be carried out in a vacuum. At about the same wavelength, absorption of radiation by quartz becomes serious and fluorite optics or reflection gratings have to be employed. Below 120 nm, fluorite absorbs the radiation and reflection gratings only can be employed. Using Schumann or Q emulsions in vacuum with a reflection grating, records may be made down to wavelengths of a few nanometres, where the ultraviolet region merges with the soft X-ray (Grenz ray) region. This technique is known as *vacuum spectrography*.

No problem of absorption by gelatin or by the equipment arises in the X-ray or gamma-ray regions. In fact, the radiation in this region is absorbed very little by anything, including the emulsion, and it is therefore necessary to employ a very thick emulsion layer containing a large amount of silver halide to obtain an image. For manufacturing and other reasons, this is normally applied in two layers, one on each side of the film base. Another way of getting round the difficulty arising from the transparency of emulsions to X-rays is to make use of fluorescent intensifying screens. Such screens, placed in contact with the X-ray film, one on either side, emit under X-ray excitation blue or green light to which the film is constructed to be very sensitive, and thus greatly increase the effective film speed. Heavy metal and, especially, rare earth intensifying screens considerably reduce the radiation dosage to patients receiving diagnostic X-ray exposures. For very short-wave X-rays and gamma-rays, such as are used in industrial radiography, metal screens can similarly be used. When exposed to X-rays or gamma-rays these screens eject electrons which are absorbed by the photographic material. The metal employed for such screens is usually lead.

Although invisible to the eye, ultraviolet radiation is present in daylight, and, to a much lesser extent, in tungsten light. Ultraviolet radiation from about

330 to 400 nm, sometimes referred to as the *near-UV region*, may under some circumstances effect the results obtained in ordinary photographs, giving increased haze in distant landscapes and blue results in colour photographs of distant, high altitude or sea scenes. Shorter wavelengths than about 330 nm are sure to be absorbed by the lens although most modern camera lenses absorb substantial amounts of radiation nearer to the visible limit at approximately 400 nm.

Response of photographic materials to visible radiation

Photographic materials that rely on the unmodified sensitivity of the silver halides are referred to variously as *blue-sensitive, non-colour-sensitive, ordinary* or *colour-blind* materials. The materials used by the early photographers were of this type. Because such materials lack sensitivity to the green and red regions of the spectrum, they are incapable of recording colours correctly; in particular, reds and greens appear too dark (even black) and blues too light, the effect being most marked with saturated colours (see Chapter 16).

For some types of work this is of no consequence. Thus, blue-sensitive materials are still in general use today for printing papers, and for negative materials used with black-and-white subjects. Even coloured subjects such as landscapes, architectural subjects and portraits can be recorded with a fair degree of success on blue-sensitive materials, as witness the many acceptable photographs that have survived from the days when these were the only materials available. One of the reasons for success in these cases is that the colours of many natural objects are not saturated, but are whites and greys that are merely tinged with a colour or group of colours. Photographs on blue-sensitive materials are thus records of the blue content of the colours, and, as the blue content may often be closely proportional to the total luminosity of the various parts of the objects, a reasonably good picture may be obtained. When the colours are more saturated, blue-sensitive materials show their deficiencies markedly, and photographs in which many objects appear far darker than the observer sees them cannot be regarded as entirely satisfactory.* It is therefore desirable to find some means of conferring on emulsions a sensitivity to the green and red regions of the spectrum, while leaving the blue sensitivity substantially unchanged.

*That such photographs were regarded as satisfactory for so long was because photographers were so accustomed to an incorrect rendering that a sort of photographic convention was set up in their minds. They regarded the reproduction of blue sky as white and bright red as black as normal.

Colour sensitizing

It was discovered by Vogel in 1873 that a silver halide emulsion can be rendered sensitive to green light as well as to blue by adding a suitable dye to the emulsion. Later, dyes capable of extending the sensitivity into the red and even the infrared region of the spectrum were discovered. This use of dyes is termed *dye sensitizing, colour sensitizing* or *spectral sensitizing*. The dyes, termed *colour sensitizers*, may be added to the emulsion at the time of manufacture, or the coated film may be bathed in a solution of the dye. In all commercial emulsions today the former procedure is adopted, although when *colour-sensitive materials* were first introduced it was not uncommon for the user to bathe his own materials. In either case sensitization follows from the dye becoming adsorbed to the emulsion grain surfaces. Dye that is not adsorbed does not confer any spectral sensitization. The amount of dye required is extremely small, usually sufficient to provide a layer 1 molecule thick over only part of the surface of the crystals of the emulsion. The quantity of dye added, and hence the sensitivity of the emulsion in the sensitized region, depends on the surface area of the silver halide crystals.

The sensitivity conferred by dyes is always additional to the sensitivity of the undyed emulsion, and is always added on the long wavelength side. The extent to which an emulsion has been dye-sensitised necessarily makes a very considerable difference to the amount and quality of light which is permissible during manufacture and in processing.

For practical purposes, colour-sensitive black-and-white materials may be divided into three main classes:

(1) Orthochromatic
(2) Panchromatic
(3) Infrared-sensitive

Some classes of sensitizing dyes are found to lower the natural sensitivity of emulsions to blue light, while conferring sensitivity elsewhere in the spectrum. This may not be desirable in black-and-white emulsions but is sometimes useful, especially in colour materials.

Orthochromatic materials

In the first colour-sensitive materials, the sensitivity was extended from the blue region of the spectrum into the green. The sensitivity of the resulting materials thus included ultraviolet, violet, blue and green. In the first commercial plates of this type, introduced in 1882, the dye eosin was used and the plates were described as isochromatic, denoting equal response to all colours. This claim was exaggerated, because the plates were not sensitive to red at all, and the response to the remaining colours was by no means uniform. In 1884, dry plates employing erythrosin as the sensitizing dye were introduced. In these, the relation between the rendering of blue and green was improved, and the plates were termed orthochromatic (= correct colour). Again, the description was an exaggeration. The term orthochromatic is now applied generally to all green-sensitive materials. Most modern green-sensitive materials have the improved type of sensitizing of which erythrosin was the first example. Although orthochromatic materials do not give correct colour rendering, they give results that are acceptable for many purposes, provided the dominant colours of the subject do not contain much red.

Spectral sensitization of the orthochromatic type is used in a few special-purpose monochrome materials and in the green-recording layers of all modern colour materials (see Chapter 24).

Panchromatic materials

Materials sensitized to the red region of the spectrum as well as to green, and thus sensitive to the whole of the visible spectrum, are termed panchromatic, i.e. sensitive to all colours. Although red-sensitizing dyes appeared within a few years of Vogel's original discovery, the sensitivity conferred by the red sensitizing dyes at first available was quite small, and it was not until 1906 that the first commercial panchromatic plates were marketed.

There are many different types of panchromatic sensitization, the differences between some of them being only slight. The main variations lie in the position of the long-wave cut-off of the red sensitivity, and in the ratio of the red sensitivity to the total sensitivity. Usually, the red sensitivity is made to extend up to 660 to 670 nm. The sensitivity of the human eye is extremely low beyond 670 nm and an emulsion with considerable sensitivity beyond this region gives an infrared effect, that is, subjects which appear visually quite dark may reflect far-red radiation that is barely visible but which leads to a fairly light reproduction when recorded by such a film.

Panchromatic materials have two main advantages over the earlier types of material. In the first place, they yield improved rendering of coloured objects, skies, etc. without the use of filters. In the second place, they make possible the control of the rendering of colours by means of filters (Chapter 11). Where the production of a negative is concerned, and the aim is the production of a correct representation in monochrome of a coloured subject, panchromatic emulsions must be used. Again,

when it is necessary to modify the tone relationships between differently coloured parts of the subject, full control can be obtained only by the use of panchromatic materials in conjunction with filters.

Infrared materials

The classes of colour-sensitized materials so far described meet all the requirements of ordinary photography. For special purposes, however, emulsions sensitive to yet longer wavelengths can be made; these are termed infrared materials. Infared sensitizing dyes were discovered early in this century, but infrared materials were not widely used until the 1930s. As the result of successive discoveries, the sensitivity given by infrared sensitizing dyes has been extended in stages to the region of 1200 nm. The absorption of radiation around 1400 nm by water would make recording at longer wavelengths difficult, even if dyes sensitizing in the region were available. Infrared monochrome materials are invariably used with a filter over the camera lens or light source, to prevent visible or ultraviolet radiation entering the camera.

Infrared materials find use in aerial photography for the penetration of haze and for distinguishing between healthy and unhealthy vegetation, in medicine for the penetration of tissue, in scientific and technical photography for the differentiation of inks, fabrics etc which appear identical to the eye, and in general photography for the pictorial effects they produce. The first of these applications, namely the penetration of haze, depends on the reduced scattering exhibited by radiation of long wavelength (see page 136). The other applications depend on the different reflecting powers and transparencies of objects to infrared and visible radiation.

Lenses are not usually corrected for infrared, so that when focusing with infrared emulsions it is necessary to increase the camera extension slightly. This is because the focal lenth of an ordinary lens for infrared is greater than the focal length for visible radiation.* Some modern cameras have a special infrared focusing index for this purpose. With others, the increase necessary must be found by trial. It is usually of the order of 0.3 to 0.4 per cent of the focal length.

*This applies even when an achromatic or an apochromatic lens is used. In an achromat the foci for green and blue-violet are (usually) made to coincide, and the other wavelengths in the visible spectrum then come to a focus very near to the common focus of green and blue-violet. Similar considerations apply to an apochromatic lens. Infrared radiation however. is of appreciably longer wavelength. and does not come to the same focus as the visible radiation. Lenses can be specially corrected for infrared. but are not generally available.

Other uses of dye sensitization

Sensitizing dyes have other uses besides the improvement of the colour response of an emulsion. In particular, when a material is to be exposed to a light source that is rich in green or red and deficient in blue (such as a tungsten lamp), its speed may be increased by colour sensitizing. Thus, some photographic papers are colour-sensitized to obtain increased speed without affecting other characteristics of the material.

The most critical use of dye sensitization occurs in tripack colour materials (see Chapter 24) in which distinct green and red spectral sensitivity bands are required in addition to the blue band. This has required quite narrow sensitization peaks, precisely positioned in the spectrum. Spectral sensitivities of a typical modern colour film are shown in Figure 13.5.

A particularly interesting and useful balance of sensitivity is provided by dye-sensitized tabular crystals of the type used in modern 'T-grain' emulsions. These crystals are of large area but are very thin, contain little silver halide, do not absorb very much blue light, and hence have a low sensitivity in that spectral region. On the other hand, they have a large surface area and relatively large quantities of sensitizing dyes can be adsorbed to them. This means that such emulsions can be selectively very sensitive to spectral bands outside the region of natural sensitivity, but have only minor natural sensitivity. They are thus well suited to use in colour materials.

Determination of the colour sensitivity of a material

The colour sensitivity of a material can be most readily determined in the studio by photographing a colour chart consisting of coloured patches with a reference scale of greys. In one such chart it has been arranged that the different steps of the neutral half have the same luminosities as the corresponding parts of the coloured half when viewed in daylight. If a photograph is taken of the chart, the colour sensitivity of the emulsion being tested, relative to that of the eye, is readily determined by comparing the densities of the image of the coloured half with the densities of the image of the neutral half. The value of the test is increased if a second exposure be made on a material of known colour sensitivity, to serve as a basis for comparison.

A more precise, yet still quite practical, method of measuring the colour sensitivity of a material is to determine the exposure factors of a selection of filters (page 132). With panchromatic materials, three filters, tricolour blue, green and red, are used. With orthochromatic materials, measurement of the

minus-blue filter factor alone provides all the information that is usually required.

In the laboratory, the colour sensitivity of a material is usually expressed in terms of filter factors or illustrated by means of a wedge spectrogram.

Wedge spectrograms

The spectral response of a photographic material is most completely illustrated by means of a curve known as a *wedge spectrogram*, and manufacturers usually supply such curves for their various materials. A wedge spectrogram, which indicates the relative sensitivity of an emulsion at different wavelengths through the spectrum, is obtained by exposing the material behind a photographic wedge in an instrument known as a *wedge spectrograph*. The spectrograph produces an image in the form of a spectrum on the material, the wedge being placed between the light source and the emulsion. A typical optical arrangement is shown in Figure 13.3

Examples of the results obtained in a wedge spectrograph are shown in Figure 13.4, which shows wedge spectrograms of typical materials of each of the principal classes of colour sensitivity. We have already seen other examples of wedge spectrograms in Figure 13.1. The outline of a wedge spectrogram forms a curve showing the relative sensitivity of the material at any wavelength. Sensitivity is indicated on a logarithmic scale, the magnitude of which depends on the gradient of the wedge employed. All the spectrograms illustrated here were made using a continuous wedge, but step tablets are sometimes used.

In Figure 13.4 the short-wave cut-off at the left of each curve is characteristic not of the material, but of the apparatus in which the spectrograms were produced, and arises because of the ultraviolet absorption by glass (to which reference was made earlier). Secondly, the curves of the colour-sensitized materials are seen to consist of a number of peaks; these correspond to the absorption bands of the dyes employed.

The shape of each curve depends not only on the sensitivity of the material but on the quality of the light employed. All the spectrograms shown in Figure 13.4 were made with a tungsten light source with a colour temperature of approximately 2850 K. Wedge spectrograms of the same materials, made to daylight, would show higher peaks in the blue region and lower peaks in the red.

The wedge spectrogram of the infrared material in Figure 13.4 shows a gap in the green region of the spectrum. This permits the handling of the material by a green safelight (page 142). Infrared-sensitive materials do not necessarily have this green gap.

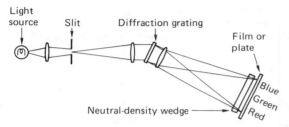

Figure 13.3 Optical arrangement of wedge spectrograph

(a) Blue-sensitive

(b) Orthochromatic

(c) Panchromatic

(d) Infrared

Figure 13.4 Wedge spectrograms of typical materials of each of the principal classes of colour sensitivity (to tungsten light at 2850 K)

The colour material whose spectral sensitivity is shown in Figure 13.5a was designed for daylight exposure and was therefore exposed using a tungsten source of 2850 K and a suitable filter to convert the illumination to the quality of daylight. The omission of the conversion filter would have resulted in a relatively higher red sensitivity peak, at about 640 nm, and a lower blue peak, at about 450 nm.

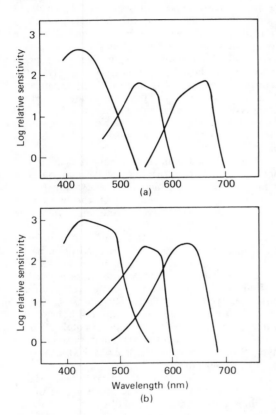

Figure 13.5 Spectral sensitivities of typical colour negative films exposed to daylight: (a) Daylight-balanced film; (b) a faster film, suitable for a range of illuminants, but optimally exposed to daylight (type G film)

The necessity to balance the exposing illuminant and the film sensitivity by the use of correction filters can be inconvenient, although generally accepted by professional photographers. The ill-effects of omitting correction filters can be substantially reduced by using a film specially designed for the purpose, termed *type G film*. An example is shown in Figure 13.5b, which should be compared with 13.5a. It will be seen that the sensitivity bands of the type G film are broader and less separated than those of the conventional film. The sensitivity characteristics of type G materials give an acceptable colour reproduction over a wide range of colour temperatures, though the optimum is still obtained with daylight exposure. This tolerance to lighting conditions is gained at the expense of a loss in colour saturation and other mechanisms may have to be used by the manufacturer to restore this to an appropriate level.

Uses of wedge spectrograms

Although they are not suitable for accurate measurements, wedge spectrograms do provide a ready way of presenting information. They are commonly used:

(1) To show the way in which the response of an emulsion is distributed through the spectrum.
(2) To compare different emulsions. In this case, the same light source must be used for the two exposures. It is normal practice to employ as a source a filtered tungsten lamp giving light equivalent in quality to daylight (approx. 5500 K) or an unfiltered tungsten lamp operating at 2850 K, whichever is the more appropriate.
(3) To compare the quality of light emitted by different sources. For this type of test, all exposures must be made on the same emulsion.
(4) To determine the spectral absorption of colour filters (Chapter 11). For this, all exposures must be made to the same light source and on the same emulsion.

14 Principles of colour photography

Materials that reflect light uniformly through the visible spectrum appear neutral, that is white, grey or black depending on the reflectance. A reflectance of 1 indicates that 100 per cent of the light is reflected, and the object appears perfectly white. Conversely, a zero reflectance indicates a perfect black. A reflectance of 0.20 corresponds to a mid-grey tone reflecting 20 per cent of the incident light. However, equal visual steps between black and white are not represented by equal steps in reflectance.

The sensation of colour arises from the selective absorption of certain wavelengths of light. Thus a coloured object reflects or transmits light unequally at different wavelengths. Reflectance varies with wavelength and the object, illuminated with white light, appears coloured. Colour may be described objectively by a graph of reflectance against wavelength; typical coloured surfaces described in this way are shown in Figure 14.1. It is possible to

so that in some instances the use of reflection or transmission density is preferable to reflectance or transmittance.

Colour matching

The colours of most objects around us are due to a multitude of dyes and pigments. No photographic process can form an image from these original colourants, but colour photography can produce an acceptable reproduction of colours in the original scene. Such a reproduction reflects or transmits mixtures of light that appear to match the original

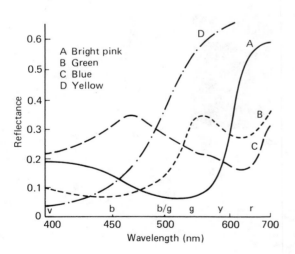

Figure 14.1 Spectral absorptions of typical colourants

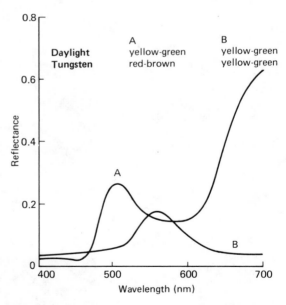

Figure 14.2 Spectral absorptions of a metameric match

describe the appearance of materials that transmit light, such as stained glass or photographic filters similarly. In such cases the term used is *transmittance*. An alternative way of describing a colour is in terms of the variation of *reflection* or *transmission density* with wavelength (see Chapter 15). Equal density differences are visually approximately equal,

colours, although in general they do not have the same spectral energy distributions. Different spectral energy distributions that give rise to an identical visual sensation are termed *metamers*, or *metameric pairs*. A typical metameric match is shown in Figure 14.2

Because of this phenomenon of metamerism it is

only required that a colour photograph should be capable of giving appropriate mixtures of the three primaries. We shall now consider the methods by which blue, green and red spectral bands are selected and controlled by colour photographs.

A convenient way of selecting bands of blue, green and red light from the spectrum for photography is to use suitable colour filters. We may select bands in the blue, green and red regions of the spectrum. This selective use of colour filters is illustrated in Figure 14.3, which shows the action of 'ideal' primary colour filters, and their spectral density distributions.

The spectral density distributions of primary colour filters available in practice differ from the ideal, and the curves of a typical set of such filters are illustrated in Figure 14.4. It will be noticed that the filters shown transmit less light than the ideal filters, although the spectral bands transmitted correspond quite well with the ideal filters previously illustrated. The blue, green and red filters available for photography are thus able to give three separate records of the original scene, and such filters were in fact used in making the first colour photograph.

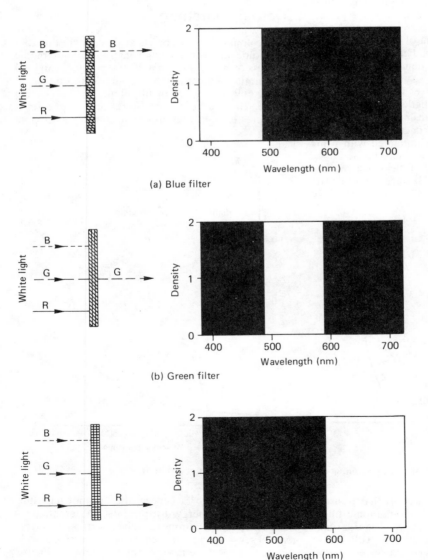

(a) Blue filter

(b) Green filter

(c) Red filter

Figure 14.3 The action of ideal blue, green and red filters, and the corresponding spectral density distributions

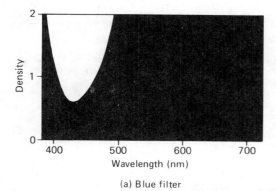

(a) Blue filter

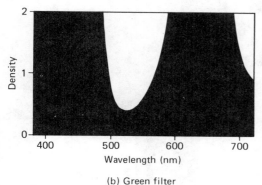

(b) Green filter

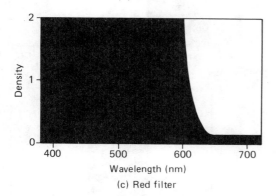

(c) Red filter

Figure 14.4 The spectral density distributions of primary colour filters used in practice

The first colour photograph

Clerk Maxwell prepared the first three-colour photograph in 1861 as an illustration to support the three-colour theory of colour vision. (The demonstration was only partially successful owing to the limited spectral sensitivity of the material available at the time.) He took photographs of some tartan ribbon through a blue, a green and a red filter in turn, and then developed the three separate negatives. Positive lantern slides were then produced by printing the negatives, and the slides were projected in register. When the positive corresponding to a particular taking filter was projected through a filter of similar colour, the three registered images together formed a successful colour reproduction and a wide range of colours was perceived. Maxwell's process is shown diagrammatically in Figure 14.5

Methods of colour photography that involve the use of filters of primary hues at the viewing stage, in similar fashion to Maxwell's process, are called *additive* methods. In the context of colour photography the hues blue, green and red are sometimes referred to as the *additive primaries*.

Additive colour photography

In Maxwell's process (Figure 14.5) the selection of spectral bands at the viewing stage was made by the original primary-colour filters used for making the negatives. The amount of each primary colour projected onto the screen was controlled by the density of the silver image developed in the positive slide.

An alternative approach to the selection of spectral bands for colour reproduction is to utilize the complementary hues yellow, magenta and cyan to absorb respectively light of the three primary hues blue, green and red. The action of ideal complementary filters listed in Table 14.1 is shown in Figure 14.6.

Subtractive colour photography

Whereas the ideal primary colour filters illustrated in Figure 14.3 may transmit up to one-third of the visible spectrum, complementary colour filters transmit up to two-thirds of the visible spectrum; they *subtract* only one-third of the spectrum.

Table 14.1 Primary and complementary colours

Primary (or additive primary)	*Complementary (or subtractive primary)*
Red	Cyan (blue-green)
Green	Magenta (red-purple)
Blue	Yellow

As with primary filters, the complementary filters available in practice do not possess ideal spectral density distributions, and examples of such filters are shown in Figure 14.7.

Combinations of any two primary filters appear black because they have no common bands of

164

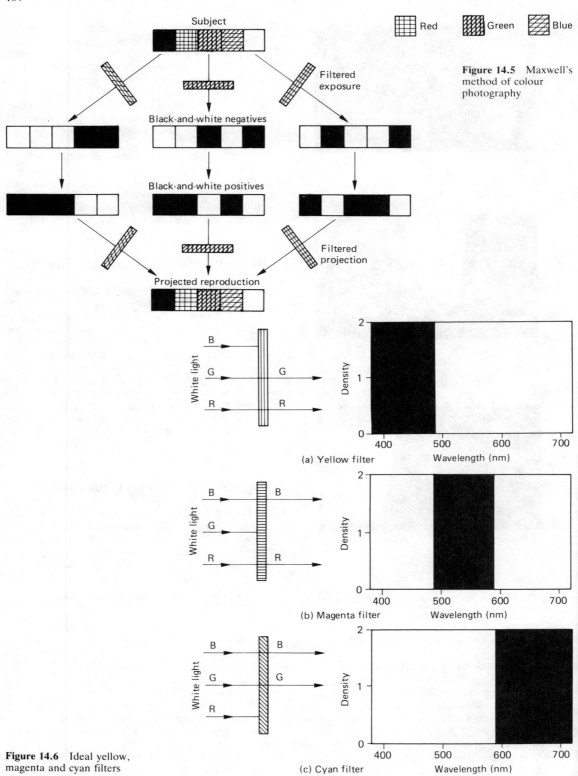

Subject

Red Green Blue

Figure 14.5 Maxwell's method of colour photography

Filtered exposure

Black-and-white negatives

Black-and-white positives

Filtered projection

Projected reproduction

White light

B
G → G
R → R

(a) Yellow filter

Density

400 500 600 700
Wavelength (nm)

White light

B → B
G
R → R

(b) Magenta filter

Density

400 500 600 700
Wavelength (nm)

White light

B → B
G → G
R

(c) Cyan filter

Density

400 500 600 700
Wavelength (nm)

Figure 14.6 Ideal yellow, magenta and cyan filters

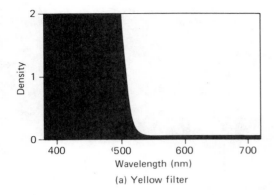

(a) Yellow filter

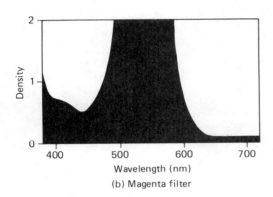

(b) Magenta filter

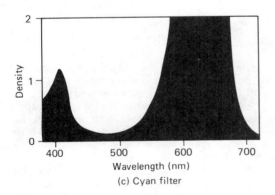

(c) Cyan filter

Figure 14.7 Typical yellow, magenta and cyan filters

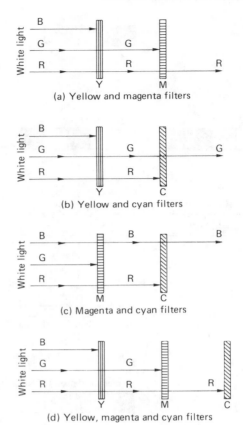

(a) Yellow and magenta filters

(b) Yellow and cyan filters

(c) Magenta and cyan filters

(d) Yellow, magenta and cyan filters

Figure 14.8 Combinations of complementary colour filters

transmission, so such combinations cannot be used together to control the colour of transmitted light. With the complementary filters the situation is quite different. Despite the imperfections of practical complementary filters it remains substantially true that each absorbs only about one-third of the visible

spectrum. Consequently such filters may be used in combination to control the colour of transmitted light. The effect of combining complementary filters is shown in Figure 14.8.

In principle, the positive lantern slides used in Maxwell's additive method of colour photography can be made as positive dye images. If we make the hue of each positive complementary to that of the taking filter – the positive record derived from the negative made using a blue filter being formed by a yellow dye and so on – then the three positives can be superimposed in register and projected using only one projector. Such methods, which involve the use at the viewing stage of dyes which *subtract* blue, green and red light from the spectrum, are called *subtractive* processes. The preparation of a subtractive colour reproduction from blue, green and red light records is illustrated in Figure 14.9.

We have examined the principles of operation of the additive and the subtractive methods of colour photography, and will now consider the operation of some practical examples of each type of process.

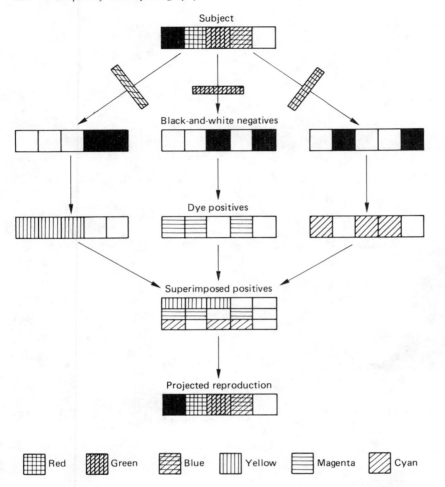

Subject

Black-and-white negatives

Dye positives

Superimposed positives

Projected reproduction

| ⊞ Red | ▨ Green | ▧ Blue | ▥ Yellow | ▤ Magenta | ◫ Cyan |

Figure 14.9 A subtractive colour photograph

Additive processes

As we have seen, the first three-colour photograph was made in 1861 by an additive process. The viewing system required the use of three projectors, and the entire process was too unwieldy for general photography. By the first decade of the twentieth century, however, an ingenious application of the additive system had made possible the production of plates yielding colour photographs by a single exposure in a conventional camera.

In order to achieve analysis of the camera image in terms of blue, green and red light, the exposure was made through a mosaic, or *réseau*, comprising a large number of tiny blue, green and red filter elements. Depending on the manufacturer, the réseau was either integral with the photographic material, or, in some cases, was placed in contact with it. Materials which employed an integral réseau were then reversal-processed, while those using a

separate réseau could be negative-processed and then printed to yield a positive which was subsequently registered with a colour réseau screen.

In each case, projection yielded a colour reproduction of the original scene, the method being exemplified by the Dufaycolor process in which the réseau was integral with the film. The system is shown in Figure 14.10.

Exposure was made through the film base, the réseau being coated on the base beneath the emulsion. After first development the silver image was completely removed using an acid potassium permanganate bleach solution, and the residual silver halide was fogged and developed to metallic silver. After fixing, washing and drying, the reproduction could be viewed.

The complexity of early additive processes is avoided by the current additive slide process *Polachrome*. The 35 mm camera film is constructed similarly to the Dufaycolor product; the integral

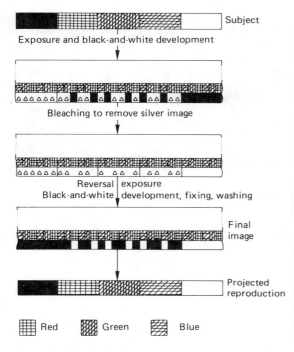

Subject

Exposure and black-and-white development

Bleaching to remove silver image

Reversal | exposure
Black-and-white | development, fixing, washing

Final image

Projected reproduction

Red Green Blue

Figure 14.10 The Dufaycolor system

réseau consists not of squares but of very fine parallel lines of red, green and blue dye. Exposure is made through the film base and the integral réseau. The exposed emulsion is processed in a very small lightweight machine to give a positive image, formed close to the réseau by diffusion transfer from the emulsion which contains the negative image. The emulsion and the unwanted negative image are stripped away after processing and discarded, leaving the additive-colour transparency. The process is described further in Chapter 24.

In such additive processes, whether employing an integral or separate réseau, the colour mosaic is present at the viewing as well as the taking stage. This means that the brightness of reproduction of white is limited by the light absorption of the réseau. Less than one-third of the light striking the film is transmitted. Such methods therefore waste about 70 per cent of the available light and generally give a dim picture.

Additive methods employing three separate analysis negatives and the corresponding positives can give very good colour reproduction and a bright image owing to the use of three separate light sources. Such methods are cumbersome in operation and suffer from registration difficulties. The more convenient methods employing réseaux have suffered from the loss of light at the projection stage and definition difficulties due to the presence of the

réseau. Even if the réseau employed is so fine as to be unobjectionable in the reproduction further generations of reproduction, such as reflection prints, tend to be unsatisfactory.

The registration and light-loss problems inherent in additive methods of colour photography have largely led to the adoption of methods based on the subtractive system for practical colour photography. The mosaic method of additive colour reproduction has, nevertheless, survived in rapid-process slide film and in colour television. The mosaic incorporated in the face of the television tube consists of red, green and blue light-emitting substances that are stimulated by electron impact. Registration of images is ensured by careful manufacture and setting-up procedures, and there is no filtering action to cause loss of brightness.

Polachrome slides suffer from the inherent difficulties of light loss, and from visibility of the réseau at large magnifications. The réseau is, however, very fine (some 25 μm per triplet of filters), and ×5 enlarged prints are in fact not objectionable when viewed in the usual way.

Subtractive processes

Subtractive systems use yellow, magenta and cyan image dyes in appropriate concentrations to control the amounts of blue, green and red light transmitted or reflected by the reproduction. Thus white is reproduced by the virtual absence of image dyes, grey by balanced quantities of the three dyes, and black by a high concentration of each dye. Colours are reproduced by superimposed dye images of various concentrations. The effects of superimposing pairs of subtractive dyes are identical to the combination of filters of the same hues and have been illustrated in Figure 14.8.

The possibility of preparing subtractive dye positives from blue, green and red separation negatives has already been referred to. If such dye positives are used then it is possible to superimpose the yellow, magenta and cyan images to obtain a reproduction that may be projected using one projector only.

Although such a separation system suffers from registration difficulties when the positives are superimposed, two important commercial processes have operated in this manner. In each case separation positives are made which are able to absorb dye in an amount depending upon the amount of image. Each positive then carries the dye and is made to deposit it on a receiving material which retains the transferred dye. The three dye images are laid down in sequence to build up the required combination. The positive transmission or reflection prints made in this way can be of very high quality provided

accurate image registration is maintained. The two processes which operate by this method are the Kodak Dye Transfer method of making reflection colour prints, and the Technicolor method of preparing motion-picture release colour prints.

Integral tripacks

While it is possible, as we have seen, to produce subtractive dye images separately, and to superimpose them to form a colour reproduction, this method finds limited application. Most colour photographs are made using a type of material which makes blue, green and red records in discrete emulsion layers within one assembly. This specially designed emulsion assembly is called an *integral tripack*. The latent-image records within the emulsion layers are processed in such a way that the appropriate dye images are generated in register within the emulsion layers by colour development. The processing chemistry is such that the blue, green and red records are made to generate yellow, magenta and cyan images respectively. We shall look further at this type of process in Chapter 24.

15 Sensitometry

The objective study of the response of photographic materials to light is called *sensitometry*. It is concerned with the measurement of the exposure that a material has received and the resultant blackening. It is possible to produce photographs without any knowledge of sensitometry, but to obtain the best performance out of photographic materials under all conditions an understanding of the principles governing the response of materials is invaluable. A knowledge of at least an outline of sensitometry is therefore highly desirable for anyone wishing to make use of any of the specialized applications of photography in science and industry.

As sensitometry is concerned with the measurement of the performance of photographic materials, it is necessary to use precise terminology in defining the quantities that are measured. The impression that a photograph makes on us depends on physiological and psychological as well as physical factors, and for this reason the success of a photograph cannot be determined from a mere series of measurements. This does not mean that we can learn nothing from a study of the factors that *are* amenable to measurement; it simply means that there are limitations to the help that sensitometry can give us.

Subject

As far as the camera is concerned, a subject consists of a number of areas of varying luminance and colour. This holds good whether the subject is a portrait or a landscape, a pictorial or a record shot. In the same way, a photographic print consists of areas of varying luminance and sometimes colour. Luminance is measured in candelas per square metre (see chapter 3).

The variations in luminance in a subject are due to the reflection characteristics exhibited by different areas of it, to the differing angles at which they are viewed,* and to variation in the illumination they receive. The ratio of the maximum to the minimum luminance in a subject is defined as its *luminance range*.

It may surprise us at first to realise that an effect

such as a sunset, or the rippling of wind over water, can be reduced to areas of varying luminance. Yet it is so in the camera, and in the eye viewing a black-and-white print too, with the difference that the mind draws not only on the eyes for its impression but, on past experience. Thus, when we look at a picture of an apple, for example, we see more than just light and shade. Our past experience of apples – their size, their weight, their taste – comes to the aid of the eyes in presenting to the mind a picture of an apple.

Our final goal in sensitometry is to relate the luminances of the subject to the luminances of the print. This involves the study first of the response of the negative material, then of the response of the positive material, and finally of the relation between the two. We shall consider each of these in turn, beginning with the negative material.

It is customary to refer to the light areas of a subject as the *highlights* and the dark areas as the *shadows*. To avoid confusion, it is desirable that the same terms should be applied to corresponding areas both in the negative and in the print, even though in the negative the highlights are dense and the shadows clear.

Exposure

When a photograph is taken, light from the various areas of the subject falls on corresponding areas of the film for a set time. The effect produced on the emulsion is, within limits, proportional to the product of the illuminance E and the exposure time t. We express this by the equation*

$$H = Et$$

The SI unit for illuminance is the *lux* (lx). Hence the exposure is measured in lux seconds (lx s).

As the luminance of the subject varies from area to area, it follows that the illuminance on the emulsion varies similarly, so that the film receives not one exposure over the entire surface but a varying amount of light energy, i.e. a range of exposures. As a general rule the exposure duration is constant for all areas of the film, variation in exposure over the film being due solely to variation in the illumination that it receives.

*A surface that diffuses light fairly completely, such as blotting paper, looks equally bright no matter from which direction it is viewed, but a polished surface may look very bright or very dark, depending on the angular relationship between source, surface and eye.

*Before international standardization of symbols, the equation was $E = It$ (E was exposure, I was illuminance).

169

It should be noted that the use of the word 'exposure' in the sense in which we are using it here is quite different from its everyday use in such phrases as, 'I gave an exposure of 1/60 second at *f*/8'. We can avoid confusion by designating the latter *camera exposure,* as we have already been doing in previous chapters.

Density

When a film has been processed, areas of the image that have received different values of illumination are seen to have differing degrees of blackness. The blackness of a negative, i.e. its light-stopping power, can be expressed numerically in several different ways. The following three ways are of interest in photography:

Transmittance

The transmittance τ of an area of a negative is defined as the ratio of the light transmitted I_t to the light incident upon the negative I_i. Expressed mathematically:

$$\tau = \frac{I_t}{I_i}$$

Transmittance is always less than 1, and is usually expressed as a percentage. Thus, if 10 units of light fall on a negative and 5 are transmitted, the negative is said to have a transmittance of 5/10 = 0.5, or 50 per cent. Although transmittance is a useful concept in certain fields, in sensitometry it is not the most expressive of units because it decreases as blackness increases, and equal changes in transmittance do not appear as equal changes in blackness.

Opacity

Opacity, O, is defined as the ratio of the light incident on the negative, I_i, to the light transmitted, I_t. That is:

$$O = \frac{I_i}{I_t}$$

Opacity is the reciprocal of transmittance i.e.:

$$O = \frac{1}{\tau}$$

Opacity is always greater than 1 and increases with increasing blackness. From this point of view, it is a more logical unit to use in sensitometry than transmittance, but equal changes in opacity still do not represent equal changes in perceived blackness.

Density

Density, D, is defined as the common logarithm* of the opacity. That is:

$$D = \log_{10}\frac{1}{\tau} = \log_{10}\frac{I_i}{I_t}$$

Density is the unit of blackening employed almost exclusively in sensitometry. Like opacity it increases with increasing blackness, but has the following practical advantages:

(1) The numerical value of density bears an approximately linear relationship to the amount of silver or image dye present. For example, if the amount present in an image of density 1.0 is doubled, the density is increased

*An explanation of logarithms is given in the Appendix.

Table 15.1 Density, opacity and transmittance

Density	Opacity	Transmittance (per cent)	Density	Opacity	Transmittance (per cent)
0.0	1	100	1.6	40	2.5
0.1	1.3	79	1.7	50	2
0.2	1.6	63	1.8	63	1.6
0.3	2	50	1.9	79	1.25
0.4	2.5	40	2.0	100	1
0.5	3.2	32	2.1	126	0.8
0.6	4	25	2.2	158	0.6
0.7	5	20	2.3	200	0.5
0.8	6.3	16	2.4	251	0.4
0.9	8	12.5	2.5	316	0.3
1.0	10	10	2.6	398	0.25
1.1	13	7.9	2.7	501	0.2
1.2	16	6.3	2.8	631	0.16
1.3	20	5	2.9	794	0.12
1.4	25	4	3.0	1000	0.1
1.5	32	3.2	4.0	10000	0.01

to 2.0, i.e. it is also doubled. The opacity, however, increases from 10 to 100, i.e. ten-fold.

(2) The final aim in sensitometry is to relate the tones of the print to those of the subject. Blackness in the print depends on the way the eye assesses it, and is therefore essentially physiological. The law governing the effect produced in the eye when stimulated is not a simple one, but over a wide range of viewing conditions the response of the eye is approximately logarithmic. Thus, if we examine a number of patches of a print in which the density increases by equal steps, the eye accepts the steps as of equal blackness increase. From this point of view, therefore, a logarithmic unit is the most satisfactory measure of blackening.

Table 15.1 gives a conversion between density, opacity and transmittance.

Where it is desired to distinguish between densities of images on a transparent base and those of images on an opaque base, the former are referred to as transmission densities and the latter as reflection densities.

Effect of light scatter in negative

When light passes through a negative it is partially scattered (see Chapter 25). One result of this is that the numerical value of density depends on the spatial distribution of the incident light, and on the method adopted for the measurement of both this and the transmitted light. Three types of density have been defined; these are illustrated in Figure 15.1.

(1) *Direct or specular density* This is determined by using *parallel* illumination and measuring only *normal* emergence.

(2) *Diffuse density* This is sometimes termed *totally diffuse* density. It may be determined in either of two ways:
(a) By using parallel illumination and measuring *total* emergence (whether normal or scattered), or
(b) By using *diffuse* illumination and measuring only *normal* emergence.
The numerical value of diffuse density is the same with either method of measurement.

(3) *Doubly-diffuse density* This is determined by using *diffuse* illumination and measuring *total* emergence.

Practical measurements of any of these types of density are based on the ratio of a reading made by a photocell when the sample is not in place (taken as

I_i) to the reading on the same photocell when the sample is in place (I_t). The difference between diffuse density and doubly-diffuse density is usually quite small, but specular density is always greater than either.

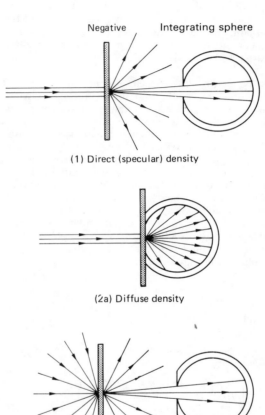

(1) Direct (specular) density

(2a) Diffuse density

(2b) Diffuse density

(3) Doubly-diffuse density

Figure 15.1 Optical systems for measuring different types of density

Callier coefficient

The ratio of specular density to diffuse density is termed the *Callier coefficient*, or *Callier Q factor*, and can be expressed as:

$$Q = \frac{\text{specular density}}{\text{diffuse density}}$$

This ratio, which is never less than 1.0, varies with grain size, the form of the developed silver and the amount of the deposit. As far as the grain is concerned, the finer it is, the lower the resultant scattering the nearer to unity is the Callier coefficient.

The factors above which influence the value of Q vary quite markedly with the degree and type of development. Consequently the Callier coefficient varies with density and contrast in a complicated way, even when a combination of only one film and one developer is investigated. A typical example of such behaviour is illustrated in Figure 15.2, where the value of γ for each curve indicates the degree of development received by the film. At low degrees of development the value of Q is approximately constant at densities above about 0.3; for more complete development, however, there is no single value of Q that can be adopted; consequently no simple correction for specularity can be applied to densitometer readings.

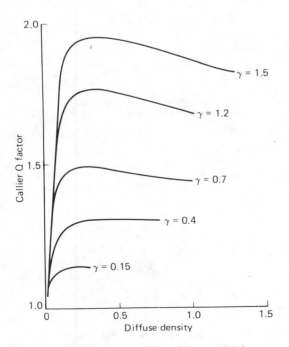

Figure 15.2 Variation of Callier Q factor with image density and degree of development

One result of the variation of the Callier coefficient with density is that the tone distribution in the shadow areas of a print produced with a condenser enlarger is likely to be different from that which appears in a print produced using a diffuser enlarger (Chapter 22). Colour photographic images, however, are essentially non-scattering, so that they possess Callier coefficients close to unity, and consequently may be measured by a variety of optical arrangements. Thus in printing colour negatives there is seldom any measurable difference between the results from diffuser or condenser enlargers.

Density in practice

The types of density related to photographic practice are as follows:

Type of work	Effective density
Contact printing:	
(a) In a box, with diffused source	Doubly diffuse
(b) In a frame, using clear bulb	Diffuse (parallel illumination, total emergence)
Enlarging:	
(a) Condenser enlarger (point source, no diffuser)	Specular
(b) Diffuser enlarger (particularly *cold cathode* types)	Diffuse (diffuse illumination, normal emergence)
Still or motion-picture projection:	
All types	Specular

Some kinds of illumination present an intermediate type of density, as, for example, when an opal bulb or a diffusing screen is used in a condenser enlarger.

Apart from the true condenser enlarger and projectors, the effective density in all the examples quoted is either diffuse or doubly diffuse. As already stated, the difference between the latter two forms of density is slight. For normal photographic purposes, therefore, densities of negatives are expressed simply as diffuse densities.

If the image in a negative or print is not neutral in tone, its measured density will depend not only on the optics employed to measure it, but also on the *colour* of the light employed and the response to colour of the device employed to measure it. Considering these last two factors, we may consider density as being of four main kinds:

(1) Density at any wavelength, spectral density
 Determined by illuminating the specimen with monochromatic radiation.

(2) *Visual density* Determined by measuring the illuminated specimen with a receiver having a spectral response similar to that of the normal photopic eye.

(3) *Printing density* Determined by illuminating the specimen with tungsten light and employing a receiver with a spectral response similar to that of photographic papers.

(4) *Arbitrary density* Determined by illuminating the specimen with tungsten light and employing an unfiltered commercial photoelectric cell of arbitrary sensitivity as the receiver.

This classification applies equally to all three main types of density: specular, diffuse and doubly diffuse. For most photographic purposes *diffuse visual density* is employed.

Colour densities are usually measured in diffuse densitometers. Colour images (see Chapter 14) are composed of three dyes, each controlling one of the primary colours: red, green and blue. In practice, therefore, colour images are described in terms of their densities to red, green and blue light, the densitometer being equipped with filters to select each primary colour in turn.

The colour filters chosen for a densitometer may simply select red, green and blue spectral bands and measure the integrated effects of all three dye absorptions within those bands. The densities measured are called *arbitrary integral densities* and are more commonly used in quality control measurements. For more useful results the densitometer filters and cell sensitivity are carefully chosen so that the densities measured represent the effect of the image either on the eye or on print paper. Such measurements correspond to density categories (2) and (3) for black-and-white images, and are referred to as *colorimetric* and *printing densities* respectively. In practice, colorimetric densities are seldom measured because suitably measured arbitrary densities can usefully describe the response of the eye to visual neutral and near-neutral tones – all that is usually required. Printing densities are, however, widely applied in the assessment of colour negatives for printing purposes (see Chapter 22), although measurements of this type can refer only to some defined 'average' system.

The characteristic (H and D) curve

If density is plotted as ordinate against exposure as abscissa, a response curve for a film or plate of the general shape shown in Figure 15.3 is obtained.

Although a curve of this type may occasionally be of value, a far more useful curve for most purposes is obtained by plotting density against the common logarithm of the exposure. This gives a curve of the shape shown in Figure 15.4, the type of response

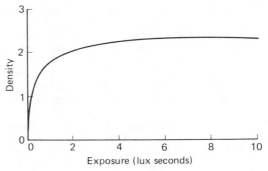

Figure 15.3 Response curve of an emulsion obtained by plotting density against exposure

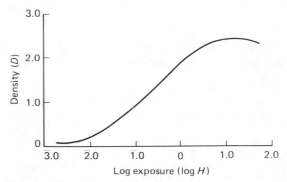

Figure 15.4 A characteristic curve — the response curve obtained by plotting density against log exposure

curve employed in ordinary photography. It is referred to as a *characteristic curve* or *H and D curve*, after F. Hurter and V.C. Driffield, who were the first to publish curves of this type. The H and D curve is simply a diagram which shows the effect on the emulsion of every degree of exposure from gross under-exposure to gross over-exposure for any one development time and any particular developer.

The use of $\log_{10}H$ instead of H as the unit for the horizontal axis of the response curve of a photographic material offers several advantages:

(1) In practice, we consider changes in camera exposure in terms of the factor by which it is altered; the natural progression of exposure is geometrical, not arithmetical. (When increasing an exposure time from 1/60 to 1/30 second, for example, we speak of doubling the exposure, not of increasing it by 1/60 second.) A logarithmic curve therefore gives the most reasonable representation of the way in which density increases when exposure is changed. The series of camera exposure times 1/500, 1/250, 1/125 etc. is a logarithmic series, as is

that of printing exposure times 2, 4, 8, 16 s etc.

(2) A D vs log H curve shows, on a far larger scale than a density–exposure curve, the portion of the curve corresponding with just-perceptible blackening, i.e. with small values of exposure. The speed of a film is usually judged in terms of the exposure needed to produce quite small values of density (Chapter 19).

(3) The use of logarithmic units for both horizontal and vertical axes enables values of density in the photographic negative to be transferred readily to the log-exposure axis of the characteristic curve of the print. This simplifies the task of relating the brightnesses of the original scene, the transmission densities of the negative and the reflection densities of the print.

Main regions of the negative characteristic curve

The characteristic curve of a negative material may be divided into four main regions: the toe or foot, an approximately linear (straight-line) portion, the shoulder and the region of solarization, as shown in Figure 15.5.

It is only on the linear portion of the curve that density differences in the negative are directly proportional to visual differences in the original scene. For this reason the linear portion was at one time referred to as the region of correct exposure, the toe as the region of under-exposure and the shoulder as the region of over-exposure. As we shall see later, however, such descriptions are misleading (see page 178). The value of density reached at the top of the shoulder of the curve is referred to as D_{max}, the maximum density obtainable under the given conditions of exposure and development.

Provided the horizontal and vertical axes use the same scale, the numerical value of the tangent of the angle c which the linear portion of the curve makes with the log H axis is termed *gamma* (γ). When $c = 45°$, $\gamma = 1$. Gamma may be defined less ambiguously in terms of the values of density and log exposure corresponding to any two points lying on the straight-line portion of the curve. Referring to Figure 15.6:

$$\gamma = \tan c = \frac{BC}{AC} = \frac{D_2 - D_1}{\log H_2 - \log H_1}$$

It is thus seen that gamma serves to measure *sensitometric contrast*, i.e. the rate at which density increases as log exposure increases in the linear portion of the curve. It should be noted, however, that gamma gives information only about the linear portion of the curve; it tells us nothing about the other portions. Further, as will be seen later, the contrast of a negative is not determined by gamma alone: other factors play an important part, and with modern emulsions no portion of the curve is strictly linear.

Sensitometric contrast is an important aspect of performance, and, with experience, is readily appreciated from a superficial examination of the H and D curve (provided the abscissae and ordinates have been plotted on the same scale).

The region of *solarization*, or reversal (though not of use in ordinary photography), is of interest. In this region an increase in exposure actually results in a *decrease* in density. The exposure necessary to produce solarization is commonly of the order of one thousand times greater than normal exposure,

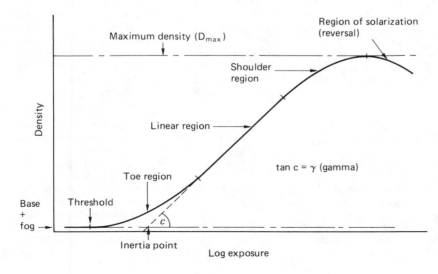

Figure 15.5 The 'geography' of the characteristic curve of a negative material

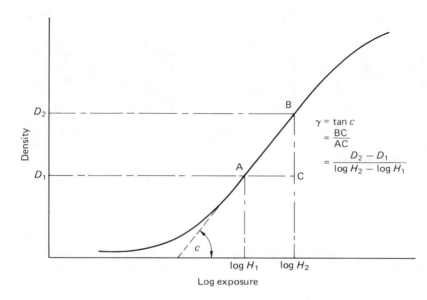

Figure 15.6 Gamma in terms of density and log exposure

and is seldom encountered. However, materials vary widely in the degree of solarization which they show. In general, the more efficient a material is at forming an image the less likely is solarization to occur.

Below the toe, the curve becomes parallel to the log H axis, a little way above it. The value of density in this region is termed *base-plus-fog density* or D_{min}, the minimum density obtainable with the process employed. Base density refers to the density of the support. Fog results from the development of unexposed grains (page 211). The point on the curve corresponding to the first perceptible density above fog is called the *threshold*.

The intersection of the extrapolated straight-line portion of the curve with the D_{min} produced is referred to as the *inertia point*, and the value of exposure at this point as the *inertia*.

On published characteristic curves the log exposure axis may be marked 'Relative log exposure', often abbreviated to 'Rel log H' or better, 'Log relative exposure', similarly abbreviated to 'Log rel H'. Use of a relative instead of an absolute scale of exposure does not affect the shape of the curve. though it does mean that absolute values of emulsion speed cannot be determined from the curve.

Variation of the characteristic curve with the material

The characteristic curves of individual materials differ from one another in their shapes and in their positions relative to the log H axis. The position of

the curve in relation to the log H axis depends upon the sensitivity or *speed* of the material. The faster the material, the farther to the left of the scale is the curve situated. Film speed is dealt with in detail in Chapter 19. The main variations in the shape of the curve are:

(1) Slope of linear portion (gamma)
(2) Length of linear portion

The length of the linear portion is usually expressed in terms of the density range from the point at which the toe merges with the straight line, to the point at which the straight line merges with the shoulder.

Photographic materials differ both in the maximum slope that can be achieved and in the rate at which the value of gamma increases. Modern negative materials are usually made to yield a gamma of 0.7 to 0.8 at normal development times. They commonly have a long toe, which may extend up to a density of as high as 0.7, and the straight line may be short or even non-existent. Some modern ultra-fast materials have a so-called bent-leg curve, which has in effect two straight-line portions of different slopes. The lower part of the curve is fairly steep, but at a density of about 1.2 the slope changes to a lower value. A curve of this shape may have certain advantages in the photography of subjects which contain relatively intense highlights, e.g. night scenes.

Materials intended for copying are usually designed to have a short toe (i.e. one which merges into the linear portion at a low density), and a long linear portion, the slope of which depends on the nature of the work for which the material is intended. Materials for copying capable of yielding

gammas ranging from below 1 up to 10 or more are available.

In the duplication of negatives it is necessary to use a material possessing a long linear portion, the slope of which can readily be controlled in processing. The exposure should be confined to the linear portion, and it is advantageous to develop to a gamma of unity. Curves for specific materials are published by film manufacturers.

Variation of the characteristic curve with development.

The H and D characteristic curve is not a fixed function of an emulsion, but alters in shape with the conditions of exposure, e.g., the colour (page 177) and intensity (page 187) of the light source, and with the conditions of processing; in particular, the curve is markedly affected by the degree of development (Chapter 17).

If the development time is varied, other conditions being kept constant, a series of H and D characteristic curves is obtained, which, in the absence of soluble bromide (or other anti-foggant) in the emulsion or developer, is of the type shown in Figure 15.7 in which density above fog is plotted against log exposure. It will be seen from this figure that whereas a single characteristic curve tells us a certain amount about the behaviour of a material, a family of curves made with varying development time gives a much more complete picture. The most obvious change in the curve with increasing development is the increase in the slope of the linear portion (gamma). For any given emulsion, then, gamma is a measure of the degree of development, and has for this reason sometimes been termed the *development factor*. Another point that may be noted is that the linear portions of all the four curves shown in the figure meet, when produced, at a common *inertia point*.

In the early days of sensitometry, a series of characteristic curves of the type shown in Figure 15.7 could be fairly readily obtainable with the sensitive materials of the time by using a developer free from bromide ion. This is not typical of materials used today, which commonly contain anti-foggants; also most modern developers now contain bromide ion in solution, and the curves obtained are usually of the general pattern shown in Figure 15.8. The straight lines are still seen to meet

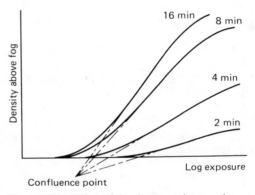

Figure 15.8 Effect of development time on characteristic curve of current sensitive materials

at a *confluence point* (although this is not invariably the case), but this point is depressed, i.e. is now below the log H axis. As a result, not only does the slope increase but the curve as a whole moves to the left as development time is increased, the inertia shifting towards a limiting value. This shift is termed *regression of inertia*. This corresponds to an increase in speed with increased development (page 229).

It is important to notice that throughout any consideration of the inertia and confluence points all densities must be recorded as values above D_{min} for each sample of film. (D_{min} itself, as well as speed and contrast, varies with development time.)

Gamma–time curve

By plotting gamma as ordinate against development time as abscissa we obtain a curve the general shape of which is illustrated in Figure 15.9.

Gamma increases very rapidly as development begins, and then increases at a more gradual rate until a point is reached where increased development produces no further increase in gamma. The value of gamma at this point is termed *gamma infinity* (γ_∞). Gamma infinity varies from emulsion to emulsion and depends to some extent on the developing solution used. A material capable of

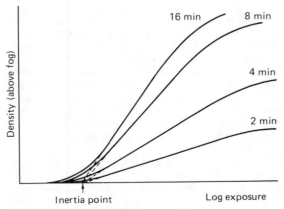

Figure 15.7 Effect of development time on charactereistic curve of older sensitive materials

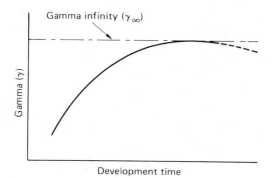

Figure 15.9 Gamma–time curve

yielding a high gamma infinity is said to be *high contrast material*. With most materials it is rarely desirable to develop to gamma infinity, as prolonged development is accompanied by an increase in fog and graininess, either or both of which may reach an unacceptable level before gamma infinity is achieved. Owing to *chemical fog*, gamma will actually fall off with very prolonged development, as the effect of the additional density due to fog is greater on low densities than on high. This fall-off is illustrated by the broken portion of the curve shown in Figure 15.9.

A gamma–time curve shows the value of gamma infinity obtainable with a given material and developer. It also shows the development time required to reach this or any lower value of gamma. We have seen that it is rarely desirable to employ the very top part of the gamma–time curve owing to the growth of fog and graininess. It is also usually unwise to employ the very bottom part, where a small increase in development time gives a large increase in gamma because in this region any slight inequalities in the degree of development across the

film will be accentuated, with the likelihood of uneven density or mottle.

Figure 15.10 contains gamma–time curves for a film in two differing developer formulae. Curve A was produced in an MQ developer of normal composition; curve B in an MQ-borax developer. Comparison of such curves assists in the choice of a suitable developer when the desired gamma is known. For example, if a gamma of 0.5 were desired the MQ-borax developer would be preferable to the MQ developer, since, with the latter, contrast is changing too rapidly with development time at the gamma required. On the other hand, to achieve a gamma of 1.1 the MQ developer would be the more suitable, the MQ-borax developer requiring an excessively long development time to reach this value.

Gamma–time curves for individual materials under stated conditions of development are published by film manufacturers. Such curves give a good indication of the general behaviour of a material, and can be of considerable assistance in the selection of a material and developer for a given task. However, because working conditions may vary from those specified and because of variations in materials in manufacture and during storage, in order to be of greatest value gamma–time curves for any given material should be determined by the user under the particular working conditions.

When plotting sensitometric results such as fog, emulsion speed or contrast against development time, it is often useful to adopt a logarithmic scale for time. This compresses the region of long development times and sometimes enables the more interesting results to approximate a straight-line graph. This is easier to draw and to use than a curve.

Variation of gamma with wavelength

Besides being dependent on development, gamma also depends to some extent on the colour of the exposing light. The variation within the visible spectrum is not great, but it becomes considerable in the ultraviolet region. The general tendency is for gamma to be lower as wavelength decreases. This variation of gamma can be ignored in ordinary photography, but must be taken into account in three-colour work and spectrography (page 156).

In the visible region the gamma of an emulsion can be controlled in manufacture by the addition of dyes. It has been possible, for three-colour work, to make available special emulsions in which the gammas achieved in the three main regions of the spectrum — blue, green and red — are very nearly equal.

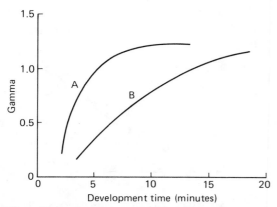

Figure 15.10 Gamma–time curves for the same material in two different developers

Placing of the subject on the characteristic curve

As we have already noted, a characteristic curve shows the response of a material under a wide range of exposures. Only a part of this curve is used in any single negative. The extent of the portion used depends on the subject luminance ratio;* its position depends on the actual luminances in the scene and on the exposure time and lens aperture employed.

We have already stated that the characteristic curves of most modern negative materials are characterised by a long toe. The part of the curve used by a 'correctly-exposed' negative includes part of this toe and the lower part of the straight-line portion. This is illustrated in Figure 15.11.

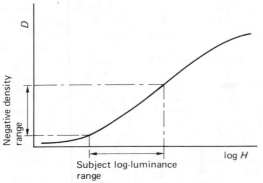

Figure 15.11 Portion of the characteristic curve employed by a 'correctly exposed' negative

Average gradient and \bar{G}

It follows from the fact that a negative usually occupies part of the toe of the curve as well as part of the straight line that gamma alone gives an incomplete picture of the contrast of an emulsion. Frequently, a better measure of contrast is obtained by taking the slope of the line joining the two limiting points of the portion of the characteristic curve employed (Figure 15.12). This is referred to as the *average gradient*. It is always lower than gamma. Several limiting points on the curve are specified in standards concerning special photographic materials. For normal negative films the quantity \bar{G} ('*G-bar*') is defined by Ilford as the slope of a line joining the point at a density of 0.1 above D_{min} (i.e. base-plus-fog density) with a second point on the characteristic curve 1.5 units log rel H in the direction of greater exposure.

*Strictly, it is the illuminance ratio of the image on the film with which we are concerned here, and, if flare is present, this will be less than the subject luminance ratio. In the present context we shall assume that flare is absent.

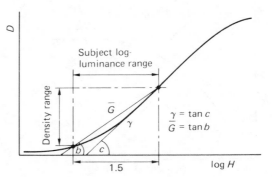

Figure 15.12 Average gradient

Contrast index

A measure of contrast used by Kodak is the *contrast index* which, like \bar{G}, takes into account the toe of the negative characteristic curve. The method of determination involves the use of a rather complicated transparent scale overlaid on the characteristic curve, although an approximate method is to draw an arc of 2.0 units cutting the characteristic curve and centred on a point 0.1 units above D_{min}. The slope of the straight line joining these two points is the contrast index.

A fuller and more rigorous description of contrast index determination is to be found in Kodak Data Booklet SE-1.

Two curves of different gamma but identical contrast index are illustrated in Figure 15.13. Negatives of identical contrast index produce acceptable prints using the same grade of printing paper. Gamma is clearly a poor guide to the density scale of a processed negative exposed partly on the foot of the curve.

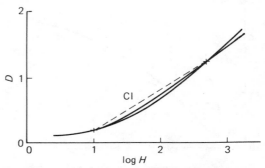

Figure 15.13 Two negative characteristic curves with different values of gamma (γ) but identical contrast index (CI)

Effect of variation in development on the negative

Let us assume that the negative represented by the curve in Figure 15.11 was given normal development. If we make two other identical exposures of the same subject, and give more development to one and less development to the other, we shall obtain two further curves such as those which are shown, together with the 'normally-developed' curve, in Figure 15.14. Because the camera exposure is the same in all three cases, the limiting points of the parts of the curves used, measured against the log H axis, are the same for all three curves.

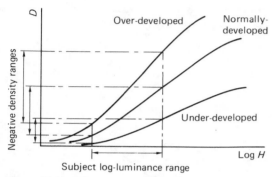

Figure 15.14 Effect on negative of variations in development

Figure 15.15 Subject tones

A study of these curves shows that over-development increases the density of the negative in the shadows to a small extent and in the highlights to a large extent. As a result, the negative as a whole is denser and, more important, its *density range* — the difference between the maximum and minimum densities – is increased. Under-development has the reverse effect. It decreases density in both shadows and highlights, in the highlights to a greater extent than in the shadows, and thus the density range of the negative is reduced and its overall density is less.

The major effect of variation in the degree of development is on the density range, known as the *contrast* (strictly, the *logarithmic contrast*) of the negative.

Effect of variation in exposure on the negative

Let us suppose that we are photographing the cube shown in Figure 15.15 and that S_1 is the darkest area in the subject, S_2 the next darkest, H_1 the highest highlight and H_2 the next highest. Then on a normally-exposed, normally-developed negative the exposures and densities corresponding to these areas will be approximately as shown in Figure 15.16.

In an under-exposed negative of the same subject, given the same development, the location of these points will be as shown in Figure 15.17.

Compared with the normally-exposed negative, the density range of the under-exposed negative is compressed. More important, the two shadow areas S_1 and S_2, although having different luminances and thus yielding different exposures on the film, yield the same density on the negative; they are thus no longer separated in any print. Some shadow detail is therefore completely lost, and the shadow detail that remains will be degraded. This is a case of gross under-exposure. Moderate under-exposure results

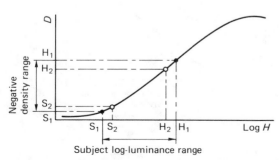

Figure 15.16 Densities on normal exposure and normal development

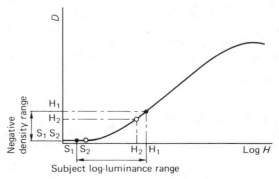

Figure 15.17 Densities on under-exposure and normal development

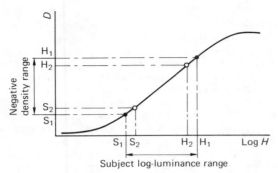

Figure 15.18 Densities on over-exposure and normal development

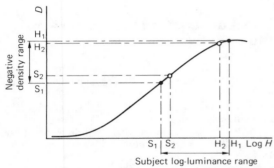

Figure 15.19 Densities on heavily over-exposed negative

in shadow detail being degraded but not completely lost.

In a moderately over-exposed negative given the same development, the four selected areas of the subject will be placed on the curve as shown in Figure 15.18. The average density of the negative is now greater than that of the normally-exposed negative, and the density range is expanded. In particular, tone separation in the shadows is increased.

However, in the case of a grossly over-exposed negative, the shoulder of the curve may be reached (Figure 15.19). In these circumstances the density range of the negative will be compressed, and highlight detail degraded if not completely lost. With modern negative films over-exposure sufficient to degrade highlight detail is fairly unusual; it is far more common to encounter under-exposure.

Exposure latitude

We define *exposure latitude* as the factor by which the minimum camera exposure required to give a negative with adequate shadow detail may be multiplied without loss of highlight detail. Latitude is illustrated in Figure 15.20.

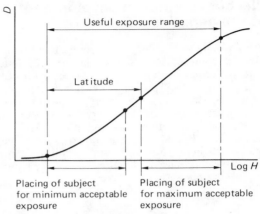

Figure 15.20 Exposure latitude

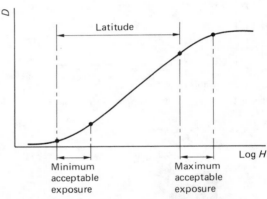

(a) Subject of low contrast — much latitude

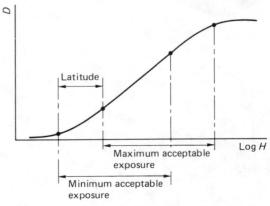

(b) Subject of high contrast — little latitude

Figure 15.21 Effect of subject contrast (luminance range) on latitude

We may call the distance along the log H axis between the lowest and highest usable points on the curve the *useful exposure range*. Useful exposure range depends principally upon the emulsion and the degree of development. These two factors also govern latitude, but this is also dependent upon the subject contrast, i.e. the subject log-luminance range. This is illustrated in Figure 15.21.

In practice, loss of highlight detail (which sets the upper limit to exposure) often results from loss of resolution due to graininess and irradiation (see Chapter 25), before the shoulder of the curve is reached. As the required level of resolution usually depends upon the negative size employed and the consequent degree of enlargement necessary in making the final print, we may add 'size of negative' to the factors above governing useful exposure range and latitude. Thus in general there is less exposure latitude with a small format than with a large one.

The log-luminance range of the average subject is less than the useful log-exposure range of the film, and there is usually considerable latitude in exposure. If, however, we have a subject with log-luminance range equal to the useful log-exposure range of the film there is no latitude, i.e. only one exposure is permissible. With the exceptional subject having a luminance range *greater* than the useful exposure range of the film no exposure will yield a perfect result; we must lose either shadow detail or highlight detail or both. All that we can do is to decide which end of the tone range we can best sacrifice.

If the subject range is below average we have extra latitude. In practice, however, this is limited on the under-exposure side by the fact that an exposure too near the minimum will be located entirely on the toe and may result in an unprintably soft negative. It is usually preferable to locate the subject on the characteristic curve in such a position that part at least of it is on the linear portion. In this way better negative contrast is achieved.

The response curve of a photographic paper

The characteristic curve of a paper is obtained in the same way as that of a film or plate, by plotting density against log exposure. Density in this case is *reflection density* and is defined by the equation:

$$D = \log \frac{1}{R}$$

where R, the *reflectance*, is the ratio of the light reflected by the image to the light reflected by the base or some 'standard' white. This definition of

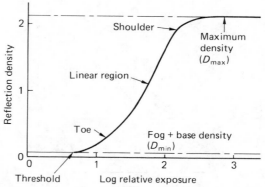

Figure 15.22 The 'geography' of the characteristic curve of a paper

reflection density is analogous to that of transmission density (page 170).

Figure 15.22 illustrates the general shape of the characteristic curve of a paper. This curve, like that of a negative material, can be divided into four main regions: toe, straight line (or linear region), shoulder and region of solarization, though the latter is seldom encountered.

The main differences between the curve of a paper and that of a film or plate are:

(1) The shoulder is reached at a relatively low density and turns over sharply, the curve becoming parallel to the log H axis at a value of D_{max} which rarely exceeds a value of 2.1.
(2) The toe extends to a fairly high density.
(3) The straight-line portion is short – in some papers, non-existent.
(4) The slope of the linear portion is generally quite steep compared with a film emulsion.
(5) Fog (under normal development conditions with correct safe-light) is absent, although the minimum density may slightly exceed the density of the paper base material alone owing to stain acquired in processing.

Differences (2) and (4) arise from the fact that when a silver image on an opaque base is viewed by reflected (as opposed to transmitted) light its effective density is increased, because light must pass through the image at least twice.

Maximum black

The practical consequence of (1) above is that the maximum density obtainable on any paper is limited, however long the exposure or the development. The highest value of density which can be obtained for a particular paper with full exposure

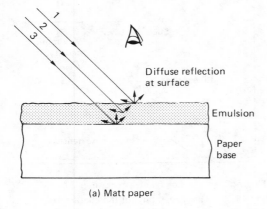

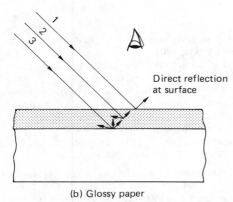

Figure 15.23 Diagrammatic representation of the reflection of light striking two papers of differing surface characteristics

and development is called the *maximum black* of the paper. The maximum density obtained on any given paper depends principally on the type of surface. It can be seen from Figure 15.23 that light incident on the surface of a print undergoes three types of reflection:

(1) Part is reflected by the surface of the gelatin layer in which the silver grains are embedded.
(2) Part is reflected by the silver grains themselves.
(3) The remainder is reflected by the surface of the paper base itself (or the baryta coating on the base).

It is the sum of these three reflections that determines the reflectance and hence the density of the print.

By increasing the exposure received by a paper, and thus the amount of silver in the developed image, we can eliminate entirely the reflection from the paper base, but reflections from the gelatin surface of the emulsion and from the individual

grains themselves cannot be reduced in this way. It is these reflections that set a limit to the maximum black obtainable.

The reflection from the surface of the emulsion depends upon the nature of this surface. A print will normally be viewed in such a way that direct reflection from its surface does not enter the eye. We are therefore concerned only with diffuse reflection. Now, the reflection from the surface of a glossy paper is almost entirely direct, so that the amount of light reflected from the surface of such a paper which enters the eye when viewing a print is very small indeed. In these circumstances, the limit to the maximum density of the print is governed principally by the light reflected by the silver image itself. This is usually a little less than 1 per cent, corresponding to a maximum black of just over 2.0. The reflection from the surface of a matt paper, on the other hand, is almost completely diffuse, so that an appreciable amount of light (say 4 per cent) from the surface of the paper reaches the eye, in addition to the light from the silver image. (There may also be light reflected from starch grains, included in the emulsion of many matt papers.) The maximum black of matt papers is therefore relatively low. Semi-matt and 'stipple' papers have values of maximum black intermediate between those of matt and glossy papers. The following figures are typical of the values of maximum black obtainable on papers of three main types of surface.

Surface	Reflection density (maximum)
Glossy, glazed	2.10
Glossy, unglazed	1.85
Semi-matt	1.65
Matt	1.30

Modern resin-coated printing papers are not glazed after processing but possess a high natural gloss and thus may achieve a D_{max} of over 2.0 without glazing. Glossy colour prints possess little

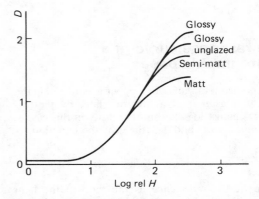

Figure 15.24 Characteristics of papers of different surfaces

reflecting material other than the paper base, and values as high as 2.5 are not uncommon.

The effect of variation in maximum black on the characteristic curve is confined largely to the shoulder of the curve, as shown in Figure 15.24.

Exposure range of a paper

The ratio of the exposures corresponding to the highest and lowest points on the curve employed in a normal print is termed the exposure range of the paper (Figure 15.25). This may be expressed either in exposure units or in log exposure units.

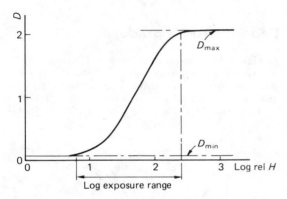

Figure 15.25 Exposure range of a printing paper

Variation of the print curve with the type of emulsion

Photographic papers are of three main types: contact (chloride) papers, chlorobromide papers and bromide papers (see Chapter 21). The characteristic curves of these papers differ somewhat in shape. To illustrate these differences, characteristic curves of two widely-differing papers of the same grade are shown in Figure 15.26.

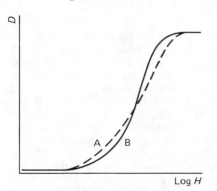

Figure 15.26 Characteristic curves of two different papers

It will be seen that although in the examples selected both papers give the same range of tones, i.e. have the same density range, and both have the same exposure range, the relation of density to log-exposure is not the same in the two cases. With paper A the density increases evenly with the increase in log-exposure, but with paper B the relation of density to log-exposure is markedly S-shaped, i.e. highly non-linear. In practice, paper A would be expected to give better tone separation in the shadows and highlights than paper B. Curve A is typical of chloride papers and curve B of bromide papers; a chlorobromide paper curve would be intermediate between the two.

Variation of the print curve with development

With papers the characteristic curve varies with development, but rather differently from that of negative film. Figure 15.27 shows a family of curves for a bromide paper. The normally recommended development time for this paper (in the developer employed) is 2 minutes at 20°C.

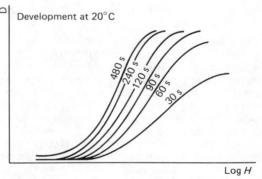

Figure 15.27 Characteristic curves of a typical bromide paper for different development times

With bromide papers, development normally requires a minimum of about 1½ minutes. At longer development times the curve moves to the left, but, unlike the curve of a chloride paper, the slope may increase slightly. In other words, both speed and contrast of a bromide paper increase on prolonged development. The increase in contrast is not great, but it is sometimes sufficient to be of practical value. The major effect of variation of development time on papers of all types is on the speed of the paper.

The situation may be complicated by the composition of 'bromide' paper, which may contain a significant proportion of silver chloride. This modifies the development behaviour so that there is no further contrast increase once maximum black has been reached.

With papers of all types, there is *development latitude* between the two extremes of under- and over-development. With the bromide paper shown in Figure 15.27, this extends from about 1½ minutes to 4 minutes. Between these times the maximum black is achieved but with no increase in fog. The ratio of the exposure times required at the shortest and longest acceptable times of development is referred to as the *printing exposure latitude*. Development latitude and exposure latitude are inter-related; both cannot be used at the same time. Thus, when once an exposure has been made there is only one development time that will give a print of the required density.

Requirements in a print

It is generally agreed that in a print:

(1) All the important negative tones should appear in the print.
(2) The print should show the full range of tones between black and white that is capable of being produced on the paper used. (Even in high-key and low-key photographs it is usually desirable that the print should show *some* white and *some* black, however small these areas may be.)

In printing, the actual exposure of the paper in any given area is governed by the density of the negative in the corresponding area; the greater the density of any negative area, the less the exposure, and vice versa. In order, then, to meet both requirements (1) and (2) above, the exposure through the highlight areas of the negative must correspond with the toe of the curve of the printing paper, and the exposure through the shadow areas of the negative must correspond with the shoulder of this curve. Expressed sensitometrically, this means that the log-exposure range of the paper must equal the density range of the negative. This correspondence is illustrated in Figure 15.28, which shows the negative characteristic curve together with that of an appropriate and an inappropriate printing paper (too contrasty).

Now, not all negatives have the same density range, which varies with the log-luminance range of the subject, the emulsion used, the exposure and the degree of development. Obviously, therefore, no single paper will suit all negatives, because, as we have seen, the log-exposure range of a paper is a more or less fixed characteristic, affected only slightly (if at all) by development. A single paper with a sufficiently long log-exposure range would enable requirements (1) to be met in all cases, but not requirement (2). Printing papers are therefore produced in a series of *contrast grades*, each of the papers in the series having a different log-exposure range. Figure 15.28 shows two such grades and relates them to the negative density range.

Paper contrast grades

In Figure 15.29 are shown the characteristic curves of a series of bromide papers. These papers all have the same surface and differ only in their contrast grades, which are described as soft, normal and hard respectively. All three papers have been developed

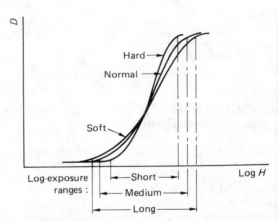

Figure 15.29 Paper contrast grades

for the same time. It will be noted that the three curves show the same maximum black, but the steepness of the curve increases and the exposure range decreases as we progress from the soft grade to the hard. From this we see that the descriptions 'soft', 'normal' and 'hard' apply to the inherent contrasts of the papers themselves, and not to the negatives with which they are to be used. The soft paper with long log-exposure range, is, in fact, intended for use with hard negatives, with high density range. Conversely, the hard paper, with short log-exposure range, is intended for use with soft negatives, with low density range.

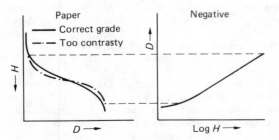

Figure 15.28 Negative and paper characteristics

If negatives of the same subject, differing only in contrast, are each printed on papers of the appropriate exposure range, the prints will be practically identical. If, however, an attempt is made to print a negative on a paper with too short a log-exposure range (i.e. too hard a paper), and exposure is adjusted to give correct density in, say, the highlights, then the shadows will be over-exposed, shadow detail will be lost in areas of maximum black, and the result will appear too hard. If, on the other hand, a paper of too long a log-exposure range is used (i.e. too soft a grade) and exposure is again adjusted for the highlights, the shadow areas of the print will be under-exposed and the result will appear flat.

The softer the grade of paper, i.e. the longer its log-exposure range, the greater is the exposure latitude (as defined earlier) in printing. It is however, generally unwise to aim at producing negatives suited to the softest available paper because one then has no grade to fall back upon if for some reason a negative proves to be exceptionally contrasty. It is therefore generally best to aim at the production of negatives suitable for printing on a middle grade of paper.

A simple, if only approximate, check on the (arithmetic) exposure range of a paper can be made by giving to a strip of it a series of progressively-increasing exposures. The exposure ratio is the ratio of the exposure time required to yield the deepest black that the paper will give to that required to produce a just perceptible density (see also page 194).

The problem of the subject of high contrast

Meeting the formal requirements (1) and (2) on page 184 does not necessarily imply that the resulting print will be aesthetically pleasing. In practice, the print will usually be satisfactory if the subject luminance range is not high; but with a subject of high contrast the result will often appear flat, even though both the formal requirements have been met. This is because the log-luminance range of a high-contrast subject is far greater than the maximum density range that can be obtained on a paper.

Two remedies are possible. The simplest is to print the negative on a harder grade of paper and to sacrifice detail at either the shadow or the highlight end of the scale. This, in effect, means abandoning requirement (1) but is often satisfactory. A preferred remedy is to use a harder grade of paper but to isolate the various tone-bands within the picture, and treat them individually by *printing in*, or by use of masks. In this way we can obtain the contrast we require within the various tone-bands of the picture without sacrificing detail at either end of the scale.

For aesthetic reasons it may be considered appropriate to produce a considerable measure of distortion in the tones of the final print.

Tone reproduction

The relation of the reflectances of the various areas of a print (or luminances when the print is suitably illuminated) to the corresponding luminances of the subject is referred to as *tone reproduction*. Our goal in photography is normally to obtain an acceptable reproduction of the various luminances of the original scene, thus keeping each tone in approximately the same relative position in the tone scale. We cannot always do this, but the very least we should strive for is to retain *tone separation* throughout the whole range of tones.

The optimum objective result to be aimed at is *proportionality* between print luminances and subject luminances throughout the whole range of the subject; *equality* can rarely be hoped for, because the range of luminances possible on a paper is less than the luminance range of the average subject.

Hurter and Driffield were the first to study the problem of tone reproduction from the sensitometric point of view. Their work extended over the period 1874–1915, their classic paper being published in 1890. At this time, the popular negative and printing materials all yielded characteristic curves with a long straight line. Hurter and Driffield took the view that perfect tone rendering in the print could only be achieved by first obtaining a negative in which all the values of opacity were proportional to the luminances of the subject. They stated that, for correct reproduction, exposure should be judged so that all the tones of the subject are recorded on the linear portion of the characteristic curve, and the negative should be developed to a gamma of 1.0. This state of affairs is illustrated in Figure 15.30,

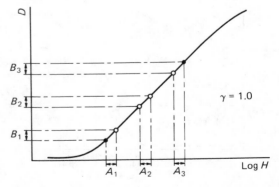

Figure 15.30 Using straight-line portion of characteristic curve

where it is apparent that if the log exposure differences, A_1, A_2 and A_3 are all equal, then the corresponding density differences B_1, B_2 and B_3 will also be equal to one another and to A_1, A_2 and A_3.

From their 'correct' negative Hurter and Driffield made prints on carbon, platinum or gold-toned printing-out-papers (POP) using only the linear portion of the paper curve. All these papers had characteristic curves with a short toe and short shoulder, so that, assuming the papers to be capable of yielding a gamma of 1.0, it was quite a simple matter to obtain technically-correct reproduction of many types of subject. If the gamma of the paper selected was not 1.0 (it was usually greater), correct reproduction could be obtained by developing the negative to a gamma equal to the reciprocal of the print gamma, so that the product of the gammas of negative and positive remained unity. Hurter and Driffield's approach, although not generally applicable to modern materials, is the basis of the methods used for the preparation of duplicate negatives.

The introduction of chloride and bromide papers early in the present century altered the situation, because these papers have a short linear portion and a long toe. It is impracticable when printing on these materials to use only the linear portion of the curve, and, therefore, with such papers, a negative made to

Hurter and Driffield's specification does not give correct tone reproduction. Some distortion is in fact inevitable at the printing operation; our aim must be to introduce the appropriate distortion in the negative to counteract this.

Now, fast modern negative materials also have a long toe, use of which does in fact introduce some distortion, fortunately in the right direction. If, therefore, as is usual, we place our shadow tones on the toe of the curve of such a negative material and the highlights on the straight line (page 178), the contrast in the shadows of the negative is lower than in the highlights. In printing, however, the contrast of the paper curve in the shadows (located on the upper half of the curve) is greater than the contrast in the highlights, which are on the toe. The overall effect in the final print, therefore, is to yield roughly proportional contrast throughout the whole tone range. This is illustrated in Figure 15.31.

The quadrant diagram

It has been found valuable to employ graphical methods to study the problems of tone reproduction, one very useful method being the so-called *quadrant diagram* originated by L.A.Jones. This enables practical problems in tone reproduction to be studied scientifically.

The simplest form of quadrant diagram is illustrated in Figure 15.32. This employs four quadrants, representing respectively the negative, the print and the overall reproduction, the remaining quadrant being a transfer quadrant. For a more complete solution of the problem, other quadrants may be

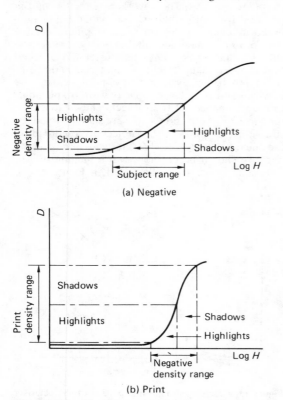

Figure 15.31 Obtaining proportional contrast in prints

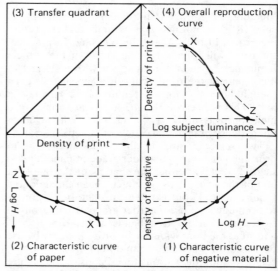

Figure 15.32 A quadrant diagram

added as desired, to illustrate the effects of flare, viewing conditions, intensification or reduction, etc.

In quadrant 1 of Figure 15.32, the densities of the negative have been plotted against the log-luminances of the original subject. If the camera is free from flare, this curve will be identical with the characteristic curve of the material, in which density is plotted against the log of the exposure received by the film. The characteristic curve of the printing paper appears in quadrant 2. This is turned through 90° in a clockwise direction from its normal position, as in Figure 15.28, to enable density values on the negative to be transferred directly to the log-exposure scale of the positive.

To relate print densities to subject log-luminances we draw lines parallel to the axes to link corresponding points on the negative and positive curves, turning the lines proceeding from the positive curve through 90° in the transfer quadrant to intersect the lines from the negative curve in quadrant 4. By linking corresponding points, such as *x*, *y* and *z*, for every part of the negative and positive curves we obtain an *overall reproduction curve* as shown. For exact reproduction this curve should take the form of a straight line at 45° to the axes. In practice it is always more-or-less S-shaped, owing to the non-linearities in the negative and positive characteristic curves. Flattening at the top of the reproduction curve indicates tone compression in the shadows, arising from the non-linearity of the toe of the negative characteristic curves. Flattening at the bottom of the curve indicates tone compression in the highlights arising from the non-linearity of the toe of the print characteristic curve.

The quadrant diagram may also be used to examine the requirements for negative duplication (Figure 15.33). A duplicate negative is defined as a negative which possesses density relations identical with those of the original negative, and produces an identical print when printed on the same grade of printing paper. It should be noted that there is no requirement for the duplicate to have the same *densities* as the original negative, merely the same *density range*: it may be lighter or darker overall than the original. It is usually darker. The first step in duplication is to produce an intermediate positive record on a film possessing a linear characteristic, the exposure being such as to locate the image entirely on that linear region, and the development controlled to give a gamma of unity. The intermediate positive is then printed on the same film material using identical exposure and development criteria to obtain a negative once more. Provided the gamma has been correctly controlled, with all exposures made on the linear portion of the intermediate film characteristic, the final negative will have the same tone reproduction properties as the original negative. It may well, however, have a higher minimum density, owing to the necessity of using only the linear region of the intermediate film characteristic. If the intermediate positive is not made at a gamma of unity, then (in order to maintain the overall tone reproduction) the gamma of the next stage must be the reciprocal of the gamma of the intermediate positive.

Reciprocity law failure

The reciprocity law, enunciated by Bunsen and Roscoe in 1862, states that for any given photosensitive material, the photochemical effects are directly proportional to the incident light energy, ie the product of the illuminance and the duration of the exposure. For a photographic emulsion this means that the same density will be obtained if either illuminance or exposure duration is varied, provided that the other factor is varied in such a way as to keep the product *H* in the equation $H = Et$ (page 169) constant.

Abney first drew attention to the fact that the photographic effect depends on the actual values of *H* and *t*, and not solely on their product. This so-called *reciprocity failure* arises because the effect of exposure on a photographic material depends on the *rate* at which the energy is supplied (see page 147). All emulsions exhibit reciprocity failure to some extent, but it is usually serious only at very high or very low levels of illumination, and for much general photography the reciprocity law can be considered to hold. In the sensitometric laboratory, however, the effects of reciprocity failure cannot be

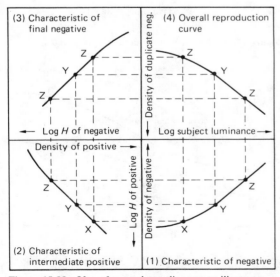

Figure 15.33 Use of a quadrant diagram to illustrate duplication of a negative

ignored, nor in certain practical applications of photography.

Practical effects of reciprocity failure

Reciprocity failure is encountered in practice as a loss of speed and increase in contrast at low levels of illumination. The degree of the falling-off in speed and the region at which maximum speed is obtained varies from material to material. The effects of reciprocity failure are illustrated in Figures 15.34 to 15.36.

Figure 15.35 shows that the variation in speed with exposure time and illumination level is quite different for two types of emulsion. In manufacture, emulsions are designed so that the optimum intensity is close to the intensity normally employed. Thus, the fast negative film is intended for use at high intensities, with exposure of a fraction of a second, and the astronomical plate is intended for use at low intensities, with exposures of minutes or hours.

The loss of speed and contrast at short exposure times assumes practical importance with high-voltage electronic flash, which may give very short exposures. It may then be necessary to increase development times to compensate for these effects.

As the result of reciprocity failure, a series of graded exposures made on a time scale yields a result different from a set made on an intensity scale. Consequently, in sensitometry, a scale appropriate to the conditions in use must be chosen if the resulting curves are to bear a true relation to practice. For the same reason, filter factors (page 132) depend on whether the increase in exposure of the filtered negative is obtained by increasing the intensity of exposure (by varying the light intensity or the lens aperture) or by varying the exposure duration. In the former case the filter factor is independent of the time of exposure, but in the latter case it depends largely on the exposure time required by the unfiltered negative. Two types of filter factor are therefore quoted for some types of work: 'intensity-scale' factors and 'time-scale' factors. (An explanation of the terms intensity-scale and time-scale is given on page 190). Because of reciprocity failure, exposure times for the making of giant enlargements are sometimes unexpectedly long (page 298).

The variation of speed and contrast with differing exposure duration is usually different for each of the three emulsion layers present in colour materials (Chapter 24). Consequently, departures from recommended exposing conditions may lead to unacceptable changes in colour balance for which no compensation may be possible.

It should be noted that although the mechanisms underlying the anomalous reciprocity effects are

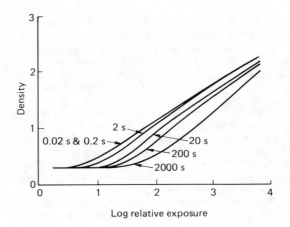

Figure 15.34 Characteristic curves of a fast negative film for different exposure times

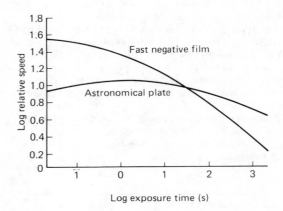

Figure 15.35 Reciprocity failure effect on speed

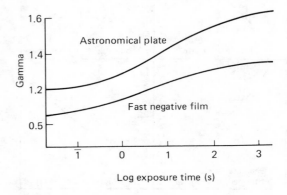

Figure 15.36 Reciprocity failure effect on contrast

dependent on the illuminance on the emulsion and can be adequately explained only on that basis, it is the *duration of the exposure* that is critical in determining the importance of reciprocity failure to the practical photographer.

Intermittency effect

An exposure given in a series of instalments does not usually lead to the same result as a continuous exposure of the same total duration. This variation is known as the *intermittency effect*. It is associated with reciprocity failure, and its magnitude varies with the material. In practical photography the intermittency effect is not important. In sensitometry, however, the effect cannot be ignored, as some sensitometers give intermittent exposures. It is found, however, that a continous exposure and an intermittent exposure of the same average intensity produce similar effects when the frequency of the flash exceeds a certain critical value, which varies with the intensity level. It is important, therefore, that intermittent exposures given in a sensitometer should be made at a rate above a critical frequency, which has to be determined by experiment for each emulsion studied.

Sensitometric practice

It would be possible to construct the characteristic curve of an emulsion, or at least part of the curve, from the negative of a pictorial subject, by measuring the log-luminances of the various parts of the subject and plotting them against the densities of the corresponding areas of the negative. This is illustrated in Figure 15.37. This would, however, be an exceedingly laborious method if many curves were required, and it is not normally adopted. Instead, a standard 'negative' is produced by giving a known range of exposures to the material under test. The production of characteristic curves by this method involves:

(1) Exposure of a strip of the material in a graded series of exposures; this is carried out in a sensitometer.
(2) Processing of the exposed material under controlled conditions.
(3) Measurement of the densities obtained; this is carried out using a densitometer.
(4) Plotting of the results.

Sensitometry requires careful work and, to be of full value, the use of special apparatus. In manufacturers' laboratories, where the production of characteristic curves is a routine, elaborate apparatus (usually designed by the manufacturer's own research staff) is employed.

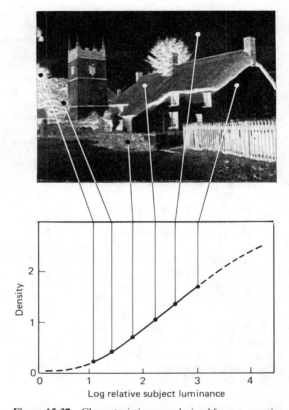

Figure 15.37 Characteristic curve derived from a negative

Sensitometers

A *sensitometer* is an instrument for exposing a photographic material in a graded series of steps, the values of which are accurately known. The essentials of a sensitometer are:

(1) *A light source of standard intensity and colour quality*. Many sources have been proposed and used at various times. The light source adopted as standard in recent years has been a gas-filled tungsten lamp operating at a colour temperature of 2850 K. The lamp is used with a selectively absorbing filter to yield the spectral distribution that corresponds to daylight of 5500 K modified by a typical camera lens. The filter used may be made of a suitable glass or employ specified solutions made up by the user. The colour temperature of 5500 K corresponds to daylight with the sun at a height typical of temperate zones during the hours recommended for colour photography and is therefore suitable for the exposure of colour and monochrome films designed for daylight

use. Any sensitometric light source, particularly when used for colour materials, must be stabilized in terms of both luminous intensity and colour temperature. Fluctuations in mains voltage can alter both quantities, and are generally compensated by sophisticated voltage stabilizers. Alternatively batteries may sometimes be used to avoid power fluctuations. In most cases a DC supply to the lamp is used to avoid AC modulation of the exposure, which may be significant at short exposure times.

(2) *A means of modulating the light intensity*. To produce the graded series of exposures, it is possible to alter either the illuminance or the time during which the exposure lasts. As already stated, because of reciprocity failure the two methods will not necessarily give the same results, and, to obtain sensitometric data which will correctly indicate the behaviour of the material under the conditions of use, the exposure times and intensities should be comparable with those which the material is designed to receive in practice.

A series of exposures in which the scale is obtained by varying the intensity – referred to as an *intensity scale* – can conveniently be achieved by use of a neutral 'step wedge' or 'step tablet'. A series of exposures in which the scale is obtained by varying the time – referred to as a *time scale* – may be achieved by use of a rotating sector wheel (Figure

15.38a), a falling plate (Figure 15.38b) or, in some cases a sectored cylindrical drum. Whichever system of modulation is chosen, a sensitometer is designed so that the exposures increase logarithmically along the length of the strip. The log-exposure steps are usually 0.3, 0.2, 0.15 or 0.1. If for any reason it is desired to interrupt the exposure, this must be done in such a way that the intermittency effect (page 189) does not affect the results. Figure 15.39 shows a typical sensitometric strip. This particular example was produced in an intensity-scale sensitometer, being exposed behind a step wedge.

As actual exposure in the camera is best represented by an intensity scale of exposures, sensitometers used for process control are of the intensity-scale type. Early commercial sensitometers were usually time-scale instruments, because the design problems are fewer, but this was not at the time a serious drawback. On occasion, however, it did cause confusion, and modern commercial sensitometers are nearly always intensity-scale instruments.

Densitometers

The name *densitometer* is given to special forms of photometer designed to measure photographic densities. Instruments designed to measure the densities of films and plates are described as *transmission densitometers*, while those designed to measure papers are termed *reflection densitometers*. Some densitometers are designed to enable both transmission and reflection densities to be measured on the one instrument.

Densitometers can be broadly classified into two types : visual and electronic. The earliest densitometers were visual instruments and, although density measurements in quantity are nowadays invariably carried out on electronic instruments, visual instruments are still of value when only a few readings are required and eyestrain is unlikely to be a problem. They have the merit of simplicity, and are relatively cheap. The Kodak RT Colour Densitometer is a visual instrument designed to enable both transmission and reflection densities to be measured. The principle of this instrument is shown diagrammatically in Figure 17.40.

Electronic densitometers are of many different types, ranging from simple direct-reading instruments to instruments with highly sophisticated cir-

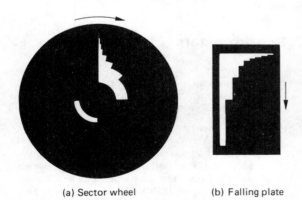

(a) Sector wheel (b) Falling plate

Figure 15.38 Two types of time-scale sensitometer shutter

Figure 15.39 A sensitometric strip

Sensitometry 191

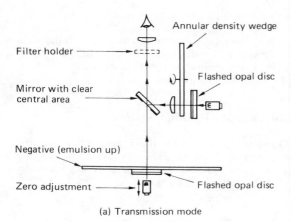

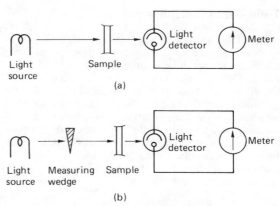

Figure 15.41 Single-beam instruments. (a) Direct-reading; (b) substitution or null-reading

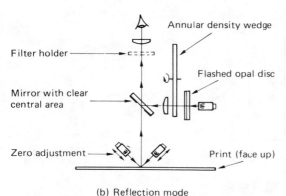

(a) Transmission mode

(b) Reflection mode

Figure 15.40 Arrangement of the Kodak RT Colour Densitometer

cuits employing a null system, with, in some instances, automatic plotting of the results.

The light detectors used in electronic densitometers may be devices using vacuum-tube technology such as photoemissive cells and photomultipliers, or solid-state devices such as photodiodes and phototransistors. Although the former devices are still widely used there is a trend towards the universal use of solid-state detectors.

Single-beam instruments, direct reading

The commonest type of densitometer uses a light-sensitive detector illuminated by a beam of light in which the sample to be measured is placed. The response of the detector is displayed on a meter calibrated in units of density. The design is illustrated in Figure 15.41a, a single-beam direct-reading densitometer. Such instruments are usually set up for measurement by adjusting the density reading to zero when no sample is present in the beam. This operation may be followed by a high-density setting

using some calibration standard, or even an opaque shutter for zero-illumination. Once set up, the instrument is used for direct measurements of the density of samples placed in the beam.

Stability of light output, of any electronics used (not shown in Figure 15.4) and of performance by the detector are required for accurate density determination. In practice fairly frequent checks of the instrument zero may be required to eliminate drift. A further requirement of the direct-reading instrument is linearity of response to changes of illuminance.

Single-beam instruments, null reading

In order to avoid difficulties due to non-linearity of response it is possible to arrange for the illumination to remain constant no matter what density is to be measured. The design of the instrument is shown in Figure 15.41b. In this, a substitution method is used.

The *measuring wedge* inserted into the measuring beam is a continuous neutral-density wedge calibrated so that its density is known at any point inserted in the beam. The instrument zero is established by moving the wedge so that its maximum density lies in the beam and arranging that the meter needle is at a single calibration position. The sample to be measured is placed in the beam and the meter restored to its null position by withdrawal of the measuring wedge. The density of the sample is given by the extent of withdrawal.

The consistency of density measurement thus depends on the same factors as for direct-reading instruments with the exception that cell non-linearity is eliminated as a source of error. On the other hand the measuring wedge calibration is introduced, but this is a less serious source of potential error.

Twin-beam instruments

Many of the sources of error inherent in single-beam instruments can be eliminated if two beams are taken from the same source, as shown in Figure 15.42. One beam, A in the diagram, has a path identical with that of a null-reading single-beam instrument, while the other beam, B, passes through an uncalibrated compensating wedge before illuminating a second photo-cell. The outputs of the two cells are compared electronically and the difference between them is indicated on the meter. Normally only one gradation is shown on the meter, all readings being of the null type.

small differences between two compared densities. From figure 15.40 it can be seen that visual densitometers compare the unknown density with that of a calibrated wedge displayed side-by-side in the visual field. The illumination is not maintained constant in the illustrated instrument.

Automatic plotting

Densitometers used for the measurement of large numbers of sensitometric strips are often arranged so that the characteristic curve is automatically plotted by the instrument.

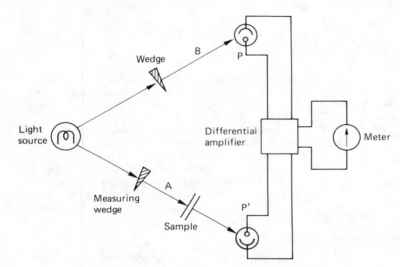

Figure 15.42 Twin-beam differential or null-reading instrument

To zero the instrument the measuring wedge is inserted into the measuring beam, A, to its maximum density. In general the meter will not then be at its null position. The uncalibrated wedge is then inserted in the compensating beam and adjusted so that the meter registers no deflection from the null position. Measurements are then made by placing samples in the measuring beam and withdrawing the measuring wedge until the null reading is restored, the extent of withdrawal indicating the density of the sample. Fluctuations in lamp output affect both beams equally and are thus compensated in instruments of this type. The detectors are maintained under constant conditions of illumination and no assumptions of linearity of response are required. The accuracy of the instrument depends on the calibration of the measuring wedge, sources of short-term errors in density being eliminated by this design.

Visual densitometers are differential twin-beam instruments. Although unreliable as an absolute judge of density, the human eye is very sensitive to

To achieve this a pen is moved across appropriately scaled graph-paper at a rate corresponding to the movement of a sensitometric strip past the measuring aperture. This requires the strip to have been exposed through a *continuous* sensitometric wedge, the density of which varies directly with distance. The density detected by the instrument is revealed as a signal which makes a servo-motor drive the plotting pen to an appropriate position relative to the density scale on the graph paper. Usually the servo-motor drives the measuring wedge to a null position using a mechanical link to which the pen is attached.

One type of automatic-plotting densitometer is illustrated in Figure 15.43. It is called a *twin-beam split and chopped* instrument. The desirable features of twin-beam operation are retained but the two beams are used to illuminate a single photo-cell. The *chopper* is a rotating shutter which allows the beams to reach the cell alternately. Any difference between the beam intensities appears as a variation of the output current from the photo-cell. The variation

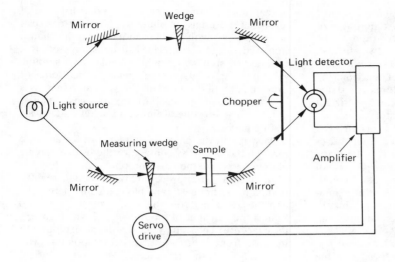

Figure 15.43 Automatic plotting densitometer (twin-beam split and chopped)

can be amplified electronically and used to drive the servo-motor and measuring wedge to the null position.

Microdensitometers

These instruments are used to examine density changes over very small areas of the image. These microstructural details are measured for the assessment of granularity, acutance and modulation transfer function as described in Chapter 25.

To measure the density of a very small area it is usual to adapt a microscope system, replacing the human eye by a photo-multiplier tube. The sample is driven slowly across the microscope stage in synchronism with graph paper moving past a pen which registers density in a manner similar to that of the automatic-plotting densitometers already considered. Microdensitomers are commonly twin-beam instruments, and the ratio of graph-paper movement to sample movement may be as great as 1000:1.

Colour densitometers

In addition to monochrome silver images, it is often necessary to make sensitometric measurements of colour images. These are composed of just three dyes absorbing red, green and blue light respectively. It is therefore possible to assess colour images by making density measurements in these three spectral regions. Colour densitometers are similar to monochrome instruments but are equipped with three primary colour filters: red, green and blue.

The behaviour of a dye image can be assessed most effectively when the densitometer measures only within the spectral absorption band of the dye.

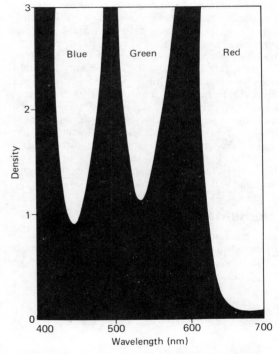

Figure 15.44 Blue, green and red filters for colour densitometry

So colour densitometers are usually equipped with narrow-band filters, a typical set being shown in Figure 15.44. In view of the unwanted spectral absorptions of image dyes (see Chapter 16) it will be appreciated that a colour-density measurement (red, green or blue), represents the sum of contributions from all the dyes present. Such measured

densities are described as *integral densities*. For most purposes no further information is required, but sometimes a single image dye is required to be measured in the presence of the other two. In such cases *analytical densities*, which reflect the individual dye concentrations, have to be calculated from the measured integral densities. Procedures for doing this are beyond the scope of this work; it is sufficient to note that, outside a research laboratory, there are no simple methods of measuring analytical densities.

An important choice of densitometer filters arises when the response of the instrument is to be matched to that of a colour print paper. The purpose of this exercise is to use a densitometer to assess colour negatives and hence to predict the printing conditions required to yield a good colour print. Instruments set up according to recommendations from Kodak for the measurement of Kodak masked negatives are said to give *Status M densitometry*. When set up so that visual neutrals formed of the three image dyes of a reversal film give red, green and blue densities which are identical and equal to those of a matching non-selective neutral (such as silver), the system is described as *Status A densitometry*. These designated types of density have become internationally-recognized ISO standards.

The spectral responses of instruments for Status densitometry are tightly specified. It may not, however, be necessary to establish a system meeting such specifications because arbitrary integral densities are often satisfactory for such purposes as quality control. As with black-and-white densitometers the commonest type is the direct-reading single-beam instrument. Instruments of this type include Gretag transmission and MacBeth transmission and reflection densitometers.

Elementary sensitometry

An elementary form of sensitometry, which (although not of a high degree of precision) can be of real practical value in testing the performance of sensitised materials or photographic solutions, can be carried out with nothing more elaborate than a step wedge and a simple visual densitometer. If a commercial step wedge is not available, a suitable substitute can be made by giving a stepped series of exposures to an ordinary film. Useful step increases in a wedge used for this purpose are density values of 0.15 for the testing of films and plates and 0.1 for testing papers.

A strip of the material under test is exposed through the wedge by contact, or the wedge may be illuminated from the rear and photographed with a camera. If the latter procedure is adopted, care must be taken to eliminate possible causes of flare. The densities obtained on the strip are then plotted against the densities of the step wedge which govern the exposure. The step wedge densities are plotted to increase from right to left, this corresponding with log exposure of the strip increasing from left to right in the usual way.

Simple sensitometry of this type may be used for various purposes, e.g.:

(1) To study the effect of increasing development on the speed and contrast of an emulsion.
(2) To compare the emulsion speeds and contrasts yielded by two developers.
(3) To compare the speeds of two emulsions.
(4) To compare the contrasts of two emulsions.
(5) To determine filter factors.
(6) To measure the exposure range of a printing paper.

The luminous intensity, distance, etc., of the lamp used are needed only if we wish to find the absolute speed of a material. All the characteristics listed above can be studied without this information, provided the luminous intensity, distance and colour temperature of the lamp remain constant and that identical exposure times are given.

16　The reproduction of colour

In photography two alternative approaches to the reproduction of colour are open to us: all objects, of any colour, can be reproduced as shades of grey varying from black to white or may be reproduced in colours that are acceptably close to those of the original. Black-and-white photography existed for nearly a century before colour photography became common, and it was found very early that the brain would accept a monochrome picture as a true record of coloured objects provided the greys of the reproduction were related to the brightnesses of the original colours. To understand how this is achieved we need to know something about the responses of the eye and of photographic emulsions to different colours. We shall then go on to consider the reproduction of colour by colour films, a rather more complicated story.

Colours in the spectrum

We saw in Chapters 2 and 4 that white light can be separated by means of a prism into light of different colours – violet, blue, green, yellow, orange and red. We also saw that these correspond to different wavelengths. White light is a mixture of light of different wavelengths. Light consisting of a single wavelength, or narrow band of wavelengths, is highly saturated in colour. Colours of this type are referred to as *spectral colours*, or more properly, *hues**.

Colours of natural objects

The pure colours of the spectrum are rarely to be found in the objects which we see around us; instead we see many colours not to be found in the spectrum. This does not mean that light of a different nature is emitted by these objects. Objects are

*'Hue' and 'colour' are not the same thing. Hue is a characteristic of colour (the other two are *lightness*, or *luminosity*, and *saturation*, or *purity*) which approximately correlates with the dominant wavelength, or in the case of purples and magentas, by the dominant wavelength of the complementary hue (with a minus sign or a suffix 'c'). The terms 'hue' and 'colour' are thus not interchangeable, although in general parlance the term 'colour' is frequently used where 'hue' would be more appropriate. In this chapter the correct terminology is adhered to as far as is possible without being unnecessarily pedantic.

visible because of the light which they pass on to our eyes, most objects deriving this light from some outside source of illumination. Coloured objects appear coloured because they absorb some wavelengths and reflect others.

Suppose we examine a number of pieces of coloured paper. Now, although we can discern six or more hues in the spectrum of white light, for many purposes we may consider it as a mixture of just three colours, blue, green and red (see Chapter 1). Suppose the first piece of paper reflects only the blue part of the light falling on it, the green and red portions being absorbed. Then, when illuminated by white light, it will look blue, and we say simply that it is a piece of blue paper. Similarly a piece of green paper will reflect green and absorb blue and red, and a piece of red paper will reflect red and absorb blue and green. Sometimes, an object reflects more than one of the three groups. For example, one of the pieces of papers might reflect green and red, absorbing only the blue; this paper would look yellow. In the same way, a paper reflecting both blue and red would look purple or magenta, while a paper reflecting both blue and green would look blue-green or cyan. In general, any common object assumes a colour which is a mixture of the spectral colours that are present in the illuminant and not absorbed by the object.

The colours described in the example above were a result of the complete absorption of one or more of the main colour groupings of white light. Such colours are called *pure*, or *saturated colours*. The pigments of most commonly occurring objects absorb and reflect more generally throughout the spectrum. The colours of natural objects (sometimes referred to as pigmentary colours) therefore contain all wavelengths to some extent, with certain wavelengths predominating. They are of much lower saturation than the colours of the papers supposed in our example. Thus, a red roof, for example, appears red not because it reflects red light only, but because it reflects red light better than it reflects blue and green. The spectral properties of some common surface colours are shown in Figure 14.1.

Table 16.1 shows the percentage reflectance in the three principal regions of the spectrum of some of the main colours in the world around us. It will be seen that the general rules connecting the kind of

Table 16.1 Typical reflectances of natural objects in the three main regions of the spectrum

Colours of natural objects	Reflectance (%)		
	Blue	*Green*	*Red*
Red	5	5	45
Orange	6	15	50
Yellow	7	50	70
Brown	4	8	12
Flesh	25	30	40
Blue	30	15	5
Green	6	10	7

absorption with the resulting impression are the same as with the pure colours of the papers considered in the example above. The figures quoted in the table, which are approximate only, are percentages of the amount of incident light in the spectral region concerned, not of the total incident light.

We see from Figure 14.1 that the spectral absorption bands of commonly encountered coloured objects are broad.

Effect of light source on appearance of colours

We noted above that the colour assumed by an object depends both upon the object itself and on the illuminant. This is strikingly illustrated by a red bus, which by the light of sodium street lamps appears brown.* We are accustomed to viewing most objects by daylight, and therefore take this as our reference. Thus, although, by the light of sodium lamps, the bus appears brown, we still regard it as a red bus.

The change from daylight to light from a sodium lamp represents an extreme change in the quality of the illuminant, from a continuous spectrum to a line spectrum. The change from daylight to tungsten light – i.e. from one continuous source to another of different of different energy distribution – has much less effect on the visual appearance of colours. In fact, over a wide range of energy distributions the change in colour is not perceived by the eye. This is because of its property of *chromatic adaptation*, as a result of which the eye continues to visualize the objects as though they were in daylight.

If we are to obtain a faithful record of the appearance of coloured objects, our aim in photo-

graphy must be to reproduce them as the eye sees them in daylight. Unlike the eye, however, photographic materials do not adapt themselves to changes in the light source, but faithfully record the effects of any such changes: if a photograph is not being taken by daylight, the difference in colour quality between daylight and the source employed must be taken into account if technically correct colour rendering is to be obtained, and it will be necessary to use colour-compensating filters. (see Chapter 11).

In practice, a technically-correct rendering is rarely required in black-and-white photography, and changes in the colour quality of the illuminant can usually be ignored. In colour photography, however, very small changes in the colour quality of the illuminant may produce significant changes in the result, and accurate control of the quality of the lighting is essential if good results are to be obtained.

Response of the eye to colours

Our sensation of colour is due to a mechanism of visual perception which is complicated, and which operates in a different way at high and low levels of illumination. In considering the reproduction of colours in a photograph we are concerned with the *photopic* mechanism, i.e. the one operating at fairly high light levels. For the purposes of photographic theory, it is convenient to consider this as using three types of receptor. A consideration of the way in which these receptors work is known as the *trichromatic theory of colour vision*. This theory, associated with the names of Young and Helmholtz, postulates receptors in the retina of the eye which differ in their sensitivity and in the regions of the spectrum to which they respond. The first set of receptors is considered to respond to light in the

<hr>

*'Brown' in this context means, strictly, 'dark yellow'. (This is a combination of words that does not normally occur in English, for cultural reasons that do not concern us here.) If the illuminant is pure yellow, then the *hue* of the reflected light cannot be other than yellow, even though the object may (as in this case) reflect little yellow. A deep red rose reflects no yellow light at all, and when seen under a (low-pressure) sodium street lamp it appears black.

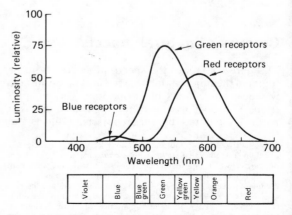

Figure 16.1 The three fundamental sensation curves of the trichromatic theory of colour vision

region of 400–500 nm, the second to light in the region of 450–630 nm and the third to light in the region of 500–700 nm. Considered on this basis, the behaviour of the eye is probably best grasped from a study of curves in which the apparent response of the hypothetical receptors (in terms of luminosity) is plotted against wavelength, as in Figure 16.1.

The perceived luminosity of blues is lower than that of either greens or reds. As a result, spectral blues look darker than reds, and reds look darker than greens. It must be clearly understood, however, that luminosity (or *lightness*) has little to do with the vividness or *saturation* of colours. Thus a dark blue may look as fully saturated as a green that appears inherently much lighter; and a differently-balanced set of curves is obtained if colour-sensitivity is substituted for luminosity as the vertical scale (as shown in Figure 16.18).

The validity of the three-colour theory was for a long time a subject of controversy, but it is now supported by experimental evidence indicating that there are indeed three types of colour-sensitive receptor in the retina of the eye. The justification of the use of the theory for our purposes is that a person with normal colour vision can match almost any given colour by mixing appropriate amounts of blue, green and red light. Colour photography itself relies on this phenomenon.

By adding together the ordinates of the three curves shown in Figure 16.1, we obtain a curve showing the sensitivity to different wavelengths of the eye as a whole. Such a curve is shown in Figure 16.2. This visual luminosity curve shows the relative luminous efficiency of radiant energy. It shows how the human eye responds to the series of spectral colours obtained by splitting up a beam of pure white light – sometimes referred to as an *equal energy spectrum* – to which sunlight approximates roughly. It is important to notice by how many times the luminosity of the brightest colour, yellow-green, exceeds that of colours nearer the ends of the spectrum.

Primary and secondary colours

When any one of the three sets of receptors of the eye is stimulated by itself the eye sees blue, green, or red light respectively. These three colours are known to the photographer as the *primary colours*, already mentioned in Chapters 2 and 14. The sensations obtained by mixing the primaries as illustrated in Figure 2.5, are called *secondary colours* and are obtained when just two sets of receptors are stimulated. If all three sets of receptors are stimulated in equal proportions the colour perceived is neutral.

It should be pointed out that in painting the theory of colour is treated somewhat differently. As a painter is concerned with mixtures of pigments rather than lights it is customary in painting to describe as 'primaries' the pigments blue, red and yellow, equivalent to the photographer's cyan, magenta and yellow; by mixing these pigments in various combinations it is possible to obtain almost any colour.

Complementary colours

Any two coloured lights which when added together produce white, are said to be of *complementary colour*. Thus, the secondary colours (cyan, magenta and yellow) are complementary to the primary colours (red, green and blue).

Low light-levels

At low light-levels a different and much more sensitive mechanism of vision operates. The dark-adapted, or *scotopic*, eye has a spectral sensitivity differing from the normal, or *photopic*, eye. The maximum sensitivity, which, in the normal eye, is in the yellow-green at about 555 nm, moves to about 510 nm, near the blue-green region. This change in sensitivity is referred to as the *Purkinje shift* (Figure 16.3). It is because of this shift that the most

Figure 16.2 Visual luminosity curve

Table 16.2 Primary and complementary colours

Primary colour	Complementary colour	Additive mixture
Red	Cyan	= Blue + green
Green	Magenta	= Blue + red
Blue	Yellow	= Green + red

efficient dark-green safelight for panchromatic materials has a peak transmittance at about 515 nm rather than at 555 nm (page 142).

Figure 16.3 The Purkinje shift

It is also found that the eye, which can distinguish a large number of colours under bright lighting conditions, becomes much less colour-sensitive at lower levels of illumination. Under very dim conditions only monochrome vision is possible. This property is not shared by colour films, so that under dim conditions the correct exposure will nevertheless reveal the colours of the subject and often surprises the photographer, whose recollection is of a far more drab original.

Black-and-white processes

A monochrome photographic emulsion is considered as reproducing colours faithfully when the relative luminosities of the greys produced are in agreement with those of the colours as seen by the eye. So far as a response to light and shade is concerned – and this, of course, has a very large part to play in the photographic rendering of the form and structure of a subject – it is clear that a light-sensitive material of almost any spectral sensitivity will answer the purpose. If, however, our photograph is to reproduce at the same time the colours of the subject in a scale of tones corresponding with their true luminosities, then it is essential that the film employed shall have a spectral response corresponding closely to that of the human eye.

We saw in Chapter 13 that although the ordinary silver halide emulsion is sensitive only to ultraviolet and blue, it is possible by dye-sensitizing to render an emulsion sensitive to all the visible spectrum. To assist us in evaluating the performance of the various materials in common use, Figure 16.4 shows

the sensitivity of the eye and the sensitivity to daylight of typical examples of the three main classes of photographic materials. Figure 16.5 contains curves for the same materials when exposed to tungsten light, the visual response curve being repeated.

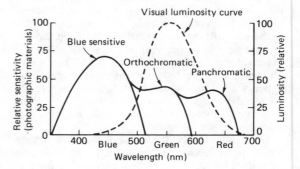

Figure 16.4 Response of photographic materials to daylight

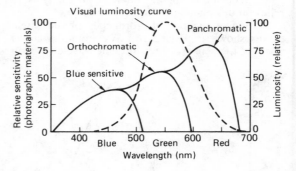

Figure 16.5 Response of photographic materials to tungsten light

Table 16.3, which lists the primary and secondary hues and indicates how each is recorded in monochrome by the three main classes of emulsion, illustrates the practical effects of the differences shown between the visual luminosity curve and the emulsion spectral sensitivity curves in the foregoing figures. The descriptions given in the table are relative to the visual appearance of the colours.

Less saturated colours than the primaries and secondaries follow the general pattern shown in the table but to a lesser extent. Thus, brown can be regarded as a desaturated and dark yellow, and pink as a desaturated and light magenta.

Table 16.3 Recording of the primary and secondary colours by the main types of photographic emulsion

	Blue-sensitive (daylight)	Orthochromatic (daylight)	Panchromatic	
			Daylight	Tungsten
Primaries				
Blue	Very light	Light	Rather light	Correct
Green	Dark	Rather dark	Slightly dark	Slightly dark
Red	Very dark	Very dark	Slightly light	Light
Secondaries				
Yellow	Very dark	Slightly dark	Correct	Rather light
Cyan	Light	Very light	Slightly light	Slightly dark
Magenta	Slightly light	Correct	Rather light	Rather light

It is clear from the curves in Figures 16.4 and 16.5 and from Table 16.3 that:

(1) No class of monochrome material has exactly the same sensitivity as the human eye, either to daylight or to tungsten light. In the first place, the characteristic peak of visibility in the yellow-green is not matched by the photographic response, even with panchromatic materials. On the other hand, the relative sensitivity of panchromatic materials to violet, blue and red greatly exceeds that of the human eye.

(2) The closest approximation to the sensitivity of the eye is given by panchromatic materials.

(3) Of the three groups of light-sensitive materials listed, only panchromatic materials can be employed with complete success for the photography of multicoloured objects as only these respond to nearly the whole of the visible spectrum.

(4) Even with panchromatic materials, control of the reproduction of colour may be needed when a faithful rendering is required, as no type of panchromatic material responds to the different wavelengths in the visible spectrum in exactly the same manner as the eye. Control of colour rendering is also sometimes needed to achieve special effects.

The control referred to under (4) above is achieved by means of *colour filters*. These are sheets of coloured material which absorb certain wavelengths either partially or completely, while transmitting others. By correct choice of filter, it is possible to reduce the intensity of light at wavelengths to which the emulsion is too sensitive. The use of colour filters is considered in detail in Chapter 11.

Colour processes

The principles of the two major types of photographic colour reproduction have been described in Chapter 14. The processes considered there illus-trate the ways in which *additive and subtractive colour syntheses* can be carried out following an initial *analysis* by means of blue, green and red separation filters. It was stated that most colour photographs are made using the emulsion assembly known as the integral tripack and the procedure of colour development in which yellow, magenta and cyan image dyes are formed to control the transmission of blue, green and red light respectively by the final colour reproduction. As shown in Figure 16.6, three emulsions are coated as separate layers on a suitable film or paper base and these emulsions are used independently to record the blue, green and red components of light from the subject. The analysis is primarily carried out by limiting the emulsion layer sensitivities to the spectral bands required.

Figure 16.6 Simplified cross-section of an elementary integral tripack film

The sensitivities of typical camera-speed emulsions are illustrated in Figure 16.7. All three layers possess blue sensitivity. Blue light must be therefore be prevented from reaching the green and red records.

In practice the film is coated as shown in Figure 16.8, with the blue-recording layer on top of the other two layers, and a yellow filter layer between the blue-recording and green-recording layers. The supercoat is added to protect the emulsions from damage. The filter layer absorbs blue light sufficiently to suppress the blue sensitivities of the underlying emulsions, and an interlayer is usually positioned between the lower emulsion layers. The resulting (effective) emulsion layer sensitivities are in Figure 16.9.

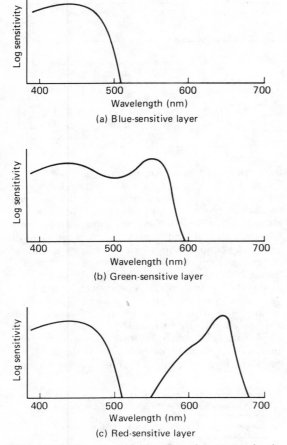

Figure 16.7 (a) Blue-sensitive layer

Figure 16.7 (b) Green-sensitive layer

Figure 16.7 (c) Red-sensitive layer

Figure 16.7 Layer sensitivities of an elementary tripack film

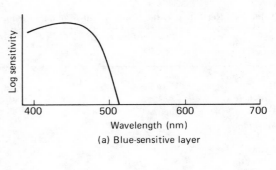

(a) Blue-sensitive layer

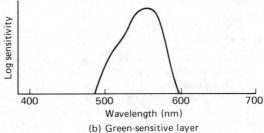

(b) Green-sensitive layer

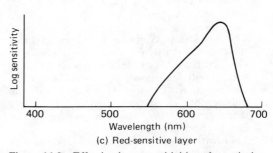

(c) Red-sensitive layer

Figure 16.9 Effective layer sensitivities of a typical tripack film

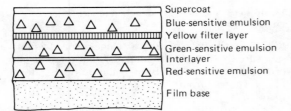

Figure 16.8 Cross-section of integral tripack film of camera speed

A more elegant solution to the problem of inherent blue-sensitivity of the green- and red-recording layers is to suppress it within the emulsion layers themselves. This may be achieved in materials for camera use by, for example, the use in those layers of tabular emulsion crystals of very high surface: volume ratio. The blue response depends on the amount of silver halide in each crystal, a volume effect; but the dye-sensitized response depends on the quantity of adsorbed dye, a surface-area effect. A high area:volume ratio therefore increases the sensitivity in the sensitized region compared with the inherent blue sensitivity, and with modern sensitization techniques this may be so low as to require no yellow-filter layer in the coated film.

In print materials it is often possible to reduce and confine the inherent sensitivity of red- and green-sensitized emulsions to the far blue and ultraviolet spectral regions, and to exclude these by a suitable filter during printing; no yellow filter layer is then required in the print material and the order of layers may be changed to suit other needs. A commonly-employed order of layers in colour-printing materials is illustrated in Figure 16.10. The most important images for the visual impression of sharpness are magenta and cyan, the latter being particularly

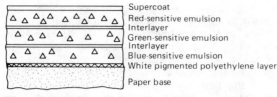

Figure 16.10 Cross-section of a typical tripack colour-printing paper. Note the different order of layers when compared with Figure 16.8

important. The red- and green-sensitive layers are therefore coated on top of the blue-sensitive emulsion so that the red and green optical images reach the appropriate layers without suffering any prior blurring due to scatter in the blue-sensitive layer.

The sensitivity distributions of two colour-negative tripack films are shown in Figure 13.5; they illustrate how the sensitivities of the individual layers contribute to the overall sensitivity balance of the film. There is little need for any particular speed balance in a colour negative, so the actual sensitivity balance is arranged to suit printing rather than visual criteria. This is not the case for positive images, which are generally designed to be viewed directly or by projection, and must therefore possess at least a satisfactory neutral reproduction. Wedge spectrograms of reversal colour films may thus be considerably different from those of negative films. Two such reversal films are illustrated in Figure 16.11, which compares typical subtractive and additive film sensitivity distributions. The differences in speed separations of the three records in the two films may be of little practical significance as the useful exposure range of the additive film in particular is rather short, i.e. it has a restricted latitude (see page 205), and all practical images may therefore possess adequate colour separation.

Formation of subtractive image dyes

Having analysed the camera image into blue, green and red components by means of the tripack film construction it is then necessary to form the appropriate image dye in each layer. Conventionally this is achieved by the reaction of the by-products of silver development with special chemicals called *colour couplers* or *colour formers*, the process being detailed in Chapter 24. Developing agents of the p-phenylene diamine type yield oxidation products, which will achieve this:

(1) Exposed silver bromide + developing agent → metallic silver + oxidized developer + bromide ions
(2) Oxidized developer + coupler → dye

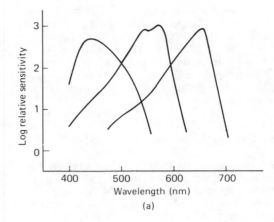

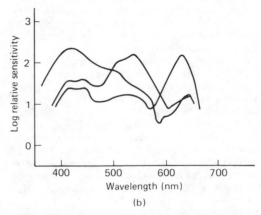

Figure 16.11 Spectral sensitivities of reversal colour films exposed to daylight. (a) A subtractive tripack film; (b) an additive film with integral réseau

Thus to form a dye image alongside the developed silver image a special type of developer is required and a suitable colour coupler must be provided either by coating it in the emulsion or by including it in the developer.

The dyes formed in subtractive processes would ideally possess spectral absorptions similar to those illustrated in Figure 14.6. However, they are not in fact ideal, and possess spectral deficiencies similar to those shown in Figure 14.7. The consequences of these dye imperfections can be seen when the sensitometric performance of colour films is studied.

Colour sensitometry

Using the sensitometric methods examined in Chapter 15, it is possible to illustrate important features of colour films in terms of both tone and colour

reproduction. Tone-reproduction properties are shown by neutral exposure, that is exposure to light of the colour quality for which the film is designed, typically 5500 K or 3200 K. This exposure also gives information about the overall colour appearance of the photographic image. Colour exposures are used to show further colour reproduction properties not revealed by neutral exposure.

Negative-positive colour

Colour negative films and printing papers have tone reproduction properties not unlike those of black-and-white materials (see Figure 24.7), except that colour-negative emulsions are designed for exposure on the linear portion of the characteristic curve. The materials are integral tripacks (see Chapters 14 and 24) and generate a dye image of the complementary hue in each of the three emulsion layers: yellow in the blue recording, magenta in the green recording and cyan in the red recording layer.

The densities of colour images are measured (Chapter 15) using a densitometer equipped with blue, green and red filters, and all three colour characteristic curves are drawn on one set of axes. Typical simple negative characteristics obtained from neutral exposure are shown in Figure 16.12, which shows that the three curves are of similar contrast although of slightly different speeds and density levels. The unequal negative densities have no adverse effect on the colour balance of the final print because colour correction is carried out at the printing stage as described in Chapter 22.

Neutral-exposure characteristic curves are not very informative about colour reproduction, but characteristic curves obtained from exposures to the primaries are better. Saturated primary-colour exposures could be expected to reveal the characteristics of individual emulsion layers. The results of such

exposures of a simple colour-negative film are shown in Figure 16.13. The characteristic curves show a number of departures from the ideal in which only one colour density would change with colour exposure. Two main effects are seen to accompany the expected increase of one density with log exposure: the first is the low-contrast increase of an unwanted density with similar threshold to the expected curve; the second is a high contrast increase (similar to that of the neutral curves) of an unwanted density with a threshold at a considerably higher log exposure than the expected curve. The former effect is due to secondary, unwanted, density of the image dye: thus the cyan image formed on red

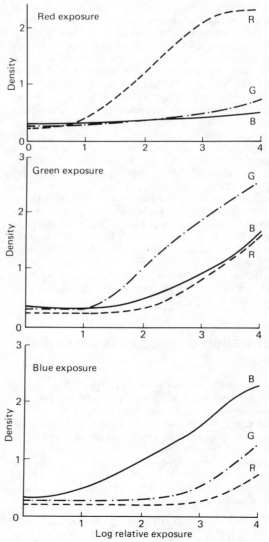

Figure 16.13 Colour exposures of a simple colour negative film

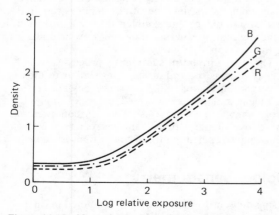

Figure 16.12 Neutral exposure of a simple colour negative film

exposure shows low-contrast blue and green secondary absorptions. The second effect is due to the exposing primary colour filter passing a significant amount of radiation to which one or both of the other two layers are sensitive. The blue exposure has clearly affected both green- and red-sensitive layers. In this case of blue exposure the separation of layer responses is largely determined by the blue density of the yellow filter layer in the tripack at exposure as all emulsion layers of the negative are blue-sensitive. The results of green exposure show a combination of the two effects, revealing secondary blue and red absorptions of the magenta dye and the overlap of the green radiation band passed by the filter with the spectral sensitivity bands of the red- and blue-sensitive emulsions.

Modern colour negative films yield characteristic curves different from those shown in Figure 16.13 owing to various methods adopted to improve colour reproduction. Sensitometrically the most obvious of these is *colour masking*, which is designed to eliminate the printing effect of unwanted dye absorptions by making them constant throughout the exposure range of the negative. The important characteristics of a masked colour-negative film are shown in Figure 16.14. The most obvious visual difference between masked and unmasked colour negatives is the overall orange appearance of the former, and this appears as high blue and green minimum densities. The mechanism of colour masking is described later, but its results can clearly be seen in the case of the red exposure illustrated. The unwanted blue and green absorptions of the cyan image are corrected by this masking. Ideal masking would result in blue and green characteristic curves of zero gradient, indicating completely constant blue and green densities at all exposure levels. In practice it can be seen that the blue and green absorptions are slightly undercorrected so that both blue and green densities do rise with increased exposure.

A second method of colour correction is to make image development in one layer inhibit development in the other emulsion layers. If an emulsion has an appreciable developed density this may be reduced by development of another layer, giving a corrective effect similar to that of colour masking. Such *inter-image effects* are not always simply detected by measuring integral colour densities but they are sometimes easy to see. Inter-image effects, for example, would appear to be operating in the negative film illustrated in Figure 16.13. Blue exposure results in development of the yellow image in the top layer of the tripack and this, in turn, inhibits development of the green- and red-sensitive layers so that the green and red fog levels fall while the blue density increases. Such unexpectedly low image densities are usually the only clue to the existence of inter-image effects to be found using integral densitometry.

The most recent colour-negative films (Figure 16.14) use a combination of colour masking with inter-image effects, and this allows excellent colour correction with much lower mask densities than were previously used. The mask density and its colour, however, remain far too high for such colour correction methods to be used in materials such as reversal films, designed for viewing rather than printing. The consequences of dye deficiencies in such systems are, however, less important than in negative-positive systems where two reproduction stages are involved with a consequent reinforcement of colour degradation.

Reversal colour

Colour-reversal films are constructed similarly to integral tripack negative films. The positive nature of the image springs from a major difference in the processing carried out, not from the emulsions used in the film. As in the negative, the dye image generated in each layer is complementary to the sensitivity of the emulsion: a yellow dye is generated in the blue-sensitive layer etc.

Sensitometry is carried out as for the negative film and characteristic curves plotted. The results of neutral exposure are illustrated in Figure 16.15 and show typical positive characteristic curves. Unlike the colour negative material it is important that the results of a neutral exposure on reversal film shall appear neutral; no simple correction can be carried out once the image has been developed. In the case illustrated the curves show sufficiently similar densities for the result to be visually satisfactory. The major difference is at so high a density as to be imperceptible – there is rarely any perceivable colour in regions of deep shadow.

Colour exposures (Figure 16.16) show various departures from the ideal and are sometimes quite difficult to interpret. The two main effects are, however, as easily characterized as they were for colour negatives; the unexpected decrease of density with log exposure at low-contrast and the decrease in a colour density other than that of the exposure at high contrast. The former effect is generally caused by the secondary absorption of an image dye, and the latter shows the overlap between the spectral region passed by the exposing filter and the sensitivity band of the emulsion concerned.

Red exposure yields characteristic curves showing the effects of secondary absorptions and inter-image effects. The expected result of red exposure is a decrease in red density with increasing exposure. This is seen in Figure 16.16; but other results are also observed. The initial large decrease in the density of the cyan dye image with increased exposure is accompanied by a small decrease in the green density, caused by the unwanted secondary green

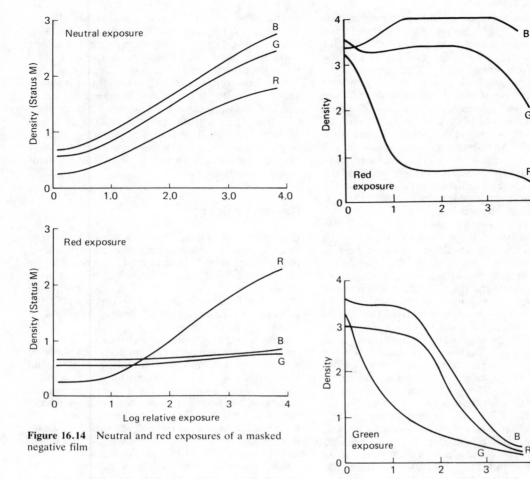

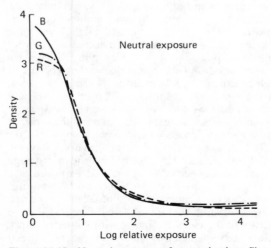

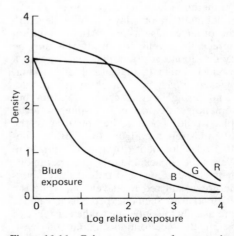

Figure 16.14 Neutral and red exposures of a masked negative film

Figure 16.15 Neutral exposure of reversal colour film

Figure 16.16 Colour exposures of a reversal colour film

absorption of the cyan-image dye. A considerable increase in blue density takes place over the same exposure range, and this indicates the existence of an inter-image effect in which the development of an image in the red-sensitive layer inhibits the development of an image in the blue-sensitive layer. This effect may take place at the first (non-colour) development stage, or during colour development, and represents a colour-correction effect akin to masking. The apparently high minimum density to red in the case of red exposure is due to unwanted red absorptions of the yellow and magenta image dyes present in maximum concentration. At high exposure levels, when the blue- and green-sensitive layers respond and the yellow and magenta dye concentrations fall, the red density is also reduced. The response of the blue- and green-sensitive layers to exposure through a red filter is due to the small but appreciable transmission of the red filter in the green and blue regions of the spectrum.

Green exposure causes the expected reduction in green density giving a green characteristic curve with a long low-contrast foot. This is not due to a low-contrast reduction of magenta image at the foot, as there is probably no magenta dye present. It is due to a fall in the total secondary green absorptions of the yellow and cyan dyes as they decrease in concentration at high exposure levels. This is caused by a significant overlap between the pass-band of the green exposing filter and the spectral responses of the red- and blue-sensitive layers. It will also be noticed that the initial fall in magenta dye concentration at low exposure levels is accompanied by reduced red and blue densities. This is due to the unwanted secondary red and blue absorptions of the magenta image dye; as the concentration of magenta dye decreases so do its absorptions, both wanted and unwanted.

In the case of blue exposure all three layers show the effects of actinic exposure, the speed separation of the emulsions being mostly due to the yellow-filter layer present at exposure. As with colour-negative material, all the emulsion layers are sensitive to blue. The low-contrast shoulder of the green characteristic curve shows the reduced green absorption associated with decreasing yellow dye concentration. The yellow image clearly has a green secondary absorption. The long low-contrast foot of the blue characteristic curve is due, not to the yellow image dye which is probably present at minimum concentration, but to the blue secondary densities of the magenta and cyan dyes which are decreasing in concentration with increased exposure.

In essence, each of the colour-exposed results may be analysed in terms of three main regions. The first, at low exposure levels, shows one dye decreasing in concentration; its secondary densities are revealed by low-contrast decreases in the other two densities. The second region, at intermediate exposure, shows no change in any of the three curves, but the level of the lowest is well above the minimum found on neutral exposure, owing to the unwanted absorptions of the two image dyes present. This is exemplified by the red exposure (Figure 16.16) at a log relative exposure of 2.0. Lastly we find, at high exposures, the region where sufficient actinic exposure of the remaining two emulsions leads to a decrease in the concentration of the corresponding image dyes. The secondary absorptions of these two dyes are shown by a low-contrast decrease in the third curve – for example the blue density at log relative exposures of 1.5 or more. For reversal film, departures from this scheme are caused by inter-image effects which appear as unexpected increases in density with increased exposure or by overlap of filter pass bands with sensitivity bands of the emulsions. This last departure from the ideal results in a compression of the three regions with the possible loss of the middle one and overlap of the other two. In the examples shown, the middle region is not evident on green or blue exposure owing to the sensitivity separations of the three emulsions being only as much as is needed for adequate colour reproduction. Only the red exposure has sensitivity separation to spare. Indeed the extensive range of exposures over which no change is seen in the image may be the cause of poor reproduction of form and texture of vivid red subjects. Red tulips or roses, for example, may simply appear as red blobs with no visible tone quality or texture.

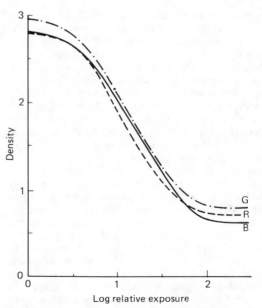

Figure 16.17 Neutral characteristics of a typical additive colour reversal film

Inter-image effects are extremely common in colour processes, either by design or accident. They are not usually detectable by integral densitometry, although we have seen a number illustrated in Figures 16.11 and 16.16.

Additive systems

The neutral characteristics of a typical additive colour reversal film are shown in Figure 16.17. A number of the limitations of such processes are immediately obvious. The useful upper limit of density in images designed for projection is approximately 3.0 so an upper limit is therefore set on the density scale of a reversal film. The necessarily high minimum density caused by the integral réseau of additive colour filters imposes a downward limit on the density of highlights that is considerably higher than that of subtractive reversal films. Transparencies made using additive films tend therefore to appear rather dark and to have a shorter tonal scale than subtractive materials. Not only does this short tone-scale limit the latitude of the film, but it also limits the range of colours available.

Imperfections of colour processes

Additive system

Typical spectral sensitivity curves of the eye are shown in Figure 16.18a; the sensitivies of the three colour receptors overlap considerably. While the red receptor alone is stimulated by light of a wavelength of 650 nm or greater, there are no wavelengths at which unique stimulation of the blue or green receptors is possible. A good approximation to the ideal can be achieved by using a wavelength of about 450 nm for the blue stimulus, but the best that can be done for the green is to select light of a wavelength of about 510 nm. Even at this wavelength there is still considerable red- and blue-sensitivity in addition to green.

In practical systems of additive colour photography shortage of light usually dictates the use of fairly wide-band filtration. The green record will thus elicit a significant response from the blue and red sensitive receptors of the retina as well as from the green receptors. The green light appears to be mixed with some blue and red light, and in consequence appears a paler green. Reproductions of greens thus appear paler than the originals. Similar, but less severe, desaturation of blues and reds is also encountered owing to the broad spectral bands used in practice. The overall effect is to desaturate colours by the addition of white light.

The impossibility of achieving separate blue, green and red stimulation of the retina is common to both additive and subtractive three-colour systems of colour reproduction.

Subtractive system

The subtractive system not only shares the limitations of the additive system in the reproduction of colour, but also suffers from defects introduced by the use of subtractive image dyes. Ideally, each subtractive dye controls one-third, and only one-third, of the visible spectrum. If the regions controlled were made narrower than this, it would not be possible to reproduce black, or saturated colours, owing to uncontrolled transmission in one or two bands of the spectrum.

The subtractive system thus uses blue, green and red spectral bands that may be somewhat broader than those used in the additive system, and the reproductions of vivid colours are accordingly more desaturated. This would result in reproduced colours appearing markedly paler than the originals, if certain steps (detailed later) were not taken to improve matters.

In addition to the inherent inferiority of the subtractive system when compared with the additive system, a further difficulty arises from the imperfections of the image dyes. In particular, magenta and cyan image dyes have additional absorptions in regions of the spectrum other than those required. Thus the blue secondary absorption of the magenta dye results in dark blues, bluish greens, poorly saturated yellows and reddish magentas. The blue and green secondary absorptions of the cyan dye cause dark blues, dark greens, poorly saturated reds, yellows and magentas, and dark cyans of poor saturation. It is clearly important to correct such deficiencies where possible.

Correction of deficiencies of the subtractive system

Various means are adopted to minimize the deficiencies of the subtractive system. One common procedure is to construct the photographic emulsions so that the blue, green and red sensitivities have steeper peaks, which are also more widely separated than the peak sensitivities of the retinal receptors. A comparison between typical colour film sensitivities and those of the eye is shown in Figure 16.18. This expedient improves the saturation of many colours, but may introduce errors, either because the emulsion sensitivities extend beyond those of the eye, or because of a gap in the film sensitivities such as that shown at a wavelength of about 480 nm in the illustration.

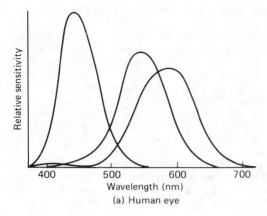

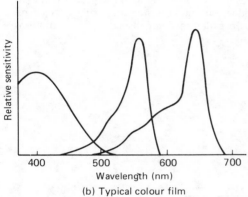

Figure 16.18 Spectral sensitivities of the human eye and a colour tripack film

The extension of emulsion sensitivity farther into the short-wave region than that of the eye may result in blue skies being reproduced incorrectly, and distant views appearing pale and blue. If these faults are encountered, the remedy is usually to employ an ultraviolet-absorbing filter over the camera lens. At the long-wave end of the spectrum, the extended sensitivity of the colour film compared with that of the eye leads to an interesting effect. Flowers which reflect blue light, particularly bluebells and 'morning glory', often also possess a high reflectance close to the long-wave limit of retinal sensitivity. The result is that in colour photographs it is frequently found that these flowers appear pink or pale magenta instead of blue. There is no simple remedy for this fault, as filters which cut off the extended sensitivity region adversely affect colour reproduction within the visible region.

It is found that the desaturation of colour reproductions described above is reduced by adopting a higher emulsion contrast than would be ideal in theory. The reproduction thus possesses a higher contrast than the original and this results in an increase in saturation of vivid colours together with

a decrease in saturation of pastel colours and a departure from objectively correct tone reproduction. In most cases faults due to the increased tone contrast are outweighed by the superior colour saturation. It is, however, often advisable to keep the lighting ratio of the subject low in colour photography, if the increased tone contrast of the reproduction is not to be objectionable.

In the processing of colour materials it is often found that development of the record of one colour inhibits the development of an adjacent emulsion layer. This *inter-image effect* is in many ways similar to the Eberhard effect encountered in black-and-white processing (page 238); the products of development of the colour record diffuse into adjacent emulsion layers and inhibit development. An important difference lies in the fact that whereas the action of the Eberhard effects extends parallel to the film base, the useful colour inter-image effects act in a direction perpendicular to the film base.

The useful inter-image effects found in colour processes may be promoted by design of the system, and harnessed to improve colour reproduction. The development of the record of any colour is made to inhibit the development of other colour records. Thus the neutral scale reproduction may possess a contrast which is much exceeded by the contrast of the reproduction of colours, such a situation being illustrated in Figure 16.19. Successful use of inter-image effects gives increased colour saturation with little distortion of tone reproduction, and can lead to very acceptable results.

Compensation for deficiencies of the subtractive system achieved by these means may be successful in a first generation reproduction. This category

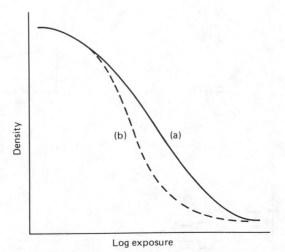

Figure 16.19 The characteristic curve of the red-sensitive layer of a colour reversal film. (a) In the case of a neutral exposure; (b) in the case of a red exposure

embraces colour transparencies produced by reversal processing of the original camera film. In many cases further generations of reproduction are required. Such further reproductions include reflection prints made from colour negatives or reversal transparencies, and duplicate positive transparencies. It is generally true that further reproduction stages accentuate the departures from ideality of the first generation. Saturated colours become darker and may change hue, pale colours become paler and lose saturation, and tone contrast increases so that highlight detail is lost, while the shadow areas become totally black. From the point of view of colour reproduction, therefore, it is usually preferable to make the camera record on negative film which can be made relatively free from deficiencies of colour and tone reproduction. The method used to achieve this freedom from deficiencies of colour reproduction is called *colour masking*.

Masking of colour materials

The spectral density distribution of a typical magenta image dye is shown in Figure 16.20. The characteristic curve of the green-sensitive emulsion which generates the dye is shown alongside and represents the green, blue and red densities of the dye image. It will be seen that the density to green light increases with exposure as would be expected, and that the unwanted blue absorption of the dye is shown by the increase in blue density over the same exposure range.

At the printing stage an unmasked negative record employing this dye will convey spurious information to the printing paper about the distribution of blue light in the camera image. This is undesirable and results, for instance, in bluish greens in the print reproduction among other shortcomings (see page 206). In order to compensate for the variation of

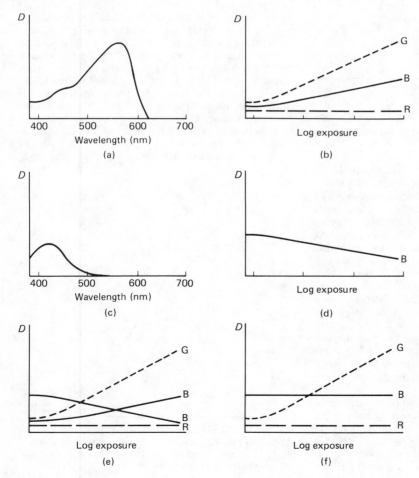

Figure 16.20 Elements of masking the blue absorption of a magenta dye: (a) Spectral density distribution and (b) characteristic curves of the magenta dye image; (c) spectral density distribution and (d) characteristic curve of the yellow mask; (e) image and mask characteristic curves; (f) combined characteristic curves of the masked green-sensitive layer

blue density with the magenta dye content of the negative, it is merely necessary to prepare a corresponding positive yellow dye record, as shown in Figure 16.20(c) and (d). The yellow positive is then superimposed in register with the negative as shown in (e). Provided the blue-density characteristic curve of the positive is of the same contrast as that of the negative, the combined effect of the mask and the unwanted secondary density of the image dye is as shown in (f). The printing effect of the unwanted absorption of the magenta image dye has been entirely compensated at the expense of an overall increase in blue density.

Making separate coloured masks is usually inconvenient and modern colour masking systems rely on the formation of masks within the negative colour film. This is called *integral masking*, and is widely used in colour-negative films. The overall orange appearance of such negative films results from the yellow mask of the magenta dye together with the reddish mask required by the cyan image dye. The yellow image dye is usually sufficiently free from unwanted absorptions for masking to be unnecessary.

Integrally-masked colour images cannot be used for projection purposes, as the colour cast is too great. If a colour negative (say of a poster) is required for direct projection it is necessary to use a slide film developed by a colour-negative processing method. It is worth noting that although integral colour masking cannot be used for materials intended for viewing (directly or via a projector), the use of inter-image effects is analogous to masking, and can be so used.

In Chapter 24 we shall examine the methods by which subtractive dye images are produced in practice.

Problems of duplication

So far we have considered the reproduction of colour by reversal colour film to prepare transparencies and the use of negative film designed for the production of prints. Satisfactory though they may be for viewing, the use of transparencies for the production of further generations of reproduction involves a number of rather awkward problems. An important case is the requirement for the production of a duplicate of a transparency. Clearly, if the original transparency is satisfactory, the duplicate should resemble it as closely as possible. This is difficult to achieve without taking special steps. Although it is possible simply to photograph the transparency on a film similar to that used for the original, this is rarely satisfactory, as can be shown by a simple quadrant diagram (Figure 16.21).

In quadrant 1 the characteristic curve of the original reversal film is shown together with three

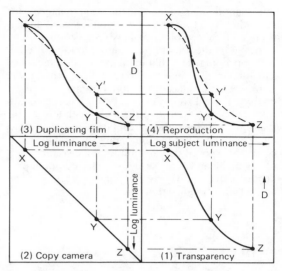

Figure 16.21 Tone reproduction of duplicate transparencies. (a) XYZ in quadrant 4 represents the result of duplication on to the original camera film stock; (b) XY′Z is the result of duplication on a film of linear characteristics of gradient 1.0

representative tones X, Y and Z. The record of tones within the range XYZ represents the image to be duplicated, and the shape of the curve indicates what is desired in the final reproduction following duplication. The original transparency is copied using a system possessing linear tone transfer characteristics as shown in quadrant 2; this system could be a contact printer or a flare-free copy camera. In quadrant 3 the solid curve XYZ represents the characteristic of the duplicating film when the original camera film stock is used for that purpose. The resulting tone reproduction in the duplicate transparency is shown as the curve XYZ in quadrant 4, and can be seen to have a very much higher midtone gradient than the original transparency as well as severely compressed highlight and shadow detail. The consequences for colour reproduction are that pastel colours tend to appear as white in the duplicate, while more saturated colours appear at maximum saturation, but may also be very dark.

The same quadrant diagram may be used to find the optimum shape for the characteristic curve of the duplicating film if the original transparency is assumed to have the tone reproduction required of the final duplicate. What is done is to plot that curve, XYZ in quadrant 1, as XY′Z in quadrant 4 and then to work back to quadrant 3 to find the characteristic curve required of the duplicating film. This is shown as XY′Z in quadrant 3: a duplicating film with a linear characteristic curve of gradient 1.0 is required. Reversal films are, in fact, made especially for duplicating colour transparencies, and they have characteristics similar to those predicted from

the quadrant diagram. The films are balanced for use either with tungsten or electronic-flash illumination, and exact colour-balance correction can be achieved by the use of filters similar to those used in colour printing. The characteristic curves of a typical slide duplicating film are shown in Figure 16.22, the curves being displaced from the optimal neutral for clarity. It will be seen that the characteristics obtained are very close to the ideal, with long linear regions and short toes. Duplicate transparencies made on such films can be highly successful, and if correctly exposed they exhibit minimal compression of highlight and shadow detail. The colour reproduction can also be correspondingly successful if the correct filtration is determined.

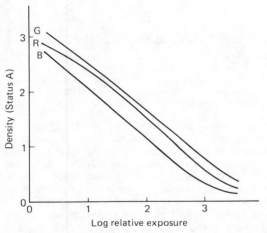

Figure 16.22　Characteristics of a typical slide-duplicating film with curves displaced with respect to the log exposure axis for clarity. In normal use correction filters are used to give optimal neutral reproduction

An important problem arises in the preparation of prints from positive transparencies. Prints made directly on reversal colour paper tend to be inferior to those made from camera negatives using the negative-positive system, particularly with respect to the rendering of highlight detail and colour reproduction. The former difficulty arises from the printing of the low contrast toe of the transparency on the low contrast toe of the reversal print material; colour reproduction is limited by the lack of masking to correct for dye deficiencies in the camera record and the print. Although a number of complicated masking procedures using specially-prepared silver masks may be adopted to correct these deficiencies, the most practical solution is to make an intermediate negative, using a film specially made for the purpose, and then to print the negative on conventional colour-negative printing paper. The internegative film is masked to correct for dye deficiencies, and in addition possesses tone reproduction properties designed to retain the important highlight contrast which would otherwise be lost. The characteristics of an internegative film are shown in Figure 16.23.

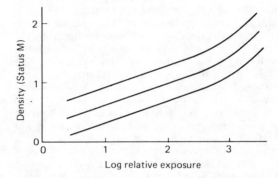

Figure 16.23　Characteristics of an internegative film

The internegative film illustrated is exposed so that the highlights of the transparency to be printed lie on the high-contrast portion of the characteristic curves whereas the higher-contrast mid-tones are recorded on the lower contrast region. Shadow detail is also recorded at low contrast, but this is not usually a serious matter. The enhanced highlight contrast enables prints to be made on negative-positive paper, retaining the highlight detail of the original transparency. The internegative is also integrally colour-masked to correct for dye deficiencies, and this results in enhanced colour reproduction in the final print. The use of a correctly-exposed internegative can thus improve both tone and colour reproduction in the printing of colour transparencies.

17 Developers and development

The purpose of development is to darken those parts of the light-sensitive material that have been influenced by light, i.e. to produce a visible image corresponding to the invisible latent image. Development, strictly *chemical development*, is employed for most photographic materials. This involves the reduction of the individual silver halide crystals to metallic silver.

Silver halide + reducing agent → metallic silver + oxidised reducing agent + halide ion

In this process each crystal of the emulsion acts as a unit, in the sense that it is either developable as a whole or is not developable. There is a second type of development in which the silver forming the developed image is derived from a soluble silver salt contained in the developing solution itself. This is called *physical development*; it is not generally employed with modern photographic materials. Some physical development does in fact occur in many types of developers, because they contain complexing substances which dissolve some of the silver halide and so provide soluble silver compounds in the developer solution.

On exposure to light, photographic emulsions form latent images which are mainly on the surfaces of the crystals, as was shown in Chapter 12. With sufficient exposure latent images of a developable size are formed. These are termed *development centres*. When a photographic emulsion is immersed in a developing solution the crystals are attacked at these points by the *developing agent*, and, in chemical development, each crystal which has received more than a minimum exposure is rapidly reduced to metallic silver. The degree of blackening over the surface depends principally upon the number of crystals which have been attacked, although it is also influenced to some extent by the fact that some grains which start to develop may not develop to completion in the time for which the developer is allowed to act.

Developing agents are members of the class of chemical compounds known as *reducing agents*. Not all reducing agents may be used as developing agents; only a few are able to distinguish between silver halide crystals which bear a latent image and those which do not. With reducing agents that have been found suitable for photographic use, the action of the agent on exposed and unexposed (or insuffi-ciently exposed) crystals is distinguished by its rate. It is not that unexposed silver halide crystals do not develop at all, but that exposed crystals develop very much more quickly than unexposed crystals. The latent image is essentially a catalyst that can acccelerate the rate of development, but cannot initiate a reaction that would not occur in its absence. Under normal conditions, the proportion of unexposed crystals developed is quite small, but with very prolonged development practically all the crystals in an emulsion, both exposed and unexposed, will develop. Density resulting from the development of unexposed crystals is called *fog*.

Composition of a developing solution

Developing agents are not used alone; a developing solution, usually referred to simply as a *developer*, almost always contains certain other constituents whose presence is essential for the proper functioning of the solution. A developing solution usually comprises:

(1) *developing agent (or agents)* to convert the silver halide grains in the emulsion to metallic silver.

(2) *preservative* (a) to prevent wasteful oxidation of the developing agent, (b) to prevent discoloration of the used developing solution with consequent risk of staining of negatives and prints and (c) to act as a silver halide solvent in certain fine-grain developer formulae.

(3) *alkali* (sometimes termed the 'accelerator') to activate the developing agent, and to act as a buffer to maintain the pH or alkalinity at a constant value.

(4) *restrainer* to increase the selectivity of the development reaction, i.e. to minimize fog formation by decreasing the rate of development of unexposed grains to a greater extent than that of exposed grains.

(5) *miscellaneous additions*; these include wetting agents, water softening agents, solvents for silver halides, anti-swelling agents for tropical processing, development accelerators etc.

In addition, there must be a *solvent* for these ingredients; this is nearly always water. We shall consider each of these constituents in turn, in detail.

The developing agent

A large number of different substances have been used from time to time as photographic developing agents. Almost all of those in use today are organic compounds. Not all developing agents behave in exactly the same way, and for certain purposes one agent may be preferred to another. Consequently, a number of different agents are in use for one purpose or another, the characteristics of the more important ones being described below.

Metol

Metol (4-methylaminophenol sulphate), introduced by Hauff in 1891, is a white crystalline powder readily soluble in water. Metol developers are characterized by high emulsion speed, low contrast and fine grain. They are valuable when maximum shadow detail is required. Useful low-contrast developers may be made up, using metol, sulphite and sodium carbonate, or simply metol and sulphite alone. In general, however, metol is used in conjunction with a second developing agent, hydroquinone (see below), as a superadditive combination, developers containing the mixture having certain advantages over developers based on either developing agent alone (page 217). Metol-hydroquinone developers are usually referred to simply as MQ developers, the letter Q being derived from the name 'quinol', a synonym for hydroquinone.

Phenidone

Phenidone (1-phenyl-3-pyrazolidone), the developing properties of which were discovered in the Ilford laboratories in 1940, possesses most of the photographic properties of metol together with some unique advantages. It shares with metol the property of activating hydroquinone so that a Phenidone-hydroquinone (PQ) mixture forms a useful and very active developer. Used alone, Phenidone gives high emulsion speed but low contrast, and has a tendency to fog. It is not, therefore, normally recommended for use by itself. Mixed with hydroquinone, however, and with varying concentrations of alkali, Phenidone produces a wide range of developers of differing types. The activation of hydroquinone requires a much lower concentration of Phenidone than of metol. A detailed comparison of the relative merits of PQ and MQ developers is given on page 218.

More stable derivatives of Phenidone have been proposed especially for use in concentrated liquid developers (see page 224). These include Phenidone Z (1-phenyl-4-methyl-3-pyrazolidone) and dimezone (1-phenyl-4,4-dimethyl-3-pyrazolidone).

Hydroquinone

Hydroquinone (quinol, 1,4-dihydroxybenzene), whose developing properties were discovered by Abney in 1880, takes the form of fine white crystals, fairly soluble in water. The dry substance should be kept well-stoppered, as there is a tendency for it to become discoloured. Hydroquinone is used mainly in combination with metol or Phenidone with which it forms superadditive mixtures (see page 217), or as the single developing agent in lithographic developers.

Amidol

Amidol (2,4-diaminophenol hydrochloride) is a fine white or bluish-white crystalline powder, readily soluble in water. An amidol developer can be made simply by dissolving amidol in a solution of sodium sulphite, without other alkali. Amidol developer should be made up when required, as it has poor keeping qualities. The solution of amidol and sulphite, while not becoming discoloured to any extent, loses much of its developing power within two or three days, though it keeps well if slightly acidified with sodium or potassium metabisulphite, and still develops, if a little more slowly. Amidol developing solutions, although not themselves coloured, produce heavy bluish-black stains on fingers and nails. In the dry state, amidol is slowly affected by air and light; it should therefore be kept in dark brown, well-stoppered bottles. Amidol developers develop rapidly. They were at one time widely used with papers but are now rarely used other than for the developing of nuclear track emulsions.

Glycin

Glycin (4-hydroxyphenylaminoacetic acid) is a white crystalline powder, only slightly soluble in water but freely soluble in alkaline solutions. Glycin developers are non-staining and have exceptionally good keeping properties, but, unfortunately, they are too slow in action for general use. To obtain as much activity as possible, potassium carbonate is to be preferred as the alkali for glycin developers because it can be used at a greater concentration than sodium carbonate. Glycin is used in certain warm-tone developers for papers. It is also used, in conjunction with other developing agents, in some fine-grain developer formulae of low energy. (See paraphenylenediamine, below.) The action of glycin is considerably restrained by bromide. The non-staining properties of glycin and its very slow oxidation in air make it very suitable for any process in which the sensitive material is exposed to the air during development.

Para-aminophenol

Para-aminophenol (4-aminophenol) is a developing substance which has been widely used for compounding highly concentrated developers. The active agent in these is an alkali salt of 4-aminophenol, produced by the action of sodium hydroxide. The solution is diluted with from 10 to 30 times its volume of water to form the working developer.

Paraphenylenediamine

At one time, many popular fine-grain developers were based on paraphenylenediamine (p-phenylenediamine, 4-aminoaniline, 1,4-diaminobenzene) as the developing agent. Paraphenylenediamine itself is poisonous, and used alone requires very long development times. To obtain convenient developing times, most paraphenylenediamine developers contain another developing agent, e.g. glycin or metol. In such developers, the paraphenylenediamine probably acts primarily as a silver halide solvent, favouring a physical type of development. See Table 17.1 for colour developing agents based on 4-aminoaniline.

Pyrogallol

Pyrogallol (pyro, pyrogallic acid, 1,2,3-trihydroxybenzene) is poisonous and is very soluble in water. The image formed by a pyrogallol developer consists not only of silver but also of brownish developer oxidation products which stain and cross-link (tan) the gelatin. Pyrogallol was formerly used in combination with metol in a developing solution without sulphite, for processing negatives known to be severely under-exposed. It is now seldom if ever used for photographic negatives, but has found an important niche as a developer for reflection holograms, where its staining properties reduce scatter and its cross-linking effect on gelatin minimizes emulsion shrinkage.

Catechol

Catechol (pyrocatechin pyrocatechol, 1,2-dihydroxybenzene) is sometimes used to provide tanning developers and warm-tone developers for certain papers. With caustic alkalis it gives rapid development with high contrast, in a similar manner to hydroquinone.

Of all the developing agents described above only Phenidone, metol and hydroquinone are in widespread use today for the development of monochrome materials, while analogues of p-phenylenediamine (4-aminoaniline) are used for the development of colour materials (see Table 17.1).

The preservative

Sodium sulphite is commonly used as the preservative in developing solutions, although potassium (or sodium) metabisulphite is sometimes used as an alternative, either by itself or in addition to sulphite. Sodium sulphite is sold both in crystalline and in anhydrous (desiccated) forms, one part of the latter being equivalent to two parts of the former. Sulphite

Table 17.1 Colour developing agents: generally specific to a particular colour material and the formulation used

Chemical name	Trade name
Diethyl-p-phenylenediamine sulphite, or 4-amino-N,N-diethylaniline sulphite	Genochrome (May & Baker)
Names as above but hydrochloride	CD 1 (Kodak)
Ethylhydroxyethyl-p-phenylenediamine sulphate	
or 4-amino-N-ethyl-N-(β-hydroxyethyl)aniline sulphate	Droxychrome (May & Baker)
N,N-diethyl-3-methyl-p-phenylenediamine hydrochloride	Tolochrome (May & Baker)
or 4-amino-N,N-diethyl-3-methylaniline hydrochloride	CD 2 (Kodak)
N-ethyl-3-methyl-N-(β-methylsulphoamidoethyl)-p-phenylenediamine sesquisulphate	Mydochrome (May & Baker)
or 4-amino-N-ethyl-3-methyl-N-(β-methylsulphonamidoethyl)aniline sesquisulphate	CD 3 (Kodak)
N-ethyl-N-(β-hydroxyethyl)-3-methyl-p-phenylenediamine sulphate	CD 4 (Kodak)
or 4-amino-3-methyl-N-ethyl-N-(β-hydroxyethyl) aniline sulphate	

Note: All the compounds listed are potentially hazardous by skin absorption and rubber gloves should always be worn when preparing or using colour developing solutions.

crystals dissolve most freely in water at about 40°C, giving a weakly alkaline solution (pH approx 8.5)*. Anhydrous sulphite is a white powder which dissolves readily in water. Supplies of both crystalline and anhydrous sulphite should be kept in well-closed containers.

Potassium metabisulphite takes the form of transparent crystals which usually have a slight opaque incrustation. This, however, does not denote deterioration to any appreciable extent. In the dry state, metabisulphite keeps very much better than sulphite. It dissolves fairly readily in warm water. One advantage in using metabisulphite in preference to sulphite is that it forms a slightly acidic solution (pH 4–5) which helps to decrease the rate of aerial oxidation in concentrated two-solution developers, i.e. one solution containing the developing agent and preservative and the other containing the alkali. Sodium metabisulphite may be used instead of potassium metabisulphite, the quantity required being 85% of the weight given for the potassium salt.

As stated earlier, one of the main functions of the preservative is to prevent wasteful oxidation of the developing agent by air. It is convenient to think of the sulphite as removing the oxygen from the air dissolved in the solution or at the surface of the solution, before it has time to oxidize the developing agent. This, however, is an over-simplification. The action of the preservative is not simply a matter of preferential reaction between sulphite and oxygen; the rate of uptake of oxygen by a solution of sulphite and hydroquinone, for example, is many times smaller than the rate of uptake by either the sulphite or hydroquinone alone.

Sulphite also reacts with developer oxidation products and prevents staining of the image by forming soluble and often colourless sulphonates:

Silver halide + developing agent →
 oxidized developing agent + metallic silver
 + halide ion + hydrogen ion (acid)

Oxidized developing agent + sulphite ion + water →
developing agent sulphonate + hydroxyl ion (alkali)

*An explanation of the pH scale is given in the Appendix.

In addition to its function as a preservative and prevention from staining, sulphite has a third function. It acts as a solvent for silver halides and so promotes some physical development, which leads to finer-grained images provided that its concentration is sufficiently high.

The alkali

Almost all developing solutions require an alkali to activate the developing agent. By suitable choice of alkali, the pH of a developing solution can be adjusted to almost any required level, and in this way a range of developers of varying activity can be prepared. One alkali commonly used is sodium carbonate, of which there are three forms available commercially: crystalline or decahydrate, containing 37 per cent of the salt itself; monohydrate, containing 85 per cent of the salt; and anhydrous or desiccated, containing practically 100 per cent of the salt. The monohydrate has the advantages of being more stable and more easily dissolved than the other forms. One part of the anhydrous may be replaced in formulae by 2.7 parts of the crystalline form or by 1.17 parts of the monohydrate. Ordinary washing soda is an impure form of crystalline sodium carbonate, and should *not* be used for photographic purposes.

In some developer formulae, potassium carbonate is used as the alkali. It is supplied in its anhydrous form, and should be kept tightly sealed; if left exposed to the air, it rapidly becomes damp or even semi-liquid, in which state its strength is greatly reduced. Potassium salts offer no advantage over sodium salts as the alkali in developers, apart from increased solubility, which permits them to be used at a higher concentration.

In the high-sulphite, low-energy class of fine-grain developers, borax (sodium tetraborate) is a common alkali. The use of sodium metaborate as alkali has been advocated in certain formulae. Identical results are obtained by employing equal parts of sodium hydroxide and borax.

Table 17.2 Some buffering agents and their useful pH ranges

Buffer	pH range
Sodium or potassium hydroxide	above 12.5
Trisodium phosphate/sodium hydroxide	12.0–13.0
Trisodium phosphate/disodium hydrogen phosphate	9.5–12.6
Sodium carbonate/sodium hydroxide or potassium carbonate/potassium hydroxide	10.5–12.0
Sodium carbonate/sodium bicarbonate or potassium carbonate/potassium bicarbonate	9.0–11.0
Borax/boric acid	8.0–9.2
Sodium sulphite/sodium metabisulphite or potassium sulphite/potassium metabisulphite	6.5–8.0

Certain alkaline salts also acts as *buffers* to maintain the pH value constant during the development reaction and on storage or standing of the developer in a tank line or processing machine. A solution is said to be *buffered* when it shows little or no change in pH on the addition of acid or alkali. Water is unbuffered and its pH is greatly affected when only a little acid or alkali is added. Buffering of photographic solutions is commonly achieved by the use of relatively large amounts of a weak acid, e.g. boric acid, and the sodium salt of that acid, e.g. borax (see Table 17.2).

The relative amounts of the buffer components determine the pH value of the solution and their concentrations determine the buffering capacity. For example, a solution containing 21.2 grams per litre of anhydrous sodium carbonate has a pH value of 11.6. So has a solution containing 0.13 grams per litre of sodium hydroxide, but the latter would rapidly become neutralized.

The restrainer

Two main types of restrainer are employed, inorganic and organic. The function of a restrainer is to check the development of unexposed silver halide crystals, i.e., to prevent fog; restrainers also check the development of the exposed crystals to a greater or lesser extent and so affect film speed. The effectiveness of a restrainer in minimizing fog, and its effect on film speed, varies from one developing agent to another and depends on the emulsion. It is also influenced by the pH of the developing solution.

Potassium bromide, an inorganic substance, is the most widely-used restrainer. Soluble bromide is produced as a by-product of the development process and affects the activity of the developer. Inclusion of bromide in the original developing solution therefore helps to minimize the effect of this release of bromide. For this reason most developer formulae employ bromide as a restrainer, including those formulae which also contain organic restrainers. Among the few developers that do not include bromide are the low-contrast MQ-borax formulae. Developers for papers always include bromide, because with papers any trace of fog is objectionable. High-contrast developers usually contain comparatively large amounts of potassium bromide. The purpose of this is to obtain a charactereistic curve with a very short foot, which leads to higher contrast. Phenidone is much less influenced by bromide than is metol, especially at a low pH.

Of the several organic substances that have been found suitable for use as restrainers, benzotriazole is widely employed. Organic restrainers are especially valuable in Phenidone developers, the activity of most Phenidone formulae being such that to prevent fog with high-speed materials the amount of bromide required as restrainer would be so great that there would be a risk of stain, because bromide when present in excess is a mild silver halide solvent. Use of an organic restrainer avoids this risk. A certain amount of bromide is, however, usually included in Phenidone formulae to help to keep the activity of the solution constant with use, for the reason already explained. Benzotriazole has been found to be very suitable for use as an organic restrainer in phenidone developers. With contact papers, it combines a blue-black toning action with its restraining action, making it very suitable for use in PQ formulae intended for the development of contact prints.

Organic restrainers appear to be capable of restraining fog without affecting film speed, to a greater extent than inorganic restrainers. For this reason they have come to be widely used as *anti-fogging agents* (anti-foggants), for addition to standard developer formulae whenevere there is particular danger of chemical fog or staining. In this role, organic restrainers are commonly used:

(1) To minimize the risk of fog and staining on material subjected to prolonged development or to development at high temperatures

(2) To help to prevent fog or veiling on materials which have been stored under unfavourable conditions or which are of doubtful age.

The use of anti-foggants is particularly valuable with prints, because fog is more objectionable than with negatives. Organic anti-foggants are very potent and must be used with care. Their use in excess may lead to a loss of effective emulsion speed, a slowing of development, and, with prints, to poor blacks.

Water for developers

While distilled water is always best as a solvent, its degree of superiority is not usually sufficient to justify its extra cost; tap water is normally a perfectly satisfactory alternative. The mineral salts in tap water are usually without photographic effect. If they give rise to calcium sludge, a calcium sequestering agent (see below) may be added to the water before making up the developer.

Miscellaneous additions to developers

Besides the main ingredients, i.e. developing agent(s), alkali, preservative, restrainer, a developing solution sometimes contains other ingredients

for specific purposes. These may include wetting agents (page 249), silver halide solvents (page 234) anti-swelling agents for tropical processing (page 241), calcium-sequestering agents (water softening agents) and development accelerators.

The presence of calcium salts in tap water sometimes causes a calcium sludge to be precipitated by the sulphite and carbonate in the developer. This may cause a chalky deposit to appear on films and plates on drying. This scum is most likely with developers with a high sulphite content and low pH, e.g. MQ-borax formulae, especially if hard water is used. (In developers containing caustic alkali, the calcium salts do not generally precipitate.) Calcium scum may be removed by bathing negatives in a 2 per cent acetic acid solution after washing, and then briefly rinsing them.

The function of a *calcium sequestering agent* in a developer is to prevent scum from forming on negatives, by transforming the calcium salts into soluble complexes which cannot be precipitated by the sulphite and carbonate in the developer. Sodium hexametaphosphate (Calgon) is commonly used for this purpose. A suitable concentration in most circumstances is about 3 grams per litre. This should be added to the water before the other developer constituents.

EDTA (ethylenediaminetetraacetic acid) is used also as a sequestering agent in developers but suffers from some disadvantages although it is an efficient sequestering or complexing agent for calcium ions. In the presence of trace amounts of copper or iron ions it catalyses or speeds up the rate of aerial oxidation of developing agents. Also EDTA is able to form complexes with silver ions that may cause dichroic fog, owing to physical development. This effect is especially noticeable with chloride emulsions because of their higher solubility.

Some developers also contain development accelerators which increase the rate of development independently of the alkali (which is also sometimes erroneously termed an 'accelerator'). Examples of these compounds include cationic (positively charged) wetting agents such as cetyl pyridinium bromide, organic amines, e.g. ethylenediamine, non-ionic polymers, e.g. polyethylene glycols, and urea in extremely small quantities).

Monochrome developer formulae in general use

Many thousands of different developer formulae have been published through the years and a great number of different formulae are still in general use. Nevertheless, the basic types of formulae employed today are relatively few in number.

Unfortunately there is no generally-agreed method of classifying developer formulae. At one time developers were classified according to the developing agents they contained; this taxonomy persists to a limited extent. Thus, developers are still termed MQ and PQ for metol-hydroquinone and Phenidone-hydroquinone respectively. Developers are also classified according to their action (fine-grain, low-contrast, high-contrast, acutance etc) or according to the materials for which they have been formulated (print, colour-negative, line, X-ray, lithographic, etc). In addition to this confusing and overlapping terminology, developers are also known by a number of trade names or code numbers.

Kodak *D-76, HC-110, Technidol LC, Microdol-X;* Ilford *ID-11, Bromophen, Microphen, Perceptol*; Agfa *Rodinal, Refinal, Neutol*, are trade names of some representative developers from manufacturers of sensitized products. There are also many other named developers from specialist manufacturers of processing chemicals who provide developers for processing a wide variety of films.

For convenience, developer formulae may be classified into various types which combine the type of developer, its action and the material for which it has been designed, thus avoiding the use of uninformative trade names.

(1) *Universal* Suitable for developing all types of materials such as roll film, sheet film, 35 mm film, papers. However, although such developers are very convenient because of their universality, it is better to select a developer that is specially formulated for the material concerned.

(2) *Fine-grain* For yielding negatives such that graininess is optimized in the prints. These are particularly suited for the development of 35 mm films which may require a high degree of enlargement.

(3) *Low-contrast* Designed to give negatives of very low contrast, either for recording scenes of exceptionally high contrast, or for developing films which are inherently high in contrast to give negatives that can be printed with a full range of tones. Also suitable for making low-contrast printing masks, for unsharp-masking techniques.

(4) *High-contrast* For developing line, X-ray, aerial films, i.e. where it is necessary to produce a contrast that is higher than normal.

(5) *Extreme-contrast* Also termed 'lithographic'. Developers formulated for use with lithographic films, to give the extreme contrast as required in the production of line and half-tone screen images for photomechanical work.

(6) *Acutance* Specially formulated for maximizing *edge effects* for increased image definition (see page 345).

(7) *General-purpose* Designed for developing all types of negative films. They are more suited for negative development than the universal formulae (1) but do not optimize graininess.

(8) *Paper or Print* Specially formulated for developing prints in dishes or for machine-processing of prints.

(9) *Chromogenic* Colour-negative developers used for the development of monochrome films that have dye images rather than images of metallic silver (*Agfa Pan Vario X1* and *Ilford XP-1*).

(10) *Concentrated* For one-shot use. The developer is diluted by a large amount, used once only and then discarded.

Table 17.3 Types and examples of proprietary monochrome developers

Developer	Example
Universal	ID-36 (I)
Fine-grain	ID-11 (I), D-76 (K), Refinal (A)
Low-contrast	Technidol-LC (K), D-23 (K)
High-contrast	D-11 (K), D-19 (K)
Extreme-contrast	Kodalith (K)
Acutance	Neofin-Blue (T)
General-purpose	D-61A (K)
Print	Bromophen (I), Ilfospeed (I), PQ Universal (I), D-163 (K), Neutol (A)
Chromogenic	XP-1 (I), AP-70 (A), C-41 (K)
Concentrated	Ilfosol 2 (I), HC-110 (K), Rodinal (A)

The letters in parentheses after the developer refer to the manufacturer. (A) = Agfa (I) = Ilford (K) = Kodak (T) = Tetenal

Table 17.3 lists examples of the above types of developers; examples of specific formulae are given in the appendix.

The most widely-used developers are based on mixtures of metol and hydroquinone, and Phenidone and hydroquinone. Although, for special purposes, other developing agents have found favour from time to time, for general photography nothing has been found to equal MQ and PQ mixtures in all-round efficiency and flexibility.

Metol-hydroquinone developers

Until the introduction of Phenidone, the general-purpose developers used in practical photography with very few exceptions employed metol and hydroquinone as developing agents. The success of these depends on the fact that their photographic

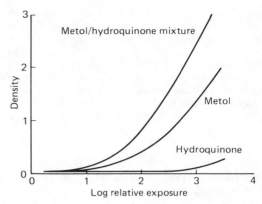

Figure 17.1 Superadditivity in a metol-hydroquinone developer

properties are superior to those of the components taken separately and are not just equal to the average of their individual effects. This phenomenon is called *superadditivity* or *synergesis*.

The following simple demonstrations illustrate the phenomenon of superadditivity (see Figure 17.1). If a film is developed in an MQ-carbonate developer for the recommended time an image of normal contrast showing both highlight and shadow detail is obtained. If, however, the film is developed in the same basic developer formulation for the same time but omitting metol only a trace of the brightest highlights are recorded. If the film is developed for the same time in the developer omitting hydroquinone an image is obtained that contains both highlight and shadow detail but is somewhat lacking in contrast.

It is clear from these experiments that a developer containing both metol and hydroquinone produces a photographic effect that is greater than would be expected from a mere addition of the effects of metol and hydroquinone. Thus metol and hydroquinone in combination are said to from a *superadditive* (or *synergistic*) *system*.

The mechanism of superadditivity may be explained as follows: Metol or the *primary* developing agent is adsorbed to the silver-halide crystal surface, where it reduces a silver ion to metallic silver. In doing so it becomes oxidized and the oxidation product remains adsorbed to the developing grain. Hydroquinone, or the *secondary* developing agent, then reduces the primary developing agent oxidation product and so regenerates the primary developing agent at the grain surface. The secondary developing agent is oxidized and its oxidation product is removed by reaction with sulphite. this cycle repeats itself until that grain is fully developed. Thus superadditivity involves a regeneration mechanism in which a constant supply of active primary developing agent is maintained at the surface of the

developing grain. The efficiency of the development reaction is far greater in superadditive developers than in developers containing single developing agents where fresh developing agent has to diffuse to the grain surface and the oxidation product has to diffuse away, react with sulphite and be replaced by the diffusion of more developing agent. By varying the ratio of hydroquinone to metol it is possible to formulate developers which give any desired contrast.

Phenidone-hydroquinone developers

Phenidone forms a superadditive system with hydroquinone just as metol does, but it is much more efficient than metol in this respect. Whereas a given weight of hydroquinone requires about one quarter of its weight of metol to activate it, it needs only a fortieth part of its weight of Phenidone. This means that a PQ developer is cheaper than its MQ equivalent, and highly concentrated liquids can be produced with a PQ system without so much danger of the developing agents precipitating out. The latter feature has led in recent years to a considerable increase in the use of ready-compounded developers in liquid form.

For a given pH, a PQ developer is slightly more active than its MQ equivalent. Therefore, to attain the same activity as its MQ counterpart, a PQ developer can work at a slightly lower pH, giving better keeping properties in use and a longer shelf life. In some formulae, use of a PQ mixture in place of an MQ mixture can avoid the need for the use of caustic alkali.

In a hydroquinone developer containing sulphite, the oxidation product of hydroquinone is hydroquinone monosulphonate. With metol this forms an almost inert system so that development virtually stops when the hydroquinone has all been oxidized, but with Phenidone it forms a superadditive system of appreciable developing power. This means that a PQ developer will last longer in use than its MQ counterpart. As stated earlier, with the MQ system the hydroquinone tends to regenerate the metol. This process, however, has a low efficiency and some of the metol is lost by conversion to an inactive monosulphonate. In PQ developers, the regeneration of hydroquinone of the primary oxidation product of Phenidone appears to be much more efficient and is not accompanied by any Phenidone sulphonation. This results in a longer working life. It also simplifies the control of replenished PQ developers, since only a small fixed allowance need be made for the loss of Phenidone.

Bromide ion has less of a restraining action on PQ developers than on MQ ones, especially at a low pH. (A very marked difference is apparent in borax-buffered developers.) This means that replenisher systems operating on a 'topping-up' basis can be worked for longer periods when Phenidone is used. Further, the PQ borax type of negative developer is less likely than an MQ borax developer to give 'streamers' (page 237).

Phenidone is also less likely than metol to produce dermatitis on hands. Because the ultimate oxidation product of phenidone is colourless, PQ developers are less apt to cause staining on fingers and clothes than MQ developers. Staining from the oxidation products of hydroquinone cannot be completely avoided. Metol, particularly at high pH, tends to become hydrolysed to form methylamine, giving rise to an unpleasant fishy odour. Phenidone is not open to this objection. PQ developers also tend to give a later start to the image formation and subsequently to build up the image rather more quickly than their MQ counterparts. This effect is especially noticeable in paper developers.

At the pH levels associated with carbonate buffering, (see Table 17.2). PQ developers tend to give fog with high-speed materials. For this reason, it is necessary in most PQ developers to include an organic antifoggant such as benzotriazole (page 215). PQ borax formulae do not require this.

Fine-grain developers

All photographic images have a granular structure (see Chapter 25). Although this structure is not normally visible to the unaided eye it may become so on enlargement, especially at high magnifications. The tendency to use smaller negative sizes and make all prints by enlargement aroused early interest in the possibility of obtaining a less grainy image than is normally yielded by conventional developers. As a result, special fine-grain and extra-fine-grain developers have been evolved. These developers achieve the desired result in several ways. First of all, they are usually low-contrast, as this minimizes clumping of the silver grains: with active development silver filaments formed from an exposed grain may come into contact with neighbouring grains and make them developable. Some formulae actually produce smaller individual grains, though this tends to result in reduced emulsion speed.

Most fine-grain developers yield negatives of comparatively low contrast due in part to a *compensating effect* in which developer in the highlight areas of the negative becomes exhausted and effectively gives less development in the more dense areas of the negative than would be obtained in the absence of any compensating effect (see Figure 17.2). Although a reduction in contrast serves to minimize the graininess of the negative, it is doubtful whether

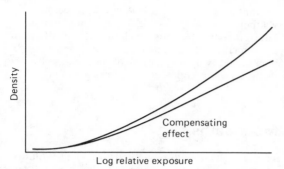

Figure 17.2 Hypothetical example of compensation in development

it contributes significantly to a reduction in the graininess of the final print. Any reduction in graininess achieved by lowering the contrast of the negative is likely to be offset to a large extent by the increased contrast of the harder paper required to print it.

Fine-grain developers can be divided into two basic types:

(1) Low-pH, non-solvent (other than sulphite)
(2) Solvent, containing silver-halide solvents other than sulphite

Both of these act to some extent by processes involving physical development. This has the effect of inhibiting the filamentary growth of silver that occurs in normal chemical development, and thus minimizes clumping. The penalty is the total loss into solution of a proportion of the silver halide, and a corresponding fall in effective emulsion speed. Type (2) developers are now seldom used because of this and the risk of fog with some types of emulsion.

It should be noted that the influence of the developer on graininess has been much exaggerated.

The most important condition for obtaining negatives of low granularity is the choice of a fine-grained emulsion (page 344). A table indicating very approximately the degree of enlargement permissible with various combinations of film and developer is given on page 301.

Low-contrast developers

The original application of low-contrast developers was for the recording of scenes of exceptionally high contrast. More recently such developers have been revived for developing films such as *Kodak Technical Pan Film* which is an ultra fine-grain film of high contrast. Low-contrast images are also required for certain duplication processes, and in pictorial manipulative techniques for making low-contrast masks for unsharp-masking and other purposes. Low-contrast developers are based on solutions of single developing agents, and are very simple formulae. For example the developer POTA, recommended for the above material, is a solution of Phenidone (1.5g) and sodium sulphite (30g) in one litre of water. No other chemicals are used. (An earlier low-contrast developer is *Kodak D-23*, which consists of metol (7.5g) and sodium sulphite (100g) in one litre of water. An advantage of POTA is that it gives low contrast without loss in film speed. This is shown in Figure 17.3, in which the action of POTA is compared for the same film with that of a conventional fine grain developer (D-76). POTA is able to record scenes with an arithmetical contrast of 1 000 000:1, whereas with D-76 the curve begins to level off at much lower log-relative-exposure values, and so is unable to record adequate detail beyond a ratio of about 1000:1.

High-definition developers

High-definition or *high-acutance developers* are solutions which give increased definition to photographic images by enhancing the contrast of edges and fine detail in the negative, although the resolving power of the emulsion may not be any higher than usual. This is achieved by the use of a formula containing low concentrations of developing agent, sulphite and bromide and a high pH. This promotes the production of adjacency effects (page 237). High-definition developers may increase emulsion speed by a factor of one stop or more, but they also increase graininess. They are, therefore, generally recommended for use only with fine-grain (i.e. slow- or medium-speed) emulsions. Because of their low concentration of developing agents, most high-

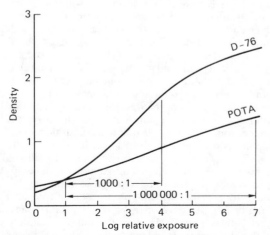

Figure 17.3 Low-contrast development

definition developers should be made up only when required for use and used once only. Enhanced adjacency effects may be obtained in MQ-borax and other soft-working fine-grain developers by using them at greater dilutions, e.g. by diluting the stock solution 1 + 1 or 1 + 3, and increasing the developing time by the appropriate amount.

Extreme-contrast (lithographic) developers

Lithographic development is characterized by a *D*-log *H* curve showing very low fog, very high contrast and a very sharp toe (see Figure 17.4). It results from a combination of special lithographic emulsions and developers. The *lith effect* (Figure 17.4) is not given by developing normal negative emulsions in a lithographic developer nor by developing a lithographic emulsion in a high-contrast developer.

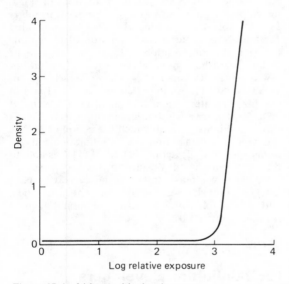

Figure 17.4 Lithographic development

Lithographic developers contain hydroquinone as the developing agent and depend for their effect on *infectious development*, i.e. the acceleration of the development of low densities adjacent to high densities. Although these developers give extreme contrast with the appropriate emulsions they are usually much less alkaline than developers normally associated with high contrast. A very low concentration of sulphite is maintained in the developer, either by the addition of paraformaldehyde which forms formaldehyde-bisulphite in the developer on reaction with sulphite. The aldehyde-bisulphite compound dissociates slightly into its component chemicals, thus supplying a constant and small amount of sulphite, sufficient to protect the developer from aerial oxidation but not enough to interfere with infectious development. The pH value for infectious development is critical and must be maintained within very small tolerances by the inclusion of an appropriate buffering compound.

Monobaths

The term *monobath* is applied to a single solution which combines the actions of development and fixation. Solutions of this type have attracted interest for many years but it is only comparatively recently that the difficulties associated with their formulation have been overcome. The main problem has been the loss of emulsion speed which results if the exposed silver halide is dissolved away by the fixation process before development can take place. To prevent this, developing agents of high activity and short induction period are required. Modern monobaths usually contain Phenidone and hydroquinone as developing agents, and sodium thiosulphate as fixing agent. Monobaths have the advantages of simplifying and speeding up processing, but it is usually necessary to provide a specially-balanced monobath formula for each emulsion or group of similar emulsions. For these reasons, monobaths have found their main application in fields in which rapid access to photographic records is important, as in data and trace recording, etc, and where the inflexibility of the system is not a disadvantage.

Chromogenic developers

Colour (or *chromogenic*) developer solutions have many similarities with monochrome developers. They contain the same types of constituents with some modifications, i.e. a developing agent based on p-phenylenediamine (see Table 17.1), a preservative such as sodium sulphite, an alkali (see Table 17.2) and a restrainer or antifoggant such as potassium bromide or potassium iodide in very small quantity. Apart from the developing agent, a major difference between a colour developer and a typical monochrome developer is that in a colour developer sulphite is present at a much lower level (generally less than 2 grams per litre). The reason for this is that in the colour development reaction the developer oxidation products are required to form the dye image by reaction with a colour coupler (see also Chapter 24). As developer oxidation products also react with sulphite a significant amount of sulphite in the developer would compete with the colour

coupler and the yield of dye image would be reduced:

Silver halide + colour developing agent →

metallic silver + halide ion

+

oxidized colour developing agent

+ colour coupler ↓ ↓ + sulphite

dye sulphonate

Chromogenic developer solutions may also contain an *antioxidant* or *anti-stain agent* such as hydroxylamine or ascorbic acid, which provides some protection from the effects of aerial oxidation (which promotes colour coupling and hence dye formation or staining in unexposed areas). Other constituents of colour developing solutions include competing couplers, e.g. citrazinic acid or a competing black-and-white developing agent to control colour contrast, benzyl alcohol to aid the diffusion of the oxidized developing agent to the colour coupler which in some materials is incorporated in the emulsion in solution in oil droplets. With materials processed at higher temperatures, using active colour developing solutions and conditions, benzyl alcohol appears to be no longer necessary. In colour reversal processing the chromogenic developer often contains a chemical fogging agent to avoid the inconvenience of the reversal exposure. Chromogenic developers also contain some of the additional developer constituents mentioned on pages 215–216.

Chromogenic developers are used for the development of almost all colour camera materials except Polaroid, and are also used in the processing of certain types of monochrome dye materials such as Ilford XP-1. The latter film uses the emulsion technology associated with modern colour-negative films, but produces a monochrome dye image.

Changes in a developer with use

As the function of a developer is to effect a chemical change in the exposed film, the composition of the developing solution itself must change with use. As a developer is often used more than once, in particular when tank development is employed, it is important to know what changes to expect, how these changes affect the function of the solution, and what can be done to prevent compensate for them.

The first change occurs because some developer solution is carried out of the tank with the film, both on its surfaces and in the emulsion. This removes some of each ingredient from the solution. The amount removed depends upon the size of the film,

the type of clip or holder employed and the time during which developer is drained back from the film into the tank.

The second change occurs because the developing agents are used up by reducing the silver halide in the negative to silver, and by aerial oxidation. When the developing agents are used up by reducing silver halide, the products of the reaction tend to cause a *fall* in pH; when, however, the developer is used up by aerial oxidation, the pH tends to rise. The reactions involved, expressed in simple form, are as follows:

Exhaustion through use
Developing agents + silver bromide →
 oxidized developing agents + metallic silver
 + bromide ions + hydrogen ions (acid)

Exhaustion through standing
Developing agents + oxygen →
oxidized developing agents + hydroxyl ions (alkali)

With the less alkaline developers, e.g. MQ-borax and PQ-borax developers, changes in pH have a very marked effect on the activity of the solution. These changes may be countered by incorporating in the developer a buffer system in place of the normal alkali (page 215).

The third change occurs because the sulphite is used up.

The fourth change occurs because the bromide content of the developer is increased, as bromide is liberated from the emulsion itself.

The main effects of these changes on the working of the developer are:

(1) The development time required to reach a given contrast increases, due to exhaustion of the developing agents and increase in the bromide content. If, therefore, it is desired to use a developer repeatedly, the development time must be increased as more and more material is put through the bath; alternatively, the developer must be replenished.

(2) The effective emulsion speed produced in the developer decreases owing to the increase in bromide. This speed loss may be partially offset by the increased development time required to maintain contrast.

Complete exhaustion of the solution occurs when the developing agents are entirely used up. Exhaustion of the developing agents is bound up with exhaustion of the sulphite, since, if the sulphite is completely oxidized before the developing agents are used up, the developing agents, lacking a preservative, will rapidly oxidize too. (The *shelf life* of a developer is largely determined by the sulphite content; its *working life* may be governed either by exhaustion of the developing agents or by exhaustion of the sulphite.) With many developers, the

approach of exhustion is characterized by the acquisition of a brown coloration. Since a solution in this condition can stain sensitized materials, developers should not be overworked.

For the amateur, it is a good rule to discard a developer after it has been used once, or, with expensive fine-grain developers, after the amount of material recommended by the author of the formula has been passed through it. For the professional who handles large quantities of material, a more economical use of solutions can be achieved by use of a replenishment technique, as described below.

Replenishment

Replenishment ideally involves a continuous replacement of part of the used developer by a solution which has been formulated so that the mixture maintains photographic characteristics in the material developed constant. The aim is to keep the activity of the bath constant rather than its composition. Two methods of replenishment are commonly employed. The first is known as 'topping up' and the second as the 'bleed' method. In the former, which is used extensively in tank processing in the larger photofinishing establishments, the developing solution is maintained at a constant level either by periodical addition of the replenisher or by a feed system, so that the volume added is equal to the volume of developer carried over by absorption in the gelatin and on the surface of the material being developed. With the MQ and PQ formulae of high pH, owing to a gradual rise in the bromide content of the mixed solutions it is possible to maintain reasonable constancy of characteristics only for a certain period of replenishment. After a given volume of replenisher has been used, therefore, the mixture is discarded and the procedure repeated with fresh developer. PQ formulae of low pH are not greatly affected by bromide, so that replenishment by the topping-up method may be continued almost indefinitely.

In the 'bleed' system, which is commonly employed for machine processing of film with a circulating developer system, used developer is run off and replenisher fed in continuously, so that the level of the developer and its characteristics remain constant. The bled-off developer, after modifications, may be used for other purposes. The bleed system of replenishment is the only one in which it is possible to maintain absolute constancy in the bromide concentration. In certain circumstances, this offers practical advantages.

Although many processing machines have a fully-automated replenishment system, adjustments to the replenishment rate may have to be made to keep the process within the limits set by the manufacturer

(see quality control, page 233). To assist the operation of non-automatic processing equipment and the setting-up of automatic processing equipment, suppliers of chemicals provide tables or graphs which relate the volume of replenisher to the area or number of films being processed.

Formulation of replenishers

For any developer, the formulation of a satisfactory replenisher depends largely upon the processing conditions employed and the photographic material being developed. Storage conditions, and the frequency with which the developer is used and its surface agitated during passage of the photographic material, affect the allowance which must be made for atmospheric oxidation. The coating weight and the average amount of developable silver per unit area of material developed (determined by the exposure and the degree of development) are also factors which must be considered. The carry-over, which depends largely on the type of holder employed and the draining time, has a considerable bearing on the formulation of a replenisher. Only for standard conditions of work, therefore, is it possible to recommend a single replenisher, which can be formulated from the data obtained by quantitative study of the chemical changes in the developer solution under working conditions. This procedure is normally followed by the manufacturers of packed developers in devising replenishers for use under standard conditions of processing. In the absence of a specially formulated replenisher, the developer itself (omitting bromide) may be used as a replenisher solution, but the performance of a bath replenished in this way cannot be expected to maintain constancy of performance over a very long period.

If facilities for analysis of a developer bath are available, addition of individual ingredients may be made to it as required, even under varying conditions of work, and the life of the solution maintained indefinitely. This procedure is adopted in cine processing laboratories where very large volumes of solution are employed and constant performance of the bath is of utmost importance.

Preparing developers

In general, developers should be made up using warm water to speed up the dissolving of the chemicals. With developers containing metol it is recommended that this water should be at a temperature of not more than 50°C, otherwise the metol may decompose. Developers containing Phenidone can, however, be made up at about 50°C. When

making up a developer, only about three-quarters of the required final volume of water should be taken to start with, so that by adding the remainder after the various chemicals are dissolved the volume can be made up to exactly the required quantity. This final addition should be of cold water.

The order in which the constituents of a developing solution are dissolved is important. In general, the best order is:

(1) Preservative
(2) Developing agent(s)
(3) Alkali
(4) Other components

This order is governed principally by the need to guard the developing agents from oxidation. Solution of the preservative first will prevent oxidation of the developing agents while the solution is being made up. The rate of oxidation of the developing agents is very much accelerated by the presence of alkali. It is, therefore, usually best for addition of the alkali to be left until both preservative and developing agents have dissolved completely. The other components have little influence on the rate of oxidation of the developing agents and can be left until last.

There are important exceptions to the above general rules:

Developers containing metol

Metol is relatively insoluble in concentrated solutions of sodium sulphite, so that with metol and MQ developers only a small quantity of sulphite should be added first as a preservative, then the developing agent and then the balance of the sulphite.

Developers containing Phenidone

Phenidone is not as readily soluble as some developing agents, but its solubility is assisted by the presence of alkali. It is, therefore, best added after both sulphite and alkali. (Phenidone does not share with metol the difficulty of dissolving in strong solutions of sulphite.)

Developers containing glycin

Glycin is almost insoluble in neutral solution. Hence, it is even more desirable with glycin to add the developing agent after the alkali has been dissolved.

Chromogenic developers

To prolong the life of a chromogenic developer prepared from the individual chemicals, all the ingredients except the developing agents should be dissolved in the order given in the formula, and the developing agent added immediately before use.

Stock and working-strength solutions

Some proprietary developing solutions are made up in concentrated form, and are diluted one to two times (or more) for use. If the solutions are diluted with tap water, which contains chlorides and other salts as well as dissolved oxygen, this working solution does not keep, and must be discarded after use. For this reason there is a strong body of opinion in favour of 'one-shot' processing, using developers diluted beyond the normal ratios and discarded after use. Solutions for dish processing are frequently made up at two or three times the concentration of those used for tank processing, as agitation can be more efficient and uniform development achieved for processing times as short as two or three minutes. Tank solutions must not be diluted in colour processing, where speed of penetration of the emulsion and rate of reaction are critical in the establishment of correct colour balance.

Pre-packed developers

To avoid the inconvenience of preparing developers and replenishers from their constituent chemicals, many compounded developers and replenishers are available for processing virtually all black-and-white and colour materials. The two main types are *powdered chemicals* and *liquid concentrates*. For ease of use liquid concentrates are often preferred because they require only dilution before use; this is much simpler to carry out than the more lengthy procedure involved in dissolving powders. The modern trend is toward the use of liquid concentrates, and many developers are available only in this form. However, liquid concentrates are more bulky, more expensive and have a more limited shelf life than powdered chemicals.

Powdered chemicals

Powdered chemicals are usually dissolved in warm water (approx. 40°C) to make up the working strength solution directly; but in some cases, they are used to prepare a stock solution which is then diluted as required. The main problems encountered in packaging developers in a powdered form are the stability of the mixture and the selection of appropriate chemicals such that the powders dissolve rapidly. Generally anhydrous powdered chemicals are used. They must not absorb moisture to any great extent or they may form a hard cake that is difficult to dissolve. To increase the stability of the powdered chemicals it is usual to pack the developing agent and alkali separately. The packet that

contains the developing agent may also contain some sodium or potassium metabisulphite as a preservative. The remainder of the developer components, preservative, restrainer and alkali are packed in the second packet or container. In some cases a third packet is included. This contains a sequestering agent (e.g. EDTA) and should be dissolved first.

For dissolving powdered chemicals the following sequence is followed:

(1) Dissolve the contents of the first packet containing the developing agent and some preservative by stirring it into approximately two-thirds of the final solution volume of warm water.
(2) When the contents of this packet have dissolved add the contents of the second packet slowly and continue stirring until all the chemicals are fully dissolved.
(3) Make up the solution to the required volume with cold water.

The recommended temperature for dissolving the chemicals must not be exceeded and stirring must be moderate. It has to be sufficient to agitate the solution but must not be so vigorous that air is drawn into the solution to oxidize the developer.

Powdered chemical packs should not be divided into smaller quantities for making up less than the recommended solution volume. The chemicals are not perfectly mixed in their packets and taking less than the complete packet may result in the preparation of developers with totally wrong proportions of the various constituents. Shaking the packets does *not* produce uniform mixing and can actually increase the non-uniformity of the mixture.

Liquid concentrates

Liquid concentrates are widely available for processing most types of photographic material. However, single-solution liquid concentrates are inherently less stable than their powder counterparts and therefore may have a more limited shelf-life. They have the advantage, however, that large quantities can be purchased and divided for storage into smaller airtight containers, before diluting to the required volume. Unlike powdered chemicals, liquid concentrates are perfectly homogeneous. For economic considerations they are made as concentrated as possible. Some liquid concentrates for one-shot processing may be diluted by as much as one hundred times, but more usually the required dilution to repare the working strength solution is within the range of 1:3 to 1:50. Because they are diluted with large volumes of (tap) water, liquid concentrates often contain EDTA (see page 216) to prevent the precipitation of calcium salts. In compounding liquid concentrates one of the major prob-

lems is that of the limited solubilities of the chemicals and the tendency of some to crystallize from solution, especially when subjected to storage or transport at low temperatures. Normally potassium salts are used in preference to sodium salts because of their greater solubility. In some formulae organic amines or amine-sulphur dioxide compounds may be used to provide an alkali and preservative that are more soluble than their inorganic equivalents. In addition to the usual developer chemicals, liquid concentrates may contain a water-miscible solvent such as ethylene glycol or methylcellulose to keep the developing agents in solution. In general, phenidone-hydroquinone systems are used in preference to metol-hydroquinone systems because they enable more concentrated developers to be prepared (see page 218). In some liquid concentrates, 4-aminophenol (see page 213) is used as the developing agent because of its high solubility in alkaline solution.

Because of the high pH of the concentrate, an additional problem is that of stability of the developing agents. For example phenidone decomposes in aqueous solution at high temperatures. Accordngly, more stable derivatives of phenidone such as phenidone-Z or dimezone (see page 212) may be used in liquid concentrates. To increase the stability and shelf life of liquid concentrates, some are packed in the form of two solutions, one containing the developing agent and preservative, the other containing the remainder of the developer chemicals. This is important for colour developers and various special-purpose developers such as lithographic and high-contrast developers.

For simplicity and versatility in packaging developers and replenishers for large-scale processing a 'starter' solution is included in a separate and smaller bottle. This contains the restrainer together with possibly a small amount of developing agent oxidation product which when added to the remainder forms the actual developer solution. The 'developer' when diluted appropriately forms the replenisher.

The technique of development

The manipulation of the sensitive material during development depends largely upon the nature of the material. Sheet films, plates, and roll films each require different methods of handling. Details of the procedures recommended with each of these classes of materials are given in the following pages.

Development of sheet films

Sheet films may be developed in a dish, lying flat, emulsion upwards, or in a tank, suspended vertically

in hangers of special design. For dish development, the best practice is to place the film in the empty dish and to flood it with developer. The surface must be wetted quickly and evenly, otherwise developing marks will result. During dish development, the dish must be rocked continuously to provide agitation. Care must be taken to ensure that the rocking is not too rapid and that it is varied at intervals, e.g., first to and fro, then from side to side, to avoid patterns of uneven density caused by standing waves. In tank development, the agitation should be intermittent, and achieved by lifting the films (in their hangers) from the tank, allowing them to drain to one corner, and replacing them in the bath, once every two minutes. At the beginning of development, films should be agitated vigorously for about 30 seconds to dislodge any *airbells* and ensure even wetting. Vigorous agitation throughout the whole of the development process is, however, to be avoided, as it may lead to uneven development owing to the variation in the degree of agitation at the edges of films.

Roll, 35mm and 110 size films

It is the general practice today, except where quantity or convenience dictates the use of processing machinery, to develop roll films in individual tanks. Many different types of tank have been designed for this purpose. Some permit daylight loading, although the majority involve darkroom loading. All are suitably light-trapped to make it possible to carry out the actual developing process in the light. The film is wound into a special holder comprising a spool having wide flanges, the inner surfaces of which bear spiral grooves. In some tanks of this type, the distance between the flanges can be adjusted to accommodate various widths.

There are two basic types of spiral available for developing tanks, namely *self-loading* and *centre-loading types*. In self-loading spirals, which are usually made from plastics materials, the film is loaded from the outside of the spiral flanges towards the central core. The flanges of the spirals are free to rotate by a limited amount, and the outermost grooves of the flanges have gripping devices which allow the film to pass in one direction only. Loading the film on the spiral is accomplished by pushing the film into the grooves just past the gripping mechanisms and then rotating the flanges backward and forward by small amounts, so causing the film to be drawn into the spiral.

Centre-loading spirals, which are usually made from stainless steel, have fixed flanges, and loading is accomplished by clipping the film to the central core and then rotating the entire spiral in one direction whilst holding the film in a curved position so that it clears the outermost grooves and is loaded

Figure 17.5 Developing tanks and spirals. (a) Developing tank, which may be used with 1, self-loading spiral, 2 centre-loading spiral or 3, automatic loading spiral, (b), (c) Two models of daylight-loading tanks

from the centre towards the outside. These spirals are sometimes provided with a device which maintains the film in a curved position and aids the loading operation. Stainless-steel spirals are robust, and can be dried rapidly by heat.

A darkroom-loading roll film tank is essentially a miniature darkroom. Once the film has been loaded into the tank, all processing operations, as well as the removal of the film, may be carried out in full daylight; only the actual loading need be done in the dark. It is best to practise loading, using a length of old film, until one becomes sufficiently familiar with the operation for it to be easy to repeat it in total darkness. The atmosphere of the room in which loading is done must, of course, be dust-free.

The actual loading procedure for the various types of tank varies in detail, and full instructions for loading usually accompany each tank. After loading, the tank may be brought into the light. Developer is usually introduced into the tank through a central light-tight opening in the lid. During development, agitation is obtained by movement of the film through the solution. If the tank is spill-proof this may be achieved by periodic inversion of the complete tank. Alternatively, the holder carrying the film may be rotated in the tank. Rotary action is usually by a rod which is inserted through

the central opening to engage the film-holder spindle; it is usually recommended that the film should be agitated every thirty seconds. This agitation should be to-and-fro, since continuous rotation of the film holder in one direction may cause the film to pull out of the spiral.

After development is complete, the solution is poured from the tank by the spout provided and replaced by a stop bath or the tank flushed with water. The tank should then be filled with fixing solution. About five minutes should be allowed for fixation (in a fresh fixing bath) and during this time the film holder should be rotated once or twice by means of the rod. After this period has elapsed, the fixing solution should be poured from the tank, which should then be placed so that running water enters the central hole, preferably via a piece of flexible tubing. Washing should be continued for at least 20 minutes. If running water is not available, the tank should be filled and emptied with clean water at least six times, allowing five minutes to elapse between each filling and emptying. This is also advisable even when using running water.

After washing, the tank should be opened, a drop of wetting agent added and the film removed as carefully as possible. The film should then have a clip attached to each end and be hung by one of these clips in a warm, clean atmosphere and allowed to dry (page 249). The tank should be thoroughly washed, wiped, and placed to dry. It is important that this drying should be thorough and that the wiping should not leave traces of fibrous material in the spiral grooves. Only moderate heat should be used to speed up the drying of a tank made of plastics material, as it can warp with excessive heat.

Tank lines

For larger-scale processing, *tank lines* are a useful form of equipment. There is still a place for these in the modern darkroom, despite their having to be manually operated in total darkness. They are inexpensive and versatile, capable of accommodating virtually any format or process. They comprise a series of rectangular tanks of 7–15 litres capacity, surrounded by a water or air jacket which maintains the temperature of the processing solutions at the correct value. Photographic material is held in baskets (see Figure 17.6). Agitation is effected by raising and lowering the baskets in the tanks, and the operator transfers them from tank to tank at the times appropriate for the process.

Tank lines are usually operated as replenished systems, and with care can be maintained over long periods. When not in use the tanks are covered with lids which float on the surface of the solution, to minimize atmospheric oxidation; they also have a

Figure 17.6 Tank line film holders, showing spirals and baskets for roll and 35 mm films and sheet-film holders

cover over the top. To overcome the limitation of the manual nature of tank lines, many types of automatic processing devices are used, even for relatively small scale processing; these are described in the following section.

Machine processing

For processing large quantities of film or print materials neither simple tank processing of films nor dish processing of papers is appropriate. A number of processing machines with various capacities suitable for all scales of operation from the amateur photographer to the large-scale photofinishing laboratory are available. Table 17.4 gives approximate capacities of various types of processing device.

The various approaches to machine processing of photographic materials are shown in Figure 17.7.

Table 17.4 Approximate capacities of processors

Processor	Approximate capacity
Multispiral developing tank (manual)	Up to five 135–36 exposure films
Tank line (13.5 litres) using spirals loaded in processing racks (manual)	Up to 30 135–36 exposure films, 30 8 × 10 prints/batch
Tube or drum (machine)	Up to 50 135–36 exposure films/batch, 60 A4 prints/batch
Self-threading roller (machine)	6 m/min : 450 A4 prints/hour (B & W), 25 A4 prints/hour (colour)
Continuous, roller (machine)	Up to 20 m/min (film), 10 m/min (prints)
Dunking (machine)	400 films/h

These include a variety of *tube* or *drum processors* (a) to (d), which are relatively small-scale batch processors and have the advantage of versatility. One such processor may be used for processing almost any photographic material provided that the appropriate roll film, sheet film or paper holders are available. Many tube or drum processors use *one-shot processing*, in which fresh processing chemicals are used for each batch of material being processed and are discarded after their use. The more sophisticated types re-use the solutions and require replenishment.

The simpler versions are non-automatic and require the operator to pour in the processing chemicals and to drain the drum at the end of each processing cycle. However, once loaded these machines may be operated in the light as the tube or drum is itself light-tight or is contained in a light-tight box. These processors have the disadvantage of an intricate loading procedure. For higher throughput of films or papers and ease of loading, *self-threading roller processors* (Figure 17.7e) are commonly used, especially for RC black-and-white and colour papers, X-ray films and graphic-arts materials, provided that the scale of operation justifies their use. As the name implies, the material film lengths, sheet films or papers is fed in at one end of the machine, is guided in and out of the processing tanks by a number of closely-spaced rollers, and emerges from the machine dry. These machines are fully-automatic and use replenishment systems to maintain solution activity. Another example of this type of processing machine is shown in Figure 17.7f. This is an *in-line* or *straight-through* processing machine in which the material travels horizontally through the machine, guided by rollers, through applicators into which solutions are pumped from reservoirs contained in the machine.

To avoid carry-over of solution from one tank to another (which would affect the replenishment rate) these machines are fitted with squeegee rollers between the tanks, as shown in Figure 17.8. The rollers in these machines are a critical feature: some

Figure 17.7 Machine processors. (a)–(d) Types of drum processor; (e) self-threading roller processor; (f) 'Transflo' processor; (g) continuous roller processor; (h) dunking machine

Figure 17.8 Rack system in the *Colenta* self-threading roller transport processor; A squeegee rollers, B water, C material path, D staggered rollers

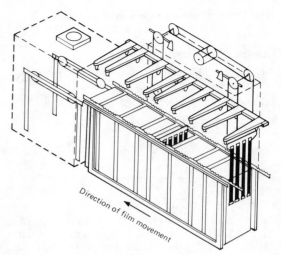

Figure 17.9 'Dunking' processing machine

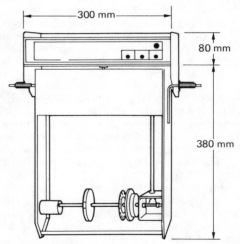

Figure 17.10 A disc rack (*Propak*) for use in a dunking machine

manufacturers use hard rollers, others use soft rollers; the rollers may be either in a staggered configuration (as in Figure 17.8) or in pairs directly opposite one another. Most modern materials are designed to be processed in machines of this type, with emulsions that are thinly coated and hardened so as to be able to withstand the pressure of the rollers. These machines are a rapid and convenient method of fully-automated processing, and are available as small-scale table-top processors which lend themselves to the processing of prints (see Chapter 21), but they require careful maintenance and regular cleaning. They are available in various sizes and configuration as to suit many different applications, from the advanced amateur to the professional processing laboratory; they are available as complete systems for use by mini-labs. For this application there is a trend to waterless systems and daylight operation. These systems use conventional wet-processing solutions, but have a self-contained water reservoir for washing. This requires changing regularly, but does not need to be plumbed in to a mains water supply.

For very large-scale processing, in photofinishing laboratories, either *continuous-roller processors* (Figure 17.7g) or *dunking* machines (Figure 17.7h) are used.

These machines have a high throughput, and employ replenishment to maintain the activity of processing chemicals. Continuous roller processors contain relataively few rollers compared with self-threading roller processors, but require a leader to be used for attaching the roll of material to be processed. Both types of processor lack the versatility of tube or drum processors, as they are normally designed for a film or paper. Dunking machines are used for processing films in individual lengths, which obviates the need for splicing films together before

processing. A typical machine of this type is shown in Figure 17.9. Films are placed in clips and hung on bars or frames that are automatically raised and lowered into the processing tanks by a chain-driven hoist mechanism. The bars or frames are moved forward in each tank by serrated tracks along the sides of the processing tanks. To move the film forward the outer tracks move upward past the inner stationary tracks and move the ends of the rods supporting the films over and into the next serration. When the bars reach the last serration in the tank the hooks on the lifting mechanism pick them up and transfer them to the next tank. By the use of

special racks, dunking machines can be adapted for processing disc films (Figure 17.10). These racks allow the discs to be rotated at 200 rev/min in the processing solutions and 2000 rev/min before drying.

The required degree of development

When an exposed film is immersed in a developer, the highlights the most heavily exposed parts of the negative appear almost at once; then the middle tones appear, and finally the shadow details. If the film is taken out of the developer as soon as the shadows appear, a thin negative of soft gradation results. If, however, development is continued further, every tone gains in density, but the highlights and middle tones gain in density more rapidly than the shadows. This means that the negative increases in contrast as well as in density. If neither the emulsion nor the developer contains soluble bromide, no increase in shadow detail will be noticeable on continuing development; but in practice all modern emulsions and most developers do contain bromide, and the result is that on increasing development, shadow detail not apparent on short development appears. Lengthening the time of development can, therefore, be said to increase both contrast and speed, i.e. ability to record shadow detail. There is a limit to which this can be carried. After a certain time in the developer, no further detail appears, the emulsion having reached the maximum speed achievable in the particular developer used. Similarly, after a certain time, contrast reaches its highest value, referred to as *gamma-infinity*. Frequently, speed and contrast increase together, though this relationship varies with different emulsions. Fog and graininess also increase with increasing time of development.

The point at which development is stopped in practice depends upon the nature of the work being undertaken. Thus in the making of continuous-tone negatives, development is continued until a degree of contrast which will give negatives of suitable printing quality is achieved. Occasionally, this criterion is abandoned in favour of continuing development until maximum emulsion speed is obtained. This, however, is a specialized technique (see page 235). When copying line originals, development is continued until maximum contrast is achieved. In processing colour materials the degree of development is defined by the fixed times and temperatures recommended by the manufacturers. With a few exceptions, departures from these recommendations are likely to lead to inferior results.

Obtaining the required degree of development

There are two ways by which it may be ensured that a negative is given the required degree of development. The first is development by inspection; the second, development by the time-temperature method.

Development by inspection

In development by inspection, the appearance and growth of the image is watched by light from a safelight. Development is stopped when the negative is judged to have a suitable range of densities. This calls for skill and experience. In the early days of photography, development was always by inspection. Adoption of this method was in fact almost essential because printing papers were available in one contrast only, and it was necessary for all negatives to be of a similar density range, to suit the paper. Development by the time-temperature method does not generally achieve this. Development by inspection is seldom practised today, except in the development of negatives on slow blue-sensitive materials, as, for example, in copying and in the development of papers (Chapter 21) and in lithographic work.

Development by time and temperature

Development of negatives today is performed almost entirely by the time-and-temperature method. Standard developer formula is used, and a development time is given which will produce a known degree of contrast. The time of development is based either on the recommendations of the manufacturer for the emulsion employed, or on the user's experience. This method of development does not allow compensation for variation in subject range or for errors in exposure, but, provided reasonable care is taken in determining exposure, the latitude of the photographic process is such that satisfactory results are usually achieved. Development by the time-and-temperature method is carried out in total darkness, and is thus well suited to the development of modern panchromatic negative materials. The development time required to obtain a given contrast with a given material depends principally on:

(1) Film used
(2) Nature, dilution and state of exhaustion of developer
(3) Temperature of the developer
(4) Degree of agitation employed

The effect of each of these factors is discussed below.

Film used

Materials differ appreciably in the rate at which they develop (see Chapter 15).

Developer

The effects of variations in the composition of a developer on the development time required to reach a given contrast have been referred to earlier.

The temperature of the developer

Rate of development is dependent on the temperature of the developing solution, the rate of reaction increasing with temperature. For photographic processing it is usually best to work at a temperature in the region of 18–21°C. This has traditionally represented a compromise between low temperatures, which lead to inconveniently long development times, and high temperatures which lead to uncontrollably short development times, fog, stain, frilling, reticulation, etc. Published development times are usually related to a standard temperature of 20°C, a temperature selected as easily maintainable (in temperate climates) all the year round. However, with modern colour materials and some special-purpose hardened monochrome emulsions, far higher temperatures are now used. For example, processing temperatures of 38°C are used for many colour materials. It is recommended that where possible the temperature of the developing solution should be maintained at this figure. Where conditions are such that working within the range 18–21°C is not practicable, development of most materials may be carried out satisfactorily at any temperature from 13

to 24°C, provided that the development time is adjusted accordingly. At temperatures below 13°C, development in the usual solutions is inconveniently slow, and above 24°C special precautions have to be taken because of the risk of softening the emulsion. Within the range 13–24°C, the development time required may be ascertained approximately by multiplying the published time (related to 20°C) by an appropriate factor. The factor to be used in any given circumstances will depend upon the *temperature coefficient* of the developing agent employed. This is defined as the ratio of the development times required to give the same contrast at two temperatures 10°C apart. With many MQ and PQ developers the temperature coefficient is between 2.5 and 3.0. Development-time factors corresponding to a temperature coefficient of 2.75 are given in Table 17.5.

Table 17.5 Development-time factors for use when development time at 20°C is known

Temperature of developer (°C)	Factor
13	2.02
14	1.83
15	1.66
16	1.50
17	1.35
18	1.22
19	1.11
20	1.00
21	0.90
22	0.82
23	0.74
24	0.67

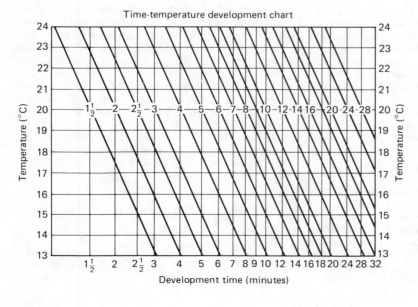

Figure 17.11 Time-temperature development chart for MQ and PQ developers of normal composition

Calculation of development times for the time-and-temperature method is facilitated by use of curves in which temperature is plotted against time of development for a given gamma. Such curves, referred to as *time-temperature curves*, are usually plotted with a linear temperature scale and a logarithmic development-time scale, because the 'curves' then become approximately straight lines. A *time-temperature chart* usually comprises a series of such curves, each related to different value of gamma. Such a chart is shown in Figure 17.11. This chart, like the development factors given in Table 17.5, is based on a temperature coefficient of 2.75. It will be noted that in the chart the slopes of all the curves shown are the same. The slope, which depends directly on the temperature coefficient, is, in fact, more or less constant for all emulsions in any one developing agent, although it varies from agent to agent. Use of a time-temperature chart avoids the calculation required with development-time factors.

To use a time-temperature chart one has first to find the development time required at the published temperature (usually 20°C) and then follow the diagonal line corresponding to this time until it cuts the horizontal line representing the temperature to be used. The point on the horizontal axis immediately below the intersection gives the development time required.

Colour processing requires very accurate control of the temperature (to within ±0.25°C) in order to maintain contrast and speed balance at 38°C) between the layers. These times and temperatures are fixed and should not be varied from those recommended unless the speed rating of the film is being increased (pages 235–237).

Degree of agitation

The degree of agitation employed in the development of a film or plate affects the development time required; the more vigorous the agitation, within limits, the shorter the development time required. Thus, the continuous form of agitation recommended in dish development permits the use of development times about 20 per cent less than those requird when developing in a tank with intermittent agitation.

The basis of published development times

For a given material and developer, the degree of development required by an ordinary (continuous-tone) negative depends principally upon the nature and lighting of the subject (subject luminance ratio) and, to a lesser extent, on the printing conditions to be employed (type of enlarger, etc; see Chapter 22).

Published development times assume a subject of average log-luminance range and are designed to give negatives suitable for printing on a medium grade of paper with a typical enlarger. This usually corresponds to a gamma of 0.65 to 0.80 or an average gradient (\bar{G}) of 0.55 to 0.70. (The times published for general-purpose developers usually yield a level of contrast at the upper limit of the range quoted; those quoted for fine-grain developers usually yield a level of contrast at the lower limit.) With subjects of below-average or above-average log-luminance range, published development times will usually yield negatives which require to be printed on harder or softer grades of paper respectively.

For sheet films separate development times are usually published for dish and tank use. The difference between the two sets of times takes into account the differing forms of agitation employed in the two cases. If the recommended tank dilution of the developer differs from the dish dilution, the change in dilution is also allowed for. Development times for roll and 35 mm films are usually given only for tank development (with intermittent agitation).

Published development times for high-contrast materials used for the photography of line subjects are designed to be sufficient to produce the maximum contrast that the material is capable of yielding.

Where a specific value of gamma is required, the published gamma-time curve (page 176) for the material and developer concerned will give an indication of the required development time, provided that the working conditions are similar to the conditions under which the curve was determined.

Development at low temperatures

The activity of all developers slows down at low temperatures and development times must be increased accordingly, the increase required depending on the temperature coefficient of the developer used. With MQ and PQ developers, however, development at temperatures below 13°C is slowed down to an extent greater than would be expected from the temperature coefficient. This is because the superadditivity of these mixtures is markedly reduced at low temperatures, an MQ developere, for example, behaving in these circumstances as if it contained metol only. In practice, therefore, MQ and PQ mixtures should not normally be employed at temperatures below about 13°C. It should be noted, however, that although metol and Phenidone fail to activate hydroquinone at low temperatures, the developing action of hydroquinone itself, in, for example, a hydroquinone-caustic solution, is not impaired, although development times have to be

increased to allow for the temperature coefficient. Hydroquinone-caustic solutions are in fact recommended for low-temperature work in preference to other formulae, and have been used with success at temperatures below 0°C, an anti-freezing compound being added to prevent solidification of the solution.

Development at high temperatures

Although many modern processes operate at relatively high temperatures (up to 38°C), processing may be required under tropical conditions in which the ambient temperature exceeds that recommended and where it is not possible to cool the solutions to the required temperature. For colour materials, processing under these conditions is not possible as temperatures have to be maintained very accurately within the manufacturer's specifications. However for black-and-white materials some modifications are possible in order to reduce the adverse effects of processing at high temperatures. Apart from reducing the time of development it is also necessary to minimize softening and swelling of the gelatin of the emulsion which may otherwise result in mechanical damage to, or even removal of, the emulsion. In general, the more alkaline the developer the more the gelatin swells and the more rapidly development takes place. When processing at high temperatures a mildly-alkaline buffered borax developer is recommended. Alternatively a pre-hardening bath or a specially-formulated tropical developer may be used. Tropical developers are characterized by low alkalinity, the inclusion of sodium sulphate to minimize swelling of the gelatin, and the addition of extra anti-foggant. Whatever the procedure adopted, it is advisable to consult the film manufacturer to obtain recommendations for processing under these conditions.

Obtaining uniform development

Recommended methods of development are designed to give a good degree of uniformity. Slight unevenness is not unknown using these methods, but in normal photography this is not of importance. For certain types of work, however as in the processing of colour-separation negatives, spectrographic plates, sensitometric strips etc, a high degree of uniformity is essential. The following points should be noted:

(1) Use of a considerable amount of developer in a large dish, e.g. a size larger than the negative to be processed, helps to minimize the risk of uneven development at the edges,

which arises if a dish of the same size as the film or plate is used.

(2) Since the degree of agitation affects the degree of development, variation in the degree of agitation received by different areas of the negative may result in uneven development. This problem can be overcome in dish development by employing a degree of agitation so great that further increase does not affect the degree of development.* In sensitometric work, the required degree of agitation can be obtained by use of a wiper which moves rapidly to and fro about 1 mm above the negative.

(3) When more normal methods of agitation are employed, i.e., rocking in a dish or intermittent agitation in a tank, uniform development is assisted if the dilution of the developer is so arranged that the development time required is not less than 5 minutes in a dish or 10 minutes in a tank.

(4) Employment of a material whose contrast is such that it is possible to work near gamma-infinity will help to ensure uniformity, because small changes in the degree of development affect density little. Further, variation of emulsion speed due to variation in the amount of bromide in the developer – which may arise from ageing of the developer (especially if it is in a tank) – is smallest near gamma-infinity.

*This principle cannot be applied in tank development because in a tank a high degree of agitation can actually lead to uneven development, because of interruption in the flow of developer by hangers, racks etc.

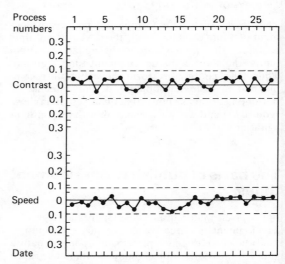

Figure 17.12 Typical process control chart for a black-and-white process

(5) In automatic processing devices agitation is carried out by a number of methods to ensure evenness of development and freedom from development effects (see page 237). Agitation is by one or more of the following methods:

(a) *solution recirculation* by pumps, used in some continuous-processing machines;

(b) *film travel*; the motion of the film through the solution provides a form of agitation, and is used in a number of uncritical processes (usually in combination with (a);

(c) *Gas-burst* agitation, widely used, providing a uniform and reproducible form of agitation by means of the release of gas bubbles through small holes in a distributor at the bottom of the tank at precise time intervals. Nitrogen is used for developers, and air can be used for other solutions such as bleaches;

(d) *spray application*, generally restricted to the washing stage; but if the spray device is below the surface of the solution it can be used for processing solutions.

The importance of correct agitation cannot be over emphasized, not only for uniform development across wide areas but also for processes which depend upon edge effects and may have their image quality adversely affected by over-agitation. When processing photographic materials there is an almost stationary layer of liquid close to the film surface, the *laminar layer*, which arises from frictional forces between the microscopically-rough emulsion surface and the solution. This layer decreases the rate at which chemicals can diffuse in and out of the emulsion. Most agitation methods are designed to minimize the thickness of the laminar layer by creating turbulent flow in the solution, close to the emulsion surface.

Quality control

To ensure consistency of processing from day to day or from batch to batch, adequate quality-control procedures are essential, especially in large-scale processing systems involving replenishment. This is commonly carried out sensitometrically, using pre-exposed control strips processed with the batch of films or at regular intervals in a continuous processor. Control strips comprise a step tablet pre-exposed under strictly-controlled conditions by the film or paper manufacturer. After processing, the steps are read using a densitometer together with a master strip, which is a processed control strip provided by the manufacturer along with the pre-exposed but unprocessed strips. From the density readings, fog, speed and contrast are derived and the differences between the values for the user-processed strip and the master control strip are

plotted on a quality-control chart against the date or process number. Specified control limits appear on the chart as horizontal lines above and below the central line (see Figure 17.12). The process must be maintained within these limits; the intelligent use of control charts enables this to be done and consistent results to be obtained. Thus if the control limits are exceeded action has to be taken to bring the process back into control. This may involve an adjustment in the replenishment rate after checking that processing times, temperatures and agitation are correct for the process. For colour processes the same principles apply, but the charts are more complicated: they involve three lines for each parameter, relating to the behaviour of each layer (i.e. the red, green and blue records).

A useful form of presentation of colour balance is by the use of *trilinear plots*, which can give a direct indication of the shifts in colour balance of a standard patch for different materials, batches, processes or colour printing conditions. Figure 17.13 shows

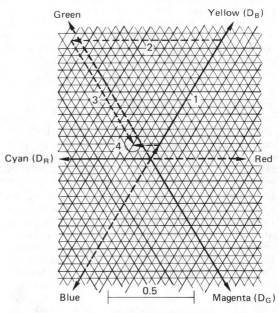

Figure 17.13 Trilinear plot (for explanation of 1 to 4, see text)

a typical plot comprising three main axes at 120° (the full lines labelled respectively yellow, magenta and cyan) and three additional axes also at 120° to each other but opposite to the main axes. These are shown as broken lines labelled respectively blue, green and red. If, for example, a 'neutral' patch has measured density values D_B (yellow), D_R (cyan) and D_G (magenta) of 0.80, 0.85 and 0.75 respectively, its position on the trilinear plot can be determined as follows:

(1) Plot a 'yellow' vector 0.80 units along the 'yellow' axis

(2) From this point plot a 'cyan' vector 0.85 units parallel with the 'cyan' axis (the dotted line)

(3) From this point plot a 'magenta' vector 0.75 units parallel with the 'magenta' axis (the dotted line 3).

(4) Mark the end of the final vector with a cross or circle.

This is the plot of the colour balance of this patch. From its position it can be seen that it is greenish cyan in hue. The same point is reached regardless of the order used in plotting the vectors. A true neutral, i.e. all density values equal, would plot at the centre of the diagram.

Alternatively, these plots can be carried out by first subtracting the lowest density value from the other two (i.e. subtracting a neutral) and then plotting the remaining two vectors as before. For the above example, subtracting 0.75 from the other values gives values of 0.05 and 0.10 for D_B and D_R respectively (and 0 for D_G). This plot is also shown in Figure 17.13 (the arrowheads and dotted line close to the centre). The same point is reached on the diagram; it is a matter of personal choice which procedure is adopted.

Two-bath development

The aim of two-bath development is to limit the density range of the negative. It is an extreme form of compensating development (see 218) and is carried out by first immersing the film in a solution containing the developing agent, preservative and restrainer, then, after thorough draining of the solution from the film, immersing it in a solution containing the alkali. This technique allows full use to be made of the film speed, while restricting contrast (due to exhaustion of developer in the more heavily-exposed areas). It finds some application in the recording of scenes of high subject luminance ratio such as those encountered in architectural photography. A similar technique known as *water-bath development* has also been used. This technique involves immersing the film alternately in developer and water according to a planned schedule. It was of value when it was usual to develop by inspection, but it is rarely used today.

Reversal processing

As we have seen, normal methods of processing involve the production of a negative from which a positive is produced on another material by a separate printing operation. It is, however, possible to

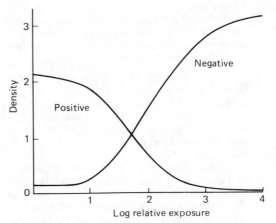

Figure 17.14 Characteristic curves for reversal processing

carry out these two operations on the one material, producing the positive image by what is called *reversal processing*. By this method a negative image is first obtained in the usual way by development of the original latent image. This negative image is then dissolved away in a bleach bath (see page 246), and the silver halide remaining is exposed and developed to provide the required positive image. The second exposure may or may not be controlled. The second development may be followed by fixing, though this is not usually necessary. The first developer normally contains a silver halide solvent which may be sodium thiosulphate or ammonium thiocyanate. Inclusion of a solvent is necessary to dissolve some of the excess silver halide which would otherwise be developed to metallic silver in the second developer. This reduces the density of the positive image and helps to give clear highlights. Figure 17.14 shows a typical negative characteristic curve together with the corresponding positive curve. The positive curve is not quite the mirror image of the negative curve because of the presence of the silver halide solvent in the first developer. For the final developer, any normal formula may be used. In some methods of reversal processing, the second exposure before final development is replaced by a chemical foggant, which may be incorporated into the positive developing solution.

Films especially designed to be processed by reversal methods are supplied by some manufacturers. Many, although not all, monochrome negative materials may also be reversal processed, but the procedures to be followed for best results will vary from one material to another. Manufacturers should be consulted for details of materials suitable for reversal processing and for appropriate processing procedures.

Colour reversal processing (see Chapter 24) differs from monochrome reversal processing in the

way in which the negative and positive images are differentiated from each other and in the means by which the unwanted silver images are removed. In colour reversal processing the negative image is obtained using a black-and-white negative developer similar to the one described above. The positive colour image is then obtained together with its associated silver image by deveopment in a colour developer after re-exposure or fogging treatment. Both the negative and positive silver images are then removed by bleaching and fixing, leaving the positive image in the form of coloured dye.

Instant-print materials

Instant-print (or *self-developing*) *materials* are find-creasing application in both black-and-white and colour image formation. Special cameras or camera backs are required for these materials. As the name implies, the material contains not only the light-sensitive emulsion but also the chemicals necessary to bring about development to form a stable image (in the form of a reflection print) within seconds of exposure. In one type of self-developing material a negative is also obtained with the print, and can be subsequently printed on paper by conventional printing techniques after removing the processing chemicals and drying. Colour self-developing materials are described in detail in Chapter 24. These materials were originally invented by Edwin Land, and are sold under the name *'Polaroid.'*

The black-and-white materials comprise a negative light-sensitive layer, processing chemicals in a viscous solution incorporated in pods, and a receptor layer that is not itself light-sensitive. After exposure, the negative layer is brought into contact with the receptor layer by pulling the film from the camera. By this action the film passes between two pinch rollers; the pods containing the processing chemicals are ruptured, and the viscous processing solution is spread between the negative layer and the receptor layer. After the required time the two layers are separated to yield a negative in the light-sensitive layer and a positive image in the receptor layer.

There are some similarities between the processing solutions used for self-developing materials and monobaths (see page 220). Like monobaths the processing solution for self-developing materials contains an active combination of developing agents in an alkaline solution, together with a fixing agent; but a thickening agent such as carboxymethyl cellulose is also present to hold the solution between the two layers during processing. During processing the fixing agent dissolves the unexposed silver halide from the negative layer and the soluble silver complexes diffuse into the receptor layer which contains *catalytic nuclei*. On reaching the receptor layer the

Figure 17.15 Black-and-white self-developing material during 'processing'

soluble silver complexes react with the developing agent and are reduced to metallic silver in the presence of the catalytic nuclei to form a positive image (see Figure 17.15).

Control of effective emulsion speed in development

With all the aids to exposure assessment available today, the photographer concerned only with normal subjects should never obtain seriously incorrectly-exposed results. There are, however, occasions when mistakes happen, or when under-exposure is inevitable and it is desired to correct for the error, as far as possible, in development. In such cases, some control is possible.

Variation of development time

Although the main effect of variation of development time is on contrast, there is also an effect on emulsion speed. Shortened development decreases the effective speed; lengthened development increases it (see Figure 17.16). The limit to the control of speed possible by varying development time is set largely by the accompanying variation in contrast; development must not be such that negatives are to low or too high in contrast to be printed on the papers available. The maximum development time may also be limited by granularity and fog, both of

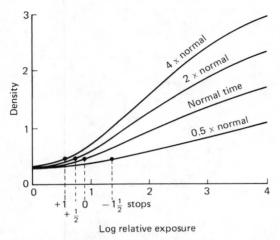

Figure 17.16 Effect of development time on speed

which increase with increasing development time. The practice of continuing development to obtain maximum speed is sometimes referred to as *forced development* or *push-processing*. Because this technique yields a high contrast, it is generally suitable only for negatives of subjects of short log-luminance range. Figure 17.16 shows the effect of changes in development time on speed, where speed has been defined as the log relative exposure required to reach a density of 0.1 above base-plus-fog (see Chapter 19). It can be seen that changes in effective speed have been obtained at the expense of alteration of contrast. However, dilution of the developer and extension of the development time gives a compensating effect (see page 218) that slows down the rate of increase in contrast while giving a small speed increase.

Choice of developer

Certain active developers give the maximum speed that the material is capable of, normally at the expense of high contrast and increased granularity (for example by using an active MQ-carbonate developer). However, many manufacturers supply specially-formulated developers that yield optimum negatives with respect to speed gain, contrast and granularity. The gains in speed with such developers may be of the order of one-third to two-thirds of a stop. It must be stressed that film speed is fixed by the development of the film under standard conditions defined in the appropriate American, British or other national or international standard (see Chapter 19) and as such cannot be varied. Film speeds for general photography are based on a camera exposure slightly greater than the minimum

required to yield a negative that will give an 'excellent' print. A safety factor of one-third of a stop is included in their determination. Thus by extending development only a very little extra shadow detail may be recorded.

The majority of claims for vast speed increases are based to a very great extent on the exposure latitude of the film when used for recording scenes of low contrast or low subject luminance ratio (see page 180) which contain virtually no shadow detail. In such cases the film is effectively being underexposed and the scene is recorded further down the characteristic curve (see Chapter 20). In practice it is possible to up-rate certain films by as much as two to three stops depending on the scene contrast and the individual criteria for acceptability of prints that contain little or no shadow detail. Techniques of forced development or push-processing give only marginal improvements in image quality for underexposed negatives of low-contrast subjects.

Real and significant speed increases *are* possible with reversal films. These are achieved by increasing the time spent in the first developer. Speed increases of two to three stops are common for certain colour-reversal materials. In reversal processing the situation is quite different from that for negative materials. Shadow detail is recorded even if the film is underexposed, but remains unrevealed in the dense areas of the transparency when subjected to standard conditions of processing. Increasing the time in the first developer leads to less silver halide being available for the second development, and hence a less dense positive image, which reveals underexposed shadow detail.

Figure 17.17 shows the effect of increasing the time in the first developer for a typical colour

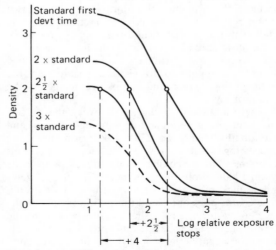

Figure 17.17 Effect of first development time on speed for a reversal process

reversal film. Speed changes have been arbitrarily defined as log relative exposures required to give a density of 2.0. However there is a limit to speed increases with reversal films. For example the lowest curve in Figure 17.17 shows that the maximum density is far too low for acceptibility and that the curve is too short to record both highlight and shadow detail even for scenes of moderate subject log-luminance range. Another limitation that is not shown by the plotting of visual densities from a material that has been exposed to a neutral light source is that the three sensitive layers may be affected differently by modifying the processes, which affects the colour balance as well as the tone reproduction.

Increasing the speed rating of colour reversal films by increasing the time of the first development also reduces image quality to some extent. Maximum density is reduced, graininess and contrast increase, and there is some change in colour rendering and a reduction in the ability of the film to record scenes of moderate to high contrast. However, up-rating reversal films is a very useful (and much-practised) undertaking for recording poorly-lit scenes, or for recording action where short exposure times are essential.

Adjacency effects

The action of development results in the production of soluble bromide, which is liberated in proportion to the amount of silver developed. Since bromide restrains development, local concentrations resulting from stagnant development would render the resulting negative very uneven. Agitation during development is designed to prevent such local con-

centrations of exhausted developer. If, however, insufficient agitation is given, a number of *adjacency effects* may arise. These are sometimes given the general title of Eberhard effects, although this term is properly applied to only one particular manifestation of these effects, as described below.

Adjacency effects may take the following forms:

Streamers

Insufficient agitation of films developed in a vertical plane leads to light *bromide streamers* from heavily exposed areas and dark *developer streamers* from lightly exposed areas. If a film is developed in a horizontal plane the effect may take the form of 'mottle'.

Mackie lines

This effect is sometimes seen where there is a sharp boundary between two areas having a large difference in density. The passage of relatively fresh developer from a lightly-exposed area to a heavily-exposed area accelerates the growth of density at the edge of the heavily-exposed region, while the diffusion of bromide in the reverse direction retards development at the edge of the lightly-exposed area. The result is a dark line just within the edge of the heavily exposed area and a light line just within the lightly exposed area, the two being called *Mackie lines*. The effect is illustrated in Figure 17.18, which shows a microdensitometer trace across a boundary between a lightly-exposed area and a heavily-exposed area.

Eberhard effect

The density of a developed image of small area is influenced by the actual size of the area and upon the density of adjcent image areas, being in general greater for smaller and darker areas and where the surround is lighter. Further, the density of an image

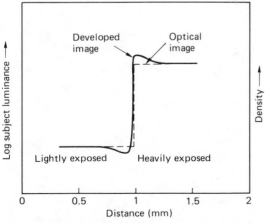

Figure 17.18 Microdensitometer trace across boundary between lightly exposed and heavily exposed areas of a negative

Figure 17.19 Kostinsky effect

area may vary from point to point, even though exposure has been constant all over the area. This is known as the *Eberhard effect*. It is due to the same causes as the Mackie lines.

Kostinsky effect

Not only the density but the mean position of a small image area may be reduced by the presence of an adjacent image area. The effective separation between the two areas is therefore increased (Figure 17.19). This is known as the *Kostinsky effect*, after the astronomer who first recorded the effect.

Sabattier effect

If an exposed film or plate is partly developed and washed (but not fixed), and then given a second overall exposure and redeveloped, certain parts of the original image may be found to be reversed in tone. This is known as the Sabattier effect. The effect is often observed when films or plates are developed in an unsafe light. It is believed to result partly from optical shielding by the image produced by the first exposure and development, and partly from a desensitizing effect resulting from the first exposure and development.

The Sabattier effect is sometimes used to obtain special effects in pictorial photography, where it is commonly (but incorrectly) termed 'solarization' (see page 174).

Safety precautions in handling developers

All processing solutions should be regarded as potentially harmful, and safety precautions are largely a matter of common sense and good housekeeping. The four main types of possible exposure to chemicals are: contact with skin and eyes, inhalation, swallowing, and injection via accidental cuts. Direct contact with all photographic chemicals must be avoided by the use of rubber or plastic gloves when preparing and using solutions. If dish or tank processing is being undertaken do not immerse your fingers in the solutions but use protective gloves, or print tweezers when developing photographic papers.

Many of the components of developers are toxic or are known irritants which cause allergenic reactions, contact dermatitis or skin sensitization. For example, metol, amines, black-and-white developers, colour developers and colour developing agents are know irritants. Specific warning notices are usually given on the label on the bottle or packet of the chemcials being used.

If chemicals are accidentally splashed into the eyes, wash at once with running water and seek medical advice. Also if processing chemicals come into contact with the skin, wash immediately in water. With alkaline materials, such as developers, an acidic hand cleanser should be used (*Phisoderm* or *Phisohex*); if any sort of rash or skin irritation occurs seek medical advice.

Always wear an apron or laboratory coat when dealing with chemicals to avoid accidental splashes to clothing. Always store solutions in properly labelled and dated bottles which cannot be mistaken for drink bottles. Never store solutions in a refrigerator or take food or drink into the mixing or working areas. Large-scale users of processing solutions should ensure that their mode of use conforms with the current health and safety regulations or codes of practice.

18 Processing following development

Once a film has been developed it bears a visible silver image and in the case of colour materials also a dye image, but it is not in a condition to be brought into the daylight or be used in the further operation of making positive prints. In the first place, the silver halide crystals which were not affected by exposure and which have not undergone reduction by the developer remain in the emulsion, making it difficult to print from the negative. Further, the silver halide is still sensitive to light and will gradually print out, changing colour and masking the image to a greater and greater extent as time goes on. Also, the gelatin is in a swollen condition and has absorbed a considerable amount of the developer solution.

The purpose of *fixation* is to remove the unwanted silver halide without damaging the silver image, and, at the same time, to stop development. The fixing operation also may be used to harden the gelatin, to prevent further swelling.

Rinse baths

A plain rinse bath is very commonly employed between development and fixation to slow the progress of development by removing all the developing solution clinging to the surface of the film. A rinse bath does not completely stop development, as developer remains in the emulsion layer, but it does remove much of the gross contamination of the film by the developing solution. Rinsing is carried out by immersing the material in clean water. To ensure that this does not become loaded with developer, running water should be employed, if possible.

Rinsing in plain water must be followed by fixation in an acid fixing bath to stop development. The rinse bath then serves not only to slow development, but also to lessen the work that has to be done by the acid in such a fixing bath. Rinsing thus protects the fixing bath.

Stop baths

Although a plain rinse can be used between development and fixation, a better technique is to use an *acid stop bath*, the function of which is not only to

remove the developer clinging to the surface of the film, but also to neutralize developer carried over in the emulsion layer, and thus to stop, not merely slow, development, as developing agents are inactive in acid conditions.

In selecting an acid it must be remembered that some of the bath will be carried into the fixer as films pass through it. This rules out use of the stronger acids (e.g., sulphuric acid) as these would cause precipitation of sulphur in the fixing bath. Solutions of potassium or sodium metabisulphite (2.5 per cent) or acetic acid (1 per cent) are commonly used.

Fixers

Although, as stated earlier, a *fixing bath* may perform several functions, its primary action is the removal of unexposed silver halide from the emulsion.

Silver halide + fixing agent →
 silver/fixing agent complex (soluble) + halide ion

Fixing solutions always contain a solvent of silver halide. For use in photographic processing, the solvent must form a complex with silver which can be washed out, must not damage the gelatin of the emulsion, and must not attack the silver image to any measurable extent. Of the possible solvents for the silver halides, only the thiosulphates are in general use, as all the other solvents have disadvantages of one kind or another.

By far the most widely-used silver-halide solvents are ammonium and sodium thiosulphte. Besides being a solvent for silver halides, sodium thiosulphate ('hypo') when in acid solution has a weak solvent action on the silver image itself. Although this action is negligible during the time required for fixation, prolonged immersion in the fixing bath may reduce the density of the image, the effect being most marked with fine-grain negative emulsions and printing papers. In the latter case, image colour may be affected as well as image density.

The fixing bath removes the residual silver halide by transforming it into complex sodium argentothiosulphates. These substances are not particularly stable and, after fixation, must be removed

from the emulsion by washing. If left in the emulsion, they will in time break down to form yellowish-brown silver sulphide.

In the presence of a high concentration of soluble silver, or low concentration of free thiosulphate, as when the fixing bath is nearing exhaustion, there is a tendency for the complex sodium argentothiosulphates to be adsorbed, or 'mordanted', to the emulsion, in which condition they are difficult to remove by washing. Fixation in an exhausted bath is therefore attended by risk of subsequent staining, as a result of the breakdown of the silver complexes remaining in the emulsion, however efficient the washing process.

To avoid the danger of such staining, the best practice is to use two fixing baths in succession, according to the following procedure. Initially, two fresh baths are prepared and materials are left in the first bath until they are just clear,* being then transferred to the second bath for an equal period. In the course of time, the clearing time in the first bath which is doing practically all the work of fixation will become inconveniently long. When clearing requires, say, double the time required in a fresh bath, the first bath should be discarded and replaced by the second, which, in turn, should be replaced by a completely fresh bath. This process is repeated as required, with the result that the second bath is always relatively fresh. Adoption of this procedure ensures that all films leave the second fixing bath in good condition from the point of view of subsequent permanence; as good in fact as if they had been fixed throughout in a fresh bath. The method is also economical, in that it enables all the fixer in turn to be worked to a point far beyond that at which a single bath would have to be discarded.

A fixing bath for negatives is usually made to contain 20–40 per cent of crystalline sodium thiosulphate. A bath intended for papers is usually made not stronger than 20 per cent; a stronger bath will be attended by the risk of bleaching the image on prolonged fixation, and may aggravate the problem of removing sodium thiosulphate from the paper on washing, a problem which with papers is more serious than with films, owing to the absorbent nature of the base (see page 247), although this problem has been overcome with the use of resin-coated papers. As the average coating weight of papers is only about one-quarter of that of negative materials, fixing times for papers are shorter than those required by negative materials, and the times

required in the weaker bath are not excessive. (For the fixing of papers see also Chapter 21.)

Ammonium thiosulphate is now commonly used as a fixing agent, the usual concentration being around 10–20 per cent. Ammonium thiosulphate fixes much more rapidly than sodium thiosulphate (owing to the presence of the ammonium ion, the rate of fixation of ammonium thiosulphate is between two and four times that for an equivalent concentration of sodium thiosulphate). However ammonium thiosulphate does have some limitations as a fixing agent. It is less stable than the sodium compound and attacks the silver image more readily. Exhausted ammonium thiosulphate fixing baths cause staining, owing to the more rapid breakdown of the silver complexes. Despite these limitations, ammonium thiosulphate is the basis of most rapid fixers now on the market.

Acid fixing bath

At one time it was common to use a plain fixing bath containing sodium thiosulphate alone. Except for certain specialized purposes plain fixing baths are no longer used owing to the dangers of staining and dichroic fog that result from development continuing in the fixing bath. The addition of a weak acid to the fixing bath ensures that development ceases immediately on immersion irrespective of whether an intermediate stopbath was used.

An additional convenience when an acid fixing bath is used is that white light may be switched on as soon as the sensitive material has been placed in the bath, provided that the material is completely immersed and agitated for the first few seconds after being placed in the bath.

Strong acids cause thiosulphate to decompose with the formation of colloidal sulphur, which causes the solution to become milky in appearance and may contaminate the emulsion. This reaction is enhanced by the presence of sulphur, with the result that once sulphur has appeared in it the solution deteriorates rapidly. The presence of sulphite in the solution, however, tends to prevent this decomposition of the thiosulphite. Acid fixing baths are therefore usually made up either by the addition of potassium or sodium metabisulphite to the solution of sodium thiosulphite or, alternatively, by the addition of a weak acid such as acetic acid, together with sodium sulphite. (A stronger acid than acetic for example, hydrochloric acid or sulphuric acid would decompose the thiosulphite even in the presence of sulphite.)

Hardening

When, for any reason, it is necessary to process in warm solutions or to carry out rapid drying by the

*It is not always easy to tell when a piece of film is completely clear. The following method of testing the clearance time has proved successful: take a small piece of dry unexposed film and place a drop of fixing solution in the centre. After about 30 seconds immerse the film in the fixing bath, and by comparing the clear central spot with its surround, determine the length of time taken to clear by the remainder of the film.

application of heat, it is more or less essential to harden photographic materials. Even at ordinary temperatures hardening has important advantages. First, it reduces swelling and consequent softening of the emulsion layer. A hardened film is thus less easily damaged in subsequent processing operations. Further, since less water is taken up by a hardened emulsion, there is less to be removed on drying, which in consequence is more rapid. Secondly, hardening raises the softening temperature of the emulsion. It thus allows a higher temperature to be used for drying. For this reason, and because there is less water to be removed, hardening speeds up the drying operation.

The extent to which an emulsion takes up water is limited if it is in a solution containing a high concentration of salts. Thus in normal processing only a limited amount of swelling takes place in the developer and fixer, and this is not usually serious. There is a tendency for further swelling to take place in the rinse between developer and fixer, but provided the rinse is brief this swelling is also not serious. On finally washing in plain water, however, an unhardened gelatin layer may swell considerably, and it is then that the emulsion is weakest. This is illustrated in Figure 18.1. The use of soft water

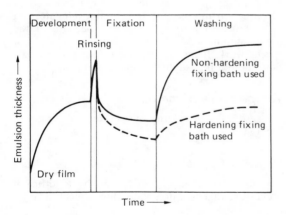

Figure 18.1 Swelling of an emulsion layer during processing

aggravates this swelling, because of its low salt concentration. From this it is seen that for hardening to be of value it must take place before washing begins. In practice, it is usually most convenient to combine the hardening process with fixation, and this is done by the addition of a *hardening agent* to the fixing bath, to form a *hardening fixing bath*. This avoids the need for an aditional processing operation. Most modern emulsions are thin, and are

hardened during manufacture, thus minimizing both swelling during processing and carry-over of processing solutions.

The degree of swelling of an emulsion increases with temperature. In tropical processing, therefore, even the partial swelling which takes place in the developer may assume significant proportions. Under these circumstances it is common practice to harden the film before development.

Typical hardening agents are ordinary alum (white alum or potash alum) and chrome alum. These are respectively aluminium potassium sulphate and chromic potassium sulphate, in crystalline form. Hardening by means of these agents is a chemical process in which aluminium or chromium ions combine with the gelatin to form *cross-links*[*] and make it more resistant to water, heat and abrasion.

Both chrome alum and potash alum are widely used in hardening-fixing baths. Chrome alum acid hardening-fixing baths can be made up with a higher concentration of sodium thiosulphate (up to 40 per cent) than potassium alum baths (maximum of 30 per cent). This does not, however, make it possible to process more quickly in the former, because, for efficient hardening with chrome alum, the film must be in the bath for about 10 minutes at 20°C, as opposed to the 5 minutes required in a potassium alum bath. It is stated that chrome alum is capable of yielding a greater degree of hardening than potash alum. However, the hardening properties of a chrome alum hardening-fixing bath become negligible after two or three hours whether the bath is used or not. For these reasons, chrome alum is most useful when a hardening-fixing bath is required for use over a short period only after mixing; when a hardening bath is required for continuous use, potassium alum is to be preferred. Potassium alum is always to be preferred when it is required to harden prints, because with chrome alum papers acquire a greenish tint which will not wash out. Chrome alum is commonly used when a hardening rinse bath is required between development and fixation, as when processing is carried out a high temperatures.

A fairly careful adjustment of pH is required in both chrome alum and potash alum hardening-fixing baths. If the pH is too low there is a danger of sulphurization; if too high, of precipitation. A safe range is 4 to 6.5. For optimum hardening, the pH should be at about the middle of this range. Hardening-fixing baths are therefore made to contain ingredients which ensure good buffering properties; this

[*]Gelatin molecules consist of long chains of atoms, and these chains are bound to each other only loosely, so that water molecules are taken up freely. *Cross-linking* binds the chains closely together, inhibiting swelling or shrinking. The 'tanning' action of pyrogallol and catechol is another example of cross-linking.

prevents carry-over of developer from affecting the pH adversely.

Formalin or other organic hardening agents are sometimes used to harden photographic materials when a hardening rinse bath is required, as, for example, when processing under tropical conditions. To obtain maximum hardening with formalin, the solution must be alkaline. A formalin bath is generally employed either before development or after fixation, depending upon circumstances. It should not be employed immediately after development, since developer carried over in the emulsion layer may combine with the formalin to soften the emulsion layer. Formalin is not suitable for use in combined hardening-fixing baths.

Preparing fixers

The principal ingredient of traditional fixing baths is sodium thiosulphate (hypo). This is available in two forms: crystalline (sodium thiosulphate pentahydrate) and anhydrous. The crystals are clear hexagonal prisms about the size of a pea. Anhydrous sodium thiosulphate is a white powder. Crystals of sodium thiosulphate contain 36 per cent of water and only 64 per cent of the salt, whereas anhydrous sodium thiosulphate contains practically 100 per cent of the salt. It is common practice to specify the concentration of fixing baths in terms of crystalline sodium thiosulphate. Thus, a 40 per cent sodium thiosulphate bath contains 40 grams of crystalline sodium thiosulphate per 100 ml of solution, or 25 grams of anhydrous sodium thiosulphate.

Crystalline sodium thiosulphate should be dissolved in hot water, as it has a negative heat of solution. Anhydrous sodium thiosulphate, on the other hand, has a positive heat of solution and should be dissolved in cold water with vigorous stirring to prevent caking. In both cases the metabisulphite should be added to the solution only when it has returned to room temperature, otherwise sulphur dioxide gas may be given off and the thiosulphate may become partially decomposed.

The formulae of acid-hardening fixing baths are more complicated than those of ordinary acid fixing baths, and greater care is therefore needed in making them up. The procedure to be followed in making up a hardening-fixing bath will depend on the particular formula employed; detailed instructions are given with each formula and packing. Provided that these instructions are carefully followed no difficulty should be experienced. One general rule that may be noted in making up potassium alum hardening fixers supplied as single-powder mixtures is that the water used should not be above 27°C; if hot water is used the fixer may decompose. Most proprietary fixers are based on

ammonium thiosulphate, and are supplied as concentrated liquids which only require dilution before use.

Time required for fixation

Rate of fixation depends principally upon the following factors:

Type of emulsion and thickness of coating

Other things being equal, fine grain emulsions fix more rapidly than coarse ones, and thin emulsions more rapidly than thick ones. Silver chloride emulsions fix more rapidly than silver bromide emulsions.

Type and degree of exhaustion of the fixing bath

The rate of fixation depends on the concentration of the fixing agent up to about 15 per cent for both sodium and ammonium thiosulphate, but increasing the concentration above 15 per cent hardly alters the rate. As stated earlier, the concentration of sodium thiosulphate usually employed in practice is between 20 and 40 per cent. A partially-exhausted bath fixes more slowly than a fresh bath, not only on account of reduction in concentration of thiosulphate, but also, if used for fixing negatives, because of the accumulation of soluble silver and of iodide. For special work, fixing agents which clear more rapidly than sodium thiosulphate may be employed.

Temperature of the bath

Increase in temperature gives increased rate of fixation.

Degree of agitation

The rate of fixation is controlled by a diffusion process, so that agitation materially reduces the time required.

Degree of exposure

The heavier the exposure, the less the amount of unused silver halide remains to be removed in the fixing bath, and hence the more rapid the rate of fixation.

As a general rule, a material may be considered to be fixed after approximately twice the time required for clearing. In a fresh acid fixing bath of normal composition, fixation of films may be regarded as complete in about 10 minutes at 20°C. Fixation is complete when all visible traces of the silver halide have disappeared, but as the exact moment of

clearing is not easily determined it is good practice to give double the apparent clearing time. With papers, clearing of the image is even less readily observed, but fixation may be regarded as complete in about 5 minutes in a fresh bath for sodium thiosulphate; 30–60 seconds for ammonium thiosulphate. Hardening takes place slowly, and usually requires longer than clearing. To be efficient, hardening is therefore assisted by allowing materials to remain in the fixing bath for twice as long as they take to clear.

The temperature of the fixing bath is by no means as critical as that of the developing solution, but for films it should normally lie within a few degrees of the temperature of the developer, to avoid the danger of *reticulation* of the gelatin (see page 359).

Changes in fixers with use

The composition of a fixing bath, like that of a developer, changes with use. We can best understand the reasons for these changes by considering the sequence of events following development, assuming that an acid-hardening fixing bath is used, preceded by a plain rinse.

(1)　The rinse bath removes much of the gross contamination of the film by the developing solution, and thus slows development.
(2)　The film is transferred to the fixing bath where the acid neutralizes the alkali of the developing solution in the emulsion layer and stops development.
(3)　The thiosulphate converts the silver halide in the emulsion to soluble complex sodium argentothiosulphates and halide ions. Thus the concentration of silver complexes and halide ions increases.
(4)　The hardening agent diffuses into the gelatin and begins its hardening action.

As the bath continues to be used, more and more of the alkaline developer is carried over and the acid becomes exhausted. A good guide to the degree of acid exhaustion is provided by an indicator paper. The pH of the bath should preferably not be allowed to rise above about 6.0. If the bath becomes alkaline, it will not stop development and there will be risk of staining. If the bath is a hardening-fixing bath there will also be a serious reduction of hardening power. If a hardening-fixing bath becomes very alkaline, a precipitate may be formed from the interaction of the hardening agent and the alkali. This will tend to deposit on negatives in the form of a scum which may be difficult to remove.

Not only does the acidity of the bath decrease as the bath is used, but the clearing action itself becomes slower. This is partly due to exhaustion of the thiosulphate, but with negative materials it is also due to a concentration of iodide derived from the emulsion, which builds up in the bath. Silver iodide, present in many negative emulsions, is extremely difficult to dissolve in a solution of sodium thiosulphate, and has the effect of depressing the solubility of silver bromide and so retarding the clearing process as a whole. We thus have a symptom of apparent exhaustion which is brought about by the accumulation of an antagonistic end-product. Among other important products which build up in the bath are the complex sodium argentothiosulphates. These also retard clearing but their most important effect is upon the permanence of the negatives and prints. Silver indicator test papers are available; these change colour on immersion in a fixing bath containing silver. These papers are calibrated so that the intensity of the coloration may be read from a chart which relates the colour to the silver content.

A further cause of exhaustion of a hardening-fixing bath can (theoretically) be exhaustion of sulphite; but the quantity employed is usually sufficiently large to ensure that trouble from this source is rare.

Lastly, since a small volume of water from the rinse bath is carried into the bath on each film and a small volume of the fixing solution is carried out, the fixing bath becomes progressively diluted with use. This also leads to an increase in clearing time.

Useful life of fixers

A fixing bath is usually discarded when its useful life is ended. Its life depends upon several factors, of which the number of films passing through is only one. For this reason, it is not possible to state with any degree of precision the number of films which may safely be fixed in a given bath. The following figures may, however, be taken as a rough guide.

Table 18.1 Approximate capacity of fixer

Material	No per litre of 24% sodium thiosulphate solution
20.3 × 25.4 cm sheets	26
10.2 × 12.7 cm sheets	104
120 film	26
135–20 film	42
135–36 film	26

It is common practice to discard a bath when the clearing time has risen to double the time required when the bath is fresh. When a bath is used solely for papers this rule is not readily applicable, as it is not easy to tell when a paper emulsion is clear. In this case, the bath should be discarded when a known area of paper has been passed through.

It will be appreciated from the foregoing that it is highly desirable to keep a record of the number (or, better,the area) of films or papers that have passed through a given fixing solution.

Replenishment of fixing solutions

Although at one time a fixing bath was invariably discarded when exhausted, it has increasingly come to be recognised that this is unnecessarily wasteful of both fixing agent and silver, and the possibility of replenishing a fixing bath has therefore been studied. The first property of a fixing bath to fall off with use is its acidity, then its hardening propeties. The life of a bath may, therefore, be usefully increased by the addition of a suitable acid mixture. If this is made to contain a hardener, both acidity and hardening power can be restored to a certain extent. This process cannot, however, be continued indefinitely because of the accumulation of iodide and silver in the bath. It is therefore, not worth while to attempt to replenish a fixing bath by the addition of thiosulphate unless some means of removing the silver is available, as, for example, by electrolytic silver recovery (see below).

Where silver recovery is being practised a bath may be replenished by adding fresh sodium thiosulphate and hardener (say, 10 per cent of the amount used initially) when the initial clearing time has been exceeded by about 50 per cent. Following this, the acidity of the bath should be restored by adding (with vigorous stirring) 50 per cent acetic acid solution, until a pH of about 5.0 is achieved. This may be checked with an indicator paper. It is desirable before replenishing to draw off a quantity of the solution, to ensure that the bath does not overflow on replenishment.

Silver recovery

The recovery of silver from a fixing bath is attractive because of the high market value of silver, quite apart from the possibility of replenishing the fixing bath.

In black-and-white materials only a relatively small amount of the silver halide is reduced to silver by the developer to form the image. The remainder is dissolved from the sensitive layer and ends up as silver complexes in the fixer solution. In colour materials all the silver halides are removed from the material by the bleach or bleach-fixing solutions. Thus if sufficient material is processed, recovery of silver becomes worthwhile. Table 18.2 gives the approximate recoverable silver from various types of photographic materials.

Table 18.2 Amounts of potentially recoverable silver in photographic materials

Photographic material	Recoverable silver, grams per 100 units processed
B & W negative (1–120, 1–135–36, roll)	10–16
B & W print (20.3 × 24.5 cm)	3–6
Colour negative (1–120, 1–135–36, roll)	24–28
Colour print (20.3 × 25.4 cm)	1–2
Lithographic film (20.3 × 25.4 cm)	10–17
Industrial X-ray (35 × 43 cm)	155–249
Medical X-ray (35 × 43 cm)	46–93)

The various methods of silver recovery commonly practised at the present time may be divided into three main groups:

(1) Electrolytic
(2) Metallic replacement
(3) Chemical

Electrolytic

Electrolytic silver-recovery units operate by passing a direct current through the silver-laden fixer between two electrodes, usually a carbon anode and a

Figure 18.2 A small-scale electrolytic silver recovery unit (*Rotex Ultra*). A, tank; B, rotation and control unit; C, rotating cathode

stainless steel cathode,onto which almost pure silver is deposited (by cathodic reduction of silver ions). The silver is periodically stripped from the cathode and sent to a silver refiner. There are many electrolytic units commercially available. Some types employ a high current density, which requires efficient agitation by re-circulation of the fixer solution, and use rotating cathodes to prevent the formation of silver sulphide. Low current density units make use of a large area cathode and do not need agitation.

With all types of electrolytic silver recovery unit, careful control of the current density is required. If it is too low silver recovery is slow and inefficient, and if it is too high silver sulphide is formed. Fixer solutions that have been electrolytically de-silvered may be re-used after replenishment. During electrolysis both sulphite and thiosulphate ions are oxidized at the anode. Thus before re-use thiosulphate and sulphite must be added. During the recovery of silver by electrolysis the pH must be maintained below 5; there must be sufficient sulphite present, also a small amount of gelatin is desirable as an aid to the even plating of silver.

Electrolytic methods may be used for recovering silver from fixers based on sodium and ammonium thiosulphates and from bleach-fix solutions used in some colour processes. The solution may be re-used and the silver is recovered in a pure form (92–99 per cent). The main limitations of this method are the expense of the units, the consumption of electricity and the degree of control that has to be exercised by the operator.

Figure 18.3 A small-scale metallic replacement cartridge (*SRS-22*) capable of recovering 2.5 kg of silver

Metallic replacement

These methods, although simpler result in a fixer solution that is contaminated by other metal ions after recovery of silver. The fixer solution cannot be re-used, and the recovered silver is in a less pure form than that obtained by the electrolytic methods described above. Metallic replacement depends on the principle that if a metal that is higher on the electrochemical scale than silver (e.g. copper, zinc, iron) is added to a solution containing silver ions,it will displace silver metal from the solution.

The modern application of this method is to pass the silver-laden fixer through a cartridge of steel wool in which the metallic displacement takes place. When silver is detected in the effluent from the cartridge, the cartridge is replaced by a fresh one and the exhausted cartridge is sent away for silver refining. For efficient recovery the pH of the fixer should be between 4.5 and 6.5 Below 4.5 the steel wool dissolves; above 6.5 replacement is slow. This is a simple, efficient, inexpensive and non-electrical method, but has the limitation that the fixer solution cannot be re-used. Bleach-fix solutions so treated

can, however, be re-used after appropriate replenishment and adjustment of concentration. A number of firms supply cartridges, and on return of the exhausted cartridge pay the processing laboratory for the silver recovered (less a charge for refining, etc). Figure 18.4 shows three modes of silver recovery. In all these, electrolytic units may be used for both fixer and bleach-fix solutions. For fixer solutions the 'terminal' mode can be used only with the metallic-displacement method of silver recovery. Silver recovery may also be carried out as a batch process.

Chemical methods (sludging)

These involve the addition of certain compounds to the silver-laden fixer which precipitate either an insoluble silver compound or metallic silver. For example, when a solution of sodium sulphide is added to an exhausted fixer, silver sulphide is precipitated. The solution must be alkaline, or toxic hydrogen sulphide is produced. Alternatively, sodium dithionite (hydrosulphite) precipitates metallic silver from a used fixer solution.

Figure 18.4 Modes of silver recovery in machine processing: (a) Terminal; (b) regeneration/replenishment; (c) recirculation; (i) processing tank, (ii) recovery unit, (iii) drain, (iv) replenisher tank

Although these methods are efficient, they are potentially hazardous, and the chemicals can contaminate photographic materials and solutions. The de-silvered solution is not re-usable, and this method is not recommended for use in or near a processing laboratory.

Rapid fixing

We have seen earlier (page 242) that rate of fixation is influenced by a number of factors. Rapid fixing is normally achieved in three ways: by using sodium thiosulphate at its optimum concentration; by using fixing agents such as ammonium thiosulphate which clear more rapidly than sodium thiosulphate; and by raising the temperature of the bath. If it is desired to raise the temperature above about 24°C, special precautions must be taken to prevent the emulsion layer from swelling unduly.

The concentration of sodium thiosulphate (crystals) that is normally employed in practice is 20 to 40 per cent, but the reduction in fixing time that can be achieved by working at a higher concentration is not very great. As already noted, however, ammonium thiosulphate clears materials much more rapidly than sodium thiosulphate. Ammonium thiocyanate is a very rapid fixer, and is particularly useful for emulsions containing silver iodide. It cannot be used with unhardened emulsions owing to its propensity to soften gelatin. Also, some of the products of fixation with thiocyanate are insoluble in water and darken rapidly on exposure to light. If permanent records are required, fixation with thiocyanate must be followed by immersion in a solution of sodium thiosulphate.

Bleaching of silver images

The removal of silver images is necessary in a number of processes. For example, in black-and-white reversal processes the negative silver image is removed after the first development stage, leaving the originally unexposed silver halide unaffected. In chromogenic processes (see Chapter 24) it is necessary to remove the unwanted silver image that is formed together with the dye image, leaving the dye image alone; in various methods of after-treatment such as intensification and reduction bleaching of silver is also involved. Holograms made for display purposes are also bleached rather than fixed.

Bleaching of silver images involves the oxidation of metallic silver to silver ions which combine with other ions to form either soluble or insoluble silver compounds. In black-and-white reversal processing the negative silver image is removed by immersing the material in an acidic solution of an oxidizing agent such as potassium dichromate or permanganate:

Metallic silver + oxidizing agent + sulphuric acid →
silver sulphate (soluble) + reduced oxidizing agent

With the exception of silver sulphate the products of the reaction tend to remain in the emulsion and may cause staining. The bleaching reaction is therefore followed by a clearing solution of sodium or potassium metabisulphite which removes these products.

Different bleach solutions are used in chromogenic processes. To remove metallic silver in these processes two basic methods are used. The first is the conversion of metallic slver to silver bromide by the use of an oxidizing agent in the presence of bromide ions (*rehalogenating bleach*):

Metallic silver + oxidizing agent + bromide ions →
silver bromide + reduced oxidizing agent

The silver bromide so formed may then be removed in a conventional fixing solution. Potassium ferricyanide (hexacyanoferrate) has now been replaced by

ferric EDTA (see below) as the oxidizing agent because the latter is not harmful when discharged into streams, whereas ferricyanide decomposes under the influence of air and sunlight to give toxic cyanide.

The second is a combined bleaching and fixing solution (*bleach-fix* or *blix*):

Metallic silver + oxidizing agent + thiosulphate → silver-thiosulphate complexes (soluble) + reduced oxidizing agent

The choice of the particular oxidizing agent for use in combination with thiosulphate in a bleach-fix solution is critical. Strong oxidizing agents such as potassium permanganate, dichromate or ferricyanide cannot be used because they would oxidize thiosulphate. The most commonly used oxidizing agent is ferric EDTA (iron (III) ethylenediaminetetra-acetic acid). This oxidizing agent is strong enough to convert metallic silver to silver ions, but does not decompose thiosulphate.

The earliest bleach-fix solution to be used was *Farmer's reducer*, which is an unstable solution based on ferricyanide and thiosulphate and is normally prepared immediately before use and then discarded. It did find use in some colour processes in which the material was first immersed in a solution of ferricyanide and then transferred to a second solution of fixer without an inermediate rinse. The ferricyanide carried over in to the fixer formed an unstable bleach-fix but this approach could only be used in one-shot processing methods. Farmer's reducer is used in after-treatment of negatives.

Washing

The purpose of the washing operation is to remove all the soluble salts left in the emulsion layer after fixing. The important salts to be removed are sodium (or ammonium) thiosulphate and the complex silver salts. If thiosulphate is allowed to remain, it can cause the silver image to discolour and fade, the sulphur in the residual thiosulphate combining with the silver image to form yellowish-brown silver sulphide. If the complex silver salts are allowed to remain they also may decompose to form silver sulphide, which will be especially noticeable in the highlights and in unexposed areas.

Sheet films are best kept in their hangers and washed in a tank with a siphon. Films which have been developed in roll-film tanks may usually be washed in the same tanks, as described in Chapter 17. For efficient washing of films or papers, running water is recommended as this ensures that fresh water is continuously brought to the gelatin surface. In practice, this method is very wasteful of water, and satisfactory washing can be obtained by using

several changes of water. The removal of thiosulphate from an emulsion layer is a simple process of diffusion of soluble salt from the layer to the water, the rate increasing with the difference between the concentrations of salt in the layer and in the adjacent water. If the concentration of salt in the water becomes equal to that in the emulsion layer no further diffusion of salt from the emulsion can be expected. From this, the advantage to be gained by frequent changes is easily seen. Agitation during washing is very advantageous, because it displaces water heavily loaded with soluble salt from the emulsion surface and replaces it with fresh water. For quick and efficient washing of films, six changes, each lasting for two minutes with agitation, will usually prove satisfactory. (With extreme agitation, three changes of half-a-minute will provide adequate washing for many purposes.) Without agitation, six changes of five minutes each may be given. This system is employed in tanks fitted with siphon devices to give periodic emptying. (See Figure 18.5).

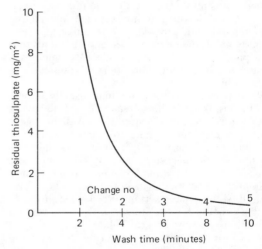

Figure 18.5 Washing in changes of water

Washing is even more important with prints than with negatives, because paper emulsions are of finer grain than negative emulsions and consequently fade much more readily in the presence of thiosulphate. Whereas in the fixation of films only the gelatin layer becomes impregnated with sodium thiosulphate, with prints sodium thiosulphate permeates the base and becomes held in the paper fibres and baryta coating, from which it is very difficult to wash out. For normal purposes, washing times of 30 minutes for single-weight papers and 1 hour for double-weight papers are adequate. However, even with these times of washing, traces of sodium thiosulphate are retained in prints and are sufficient to cause fading in time under storage

conditions of high temperature and high humidity. If archival permanence is required, use of a so-called hypo eliminator is necessary (see below). Modern resin-coated papers do not suffer from these problems and a washing time of only two minutes is necessary.

As the effects of faulty washing (and faulty fixation) appear only after the image has been stored for some considerable time, there is a tendency for the dangers inherent in such faulty processing to be overlooked. It is, however, important that these stages of processing should be treated seriously; all the work that goes into the making of a photograph is wasted if they are ignored.

Hypo eliminators and washing aids

With negative materials, water-washing, properly carried out is all that is usually required for permanence. Good washing removes practically all the thiosulphate, and, provided the negative has been properly fixed, the unwanted silver compounds too. With papers, however, traces of thiosulphate may be detected in a print even after 60 minutes thorough washing.

When permanence is more than usually important, the last trace of thiosulphate may be destroyed by a *hypo eliminator*, essentially an oxidizing agent which converts thiosulphate to sulphate (which is inert and soluble in water). Various hypo eliminators have been suggested, such as potassium permanganate and perborate, sodium hypochlorite and persulphate, and iodine in potassium iodide solution; all of these have serious drawbacks; probably the best method is to immerse the well-washed material in an ammoniacal solution of hydrogen peroxide for five minutes, following this with ten minutes further washing.

As already stated, the use of a hypo elimintor appears to be justified only when it is impossible to remove the hypo by washing, a situation which normally arises only with prints. Hypo elimination is not intended as a short cut to do away with washing. There are, however, occasions when it is desired to shorten the washing time, and this can be achieved by the use of washing aids. These are based on an observation that the constitution of processing solutions can greatly influence the rate of removal of hypo from a photographic material during the final wash. One recommended technique is to rinse the material being processed briefly after fixation and then immerse it for two minutes in a 2 per cent solution of anhydrous sodium sulphite. By the use of this technique, the subsequent washing time can be reduced to one-sixth of that normally required.

Tests for permanence

It is sometimes desirable to test the completeness of the fixing and washing of negatives and prints. Two tests are required: one for the presence of unwanted silver salts, the other for the presence of thiosulphate. If either of these tests is positive the permanence of the negative or print cannot be assured.

Test for residual silver

A simple test for the presence of injurious residual silver compounds is to apply a drop of 0.2 per cent sodium sulphide solution to the clear margin of the negative or print after washing and drying (or squeegeeing).* After two or three minutes the spot should be carefully blotted. If silver salts are present, silver sulphide will be formed. Any colouration in excess of a just-visible cream indicates the presence of unwanted silver salts. For control, a comparison standard may be made by processing an unexposed sheet of material through two fixing baths and making a spot test on this sheet. The presence of unwanted silver salts may be due to too short an immersion in the fixing bath, use of an exhausted fixing bath, or insufficient washing.

Test for residual sodium thiosulphate

Tests for residual thiosulphate are of many kinds; some are intended to be applied to the wash water, others to the photographic material itself. A test applied to the wash water gives an indication of the readily diffusible thiosulphate in the emulsion layer, but no indication of the amount of thiosulphate held by upper fibres or baryta coating. Such tests may therefore be useful with films but are of no value with papers. With all materials, a test of the residual thisoulphate in the photographic material itself is to be preferred.

One of the usual solutions for detecting the presence of thiosulphate in the wash water is an alkaline permanganate solution. The procedure for the use of this is as follows: Dissolve 1 gram of potassium permanganate and 1 gram of sodium carbonate (anhydrous) in 1 litre of distilled water. Add one drop of this solution to each of two vessels, one containing drops of water from the washed film and the other an equal quantity of water straight from the tap. If the colour persists for the same time

*This operation must be carried out in a well-ventilated space, preferably in the open air, and well away from sensitive materials or processing solutions. In contact with acid, sodium sulphide gives off toxic hydrogen sulphide gas which also fogs photographic material. Keep the solution away from skin, eyes and clothing.

in both, then washing has been satisfactory. If, however, the colour of the water drained from the washed material clears first, washing is incomplete. (The tap water control is required because tap water itself may contain substances which decolorize permanganate.)

The detection of thiosulphate in the processed photographic material may be carried out quite simply by applying one spot of a 1 per cent silver nitrate solution to the clear margin of the negative or print after washing and drying (or squeegeeing). After 2 or 3 minutes the negative must be thoroughly rinsed to remove excess reagent, which if not removed will darken on exposure to light. If thiosulphate is present, silver sulphide will be formed where the spot was applied. Any coloration in excess of a pale cream indicates the presence of an unsafe amount of hypo. This test is suitable for use with both films and papers.

Drying

After washing, the film should preferably be given a final rinse for a minute or two in a bath containing a few drops of wetting agent. This will improve draining and so help to prevent the formation of tear marks on drying. The material should then be taken straight from this bath and placed to dry. Surplus moisture from the surface of the material may be wiped off with a clean, soft chamois leather or a cellulose sponge dipped in water and wrung dry. For satisfactory drying, care should be taken to avoid placing films close together, as this will prevent effective access and circulation of air, with the result that negatives will dry slowly from the edges, the centre being the last to dry, which may result in variations in density. This effect is probably due to variation with drying rate of the packing or orientation of the silver grains in the emulsion. Sheet films and roll films are best dried by clipping them on a line in such a manner that they cannot touch one another if blown about by a draught.

Rapid drying by heat is not recommended except in properly-designed drying cabinets; even if the films have been hardened, quick drying involves risk. Good circulation of clean air is much more expeditious than drying by heat. The air stream must not, however, be too violent; a steady current is all that is required. Under normal conditions, a roll film hung to dry about five feet from an electric fan will dry in 20–30 minutes. Care must be taken to maintain the flow of air until drying is complete, for the reason explained above. A fan must not, of course, be used in a room where it is likely to raise dust.

Where rapid drying of a lage number of films is required, the use of heated drying cabinets is essential. When such cabinets are employed, it is desirable that ducting to the outside of the building should be installed.

It is extremely important that no drops of water remain on either surface of a film before drying begins, as these will give rise to irremovable marks ('drying marks'). Use of hard water for washing aggravates this risk, and in hard-water areas it is advisable to give a final bath of distilled water, with or without wetting agent.

In large-scale processing systems, drying is normally carried out within the processing machine. For high output and more rapid procesing more efficient drying techniques are required. *Jet-impingement dryers* which direct air onto the film surface by slots or holes perpendicular to the surface are one such example. Other drying techniques include infrared and microwave radiation.

Stabilization processing

A method of processing in which an exposed material is developed, stabilized to light without fixing, and then dried without washing has been evolved. In this process, known as stabilization, the silver halide remaining in the sensitive layer is converted into compounds which are relatively stable to light. The image on an unwashed print is in fact more stable than that on an incompletely-washed print, though by no means as stable that on a completely-washed print. The fixing (stabilizing) agent employed may be ordinary sodium thiosulphate, although other compounds are usually preferred.

Stabilization processing has come to be widely used with the introduction of materials, in particular, papers in which a developing agent is incorporated in the emulsion. Such materials develop in a few seconds in alkaline solution and, by combining this rapid development with the use of a rapid-acting stabilizing agent such as ammonium thiocyanate, semi-dry prints can be produced in as little as ten seconds. The two solutions are usually applied to the material by surface application, in a machine through which the material is transported by rollers.

The life of stabilized prints is not as great as that of conventionally-processed prints, but they will not normally show significant fading for some months and can, in any event, be fixed by normal methods at any time after stabilization. However modern resin-coated papers may also be processed rapidly by processing machine (see Chapter 21) to yield stable dry prints, and are gradually replacing stabilization materials.

Uses of wetting agents in photography

Wetting agents are compounds which, when added in small amounts to liquids, enable them to spread more easily. Their use is of value whenever a dry photographic surface has to be wetted or a wet surface has to be dried. Special wetting agents are available for photographic purposes. They are particularly useful:

(1) For minimizing water marks when drying films. The washed films should be immersed for about 1 minute in a bath containing wetting agent, and then placed to dry in the usual way.

(2) For improving the glazing of prints. The washing prints should be immersed for about 1 minute in a bath containing wetting agent, and then glazed in the usual way.

(3) For promoting the flow of developers. A few drops of wetting agent added to the developer will help to prevent the formation of airbells.

(4) For facilitating the application of water colours, opaques, etc. A few drops of wetting agent should be added to the water used to make up the water colour, etc.

Photographic wetting agents are usually supplied as concentrated liquids, a few drops of which should be added to the solution concerned. Wetting agents are not in general suitable for addition to fixing baths.

19 Speed of materials

Two films are said to differ in speed if the exposure required to produce a negative on one differs from the exposure required to produce a negative of similar quality on the other, the material requiring the lower exposure being said to have the higher speed. The speed of a material thus varies inversely with the exposure required, and we can therefore express speed numerically by selecting a number related to exposure. The response of the photographic emulsion is complex, and speed depends on many factors, of which the following are the most important:

Exposure

(1) The colour of the exposing light, e.g. whether daylight or tungsten light.
(2) The intensity of the exposing light. This is because of reciprocity law failure (Chapter 15).

Development

(1) The composition of the developing solution, especially as regards the developing agent used and the amount of bromide or other restrainer present.
(2) The degree of development, e.g. as measured by the contrast achieved. This depends principally upon the development time, the temperature and the degree of agitation.

We must, therefore, disabuse our minds once and for all of the idea that the speed of a material can be *completely* expressed by any one number. Nevertheless, a speed number can provide a useful guide to the performance that may be expected from a material.

Methods of expressing speed

The problem of expressing the speed of a material numerically is one that has exercised the minds of photographers and scientists almost from the beginnings of photography; but only comparatively recently has a *speed system* that has gained anything

approaching universal approval been produced. From some points of view, the problem of allotting a speed number appears simple. It would seem, for instance, that if we wish to compare the speeds of two materials, all we have to do is to make exposures on each to yield comparable negatives, and the ratio of the exposures will give us the ratio of the speeds. It is true that we can usefully *compare* speeds in this way, but the comparison may not be typical of the relation of the two materials under other conditions, and in any case will tell us nothing about the *absolute* speed of the materials. It is in trying to obtain absolute speed numbers for general application that difficulties arise.

The problem of allotting speed numbers arose first in connection with the use of black-and-white negative materials, and it is with such materials that we shall be primarily concerned in this chapter. The evolution of speed systems for colour materials followed on similar lines and is explained later in the chapter.

One of the first problems in allotting speed numbers is connected with the variation in the speed of photographic materials with the conditions of use. This problem is generally overcome by agreeing upon standard conditions of exposure and processing for the speed determination. A further problem is concerned with the *criterion* of exposure to be used as the basis for the measurement of speed, i.e. the particular concept of speed which is to be adopted. This problem arises from the fact that a negative consists not of a single density but of a range of densities. Consequently, it is not immediately apparent which density or other negative quality should be adopted as the basis for comparison. The characteristic curve is a help here, and several different points related to this curve have from time to time been suggested as speed criteria. Most of these points are related to the toe of the curve, i.e. to the shadow areas of the negative. These criteria can be divided into five main types, as follows:

(1) Threshold
(2) Fixed density
(3) Inertia
(4) Minimum useful gradient
(5) Fractional gradient

The underlying principles of these various criteria are outlined below. Later in the chapter, specific

speed systems which are or have been in general use, employing one or other of these criteria, are described.

Threshold systems

The threshold is the point on the characteristic curve corresponding to just perceptible density above fog, i.e. the point where the toe begins. Under the heading 'threshold systems' are those systems in which speed is based on the exposure required to give such a density (Figure 19.1).

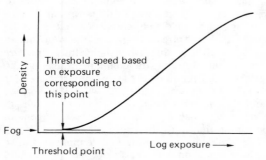

Figure 19.1 Threshold criterion of speed

The disadvantages of the threshold as a criterion of speed are that it is difficult to locate exactly, and that it is not closely related to the part of the characteristic curve used in practice.

Fixed density

Another method of comparising film speeds is in terms of the exposure required to produce a given density above fog. For general-purpose films, a (diffuse visual) density of 0.1 or 0.2 above fog is frequently selected, to correspond roughly with the density of the deepest shadow of an average negative. With high-contrast materials in which a dense background is required, a density of from 1 to 2 is a

more useful basis for speed determination, while for materials used in astronomy, a density of 0.6 has been suggested. It will be apparent that the exposure corresponding to a specified density can be more precisely located than the threshold.

A fixed density criterion ($D = 0.1 + $ fog) was adopted in the first National Standard speed system, the DIN system, in 1934, and is now employed in all current systems.

Inertia

This was the basis selected by Hurter and Driffield for their pioneer work. The inertia point is the point where an extension of the line representing portion crosses the line representing the base-plus-fog level (see page 174). Under the processing conditions which were prevalent in Hurter and Driffield's day, inertia is independent of development and so offers a fixed point of reference. Further, the inertia point is related to the linear portion of the characteristic curve, i.e. the part of the curve in which objectively-correct reproduction in the negative is obtained. With short-toe materials as used by Hurter and Driffield this would be advantage. With modern long-toe materials, the linear portion of the curve has little relevance (page 175).

Minimum useful gradient

Threshold speed systems work at the very bottom of the toe of the characteristic curve, while systems based on inertia ignore the toe completely. Neither system approximtes very closely to actual practice today, where a part (but only a part) of the toe is used. It was at one time suggested that a criterion more closely related to practice could be obtained from that point on the toe of the characteristic curve at which a certain minimum gradient is reached. A value of 0.2 for tan *a* in Figure 19.3 was proposed.

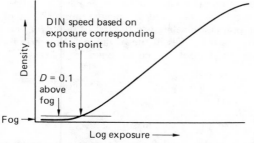

Figure 19.2 DIN speed criterion (fixed density)

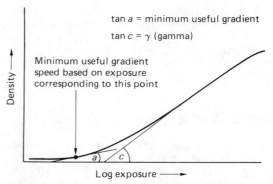

Figure 19.3 Minimum useful gradient criterion

The *minimum useful gradient criterion* was based on the idea that loss of tone separation in the shadows (shadow detail) is the first sign of under-exposure, and that this in turn is due to unacceptably low contrast in the portion of the characteristic curve occupied by the shadows. The minimum-useful-gradient criterion did not come into general use, but is of interest because it led to the more fundamental fractional-gradient criterion.

Fractional gradient

The main argument against the minimum-useful-gradient criterion is that the minimum value of contrast acceptable in the shadows is not a constant, but depends upon the contrast grade of the paper on which the negative is to be printed. If the overall contrast of the negative is such that it needs a hard paper, the contrast of the negative in the shadows can afford to be lower than with a negative requiring a soft paper. In other words, the minimum contrast acceptable in the toe depends upon the contrast of the negative as a whole. Realisation of this fact led to the conception of the *fractional gradient criterion*. The point chosen for this criterion is the point A in Figure 19.4, where the slope of the tangent to the curve at A equals a given fraction of the slope of AB, the line joining the points marking the ends of the portion of the curve employed. This is usually expressed by the equation:

$$G_{min} = K \times \overline{G}$$

where $G_{min} = \tan a$, $\overline{G} = \tan b$ (provided the density and log-exposure axes are equally scaled), and K is a constant determined empirically.

Practical tests by L.A. Jones showed that a value for K of 0.3 gave results corresponding very well with the minimum exposure required to give a negative from which an 'excellent' (as opposed to merely 'acceptable') print could be made. In Jones's work, the *fractional gradient point A* was located by the equation:

$$G_{min} = 0.3 \times \overline{G} \ (1.5)$$

where \overline{G} (1.5) means the average gradient over a log-exposure range of 1.5, a value which has been shown to be fairly typical for exterior scenes in daylight. When located in this way, point A is sometimes referred to as the 'Jones point'.

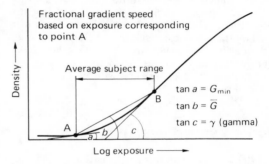

Figure 19.4 Fractional gradient criterion

Table 19.1 The principal methods of expressing film speed of negative monochrome materials

System	Date of introduction	Type of unit	Speed criterion	Development
H and D	1890	Arithmetic	Inertia	Developer to be bromide free; development time not important
Scheiner	1894	Logarithmic	Threshold	Not specified
DIN*	1934	Logarithmic	Fixed density (0.1 + fog)	To be continued until maximum speed is obtained (optimal development)
BS*	1941	Logarithmic	Fixed density (0.1 + fog)	
ASA*	1943	Arithmetic	Fractional gradient	
BS and ASA	1947	Arithmetic and logarithmic	Fractional gradient	To be under carefully controlled conditions giving a degree of development comparable with average photofinishing. See Figure 19.5 and accompanying text
DIN	1957	Logarithmic	Fixed density (0.1 + fog)	
ASA	1960, 1972	Arithmetic	Fixed density (0.1 + fog)	
DIN	1961	Logarithmic		
BS	1962, 1973	Arithmetic		
ISO	1956, 1962			

*DIN, ASA and BS stand respectively for Deutsche Industrie Normen, American Standards Association (now American National Standards Institution or ANSI), and British Standard. ISO stands for International Standards Organization, which at the time of writing (1988) is in the process of unifying all the separate national standards (see text).

This criterion was employed first by Eastman Kodak in 1939, and was later adopted by the then American Standards Association (in 1943) and the British Standards Institution (in 1947) as the basis for national standards.

Speed systems

So far we have described speed *criteria* only. We shall now describe the more important of the speed *systems* which are or have been in general use. The essentials of the systems described are given in Table 19.1. Through the years many systems have been evolved and discarded in turn. Some were discarded because the criterion employed was insufficiently related to practice; others because exposure and development conditions were not sufficiently well defined. The preferred systems today are those based on the American, British and German national standards. These standards have been laid down after much study of the various factors involved, and in compiling them experience with earlier systems has been put to good use.

Modern speed systems

In 1960–2, the American, British and German Standard speed systems were brought into line in all respects except for the type of speed rating employed, the American and British Standards specifying arithmetic numbers and the German Standard logarithmic ones. This agreement was made possible by work which showed that good correlation exists between speeds based on a fixed density of 0.1 above fog and the fractional gradient criterion, for a wide variety of materials when developed to normal contrast. Speed in all three systems is therefore now determined with reference to the exposure required to produce a density of 0.1 above fog density, this criterion being much simpler to use in practice than the fractional gradient criterion.

The American and British standards were further modified in 1972 and 1973 respectively. Both use the same speed criterion mentioned below but the developer solution and the illuminant specified are slightly different from those specified in the earlier standards.

The common method adopted for determining speed in the three Standards is illustrated in Figure 19.5. In this, the characteristic curve of a photographic material is plotted for specified developing conditions. Two points are shown on the curve at M and N. Point N lies 1.3 log exposure units from point M in the direction of increasing exposure. The development time of the negative material is so chosen that point N has a density 0.80 ± 0.05 greater

than the density at point M. When this condition is satisfied, the exposure corresponding to point M represents the criterion from which speed is calculated. It is for the degree of development thus obtained that the correlation between the fixed density criterion and the fraction gradient criterion that was referred to above holds good.

In the American and British Standards, speed (arithmetic) is computed by use of the formula:

$$\text{Speed} = \frac{0.8}{H_M}$$

where H_M is the exposure in lux seconds corresponding to the point M.

In the German Standard, speed (logarithmic) is computed by use of the formula:

$$\text{Speed} = 10 \log \frac{1}{H_M}$$

where H_M is the exposure in lux seconds corresponding to the point M.

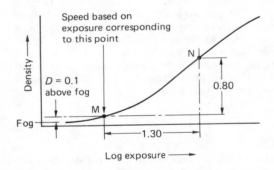

Figure 19.5 Method adopted for determining speed in current ASA, BS, ISO and DIN systems (ANSI PH2.5-1979, BS 1380:Part 1:1973, ISO 6-1974)

The International Organization for Standardization (ISO) also issues standards, and ISO recommendations are intended to be used as a basis for national standards of the various member countries of ISO. Many of the BS and ASA standards mentioned in the chapter are in agreement, or at least in partial agreement, with ISO standards. For example ANSI PH2.5-1979 for determining the speed of monochrome negative materials is in agreement with ISO 6-1974, and the British standard BS 1380: Part 1:1973 also agrees with the international standard (ISO 6-1974), provided that the ISO developer formulation specified in the standard is used for the determination of film speed. Thus there is general agreement between the national standards, and standards for the determination of film speed are becoming unified and accepted on an international basis.

Arithmetic and logarithmic speed systems

In Table 19.1 and elsewhere in the text reference has been made to arithmetic and logarithmic speed ratings. With the former type the progression of numbers is arithmetic, i.e. a doubling of film speed is represented by a doubling of speed number. With the latter type of numbers formerly distinguished by a degree (°) sign the progression is logarithmic.

Logarithmic speeds are expressed on a common logarithm (base 10 scale). The common logarithm of 2 is almost exactly 0.3, and logarithmic film speeds are scaled so that a doubling of film speed is represented by an increase of 3 in the speed index.

Conversion between speed systems

Because the methods of defining and determining speeds differed in the early speed systems there was not necessarily any parallelism between the results obtained, and any conversions between the various systems could therefore only be approximate. However, now that a common basis has been adopted for the determination of America, British and German standard film speeds, direct conversion between the systems is possible, as indicated in Table 19.2.

Speed ratings in tungsten light

Because the quality of tungsten light differs from that of daylight, different speed ratings may have to be used when an exposure meter is employed in tungsten light. Light emitted by a tungsten filament lamp has a higher red content and a lower blue content than daylight. As all photographic materials derive a large proportion of their speed from their sensitivity to blue light (Chapter 13), some drop in speed is to be expected in tungsten light. With fully colour-sensitive (panchromatic) materials this drop in speed is quite small, and may normally be ignored, but with orthochromatic and blue-sensitive materials the loss is considerable. Speed ratings for use in tungsten light for all except panchromatic materials are therefore lower than daylight ratings.

Speed ratings of commercial films

The ISO speed ratings printed on the boxes of films are daylight ratings of two types; arithmetic and logarithmic. These ratings are determined on the basis of sensitometric tests confirmed by practical tests in the camera.

Table 19.2 Conversion table between ISO speed ratings

ISO speed rating	
arithmetic	logarithmic
3200	36
2500	35
2000	34
1600	33
1250	32
1000	31
800	30
650	29
500	28
400	27
320	26
250	25
200	24
160	23
125	22
100	21
80	20
64	19
50	18
40	17
32	16
25	15
20	14
16	13
12	12
10	11
8	10
6	9
5	8
4	7
3	6
2.5	5
2.0	4
1.6	3
1.2	2
1.0	1

Speed ratings are not published for high-contrast materials such as those used in the graphic arts or for microcopying, nor for special materials such as astronomical plates, holographic materials and recording films. As we have already seen, any system for expressing the speed of a photographic material must take into account exposure and development conditions, and must be related to some particular criterion of correct exposure. The systems in general use for ordinary photographic materials cannot be applied to high-contrast or special materials since the conditions of exposure and development are quite different.

Table 19.3 Speed systems for some specialized applications (H = exposure in lux seconds)

Name and application	Speed point	Formula
Copying index. Copying of line and continuous tones where bright objects must record at high density	Fixed density 1.2–1.7 above gross fog	$S = 1/H$
Aerial film speed. Air-to-ground photography with aerial films	Fixed density 0.3 above gross fog	$S = 1.5/H$
Printing index. Comparison of sensitivities of printing papers and for estimating exposures when printing onto different papers	Fixed density 0.6	$S = 1000/H$
CRT exposure index. Comparison of sensitivities of films for CRT recording	Fixed densities, 0.1, 1.0 and 2.0 above gross fog	$S = 1.5/H$
Photorecording sensitivity. Comparison of sensitivity of photorecording emulsions	Fixed density 0.1 above gross fog	$S = 45/H$

ISO speed ratings should not be confused with manufacturers' exposure indexes, which are suggested values for use with exposure meters calibrated for ISO, BS, ASA or DIN speeds, and have been arrived at by the manufacturers' testing procedures for determining camera settings. A speed rating preceded by the letters 'ISO' implies that this rating was obtained by exposing, processing and evaluating exactly in accordance with the ISO standard.

Speed ratings for specialized applications

Various criteria have been adopted for certain more specialized uses of photographic materials such as copying, aerial photography, printing, cathode ray tube recording etc. These are included in Table 19.3 together with the criteria on which they are based:

Speed ratings for colour materials

Colour-negative film

The principles of speed determination for colour-negative films follow those previously described for monochrome materials. However, speed determination is complicated by the fact that colour materials contain layers (sensitive to blue, green and red light and the standards involve averaging the speeds of the three sensitive layers. The British standard (BS 1380: Part 3: 1980) adopts fixed-density criteria for locating the speed points of the three layers, exposed in a defined manner and processed according to the manufacturer's recommendations after storage at $20 \pm 5°C$ for between 1 and 10 days. Blue, green and red densities are measured (see Chapter 15) and the characteristic curves shown in Figure 19.6 are plotted.

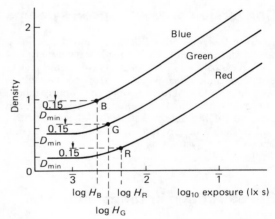

Figure 19.6 Methods for determining speed of colour negative films (BS 1380: Part 3:1980)

On these characteristic curves the points B, G and R are located at densities of 0.15 above the minimum densities for the blue, green and red sensitive layers. The log-exposure values corresponding to these points are $\log H_B$, $\log H_G$ and $\log H_R$ respectively. The mean exposure, H_M, is then calculated from two of these values (H_G and the slowest layer, usually the red-sensitive layer H_R) according to the following formula:

$$\log H_M = \frac{\log H_G + \log H_R}{2}$$

The arithmetic speed is then calculated from the value of H_M by the formula:

$$\text{Speed} = \frac{\sqrt{2}}{H_M}$$

where all exposure values are in lux seconds.

Colour reversal film

For colour reversal (colour-slide) films both American and British Standards adopt the same criteria for the determination of speed (ANSI, PH2.21–1983 and BS 1380:Part 2: 1984). However, unlike the previously-described standard for colour negative films, that for colour reversal films involves measurement of *diffuse visual density* (see page 173) and the plotting of a single characteristic curve shown in Figure 19.7. Films are exposed in a defined manner and processed according to manufacturer's recommendations. For the determination of speed two points (T and S) are located on the characteristic curve of Figure 19.7. Point T is 0.20 above the minimum density. From point T a straight line is drawn such that it is a tangent to the shoulder of the curve at point S. However if it happens that the shape of the curve is such that point S is at a density greater than 2.0 above the minimum density then point S shall be taken as that point on the curve at which the density is 2.0 above the minimum density.

The log-exposure values (log H_S and log H_T) corresponding to points S and T are read from the curve and their mean value (H_M) calculated:

$$\log H_M = \frac{\log H_S + \log H_T}{2}$$

from which the speed may be calculated:

$$\text{Speed} = \frac{10}{H_M}$$

All exposure values are in lux seconds.

This method of speed determination for colour reversal films for still photography is also in agreement with the international standard ISO 2240-1972 and with ANSI PM2.21-1983.

Practical value of speed numbers

The only useful speed number in practice is one which adequately represents the speed of a material under the conditions in which it is likely to be used.

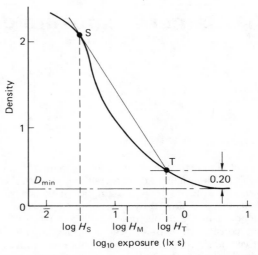

Figure 19.7 Method for determining the speed of colour reversal films (ANSI PH2.21–1983, BS 1380:Part 2:1984)

Published speed numbers aim at providing exposures which will secure a printable negative under a wide range of conditions. The published number for a given material cannot therefore be the best to use under every condition.

As a serious photographer you should determine for yourself the correct exposure index for your material, to suit your own equipment, processing conditions and desired image quality. Published exposure indexes provide a valuable starting point. Nevertheless, although you may have selected an exposure index that suits your needs you should remember that it is no more 'correct' than the published figure, except for your own conditions of working.

Camera exposure determination is discussed in detail in Chapter 20. ANSI PH 2.7-1986: *Photographic Exposure Guide* provides a useful standard for this.

20 Camera exposure determination

Camera exposure

Previous chapters have detailed the formation of an image on film by a lens and camera together with the response to light of photographic materials of various types, followed by processing to produce a permanent image in negative or diapositive form. After consideration of subject composition, perspective and sharpness, the photographer also judges the best moment at which to make an exposure by allowing an optical image of appropriate intensity to be transmitted by the lens and to fall upon the film for an appropriate length of time. This *camera exposure* is controlled by the combination of lens aperture and shutter speed. More generally, the photographic result of exposure (H) is the product of image illuminance (E) and exposure duration (t), so that

$$H = Et \tag{1}$$

Determination of the optimum camera exposure is important for any photographic situation in terms of the resulting quality of the photographic image. As explained in Chapter 15, any subject for the camera usually contains areas of different luminances giving an overall *subject luminance ratio*, so that taking a photograph gives a range of exposures to the film, which on processing produces a range of monochrome or colour densities that form the photographic image. The range of densities produced depends principally upon the characteristic curve of the film, which in its turn depends on the type of film and the development conditions used, together with the positioning of the range of log-exposures on the curve; this last depends, of course, on camera exposure.

Apart from exposure duration, the components of camera exposure are given by equation (14) in Chapter 5, which includes the major factors of subject luminance, lens aperture and magnification as well as others such as lens transmittance (including the necessary factor for any filter used) and vignetting, both optical and mechanical. Camera exposure may be determined by practical trial, e.g. by an estimate based on previous experience, followed by assessment of the resultant image after processing. However, measurement by some kind of light-meter is quicker and usually preferable. Essentially this may be done by measurement of the *luminance* of various parts of the subject, which is the resultant of the *illuminance* on the subject and its *reflectance*. Allowance may then be made for the other factors determining camera exposure, including the *effective* film speed, which depends on film type and processing, lens aperture, filter factor and shutter speed. These are all known quantities.

The four essential quantities involved in camera exposure are subject luminance, film speed, lens aperture and shutter speed. As shown in Figure 20.1, for any particular camera exposure there is a range of combinations of shutter speed and lens aperture which may be used for a given film speed. The selection of a suitable combination is a primary creative control in photography and may be dictated by the subject itself or the treatment required. For example, a moving subject may require a certain minimum shutter speed in order to provide a sharp image. Alternatively, the focal length of lens used or the limitations of camera steadiness may also dictate shutter speed as the important factor. In such cases the aperture must be chosen to suit this exposure duration. But for subjects requiring specific depth of field or optimum performance from a lens, then choice of aperture is of primary concern and the shutter speed must be chosen to suit. Ability to vary the illumination on the subject allows more choice of both of these variables. The use of tungsten illumination or electronic flash allows such variations in practice.

Optimum exposure criteria

Before considering the various ways of measuring subject luminance or illumination and relating these to camera exposure, it is useful to consider the criteria by which the correctness of exposure is judged. In the case of black-and-white or colour negatives, the criterion rests finally on the printing quality of the resulting negative. So a *correctly exposed negative* may be defined as a negative which will give an excellent print with least difficulty. Colour reversal material will be considered later. The visual judgement of black-and-white negative quality requires considerable experience due to related printing circumstances such as the print material used and the illumination system of the enlarger,

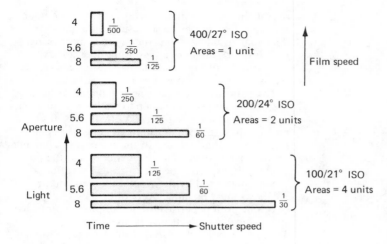

Figure 20.1 Exposure relationships. The diagram shows the relationships between film speed, exposure duration and aperture setting to give equivalent exposures (shown here as the areas of rectangles). A long exposure duration implies a reduced aperture and a slow film a larger rectangle, for a subject of given luminance

together with personal preferences for the overall density level of a negative. An approximate qualitative guide that has been suggested for many years is that a correctly exposed and processed negative made on continuous-tone material will usually have some detail in the shadows (low density regions) and with highlights (high density regions) that just permit newsprint to be read through them if the negative is laid on a newspaper in good light. For negatives on line film the correct exposure is judged from the appearance of the low-density fine line detail, which should be completely transparent and sharp-edged, without any filling-in; and from the whites of the original, which should be totally opaque.

Colour negatives are much more difficult to judge visually than black-and-white negatives, owing to the presence of the coloured dye masks. Again, the presence of shadow detail is a useful clue, but these regions are heavily masked. A suitable densitometer can provide a quantitative guide to optimum exposure. With a red filter in the measuring beam, a density of 0.7 to 0.9 in an '18 per cent grey card' region, of 1.15 to 1.35 in a highlight region, or 1.10 to 1.30 in a diffuse highlight in the forehead of a light-skinned subject, are indicative of correct camera exposure.

Further quantitative criteria for optimum exposure of negative materials relate to the systems used for determining film speed. In the case of black-and-white pictorial materials, the sensitivity may be determined from the minimum exposure necessary to give a density of 0.1 (above base-plus-fog density), which pegs this density to the image detail of lowest luminance, i.e. the deepest shadow for which detail is to be recorded. In the case of colour-negative material, this minimum density level may be 0.15 or greater (see Chapter 19). In the case of a colour transparency, correct exposure gives a result

which retains details in the highlights (low-density regions) so that there are no totally blank areas. Note that even with subjects having white highlight areas, the minimum density above base-plus-fog density, and the shape of the characteristic curve, are such that a value of some 0.2 to 0.3 is necessary to avoid the highlight appearing as a 'hole in the transparency'. Correct exposure pegs the important highlights at this point, (which is also used for speed determination).

Exposure latitude

As defined in Chapter 15, with reference to the *characteristic curve* of a material, the distance on the log-exposure axis between the maximum and minimum useful density points on the curve is termed the *useful log-exposure range*. As stated above, the subject luminance ratio that is required to be recorded determines the *log-exposure range* given to the material. This may be less than, equal to or greater than the useful log-exposure range the material can accept, related to its intrinsic contrast properties and the subsequent development conditions. Given that the log-exposure range is less than the inherent useful log-exposure range of the material, as may often be the case, then the *exposure latitude* of the material is the factor by which the minimum camera exposure necessary to give adequate shadow detail in the case of negatives (highlight detail in the case of reversal materials) may be multiplied, without corresponding loss of highlight detail (or shadow detail). Detail may be defined as discernable density differences in adjacent tones corresponding to resolved regions of the subject.

Figure 20.2 shows the concept of exposure latitude for negative materials. In the case of colour-

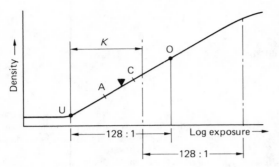

Figure 20.2 Latitude to over-exposure for negative materials. The index, U, O, A and C markings of the Weston Master exposure meter are shown relative to an average subject luminance range. The exposure latitude K is a multiple of the minimum useful exposure

negative materials, exposure latitude is also dependent upon the material being exposed with an illuminant of appropriate colour temperature; thus an excess (or deficiency) of say the blue component of the illuminant will cause the blue-record layer to receive more (or less) exposure relative to the green- and red-record layers, and position the blue exposure range on a different region of the characteristic curve relative to the other two. This reduces exposure latitude, as exposure outside the region that is linear for all three emulsions simultaneously will result in coloured highlights or shadows.

The high contrast of colour reversal material, typically equivalent to a gamma value of some 1.4, results in a restricted exposure latitude, even with a subject of luminance range not exceeding some 30:1. The lower inherent contrast of negative materials gives correspondingly greater exposure latitude, and the ability to record subjects of much greater luminance range. Conventionally, exposure latitude is expressed as tolerance in stops or *exposure values (EV)* (see page 266) relative to the optimum exposure. Colour reversal materials usually have a latitude of ±0.5 EV, or (less often) ±1 EV, where ±1 EV indicates a permissible error of double or half the optimum exposure. In this connection it should not be forgotten that natural vignetting across an image field from a lens may give an illumination level that varies as much as this. Ideally, reversal material should be exposed to within 0.3 EV of optimum.

The binary code arrangement of the DX coding system used on 35 mm film cassettes for *camera auto-sensing* (CAS) of film speed can provide the metering system with details of film exposure latitude. Four alternative ranges of ±0.5; ±1; +2, −1 and +3, −1 EV may be set. The primary use is for automatic exposure metering; for example, if the camera is set on aperture-priority mode, and the

overall subject luminance is so high that the aperture chosen requires an exposure duration shorter than that available from the shutter speed range, then if the resultant over-exposure does not exceed the latitude of the material, the shutter will be released; otherwise it will lock.

The majority of colour-negative materials have a useful exposure latitude of up to +3 EV (factor × 8) to over-exposure, and −1 EV (factor × 0.5) to under-exposure, while still yielding acceptable prints. Note that because of the fixed development conditions of colour-negative material and the non-scattering properties of the dye images (print contrast is unaffected by the type of illumination in the enlarger) most manufacturers offer only one grade of colour-print paper. Alteration of print contrast to suit particular subjects or negatives can as a rule be achieved only by the use of contrast-altering silver masks. Black-and-white negative material has similar (or greater) exposure latitude than colour-negative material, but with the added facility of the alteration of processing conditions to cope with extremes of subject luminance ratio.

Subject luminance ratio

For the purposes of exposure determination a primary classification of a subject is by its *luminance ratio*, sometimes called the 'subject luminance range'. This is numerically equal to the product of the *subject reflectance ratio* and the *lighting ratio*. For example, a subject whose lightest and darkest parts have reflectances of 0.9 and 0.09 respectively, i.e. a reflectance ratio of 10:1, when illuminated such that there is a lighting ratio of 5:1 between maximum and minimum illumination levels, has a subject luminance range of (10 × 5): 1, i.e. 50:1. A high luminance ratio denotes a subject of high contrast. Luminance ratios from as low as 2:1 to 1 000 000:1 (10^6:1) may be encountered. Integration of individual luminance levels gives a value for the *average reflectance* of a scene, and this value is dependent upon the subject luminance ratio. Based upon appropriate scene measurements, it is usually assumed that an average subject has a luminance ratio of 128:1 or 2^7:1, corresponding to a seven-stop (or EV) range. The subject is also assumed to have a mean reflectance of 18–20 per cent. Neutral grey cards of 18 per cent reflectance are available from photographic specialists; these may be used as substitute 'average' subjects for techniques of exposure determination based upon measurements of subject luminance. Subject matter with a reflectance ratio of 2048:1 (2^{11}:1) has a mean reflectance of about 11 per cent; subject matter with a reflectance ratio of only 8:1 (2^3:1) has a mean reflectance of about 40 per cent. If the exposure meter is calibrated (as it usually is) for a mean reflectance of 18 per cent, this

Table 20.1 Subject classification by luminance range

Subject luminance ratio classification	Luminance ratio	EV range	Average luminance as percentage of illumination	Weston Master series exposure meter index	Approximate exposure correction factor
Very high	2048:1 (2^{11}:1)	11	11	C	+1 EV
High	512:1 (2^9:1)	9	14		+0.5 EV
Average	128:1 (2^7:1)	7	18	▲ arrow	0
Low	32:1 (2^5:1)	5	25		−0.5 EV
Very low	8:1 (2^3:1)	3	41	A	−1 EV

would result in exposure errors respectively of +80 per cent and −60 per cent. It is therefore necessary, where the subject matter is of excessively high or low contrast, to apply a *subject correction factor*. Table 20.1 lists some values of subject reflectance and luminance range.

It is possible in many situations to reduce the subject luminance ratio by the use of additional illumination, for example in the form of *fill-in flash* or *synchro-sunlight* techniques. In some cameras with automatic exposure metering, a *segmented photocell* monitors the average luminance and luminance ratio of the subject matter by measuring the central area and the background separately. Supplementary fill-in light from an integral flash unit (to reduce subject contrast) may be provided automatically over a limited range of flash-to-subject distances. The required amount of flash is monitored by off-the-film measurement.

Development variations

For a given set of processing conditions, a variation in development time can be used to control the contrast of black-and-white negatives, as measured by the *negative density range* corresponding to the *log-exposure range*. Remember that a change in development time alters density range (contrast) of a negative, whereas a change in camera exposure determines the position of the density range on the characteristic curve. The effects of exposure and development are summarized by the curves in Figure 20.3. By giving normal, reduced or increased development and exposure in various combinations, some nine varieties of negative are possible. Not all of these have ideal printing characteristics, of course: some cannot adequately be matched to the available grades of printing paper, and others do not have a suitable overall density level.

For example, an under-exposed and under-developed negative is of low average density and low density range, and requires a hard grade of paper (which has a low exposure latitude and

emphasizes graininess). Also, areas of low density show marks and scuffs to a greater extent than areas of higher density. On the other hand, an over-exposed, over-developed negative is grainy, and requires a long printing exposure on a soft grade of paper, which does not in general record shadows and highlights well owing to the shape of its characteristic curve. Variation in development time changes effective film speed, too; in particular, prolonged development results in a higher effective exposure index for the material, producing what amounts to an over-exposed result if the exposure was based on a normal speed rating. Reduced development, however, can match the useful log-exposure range of a material to a high subject log-luminance range, to yield a negative of density range printable on a normal grade of paper. A side effect of under-development is a loss of effective film speed, so the material must have its camera exposure adjusted accordingly. This technique of increased exposure (or down-rating of speed) and reduced development to deal with high-contrast scenes works best with materials of nominal speed ISO 400/27°.

The possibilities of individual development of exposed material to suit scenes whose luminance ratios have been measured using a spot photometer, form the basis of the Zone System of exposure determination.

Colour-negative material cannot be treated in this way, but colour-reversal film may have its efffective exposure index varied, (usually increased) by alteration of first development time, contrast is also affected, though the exact nature of the variation depends on the material.

Exposure determination

In the early days of photography the practice of development by inspection, in order to produce negatives from different subjects that would nevertheless all print on the single grade of paper then available, led to the empirical rule of exposure:

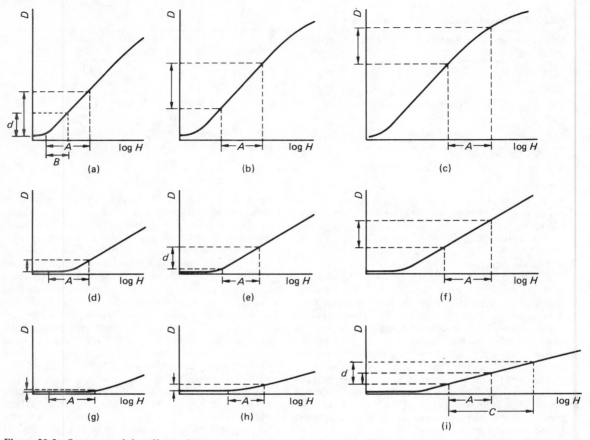

Figure 20.3 Summary of the effects of exposure and development variations on negative density range and density values: (a) Under-exposure and prolonged development; (b) correct exposure and prolonged development; (c) over-exposure and prolonged development; (d) under-exposure and normal development; (e) correct exposure and normal development; (f) over-exposure and normal development; (g) under-exposure and curtailed development; (h) correct exposure and curtailed development; (i) over-exposure and curtailed development. Key: *A*, normal subject log-luminance range; *d*, negative density range, to print on normal grade paper; *B*, low subject log-luminance range; *C*, high subject log-luminance range

'expose for the shadows and develop for the high-lights'. The introduction of roll film, development by time-and-temperature methods, and the availability of paper with a variety of contrast grades, made it possible for the various subjects to be exposed and processed to a common negative contrast while giving acceptable prints. As a result the rule was modified to 'expose for the shadows and let the highlights take care of themselves', and this advice still holds to a large extent for black-and-white negatives.

Colour negatives may also be exposed for shadow detail, but the minimum exposure should locate shadows on the linear portion of the characteristic curves and not on the toe regions. This gives correct reproduction of tone and colour. Provided the high-lights are also on the linear portion, tone and colour

reproduction are acceptable throughout the range of densities. A colour print cannot handle such a large tone range as a black-and-white print, as tonal distortions acceptable in the latter are unacceptable in colour prints due to the colour-balance errors in the deepest shadows, and the low tolerance of most viewers to such 'skewed' colour balance. Such local colour imbalances are not correctable at the printing stage, as corrective filtration is only effective for *overall* colour casts.

In the case of reversal materials, the method of camera exposure determination by measurement of both shadow and highlight luminances is equally valid, the shadows and highlights being pegged on the characteristic curve in the most appropriate position. This time the highlights are recorded as *low* densities, as described above. So it is sensible in

this case to base exposure on subject *highlights*, and let the shadows 'take care of themselves'. This arrangement is satisfactory for most subjects, but for high-key subject matter (i.e. with no important dark areas), exposure is best increased by $+\frac{1}{2}$ to $+1$EV to avoid a 'washed-out' appearance. Likewise, a low-key subject (i.e. with minimal highlight detail) needs a reduction in exposure of $-\frac{1}{2}$ to -1 EV.

It may not be convenient or easy to measure the highlight luminance of a subject directly. But an incident-light measurement gives a good approximation, since the highlights of most subjects are white or near-white, with a high reflectance, so an illumination measurement is similar to a highlight luminance measurement.

An *artificial highlight* may be provided in a scene for easy measurement of reflectance by making the exposure measurement on a matt white card. If the assumed reflectance of this is 90 per cent, i.e. 5 times more than the average scene reflectance of 18 per cent, and the meter used is calibrated in the normal way, for 18 per cent reflectance, the indicated exposure should be multiplied by 5 to indicate correct exposure. The artificial highlight method is useful in copying work, and is particularly worthwhile when colour slides are being made of material with unusual reflectance properties (snow scene, dark forest glades).

Practical exposure tests

It is possible to determine optimum exposure by a series of practical tests, if the material has no film speed rating, as is the case for materials intended for copying, photolithography and similar tasks. The instruction sheet supplied with the material may suggest starting points for exposure level with particular illuminants, filters, development and subjects. Such techniques are suited to the studio and photographic laboratory, as processing and evaluation are carried out immediately after exposure. When using a large-format studio camera, for example, the darkslide of the filmholder may be progressively inserted to allow a doubling sequence of timed exposures to be given. Thus a sequence of 1, 2, 4, 8 and 16 seconds exposure is given by consecutive additive exposures of 1, 1, 2, 4 and 8 seconds respectively. The camera must remain stationary during the tests, of course. For small- and medium-format cameras a similar test series is given by exposing a sequence of individual frames. Either the shutter speed can be varied while the aperture is held constant or vice versa. Of these choices, the shutter-speed variation gives a constant image luminance but may cause reciprocity-failure effects, and the depth of field is constant. If aperture variation is used, two series of exposures should be made, one with increasing and one with decreasing aperture

size. This is because many iris diaphragm systems have up to a quarter of a stop backlash. Aperture variation is mandatory if flash illumination is being used.

Certain 35 mm SLR automatic cameras with integral power-wind offer an 'automatic bracketing' feature in some automatic exposure modes, so that on setting a choice of up to ±3 EV in $\frac{1}{3}$ EV increments, a range of exposures is given with exposure variations to bracket the exposure in cases of doubt or where the necessity for a good result overrides the cost of the film. Either shutter speed or aperture may be varied in such a series.

The use of self-developing materials, such as Polaroid film, of a known exposure index, gives a means of determining or verifying exposure, and may be used on location. A Polaroid back is used on the camera, and the results examined after exposure. Differences in exposure indexes between the self-developing film and the (colour) material can be allowed for by simple calculation or the use of a neutral density filter. Composition, positioning of subject and props, lighting balance and the presence of any undesirable reflections may also be checked.

Light measurement

Correct exposure is determined by measurement of the luminance of the subject matter (or parts of it), or, alternatively, the illumination on the subject (incident light), followed by location of the log-luminance ratio in a suitable position on the characteristic curve of the material. Ideally, the luminance ratio itself should be determined; but this requires experience in locating suitable zones, and is by no means easy to measure accurately. This method is in general too complicated and difficult for everyday use. Other methods are simpler, and may be preferred in practice, even though they may, in theory, be less accurate.

Measurement of luminance of darkest shadow

This locates this tone at a fixed point on the toe of the characteristic curve, giving the correct density to the deepest shadow that is to record. Practical difficulties include the metering sensitivity required, the effects of flare light on measurements and disregard for highlight detail which may be difficult to exclude from the field of view of the meter. Some meters have an indicator for this measurement; for example, Weston exposure meters have a 'U' mark which should be set to the darkest-shadow reading.

Measurement of luminance of lightest highlight

This pegs the highlight at a fixed point with highlight detail and other tones as differing densities. Shadow detail is usually adequately recorded, but a subject of average contrast may receive more exposure than necessary. The Weston exposure meter has an 'O' setting for this method; with other meters the indicated exposure should be divided by 5. This method is similar to the *artificial highlight* method described on page 263, which works well for colour-slide material. Note that when using this method, measurements must not be made on specular highlights.

Measurement of a key tone

An object of intermediate luminance or mid-tone, is selected and pegged at a fixed point on the characteristic curve. Typically an exposure 10 to 16 times more than that for the shadow or speed point is given. This *key tone* may be a flesh tone (about 25 per cent reflectance). Control of scene illumination allows the shadows and highlights to be suitably located too. A substitution method may also be used: a Kodak grey card (18 per cent reflectance) is held so as to receive the same illumination as the subject it is replacing. The light meter is used close up so that the card fills the acceptance angle of the photocell. The 'arrow' setting of a Weston meter is calibrated for a mid-tone, as are most metering systems.

Cameras with automatic exposure control may offer an 'exposure memory lock' feature to allow the metering system to measure and set an exposure for a key or substitute tone, after which the picture is recomposed and the stored exposure given. This memory may be self-cancelling after exposure, or may require manual cancellation.

Measurement of total scene luminance

This 'integration' method accepts all the light flux from the subject area to be recorded. Such a *reflected light measurement* is widely used, as it is simple to carry out and requires little selective judgement. It is used in hand-held meters, in flashmeters and for in-camera metering systems for both ambient and flash illumination. Its high success rate is largely because the useful log-exposure range of negative materials is greater than the log-luminance range of the average subject.

A correction to the indicated values of exposure settings is usually necessary for subjects of very high or very low contrast, or for a subject of non-typical tone distribution, such as a high-key or low-key subject. Typical corrections necessary are a doubling of indicated exposure for high-contrast or high-key subject matter, and a halving of indicated exposure for low-contrast or low-key subject matter. The Weston exposure meter has two exposure index marks denoted 'C' and 'A' to cope with high and low contrast (or high- and low-key) subjects. These settings give corrective alterations of $+1$ EV and -1 EV respectively.

Most cameras with an automatic-exposure mode have an associated *exposure compensation control* which offers manually-set increases or decreases of up to 3 EV in increments of $\frac{1}{2}$ or $\frac{1}{3}$ EV to cope with atypical subjects or luminance distributions.

Measurement of incident light

The *incident light method* measures the light incident on the subject rather than the light reflected from it. It is an easy measurement to make with a hand-held light meter, but is not suitable for an in-camera metering system. It positions the highlights (rather than the mid-tones) on the characteristic curve, and is thus particularly suitable for use with colour reversal materials. No information is given with regard to the shadows, and exposure corrections may have to be made if the subject is very dark or back-lit.

Exposure meter calibration

A hand-held light meter may be used to measure either subject luminance or subject illumination. It is a form of photometer not dissimilar to those used by lighting engineers, with its readings convertible into camera exposure settings. The usual form of meter calibration and its relationship to subject, camera and film speed parameters are shown in Figure 20.4, where a reflected light reading is being taken.

Consider a small off-axis area of the subject of luminance L that is imaged in the focal plane of the camera with image illuminance E_F. The values of L and E_F are related by equation (14) in Chapter 5, so that if the lens has a transmittance T, and f-number N, and the region is at an angle θ from the optical axis,

$$E_F = \frac{L\pi T \cos^4 \theta}{4N^2} \tag{2}$$

Equation (2) may be rewritten as

$$E_F = \frac{qL}{N^2} \tag{3}$$

where q is a constant derived from known (or assumed) values of the quantities above.

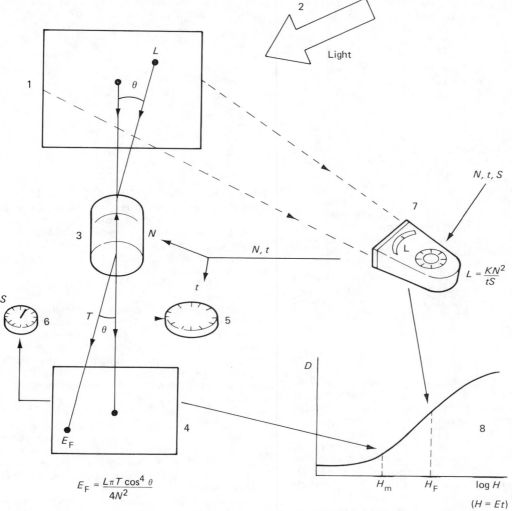

$$E_F = \frac{L\pi T \cos^4 \theta}{4N^2}$$

Figure 20.4 The calibration of a light meter. The subject (1) is illuminated by light (2) and imaged by the lens (3) onto the film plane (4). The camera has a shutter speed setting dial (5) and film speed setting control (6). The luminance of the scene is measured by a light meter (7).

The film speed and exposure are related by the characteristic curve (8) of the film. (The other values are referred to in the text.) Film speed is determined from the value H_m and the exposure meter indicates an exposure corresponding to H_F

So from equation (1), the exposure H_F at the focal plane is given by

$$H_F = \frac{qLt}{N^2} \tag{4}$$

H_F can be replaced by a sensitometrically determined speed number S for the film used where

$$S = \frac{H_O}{H_m} \tag{5}$$

where H_O is a constant and H_m is the *speed point* or *minimum useful exposure*. Now,

$$H_F = kH_m \tag{6}$$

where k is constant and a multiple of H_m therefore,

$$H_F = \frac{kH_O}{S} \tag{7}$$

So, by substituting for H_F in equation (4) and rearranging, we have

$$t = \frac{kH_O N^2}{qLS} \tag{8}$$

Choosing a new constant K, usually called the *calibration constant* for luminance, gives

$$K = \frac{LtS}{N^2} \qquad (10)$$

Similarly, for an incident light reading when the illuminance E_S of the subject is measured,

$$C = \frac{E_S tS}{N^2} \qquad (11)$$

where C is the calibration constant for illuminance. The calibration procedures are detailed in a number of national and international standards such as those published by ANSI, BS, DIN and ISO.

For black-and-white materials, the exposure for a mid-tone of 18 per cent reflectance is pegged at approximately 16 times that for the speed point, to distribute the subject tones along the characteristic curve. The value of k in equation (6) would be 16 in this case. Typical values of the constants K and C for a mid-grey (18 per cent) tone are 3.33 and 20.83 respectively; more precise values may be given in the instruction manual for a particular exposure meter. For an average subject of 18 per cent reflectance $L = 0.18E_S$. From equations (10) and (11), $t \propto N^2$, so that

$$\frac{t_1}{t_2} = \frac{N_1^2}{N_2^2} \qquad (12)$$

Given an appropriate film speed and scene luminance or illumination value, the *calculator dials* of an exposure meter will solve equation (12) for a wide range of equivalent pairs of shutter speed (t) and lens aperture (N). The pair most appropriate to subject treatment may then be chosen. Alternatively a microprocessor with digital readout may give a comprehensive display of exposure data on a LCD.

For various forms of in-camera metering, if shutter speed or aperture is pre-selected then the appropriate value of the remaining variable will be given. If *program exposure mode* is set, a combination of both t and N will be set. (Such behaviour is best explained in terms of *exposure values*).

Exposure values

The term *exposure value* (EV) must not be confused with *light value* (LV) which is simply a number on an arbitrary scale on an exposure meter as a measure of subject luminance or illuminance. The Exposure Value (EV) system originated in Germany in the 1950s and was intended as an easily-mastered substitute for the shutter speed/aperture combination, giving a single small number instead of two (one of which was fractional). The EV system is based on a geometric progression of common ratio 2, and is thus related to the doubling sequence of shutter and aperture scales. The relationship used is

$$2^{EV} = \frac{N^2}{t} \qquad (13)$$

Taking logs and rearranging

$$EV = \frac{1}{\log 2} \log \frac{N^2}{t} \qquad (14)$$

or

$$EV = 3.32 \log \frac{N^2}{t} \qquad (15)$$

For example, a combination of 1/125 second at $f/11$, from equation (15), gives an EV of 14. Similarly, all exposures equivalent to this pair will give an EV of 14. Some cameras made in the 1950s and 1960s have shutter speed and aperture setting controls linked together and to an EV scale, but this practice has now been discontinued.

Although no longer used for such purposes, the idea of the EV scale has had useful functions in exposure measurement practice, remembering that an increment of 1 in the EV scale indicates a factor of two in exposure. A primary use is to give a quantitative measure of the sensitivity of a metering system by quoting the minimum EV that can be measured for a film speed of ISO 100/21°. For example, a modern hand-held exposure meter using a silicon cell has a typical measuring sensitivity of between EV -2 and EV -8, with a range of 16 EV. A sensitivity of EV -2 can allow metering in moonlight. The use of various attachments such as spotmeter arrangements or fibre-optic probes reduce the sensitivity considerably; a high initial value is therefore needed for meters intended for such accessories.

In-camera meters are limited in their sensitivity by the light losses involved in their optical systems, and by the maximum aperture of the lens for full-aperture TTL metering. For comparisons this aperture must be quoted: for an $f/1.4$ lens a sensitivity of EV 1 at ISO 100/21° is typical. The operating limit of an in-camera autofocus system is quoted similarly. Another use of the EV system is the *EV graph* (Figure 20.5), where the scales on the rectangular axes are shutter speed and aperture. A series of diagonal lines connecting pairs of values of equivalent exposures represent the EV numbers. These EV loci may be extended to an adjacent graph of film speed and subject luminance. On such a graph it is possible to show the behaviour of a particular camera, for example in terms of the envelope of performance with the range of settings available. Additionally in the case of an automatic camera the different exposure modes and forms of programmed exposure can be compared.

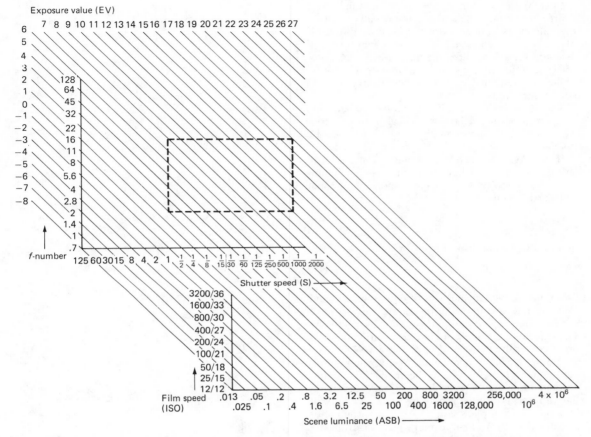

Figure 20.5 Exposure value (EV). Relationship between scene luminance and film speed can be expressed in terms of an exposure value which is a combination of aperture and shutter speed

Finally, EV 'plus' and 'minus' scales are commonly used on the exposure compensation and auto-bracketing controls of automatic cameras, and to indicate filter factors and exposure compensation for interchangeable focusing screens.

Incident light measurements

As explained above, measurements of scene reflectance or luminance are not always ideal, as some subjects have non-typical tone distribution or extremes of luminance. Assuming that for an average scene both incident- and reflected-light measurements give the same correct camera exposure, then equations (10) and (11) are equal, so that

$$\frac{L}{E_S} = \frac{K}{C} \tag{16}$$

But as $L = RE_S$, then

$$R = \frac{K}{C} \tag{17}$$

Subject reflectance is thus assumed to be equal to the ratio of the exposure constants K and C. For example, a meter may be calibrated for a midtone so that $K = 3.64$ and $C = 25.6$, so that R is approximately 0.14 or 14 per cent. Other values such as the 18 per cent reflectance of the Kodak neutral grey test card are used as a substitute 'average subject'. The reasoning for use of an incident light reading of subject illuminance E_S is that by definition no subject can have a reflectance greater than 1.0, and exposure may be adjusted so that the brightest highlight renders an acceptable maximum or minimum density in a negative or transparency respectively. But since in equation (11) the illumination E_S is not precisely defined as to source size or direction,

the light meter must integrate the incident light over a large acceptance angle to account for all contributing sources. For this purpose a translucent diffuser is placed over the photocell for incident light readings. The diffuser also reduces the response of the photocell, and different transmittance values may be used to limit the reading with intense light sources such as studio flash units.

The diffuser may be flat or dome-shaped (the Weston meter has a hollow conical diffuser); configurations determine how the reading may best be taken.

If the angle between the normal to the photocell surface and a ray of light from the primary illuminant is denoted by θ, then the response *r* of a flat diffuser is given by

$$r = k_a \cos \theta \qquad (18)$$

and of a hemispherical diffuser by

$$r = \tfrac{1}{2}k_b (1 + \cos \theta) \qquad (19)$$

From the mathematical forms of equations (18) and (19) the flat and dome diffusers are said to have *cosine response* and *cardioid response* respectively. The constants k_a and k_b are not necessarily identical and may be the value of *r* when θ is zero.

The flat *cosine receptor* is necessary when illuminance measurements are to be made taking into account Lambert's Cosine Law. However, when a flat diffuser is used for making measurements of illuminance for a photographic exposure, the meter is pointed in turn at the camera position from the subject, then at the brightest source of illumination from the subject. The log arithmic mean of the two readings is then taken. This average is the mid-point of the readings on the (logarithmic) scale of the meter. This technique is called the *Duplex Method*. Alternative methods include pointing the meter towards the camera, or, pointing midway between the camera and a single illuminant, or taking averages of readings towards the camera and each illuminant in turn.

To determine the lighting ratio, based upon the measurement at the subject with the meter pointed at each illuminant in turn, the directional response of the flat diffuser is essential. For this reason many flash exposure meters are fitted with a flat diffuser. When an exposure meter is converted for use as a *photometer* to indicate illuminance on a surface, again a flat diffuser is essential.

A more convenient method of incident-light metering is to use a diffuser of hemispherical shape; in this case the meter is simply directed from the subject towards the camera position for a single measurement. Its shape effectively presents a surface that is equally oriented in all directions relative to the subject-camera axis and its projected area

Figure 20.6 Techniques of incident light metering: (a) Flat diffuser Duplex method, C camera, S subject, L brightest source, D diffuser; (b) flat diffuser and measurement of lighting ratio; (c) domed diffuser taking a single reading; (d) Invercone diffuser includes backlighting

relative to a beam of light at any angle of incidence is the same.

The Invercone design of diffuser as used on the Weston series of exposure meters is a truncated hemisphere with an inverted cone inside it. It overhangs the meter body and picks up any significant backlighting on the subject.

Exposure meters in practice

The photocell

Although the majority of cameras now have some form of in-camera exposure determination system, the hand-held *light meter* or *photometer*, usually

Table 20.2 Properties of photocells used in exposure determination systems

Photocell type	Se	CdS	SPD	GPD
Battery needed	No	Yes	Yes	Yes
Amplifier needed	No	No	Yes	Yes
Speed of response	Slow	Slow	Fast	Very fast
Memory effects	Eventually	Yes	No	No
Sensitivity	Low	Medium to high	High to very high	High
Linear response	Approximately	Poor	Yes	Yes
Spectral (colour) sensitivity	Matches eye	Red bias	Needs blue filter	No infrared sensitivity
Size	Large	Small	Small	Small
Range change device needed	Yes	Yes	No	No
Electrical property	Photovoltaic	Photoconductor or photoresistor	Photovoltaic	Photovoltaic
Cost of unit	Medium	Low	High	High

called an *exposure meter*, is still widely used. It can be used with cameras that do not have their own metering system; as a check on in-camera systems or for difficult subjects or extremely low-light conditions; for incident-light measurement; and as the basis of a system of specialised accessories for a range of light measurement tasks. It also has a role in the measurement of ambient light and electronic flash illumination.

An exposure meter consists basically of a light-sensitive electronic device, some means of limiting its acceptance angle, an on-off switch and a range-change switch, a power source (as necessary), a scale in light values, a set of calculator dials or readout of exposure data, and a diffuser for incident light readings. A variety of types of photocell are in use including selenium 'barrier-layer' photovoltaic cells, cadmium sulphide (CdS) and cadmium selenide (CdSe) photoresistors, silicon photodiodes (SPD) and gallium arsenide phosphide photodiodes (GPD). The main properties of these are listed in

Table 20.2; suitable circuitry is described in Chapter 9. The spectral sensitivity of the various types differs markedly (see Figure 20.7). The CdS and SPD types have high infrared sensitivity. The SPD is usually encapsulated with a blue filter to reduce this sensitivity and is referred to as a 'silicon blue' cell. A selenium cell is also usually filtered to match its spectral response to that of the standard CIE photopic visual response curve.

The response of the selenium cell to light is dependent upon cell area, limiting sensitivity unless the cell area is large. Sometimes a plug-in booster cell is available to increase sensitivity by some 2 EV. The Weston series of exposure meters uses a hinged perforated baffle arrangement over the large photocell to limit response at medium to high light levels. For low light levels the baffle is swung back to uncover the full cell area for greater response. This action also changes the light-value scale from high to low range.

A CdS photocell meter may use a resistor network to change its response range; alternatively it may use a neutral-density filter or a small aperture in front of the cell. The SPD gives a near-linear response over a range of some 15 to 20 EV and does not require a range changeover switch. Its response is unaffected by its previous exposure to light, unlike the CdS photocell.

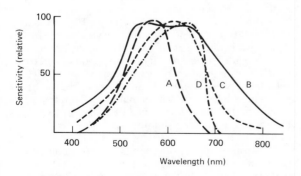

Figure 20.7 Spectral sensitivity of photocells. The graph of relative spectral sensitivity against wavelength shows the approximate spectral response or sensitivity of photocells used in exposure metering systems: A visual spectral sensitivity and a filtered selenium cell, B CdS photoresistor, C silicon photodiode (SPD) fitted with a blue filter ('silicon blue' cell), D gallium arsenide phosphide photodiode (GPD)

Acceptance angle

Both the CdS and SPD photocells are very small devices with a response that is unaffected by cell area; they thus require special optical arrangements when used in exposure meters. All photocells are non-imaging devices, which integrate the incident light flux. It is necessary to restrict this reponse to the subject area covered by the camera lens in use, or a smaller area, to give the alternative techniques of integrated, small-area and spot readings.

Traditionally, the selenium-cell meter was limited to have an acceptance angle of some 50°, corresponding to that of the standard lens of a camera format, but with a much more rectangular aspect ratio, to reduce the effect of a bright sky area. The removal of the baffle increases the acceptance angle to some 75°, to assist sensitivity. The acceptance angle is determined by a field angle limiter of honeycomb grid type, or by a refraction type using a transparent lenticular screen with a grid in front of the selenium cell. The much smaller CdS and SPD cells may simply be located at the bottom of a cylindrical black-lined well or have a positive lens bonded to the receptor surface. These arrangements give acceptance angles of some 30°, allowing more selective readings of zones of the subject area. A small viewfinder may help to aim the meter cell at the desired area. Accessory devices may reduce this angle even further to 15° or even 7°, with a reduction in sensitivity due to light losses in the optical system used. The *spot meter* or *exposure photometer* is a specialist meter of acceptance angle 1° or less (see below).

Optical attachments

A modern professional exposure meter is the basic unit of a 'system' of accessories and attachments for conversion to alternative measurements or purposes. The use of acceptance-angle reducing devices and viewfinders has been described above. Other devices may allow small-area readings of incident light to be made in the plane of the projected image on the easel of an enlarger or at the copyboard of a copying set-up. These *enlarging* and *repro attachments* may incorporate a diffuser and a plastic or fibre-optics *light guide* to enable the meter to be used flat upon the easel or copyboard. The enlarging attachment is used for techniques of printing exposure determination by comparative image photometry using a calibration obtained from an 'excellent' black-and-white print made by trial-and-error methods. Other accessories may include a small dome diffuser on a rod and lead to permit readings from within a table-top set-up or an *eyepiece adapter* for attachment to the viewfinder of a camera to monitor the screen image. A flexible *fibre-optics probe* attached to the photocell may act as an angle limiter or allow *ground-glass screen measurements* to be made. The meter then requires an additional calibration mark to allow for the effect of the transmission of the screen (or a comparative method may be used). A *microscope attachment* allows the meter to be fixed to the eyepiece end of a microscope tube with the eyepiece lens removed, so as to measure the luminance of the intermediate aerial image from the objective lens and indicate exposure time by comparative image photometry from known

exposure parameters. An accessory photocell probe on a flying lead can be inserted via a special dark-slide into the focal plane of a large-format camera and make small-area readings in the plane of the focused optical image. This could be considered as possibly the ideal metering arrangement. Other attachments may convert the meter into a colour-temperature meter, for measurement of electronic flash, or with a reduced acceptance angle, as a spot meter.

Many systems no longer use a moving-coil arrangement to move a pointer over a light value scale. Instead, solid-state devices give a digital readout, and a LED or LCD panel gives the values, operational status and mode of the meter. The meter may also have a flash-metering mode, offering the same range of incident and reflected light readings and use of most of the accessories. These facilities are described in Chapter 21. Some exposure meters may also be used in a photometer mode where the light values are converted into luminance or illuminance readings in SI units. Alternatively, digital lightmeters may give a direct digital readout of the values in various chosen units.

Luminance units

The SI unit of luminance is the candela per square metre (cd/m²), formerly called the *nit*. The SI unit of illuminance is the *lux* (lx), which represents an illuminance of 1 lumen per square metre. These units and their use in photometry are discussed in Chapters 3 and 5. Most meters that are adapted for incident-light measurements can be used for direct measurements of illuminance, using conversion tables; some (such as the Gossen Lunasix) are supplied with such tables on the meter itself. Table 20.3 shows the relationships between EV numbers (for ISO 100/21°) and illuminance values in luxes. They also show the relationship between EV numbers and luminance in candelas per square metre, which is what a reflected-light meter measures. The relation between luminance and illuminance is that a perfect diffuse reflector illuminated by 1 candela per square metre has a luminance of 1 lux, so that for the same EV reading, luminance (cd/m²) = $1/\pi \times$ illuminance (lx).

Unfortunately, the situation is complicated by the persistence of a number of archaic units left over from the obsolete FPS and CGS systems. These are sometimes found in descriptions of lighting units and in the instruction booklets for older types of exposure meter. As conversion tables for these units are becoming scarce, they are included in Table 20.3. The foot-lambert (ft L) is still often encountered in connection with screen luminance of a projected image. The stilb (sb) was (and still is) used for the

Table 20.3 Photometric units and camera exposure. Approximate corresponding values of various units of luminance and illuminance related to exposure value (EV) for camera exposure determination with a film of speed ISO 100/21°

EV (for ISO 100/21°)	Subject luminance (brightness)						Illuminance (illumination on subject)			
	cd/m² (nit)	stilb cd/cm² (sb)	apostilb lm/m² (asb)	cd/ft²	lambert (L)	foot-lambert (ft L)	lux lm/m² (lx)	phot lm/cm²	lm/ft²	EV (for ISO 100/21° and R = 1)
−2	0.03		0.1			0.01	0.1		0.01	−2
−1	0.06		0.2			0.02	0.2		0.02	−1
0	0.13		0.4	0.01		0.04	0.4		0.04	0
1	0.25		0.8	0.02		0.07	0.8		0.07	1
2	0.5		1.6	0.05		0.15	1.6		0.15	2
3	1		3.14	0.09		0.29	3.1		0.29	3
4	2		6.28	0.2		0.58	6.3		0.58	4
5	4		12.57	0.4		1.17	12.6		1.2	5
6	8	0.001	25.1	0.8		2.34	25		2.3	6
7	16	0.002	50.3	1.5		4.67	50		4.7	7
8	32	0.003	100.5	3	0.01	9.34	100	0.01	9	8
9	64	0.006	201	6	0.02	18.7	201	0.02	19	9
10	128	0.01	402	12	0.04	37.5	402	0.04	37	10
11	256	0.03	804	24	0.08	75	804	0.08	75	11
12	512	0.05	1609	48	0.16	150	1609	0.16	150	12
13	1024	0.1	3217	96	0.32	299	3217	0.32	299	13
14	2048	0.21	6434	190	0.64	598	6434	0.64	598	14
15	4096	0.41	12868	381	1.29	1196	12868	1.29	1196	15
16	8192	0.82	25736	761	2.57	2392	25736	2.57	2392	16
17	16384	1.64	51472	1522	5.15	4784	51472	5.15	4784	17
18	32768	3.23	102944	3044	10.29	9568	102944	10.29	9568	18

luminance of light sources and the apostilb (asb) for the luminance of non-self-luminous sources. It will be noticed from the table that the apostilb is numerically equal to the lux; but it is a unit of luminance, not illuminance.

Exposure photometers

A photometer or exposure meter with an acceptance angle of 1° or less is usually referred to as a *spotmeter*. Its applications are for precise measurement of the luminance of small areas of a large subject, for example when a long-focus lens is to be used, or if the subject matter is inaccessible or if the area of interest is itself small. A complex optical system is needed. Such a meter will typically show a field of view of some 5–20° horizontally, in a viewfinder with focusing capabilities. The much smaller measuring spot area is shown in the field together with a light value scale which may be in digital form. A measuring accuracy of ±0.1 EV is possible. The classic design of the SEI visual spot photometer used a Kepler telescope configuration and a split cube carrying a 'spot mirror' to image an internal reference light source in the measurement area. The spot was matched to the subject tone by attenuation using sliding density wedges (Figure 20.8). The principle was essentially that of the Bunsen grease-spot photometer. Two calibration

indices were provided for use of either highlight or shadow readings of luminance. The image was inverted (a minor inconvenience) and could be focused for close distances. To combat flare effects

(a)

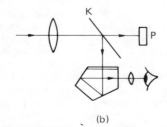

(b)

Figure 20.8 Spotmeters: (a) Visual; M spot mirror, W optical density wedge, S reference source; (b) photoelectric; P photocell, K aperture mirror or beamsplitter

which could otherwise seriously affect readings, a long lens hood could be used on the objective lens.

More recent designs use photoelectronic devices, and have an additional lens and prism erector system (or a pentaprism) to give an upright, unreversed image in the viewfinder. A flare-free arrangement typically uses an *aperture mirror* containing a small aperture in front of the photocell; this avoids the necessity for a beamsplitter which could otherwise affect the polarization of the emergent light. The majority of instruments are calibrated for a mid-grey tone, but shadow and highlight readings may be used as well as an averaging arrangement. A digital display gives comprehensive summaries of relevant exposures for various camera modes, scene luminance range and other data. Several separate readings may be stored, displayed on recall and averaged as required. Both ambient-light and flash-metering modes are available. Incident-light readings are not possible.

Certain SLR cameras with TTL metering systems offer the alternative of a true *spot mode* reading using a separate optical system for the photocell in the camera. The acceptance angle of the spot field varies with the focal length of the camera lens in use, but with long-focus lenses this can be very small. Full metering facilities are offered, together with a comprehensive data display in the viewfinder. A number of successive spot readings may be taken in the subject area, stored, averaged and the calculated exposure then given automatically by the camera in the appropriate exposure mode. This form of TTL metering should not be confused with small-area readings, where an acceptance angle of some 5–20° is used (5 to 10 per cent of the viewfinder area), and calibration is for a mid-tone.

In-camera metering systems

Automatic exposure

It is usually convenient to have a light-metering system built into a camera body and directly coupled to the camera controls either for manual control and setting or for use of one of several alternative *automatic exposure (AE)* modes. The necessary photocell(s) may be located in various positions, requiring different optical systems for each variant. Non-SLR cameras may have the metering system separately attached or located externally to read directly from the subject, with a choice of reflected- or incident-light measurements. A selenium photocell may be placed in the top plate of the camera or as an annulus round the lens, using lenticular baffles to determine the acceptance angle.

The more compact CdS or SPD cells can be located behind an aperture fitted with a small lens either on the camera body or near the camera lens. The latter is preferable, as such positioning makes it possible for the effects of lens attachments such as filters to be compensated for. Metering sensitivity is high as light losses are low compared with TTL metering. A frame line in the viewfinder may indicate the measurement area. Often a metal plate with a series of graded apertures, or a tapered slit, is located in front of the photocell and is linked to the film speed setting control, using a change in the incident light, rather than electronic circuitry to provide variation of the cell output.

The superiority and convenience of TTL measurements of subject luminance are well established. Only the imaged area is used, regardless of the lens in use, and compensation of exposure is usually automatic for bellows extension and optical attachments. Exceptions include infrared and linearly-polarizing filters.

Such compensation is particularly important when zoom lenses are being used, as the *f*-number may change with change in focal length. In such cases some means of constantly monitoring image luminance is essential.

The ideal location for the photocell would be in the true focal plane of the camera, as realized in some insertable metering systems for large-format cameras, but an equivalent focal plane may be used instead. Full details of photocell locations and optics are given in Chapter 9. Such TTL systems are normally limited to simple measurements of subject luminance, and the uncertainties of exposure determination with non-average scenes using a simple integrated measurement have led to the use of alternative sensitivity patterns for meters, also described in Chapter 9, to improve the proportion of acceptable exposures. The usual patterns are those of approximate integration with central bias, of centre-weighted measurement (possibly with directional bias) and of small-area measurement. More sophisticated systems may use true spot-metering of very small areas, or zone measurements by segmented photocells to provide scene categorization information. The sensitivity pattern is obtained by positioning the planar photocell behind spherical or aspherical lenses, or by illuminating them from patterned Fresnel mirrors. Pairs of photocells with overlapping fields of view may also be used.

A particularly accurate form of TTL metering is that of *off-the-film (OTF)* metering, in which image luminance measurements are made using the light reflected from patterned shutter blinds or from the film surface itself during exposure; off-the-film monitoring is possible even with rapidly-fluctuating light levels. For short exposure times, the patterned shutter blind simulates average image luminance over the obscured area of the film gate during travel of the slit.

In-camera metering is normally used in semi-

automatic or automatic mode. In the former, either shutter speed or aperture or both together are varied manually, until a readout indicates that correct exposure has been set. The camera can be used to scan and sample the scene in chosen areas, and a modified exposure given as judged necessary. Automatic exposure offers a choice of shutter priority, aperture priority and various program modes. Additionally, *metering pattern* may be altered, an *exposure compensation control* may be used or an *exposure memory lock* employed to improve the proportion of acceptable pictures from non-average scenes.

Metering sensitivity is dependent upon the effective maximum aperture of the lens in use. Measurement may have to be carried out in a *stopped-down mode* if a lens without automatic iris diaphragm operation or maximum-aperture indexing is used. Metering is of the reflected light from a subject as the incident-light mode is not available to TTL metering systems. Metering sensitivity with an *f*/1.4 lens and ISO100/21° film is generally of the order of 1 EV, significantly less than that of a hand-held meter.

Segmented photocell systems

The major barriers to accurate determination of camera exposure, especially by in-camera TTL AE systems, are variations in subject luminance ratio and non-typical subject tone distributions, necessitating their recognition and classification by the user. The provision of spot metering, small-area and various weighted integrated readings can help, with intelligent use. A significant improvement in acceptability of results and yield is possibly by use of a *segmented photocell* arrangement; the viewfinder image in a SLR camera is measured, assessed, compared to stored data on patterns and categorized for subject type. Adjustments are then made automatically to the basic camera exposure. The idea was introduced in 1983 in the Nikon FA camera; alternative systems soon followed. For example, the screen area may be measured as five or six separate zones (with some overlap) by means of two symmetrically-opposed segmented photodetector arrays with three independent measurement areas (Figure 20.9). Various alternatives are possible. The weighted response data from the separate segments is classified by signal-processing techniques, using analytical microcircuitry. Analysis of luminance difference values and the total subject luminance value, plus the metering pattern, allows classification into some 20 computer-simulated subject types. The basic exposure is then modified using correction data for such subject types as determined from practical tests or evaluation of photographs.

The *tone distribution* may be determined, often just as a comparison of central foreground to back-

Figure 20.9 Segmented photocell arrays

ground luminance, and if a chosen difference value in EV is exceeded, then an integral flash unit may be charged automatically and used for fill-in purposes. The lens aperture and shutter speed are optimized separately for subject distance (using autofocus data) and flash synchronization. Additionally, separate segments may be switched out or used in different configurations to provide various alternative forms of metering sensitivity patterns (small-area, centre-weighted).

Programmed exposure modes

An automatic camera with choice of exposure modes will include at least one *programmed exposure mode*; this is the 'snapshot' form of setting for such a camera. This was the original form of automatic exposure as pioneered in early cameras of the point-and-shoot variety with no alternative exposure modes other than one for flash that gave a fixed shutter speed and allowed the aperture to be set manually. More recently, multi-mode cameras may offer choice of user-selectable or calculated programs as well as one set by the lens in use.

The main advantage of a programmed AE mode is that photography is speeded up when rapid response to fugitive subject matter is vital. Seconds can be lost in the preselection of aperture or shutter speed or the taking of a meter reading, whereas the programmed-mode camera gives a usable result almost every time on pressing the release. Even the time taken to focus can be crucial, but the combination of autofocus with programmed AE gives a swift response. Programmed exposure is also convenient at times when the user wishes to be relaxed and not to have to concentrate on decisions about exposure, as well as being a safety-net for inexperienced photographers. The principles of programmed AE, often designated on a camera as the *'P' mode*, are

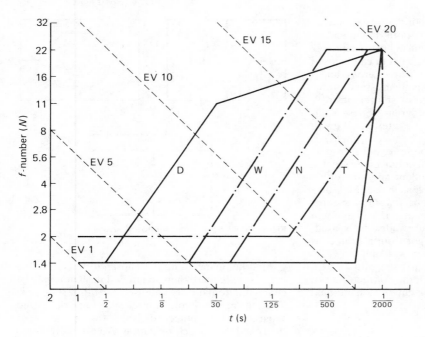

Figure 20.10 Programmed exposure modes. The EV graph shows five possible program profiles over an exposure range from EV 1 to 20. These are D (depth), W (wide), N (normal), T (telephoto) and A (action). Both D and A may be selected manually while W, N and T are usually set by the focal length of the lens in use

simple. As previously explained, the photocell output and the set film speed will determine the necessary exposure for a scene in terms of exposure value (EV), which represents a wide range of equivalent combinations of lens aperture and shutter speed. The electronic circuitry in the metering system is programmed to give one particular combination according to the EV data fed in. Examples of such programs are shown in Figure 20.10, in which a program is given as a straight line with a chosen slope and one or more changes in direction to span the EV measuring range of the camera.

A horizontal or vertical line shows that one variable is kept constant while the other changes continuously; for example, shutter speed may change continuously over the range 8 s to 1/8 s while the aperture is held constant at $f/1.4$. A sloping line shows that both variables change continuously. A steeply-sloping line shows that priority is given to the maintenance of short exposure durations, to minimize the risk of camera shake or to stop subject motion, while relying upon lens performance and accurate focusing at the corresponding large aperture. A required EV of (say) 12 for correct exposure is interpreted in various ways by programmed cameras. It could mean settings of 1/30 s at $f/11$ for one camera or 1/80 s at $f/7$, 1/125 s at $f/5.6$ or even 1/500 s at $f/2.8$ for other cameras. An electronically-controlled shutter and fractional control of lens aperture setting allows non-standard exposure settings. Note that a viewfinder readout of the analogue type usually indicates rounded-off values for

shutter speeds and apertures; for an analogue display the values of 1/80 s at $f/7$ in the example above may be shown rounded off to the nearest conventional values of 1/60 s and $f/8$ (the actual camera exposure will be the true value). A digital display will usually show the true values.

It was soon realized that, convenient as the programmed AE mode might be, some decision should be left to the user as to whether shutter or aperture priority might be appropriate under different circumstances, such as moving subject matter, depth-of-field requirements, low light levels or long-focus lenses. Consequently, the user may choose between 'normal', 'action' and 'depth' AE programs to satisfy the above. Additionally, the insertion of an alternative lens of different focal length may automatically select one of three shutter-biased program modes usually referred to as 'wide', 'standard' and 'tele', with the turning point of the program line on the EV graph at the point where the minimum hand-held shutter speed may be used. The slope of the program line may increase progressively from 'wide' to 'tele'. A zoom lens may alter the program selected continuously as focal length is altered. It may even be possible for the user to designate a non-standard program profile for the camera.

The use of any programmed AE mode requires that the lens aperture control is locked at a minimum value *AE setting* as for shutter-priority exposure mode; the aperture value is then selected by the camera in increments that may be as small as 0.1 EV. When used with a metering-pattern system

capable of some analysis of tonal distribution of the subject matter, for example centre-weighted or segmented-photocell types, then programmed exposure modes are capable of producing a high proportion of acceptably exposed, sharp results.

This form of decision-free photography may be less acceptable in situations requiring critical creative control of focus and subject sharpness.

Flash exposure metering

Electronic flash may be used as the main light source for a picture or in combination with ambient light to provide a means of reducing the subject luminance ratio. The properties of electronic flash, including production, spectral and temporal properties and the control of output, are detailed in Chapter 3; but it is useful here to emphasise its widespread and popular use as an illuminant either in the form of a studio flash unit, as a unit that can be attached to the camera, as a 'dedicated' unit with secondary roles such as autofocus assistance, or as an integral unit within the camera body. The useful properties of flash are a controllable luminous output, a constant colour temperature close to that of daylight, motion-stopping abilities, low heat emission and, in some cases, strobing capability. Its only drawback is the difficulty of synchronization with a focal plane shutter at high shutter speeds. The illumination on a subject is a combination of direct and indirect light, the reflective properties of the surroundings of a subject often having a pronounced effect on the illumination. In the absence of any flash modelling lights, it can be difficult to allow for such effects. Also, as the flash duration is short, any visual judgement as to illumination level and the necessary exposure is not possible, so some means of flash exposure determination is desirable. Various methods are used, but in general, flash exposure control is by use of lens aperture alone due to the necessity of synchronizing the flash output with the camera shutter.

Self-developing materials

The use of these materials has been described above (with the necessary cautionary remarks), but such a test exposure with flash also serves the role of giving a positive confirmation of flash synchronization, and of ensuring, at the very least, that the 'M' setting has not been used by mistake. Flash synchronization can be checked visually by opening the camera back, placing the eye about 30 cm behind the focal plane, opening the lens aperture fully and operating the camera shutter with the camera pointed at a white wall. A bright disc indicates correct functioning. If a star, or a segment of a disc – or nothing at all – is seen, the shutter is out of synchronization.

Modelling lights

Most studio flash units have modelling (guide) lights integral with the flash tube. These lights may indicate lighting distribution and balance and can be either turned off or left on when the flash operates. They may be tungsten or tungsten-halogen and the light output is altered in proportion to the flash output if this is variable. Modern studio flash units may offer a variety of power increments, some allowing increments as small as 0.1 EV.

A conventional exposure meter may be used in conjunction with these modelling lights to provide a measure of the related flash output. The technique is simple. Using an approved lighting arrangement, a bracketed series of test exposures is made using the flash illumination and then the correct *f*-number is determined by visual inspection of the results. The subject is then metered using an incident-light technique, and from the calculator dials, a shutter speed is found that corresponds to the *f*-number determined by tests for the same film speed setting. This shutter speed marking now acts as the flash calibration index; if the lighting arrangement or subject is changed, the meter will indicate the new *f*-number required for flash exposure opposite the shutter speed marking found.

Flash exposure guide numbers

The light output and the required camera exposure for a given flash unit can conveniently be expressed by an *exposure guide number* or *flash factor* (the derivation is explained in Chapter 3). For a film of speed ISO 100/21° and a subject distance *d* (in metres), the necessary *f*-number N is given from the guide number by the relationship

Guide number $= Nd$

This guide number is often included in the alpha-numeric code designation of a flash unit. For example, inclusion of the number 45 would usually indicate a basic guide number of 45 in metres for ISO 100/21° film material. The guide numbers *are* only guides, and practical tests are needed to establish their correctness, which depends to some extent on the effects of the surroundings, ambient light level and the shutter speed used. The guide number also changes with *fractional power output* selection as offered by many units, some of which are able to select full, half, one-quarter, one-eighth and one-sixteenth power, or, when a camera motor-drive setting is selected, giving reduced power and rapid recycling. Likewise an alteration in *flash covering*

power to suit different lenses will also affect the guide number.

To assist the determination of the necessary *f*-number for correct exposure given the variables concerned, most flashguns incorporate some form of calculator in the form of annular dials, or as a comprehensive LED or LCD display. Additional useful data shown are the *subject distance range* covered and especially the *maximum subject distance* possible for correct exposure at the indicated *f*-number. Guide numbers are devised on the assumption of a near-point source and are based on the Inverse Square Law. A doubling of flash output or doubling of film speed used increases the guide number by a factor of 1.4. A quadrupling of output or film speed doubles the guide number. Doubling the distance between the flash source and the subject distance needs a change of +2 EV in exposure (factor ×4).

While such calculations are reasonably simple for one flash source, it becomes increasingly difficult to do so for two or more sources, especially if they are at different distances and of differing powers. The positioning of flash-heads without the assistance of modelling lights is a task requiring experience and skill. But as a guide to simple twin-head flash, using one flash off-camera as the main (modelling) light and the other on-camera as fill-in light, the fill-in light should provide approximately one-quarter to one-half the output of the main light.

The guide number system has largely been replaced in automatic flash units by the use of *variable flash duration* as a means of controlling exposure, but it is still applicable in situations such as the use of *ring flash* units or in lenses where a guide number may be set and linked to the focusing control to give a readout of the *f*-number necessary for a given subject distance. Similarly it is used in autofocus cameras where the flash output is fixed, and the appropriate *f*-number set by the distance setting from the autofocus system.

The use of guide numbers with fractional flash output settings of 1/2, 1/4 etc of full power is useful with *synchro-sunlight* techniques where the flash output is selected given the camera settings for the ambient-light exposure. For example, let us suppose that a particular subject, at a distance of 4 metres from the camera, and in bright direct sunlight, requires 1/125 s at *f*/11 with ISO 100/21° film, and that the fill-in flash on the camera has guide numbers of 44, 22 and 11 (in metres for ISO 100/21°) for full, one-quarter and one-sixteenth power respectively. Using the flash at full power for a flash-only exposure would also need *f*/11. Hence at quarter power, leaving the aperture at *f*/11 provides one-quarter of the exposure; but this is just about correct to provide the necessary fill-in for the ambient-light exposure. The use of a between-lens shutter with flash synchronisation at every setting allows greater flexibility in the choice of *f*-number to suit the power and distance of the flash fill-in unit.

Automatic electronic flash

The introduction of automatic exposure by electronic flash, using a fast-reacting phototransistor or SPD photocell to operate a thyristor switch to quench the flash discharge, was a great convenience. Full details are given in Chapter 3. The photocell monitors the subject luminance and assumes a scene of average tonal distribution. The usual exposure errors are possible due to non-typical subject matter or measurement of luminance. For example, a small close subject with a large distant background will tend to be heavily over-exposed as the flash output endeavours to light the background to a suitable level. The photocell usually has a modest acceptance angle of some 30° or less, to overcome such problems by reading from the centre of the subject area only, though some means of aiming is helpful. Since only reflected-light readings are possible, the photocell must be maintained in a 'look-ahead' position directed at the subject. *Bounce flash* requires a tilting flash reflector assembly; alternatively the photocell is equipped with a flying lead to enable it to be used in the hot shoe of the camera. Parallax errors arise for close-up work, where the photocell may not be pointing directly at the subject area. In such cases a fibre-optics light guide is useful, to conduct light from the subject to the photocell.

An automatic flash unit usually has a calculator device which offers a choice of one, two or more alternative apertures or a continuous variation. At the chosen aperture, the variable flash output then gives a range of subject distances over which correct exposure is possible. The user may choose a large aperture to extend the range of subject distance or a small aperture in order to give maximum depth of field. With nearby subjects, a large aperture also gives a minimum flash recycling time and more flashes per set of batteries. Manual allowance has to be made for filter factors and image magnification in close-up work. As well as a far limit, there is a near limit to subject distance; below this over-exposure results, as the flash cannot be quenched quickly enough. Automatic flash can be used successfully for synchro-sunlight by the subterfuge of setting a film speed some four times greater than that in use, or an aperture two stops more than actually set on the camera. Multiple-flash set-ups, each using thyristor control, are less easy to control for correct exposure.

Off-the-film (OTF) flash measurement

Many of the limitations of automatic flashguns are removed if *in-camera flash metering* is available.

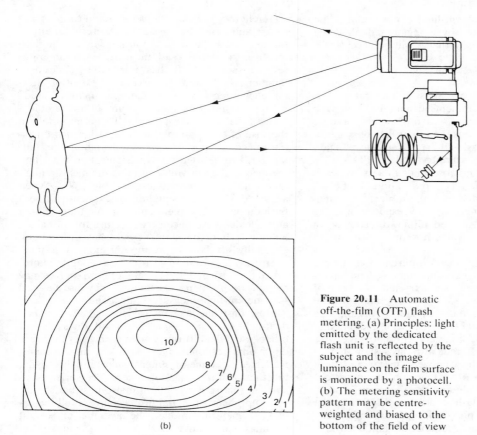

(b)

Figure 20.11 Automatic off-the-film (OTF) flash metering. (a) Principles: light emitted by the dedicated flash unit is reflected by the subject and the image luminance on the film surface is monitored by a photocell. (b) The metering sensitivity pattern may be centre-weighted and biased to the bottom of the field of view

This operates by means of off-the-film (OTF) measurement of image luminance. The monitoring photocell operates the quench circuit of a dedicated flashgun. A special lead is required for off-camera flash. Variables such as lens aperture, filters, magnification and lens transmittance are all allowed for, and indication is given if the controlled flash duration has given over or under-exposure, to allow manual correction for a repeat photograph. A simple table or indicator on the flashgun shows the useful subject distance range with the chosen aperture and film speed. Again, a reflected-light measurement is made of the actual image on the film surface when the film gate is uncovered by the shutter. The metering pattern is usually of weighted form and asymmetrical due to the position of the photocell optics in the base or side of the camera dark chamber (see Figure 20.11). The difference in reflectance of different emulsions do not seem to be significant, with the exception of Polachrome self-developing material which is exposed through its base and adjacent filter mosaic and thus presents a

dark surface to the meter.

OTF systems in general give a high proportion of correct exposures, and are especially useful for photomacrography and the use of ring flash where the subject is close to the lens, making conventional forms of exposure measurement difficult. Synchro-sunlight operation, however, is not possible with OTF systems.

Large-format cameras may also employ a photocell mounted in the rear of the lens panel to measure the illuminance on the film surface during the flash exposure. An alternative related system is to position a probe in the film plane, then to fire a test flash at the subject; a readout of correctness of exposure at a chosen aperture will be given.

A *programmed automatic flash mode* is offered in some cameras. In this system the shutter speed is fixed at the usual synchronization setting, and the camera sets the lens aperture to an appropriate value, which may be obtained from focused distance data. A pre-flash may be used to obtain the required data. Another possibility is that of automatic fill-in

flash mixed with ambient-light exposure, if scene contrast measurements by a segmented photocell metering system indicate that it will be necessary.

Flash meter

The normal designs of exposure meter used for ambient light measurements cannot be used with flash exposures owing to their slow response to changing light conditions, and their lack of synchronization with the flashgun. A *flash meter* (Figure 20.12) uses different circuitry and a SPD with a response time of 10 microseconds or less, so as to measure both the intensity and duration of the flash output as light reflected from the subject. An integrating circuit measures the total response, and the output is usually displayed either directly as an *f*-number or as a light value for conversion into an *f*-number.

There are other significant differences compared with a conventional exposure meter. The meter circuitry is cleared, reset and activated on receipt of the flash output and so requires some form of synchronization with the flash unit. This may be done by a conventional flash lead from the unit and a PC socket in the flash meter. Alternatively, cordless control may be offered; with this system there is no electrical connection between meter and flash unit. Instead, a control switches on the meter circuitry to stand-by mode and the flash unit is operated using the 'test flash' control, or fired from the camera shutter. The photocell then responds to the momentary change in illumination and measures flash output. Another cordless alternative is for the flash meter to emit a pulse of infra-red radiation when triggered manually; this operates suitable

slave photocells on each flash unit and causes them to fire and hence be measured. A useful feature is that of 'accumulative flash'; in this feature the flash meter is activated, and measures and integrates several successive flashes until the required *f*-number is indicated. No account is taken of intermittency effects in the photographic material used.

Most flashmeters take account of the ambient light as well as the flash output. This is important in the case of (for example) a slow flash synchronization speed and powerful modelling lights. The shutter speed to be used for synchronization is set into the meter, and this will determine the measurement time gate of operation, for example 1/60 s. When activated, the meter simultaneously measures both flash output and ambient light for this 1/60 s chosen and calculates the necessary aperture for the mixed lighting. Often the ambient light has little effect, especially at short exposure durations and small apertures. It may be measured by a separate photocell in the flash meter. The ratio of both sources may be indicated. Often a flash meter may also be used for ambient-light measurements alone.

Most flash meters are used principally for incident-light readings using a domed diffuser, but others use a flat diffuser, and in such cases the more directional response must be taken into account. Reflected-light measurements may also be made, together with the range of system accessories available, so that spot readings are also possible.

Comprehensive digital displays give a full indication of metering mode, the average of several readings, cumulative flash exposure and so on. Metering sensitivity is again usually assessed in terms of the minimum EV indicated for ISO 100/21° material. A sensitivity of 1 EV is typical.

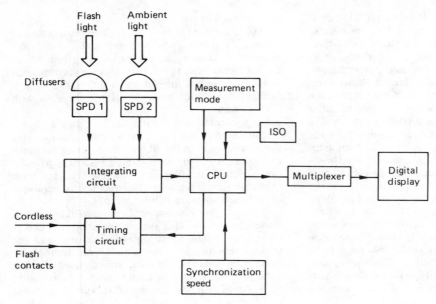

Figure 20.12 Flash meter. Schematic diagram of the usual components of a flash meter for shutter-synchronized or cordless use. Twin photocells measure both ambient light and flash light.

21 Photographic papers

We have confined our attention in this book so far largely to the preparation of negatives. The negative, although important, represents only the first stage in the preparation of a photograph. We now have to deal with the second stage, namely the preparation of the positive from the negative. In this chapter we shall consider the papers used for printing, and in the following chapter the printing operation itself.

Types of printing paper

As far as the method of image production is concerned, printing papers behave in exactly the same way as negative materials, using a similar light-sensitive material, i.e. a suspension of silver halides in gelatin. It is coated on paper base which must be entirely free from substances that would have a harmful effect on the emulsion.

Many different types of printing paper are made. They may be classified into two overall types: monochrome papers and colour papers. Within each of these types there exist many different papers for various purposes, but in this chapter we will restrict our discussion to those that are used in photographic printing. For convenience we may classify the characteristics of monochrome papers under the following headings:

(1) Type of silver halide emulsion
(2) Contrast of the emulsion
(3) Nature of the paper surface
(4) Nature of the paper base

Colour print materials may be classified under the following headings, although items (3) and (4) above are also relevant to colour papers:

(1) Papers for printing from colour negatives
(2) Reversal papers for printing from colour positives or transparencies
(3) Dye-bleach print materials also for printing from colour transparencies.
(4) Dye-diffusion materials for printing from colour negatives or transparencies.

Type of silver halide emulsion

Monochrome papers can be divided into three main classes in terms of the type of silver halide employed in the sensitive layer. These are *chloride papers, bromide papers* and *chlorobromide papers*, the sensitive material in the latter being a mixture of silver chloride and silver bromide in which the individual crystals comprise silver, bromide and chloride ions. Bromide and chlorobromide emulsions may also contain a small percentage of silver iodide. Most emulsions for papers contain varying ratios of silver chloride to silver bromide, from 1:3 to 3:1. Chloride papers intended for contact printing are now rarely used. The nature of the silver halide employed in a paper emulsion largely determines its speed, rate of development, image colour and tone reproduction qualities.

Speed and development rate

Papers differ widely in their speed, chloride papers being the slowest and bromide the fastest with chlorobromide papers in between. Similarly, silver chloride, although less sensitive than silver bromide, develops faster. Generally speaking chlorobromide papers are of greater speed and softer in contrast as their bromide content increases. The fastest of them are in the same speed range as bromide papers.

Spectral sensitivity

As the bromide content increases the spectral sensitivity extends to longer wavelengths. Whereas monochrome negative materials are spectrally sensitized to enable the reproduction of colours to be controlled, printing papers that are employed only to print from monochrome negatives have no need of spectral sensitization other than as a means of increasing their sensitivity to tungsten light or as means of obtaining differing spectral sensitivities for multigrade papers (see Figure 21.1). However some monochrome papers are spectrally sensitized so that they can be used for producing black-and-white prints with correct tones from colour negatives. Such papers are therefore sensitive to light of all wavelengths and require handling in total darkness or by a dark amber safelight.

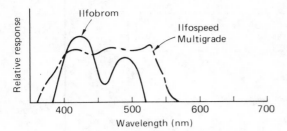

Figure 21.1 Spectral sensitivities of Ilfobrom and Ilfospeed Multigrade papers exposed to tungsten light (2850 K)

Image colour

The colour of the image on a photographic paper (untoned) depends primarily on the state of division of the developed image, i.e. on its grain size, although it is also affected by the tint of the base. The grain size of the image depends in turn on the nature and size of the silver halide crystals in the original emulsion, or any special additions which may be made to the emulsion and on development.

The size of silver halide crystals in paper emulsions is very small, so that no question of visible graininess due to the paper ever arises, even with the fastest papers. In fact, with many paper emulsions, the individual grains of silver in the developed image are so small that their size is comparable with the wavelength of light; the image then appears no longer black but coloured. As grains become progressively smaller, the image, which with large grains is black, becomes first brown, then reddish and then yellow, finally becoming practically colourless. When a paper is developed, the grains are small at first but grow as development proceeds; it is, therefore, only on full development that the image gets its full colour. The finer the original crystals of the emulsion, the greater the possibility of controlling the image colour, both in manufacture and by control during development.

Bromide papers yield relatively coarse grains and, when developed normally, yield images of a neutral-black image colour. Contact (chloride) emulsions are of finer grain. Some papers are designed to yield blue-black images by direct development, others to yield warm-black images by direct development, the colour depending on the treatment the emulsion has received in manufacture. For example some paper emulsions contain toning agents that change the image colour on development, probably by modifying the structure of the developed silver image so that it appears bluer in colour. Chlorobromide emulsions are intermediate in grain size between chloride and bromide papers. Some chlorobromide papers are designed to give only a single warm-black image colour; others can be made to yield a range of tones from warm-black and warm-brown to sepia.

Tone reproduction qualities

Most monochrome printing papers are available in a range of *contrast grades*, or *gradations*, to suit negatives of different density ranges. We saw the need for this in Chapter 15. With any given negative, therefore, it is usually possible to make a good print on any type of paper, provided that the appropriate contrast grade is chosen. There will, however, be certain differences in tone reproduction between prints on different types of paper. The differences arise because the characteristic curves of different papers vary somewhat in shape (see page 184).

Although the type and ratios of silver halides present in the emulsions of photographic papers are of considerable importance, the amount of silver per unit area (*coating weight*) and the ratio of silver to gelatin also have important effects on their properties. Emulsions for papers have a much lower silver-to-gelatin ratio than negative emulsions because of the surface characteristics required in prints.

Besides their resin-coated papers, most manufacturers offer high-quality papers of the traditional type, i.e. fibre-based papers of high coating weight. These are designed for fine-art or exhibition work, where extremely high image quality and archival permanence are required. Because of their high coating weight they are capable of achieving high densities (about 2.2) and give rich blacks and excellent tonal gradation. Examples of this type of paper include *Ilfobrom Galerie*, *Kodak Elite* and *Agfa Brovira*, which are double-weight papers of exhibition quality.

Paper contrast grades

The contrast of a paper print, unlike that of a negative, can be varied only within narrow limits by altering development (see page 183). To print satisfactorily from negatives of different density ranges, papers are required in a range of contrast grades.

At one time, printing papers were manufactured in one contrast grade only, and it was standard practice to control the contrast of each negative by individual development, in order to produce a satisfactory print on the paper available. The introduction of the roll film, however, made this method of working impossible, and it was probably this as much as anything that necessitated the manufacture of papers in several contrast grades. Most papers are therefore made today in several grades. Glossy-surfaced papers, the most widely used variety, are usually made in five or six grades, although some other surfaces are available only in two or three grades.

The selection of a suitable grade of paper for a

given negative is a matter for personal judgement based on experience, or for practical trial. If a trial is considered necessary, it is important that development should be standardized at the recommended time and temperature. If the correct grade of paper has been selected, and exposure adjusted so that the middle tones of the picture have the required density, then the lightest highlights in the picture will be almost white (though with just a trace of detail) and the deepest shadows black. If the highlights show appreciable greying, and the shadows are nowhere black, the paper selected is of too soft a contrast grade for the negative; a harder paper should be tried. If the highlights are completely white with no detail at all, and not only the shadows but the darker middle tones are black, the paper selected is of too hard a contrast grade for the negative; a softer paper should be tried.

Variable-contrast papers

In addition to the conventional printing papers so far described, special types of paper are manufactured (e.g. *Ilfospeed Multigrade, Kodak Polycontrast*) in which the effective contrast can be changed by varying the colour of the printing light. With these *variable-contrast papers* it is possible to produce good prints from negatives of any degree of contrast on one paper which thus does the work of the entire range of grades in which other printing papers are supplied, and makes it unnecessary to keep stocks in a variety of grades.

A variable-contrast paper such as *Ilfospeed Multigrade* depends upon the use of two emulsions with differing spectral sensitivities (Figure 21.1) and contrasts, mixed together in the coated layer. One emulsion is blue-sensitive and high in contrast and the other is green-sensitive and low in contrast. Thus exposing the paper to blue light will give a high-contrast image (equivalent to a grade 5 in conventional papers) and exposing it to green light a low-contrast image (equivalent to grade 0). Varying the proportions of blue and green light in the enlarger will give intermediate grades. The colour of the exposing light is controlled by the use of specially-calibrated filters, by the use of a colour enlarger (see Chapter 22), or by the use of a purpose-made enlarger head with an appropriately-filtered light source.

In addition to the advantage of needing only one box of paper rather than 6 boxes for 6 grades of paper, it is also possible to obtain intermediate grades of paper with the Ilfospeed system; eleven filters are provided for Ilfospeed Multigrade II, allowing half grades between 0 and 5. Grades 0 to 3½ are all of approximately the same speed whilst grades 4 to 5 are half the speed of the others (see

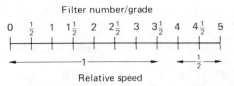

Figure 21.2 Contrast grades and relative speeds for Ilfospeed Multigrade II

Figure 21.2). The same image colour is obtained throughout the range of contrast grades.

Paper surface

The surface finish of a paper depends on two factors, namely the texture, or mechanical finish of the paper, and its sheen. The texture of a paper depends on the treatment that the paper base receives in manufacture. Glossy papers, for example, are calendered, to produce a very smooth surface, while grained papers are usually embossed by an embossing roller. Rough papers receive their finish from the felt on the paper-making machine. Surface texture governs the amount of detail in the print. Where maximum detail is required, a smooth surface is desirable, whereas a rough surface may be employed to hide graininess or slight lack of definition. A smooth surface is also desirable for prints that are required for reproduction and have to be copied using a camera. Various textures are available for special effects.

Surface finish arises largely from the supercoating, the thin layer of gelatin that is applied over the emulsion of many papers in manufacture, to provide protection against abrasion (page 151). This layer gives added brilliance to the print, by increasing the direct (specular) reflecting power of the paper surface. Glossy papers are smooth with a high sheen; a higher maximum black is obtainable on glossy papers than on others. Matt papers are smooth but have no sheen; starch or powdered silica is included in the emulsion to subdue direct reflection. At one time a large variety of surfaces was available, but rationalization in the photographic industry has greatly reduced the number. Papers with a fine irregular patterned surface are called variously 'lustre', 'stipple', etc, and those with a regular pattern are called 'silk' or a similar name. There are also semi-matt surfaces which are smooth but not glossy.

Nature of the paper base

The colour, or tint, of the base paper used for photographic papers may be white or one of a

variety of shades of cream or blue. In general, cream papers tend to give an impression of warmth and friendliness; they are very suitable for prints of warm image colour. A white base may be used to simulate coldness and delicacy. Many white-base papers contain optical whiteners which fluoresce when irradiated with blue or UV, thus increasing their apparent whiteness.

Special-purpose papers are also available on heavily-tinted bases such as gold, bronze, metallic blue, etc. Because of the low reflectance of the base, such materials can produce only a limited range of tones.

Two thicknesses of base are commonly available, designated single-weight $(100-150 \text{ g/m}^2)$ and double-weight $(200-250 \text{ g/m}^2)$ respectively. Both double-weight and single-weight papers are used for enlargements; single-weight is often sufficient if the print is to be mounted, but in the larger sizes double-weight paper is to be preferred because with thinner papers there is a danger of creasing in a wet state.

Resin-coated papers

Many printing papers consist of a paper base coated or laminated on both sides with an impervious layer of a synthetic organic polymer such as polyethylene (polythene). Such papers are termed RC (resin-coated) or PE (polyethylene) papers. Although more expensive than their baryta-coated-paper equivalents they offer a number of advantages for the user. Because the base on which the emulsion is coated is impervious to water and most processing chemicals, washing and drying times are considerably shorter than with conventional papers. For example, washing times are reduced from 30–45 minutes to about 2 minutes, which saves not only time but also water. RC papers cannot be heat-glazed, but the glossy-surface variety dries to a gloss finish, and the papers lend themselves very readily to rapid machine processing. They also dry almost completely flat. Processing can be considerably quicker than with baryta-coated papers if the chemistry devised specifically for RC papers is used. However they also have their limitations: processing a number of sheets at one time in a processing dish may lead to damage of the emulsion surface by the sharp edges; different retouching techniques and materials are required; and some papers 'frill' or de-laminate at the edges, especially if dried too rapidly. Dry mounting of RC type papers generally requires the use of special low-melting-point mountants.

RC papers are available in a limited number of surfaces. These include glossy, 'silk' and 'pearl'. Only one weight of RC paper, intermediate between single-weight and double-weight, is currently available.

Colour papers

Colour papers are provided for both negative-positive and positive-positive printing (see Chapter 22). All colour-print papers are polythene-coated and, unlike monochrome papers, are available only in one or at most two contrast grades. Some materials, such as *Cibachrome* silver-dye-bleach materials, may be coated on a white pigmented plastic film base which has a similar appearance to paper.

Because colour negatives are developed under standardized conditions for fixed times, temperature and agitation, their inherent contrast is always the same, so that one reason for needing different contrast grades of paper is removed. Also, colour negatives are unaffected by the illumination conditions in the enlarger because they have a Callier coefficient close to unity (see page 172) which also reduces the requirement for more than one contrast grade of paper.

However, for negative-positive colour printing two contrast grades are provided by some manufacturers. The higher contrast grade gives increased colour saturation with some sacrifice in latitude; the lower contrast grade is more appropriate for negatives of high-contrast subject matter.

All colour papers, whatever their chemical principles of image formation, depend on the subtractive principle of colour reproduction (see Chapter 14), and have individual emulsion layers that are sensitive respectively to red, green and blue light. Chromogenic materials comprise layers containing cyan, magenta and yellow colour couplers which form dyes after colour development. Silver-dye-bleach (*Cibachrome*) materials contain cyan, magenta and yellow dyes that are bleached in correspondence with the image (see page 325). Dye-diffusion materials (*Kodak Ektaflex, Agfachrome-Speed* contain stored dyes which upon activation diffuse, in correspondence with the image, into a receiving layer (see Chapter 24).

Chromogenic papers are provided for both negative-positive and positive-positive printing, the latter via a reversal process, as shown in Table 21.1. The *Kodak Ektaflex* system can be used for making prints from either colour negatives or positive transparencies, but *Cibachrome* and *Agfachrome-Speed* can be used only for positive-positive printing.

In the case of the most widely-used chromogenic systems for printing from colour negatives there has been standardization amongst the manufacturers, who all provide compatible materials and processing solutions. There are also may independent suppliers of processing chemicals. All chromogenic negative-positive papers are processed by the *Kodak Ektaprint-2* process (or equivalent system of other manufacturer, e.g. *Agfacolor Process 92, Fujicolor Process CP-21*).

The characteristics of colour print materials and

Table 21.1 Summary of processing sequences for colour print materials

Chromogenic negative-positive (Ektaprint-2)		Chromogenic positive-positive (Ektachrome R-3)		Silver-dye-bleach positive-positive (Cibachrome P-30)		Dye-diffusion positive-positive (Agfachrome-Speed)	
1	Colour develop	1	B&W develop	1	B&W develop	1	Activate (develop)
2	Bleach-fix	2	Wash	2	Rinse	2	Wash
3	Wash	3	Colour develop	3	Bleach (dye and silver)		
		4	Wash	4	Fix		
		5	Bleach-fix	5	Wash		
		6	Wash				

the chemical principles on which they are based are described in detail in Chapter 24. Table 21.1 summarizes the basic processing sequences for various types of colour papers.

Development of papers *(see also Chapter 17)*

The developers used today for monochrome papers of all types are commonly MQ or PQ formulae. Formulae for typical monochrome paper developers are given in the Appendix (page 370). We saw earlier that the colour of the image is influenced by development. The three components of the developer that have the most important influence on image colour are the developing agent, bromide restrainer and organic antifoggant. For example developing agents such as glycin or chlorohydroquinone (chlorquinol) give a warm image tone in the absence of organic antifoggants but are little used now in print developers. Organic antifoggants such as benzotriazole tend to give a cold or bluish image. Thus PQ developers will give a bluish image because they usually contain an organic antifoggant. As the bromide content is increased the image becomes warmer in tone. Thus MQ developers tend to give warmer images than PQ developers. Chromogenic colour development depends upon colour couplers in the paper reacting with oxidized developing agent to form the image dyes (see page 220), whereas silver dye-bleach materials involve the bleaching of dyes already present, and dye-diffusion materials involve the diffusion of dyes to a receptor layer (see Chapter 24).

Development time and temperature

The timing of the development of monochrome papers usually done on the basis of a combination of time-temperature and inspection methods. Initially, the exposure time is adjusted so that a correctly-exposed print is obtained in the development time recommended by the paper manufacturer at the recommended temperature (normally 20°C). This means that any trial exposures must be developed strictly by the time-temperature method. We saw, however, in Chapter 15 that there is a range of development times within which a paper will yield good prints, provided that the exposure time is adjusted accordingly. The development time recommended by the manufacturer lies within this range. A print that has been given slightly more exposure than normal may usually be removed from the developer after a little less than the recommended time without loss of quality. Similarly, a slightly under-exposed print can usually be brought to the required density by a little longer development than recommended. This latitude between exposure time and development time, permitting slight errors in exposure to be compensated in development on the basis of inspection of the print, is of great practical value. It must not, however, be pushed to extremes, i.e. the latitude of the paper must not be exceeded. Excessively short development times are to be avoided because dense blacks are not achieved, image colour is often poor, and the degree of development may not be uniform across the print. At the other extreme, excessively long development is accompanied by a risk of fog and staining.

The degree of latitude varies to some extent with the type and contrast grade of the emulsion. With bromide papers the development latitude is limited by the fact that contrast varies by a small amount with the degree of development. Development latitude is greater for soft than for hard papers, and is very little for ultrahard grades.

Resin-coated (PE or RC) papers generally have shorter process times than their fibre-based equiva-

Table 21.2 Process times for monochrome papers (dish processed at 20°C)

Process		Fibre-based (baryta-coated)	Resin-coated (PE or RC)
1	Development	90–120 s	60 s
2	Stop bath	5–10 s	5–10 s
3	Fixation	3–5 min	30 s
4	Wash	30–60 min	2 min

lents, and lend themselves to machine processing where speed of access and throughput warrant the expense of a processing machine. Table 21.2 summarizes the approximate processing times for fibrebased and resin-coated papers.

For colour print development the processing conditions are fixed, and departures from the recommended times and temperatures are likely to lead to inferior results. Most colour print materials require the temperature to be kept within ±0.3°C whilst the Cibachrome silver dye-bleach process is more tolerant and allows variation of ±1½°C.

Development technique

For dish processing, the exposed print should be immersed in the developer by sliding it face upwards under the solution. Development of papers is a straightforward operation, but prints must be kept on the move and properly covered with solution. The busy printer will find it convenient to develop prints in pairs, back to back, feeding them into the solution at regular intervals, keeping the pairs in sequence and removing them in order when fully developed. Several prints may be developed at one time in the same dish provided there is sufficient depth of developer and that the prints are interleaved throughout. The action of interleaving the prints, i.e. withdrawing pairs sequentially from the bottom of the pile and placing them on the top, will help to dislodge any air-bells which may have formed on the prints.

When making enlargements of very large size, the provision of large dishes or trays sets a problem. Where very big enlargements are made only occasionally, the dishes need be only a few inches larger than the narrow side of the enlargement, because development can be carried out by rolling and unrolling the paper in the processing baths, or by drawing it up and down through the solution. In exceptional cases, development can be carried out by placing the enlargement face up on a flat surface and rapidly applying the developer all over the print with a large sponge or swab. Previous wetting with water will assist in obtaining rapid and even coverage of the print by developer. Fixing can be done in the same way. Alternatively, makeshift dishes can be made from large pieces of cardboard by turning up the edges, clipping the corners (which should overlap), and lining them with polythene sheet.

For processing prints, especially colour prints, many small-scale tanks and machines are available and are becoming increasingly popular. These may be operated in the light once they have been loaded with the paper in the darkroom. They range from the simple and relatively inexpensive *tube* or *drum processors* to the more costly and somewhat larger

Figure 21.3 Drum processors: (a) Durst Codrum; (b) Simmcolour (Besseler); (c) Cibachrome (US); (d) Kodak Printank; (e) Paterson Color Print Processor; (f) Jobo processor with automatic agitation and constant-temperature bath

roller processors (see Figures 21.3 and 21.4). These are all small-scale processing devices used by both amateurs and professionals. Larger-scale machines are described in Chapter 17.

The simple drum processor is the print analogy of the daylight film developing tank, and is available in a number of sizes ranging from one suitable for processing a single sheet of paper 20.3 × 25.4 cm (8 × 10 inches) to one large enough to process a single sheet of paper 40.6 × 50.8 cm (16 × 20 inches). An appropriate number of smaller sheets can also be accommodated in this larger drum. The exposed paper is loaded into the tank in total darkness with its emulsion surface facing inwards and its other side in contact with the inner surface of the drum. All subsequent processing operations are then carried out in the light. Temperature control is achieved by two main methods: either by rotating the drum in a bowl of water at the appropriate temperature, or by a pre-rinsing technique in which water is poured into the drum at a temperature above that of the surroundings and the final processing temperature.

(a)

(b)

Figure 21.4 Examples of table-top processors: (a) *Agfaprint CR37*, showing replenisher reservoirs on the left and the dryer unit at the back; (b) *Durst RCP 50*, with the dryer unit attached on the right

Details of the required temperature of this pre-rinse are provided by the drum manufacturers in the form of a nomogram or calculator. These simple processing drums use very small quantities of solutions for processing each print but suffer from the disadvantage that they have to be washed thoroughly after each use to prevent contamination. Washing of prints is carried out outside the drum.

An alternative approach to the simplification of print processing is by using a table-top self-threading roller transport processor. This finds application in the processing of both monochrome resin-coated papers and colour-print materials. Machines of varying degrees of sophistication are available. The more advanced versions are microcomputer-controlled, with built-in sensors and automatic replenishment systems, solution recirculation and agitation by pumps, together with variable speed, adaptable to the processing of monochrome or various types of colour papers. The majority of machines require separate washing and drying of the prints, but they may be provided with additional modules so that dry-to-dry processing can be carried out. Two examples of table-top processors are given in Figure 21.4. Machines of this type are capable of processing up to approximately 60 colour or 300 black-and-white 8 × 10 inch prints per hour, and no plumbing in is required.

Fixation

Monochrome prints

Prints are fixed in much the same way as negatives. Acid fixing baths are invariably used; formulae are given in the Appendix. The thiosulphate concentration of print fixing baths does not as a rule exceed 20 per cent, compared with a concentration of up to 40 per cent for films and plates. A fixing time of about 5 minutes is quite adequate, and only around 30 seconds is needed for resin-coated papers. To avoid the risk of staining, prints should be moved about in the fixing bath, especially for the first few seconds after immersion. Prolonged immersion of prints in the fixing bath beyond the recommended time should be avoided. It may result in loss of detail, espcially in the highlights, because the fixer eventually attacks the image itself. The action is most marked with chloride and chlorobromide papers.

The print is the consummation of all the efforts of the photographer; thus everything should be done to ensure its permanence, and proper fixation is essential. Improper fixation may lead not only to tarnishing and fading of prints, but also to impure whites on sulphide toning. For the most effective fixation of papers, it is probably better practice to use a single fairly fresh bath, than to use two fixing baths in succession. With the latter method, the first

bath contains a relatively high silver concentration. Silver salts are taken up by the paper base in this bath, and tend to be retained in the paper even after passing through the second, relatively fresh, bath. This, of course, does not apply to RC papers.

Where processing temperatures are unavoidably high, as in tropical countries, a hardening-fixing bath should be employed. For the hardening of papers, potassium alum is mandatory, as chrome alum produces green stains. Several proprietary liquid hardeners are available for addition to paper fixing baths. Use of a hardener is often an advantage even in temperature climates if prints are to be hot glazed or dried by heat.

Never use a fixing bath for papers if it has previously been used for fixing negatives. The iodide in the solution may produce a stain.

Bleach-fixing

For colour-print processing the removal of the unwanted silver image and unexposed silver halides is usually carried out in a single bleach-fix solution. We saw earlier (page 246) that such solutions contain an oxidizing agent that converts metallic silver to silver ions, together with a complexing agent (thiosulphate) that forms soluble silver complexes with the oxidized silver and with any unexposed silver halide remaining in the emulsion.

Bleach-fixing is carried out for the recommended time at the recommended temperature, and in small-scale processing is discarded when the specified number of prints has been passed through the solution or when its storage life has been exceeded. In larger scale processing it is normal practice to recover silver from the solution and reuse the bleach-fix after aeration and replenishment. The electrolytic method of silver recovery or the metallic displacement method may be used (see page 244). In the case of the latter method the presence of iron salts in the solution after silver recovery does not have the disadvantage it has when this method is used to recover silver from fixer solutions, because the oxidizing agent is ferric EDTA, which can be formed by the addition of EDTA (ethylene diamine-tetra-acetic acid) to the de-silvered solution. Thus the recovery and replenishment operation forms extra oxidizing agent. It is important to bleach-fix the print material for the specified time and temperature because incomplete removal of silver and silver halide results in a degraded print, especially noticeable in the highlight areas. Bleach-fixing is a less critical stage than development and a larger amount of temperature variation is permitted (usually ±1°C).

Washing

The purpose of washing prints is to remove all the soluble salts (fixer, complex silver salts) carried on and in the print from the fixing bath. Where only a few prints are being made they may be washed satisfactorily by placing them one by one in a large dish of clean water, letting them soak there for five minutes, removing them singly to a second dish of clean water, and repeating this process six or eight times in all. A method that is equally efficient and much less laborious, though requiring a larger consumption of water, consists of the use of three trays, arranged as in Figure 21.3, through which water flows from the tap. Prints are placed to wash in the bottom tray of this so-called *cascade washer*. When others are ready for washing, the first prints are transferred to the middle tray and their place taken by the new ones. When a further batch is ready, the first prints are put in the upper tray and the second batch in the middle one, leaving the bottom tray for the latest comers. In this way, prints are transferred from tray to tray against the stream of water, receiving cleaner water as they proceed. For washing large quantities of prints, this type of washer is made with fine jets for the delivery of water to each tray. These afford a more active circulation of water and dispense with the occasional attention required with the simpler pattern.

Figure 21.5 'Cascade' print washer

Other efficient arrangements for washing prints are shown in Figure 21.6. One method consists of a sink fitted with an adjustable overflow; water is led in by a pipe which is turned at right angles to the sink and terminates in a fine jet nozzle. The effect of this is to give a circular and also a lifting motion to the water and the prints which overcomes the tendency of the prints to bunch together. The overflow is a double pipe which is perforated at the base. This extracts the contaminated water (which has a higher density than fresh water) from the bottom of the sink and prevents it from accumulating. If the top of the outer pipe is closed off, the overflow becomes a siphon which periodically empties the water away, down to the level of the perforations.

It is possible to buy siphons that convert processing dishes into washing tanks (Figure 21.6b). As the

Figure 21.6 Examples of print washing devices: (a) Simple sink syphon; (b) syphon attached to a processing dish; (c) 'toast-rack' print washer

(1) Efficient removal of fixer from the print surface by the use of squeegees or air-knives.
(2) Control of the temperature of the water.
(3) Uniform time of immersion in the processing solutions.
(4) Control of exhaustion of the fixer by replenishment and possibly by silver recovery.
(5) Efficient separation of the prints, allowing free access of the wash water.
(6) Reduction of carry-over of chemicals from one solution to another by the use of squeegees between the solutions.

All the above features of automatic print processors result in a shorter wash time than is required in manual or batch processing in order to yield prints of comparable permanence. However some of these features can be incorporated in manual processing. For example tempered wash water can be used, fixers can be replenished at the proper intervals, and wash tanks can be designed to give efficient washing.

Drying

Once they have been thoroughly washed, prints intended to be dried naturally can be placed face upwards in a pile on a piece of thick glass. The excess of water should then be squeezed out and the surface of each print wiped gently with a soft linen cloth or chamois leather. The prints can be laid out on blotters or attached to a line with print clips. Alternatively, an efficient drying apparatus can be made by stretching cheesecloth on wooden frames, and placing the prints face downward on the cloth. Where a large volume of work is being handled, fibre-based prints may be dried by heat using flatbed or rotary glazing machines (see below), or special rotary dryers. For drying on a glazing machine, prints are placed facing the apron instead of towards the glazing sheet or glazing drum. Rotary drying machines are similar in construction to rotary glazing machines, except that the drum is covered with felt or cloth. It is usually an advantage to use a hardening-fixing bath when prints are to be dried by heat.

The drying of matt and semi-matt papers by heat gives a higher sheen than natural drying, because raising the temperatures of the paper causes bursting of starch grains included in the emulsion to provide the surface texture. With semi-matt papers the higher sheen may in some instance be preferred, but with matt papers it wil usually be considered a disadvantage in which case natural drying should be employed.

When dry, a print will sometimes be more or less curled. If so, it may be straightened by laying it face downwards on a smooth flat surface and drawing a

water enters from the same end of the dish as it leaves, these are somewhat less efficient.

When large batches of prints have to be handled, the above arrangement can be duplicated or increased in size as desired, providing a practical and efficient method of ensuring thorough washing.

Another form of print-washer solves the problem of prints sticking together by holding them in a rocking cradle like a toast-rack. (Figure 21.6(c)). The in-flow of water causes the rack or prints to rock backwards and forewards so ensuring that the prints are in constant motion and that there is an efficient flow of water around them.

Numerous mechanical print washers are sold which are designed to keep prints moving while water passes over them. In purchasing any print washer it is necessary to be satisfied that prints cannot come together in a mass so that water cannot get at their surfaces, nor be torn or kinked by projections in the washing tank. Commercial print washers are in general suited only to prints of relatively small size.

Washing in automatic print processors is more efficient than that for manual or batch processing. The reasons for this may be summarized as follows:

ruler along the back from end to end or from corner to corner, the end or corner being lifted fairly sharply but steadily as the rule is drawn back. This must not be done too enthusiastically, as a heavy pull is likely to damage the emulsion and crease the print. If the prints are not required in a hurry it is better to stack them face to face under a heavy board and leave them overnight. Prints dried on heated machines do not usually require straightening.

Figure 21.7 Dryer for resin-coated papers (*Ilfospeed 1050*), capable of drying 380 8 × 10 inch prints per hour

Resin-coated papers may be dried by hanging up the prints in the air or in a drying cupboard in the same way as films or by the use of one of the many commercially available purpose-made dryers for RC papers shown in Figure 21.7. They dry rapidly without curling. They may also be dried on glazing machines provided that the following precautions are observed:

(1) *All* surface moisture is removed.
(2) The base is towards the heated 'glazing' surface
(3) The temperature of the glazing surface is below 90°C

RC papers are impervious to water so that it is essential that the emulsion is not placed in contact with the heated surface and that surface moisture is thoroughly removed by squeegeeing.

Glazing

The appearance of prints on glossy fibre-based papers is considerably enhanced by *glazing*, a process which imparts a very high gloss. Glazing is effected by squeegeeing the washed prints on a polished surface; when dry the prints are stripped off with a gloss equal to that of the surface onto which they were squeegeed. Glazing is best carried out immediately after washing, before prints are dried. If it is desired to glaze prints that have been dried, they should first be soaked in water for an hour or more. Glass is usually considered to give the finest gloss, although some other surfaces are also

suitable. Chromium-plated metal sheets and drums are widely used, as is polished stainless steel.

Before prints are squeegeed on to the glazing sheet, the surface of the sheet must first be thoroughly cleaned, and then prepared by treating it with a suitable glazing solution to facilitate stripping of the prints. For the finest glaze, it is probably best to allow prints to dry naturally on glass, e.g. overnight. Where a considerable volume of work is handled it is usual to employ glazing machines, on which prints are dried by heat, to speed up the operation. These machines are of two types, flat-bed and rotary. Glazing can be completed in a few minutes. Flat-bed glazers accommodate flexible chromium-plated sheets on to which prints are squeegeed. The glazing sheet is placed on the heated bed of the glazer and assumes a slightly convex form when held in place by a cloth apron which serves to keep the prints in close contact with the glazing sheet. In rotary machines, prints are carried on a rotary heated chromium-plated (or stainless steel) drum on which they are held in place by an apron.

Clearing and reducing prints

Clearing or reducing of prints by chemical means is rarely required once the technique of printing has been mastered. There are, however, some cases where chemical treatment improves the results. Such techniques are described in Chapter 23, and formulae for this purpose are given in the Appendix (page 371).

Toning prints

This process is described in full in Chapter 23.

Stabilization papers

There are some types of bromide paper in which a developing agent, usually hydroquinone, is incorporated in the emulsion. They are designed for rapid processing in small machines. The paper passes first through an activator, a strongly alkaline sulphite solution, then through a stabilizer (Figure 21.8). The print emerges from the machine in a semi-dry

Activator Stabilizer

Figure 21.8 Activation-stabilization processor, showing surface application of solutions

state, the whole processing operation having taken only about 10 seconds. The restrainer required in development may be incorporated in the activator or in the paper, so that not all stabilization papers and activators are compatible. It is therefore prudent to employ the chemicals recommended by the manufacturer of the paper.

Stabilization papers are available in speeds that are suitable for both contact and projection and in a range of contrast grades and surfaces. However, the introduction of RC papers and associated processing equipment is threatening the popularity of stabilization methods because the prints are not permanent but are subject to yellowing and fading on storage unless subsequently fixed in the orthodox manner. With RC papers permanent, dry prints can be obtained in a reasonably short time (100 seconds for a 10×8 in print in the Kodak Veribrom processor). Such rapid processors are, however, many times more expensive than stabilization processors.

22 Printing and enlarging

In the previous chapter we considered the characteristics of the various types of printing paper. In the present chapter we shall deal with the printing operation itself. There are two main ways of making prints: *contact printing* and *projection printing*, the principal difference between the two being in the method of exposing. In contact printing the sensitized paper is literally in contact with the negative, while in projection printing the paper is placed at a distance from the negative, the negative image being projected on to the paper by optical means.

Contact printing

This form of printing is a more simple operation than projection printing, and requires only the minimum of apparatus and equipment. As the fundamental principles are the same for both methods of printing, experience of contact printing provides a valuable introduction to projection printing.

Apparatus for contact printing

Contact prints are made using either a *printing frame* or a *printing box*, the latter being essentially a piece of apparatus combining a printing frame with a light source. Printing frames and boxes are intended to ensure as perfect a contact as possible between the negative and the print paper during printing. More commonly, however, contact printing is used to provide proofing sheets from 120 to 35 mm film. Then the paper may be placed on the enlarger baseboard with the negatives on top, emulsion to emulsion. A glass plate holds them in close contact and the enlarger beam is used as a light source. A sheet of paper 20.3 × 25.4 cm (8 × 10 inches) can accommodate twelve negatives 6 × 6 cm in three strips of four or 36 negatives 24 × 36 mm in six strips of six. Special printing frames which hold strips of negatives in the manner indicated above are available. If the negatives are reasonably uniform in density and contrast they can be printed with a single exposure. If not, such a sheet may be used as a guide for selection of a more appropriate paper grade and/or exposure for particular negatives.

Projection printing (enlarging)

Projection printing is the process of making positive prints by optical projection of the negative image on to print paper. The projected image may be enlarged, the same size as the negative or reduced. As projection printing is usually employed for the production of enlarged prints, projection printers are usually referred to as enlargers, and the term 'enlarging' is loosely used to cover all forms of projection printing, whether the image is actually enlarged or not. Enlarging allows control in various directions to be introduced during printing, by, for example:

(1) *Selection of the main area of interest in the negative*, and enlargement of this area to any suitable size. This enables unwanted and possibly distracting areas around the edges of the picture to be eliminated, thus concentrating interest on the main subject.

(2) *Dodging and shading* This enables detail in highlights or shadows, which would otherwise be lost, to be revealed.

(3) *Local fogging* by a small external light can be used where dark areas are required, e.g. around a portrait, to concentrate attention on the face.

(4) *Modification of the appearance of the image* by use of diffusers, etc. between lens and paper.

(5) *Correction or introduction of perspective distortion* by tilting the enlarger easel and/or negative carrier.

Apparatus for enlarging

Early enlargers resembled large slide projectors, with the optical axis horizontal. To save bench space, later enlargers were designed with the axis vertical; today, most enlargers are of this type. Not only do vertical enlargers save space, but they are much quicker in use. In some of them, operation is speeded up further by means of automatic focusing devices. Horizontal enlargers are, however, still used for very large prints.

The optical systems of most enlargers are of three main types:

(1) Condenser
(2) Diffuser
(3) Condenser-diffuser

Figure 22.1 Optics of condenser enlarger

The condenser type, based on the slide projector, was the earliest form of optical system. Later, diffuse or semi-diffuse illumination tended to displace the straightforward condenser type.

Condenser enlargers

Figure 22.1 illustrates the arrangement of a condenser enlarger. The purpose of the condenser C is to illuminate the negative evenly and to use the light output of the lamp as efficiently as possible. These aims are achieved if the condenser forms an image of the light source S within the enlarging lens L. The latter is employed to form an image of the negative N in the plane of the easel E. The negative causes

Figure 22.2 Relationship between circular fields covered by enlarging lenses of focal lengths of 50 mm and 80 mm and the negative size

some scattering of the light, so that a cone of light spreads out from each image point, as indicated by the broken lines in the figure. This cone fills the lens L, but very unequally, the intensity of the part of the beam that passes through the central area of the lens being much greater than that of the part that passes through its outer zone. One result of this is that stopping down the lens of a true condenser enlarger does not increase exposure times by as much as might be expected (page 298), but tends to increase contrast, as it cuts down the light scattered by the negative.

The required diameter and focal length of an enlarger condenser depend on the size of the largest negative to be used. The diameter must be at least equal to the diagonal of the negative, and the focal length should be about three-quarters of this value.

The choice of focal length for the enlarging lens is restricted by a number of practical considerations. If it is too short in relation to the negative size, it will not cover the negative at high degrees of enlargement. If it is too short in relation to the focal length of the condenser, the light source must be a long way from the latter in order to form an image of the source within the lens. This necessitates a big lamphouse. It also means that the area of negative illuminated by the condenser is reduced. If, on the other hand, the focal length of the enlarging lens is too great, the distance from lens to baseboard is inconveniently long when big enlargements are required. The best compromise is usually achieved by choosing a lens with a focal length at least equal to that of the condenser but not exceeding it by more than one-third. This results in a lens of focal length equal to or slightly longer than that of the 'normal' camera lens for the negative size covered (Figure 22.2).

Figure 22.2 indicates that any negative size which fits into or is smaller than the circular image field of the lens can be enlarged with that lens. Thus a 50 mm focal length lens can be used for full- and half-frame 35 mm negatives and for smaller negatives such as 110 size (13 × 17 mm). Although this choice of focal length ensures even ilumination, and a 24 × 36 mm negative could be enlarged with an 80 mm focal length enlarging lens, this would result in the enlarger head being raised higher than if a 50 mm lens were to be used (see Figure 22.3). This may be inconvenient, and it may be impossible to obtain a sufficiently high degree of enlargement. In Chapter 4 we saw that the simple lens equation could be written in the form $v = f(1 + m)$, where v is the lens-to-baseboard distance, f is the focal length of the lens and m is the magnification. Thus in Figure 22.3, if the degree of enlargement is × 4 (i.e. $m = 4$) we can see that the lens-to-baseboard distance is 25 cm for the 50 mm lens and 40 cm for the 80 mm lens. Although at this magnification these distances are unlikely to cause problems, with high-

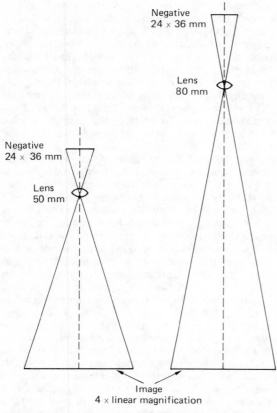

Negative
24 × 36 mm

Lens
80 mm

Negative
24 × 36 mm

Lens
50 mm

Image
4 × linear magnification

Figure 22.3 Lens-to-baseboard distances for lenses of different focal length and the same degree of magnification

er magnifications v could become unacceptably large.

To achieve optimum illumination in a condenser enlarger, the various parts of the optical system must be so located that the light beam from the condenser converges to its narrowest cross-section within the enlarging lens. Now, when the degree of enlargement is altered, the distance of the enlarging lens from the negative is altered to obtain sharp focus. As the negative and condenser are fixed in relation to one another, it is obvious that some adjustment of the light source in relation to the condenser must be made if the image of the source formed by the condenser is to be kept within the enlarging lens. This involves setting up the enlarger each time the degree of enlargement is changed. Most modern enlargers are of the diffuser or condenser-diffuser type, which avoids the necessity for these tedious adjustments.

Diffuser enlargers

Diffuse illumination may be obtained by direct or by indirect lighting of the negative, the different methods being illustrated in Figure 22.4.

For small negatives, an opal or frosted tungsten lamp with a diffusing screen (opal or ground glass) between lamp and lens is all that is required (Figure 22.4a). This method can be extended to somewhat larger negatives by using a bulb silvered at the tip, or a diffuser specially treated to that the transmission of the central part is reduced, to assist in obtaining uniform illumination of the negative. To illuminate

(a) (b) (c)

Figure 22.4 Optics of three types of diffuser enlargers. (a) Direct (illumination through opal diffuser; (b) indirect illumination; (c) cold-cathode illumination

a really large negative directly, an assembly of small bulbs must be employed behind the diffuser.

The indirect method of illumination, shown in Figure 22.4b, is another commonly-used method for obtaining diffuse illumination which is suitable for large negatives. A tungsten-halogen lamp is placed at right angles to an integrating or diffusing box, i.e. a box with an inside surface that acts as an efficient diffuse reflector.

A method of obtaining diffuse illumination by means of a cold-cathode lamp is illustrated in Figure 22.4c. Lamps of this type, in the form of a grid or helix, provide a large intense source of uniform illumination.

Practical differences between condenser and diffuser enlargers

Many negatives can be enlarged equally well on a condenser or a diffuser enlarger. For certain types of work, however, the choice of enlarger is important.

The main differences in operation between the two types of enlarger are listed below.

Condenser enlarger

(1) Gives maximum, tone-separation, especially in highlights.
(2) Is unsuitable for negatives that have been retouched; the ridges of the retouching medium print as dark lines.
(3) Tends to accentuate blemishes and grain.
(4) Is very suitable for work at a high degree of enlargement, because of its high optical efficiency.
(5) Image contrast is higher than when contact printing or using a diffuser enlarger, thus requiring the negatives to be developed to a lower contrast (see Table 22.1) or, alternatively, a lower contrast grade of paper to be used.
(6) Suffers from the inconvenience of requiring readjustment of the lamp position whenever the degree of enlargement is altered appreciably.

Condenser enlargers are therefore often preferred when large prints are required and retouching is usual, e.g. for commercial and industrial photography.

Diffuser enlarger

(1) Is essential where retouching is used. In re-touching, matching is done over an opal dif-fuser, so retouched negatives must be printed under similar conditions for the retouching to yield the desired effect, without being obtrusive.
(2) Subdues scratches, grain, etc.
(3) Is not suitable for work at a high degree of enlargement (unless a high-power light source is employed) because of the low optical efficiency of the diffuse negative illuminating system.
(4) Image contrast is similar to that obtained when contact printing (i.e. lower than when using a condenser enlarger), requiring negatives to be developed to a higher contrast (see Table 22.1), or a higher contrast grade of paper to be used.

Table 22.1 Negative contrast and type of enlarger

	Condenser enlarger	*Diffuser enlarger*
Contrast index	0.45	0.56
\overline{G}	0.55	0.70

Diffuser enlargers are therefore essential where retouching is a routine. There is no reason why the definition obtained with a diffuser enlarger should be inferior to that obtained with a condenser enlarger.

Because of the variation of the Callier coefficient with density (page 172), the tone distribution in the shadows of a print produced with a condenser enlarger may be different from that in a print produced in a diffuser enlarger. The difference is not usually of great practical importance.

Table 22.1 relates the required negative contrast to the enlarger type.

Notes

(1) Some increase in camera exposure (up to 1 stop) may be required when developing to the lower contrast.
(2) The required contrast refers to average subjects.
(3) The contrasts quoted in the table are those recommended by film manufacturers for printing average negatives on a normal grade of paper.

Condenser-diffuser enlargers

Most popular enlargers of today employ an optical system which includes both condenser and diffuser. For many purposes such a system offers a very

practical compromise between condenser and diffuser enlargers. It permits shorter exposure times than a true diffuser enlarger, yet avoids the necessity for adjusting the position of the lamp for each variation in the degree of enlargement as is necessary in a condenser enlarger. Grain and blemishes on the negatives are subdued to a useful extent, even though not as much as in a diffuser enlarger. In most of these *condenser-diffuser enlargers*, diffusion is achieved simply by using an opal or frosted bulb as light source, instead of the point source required in a true condenser enlarger. Figure 22.5 illustrates three ways of obtaining partially-diffuse illumination in condenser-diffuser enlargers.

Figure 22.5 Condenser-diffuser illumination systems: (a) Opal lamp, diffuser and condenser; (b) tungsten-halogen lamp, integrating box, diffuser and condenser; (c) tungsten-halogen lamp, light-pipe and condenser

Some condenser enlargers are fitted with a removable diffusing screen, usually a sheet of ground glass, between the condenser and the negative carrier. This avoids the necessity for frequent readjustment of the position of the lamp, but exposures are longer. The ground glass is uniformly illuminated by the condenser and its scatter is predominately towards the lens. An alternative approach is to use a light-integrating box lined with reflective material, with a diffuser at the exit face. Such devices are widely used in colour enlargers (see page 305). This action, and the consequent increase in the amount of light passing through the lens (as compared with use of a diffuser alone), is the sole advantage of using the condenser in this case. To achieve even illumination to the corners of the negative when a diffusing screen is used in a condenser enlarger, the diameter of the condenser must be somewhat greater than usual, i.e. a little greater than the diagonal of the negative.

Figure 22.6 compares the integrating-box approach with a novel 'dioptic' light pipe which achieves uniform diffuse illumination with little light loss. A light pipe constructed from acrylic material conveys the illumination to the diffusion screen directly from the tungsten-halogen lamp, and at the same time absorbs any UV radiation.

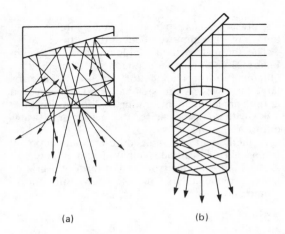

(a) (b)

Figure 22.6 Comparison of integrating box and light-pipe diffuser: (a) Integrating box showing light losses due to scatter; (b) light-pipe showing minimal light loss

Light sources for enlarging

Light sources for enlarging include:

(1) Tungsten lamps
(2) Tungsten-halogen lamps
(3) Mercury-vapour lamps
(4) Cold cathode lamps

A single tungsten lamp provides a convenient and efficient source of light for enlarging, and most smaller enlargers employ such a source. A tungsten lamp may be used in conjunction with a condenser or with a diffusing system. An opal lamp used with a condenser provides a convenient condenser-diffuser system. Some tungsten lamps are specially designed for use in enlargers. These are usually slightly over-run, to give high efficiency, and specially treated to provide uniform diffuse illumination with minimum absorption by the envelope of the lamp. Do not use an ordinary 'pearl' lamp or an opal lamp with the maker's name on the envelope, where it may be focused by the condenser. (This is less important where the lamphouse is designed for indirect illumination.)

Tungsten-halogen lamps are also used in many modern enlargers. Their spectral output differs from conventional incandescent lamps owing to some spectral absorption by iodine vapour, and they have a greater output of ultraviolet radiation because the quartz envelope of the lamp transmits this region of the spectrum.

There are a number of types of mercury-vapour lamps. The extended source provided by the larger lamps has certain advantages over tungsten lamps when diffuse lighting is required. Its light is intense, it gives out little heat and it is economical in current.

It should be noted that mercury vapour lamps do not reach full intensity until about three minutes after switching on. It is normal practice for mercury vapour enlarger lamps to be left running while in use, exposures being controlled by means of a shutter. These lamps have largely been replaced by cold-cathode or tungsten-halogen lamps.

Cold-cathode lamps are obtainable in various forms. For use in enlarging they are usually made in the form of a grid or spiral, which provides a large intense source of uniform illumination. All cold-cathode light sources for enlarging are of the diffuser type. Unlike mercury-vapour lamps, cold-cathode lamps reach their full intensity almost immediately after switching on and do not require to be left on continuously.

Lenses for enlargers

Lenses especially designed for use in enlargers are usually of the symmetrical type. Apertures are often marked not with f-numbers but with figures such as 1 (maximum aperture), 2, 4, 8, etc., to indicate the relative exposure times required. For ease in operation in the darkroom, click stops are frequently fitted. Because of the danger of overheating, the elements of an enlarger lens are sometimes not cemented.

We have seen that, for a condenser enlarger, the focal length of the enlarging lens should be similar to or slightly longer than that of the normal camera lens for the negative size concerned (page 291). This rule holds good for diffuser enlargers too. If the focal length of a lens used with a diffuser enlarger is too short, it is difficult to obtain uniform illumination at the edges of the field; if it is too long, the required throw becomes inconveniently long, just as with a condenser enlarger. An exception to the general rule for determining the focal length of an enlarger lens applies when working at or near same-size, or when reducing, e.g., when making slides for projection. The angle subtended by the lens at the negative is then much smaller, and it is possible to use a lens of shorter focal length than normal without risking uneven illumination or inadequate covering power. In fact, use of a lens of shorter focal length is often essential when reducing if the enlarger has a limited bellows extension.

Incorporation of a heat filter in an enlarger fitted with a tungsten lamp is always an advantage in protecting both negative and lens from overheating.

Selecting an enlarging lens

When selecting an enlarging lens the following should be considered:

(1) *Focal length* Is this suitable in relation to the size of negative, focal length of condenser (if employed) and range of extension? The suitability of the focal length of the lens in relation to the negative is a question of covering power. This should be tested when the angle subtended by the lens at the negative is at its greatest. This occurs at large magnifications, when the lens is nearest to the negative. Zoom enlarging lenses are now becoming available.

Figure 22.7 Typical enlarging lenses (*Schneider*)

(2) *Definition* This should be tested both in the centre and at the edges of the field, at the greatest degree of enlargement likely to be employed in practice, the test being repeated at several apertures. The most useful form of test is to make a series of actual enlargements.

(3) *Range of stops* Can the markings be read easily or are click-stops fitted? Is the smallest stop small enough to permit sufficiently long exposures for dodging to be done at same-size reproduction?

(4) *If an auto-focus enlarger is employed*, a check should be made that the focusing device operates satisfactorily with the lens concerned at all magnifications.

Many manufacturers of lenses offer enlarging lenses ranging from budget-priced three-element lenses to expensive high-quality lenses of six or more elements (see Figure 22.6). The additional optical elements are to correct for various lens aberrations (see Chapter 6). The simpler lens are designed for moderate degrees of enlargement (around 4 × or 5 ×) whereas the more complex and expensive lenses are designed for giving optimum image quality in both monochrome and colour at virtually any degree of enlargement from 1 × to 20 ×. Lens design is a compromise between cost and performance, and there seems little point in buying high-quality camera lenses and printing the resulting negatives with an enlarging lens of inferior quality. The old saying that you should not pay less for your enlarging lens than for your camera lens may be somewhat of an overstatement these days, but it is still not far from the truth.

Negative carriers

An important feature of any carrier for film negatives is that is should hold the negative flat. This is often achieved by sandwiching the negative between two pieces of glass of good quality, which must be kept scrupulously clean. With very small negatives, e.g., of the 24 × 36 mm size, the glass can be dispensed with and the negative held between two open frames, which lessens the chance of dust marks on prints. When such glassless carriers are used, there is, however, a tendency for negatives to 'pop' or jump from one plane to another under the influence of heat; if this happens between focusing and exposing, the print may be out of focus. Stopping down to increase depth of focus helps to minimize the effect but can itself cause loss of definition.

In order to prevent non-image firming light from reaching the paper from the margins of the negative, most enlargers incorporate adjustable masking blades either in the enlarger or in the negative carrier. This minimizes flare and consequent loss of contrast.

Heat filters

To protect negatives from damage due to overheating enlargers are fitted with a heat filter, i.e. a filter which passes visible radiation but absorbs infrared. The provision of a heat filter is particularly important when a tungsten lamp is employed as the illuminant and exposure times are long, e.g. when big enlargements are being made, or when using colour materials. A heat filter will also protect an enlarger lens from possible danger from overheating.

Easels and paper holders

When using a horizontal enlarger, the sensitive paper is commonly pinned to a vertical easel, which is usually parallel to the negative. For enlargements with white borders, it is necessary to fit some form of masking device to the easel. For vertical enlargers, special paper-holding and masking frames are available. The easels of some vertical enlargers themselves incorporate built-in masking devices. Easels for borderless prints are also available. One type makes use of a flat board that has a tacky surface which grips the back of the paper to hold it flat, and is readily released after exposure. The tacky surface can be reapplied from an aerosol spray when it ceases to be effective. Another method for obtaining borderless prints is by the use of spring-loaded magnetic corners which grip the edges of the paper without obscuring the surface, and so hold the paper flat on a metal base. More sophisticated easels use a vacuum to hold the paper flat.

For professional enlarging where a large number of prints are required, a roll paper holder with motorized transport may be used. This enables many enlargements to be made on a long roll of paper and the motorized paper-transport mechanism can be coupled to the exposure timer for automatic paper advance after each exposure.

For enlargements with black borders, prints are first made in the usual way, with or without a white border. A sheet of card, measuring, say, 10 mm less each way than the print, is laid centrally on it and the edges, which are not covered by the card, are fogged to white light (such as an open-film gate) for one or two seconds.

Determination of exposure times in enlarging

Of the many factors which affect exposure times in enlarging, the following are probably the most important:

(1) Light source and illuminating system,
(2) Aperture of enlarging lens

(3) Density of negative
(4) Degree of enlargement
(5) Paper speed

The exposure required will also be influenced by the effect desired in the final print.

The most reliable way of determining the exposure is by means of a test strip. A piece of the paper on which the print is to be made is exposed in progressive steps, say 2, 4, 8 and 16 seconds. This is done by exposing the whole strip for 2 seconds, then covering one-quarter of the paper with a piece of opaque card while a further exposure of 2 seconds is made. The card is then moved over to cover half the strip and a further 4 seconds exposure is given. Finally, the card is moved to cover three-quarters of the strip and an exposure of 8 seconds is given (Figure 22.8). If care is taken to move the card quickly and precisely, it may be moved while exposure proceeds, thus avoiding the need for switching the light off and on. The strip is then given standard development, and the correct exposure is assessed on the basis of a visual examination of the four steps in white light.

If the correct exposure appears to lie between two steps, the exposure required can usually be estimated with sufficient accuracy, but if desired a further test strip may be made. If, for example, the correct exposure appears to lie between 8 and 16 seconds, a second strip exposed in steps of 10, 12 and 14 seconds wil give a good indication of the exact time required.

Once the exposure time for one negative has been found by trial, other negatives of similar density may be given the same exposure. Further test prints will at first be required for negatives of widely differing density, but with experience it is possible to estimate the exposure required for almost any negative, without resort to test exposure. Such trial-and-error methods are also used when an electronic assessing device is used as a means of calibrating the instrument using a standard or representative negative (see page 299).

Figure 22.8 A processed test strip for determining the required exposure in contact printing or enlarging

Effect on exposure of variation of aperture

With a diffuser or condenser-diffuser enlarger, the effect of stopping down on exposure is similar to that experienced in the camera, i.e. the exposure time required varies directly with the square of the *f*-number, in contrast to a condenser enlarger, where the light reaching the lens from each point on the negative is not distributed evenly in the lens but is concentrated on the axis (page 291).

Modern enlarging lenses are anastigmats with a flat field and excellent definition at full aperture. Definition may be slightly improved by stopping down one or two stops, but there should not be any necessity to stop down further simply on account of definition. In fact definition in enlarging may sometimes be harmed by excessive stopping down. Considerable stopping down is required only if:

(1) A glassless negative carrier is employed and there is risk of the film buckling. Stopping down then assists by increasing the depth of field.
(2) The easel has to be tilted to correct or introduce perspective distortion. Stopping down then increases the depth of focus.
(3) Exposure times at larger apertures are too short to enable exposures to be timed accurately or to permit dodging.

Stopping down the lens of a condenser enlarger tends to increase contrast (page 291).

Effect on exposure of variation of degree of enlargement

It might at first be expected that the exposure required when enlarging would vary directly with the area of the image, i.e. with m^2, where m is the degree of enlargement (image size/object size). In fact, however, the exposure varies with $(1 + m)^2$, just as in negative making. When the exposure at one particular degree of enlargement has been ascertained, the exposures for prints at other degrees of enlargement, from the same negative, can conveniently be calculated from Table 22.2, which is based on the $(1 + m)^2$ formula. The required exposure is found from the table by multiplying the known exposure by the factor lying under the new degree of enlargement on the line corresponding to the old.

Enlarging photometers, exposure meters and timers

Various types of photometer have been devised to assist in the determination of exposures in enlarging. The general procedure when using such an instrument is to read the luminance of the image on the easel at the desired magnification, with the lens stopped down as required. The reading may be made on either the shadow or highlight areas of the image, provided that the instrument is suitably calibrated. A reading of the luminance of the shadows, i.e. the lightest part of the (negative) image, is usually the easiest to take, and is probably the best guide to the exposure required.

Use of an exposure photometer does not completely solve the problem of print exposure. With subjects of unusual luminance range or unusual tone distribution, the exposure indicated by the photometer will not always be the best. In such a case, the exact exposure must be found by trial, although use of a photometer may assist by giving a first approximation to the exposure required. Some assistance in estimating exposure can be obtained by reading the density of the negative shadows or highlights with a densitometer (*off-easel assessment*). The

Table 22.2 Exposure factors and degree of enlargement

Degree of enlargement for which exposure is known	New degree of enlargement									
	1	2	3	4	5	6	8	10	12	15
1	1	2	4	6	9	12	20	30	40	60
2	1/2	1	2	3	4	5	9	13	20	30
3	1/4	1/2	1	1½	2	3	5	8	10	16
4	1/6	1/3	2/3	1	1½	2	3	5	7	10
5	1/9	1/4	1/2	2/3	1	1⅓	2	3	4	7
6	1/12	1/5	1/3	1/2	3/4	1	1½	2½	3	5
8	1/20	1/9	1/5	1/3	1/2	2/3	1	1½	2	3
10	1/30	1/13	1/8	1/5	1/3	2/5	2/3	1	1⅓	2
12	1/40	1/20	1/10	1/7	1/4	1/3	1/2	3/4	1	1½
15	1/60	1/30	1/16	1/10	1/7	1/5	1/3	1/2	2/3	1

Notes This table holds only approximately for condenser enlargers where the lamp-to-condenser distance is altered to suit new magnification, since this has the effect of altering the illumination on the negative.

At very long exposure times, reciprocity law failure may assume significant proportions. The higher factors in this table should therefore be used as a guide only; the actual exposure time required when a large factor is indicated may be appreciably longer than that derived from the table.

help obtained in this way is not great, however, because allowance must still be made for other variables such as degree of enlargement, aperture, light source, type of optical system employed, etc.

Electronic assessing and timing devices are used extensively in colour printing and are described more fully at the end of this chapter. In order to assess the exposure required for printing a negative use is made of the fact that the light transmitted by the majority of negatives integrates to a more or less constant density, or spot readings of a small critical area such as a mid-tone (flesh tone or a grey card included in the original scene) are taken with a suitable measuring instrument. Determination of exposures by either of these methods with the negative in the enlarger and the probe of the measuring instrument on the baseboard is given the name *on-easel assessment*.

In both cases the meter requires calibration by printing a *master* or *standard* negative (see page 309) by one of the non-instrumental methods described on page 297. Once a satisfactory print has been made, the measuring probe is placed on the baseboard and the instrument is zeroed, employing either a spot or integrated measurement of the light transmitted by the master negative. Any other negative that does not depart markedly from the master should give a satisfactory print after taking a reading with the meter and adjusting the exposure by the amount indicated by the measuring device being used.

Many such assessing devices also have an electronic timer incorporated, and lend themselves to automated printing by assessing the exposure during the printing operation and turning the enlarger lamp off after the required time. These automatic assessing devices assess the total or integrated light transmitted by the negative by placing the detector or probe in one of the positions shown in Figure 22.9. The following positions may be used:

(1) Measuring light scattered by the negative before passing through the enlarger lens.
(2) By deflecting a portion of the transmitted light to the detector by means of a beamsplitter after it has passed through the enlarger lens.
(3) By measuring light reflected from the paper.
(4) By measuring light incident on the paper after it has been diffused.
(5) By collecting and measuring light after it has been transmitted by the paper.

Methods (1) and (2) are commonly used in automatic printers, while (3) and (4) are used in professional enlargers for both colour and black-and-white printing. Masking frames complete with photocell or photomultiplier tube on an arm (method 3) are commercially available and are used in the printing of both black-and-white and colour negatives; some also incorporate a timer. The probe used for method (4) may be either the photomultiplier tube itself, linked to the meter or, to enable a less bulky probe to be used, the detector is placed in the meter and light is transmitted to it by a fibre-optics light guide.

It is also possible to use a simple photographic exposure meter for assessing exposures for printing negatives. One such technique involves placing the exposure meter against the enlarger lens to measure the integrated light from the master negative after having first obtained a satisfactory print. Then with the new negative in the enlarger the aperture is adjusted to obtain the same reading as before and a print made using the same exposure time. Although seemingly crude, this technique does work and has been used in colour printing.

Variation in illuminant in enlarger

The output of a tungsten lamp falls off with age. In determining exposures allowance must be made for this, especially when a new lamp is fitted. If the new lamp is of a different type or make from the previous one, even though of the same wattage, its output may differ for this reason, as not all lamps of the same wattage have equal luminous efficacies.

Voltage fluctuations in the mains supply can make it difficult to achieve accurate exposures in enlarging. For example, a 5 per cent reduction in voltage lowers the light output by about 20 per cent and at

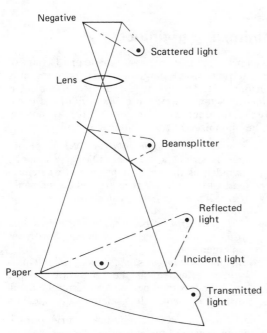

Figure 22.9 Various positions of detectors for assessing exposure

the same time alters the colour temperature considerably (Chapter 3). Normal supply variations do not usually cause trouble, but, if for any reason the variation is excessive, it may be worthwhile in critical work to fit some form of voltage regulator to the supply.

Dodging and shading

One of the advantages of enlarging is that it gives the photographer the opportunity of controlling the picture by intercepting the projected image between the lens and the easel. A straight enlargement from any negative seldom gives the best image that can be obtained, and with the great majority of subjects – landscapes, portraits, architecture or technical – a little local shielding of parts which print too deeply, or the printing in of detail in some especially dense part of the negative, results in a considerable improvement overall. Control of this kind may be used to compensate for uneven lighting of the subject, or give added prominence to any given part of the composition.

To bring out detail in a highlight, use a piece of card with a hole in it that is slightly smaller than the part to be treated. After exposing the whole picture in the usual way, use the card to shield all parts except that which is to be exposed further. Hold the card fairly close to the paper, and keep it on the move slightly for such time as a trial enlargement shows to be necessary.

To hold back shadows, e.g. a portrait in which the shadow side of the face becomes too dark before the full details of the other parts are out, use a dodger; a number of these can be made from thin card cut to a variety of shapes and sizes, a few of which are illustrated in Figure 22.10, with wire threaded through holes in the card. They may be made

double-ended as shown, with a twist in the middle of the wire for hanging on a hook in the darkroom. The shape and size of the shadow cast by a dodger can be varied by tilting it, and by using it at different angles and at different distances from the easel. Professional printers use their hands as dodgers.

Correction or introduction of perspective distortion

We saw in Chapter 10 that if we tilt a camera in order to include the whole of a building in a photograph, we shall produce a negative with converging verticals. Without camera movements these results are inevitable. The effect can be balanced out to some extent by tilting the enlarging easel. In this way the convergence can be cancelled, though as this operation elongates the image, only a small degree of convergence can be corrected in this manner. Some enlargers permit tilting of the negative holder and this can reduce the distortion provided the negative is properly centred. If the tilt of the negative holder and the baseboard satisfy the Scheimpflug requirement (see page 126) the image will be sharp overall at full aperture. The positioniong of the negative is not easy, as its precise position depends on the solution of a complicated photogrammetric equation, and a satisfactory result will depend on trial-and-error methods.

Minimizing graininess

As all photographic images are made up of grains of silver of finite size, enlargements may appear grainy (Chapter 25). The grainy appearance of a print is primarily a function of the *granularity* of the negative and the degree of enlargement. It may, however, be minimized at the printing stage by:

(1) *Choice of a suitable enlarger* Where graininess is serious, condenser enlargers should be avoided as they accentuate the effect; enlargers of the diffuser type are to be preferred.

(2) *Using a printing paper with a grained or rough surface.*

(3) *Using a diffuser between enlarger lens and printing paper* See below under 'Soft-focus enlargements'.

(4) *Setting the enlarger slightly out of focus* This is seldom effective, as the grains are sharper than the recorded detail. As a result the detail disappears before the graininess disappears.

The figures in Table 22.3 indicate very approximately the degree of magnification permissible with four common types of film, before graininess be-

Figure 22.10 Dodgers for local control in enlarging

Table 22.3 Approximate permissible magnification for four film types

Type of film	Type of developer		
	General-purpose	Fine-grain	Extra-fine-grain
Extreme-speed panchromatic (ISO 400/27°)	4	6	8
Fast panchromatic (ISO 200/24°)	6	9	12
Medium-speed panchromatic (ISO 100/21°)	8	12	16
Ultrafine-grain panchromatic (ISO 50/18°)	12	18	24

comes apparent on prints held in the hand. They assume correct exposure and development.

The graininess permissible in a print depends very much on the conditions of viewing. The graininess acceptable in a large print to be hung on an exhibition wall is much greater than can be tolerated in a small print intended for viewing in the hand. Any figures for permissible magnification can, therefore, be only approximate. When preparing 'giant' enlargements, critical judgement should not be given until the prints are finally spotted, and viewed at the appropriate distance. Giant enlargements can appear extremely coarse and full of imperfections when they are examined before mounting and finishing.

Soft-focus enlargements

Some types of subject are often greatly improved by diffusing the image so as to blur its aggressively sharp definition a little. This may be achieved by the interposition of a suitable material between the lens and the picture. A piece of black chiffon, bolting silk, fine-mesh wire or crumpled cellulose sheet may be fitted to a rim which is slipped on to the enlarging lens for part or all of the exposure. Alternatively, an optical *soft-focus attachment* can be employed. The result is to give the image a soft appearance with a slight overlapping of the edges of the shadows on to highlight areas. In addition to giving softer definition, the enlargement also shows slightly weaker contrasts, and graininess is minimized. Net-like material or cellulose sheet stretched over a card cut-out may also be used close to the enlarging paper. The texture effect is then usually more pronounced. Whatever form of diffusing medium is used, at least 50 per cent of the exposure should generally be made without the diffuser. The effect produced when diffusion is obtained in the enlarger is not the same as when a soft-focus lens is used on the camera.

Colour printing

The basic techniques of black-and-white printing are also applicable to colour printing. Contact, projec-tion and automatic printing methods are all used, but with some practical restrictions owing to the nature and properties of the colour materials. In addition, more sophisticated equipment is needed to ensure consistency and predictability of results.

The principles of colour photography are discussed fully in Chapter 14, and the technology of colour reproduction by subtractive synthesis methods using yellow, magenta and cyan dye images only, is described for both reversal and negative-positive processes in Chapter 24.

Colour printing materials, of which there are a wide variety of general- and special-purpose types, all utilize such dye images, though there is a wide diversity of order of layer sensitization, emulsion contrast, method of dye formation and type of base used, depending on the manufacturer and the purpose of the material.

Scope of colour printing

The fundamental technique of colour printing is aimed at producing a colour print of an original subject having acceptable density and colour balance. There are various forms of colour printing, depending on the materials employed; these may be subdivided into the two classes of *negative-positive* printing and *positive-positive* printing. In the former, a colour negative is printed on to colour print material which is subsequently colour developed to give the final positive result. In the latter, a colour transparency is printed onto colour material which is reversal-processed, using either chromogenic development, dye-destruction or dye-diffusion techniques. These processes may be further extended if devices such as colour intermediates or masking techniques are required.

Other forms of printing from colour originals (negative or reversal) include the making of monochrome prints, colour separation matrices for dye imbibition printing, and the production of colour inter-negatives. Figure 22.11 outlines the most common pathways to various end-products, commencing with a colour negative or transparency.

Colour print materials have an opaque white reflecting base that may be of paper, resin-coated paper or plastics to give colour prints for viewing by

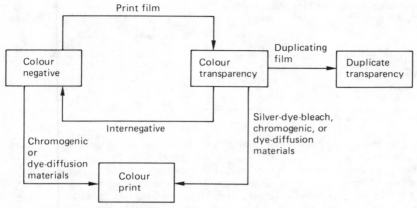

Figure 22.11 Routes in colour printing

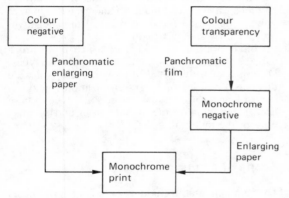

Figure 22.12 Black-and-white prints from colour negatives

reflected light. Alternatively, a transparent base may be used to give a transparency for viewing by transmitted light.

The production of black-and-white prints from colour negatives or transparencies can be carried out via the routes indicated in Figure 22.12.

Variables in colour photography and printing

The accuracy or acceptability of the final colour reproduction, in particular when colour printing by negative-positive techniques, depends on a large number of variables in the reproduction chain. Some are under the direct control of the user, others are not. An abbreviated lists of variables includes:

(1) Nature of the subject and subjective colour effects

(2) Properties of the light source used (intensity, hue etc)
(3) Camera and lens used
(4) Exposure duration
(5) Film batch characteristics, including latent image stability
(6) Film processing
(7) Colour enlarger characteristics, e.g. intensity and hue of light source and filter spectral properties
(8) Print exposure conditions
(9) Colour paper batch characteristics
(10) Colour paper processing
(11) Viewing conditions for the colour print

It might seem that colour printing is a formidable task and that the possible sources of error would make acceptable colour reproduction a difficult achievement. Fortunately, with some care, foresight and methodical operating techniques, it is possible to control most of the variables concerned with the mechanics of print production so that full attention can be given to the problems of print assessment.

Much of the necessary information regarding the use and practice of colour printing is available from the manufacturers of sensitized materials, albeit with the emphasis on their own range of products. There is now almost full compatibility between one manufacturer's products and those of another so that colour negatives taken on one product may be printed on print material from another source. In addition, paper and processing solutions from independent manufacturers are also available.

Colour filtration

Some of the inconsistencies at the camera stage, such as incorrect colour temperature of the source and reciprocity law failure effects, may be wholly or

partially correctable either overall or locally on the print by corrective colour filtration of the enlarger light source. Such colour filtration is the prime control of colour reproduction in the print. By altering the relative proportions of exposures to the red, green and blue sensitive layers of the print material, which respectively yield cyan, magenta and yellow dyes, colour reproduction may be varied at will. The peak sensitivities of the individual layers of colour print materials are matched to correspond more or less with the peak spectral absorptions of the three subtractive dyes used in colour negative materials for any one range of products. However, the individual sensitivities of the three layers of the colour print material vary greatly, to compensate for the particular position of one layer in the coating order and to give adequate separation of spectral sensitivities of the layers without the need for an additional yellow filter layer used in conjunction with the blue-sensitive layer. Also, compensation for the density of the masking layers in masked colour negative materials may also be given by this means. The difficulties of manufacture mean that each batch of colour print material will have layer sensitivities similar to but not identical with other batches. Finally, the overall response of the colour-print material depends on the spectral energy distribution of the light source in the enlarger and any selective absorption by the optical system.

The major role of colour filtration in colour printing is to compensate for such batch differences of materials and for variations in the illumination of the subject. Secondary functions include compensation for differences between enlargers in terms of the quality of light output and the correction of colour casts due to reciprocity-law failure effects. This latter are caused by the unequal response of the three image-forming layers as the image luminance decreases. Colour-filtration is, of course, also a creative tool in the hands of the user, permitting mood and effect to be introduced into prints, for 'correct' colour reproduction is not always the aim.

The necessity of controlling the relative exposures of the three layers of different spectral sensitivity of colour print materials is a fundamental aspect of the design of equipment for colour printing. Two basic methods are used: sequential (or simultaneous) selective exposure of each layer (*additive* printing) or a filtered single exposure, exposing all three layers simultaneously (*subtractive* printing). The two methods involve different sets of colour filters.

Additive (triple-exposure) printing

The colour-print material may be exposed to the colour negative (or transparency) by three consecutive exposures using tricolour red, green and blue separation filters. Thereby, the blue-sensitive layer of the paper emulsion is exposed only to the yellow dye image of the negative, carrying 'blue' information about the subject, the green-sensitive layer only to the magenta dye image and so on. The exposure level for each layer is adjusted by varying the exposure time given, though it is possible to alter the lens aperture instead and retain a constant exposure time. Because of the filters and method used, this printing method is usually referred to as *additive* colour printing.

Overall print density is controlled by the aggregate magnitude of the three exposures. Print colour balance is determined by the ratio of the three exposures. From subtractive theory we can derive tables for the effect of corrective adjustments to final colour balance. Table 22.4 refers to conventional negative-positive printing and positive-positive printing by this method.

Table 22.4 Corrective adjustments when colour printing by the additive method

	Negative-positive printing		Positive-positive printing	
	Remedy		*Remedy*	
	Either	*Or*	*Either*	*Or*
Appearance of test print on assessment	*Increase exposure through this filter*	*Decrease exposure through this filter*	*Increase exposure through this filter*	*Decrease exposure through this filter*
Too dark	–	All three	All three	–
Too light	All three	–	–	All three
Yellow	Green and red	Blue	Blue	Green and red
Magenta	Blue and red	Green	Green	Blue and red
Cyan	Blue and green	Red	Red	Blue and green
Blue	Blue	Green and Red	Green and red	Blue
Green	Green	Blue and red	Blue and red	Green
Red	Red	Blue and green	Blue and green	Red

The advantages of the additive method are that only three filters are needed, obviating the need for an expensive colour enlarger, and that it lends itself to use in colour printers for mass production. The disadvantages are formidable. Foremost is that of registration problems, if the enlarger or masking frame should be moved accidentally between exposures. There is also the possibility of widely differing exposure times for the individual layers. Some users find difficulty in assessment of colour prints and subsequent corrective action for colour and density changes. Finally, local control of density and colour by selective filtration and exposure is not easy to perform, even for skilled printers. However some colour enlargers use *simultaneous additive printing* in which three light sources can be separately varied (time or intensity) and so avoid registration problems.

Subtractive or white-light printing

The preferred alternative for manual colour printing is to give a single exposure of filtered white light instead of three exposures of coloured light. Selective exposure of the three layers with a constant exposure time and lens aperture is made by altering the proportions of red, green and blue light from the source by subtracting the excess amounts using weak colour printing filters of cyan, magenta and yellow respectively.

From the subtractive theory of colour reproduction, it is again possible to derive tables to suggest filtration changes to improve colour reproduction when a test print is assessed. Table 22.5 lists such corrections for negative-positive printing using conventional colour materials. It is worth pointing out that most colour print materials require the use of only yellow and magenta colour printing filters for all corrections.

The following principles on which Tables 22.5 is based, are summarized below for negative-positive printing.

(1) A colour cast is removed by a filter of the same colour.
(2) Colours not included in the filter set are obtained by the combination of two appropriate filters
(3) Filters of all three colours should never be used together, as they produce a neutral grey and simply increase the exposure. Thus a filter selection of 10Y, 20M and 10CV is the same as 10M + 10 grey. In such a case 10Y, 10M and 10C should be removed, leaving 0Y, 10M, 0C.
(4) The more intense the colour of the cast the higher the filter value or density is required.
(5) Filters increase the required exposure depending on their density.

For obtaining acceptable colour prints three major assessments have to be made by the printer. These are the exposure time, the colour, and the intensity of the colour cast. Of these the last two are the most difficult to assess, and are discussed under 'colour print evaluation' on page 311. Even with the most modern automatic printing equipment it is necessary to obtain a correctly-balanced colour print by a series of tests and visual examination of the prints, and to calibrate the system with a standard or representative negative.

Table 22.5 Corrective adjustments when colour printing by the subtractive method

	Negative-positive printing		Positive-positive printing	
	Remedy		Remedy	
	Either	Or	Either	Or
Appearance of test print on assessment	Add filters of this hue	Remove filters of this hue	Add filters of this hue	Remove filters of this hue
Too dark	Reduce exposure		Increase exposure	
Too light	Increase exposure		Decrease exposure	
Yellow	Yellow	Magenta and cyan	Magenta and cyan	Yellow
Magenta	Magenta	Yellow and cyan	Yellow and cyan	Magenta
Cyan	Cyan	Magenta and yellow	Yellow and magenta	Cyan
Blue	Magenta and cyan	Yellow	Yellow	Magenta and cyan
Green	Yellow and cyan	Magenta	Magenta	Yellow and cyan
Red	Yellow and magenta	Cyan	Cyan	Yellow and magenta

Table 22.5 also gives the necessary corrective filtration for colour casts when positive-positive printing is being performed. For this technique it should be noted that an increase in exposure gives a less dense print and vice versa, the reverse of the negative-positive case. Also addition of filtration of a particular colour, e.g. yellow, either gives a more yellow result, or, alternatively, removes a blue cast from a print.

The advantages of white-light printing are numerous. There are no registration problems or intricate calculations of relative exposures. More efficient use is made of the light output available. Local control of density and colour are possible by the usual shading and burning-in techniques with or without filtration. The necessary enlarger modifications may be incorporated in an accessory colour head.

One disadvantage is the higher initial cost of a large number of colour filters or of a colour head for the enlarger. Dye-based filters may fade with use.

Colour enlarger design

The majority of enlargers used for conventional black-and-white printing may be used for colour printing by the introduction of a few modifications, such as a different lamp-house complete with colour filtration arrangements, termed a *colour head*. Enlargers constructed specifically for colour printing are also available.

The particular requirements for a colour enlarger may be considered under a number of headings.

Light source

The light source must have a high light output with a continuous spectrum. Cold-cathode lamps are unsuitable because of their deficiency of red light. The additional requirements of a useful life with constant output and colour temperature as well as compact size make tungsten-halogen lamps an obvious choice for suitability. One or two such lamps are used in most colour heads. The lamp envelope may be positioned in an ellipsoidal reflector that reflects visible light but transmits infrared radiation, called a *cold mirror*. Additional forced cooling using a blower may be needed. Other light sources using tungsten filaments such as conventional enlarger bulbs, photofloods and projector lamps are also suitable but less convenient.

Optical components

The enlarger lens should be a well-corrected achromat with a flat field. Optical condensers and other glass components such as negative carriers should be of optical-quality glass and colourless. Pure condenser enlargers are unsuitable for colour printing; a completely diffused illumination system is preferred as the dye images in the colour negative do not scatter light, so there is no appreciable difference in contrast in the results given by either a condenser or difuse illumination system. But scratches and marks on colour negatives do scatter light, so diffuse illumination is preferred to reduce the need for retouching of colour prints. The loss of efficiency due to this form of illumination is more than offset by the reduction of retouching requirements. The diffuse illumination is usually provided by an integrating box above the negative. The filtered light from the enlarger light source is admitted through a small entry port into the integrating box.

Electrical supply

To prevent the occurrence of random colour casts in colour prints it is necessary to stabilize the lamp voltage to within plus or minus 1 per cent. The best way to achieve this is via a constant-voltage mains transformer, though a manual control using a variable resistance and voltmeter (adjusted to, say 210V), is usually satisfactory. Electronic stabilizers are now becoming available. Low-voltage tungsten-halogen lamps, which operate from step-down transformers, are usually less susceptible to mains voltage fluctuations.

Control units are available for colour enlargers which incorporate stepdown transformers, constant voltage transformers, an electronic timer and various unstabilized outlets for safelights and foot-switch control, all in one convenient package.

Timing

It is important to have an accurate timer. Digital timers may now be bought off the shelf, and in their versatility and accuracy they completely supersede the older electromechanical versions. However, skilled printers may chafe at the difficulty of producing shading and local control within the rigid regimes of these instruments.

Filters

Provision must be made for the various forms of filtration. An *infrared absorbing filter* or 'heat filter' must be incorporated in the light path adjacent to the light source, thereby protecting filters, optical components and the negative. The use of cold mirrors alone is insufficient. The heat filter has another function, namely absorption of the infrared

radiation to which colour paper is sensitive, thus removing a possible source of variable results. Similarly, an ultraviolet absorbing filter must be located in the light path, removing this radiation, to which colour paper is sensitive, and which constitutes another source of error. This filter may be glass or plastic.

The colour printing filters may be the tricolour or subtractive varieties. Tricolour filters are of gelatin or glass-mounted. Subtractive filters may be of gelatin, acetate, glass-mounted or interference (dichroic). Location of the filters is discussed in the evolution of colour enlarger design (see below).

Types of colour enlarger

An enlarger suitable for colour printing has to fulfil the requirements given above. Evolution of design has been fairly rapid (see Figure 22.13). The simplest method is to place individual tricolour filters below the enlarger lens for each exposure by the triple-exposure method. A simple filter turret may be used for convenience. Subtractive filtration is also possible in the same position, using gelatin colour-compensating filters (page 138). A selection of densities in the primary and subtractive colours is necessary to permit a *filter pack* being made up using the minimum number of filters. This necessitates some calculations.

The simplest modification to an enlarger is the provision of a *filter drawer* above the condenser lenses or diffuser. Colour-printing filters of low optical quality may then be used. However, it is tedious to make up a filter pack from individual filters. errors are easily made, and the process is time-consuming when an on-easel colour negative analyser is being used. Consequently, the next stage in colour enlarger design was the provision of a graduated filtration set adjusted by use of calibrated dials. By positioning the filters close to the light source only a small effective filter area was needed and the filtered light was then integrated in a suitable manner.

Typical designs included a fan-shaped array of colour printing filters dialled-in, with two lamps and an integrating-sphere; other designs used dyed gelatin-in-glass filters of uniform density, inserted progressively into the light path to increase their filtration effects. The first type was calibrated in filter density values, the second type in arbitrary numbers.

A more recent stage in development has been the introduction of interference filters (page 143), whose filtration effect is varied by progressive insertion or removal from the light path using calibrated

Figure 22.13 Types of colour enlarger. S light source, C condensers, N negative, L lens, I integrating box or sphere, D diffuser, F filter, R infrared absorbing filter. (a) Filters below lens (tricolour or subtractive); (b) filters above condenser (subtractive); (c) integrating sphere with subtractive filtration; (d) dichroic filters (subtractive); (e) three lamps with tricolour filters and integrating sphere

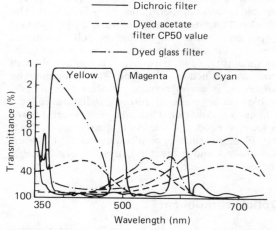

Figure 22.14 Spectral transmittance curves for different types of subtractive colour printing filters

controls reading in optical densities. Yellow, magenta and cyan filters are used. The comparative spectral transmission characteristics of dyed acetate, dyed glass or gelatin-on-glass and interference filters are given in Figure 22.14. The advantages of interference filters are improved spectral transmission properties and freedom from fading.

A hybrid form of colour head on an enlarger uses three identical light sources that are filtered red, green and blue respectively to the required amount, the three coloured beams being integrated to give a synthesized white light of the desired spectral energy distribution for the colour printing conditions (Figure 22.13e).

Further refinements to colour enlargers include the provision of some form of colour negative evaluation to assist selection of the correct filtration to give an acceptable result. This may take the form of filtered photocells inside the enlarger bellows or a unit that is inserted below the lens. They are simplified versions of the highly-automated circuitry of colour printers, and are a worthwhile addition.

More recent innovations in colour enlargers include the automation of changes in magnification by computerized motor control, autofocus, and full automation of exposure asessment. There is also a trend towards daylight operation and the combination of enlargers with paper-processing machines for mini-labs. Figure 22.15 illustrates a compact daylight colour enlarger which has cartridges or magazines for the paper and is fully daylight-operational. It is possible to convert some traditional enlargers for daylight operation by provision of an accessory shield and paper cassette or loading device, as shown in Figure 22.16. A daylight enlarger combined with a paper-processing machine is illustrated in Figure 22.17. This type of equipment is used in mini-labs and is capable of producing about ninety 8 × 10 inch colour enlargements per hour from 35 mm negatives. These daylight enlarger/print processors have been derived from equipment that has been used for many years by large-scale processing laboratories to cater for the requirements of the increasingly popular mini-labs.

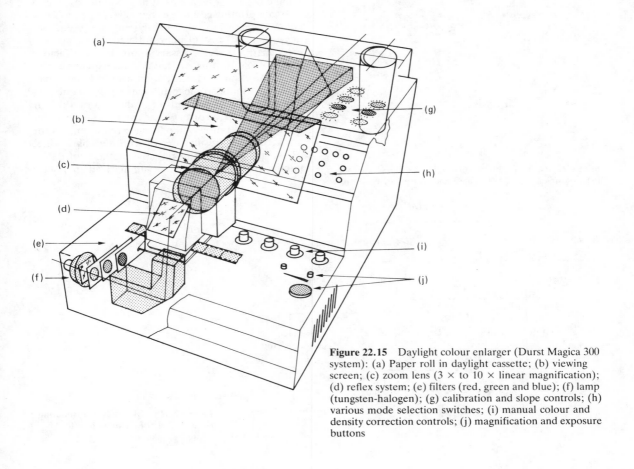

Figure 22.15 Daylight colour enlarger (Durst Magica 300 system): (a) Paper roll in daylight cassette; (b) viewing screen; (c) zoom lens (3 × to 10 × linear magnification); (d) reflex system; (e) filters (red, green and blue); (f) lamp (tungsten-halogen); (g) calibration and slope controls; (h) various mode selection switches; (i) manual colour and density correction controls; (j) magnification and exposure buttons

Figure 22.16 Daylight conversion kit for *Durst* enlargers: (a) Colour enlarger; (b) light shield; (c) paper cassette

Figure 22.17 A daylight enlarger fitted with a paper-processing unit (*Copal*)

Methods of evaluating colour negatives for printing

Unlike black-and-white printing, it is not possible to estimate printing conditions by visual inspection of a colour negative. Consequently, in the absence of any other aid, test prints combined with trial-and-error methods are necessary to obtain a satisfactory result. Colour print materials are expensive and their processing times are significantly longer than those of monochrome print paper. Consequently, any instrumental methods of evaluation of a colour negative to give a correct or near-correct estimate of the colour filtration and exposure requirements for an acceptable result are of considerable value. There are a number of possible methods of determining printing conditions, summarized in Figure 22.18.

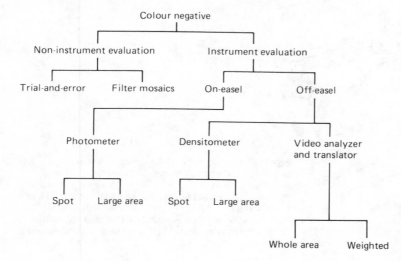

Figure 22.18 Methods of evaluating or assessing colour negatives for white-light colour printing

Non-instrument methods

Colour printing by trial and error is not recommended as a routine, but it is the only method of obtaining a first-quality print when first using new equipment and new batches of print material. Additionally, even when an instrument evaluation method is to be used with the enlarger, it is first necessary to produce such a print by trial and error from a master negative. From the printing data thus obtained, the colour negative evaluation system may be set up for subsequent use. A master negative is one taken specially for the purpose, containing a selection of suitable reference areas, colours and a reflectance grey scale. Care is taken over its exposure and processing. A master negative is required for each colour negative material to be used.

The use of a filter mosaic may be an improvement over trial and error methods. For white-light printing an array of representative filter packs are assembled and put in contact with the negative or print material during exposure. The image area with best colour balance is selected and the corresponding filter values used as a basis for more tests or for a final print. Alternatively, an integrating method may be used with the mosaic on the print material, by putting a piece of diffusing material over the enlarger lens. The image patch closest to neutral grey is then determined and the corresponding filtration used. Exposure determination is a separate problem. Suitably filtered step-wedge arrays may be used to determine exposure data for additive printing.

Instrument methods

Various instruments are available for use either *off-easel* or *on-easel*. Off-easel evaluation consists of measuring or evaluating the colour negative alone, before insertion into the enlarger. A *colour densitometer* may be used and can service a number of enlargers. The technique depends on setting up with a master negative. The known filter pack densities for this negative with a particular enlarger are added to the corresponding image dye densities of the chosen reference area, as measured by the colour densitometer. A negative to be printed is measured similarly, and its densities subtracted from the total densities of the master negative plus filter pack to give the required filter pack. No direct indication of exposure is given, and separate on-easel photometry may be required for this purpose, though exposure may be determined from off-easel measurements and knowledge of the example required to print the master negative. Although this method uses a densitometer, and evaluation is done in room light conditions, calculations are necessary and no allowances are made for the fading of colour filters, the ageing

of the enlarger lamp or any alteration in magnification.

A very accurate method of off-easel evaluation, when printing conditions such as magnification and paper batch characteristics are accurately known, is by the use of a *colour video analyser*. The colour negative is scanned in a closed-circuit colour television system and a positive colour image on a monitor screen is manipulated until the required result is given. The calibrated colour balance and density control settings are recorded and related to printing conditions by a translator device during printing.

On-easel evaluation is an application of image photometry with measurements of image illuminance made in the image plane on the enlarger baseboard. Such photometers, or *colour negative analysers*, require high sensitivity for this task as measurements are taken through tricolour filters. This is especially so when coupled with difficult printing conditions such as a dense negative, high-value filter pack and high magnification. Photomultiplier tubes and the necessary stable control circuitry have enabled suitable instruments to be made. Also, silicon sensors are finding application in this role. On-easel measurements are conveniently made using a small probe on the baseboard connected to a fibre-optics light pipe to convey the light from the area sampled to the main body of the instrument.

To use an easel photometer, a master negative with known filter pack is inserted into the enlarger, and image illuminance measured in the chosen reference area through red, green and blue tricolour filtered sensors, and finally without filters over the photocell. The instrument scale is zeroed for each condition by means of *attenuators* (small potentiometers). Many instruments have resettable attenuators, or several sets of four forming a 'memory' unit for different batches of paper. The new negative to be printed is inserted and, for the same photocell filter conditions, the subtractive filtration and lens aperture are altered to zero the instrument at each setting. Zeroing the instrument may be by setting a meter or digital display reading to zero, or by adjustment of the attenuators to light a small lamp. Dial-in filtration is a great help. After evaluation, a fixed exposure time at a suitable aperture is given to the colour paper to reduce the effects of reciprocity-law failure.

The great advantage of the easel photometer technique is that measurements allow for filter fading, lamp ageing and image magnification. Exposure and filtration are given directly. A disadvantage is that readings have to be made in darkroom conditions. Both on-easel and off-easel methods of evaluation rely for their potential accuracy on the choice of an appropriate reference area, as mentioned above. There are two methods available, *small-area* or *spot measurements* and *large-area* or *integrated measurements*. Small-area measurements

coupled with an on-easel technique are more accurate. The colour negative should contain a suitable reference area such as an 18 per cent reflectance grey card or a skin tone or other preferred colour. This area should receive the same lighting as the significant subject matter but can be positioned in an unimportant region such as the edge of the negative area.

Unfortunately, it is not always possible to include a small reference area. The subject may be back-lit or inaccessible to the photographer. Also, amateur colour negatives are not made with such requirements in mind. Consequently large-area measurements have to be made, usually from the whole negative area, hence the term 'integrated' readings. For off-easel densitometers, a large photocell may be used to take such readings. Alternatively, as for on-easel photometers, the image may be integrated by interposition of diffusing material between negative and photocell. The various filter readings may then be taken.

The integration technique must also be set up on the basis of a master negative but one that is also typical in terms of both colour and tonal distribution of the subject matter. The *integration-to-grey* of such a typical subject is the evaluation principle used, as in automatic colour printers. Unfortunately, a small but significant number of negatives contain non-typical colour or tonal distributions. One consequence is that predominance of one colour in the subject leads to a colour print with an overall colour cast of the complementary colour. Such a result is called *subject anomaly* or (incorrectly) 'subject failure'. Corrective measures are possible with automatic printers.

An interesting approach to this problem is a technique of off-easel evaluation whereby a large number of asymmetrically distributed spot readings

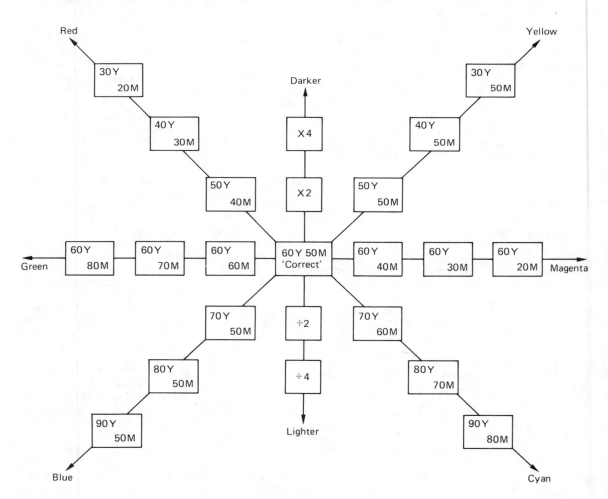

Figure 22.19 A ring-around series with units of 10 in filtration

are taken of the colour negative and average values calculated for determination of printing conditions. This is a form of weighted large-area measurement. With the advent of microcomputers, sophisticated systems of assessment can be manufactured at modest cost. These are capable of carrying out complex calculations on a large number of readings to give a high proportion of acceptable prints even with awkward subject anomalies.

Colour print evaluation

The evaluation or judgement of the colour balance of colour prints for acceptance or rejection and subsequent correction is perhaps the most difficult part of colour printing. To begin with, the printer may have no knowledge of the subject matter or the print colour balance that the client prefers. It is possible, however, to reduce some of the variables involved in appraisal so that final judgement is subjective and dependent on the printer's experience and opinion.

To begin with it is essential that the viewer has normal colour vision. A variety of clinical tests are available and used to determine the degree of normal or defective vision, as some 8 per cent of the male population are deficient in this respect. Viewing conditions are of the greatest importance. If possible, colour balance should be assessed under the same conditions as those under which the finished colour print will be viewed. The properties of the light source can influence the apparent colour

balance markedly. In the absence of such knowledge, assessment under standard viewing conditions is advised. The current recommendation is to use a suitable light source, which, if of the fluorescent type, has a colour rendering index (page 12) close to 100 and a correlated colour temperature of 5000 K. Illuminance should be 220 ± 47 lx for viewing prints or a luminance of 1400 ± 300 cd/m² for viewing colour transparencies.

Assistance as to the necessary corrective change in colour filtration may be given by using either *viewing filters* or a *ring-around set*. Viewing filters are colour printing filters, and a filter pack is made up by trial and error so that when looking at the print through the pack, an acceptable colour balance is seen. Colour adaptation is a problem. If such a pack is found, the corrective action is to add to the enlarger filter pack filters of the complementary hue that are half the density values of the visual pack. However, this method suffers from a number of drawbacks.

A 'ring-around set' of colour prints is a set of prints made from a master negative, each print having a known systematic alteration in colour balance or density. The test print may be matched to one of these prints and the known deviation taken as a basis for correction. The procedure for preparing a ring-around set is shown in Figure 22.19, starting with a correctly-balanced and correctly-exposed print, in this case shown as requiring filtration of 60Y (yellow) and 50M (magenta). Changes of 10 units are illustrated in this example, as well as changes of exposure of × 2 and × 4. The colour casts increase with distance from the centre.

23 After-treatment and archival aspects of the processed image

It is sometimes necessary to treat a photographic image after it has been processed. There are treatments for errors in exposure or processing, modifications of the image colour, treatments to make images last for long periods of time, and techniques for removing blemishes from negatives and prints. Two important after-treatments are *reduction*, or lowering of the density of the processed negative or print, and *intensification*, or increasing its density. These techniques are seldom necessary with modern black-and-white materials because of their considerable exposure latitude, but they do find application in monochrome prints for special effects and in retouching to remove artefacts.

Although similar after-treatments are not generally applied to colour materials (other than for local retouching), colour transparencies may have their densities reduced, either uniformly, to correct for underexposure, or selectively, to correct colour imbalances. Sometimes it may be desired to change the colour of a black-and-white image entirely or partially, for special effect or to improve its long-term stability. This process is known as *toning*.

In this chapter we will also consider archival aspects of images. In recent years there have been a number of significant improvements in materials and processes, particularly colour systems, which ensure that images remain almost unchanged when properly processed and stored. As there is much overlap in the chemical principles underlying the above treatments, it makes sense to gather them together in a single chapter.

Reduction

The process of 'reduction' of silver images is concerned with the removal of some of the silver from various parts of the image. This is *not* a process of reduction in the chemical sense; it is oxidation; silver is oxidized in the 'reducer' solution, and converted into a compound which is soluble in the solution. The process is the same as that described under bleaching of silver images in Chapter 18. Many reducers have been evolved, over the past century and a half. They can be classified according to the way they modify the characteristic (H & D) curve (Figure 23.1). The main classes of reducers are:

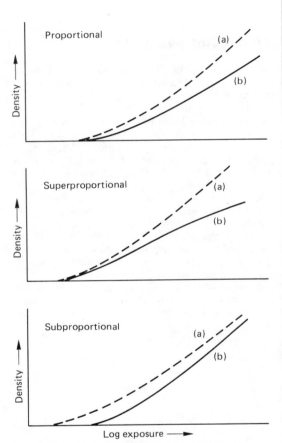

Figure 23.1 Various types of intensification and reduction: Changes from curves (a) to (b) = reduction, changes from curves (b) to (a) = intensification

(1) *Proportional* In proportional reduction all densities are lowered in the same ratio. The action of a proportional reducer is thus something like development in reverse.

(2) *Superproportional* The reduction ratio for the higher densities is greater than that for the lower ones.

(3) *Subproportional* The reduction ratio for the higher densities is lower than that for the lower ones.

(4) *Subtractive (cutting)* A special case of subproportional reduction where all densities of the image are lowered by an approximately equal amount. All practical subproportional reducers tend to approach a subtractive action so that the term 'subproportional' is rarely used.

Examples of these classes of reducers are given in Table 23.1.

Table 23.1 Photographic reducers

Class	Chemical type	Formula
Proportional	Permanganate persulphate with sulphuric acid	p.371
Superproportional	Ammonium persulphate with dilute sulphuric acid	p.371
Subtractive	Ferricyanide thiosulphate ('Farmer's') Iodine/thiosulphate	p.371

For the reduction of colour transparencies dye-bleach solutions are available, either as formulae published by the film manufacturer or as proprietary solutions. These act by oxidative destruction of the image dyes or by their conversion to a colourless form by the chemical process of reduction. Reduction of dyes can be selective; acting on a single cyan, magenta or yellow image dye, or acting on all the dyes at the same rate. Alternatively the transparency may be duplicated with the appropriate choice of filters and exposure to correct for under-exposure or colour casts in the original.

Intensification

The increased density produced by intensifiers is achieved in varying ways, e.g.

(a) by converting the silver image to a form of silver having greater covering power, or

(b) by converting the silver into a compound which is more opaque to light, or

(c) by the addition of silver or other metal atoms to the existing image.

Intensification generally involves first bleaching the silver image to convert it to an insoluble silver compound such as silver chloride, and then re-developing this silver compound in a solution which enhances the covering power of the silver or provides additional metal atoms to increase the density of the image.

A convenient classification of intensifiers, in terms of their relative action on the various densities of the silver image is as follows (Figure 23.1):

(1) *Proportional* All the densities of the image are increased in the same ratio. The action of a proportional intensifier may be regarded as equivalent to increased development.

(2) *Superproportional* The intensification ratio for the higher densities is greater than that for the lower ones.

(3) *Subproportional* The intensification ratio for the higher densities is lower than that for the lower ones.

Examples of these classes of intensifiers are given in Table 23.2.

Table 23.2 Photographic intensifiers

Class	Chemical type	Formula
Proportional	Chromium	p.371
Superproportional	Copper-silver	
Subproportional	Quinone-thiosulphate Uranium	p.372

After-treatment of prints

The process of overall reduction or intensification of black-and white prints is rarely carried out because it is usually possible to reprint an unsatisfactory print. (In the case of old yellowed and faded prints it is better to copy the print onto a suitable negative material using an appropriate colour filter and then to print the new negative, rather than to attempt any chemical treatments on what may be a unique and irreplaceable item. By this technique prints far superior to the yellowed and faded original can be produced.) However local reduction of large prints is sometimes carried out, and a subtractive reducer of the iodine/thiosulphate type is probably the most useful. Intensification of black-and-white prints by almost any process generally produces unacceptable changes in image colour. Simple marks and blemishes on black-and-white prints can be retouched by pencil or water colour or retouching dyes applied with a fine-tipped brush. Similarly colour prints can be retouched using special dyes. Black spots or marks in black-and-white prints on conventional baryta paper may be removed by careful scraping with a sharp knife or razor blade, followed by retouching by one of the methods described above. However for black-and-white prints on resin-coated paper and for colour prints, black or dense coloured marks are best removed by means of a chemical reducer (silver bleach or dye bleach) before retouching (see Appendix).

Toning

For certain purposes it may be desired to change the colour of a photographic image by means of *chemical toning*. Toning is mainly applicable to prints, but may also on occasion be desired with films or plates, e.g. for making slides or other forms of transparency.

The main methods in general use may be classified as follows:

The silver image is converted into silver sulphide (or silver selenide) Silver sulphide and silver selenide have brown and purple colours, much warmer than that of the usual silver image, so that these processes are referred to as *sepia toning* Silver selenide toning provides a means of obtaining very stable images and is less expensive than gold toning which provides the most stable images. However, selenium compounds are toxic, as are sulphides, and should be handled with caution. Indeed, *all* toning solutions should be handled carefully, and discarded with caution.

Sulphide toning is probably the most widely used form of toning, and properly carried out yields images of great permanence. Various formulae for sulphide toning exist: in one the image is first bleached in a ferricyanide-bromide solution and then redeveloped in a solution of sodium sulphide or thiourea, according to the following reactions:

Silver + ferricyanide + bromide → Silver bromide + ferrocyanide

Silver bromide + sodium sulphide → silver sulphide

In another, toning takes place in a single operation by immersing the prints in a 'hypo-alum' bath at 50°C. For formulae, see Appendix.

The silver image is replaced by means of a series of chemical reactions producing a compound of some other metal. The compounds produced are usually ferrocyanides. For example, for the single-solution copper ferrocyanide toner the following reaction occurs:

Silver + copper ferricyanide → Copper ferrocyanide (reddish-brown) + silver ferricyanide

Some of the metals used are shown in Table 23.3.

The silver image is replaced by means of colour development producing a dye image This process is essentially similar to the production of the dyes in the three layers of a colour film. Black-and-white prints produced in the normal way are bleached and redeveloped in a colour developer, i.e. a developing solution containing colour couplers (see Chapter 24). A wide range of tones may be produced by such processes of colour development. Special kits are available commercially for this and other types of toning.

The silver image is converted to to a silver compound to which dyes are firmly bound (mordant or dye-toning) This process of toning involves bleaching the silver image to silver iodide or cuprous thiocyanate to which a number of basic dyes can become firmly adsorbed after immersion in an acidic solution of an appropriate dye (0.2% of dye in 0.1% acetic acid solution):

Silver + iodine/potassium iodide → silver iodide

Silver iodide + dye → silver iodide − dye

Table 23.4 lists some typical dyes and their colours.

Table 23.4 Examples of dyes used in dye toning

Colour	Dye
Yellow	Auramine, Thiaflavine
Red	Safranines, Fuschines
Green	Malachite Green, Methylene Green
Blue	Methylene Blue, Thionine Blue

Also overall dyeing of prints can be carried out with dyes which have an affinity for gelatin. Various domestic dyes used for cold-water dyeing of textiles can be used in this simple process.

Archival properties of images

No image can be regarded as permanent, and all images degrade in various ways when stored for long

Table 23.5 Causes of deterioration in photographic materials

Effect	Cause
Overall yellow stain	Residual chemicals (thiosulphate, silver-thiosulphate complexes)
Image fading and yellowing	As above
Brown spots	Localized retention of above
Local or general damage	Bacterial or fungal attack on gelatin, degradation of gelatin and paper fibres by acidic atmospheric gases
Microspots (red/yellow)	Oxidizing atmospheric gases
Dye fading	Dark reactions and/or light-induced reactions of image dyes

Table 23.3 Metallic toners (coloured ferrocyanide)

Metal	Tone	Formula
Copper	Reddish-brown	p.373
Iron	Prussian-blue	p.372
Uranium	Orange-brown	
Vanadium	Yellow	

periods. In chapters 18 and 21 attention was drawn to the importance of properly fixing and washing black-and-white films and prints to avoid fading and yellowing on storage. However, even if photographic materials are properly processed they may suffer from any of several forms of degradation in the long term. A summary of the types of degradation and their causes for both monochrome and colour materials is given in table 23.5.

Processing conditions

Development conditions recommended by the manufacturer should be followed. Generally fine-grain images are more susceptible to degradations than larger-grain images. Prints are more susceptible than negative materials.

Acidic stop baths can influence the keeping properties of silver images. Excess acetic acid in the stop bath may cause some papers to become brittle on drying and subsequent storage. Also with carbonate-buffered developers excess acetic acid may cause bubbles of carbon dioxide gas to be formed in the paper fibres of prints. Thiosulphate and silver-thiosulphate complexes can become trapped in these bubbles and may not be readily washed out. This in turn can cause localized spots of silver sulphide to be formed on storage.

The importance of proper fixing and washing, together with appropriate procedures and test methods, has been described in detail in Chapters 18 and 21. Minimum permissible levels of thiosulphate ion for some photographic materials are specified in the standard ANSI PH 1.41–1984. For example, the limit for a fine-grain material is 0.007 g/m^2. For maximum stability of silver images it is usually recommended that all thiosulphate be removed by thorough washing or with the aid of a hypo-eliminator when a short wash time is used*. Archival keeping properties are greatly improved by the use of a selenium or gold-protective toning treatment (see Appendix).

Storage conditions

Most of the harmful effects summarized in Table 23.5 are aggravated by high temperatures and high relative humidities. In fact, subjecting processed photographic materials to such conditions is used as a test procedure for accelerated ageing techniques to find optimum processing and storage conditions and for research into the causes of deterioration. The

American Standard ANSI PH 1.41–1984 specifies as an image stability test incubating the material for 30 days at 60°C ± 2°C and a relative humidity of 70% ± 2%, and states that 'The film image shall show no degradation that would impair the film for its intended use.'

When storing photographic materials the temperature should not exceed 21°C and the relative humidity should be kept within the range of 30–50%. For archival storage a lower temperature and relative humidity is recommended (10–16°C and relative humidity of 30–45%). This represents a practical compromise for air-conditioning. Also the materials should be protected from harmful atmospheric gases (discussed in the next section). Photographic materials should be protected from the light. Recent tests have shown that subjecting silver materials to high-intensity simulated daylight (5.4 kilolux or 5400 lumens per square metre) accelerates the yellowing of images in processed materials containing small amounts of thiosulphate ion.*

The materials in which photographic records are stored as well as the processing conditions and the storage environment, are also of the utmost importance. Suitable materials for the storage of processed photographic films, plates and papers are specified in the standard ANSI PH1.53–1984. Generally, wood and wood products (plywood, chipboard, hardboard etc), formaldehyde-based plastics, polyvinyl and acrylic plastics containers should not be used. These materials may contain residual solvents, catalysts, plasticizers etc which are known to have harmful effects on photographic materials, as can many adhesives, inks and marking pens. Preferred storage containers are those made from anodized aluminium or stainless steel, or cardboard boxes made from acid-free high-alphacellulose fibres that are lignin-free and sulphur-free. The latter also applies to mounting boards for prints, envelopes for negatives etc. Fortunately there is now an increasing number of specialist suppliers of archival storage materials for processed photographic records; these are able to supply 'archival' polypropylene or polythene sleeves and envelopes for the storage of negatives and slides, also files and boxes of appropriate archival materials.

Atmospheric gases

There are many pollutants present in the environment which can have deleterious effects on photographic materials. These include oxidizing gases such as hydrogen peroxide, ozone, oxides of nitrogen, peroxides and peroxy radicals emitted by car exhausts, paints, plastics, acid rain and sulphur compounds. The general effects of oxidizing gases are to induce yellowing and fading of the image at the

*However, more recent investigations have shown that for archival purposes it is better that the material contains a very small amount of thiosulphate, e.g. 0.03 g/m^2 for microfilms.

edges of the print or negative where the atmosphere has been able to penetrate most readily. This staining may be dichroic, appearing grey by reflected light and yellow by transmitted light. Low concentrations of oxidizing gases such as hydrogen peroxide can produce *microspots*. In prints these spots appear as yellow, orange or red spots depending on the size of the silver particles, and if clustered near the surface may appear as a silver mirror. The mechanism by which microspot formation occurs involves an initial oxidation by the gas which converts silver metal to mobile silver ions. The silver ions migrate away from the silver filaments of the image and become reduced to metallic silver by the action of light, or are converted to silver sulphide by hydrogen sulphide present in the environment. This process forms microspots of approximately 60 μm or larger in diameter, comprising a concentric ring structure of particles of 5–10 nm to 0.5 μm in diameter. In laboratory experiments, using accelerated ageing techniques at 49°C and 80% relative humidity, it has been shown that microspot formation occurs with a concentration of hydrogen peroxide of 500 ppm.

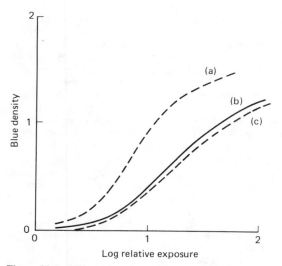

Figure 23.2 Effect of toning on image stability to hydrogen peroxide: (a) Untoned image after 3h, 5% hydrogen peroxide; (b) original image, no treatment; (c) toned image, after 3 h, 5% hydrogen peroxide

Protection against attack by oxidizing gases can be given by selenium toning. Figure 23.2 shows the degree of protection that is possible with this toning treatment when the material is subjected to an extreme test using 5% hydrogen peroxide.

Acidic atmospheric gases, often present in the environment, can degrade gelatin and paper base materials and some form of protection from these in storage is necessary for archival permanence.

Dye fading

All dyes fade to some extent and photographic images comprised of dyes are no exception and cannot be regarded as of archival quality. However, manufacturers have paid considerable attention to minimizing dye fading, and modern colour photographic materials are capable of lasting for many decades if properly stored and processed. Agfa-Gevaert claim a 100-year dark-storage capability for their current generation of colour-print materials.

The only really effective method for achieving archival permanence for colour materials is to convert them to black-and-white records by making separation positives or negatives (see Chapter 14) and to process and store these under the conditions discussed in the earlier sections. These black-and-white separations can then be reconstituted as full colour images as required, using appropriate photographic or electronic techniques.

Some dyes are inherently more stable than others. For example, those used in the dye-transfer process, those present in silver-dye-bleach materials, and metal-based dyes, are generally more resistant to certain types of fading than those formed in chromogenically developed materials (see Chapter 24). Unless stated otherwise, considerations of dye fading which follow have been applied to chromogenic materials. The fading of dyes has two causes, categorized as 'dark fading' and 'light fading'. Different mechanisms for the destruction of the dyes are involved for these two types of fading; dark fading involves chemical reactions which depend upon on the structure of the dye. These aspects will be considered separately.

A problem with colour materials is that image dyes fade at different rates; this results in a change in colour balance. Also, there is no universally-agreed criterion by which fading is judged or of the degree of fading that can be tolerated. Most manufacturers have adopted a criterion of a reduction in density of 10% (i.e. 0.1 from an original density of 1.0), though it has been argued that greater changes than this may be acceptable to the average observer. This quantitative measure of dye fading, rather than one concerned with quality, has been termed a *just noticeable difference*. It provides a useful criterion for the comparison between different products when treated in the same way for laboratory evaluations of dye stability.

Predictive tests for dye fading are being undertaken by all manufacturers, but at present there is no guarantee that these tests will predict precisely what will happen under actual conditions of storage. A further difficulty is that there are at present no internationally-agreed standards on procedures and conditions for carrying out fading tests on colour materials. This means that published data must be interpreted and compared with care, especially if differing test conditions have been used.

Dark fading

As with silver-based materials, the dark fading of image dyes is influenced by temperature, relative humidity and the chemistry of the environment. Common atmospheric gases that can cause dark fading of dyes are oxides of sulphur and of nitrogen, and ozone; but these are insignificant when compared with other causes. As with black-and-white images, dye images are affected by errors in processing. Dark fading is accelerated by the presence of residual thiosulphate ions. Inefficient washing of colour materials not only leads to incomplete removal of thiosulphate and other harmful chemicals but also can leave the material with a low pH value, which has also been shown to accelerate dark fading. These causes of poor keeping properties are avoidable if correct processing procedures are adopted.

The main reactions responsible for dark fading in chromogenic materials are those involving hydrolysis and oxidation-reduction reactions which cause the dye to be converted into a colourless form, or into forms that are different in colour from the original dye. Hydrolysis is decomposition by water and is accelerated by extremes in pH value as well as humidity and temperature. Yellow dyes are particularly susceptible to this form of destruction, whereas cyan dyes are susceptible to reduction to a colourless form by residual thiosulphate ions, ferrous ions or other reducing agents present in the material or the environment. An understanding of the mechanisms involved has led to the present generation of chromogenic materials which contain colour couplers that form image dyes with greater resistance to dark fading than earlier materials. The predictive tests for dark fading involve accelerated ageing tests carried out under a fixed relative humidity (40%) at elevated temperatures for long periods of time.

This procedure is based on the classical *Arrhenius* equation which is given below in a simplified form:

$$\log_e k \propto \frac{1}{T}$$

where k is a measure of the rate of dye fading and T is the thermodynamic temperature in kelvins. If a plot of $\log_e k$ against $1/T$ for a number of temperatures gives a straight line, then it is possible to extrapolate the straight line to other temperatures to predict the rate of fading. Also it has been shown for dark fading that $\log_e k$ is proportional to $\log t_{10\%}$, where $t_{10\%}$ is the time required to fade 10% of dye from an original density of 1.0. Hence from the simplified form of the Arrhenius equation:

$$\log_e t_{10\%} \propto \frac{1}{T}$$

In practice $1/T$ may be plotted against $\log_{10} t_{10\%}$ as shown in the lower graph in Figure 23.3.

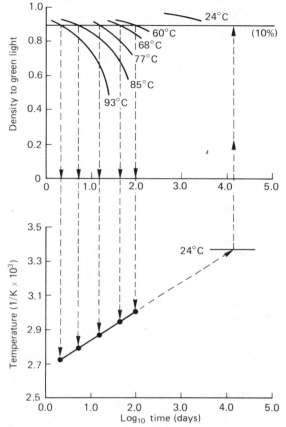

Figure 23.3 Dark fading of a magenta dye

The application of this procedure for the dark fading of a magenta dye is shown in Figure 23.3, and its use for predicting dark fading, at a temperature at which fading would take too long to measure, is given below. Dark-fading figures for temperatures ranging from 24° to 93°C at 40% RH are shown as the full curves in the top graph of green density D_g against \log_{10} time (in days). A horizontal line is drawn at the 10% fade level criterion. Where this line crosses the actual fading curves a vertical line is drawn to the lower graph where the temperature ($1/T$ in kelvins) is plotted against the log of the fading time ($\log_{10} t_{10\%}$). The linear relationship obtained is shown by the line joining the full circles. Extrapolation of this line to the required temperature of 24°C is shown as the broken line. Translation of this point vertically back to the top graph horizontal line labelled 10% gives the predicted value for the fading of the dye to the 10% level, from which it can be seen that this dye would fade 10% in antilog 4.1 days, i.e. 34 years. This procedure could be repeated for other fading levels and by this means a complete fading curve would be predicted.

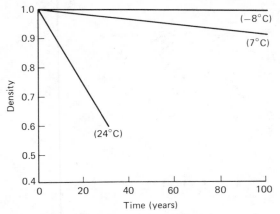

Figure 23.4 Dark fading of a cyan image dye at various temperatures

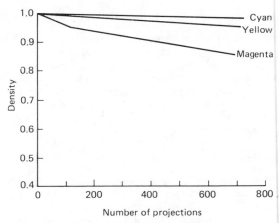

Figure 23.5 Typical light fading of a neutral-patch image of a colour reversal film

This procedure provides a predictive technique for manufacturers and researchers, and typical fading results are shown in Figure 23.4. From this it can be seen that in order to reduce dye fading to a minimum a low storage temperature should be used. If refrigerated storage conditions are used to minimize dark fading, the materials will have to be enclosed in suitable sealed containers and, because the relative humidity increases as the temperature is lowered, the photographic materials must be preconditioned at low relative humidities (25–30% at 20°C) before they are sealed in their containers. The practical conditions for storage given earlier also apply to colour materials and are relatively easy to achieve without the use of costly refrigeration facilities. Colour materials such as slides can be duplicated every few years and good colour fidelity maintained for generations; colour negatives can be reprinted.

Light fading

Predictions from light fading tests carried out in the laboratory are less easily made than those from dark fading. Light fading of dyes depends on the intensity, duration and spectral energy distribution of the light to which they are subjected. These vary considerably with the display conditions under which the materials are viewed. The fading of dyes is a photochemical reaction in which oxygen is involved, and leads to destruction of the dye. This photochemical fading is increased by high humidities.

Two laboratory methods are used for investigating light stability, relating to the viewing and display conditions. Slides can be subjected to hundreds of projections in a slide projector and decreases in density for neutral and colour patches measured and plotted against the number of projections. Results for a reversal film neutral patch of density 1.0 are shown in Figure 23.5. Most reversal films follow the trends shown in this figure, but there are variations

between different products, and current films are likely to show less steep curves or better light stability.

Colour-print materials are usually exposed to an intense xenon source (5.4 kilolux at 40% relative humidity), and the time taken for a fixed loss in density (10% or 20%) used as a measure of the light stability (from graphs of density against time). Figure 23.6 shows the progress made in light stability for chromogenic printing papers. Each generation of paper shows a distinct improvement in light stability. This trend continues, with current materials showing considerable resistance to light fading. Colour prints are now claimed to have a useful life of 20 years in typical home-display conditions. Improvements are being made by all manufacturers of chromogenic print materials; modern materials are almost as stable to light as dye-transfer prints (which can be regarded as a standard with which other materials are compared). Silver-dye-bleach materials are particularly resistant to light fading.

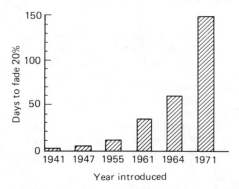

Figure 23.6 Light stability of Kodak Professional colour papers. Results expressed as time for 20% density loss of the least stable dye from a neutral patch

24 The chemistry of colour image formation

We saw in Chapter 14 that the image of a subject may be analysed in terms of blue, green and red light content. It is usual in colour photography to control these portions of the visible spectrum by means of yellow, magenta and cyan dyes respectively. In this chapter we shall be concerned with three important methods of producing the dye images commonly encountered in colour photography. The methods rely on the generation of dyes, the destruction of dyes, and the migration of dyes respectively. We shall consider each of them in turn.

Chromogenic processes

Generation of dyes

Most commercial colour processes and a number of monochrome processes employ a processing step in which the generation of image dyes takes place. This dye-forming development gives the name *chromogenic* (colour-forming) to such processes. Such a dye-forming solution is called a *colour developer* and in this solution image dyes are generated alongside the development of metallic silver. Two important chemical reactions take place in a colour developer:

(1) Silver halide grains which have been rendered developable by exposure to light, or otherwise, are reduced to metallic silver and the developing agent is correspondingly oxidized:

Developing agent + silver bromide →
 developer oxidation products
 + metallic silver + bromide ion

(2) Developer oxidation products react with chemicals called *colour formers* or *colour couplers* to form dyes. Colour developing agents of the substituted paraphenylenediamine type are used in practice, and the colour of the developed dye depends mainly on the nature of the colour former:

Developer oxidation products + colour former
 → dye

Colour photographic materials

The dye-forming development reaction allows us to generate dyes of the required colours, yellow,

magenta, and cyan, to control blue, green and red light respectively. To take advantage of colour development it has been necessary to make special photographic materials of the integral tripack variety described in Chapters 14 and 16. This means that light-sensitive emulsions are coated in three layers on a suitable support; the construction is shown in Figure 16.8. The records of blue, green and red light are made independently in the three emulsion layers. The resulting layer sensitivities are illustrated in Figure 16.9.

The demand for high film speeds and improved quality have led to important developments in the technology of colour film assembly in recent years. Some of these changes are revealed by obvious but microscopic structural changes, and one such departure from the conventional tripack is shown in

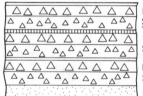

	Supercoat
	Fast blue-sensitive
	Slow blue-sensitive
	Yellow filter
	Fast green-sensitive
	Slow green-sensitive
	Interlayer
	Fast red-sensitive
	Slow red-sensitive
	Film base

Figure 24.1 Cross-section (not to scale) of a modern colour-negative film. Note the double-coated emulsion layers with fast components coated above the slow

Figure 24.1. In order to obtain the required latitude it is customary to include two separate emulsions, a fast and a slow component of similar spectral sensitization, in each layer of a tripack colour film. This arrangement usually gives the highest sensitivity when the fast component is coated above the slow and therefore has the greatest possible access to the incoming radiation. Each sensitive layer of the elementary tripack construction is then coated as a double layer and the colour-former: silver ratio in each component may be manipulated independently to optimize sensitometric and micro-image properties.

A further improvement in film speed has accompanied the structural change illustrated in Figure 24.2. In this cross-sectional diagram it will be seen that the logic which positions the fast component above the slow in the emulsion double layers in Figure 24.1 has been pursued to the point where the

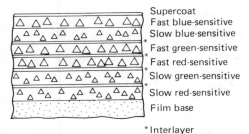

Supercoat
Fast blue-sensitive
Slow blue-sensitive
*
Fast green-sensitive
*
Fast red-sensitive
*
Slow green-sensitive
*
Slow red-sensitive
Film base

*Interlayer

Figure 24.2 Cross-section (not to scale) of a modern high-speed colour-negative film. The structure is such that it gives the maximum access to exposure to the fast-emulsion components. The use of 'T-grain' emulsions in the green- and red-sensitive layers has allowed the omission of the customary yellow filter layer below the blue-sensitive emulsions

fast green and red sensitive components both lie above the two slow components, resulting in a partial inversion of layer order, with the fast red-sensitive layer above the slow green-sensitive layer. This structure is considerably more complex than that shown in Figure 24.1, but has been used to meet very stringent targets for speed and quality. The adoption of tabular-grain emulsions in the green-and red-sensitive layers has made possible the omission of the customary yellow-filter layer from the structure shown in Figure 24.1. This change in itself tends to reduce both the overall thickness of the coating and the scattering of input light, thus improving image sharpness.

We have examined the method used to obtain separate blue, green and red latent-image records in an integral tripack. Now we shall consider the methods by which the colour-developer oxidation products evolved in an emulsion layer are arranged to react with a colour former to yield the appropriate image dye. As the colour developing agents are mobile in solution and diffuse rapidly through the swollen emulsion we shall be concerned especially with the location of colour formers in chromogenic development.

Location of colour formers

It is required that the records of blue, green and red light shall be composed of yellow, magenta and cyan dyes respectively. This distribution of dyes is achieved by presenting colour formers to developer oxidation products in a selective manner. Thus the oxidation products of development of the blue-recording emulsion are allowed to react only with a yellow-forming coupler. This coupler may be in solution in the colour developer, or it may be introduced into the emulsion during manufacture of the film.

Developer-soluble couplers can be used only when a single dye is to be formed in a colour development stage. Three colour developers are needed for a tripack and only one emulsion must be rendered developable before each colour development if separation of the colour records is to be achieved. These conditions can be satisfied only in certain reversal processes which we shall consider later.

Couplers incorporated in the emulsions are used to form all three image dyes in one colour-development step. In this case only the appropriate dye-forming couplers may be permitted in an emulsion layer, if separation of the colour records is to be adequate. The colour formers therefore have to be immobilized to prevent diffusion of the couplers from layer to layer during manufacture or later and specially-formulated interlayers incorporated to prevent migration of oxidized colour-developing agent from layer to layer.

Two main methods of immobilizing couplers have been used. The method adopted by Agfa-Gevaert has been to link the otherwise mobile coupler with a long chemically-inert chain. This chain interacts with gelatin in such a way that the molecule is effectively anchored in the layer; it is described as being *substantive* to gelatin. Processes employing this type of immobilized coupler are referred to as *substantive processes*. Processes employing developer-soluble couplers are often called *non-substantive processes*.

The second immobilizing method is due to Eastman Kodak and employs shorter chemically inert chains linked to the otherwise mobile coupler. The inert chains are selected for oil solubility and render the entire molecule soluble in oily solvents. A solution of such a coupler is made in an oily solvent and the solution dispersed as minute droplets in the emulsion, before coating. The coupler is very insoluble in water and the oily droplets are immobile in gelatin, so that the coupler is unable to diffuse out of the emulsion layer in which it is coated. Processes of the *oil-dispersed coupler* type are also sometimes loosely called 'substantive processes.'

A more recently-devised method of locating colour formers is to use a water-insoluble coupler which is capable of reacting in a progressive fashion to build up large *polymeric* molecules. This can be achieved without adversely affecting the colour-forming power of the individual molecules. Molecules capable of polymerization are called *monomers* and can often react with other monomers forming polymers of mixed composition. A coupler monomer may be mixed with a second suitable non-coupling monomer and the mixture dispersed in water as very small droplets. By allowing polymerization to take place in each droplet a dispersion is formed of large molecules which are quite immobile in a photographic emulsion but which possess the dye-forming ability of the original coupler monomer. The fine dispersion of the polymer in water is

termed a *latex* and such coupler dispersions have recently received considerable attention. An example of such a latex coupler is shown in Figure 24.27c.

Colour processing

We have already encountered a number of processing steps which are used in colour processing. Before examining the applications of such steps we will summarize the functions of processing solutions commonly encountered in colour processes (Table 24.1).

Table 24.1 The primary functions of solutions commonly used in colour processes

Solution	Function
Black-and-white developer	Develops a metallic silver image
Bleach	Bleaches a metallic silver image, usually by oxidation and rehalogenation to silver halide
Bleach-fix	Bleaches the metallic silver image and fixes the silver salts formed. Leaves only the dye image required
Colour developer	Develops dye images together with metallic silver
Fix	Dissolves silver halide present after required development has taken place
Fogging bath	Replaces fogging exposure in reversal processes
Hardener	Hardens the gelatin to resist damage in subsequent processing stages
Stabilizer	Improves the stability of dye images, may also contain wetting agent and hardener
Stop-fix	Stops development as well as removing silver halide

The major differences between the processing of black-and-white and of colour tripack film arise because of the need in the latter case to generate precisely the required amounts of the image dyes in all three layers. If this is not achieved, objectionable colour effects can occur: they may be largely independent of density level, resulting in a uniform colour cast over most of the tone scale, or density-dependent, showing a change in colour balance with density level. The former case corresponds to a speed imbalance of the three layers and is illustrated in Figure 24.3b while the latter corresponds to a contrast mismatch and is illustrated in Figure 24.3c.

The processing conditions under which a colour film will give correct values of speed and contrast for all the emulsion layers are very limited and are generally specified closely by the film manufacturer. The specifications usually include processing times and temperatures, as well as the method and timing of agitation in processing solutions. In addition, such factors as rate of flow of wash water may also be specified. It is important to realise that any departure from the exact processing specifications

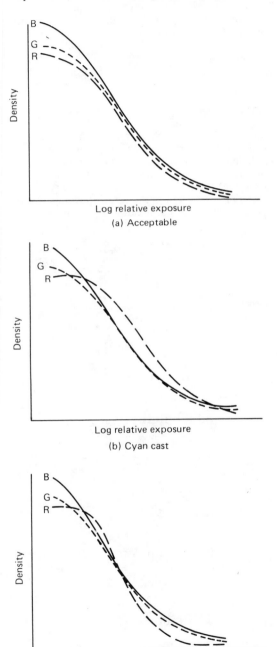

Figure 24.3 Characteristic curves of colour reversal films

laid down by the film manufacturer is likely to lead to a lower-quality result. Where manufacturers suggest process variations in order to modify a property (speed for instance) there is often a penalty in terms of some other property such as graininess.

We will now consider how solutions of the types shown in Table 24.1 are used in colour processes. We shall start by examining colour reversal processing.

Reversal process

As already described, there are two main types of chromogenic colour reversal process, the developer-soluble coupler type and the type with couplers incorporated in the emulsions. The Kodachrome process is of the former (non-substantive) type, the couplers being present in the colour developer solutions. It is illustrated schematically in Figure 24.4.

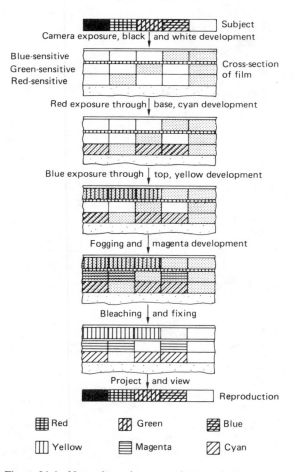

Figure 24.4 Non-substantive reversal processing

The first step is black-and-white development in which silver halide crystals bearing a latent image are developed to metallic silver – a black-and-white negative image. It is then necessary to form the required dye images by colour development of the residual silver halide crystals.

In order to develop cyan dye where red-sensitive crystals were *not* rendered developable by the camera exposure, all that is needed is to expose the film fully to red light, and to develop the fogged red-sensitive grains in a cyan-forming developer. The exposure is most efficient when unscreened by developed silver, and is therefore made through the back of the film to avoid screening by the upper two emulsion layers. The blue-sensitive layer is then exposed to blue light through the front of the film and developed in a yellow-forming developer. The green-sensitive layer may then be fogged by an intense white or green exposure, but in practice it is often preferable to use a chemical fogging agent in the magenta colour developer. In either case the remaining silver halide crystals are developed to yield a magenta dye.

At this stage in the process there are three positive dye images together with silver resulting from the complete development of the silver halide emulsions. The developed silver is quite dense and would make viewing of the dye images impractical. The silver has to be removed by a bleach bath followed by a fix. The bleach bath is usually of the ferricyanide-bromide type, although other formulations can be used, and forms silver bromide from the metallic silver. The yellow filter layer is also usually discharged during bleaching. The silver bromide may then be removed in a conventional fixing solution leaving only the required dye images present in the gelatin.

In addition to the processing steps outlined there are likely to be intermediate rinses and washes and other baths for special purposes. The apparent simplicity of putting soluble couplers in colour developers is thus offset by the complexity of such a non-substantive process, which effectively prohibits user-processing.

Reversal films incorporating couplers in the emulsion are simpler to process, and in many cases may be processed by the user. Such a reversal process is shown in Figure 24.5, and commences with black-and-white development. After the first development the film is fogged with white light before colour development, or chemically before (or in) the colour developer. The fogged silver halide grains are colour-developed to yield positive dye images together with metallic silver. The appropriate dye colours are ensured by the location of the yellow-forming coupler only within the blue-recording layer, the magenta-forming coupler only within the green-recording layer, and the cyan-forming coupler only within the red-recording layer. Bleaching and fixing

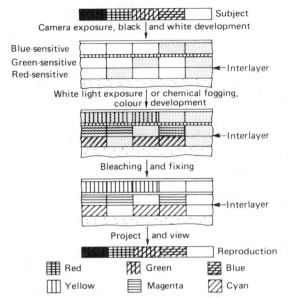

Figure 24.5 The substantive reversal process

are then carried out in order to leave only the image dyes in the gelatin layers.

An example of a Kodak reversal processing procedure, the Ektachrome E6 process, is included as illustration (Table 24.2). The colour couplers are present in oil dispersion or as latex within the emulsions of Ektachrome films.

The processing details given in Table 24.2 are the standard E-6 process designed for correctly-exposed reversal film. It is possible to make a limited correction for non-standard exposure by adjusting the first development time. Current recommendations for the first development time are:

2 stops under-exposed	11.5 min at 38° ±0.3°C
1 stop under-exposed	8 min
1 stop over-exposed	4 min

Table 24.2 Kodak Ektachrome E-6 process

Step	Temp. (°C)	Time (min)	Total time (min)
1 Developer	38 ± 0.3	6	6
2 Wash in running water	33−39	2	8
3 Reversal bath	33−39	2	10
4 Colour developer	38 ± 0.6	6	16
5 Conditioner	33−39	2	18
6 Bleach	33−39	6	24
7 Fix	33−39	4	28
8 Wash in running water	33−39	4	32
9 Stabilizer	ambient	0.5	32.5
10 Dry	not above 60°C		

Steps 1 to 3 take place in total darkness, the remaining steps in normal room light. The times recommended vary according to the type of processing employed

These manipulations of first development usually involve the sacrifice of some quality and should be used only as an emergency measure, unless the known sacrifice of quality is tolerable.

Negative-positive process

The negative-positive process is analogous to the conventional black-and-white process in that a negative record is made by camera exposure followed by processing. This record is not intended for viewing but is used to produce a usable positive by contact or projection printing on a colour print material. Since information about the blue, green and red light content of the camera image is to be available at the printing stage it is customary to use the blue-, green-, and red-sensitive layers of the colour-negative film to generate yellow, magenta and cyan image dyes respectively. Metallic silver is of course generated at the same time, and is removed by subsequent bleaching and fixing operations. The remaining dye images form the colour-negative record, the colours formed being complementary to those of the subject of the photograph. The production of a colour negative record is illustrated in Figure 24.6(a).

If integral masking is employed in the colour negative, then low-contrast positive masks may be formed at the development stage if coloured couplers are used. If some other technique of mask production is used, it may take place in the developer, or at some later stage, depending upon the chemistry involved.

The colour negative is then the subject of the printing stage. In principle, the negative is printed on to a second integral tripack which is processed in similar fashion to a colour negative. The production of a positive print is shown in Figure 24.6(b) as the preparation of a reproduction of the subject of the negative exposure. Certain differences of construction are shown in the positive. Printing papers and some print films employ red- and green-sensitive emulsions whose natural sensitivity is low and confined to wavelengths shorter than about 420 nm, a region normally filtered out in colour printing. Consequently no yellow filter layer is required to suppress unwanted blue sensitivity and the order of layers can be selected on the basis of other criteria. It is found to be advantageous to form the image that is the most critical in determining print sharpness in the topmost layer. In most cases the cyan image is crucial for sharpness and the red-sensitive emulsion is coated uppermost, so that the red image is least affected by emulsion turbidity (Chapter 25) at exposure.

Colour-print materials have characteristic curves similar to those of black-and-white print materials, as the tone-reproduction requirements are quite

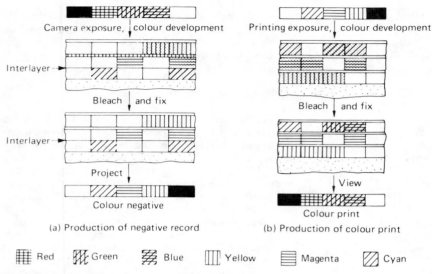

Camera exposure, colour development

Printing exposure, colour development

Interlayer →

Interlayer →

Bleach and fix

Project

Colour negative

(a) Production of negative record

Bleach and fix

View

Colour print

(b) Production of colour print

▦ Red ▨ Green ▨ Blue ▥ Yellow ▤ Magenta ▧ Cyan

Figure 24.6 The colour negative-positive process

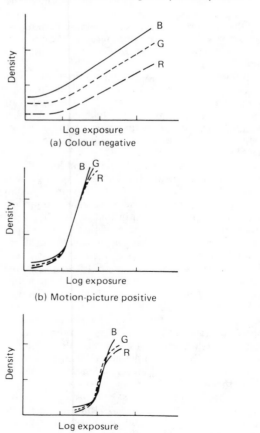

Density
Log exposure
(a) Colour negative

Density
Log exposure
(b) Motion-picture positive

Density
Log exposure
(c) Printing paper

Figure 24.7 Characteristics of negative positive colour materials

similar. Thus, the colour negative film may have characteristic curves similar to those shown in Figure 24.7a. Curves for a motion-picture release positive film are shown in Figure 24.7b and for a typical printing paper in Figure 24.7c. The negative illustrated is masked giving an overall colour cast, and this results in vertical displacements of the blue- and green-filter density curves, compared with the red curve.

The higher blue and green densities of colour negatives are compensated by manufacturing colour print materials with blue and green sensitivities correspondingly higher than the red sensitivity. The printing operation allows manipulation of the overall colour of the reproduction by modification of the quantities of blue, green and red light allowed to reach the print material from the negative (see Chapter 22). This may be achieved by separate additive exposures through blue, green and red filters ('tricolour printing'), or by making a single exposure through appropriate dilute subtractive filters, yellow, magenta or cyan ('white-light printing'). This control of colour balance being easy to achieve, it is not so important that negative and print materials should possess standard speed balances as that reversal materials should. Little or no colour correction of a reversal transparency is usually possible after the taking stage, whereas in the negative-positive process adjustment of colour balance at the printing stage is a usual procedure.

Typical colour-negative and colour-paper processes are shown in Tables 24.3 and 24.4.

Colour paper processes have recently been simplified; a typical modern process requires only two or three solutions with the necessary washes. The Kodak Ektaprint 2 process is typical of modern

Table 24.3 The Kodak C-41 process for colour-negative films

Step	Temp (°C)	Time (min)	Total time (min)
1 Developer	37.8 ± 0.2	3¼	3¼
2 Bleach	24–40	6½	9¾
3 Wash in running water	24–40	3¼	13
4 Fixer	24–40	6½	19½
5 Wash in running water	24–40	3¼	22¾
6 Stabilizer	24–40	1½	24¼
7 Dry	24–43		

Steps 1 and 2 take place in the dark, the remainder in the light. Agitation procedures suitable for the process are specified in instructions packed with the processing chemicals. Unlike the E-6 reversal process, no recommendations are made for modification of development time to compensate for exposure errors.

Table 24.4 The Kodak Ektaprint 2 process for Ektacolor 74 and 78 colour papers

Step	Temp (°C)	Time (min)	Total time (min)
1 Developer	32 ± 0.3	3½	3½
2 Bleach-fix	32 ± 2.0	1½	5
3 Wash in running water	32 ± 2.0	3½	8½
4 Dry	not above 100	–	–

Steps 1 and 2 take place in the dark or specified safelighting, the remaining steps in normal room light.

trends in colour processing. It is quick and simple, employing a bleach-fix and operating at a comparatively high temperature.

Silver-dye-bleach process

The processes so far considered have relied on the formation of image dyes by colour development within the emulsions. There are, however, alternative approaches: one of these is to destroy dyes introduced into the emulsions at manufacture. In such processes the red exposure is arranged to lead to the destruction of cyan dye; the green exposure

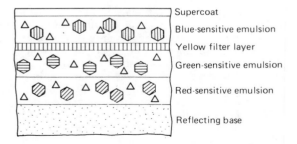

Figure 24.8 Cross-section of silver-dye-bleach material

leads to the destruction of a magenta dye; and blue exposure leads to the destruction of a yellow dye.

Commercial processes of this type have used the silver photographic image to bring about the chemical decomposition of dyes present in the emulsion layers. A current process which uses this mechanism is *Cibachrome*, a process for the production of positive prints from positive transparencies. In systems of this type, the print material is an integral tripack and is constructed as shown in Figure 24.8. The uppermost, blue-sensitive emulsion contains a yellow dye; the green-sensitive layer contains a magenta dye; and the red-sensitive layer contains a cyan dye.

Because of the high optical density of the dyes present in the emulsions, together with emulsion desensitization by some of the dyes, it is necessary to use high-speed emulsions in order to achieve short printing exposures.

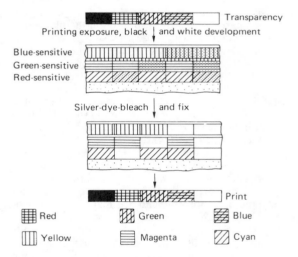

Figure 24.9 The silver-dye-bleach process

The processing of modern silver-dye-bleach materials follows the scheme illustrated in Figure 24.9. The initial step is the black-and-white development of silver halide crystals rendered developable by the printing exposure. The silver image is then used to reduce the dyes present in the emulsions. This reaction may be summarized:

Dye + acid + metallic silver →
reduced dye fragments + silver salts

It is arranged that the fragments resulting from the reduction of the dyes are colourless and/or soluble. Thus in the silver-dye-bleach bath we have imagewise reduction of the dyes by metallic silver, and corresponding oxidation of the silver. The reaction is extremely slow (owing to the immobility of

Table 24.5 A silver-dye-bleach process, Cibachrome P.3, as carried out in a roller-transport processor

Step	Temp (°C)	Time (min)	Total time (min)
1 Developer	30 ± ½	3	3
2 Wash in standing water	28–32	¾	3¾
3 Bleach	30 ± 1	3	6¾
4 Wash in running water	28–32	¾	7½
5 Fixer	30 ± 1	3	10½
6 Final wash in running water	28–32	4½	15
7 Dry	Not over 100	–	–

Steps 1, 2 and 3 take place in darkness, the remainder in normal lighting

the reacting species), and a catalyst is necessary to obtain a satisfactory rate of bleaching. The catalyst is usually incorporated in the silver-dye bleach, or it may be carried over from solution in the black-and-white developer, within the emulsion layers.

Following the silver dye-bleach, the unwanted silver salts are removed in a fixing bath. In some processes this fixer is preceded by a silver bleach to rehalogenize silver image not oxidized by the dye bleach. In a recent process, however, listed in Table 24.5 this second bleach has been omitted. The final result is the positive dye record retained within the gelatin, as shown in Figure 24.9.

Major advantages claimed for the silver-dye-bleach process follow from the freedom to use compounds classed as *azo dyes*. These possess better spectral properties than the dyes formed by chromogenic development, and are markedly less fugitive to light. The better spectral properties improve the saturation and lightness of image colours, while the improved light-fastness gives a much greater life for displayed prints. A further advantage is that the presence of the image dyes at exposure results in a decreased path length of light scattered within the emulsions. This improves the sharpness of the image to such an extent that it is higher than for any comparable chromogenic reflection print material.

The basic structure described above for silver-dye-bleach materials is not used in current materials. It has in fact been common practice to use an inerlayer between red- and green-sensitive emulsions in order to prevent the bleaching of an image dye due to the presence of developed silver in an adjacent emulsion layer. In addition, each emulsion layer is now a double-coated assembly comprising a fast component containing no image dye and a slow component which contains all the necessary image dye complementary in hue to the sensitivity of the layer. There is no interlayer between the two component emulsion layers, as the silver image in the fast emulsion is to bleach the dye in the adjacent

slow emulsion. This structure has been found to lead to a number of advantages in terms of emulsion speed, contrast and image sharpness. The structure is illustrated in Figure 24.10, and shows a yellow filter and masking layer. This last feature is of particular technological interest.

Clearly, silver-dye-bleach print materials, whether viewed by transmission or reflection, cannot be masked in the same way as colour negatives: whites have to be as light and neutral as possible. On the other hand, some form of inter-image effect could be used without adding to the minimum density, and this, in essence, is what is done in current Cibachrome materials.

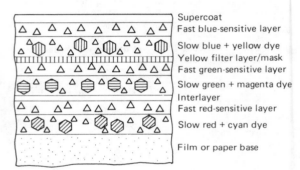

Figure 24.10 Cross-section of a modern silver-dye-bleach print material (not to scale)

The structural details are important. The filter layer contains colloidal silver, i.e. very finely-divided silver particles which are yellow in hue; the blue-sensitive layers contain no iodide in the silver halide crystals, whereas the green and red-sensitive layers contain silver iodobromide. On development the iodobromide emulsions release mobile bromide and iodide ions which diffuse out of the emulsion, passing through the filter layer. Now, the developer contains a silver-halide solvent which partially dissolves emulsion crystals, giving a solution of silver ions and developing agents. This solution is in fact a physical developer, and will deposit silver metal on any development nuclei present. Such nuclei include conventional development centres; but the most efficient nuclei present are the finely-divided silver particles present in the filter layer. Physical development therefore takes place in the filter layer. It is markedly restrained by the presence of iodide ion, and is therefore much less in the neighbourhood of developed green- or red-sensitive emulsions.

When the developed material is immersed in the bleach bath, not only are the image dyes bleached along with the images developed in the emulsion layers, but the yellow-dye layer is also affected by the physically-developed image in the filter layer. Where silver has developed in the filter layer, some of the adjacent yellow dye is bleached. This area

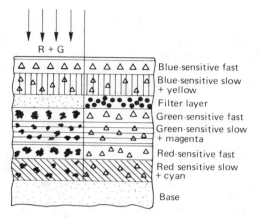

(a) Exposure and development

Base

(b) Final image

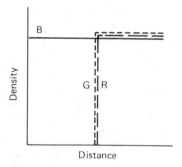

(c) Density distributions in the image

Figure 24.11 Masking in a silver-dye-bleach image. In this diagram it is assumed that the emulsions are coated on film base so that there are no difficulties in measuring the maximum image density. (a) The combined effects of exposure and development; (b) the dye images present after the bleach and fix; (c) the resulting variation of integral densities with distance in the final image

corresponds to low exposure of the green- and red-sensitive layers and a high concentration of the magenta- and cyan-image dyes. Where the green-and red-sensitive layers have been exposed, and the magenta and cyan dyes reduced in concentration,

the iodide ion released on development has inhibited physical development of silver in the filter layer, and less bleaching of the yellow dye layer takes place; so where the magenta and cyan dyes are present there is a reduced concentration of yellow dye, and where they are absent the yellow dye is at a maximum. This means that there is a low-contrast negative yellow-dye image corresponding to high-contrast cyan or magenta images; *providing of course that the blue-sensitive layer has not been totally developed and hence all the yellow dye bleached away.* This corresponds closely to the colour-masking of negative film. The masking procedure can be expected to counteract (at least partially) the unwanted blue secondary absorptions of the magenta and cyan dyes, giving substantial improvements in colour reproduction. The mechanism is illustrated in Figure 24.11.

Part (a) shows the effects of exposure of half the sample of film to red and green light, followed by the development stage of the process. Where red and green light have been incident on the coating development of a silver image has taken place in the red- and green-sensitive emulsion layers, and iodide ions have been released which have restrained physical development of silver in the filter layer. On the other hand, where no exposure has been received by the red- and green-sensitive layers, physical development has proceeded in the filter layer, and silver has been deposited. During immersion in the bleach the developed silver is oxidized, and the adjacent image dyes are reducd to a colourless form. In the exposed area all cyan and magenta dyes are destroyed, leaving the yellow dye at maximum concentration. In the unexposed area the physically-developed silver in the filter layer is oxidized, and a fraction of the adjacent yellow-image dye is correspondingly destroyed. If it were not for the secondary blue absorptions of the remaining magenta and cyan dyes the density distribution (c) would show a reduced blue density in the unexposed area. If, however, the system is ideally formulated, the unwanted secondary absorptions of the magenta and cyan dyes are exactly compensated by the change in yellow dye concentration between the exposed and unexposed regions, and the density profile shown in (c) will be obtained. It will be noted that, as with other inter-image effects, the system depends upon the presence of an image upon which the effect can act. If there were an overall fogging blue exposure, then no yellow dye would be present, and no masking could take place.

Dye-releasing processes
Polacolor

The modern trend towards instant-pictures has led to the development of a number of systems using

chemical processes initiated within the camera. Although the chemical reactions yielding the colour images actually progress to completion in a few minutes in the hand of the photographer, such systems are often called *in-camera processes*. (Other so-called instant processes may need the use of a simple processing machine.)

The first instant-picture colour process was the Polacolor system, introduced in 1963. Polacolor prints were obtained by pressing the shutter release and pulling a film and print sandwich from the camera. About one minute later the film and print were separated, and the unwanted film was discarded. A later development, SX-70 film and its associated special camera, were revealed in 1972, and in this system no discard was required, as the entire process used only a single sheet of material for both exposure and subsequent colour image formation.

Both of these Polacolor processes rely on the development of a silver image to modify the mobility of suitable image dyes which are released to diffuse into an image-receiving layer.

In the 1963 Polacolor process, a negative film of three light-sensitive assemblies is coated in the conventional order with the red-sensitive emulsion next to the base, and the blue-sensitive emulsion farthest from the support. Each light-sensitive assembly consists of two layers, one of which contains a silver-halide emulsion of appropriate sensitivity while the other, nearer the film base, contains a compound called by Polaroid a *dye-developer*, which has a molecular structure comprising a black-and-white developing agent chemically linked by an inert chain to a dye. The construction of a Polacolor light-sensitive assembly is shown in Figure 24.12.

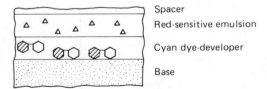

Figure 24.12 Polacolor emulsion and dye-developer layer combination

After exposure, the Polacolor film is processed to yield a positive colour reflection record. To achieve this, the film is pulled, together with a receiving material, between pressure rollers. The pressure rollers rupture a pod attached to the receiving layer, and this releases a viscous alkali solution which is spread between the negative film and the positive receiving layer.

The alkali solution penetrates the negative emulsions and activates the dye-developer molecules, rendering them soluble and thus mobile. The dye-developer molecules are very active developing

agents in alkaline solution, and on development taking place are once more rendered immobile. Dye-developer molecules which diffuse out of an emulsion-developer layer combination have to pass through a spacer, or timing, layer. They are thus delayed so that by the time they reach another emulsion layer, development of that layer has taken place and they are unlikely to encounter developable silver halide. Under these circumstances the dye-developer molecules are free to diffuse out of the negative material and into the receiving material. The structure of the dye-developer molecules does not in fact allow them to diffuse very quickly through the emulsion layers. In order to speed up development, much smaller and more mobile molecules of 'messenger' developing agent may be used. These diffuse rapidly and develop the exposed silver halide crystals. Dye-developer then regenerates the

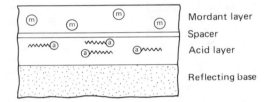

Figure 24.13 Polacolor receiving material

oxidized messenger developing agent, becoming oxidized itself in the process. The receiving material acts as a sink for dye-developer molecules and this encourages diffusion into the receiving layer. The structure of the receiving layer is shown in Figure 24.13 and the diffusion stage is shown in Figure 24.14.

Dye-developer molecules entering the receiving layer encounter a mordant which immobilizes the dye part of the molecule and thus anchors the entire molecule. The alkali present in the processing solution diffuses slowly through the spacer layer in the receiving material and reaches the layer which contains large immobile organic acid molecules. The alkali is neutralized by the acid with the evolution of water, which swells the spacer layer and assists further penetration by alkali to the acid layer and consequent neutralization. After about one minute the reactions are completed, and the reflection positive is peeled off the residual negative and is suitable for viewing. The positive image is illustrated in Figure 24.15.

The elegance and ingenuity of the process lie in the carrying out of the processing within the material, and in leaving behind in the discarded negative unwanted silver and dye-developer. Note that any emulsion fog results in a lowering of the dye density in the positive; the stain is not increased.

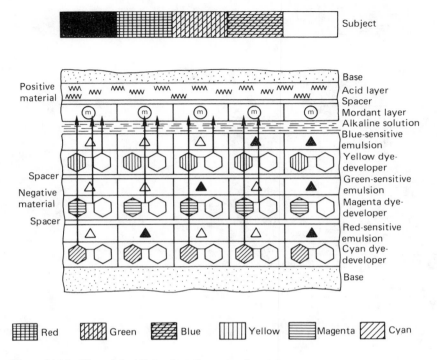

Figure 24.14 The original Polacolor – the processing stage

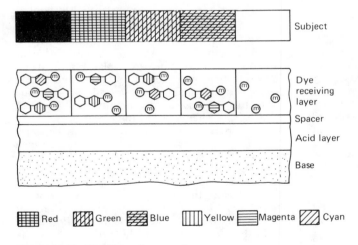

Figure 24.15 The Polacolor record

The Polacolor SX-70 process, introduced in 1972, uses the mechanisms on which the original process was based. The image-receiving material is, however, part of the same assembly as the light-sensitive emulsions and the associated dye-developer layers. Processing is initiated, as in the earlier material, by the rupture of a pod. The contents of the pod are injected into the composite assembly between the emulsion and image-receiving layers. The structure of the material and the solution injection are shown diagrammatically in Figure 24.16, which is not drawn to scale.

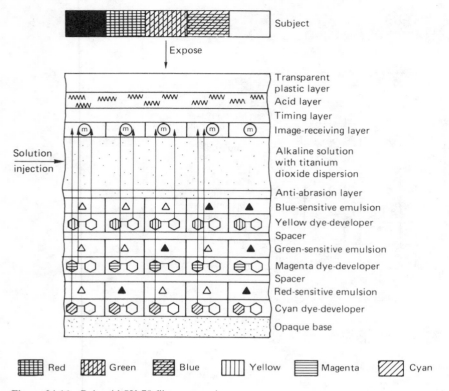

Figure 24.16 Polaroid SX-70 film, processing

It will be seen that the material consists of a large number of layers comprising the dye-releasing light-sensitive elements and an image-receiving assembly. These components are not unlike those of the earlier Polacolor materials, though certain improvements in detail have been made. The major structural difference is that the entire stack of layers is contained between two relatively thick outer layers. One of these is transparent; the exposure is made, and the image viewed, through this layer. The other is the opaque backing to the material. The processing solution is contained within a wide margin to the picture area and is injected into the picture area when the film is expelled from the camera after exposure.

The processing solution consists primarily of a strong alkali containing a dispersion of the white pigment titanium dioxide and certain dyes which are highly coloured in alkaline solution. The alkali present activates and mobilizes the dye-developers in the dye-releasing assembly and a messenger developing agent (see page 328) coated in the anti-abrasion layer of the negative. The titanium dioxide remains at the site of injection, between the blue-sensitive emulsion and the image-receiving layer,

forming a white background to the received image viewed through the transparent plastic front sheet. The protecting dyes present absorb so much light that effectively none penetrates to the emulsion layers; this gives rise to the figurative description of the dyes as a 'chemical darkroom'.

As the process continues, the dye image is released from the emulsion assembly, diffuses through the white titanium dioxide and is immobilized in the image-receiving layer just as in the original Polacolor process. This continues until the alkaline solution penetrates the spacer or *timing layer* between the dye-receiving and polymeric acid layers present immediately beneath the transparent outer sheet. As in the earlier material, the penetration of the timing layer leads to a rapid neutralization of the alkali present but this, in the SX-70 film, additionally causes decoloration of the protective dyes present and, ultimately, the colour image is seen against the white titanium dioxide background.

The dye-developers incorporated in the SX-70 material are of an improved type, being complex compounds of dyes with certain metals, notably copper and chromium. Such metal complexes have greater stability than similar uncomplexed dyes and

yield images that possess good light-fastness. The complexes used are termed 'metallized dyes' by Polaroid.

Alternative method for instant photography

An alternative approach to instant picture production was adopted by Eastman Kodak, who combined a number of novel features in a process unveiled in the spring of 1976. New immobile compounds were devised; these are derivatives of developing agents which, on oxidation, undergo a reaction that releases a chemically-bound image dye. The image dyes themselves were selected from the class of *azo dyes*, potentially giving better colour reproduction than conventional photographic image dyes. The final major innovation was the use of emulsions which on development yielded positive silver images as opposed to the customary negative images.

The construction and processing of the Kodak instant picture film is illustrated in Figure 24.17, which shows the situation after exposure and injection of the activator fluid to initiate image formation on ejection of the film from the camera. The direct-positive emulsions develop in areas unaffected by light and, in so doing, release image dyes that diffuse to the image-receiving layer, where there is a mordant to immobilize them. The dye image is thus located between a white opaque layer and the transparent film through which it is viewed. In the meantime the alkaline activator penetrates a timing layer to reach a polymeric acid which neutralizes the alkali and terminates the processing stage.

The dye-releasing species present are immobilized derivatives of typical developing agents such as aminophenols. In the activator fluid there is a highly mobile developing agent, typically a Phenidone derivative, which reacts with the unexposed silver halide crystals to give a silver image and oxidized developing agent. The developing agent is regenerated by reaction with the dye-releasing compounds

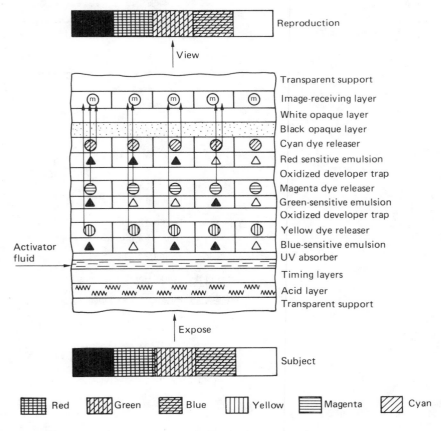

Figure 24.17 Kodak Instant Print film, structure and processing

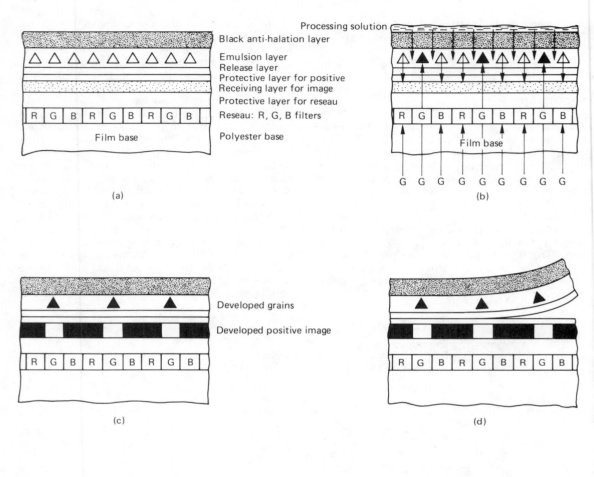

(a)

(b)

Processing solution
Black anti-halation layer
Emulsion layer
Release layer
Protective layer for positive
Receiving layer for image
Protective layer for reseau
Reseau: R, G, B filters
Film base
Polyester base

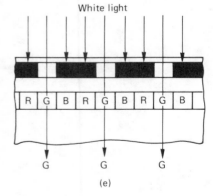

Developed grains

Developed positive image

(c)

(d)

White light

(e)

Black pigment

Undeveloped emulsion

Developed emulsion

Nuclei for physical development

Fluid developer

R G B Colours of reseau elements

Physically-developed image

Figure 24.18 Polachrome instant-colour-slide film. (a) The film; (b) exposure to green light, activation and the onset of development; (c) completion of development; (d) peeling apart; (e) projection

which are thereby themselves oxidized. The oxidized dye-releaser is unstable in alkaline solution and decomposes, yielding the mobile image dye. Thus, in contrast to the Polaroid processes, dyes are released wherever development takes place. The regenerated developing agent is free to react with further silver halide crystals. It is important to retain oxidized developing agent within the appropriate dye-releaser and emulsion pair, otherwise an inappropriate dye would diffuse to the image-receiving layer. It is thus necessary to trap any oxidized developer leaving a dye-releaser and emulsion pair, suitable interlayers being used for this purpose.

The dye-releasing process may be summarized in the following stages:

(1) Silver development of the direct positive emulsions:

Unexposed silver halide + developing agent →
silver image + halide ion + oxidized developing agent

(2) Regeneration of the developing agent:

Oxidized developing agent + dye-releaser →
 developing agent + oxidized dye-releaser

(3) Dye release:

Oxidized dye-releaser + alkali →
 mobile dye + unimportant products

As with Polacolor, neutralization of the alkaline solution is achieved by the eventual penetration of the solution through a timing layer to an acid.

The dye-releaser technology of the Kodak integral Instant Print Film was also applied to the Kodak Ektaflex colour printing system, capable of making prints from both negatives and transparencies, depending on the choice of sensitive film. Following exposure the film was sandwiched against a receiving paper in an activating solution using a simple processing machine; the laminate was ejected from the machine, and after 6–8 minutes the components were peeled apart to reveal the final print, the film being discarded. Kodak have termed the principle underlying these processes *redox dye release*, indicating that dye release follows an oxidation/reduction reaction. Similar systems of redox dye release have also been used in a Fuji integral camera film and by Agfa-Gevaert in Agfachrome-Speed, a process designed for the production of enlarged prints from transparencies.

The final instant process which we shall consider is that used by Polaroid in their instant additive-colour transparency products. These include Polavision instant motion-picture film and Polachrome 35 mm instant colour-slide film. We shall confine our attention to the latter product, which utilizes the structure shown in Figure 24.18(a).

The polyester film base carries the réseau described in Chapter 14; above this is a layer to protect it from damage. The next layer above contains nuclei for physical development, and receives the positive image during processing. Above the image-receiving layer is a further protective layer, and a separable release layer to enable the upper layers, i.e. the emulsion and anti-halation layers, to be stripped off after processing.

Exposure is made through the base, and the red, green and blue contents of the input light are analysed by the réseau and the panchromatic emulsion. As shown in Figure 24.18(b), exposure to green light results in a negative silver record only behind the green filter, and this is achieved by development in a solvent developer in a simple processing machine. The film is wound out of its cassette into contact with a strip sheet saturated with the processing solution, which immediately diffuses into the film coating and rapidly develops any exposed silver halide crystals to give a negative silver image. Where this image is not developed, silver-halide solvents present in the processing solution dissolve the undeveloped crystals forming a physical developer. Physical development then deposits silver on the nuclei in the image-receiving layer, forming a positive image of high covering power. This image is confined to the areas behind filters which did not transmit the incoming light, and is thus a positive. In this case, with green exposure, the receiving layer has no developed image corresponding to the green filter elements.

After one minute has passed, development is complete and the film is rewound into its original cassette; during this operation the strip sheet and the unwanted negative emulsion assembly and anti-halation layers are peeled away and discarded. The transparencies are then ready for viewing. Projection of the green-exposed section is shown in Figure 24.18e.

Important chemistry

For those readers with some chemical knowledge there follows a short review of chemical formulae of some compounds and reactions important in colour image formation.

Chromogenic processes

The colour-forming reaction takes place between oxidized colour developer and suitable colour formers. Colour developing agents of practical importance possess the general formula shown in Figure 24.19. Such developing agents are usually supplied as salts of acids.

R$_1$ ethyl
R$_2$ ethyl, β-hydroxyethyl or β-methylsulphonamidoethyl
R$_3$ hydrogen or methyl

Figure 24.19 General formula of common colour developing agents

(a) Acetoacet-2,5-dichloroanilide

(b) 3-methyl-1-phenylpyrazol-5-one

(c) 2,4-dichloro-1-naphthol

*Indicates the site of coupling

Figure 24.20 Simple developer-soluble colour couplers

Colour formers usually contain an active methylene or methine group activated by a group or groups adjacent to the active site, or linked by a conjugated chain. Generally, cyclic couplers require one activating group while open-chain couplers require two such groups. Examples of colour couplers are shown in Figure 24.20 in which (a) is a yellow-forming coupler, (b) is magenta-forming and (c) is cyan-forming; all three are soluble in developer. The coupling reaction has the stoichiometry shown in Figure 24.21, unless the coupling position is occupied by an electronegative substituent, when a useful change in stoichiometry is observed (Figure 24.22). Only two silver ions are then reduced to yield one molecule of developed dye, whereas without the electronegative substituent four silver ions are required.

Substitution at the site of coupling is used in methods of colour masking using coloured couplers. The coloured moiety is linked to the coupling position of the coupler and is discharged on dye formation (Figure 24.23). In this case an azo dye moiety is displaced from the 4-position of the colour former on coupling.

A similar use of substitution at the coupling position is a feature of developer-inhibitor-releasing (DIR) couplers which are used to encourage inter-image effects and improve the micro-image properties of colour photographic mterials. The developer inhibitor is released from the point of coupling, typical examples being shown in Figure 24.24.

Cyan-forming DIR couplers may thus have formulae such as those shown in Figure 24.26 and release benzotriazole or 1-phenyl-5-mercaptotetrazole respectively on colour coupling. These couplers are colourless, as are many other DIR couplers, which makes them potentially useful for the colour correction of reversal films. In the case of colour-negative film, as we have already seen, coloured couplers are frequently used for masking purposes. The mask density can be substantially reduced if the coloured couplers are arranged to yield a developer inhibitor on dye development. A typical example is shown in which benzotriazole is formed from the displaced masking dye moiety (Figure 24.25).

Other substituents in colour former molecules are added to influence solubility and mobility in the emulsion. Examples of differently immobilized cyan-forming couplers are shown in Figure 24.27. In the case (a) we have a $-C_{18}H_{37}$ anchoring group which renders the coupler substantive to gelatin, and in order to make the coupler water-soluble for coating purposes the $-SO_3Na$ group is substituted into the 4-position. In (b) the coupler is made suitable for oil dispersion by the $-C_5H_{11}$ group. No water solubilization is required or desired when oil dispersion is intended. Coupler (c) is immobilized as a latex in the emulsion (see pages 320–321).

Figure 24.21

Figure 24.22

Figure 24.23

benzotriazole

1-phenyl-5-mercaptotetrazole

Figure 24.24 Typical developer inhibitors

336

Coloured coupler

Oxidized developing agent

Dye

Developer inhibitor precursor

Spontaneous cyclization

Developer inhibitor

Figure 24.25

(a)

(b)

(c)

* Indicates continuing polymer chain

Figure 24.26 Colourless DIR couplers

Figure 24.27 Immobilized colour couplers

The silver-dye-bleach process

This process is usually operated with azo dyes and these are characterised by the azo linkage:

$$-N = N-$$

These dyes may be given the general formula:

$$R^1-N = N-R^2$$

The overall dye-bleach reaction may be represented by the stoichiometric equation:

$$R^1-N = N-R^2 + 4H^+ + 4Ag\rightarrow$$
$$R^1NH_2 + R^2NH_2 + 4Ag^+$$

It will be seen that a low pH favours this reaction and consequently the silver-dye-bleach bath is usually strongly acid and operates at a pH between 0 and 1. This pH is conveniently achieved by the use of a halogen acid which will also withdraw silver ions formed by dye bleaching, and hence favour the reaction. More recently sulphamic acid, NH_2SO_3H, also a strong acid, and sulphuric acid, H_2SO_4, have been substituted successfully for the halogen acid previously used. The concentration of free silver ion may also be kept to a minimum by the formation of a complex of high stability. Suitable complexing agents include thiourea, bromide ion and iodide ion, all of which increase the rate of bleaching.

The dye-bleach reaction is very slow even at very low pH values and at very low concentrations of free silver ions. It is necessary to employ a catalyst to speed up the reaction, and the useful compounds contain this structural group:

Figure 24.28

Examples of compounds used as catalysts are shown in Figure 24.29. Examples (a) and (b) are catalysts which have been used dissolved in the bleach bath, while (c) represents a catalyst which is dissolved in the developer and carried into the bleach in small quantities by the emulsion layers.

At the pH of the bleach bath such catalysts become protonated (Figure 24.30) and the protonated catalyst, cat H^+, acts as a redox intermediate:

$$Ag + cat\ H^+ \rightleftharpoons Ag^+ + cat\ H\cdot$$

oxidizing a silver atom and gaining an electron to form a free radical. The free radicals formed in this way are able to attack the azo linkages of the dyestuff present, and destruction of the dye results from stepwise attack summed up in the equation:

$$4\ cat\ H\cdot + R^1N = NR^2 \rightarrow 4\ cat + R^1NH_2 + R^2NH_2$$

Examples of azo dyes suitable for the silver-dye-bleach process are shown in Figure 24.31 in which

2,3-dimethylquinoxaline

(a)

2-hydroxy-3-aminophenazine

(b)

3-hydroxy-4-amino-naphthazine-5-sulphonic acid

(c)

Figure 24.29

Figure 24.30

(a) represents a yellow dye, (b) a magenta dye and (c) a cyan dye. It should be noted that for dyes to be used in the silver-dye-bleach process they must be substantive to the appropriate emulsion layer, and the amine breakdown products should be soluble enough to wash out of the emulsion in the bleach bath or at a later stage. This latter property is desirable in order to reduce stain, especially on keeping.

Dye release

The Polacolor process depends for its success on the novel dye-developer compounds incorporated in the

(a)

(b)

(c)

Figure 24.31 Dyes suitable for the silver-dye-bleach process: (a) yellow, (b) magenta, (c) cyan

negative material. The changes in mobility of these compounds arise from the behaviour of developing agents of the substituted hydroquinone type:

Figure 24.32

The neutral molecule is insoluble, and hence immobile, in acid conditions and shows no developing activity; but in alkali the developing moiety deprotonates to form the soluble and mobile developer anion (Figure 24.32). This anion is an active developer and readily reduces adjacent exposed silver halide to metallic silver with the formation of an uncharged quinone. In fact (as has been described) much of the actual development is achieved by the more mobile 'messenger' developing agent, the oxidized form of which is in turn reduced by nearby dye-developer, which is thus itself oxidized to quinone (Figure 24.33). The quinone is almost insoluble, and thus immobile, and possesses no photographic activity. Thus activation of the dye-developer by alkali yields a mobile anionic molecule which remains mobile so long as the solution is sufficiently alkaline and development does not take place.

Figure 24.33

A variety of dyes is available and selection is made on the basis of colorimetric and photographic properties, provided the mobility of the dye-developer species fits the requirements of the process. The dye-developer consists of a dye linked to a developing agent by an inert chain of some kind. Typical, simple, dye developers are shown in Figure 24.34. The developer moiety is, of course, hydroquinone in each case.

The SX-70 process, utilising metallized dye-developers, leads to compounds of considerable complexity, a consideration of which is beyond the scope of this work. It is sufficient to note that such compounds are essentially dye-developers with added structural features that enable complex compounds to be formed with some metal cations such as Cu^{2+}.

The Kodak system uses quite different chemicals from those used by Polaroid. The actual development reaction uses a substituted Phenidone (see Chapter 17) which is regenerated by reaction with the dye-releaser (an immobilized developing agent

(a) (b)

Figure 24.34 Simple dye-developers for the Polacolor process: (a) yellow, (b) magenta, (c) cyan

Figure 24.35

linked to a dye.) A typical example of such a compound is shown in Figure 24.35. which is immobilized by the $-C_{17}H_{35}$ group. Such a dye-releaser reacts with oxidized developer to reform the developer and is itself oxidized to an unstable product. This is hydrolysed to yield the immobile quinone and release the mobile dye species (Figure 24.36).

The more highly-automated and 'instant' photography becomes, the more complex are the mechanisms used, and this is reflected in processing chemistry. Fortunately, however, the photographer is often scarcely involved in the processing: its chemistry is of little or no concern. For only a few photographers does an interest in chemistry extend beyond black-and-white processing, although interesting effects can result from the manipulation of colour processes. For such purposes there is no doubt that an insight into the workings of a particular system can be most useful.

Figure 24.36

25 Evaluation of the photographic image

The purpose of this chapter is to review some of the properties of photographic emulsions and photographic image structure that have an influence on the quality of the final photographic recording. These all originate in one way or another from the heterogeneous (non-uniform) nature of the sensitive layer.

Early on in the chapter we study the photographic image in some depth, using fairly well known methods of evaluation. These are generally easy to understand and have proved valuable in many areas of photography by affording rapid and straightforward measures of image quality. Later, we take a look, at a fairly elementary level, at some fundamental approaches to image evaluation. These are based on concepts originating in the area of communications and information theory. These have had a considerable impact in the area of image evaluation, but as a rigorous exposition of the concepts involves some quite difficult mathematics the treatment will necessarily be somewhat superficial.

Structural aspects

We have seen that a photographic emulsion consists of fine silver halide crystals distributed randomly in gelatin. When an emulsion is exposed to light and processed, an image of the exposure distribution is formed. This image is made up of grains of metallic silver which, in normal chemical development, are formed by reduction of the silver halide present in the exposed emulsion. The silver grains of the image occupy approximately the same position as the original silver halide crystals from which they were formed, but do not retain their shape. Silver halide crystals are regular structures whereas silver grains produced by chemical development are generally masses of twisted filaments of silver.

Differences in exposure level on the larger scale are rendered as differences in the numbers of developed silver grains in the emulsion. The greater the exposure level, the greater is the number of silver grains produced (within the limits imposed by the concentration of the original silver halide crystals).

The silver halide crystals of an emulsion are not all of the same size; any single emulsion exhibits a range of sizes. This range depends on the method of manufacture, and is an important property of the emulsion. The larger crystals in any given emulsion are in general more sensitive to light than the smaller ones. This is probably because the larger crystals absorb more light energy, owing to their greater area and volume. It would therefore be expected that an emulsion with a wide size distribution of silver halide crystals would have a wide range of response to light, i.e. low contrast; an emulsion with a narrow grain size distribution would be expected to have a restricted range of response to light, i.e. high contrast. In practice this is generally the case.

The comparatively large silver halide crystals of a fast emulsion are usually associated with a wide range of smaller sizes. For this reason, high emulsion speed is generally associated not only with large crystal size but also with relatively low contrast. On the other hand, it is usually possible to obtain a narrow distribution of crystal sizes only if they are all small. Hence high contrast is usually associated with low speed and fine grain.

Photographic turbidity

A photographic emulsion causes light passing into it to be diffused: it is said to be *turbid*. This diffusion arises as a result of reflection, refraction, diffraction and scattering by the silver halide crystals, and depends on such factors as the crystal size, ratio of silver halide to gelatin and the opacity of the emulsion to actinic light.

Figure 25.1 depicts the formation of the photographic image of a small disc of light. It can be seen that the diffusion and subsequent absorption of light results in a developed image that is substantially larger than the true optical image. Spreading of the image into areas receiving no direct exposure in this matter is referred to as 'irradiation', and becomes objectionable with heavily-exposed images of points and edges.

However, diffusion of the exposing light is fundamentally of much greater importance than a simple lowering of the quality of heavily-exposed image detail. The diffusion occurs at all exposure levels and represents one of the major factors influencing

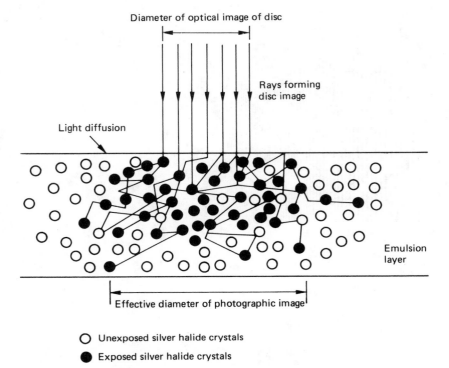

Diameter of optical image of disc

Rays forming disc image

Light diffusion

Emulsion layer

Effective diameter of photographic image

○ Unexposed silver halide crystals

● Exposed silver halide crystals

Figure 25.1 Image formation showing optical spreading

the ability of photographic materials to reproduce the detail contained in an object.

Resolving power

Generally speaking, resolving power measures the detail-recording ability of photographic materials. It is determined by photographing a test object containing a sequence of geometrically-identical bar arrays of varying size, and the smallest size in the negative the orientation of which is recognizable by the eye under suitable magnification is estimated. The spatial frequency of this bar array, in line pairs per millimetre, is called the resolving power. Figure 25.2 shows two typical test objects.

The test object is imaged on to the film under test either by contact printing or, more usually, by use of optical imaging apparatus containing a lens of very high quality. A microscope is used to examine the developed negative. The estimate of resolving power obtained is influenced by each stage of the complete lens/photographic/microscopic/visual system, and involves the problem of detecting particular types of signal in image 'noise'. However, provided the overall system is appropriately designed, the imaging properties of the photographic stage are by far the worst, and one is justified in

characterizing this stage by the measure of resolving power obtained.

Because of the *signal-to-noise** nature of resolving power measurement, its value for a particular film is a function not only of the turbidity of the sensitive layer, but also of the contrast (luminance ratio) and design of the test object and the gamma and graininess* of the final negative. It is influenced by the type of developer, degree of development and colour of exposing light, and depends greatly on the exposure level. Figure 25.3 shows the influence of test object contrast and exposure level on the resolving power of a typical medium-speed negative material.

The chief merit of resolving power as a criterion of image quality lies in its conceptual simplicity, while taking account of several more fundamental properties of the system including the *modulation transfer function** of the emulsion and optics, the gamma and granularity* of the emulsion, and the qualities and limitations of the human visual system. Very simple apparatus is required and the necessary readings are straightforward to obtain. Insofar as it is possible to assign a single value to image quality, resolving power has been widely used as an indicator

*These terms are defined and explained later

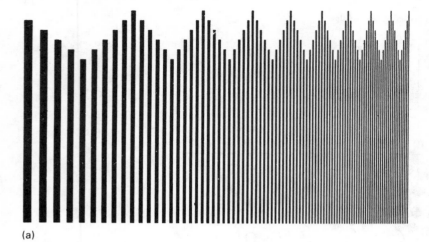

(a)

Figure 25.2 Typical resolving-power test charts: (a) Sayce chart, (b) Cobb chart

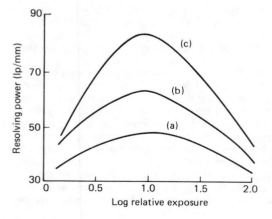

(b)

of the capabilities of photographic materials in reproducing fine image structure.

Graininess

The individual crystals of a photographic emulsion are too small to be seen by the naked eye, even the largest being only about $2\,\mu$m in diameter. A magnification of about 50 times is needed to reveal their structure. A grainy pattern can, however, usually be detected in photographic negatives at a much lower magnification, sometimes as low as only three or four diameters. There are two main reasons for this:

(1) Because the grains are distributed at random, in depth as well as over an area, they appear to be clumped. This apparent clumping forms a random irregular pattern on a much larger scale than the individual grain size.

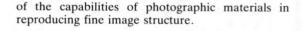

Figure 25.3 Variation of resolving power with exposure using test charts of increasing contrast (a) to (c)

(2) Not only may the grains appear to be clumped because of the way in which they are distributed in the emulsion, but they may actually be clumped together (even in physical contact) as a result either of manufacture or of some processing operation.

The sensation of non-uniformity in the image produced in the consciousness of the observer when the image is viewed, is termed *graininess*. It is a subjective quantity and must be measured using an appropriate psycho-physical technique, such as the blending magnification procedure. The sample is viewed at various degrees of magnification and the observer selects the magnification at which the grainy structure just becomes (or ceases to be) visible. The reciprocal of this 'blending magnification factor' is a measure of graininess.

Graininess varies with the mean density of the sample. For constant sample illumination, the relationship has the form illustrated in Figure 25.4. The

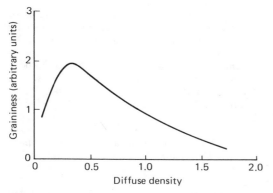

Figure 25.4 Graininess-density curve for typical medium speed film

maximum value, corresponding to a density level of about 0.3, is said to result from the fact that approximtely half of the field is occupied by opaque silver grains and half is clear, as might intuitively be expected. At higher densities, the image area is more and more covered by agglomerations of grains, and, because of the reduced acuity of the eye at the lower values of field luminance produced, graininess decreases.

We have so far referred only to the graininess of the negative material. The feature of interest in pictorial photography is however, the quality of the positive print. If a moderate degree of enlargement is employed the grainy structure of the negative becomes visible in the print (the graininess of the paper emulsion itself is not visible because it is not enlarged). Prints in which the graininess of the negative is plainly visible are in general unacceptable in quality.

Although measures of negative graininess have successfully been used as an index to the quality of prints made from the negative materials, the graininess of a print is not simply related to that of the negative, because of the reversal of tones involved. Despite the fact that the measured graininess of a negative sample decreases with increasing density beyond a density of about 0.3, the fluctuations of microdensity across the sample in general increase. This follows from a consideration of the behaviour of random distributions. As these fluctuations are responsible for the resulting print graininess, and as the denser parts of the negative correspond to the lighter parts of the print, we can expect relatively high print graininess in areas of light and middle tone (the graininess of the highlight area is minimal because of the low contrast of the print material in this tonal region). This result supplements the response introduced by variation of the observer's visual acuity with print luminance. Figure 25.5 shows the relationship between negative and positive samples.

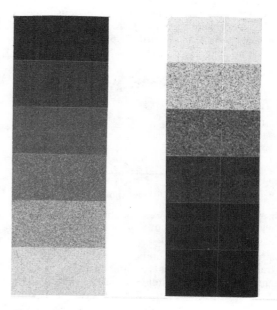

Figure 25.5 Graininess in negative and print, Left: enlargement of negative. Right: corresponding areas of print

It is now clear that print graininess is primarily a function of the fluctuations of microdensity, or *granularity*, of the negative, the graininess of the negative itself being of less relevance. Hence, when a considerable degree of enlargement is required, it is desirable to keep the granularity of the negative to a minimum.

Factors affecting the graininess of prints

(1) The granularity of the negative. As this increases, the graininess of the print increases. This is the most important single factor and is discussed in detail in the next section.
(2) Degree of enlargement of the negative
(3) The optical system employed for printing and the contrast grade of paper chosen.
(4) The sharpness of the negative. The sharper the image on the film, the greater the detail in the photograph and the less noticeable the graininess. It can be noted here that graininess is usually most apparent in large and uniform areas of middle tone where the eye tends to search for detail.
(5) The conditions of viewing the print.

Granularity

This is defined as the objective measure of the inhomogeneity of the photographic image, and is determined from the spatial variation of density recorded with a *microdensitometer* (a densitometer with a very small aperture). A typical granularity trace is shown in Figure 25.6. In general, the

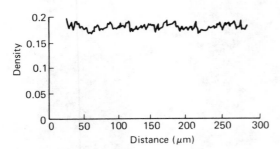

Figure 25.6 Granularity trace for a medium speed film, using a scanning aperture of 50 μm diameter

distribution of a large number of readings from such a trace (taken at intervals greater than the aperture diameter) is approximately normal, so the standard deviation σ of the density deviations can be used to describe fully the amplitude characteristics of the granularity. The standard deviation varies with the aperture size (area A) used. For materials exposed to light the relationship $\sigma\sqrt{(2A)} = G$ (a constant) holds well. This is *Selwyn's law*, and the parameter G can be used as a measure of granularity.

Other measures of granularity have been defined. In particular the syzygetic density difference should be noted. This is the average density difference between two minute neighbouring areas of the same size, and evolved as a measure of granularity that would correlate well with visual graininess.

However, it can be shown that when measured properly, using uniform, clean samples, Selwyn granularity and the syzygetic density differences are essentially equivalent, and the former, which is easier to determine, provides a useful index to sample graininess.

Factors affecting negative granularity

The following are the most important factors affecting the granularity of negatives:

(1) *The original emulsion employed* This is the most important single factor. A large average crystal size (i.e. a fast film) is generally associated with high granularity. A small average crystal size (i.e. a slow film) yields low granularity.
(2) *The developing solution employed* By using fine-grain developers it is possible to obtain an image in which the variation of density over microscopic areas is somewhat reduced.

These first two factors are closely related, for just as use of a fast emulsion is usually accompanied by an increase in granularity, so use of a fine grain developer often leads to some loss of emulsion speed. Consequently, it may be found that use of a fast film with a fine-grain developer offers no advantage in effective speed or granularity over a slower, finer-grained film developed in a normal developer. In fact, in such a case, the film of finer grain will yield a better *modulation transfer function* (see page 347) and higher

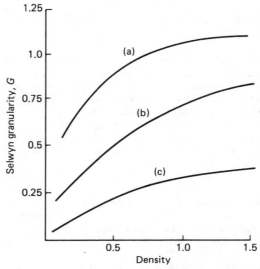

Figure 25.7 Granularity as a function of density level for (a) high, (b) medium and (c) slow speed films

(3) *The degree of development* As granularity is the result of variations in density over small areas, its magnitude is greater in an image of high contrast than in one of low contrast. Nevertheless, although very soft negatives have lower granularity than equivalent negatives of normal contrast, they require harder-papers to print on, and final prints from such negatives usually exhibit graininess similar to that of prints made from negatives of normal contrast.

(4) *The exposure level, i.e. the density level* In general, granularity increases with density level. Typical results are shown in Figure 25.7. This result leads to the conclusion that over-exposed negatives yield prints of high graininess.

Sharpness and acutance

The study of the effects of turbidity indicates that the photographic image of an edge does not exhibit an abrupt change from high to low density. Instead, there is a density gradient across the boundary. The term *sharpness* refers to the subjective impression produced by the edge image on the visual perception of an observer. The term *acutance* is used to designate the measured characteristic of an edge as determined from a microdensitometer trace.

The degree of sharpness depends on the shape and extent of the edge profile, but being subjective the relationships are complex and difficult to assess. Acutance can be measured by evaluating the mean square density gradient divided by the density difference across the edge. The number obtained is found to correlate quite well with the visual sensation of sharpness for a number of film/developer combinations.

The density profile of an edge image depends not only on the turbidity of the emulsion, but also on the nature of its development. When adjacency effects are significant, enhanced sharpness often results.

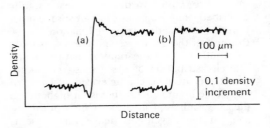

Figure 25.8 Edge traces for a typical medium speed film, (a) in the presence of and (b) in the absence of edge effects

This phenomenon is used to advantage in many developer formulations, and is illustrated in Figure 25.8. The density in the immediate neighbourhood of the high-density side of the edge is increased by the diffusion of active developer from the low density side, while development-inhibiting oxidation products diffusing from the high-density side reduce the density in the immediate neighbourhood of the low-density side of the edge.

The magnitude of adjacency effects depends on the developer formulation, degree of development, emulsion type, exposure level and subject luminance ratio.

Quality and definition

Even without defining the terms, the layman interprets 'quality' differently from 'definition'. They are subjective concepts and thus must be evaluated statistically by having a large number of observers rank appropriate photographs. They both appear to depend on the combined effects of resolving power, sharpness, graininess and tone reproduction. Sharpness and graininess appear equally important when considering the concept of quality, whereas sharpness seem to be more important than graininess when considering definition.

Improving image quality

Over the years, aspects of image quality have been steadily improved by advances in chemical and spectral sensitizing and techniques of thin- and multi-layer emulsion coating. Generally, however, it is recognized that there are fundamental relationships between emulsion speed, granularity and sharpness, so that although any one quantity may be varied by the emulsion maker, the others will also be changed. For instance, an increase in speed may be achieved by increasing the average grain size, but this will be offset by poorer sharpness and higher granularity. Inclusion of dyes ('acutance' dyes) in the emulsion will increase sharpness by reducing the diffusion of light during exposure, but at the expense of emulsion speed.

In recent years a significant improvement in image quality has become possible as a result of advances in the control of silver halide crystal shape. Emulsion chemists have been able to produce tabular (i.e. plate-like) crystals, which can be arranged to present a greatly-increased surface area to incident light. Such crystals are thus very sensitive and are of low volume. Granularity, which can be related to grain volume, is therefore lower than it normally is for an emulsion of this speed. This so-called *T-grain technology* offers other advantages. The increased surface area of the crystals

greatly improves the dye-sensitizing possibilities, which may lead to a further increase of speed with no increase in granularity. Diffusion of exposing light is reduced because of the fewer high-angle faces presented in a tabular crystal which is aligned parallel to the substrate. Hence sharpness and resolving power are improved.

Modern methods of image evaluation

Techniques developed originally in communications theory have now been established as powerful analytical procedures within the fields of optical and photographic image evaluation. This evolution has occurred over the past three or four decades, and the methods resulting from it are now applied routinely to the measurement of all aspects of image quality. Photographic materials can now be quite meaningfully compared in many ways with other imaging systems (e.g. television) even though completely different technologies may be involved. Methods of improving the photographic medium have become evident although such progress could not have occurred on the basis of measurements of resolving power alone.

Much of the remainder of this chapter is devoted to a brief outline of the more relevant of these approaches as they concern the performance of a photographic emulsion. Before proceeding with these however, it will be instructive at this point to consider what we would expect the performance of an ideal imaging system to be. The significant deviations from this ideal behaviour that are exhibited by real photographic emulsions can then serve as an introduction to the treatment in the rest of this chapter.

Photography is a method of producing a permanent record of the light distribution of an optical image. It achieves this by virtue of the interaction of light with the photographic emulsion. This interaction is between individual photons, or quanta of light, and photosensitive elements of the photographic material. The final image is composed of microscopic picture elements corresponding in position to those photosensitive elements that have received adequate exposure.

Intuitively, it would seem that the ultimate photographic process would involve as the sensitive material some form of homogeneous surface over which a one-to-one correspondence existed between exposure photons and resulting picture elements. Every single incoming photon would give rise to an independent picture element and no such element would arise without the interaction of a photon. Furthermore, in such an ideal process, each picture element should occur at the point of intersection of

the corresponding incoming photon and the sensitive surface, and should be small enough for an accurate reproduction of the original exposure distribution to result. Finally, the elements should contribute equally and sufficiently to the measured output (e.g. density), retaining tonal information and providing adequate camera speed.

Real photographic materials do not behave in such an ideal manner. The following considerations represent a summary of the fundamental shortcomings found in practice:

(1) A significant proportion of photons striking the photographic material during an exposure are not absorbed by any light-sensitive element but are reflected by the front surface of the film or absorbed by the gelatin or backing. They do not contribute to image formation and their energy is wasted.

(2) The photosensitive silver halide crystals require more than one quantum each to render them developable and so produce a image element. It appears that the silver halide crystals in an emulsion exhibit a wide range of 'quantum sensitivities' from a lower figure of about four up to many hundreds. Such a characteristic contributes to the relatively wide range of response to light exhibited in general by photographic materials. Quantum sensitivity is a feature of latent image theory and is covered in more detail elsewhere.

(3) When a crystal has absorbed its required number of photons for developability it does not 'close its doors' to any further photons for the remainder of the exposure, but continues to absorb them at the same rate as before. The additional photons do not contribute anything further to the image and their energy is thus wasted.

(4) As we saw when discussing photographic turbidity, the non-homogeneous structure of the sensitive layer leads to substantial light scatter during the exposure stage, with the result that fine detail in the image is degraded. The resolving power of the material depends closely on this characteristic although, as we shall see, photographic turbidity is most usefully described using concepts of point spread function and modulation transfer function.

(5) Because of the grain size and grain sensitivity distributions, and the random nature of the spatial distribution of the grains, the photographic recording is characterized by a level of noise (see Figure 25.13) that is far higher than the noise inherent in the original optical image. In the developed image this noise is recognised as an attribute of the heterogeneous structure of the record and is widely

studied as such using a number of techniques. We have already met the terms 'graininess' and 'granularity' as two appropriate descriptors. A more exhaustive analysis can be performed using autocorrelation and power spectrum methods (see page 349).

Spread function and modulation transfer function (MTF)

If in Figure 25.1 the disc of illumination is imagined to become infinitely small, while retaining sufficient intensity to produce a photographic response, the image resulting is not a true point. Because of the turbidity of the emulsion layer it shows a circular intensity distribution known as the *point spread function*, some 2–20 μm in diameter (depending on the film type). This is significantly greater than the individual grain size and it is this rather than any one individual grain that represents the building block of all photographic images.

Formation of extended photographic images can be envisaged as the summation of an infinite number of overlapping point spread functions each corresponding to an elementary point in the object distribution.

The measurement of point spread functions in practice is difficult owing to their small size and two-dimensional nature. It is more convenient to consider the image of an infinitely thin 'line' distribution of intensity — the *line spread function*. In practice this is also considerably easier to measure.

The mathematics of image formation, using the spread function as a building block, involves the solution of convolution integrals, and the analysis of imaging systems would be a formidable task if this approach were the only one available. Fortunately, methods developed originally for telecommunication and information transfer yield an equivalent method of analysis that is far easier to implement in practice. This is the Fourier approach.

Basically, this depends on the fact that the distribution of illuminance in any optical image can in principle be expressed as the sum of a large number of *sinusoidal* components (bar pattern fluctuating sinusoidally with distance) of varying contrast, orientation and spatial frequency (i.e. number of cycles per millimetre). Because of light diffusion within the sensitive layer, the overall exposure distribution is degraded. In terms of the individual spatial sine waves however, the degradation exists only as a reduction of contrast, or modulation; they retain their sinusoidal form. The degree of modulation reduction, or attenuation, increases with spatial frequency. Thus fine detail is recorded less satisfactorily than coarse detail.

Figure 25.9 shows a computer simulation of image formation in a photographic material. At the top is a representation of two sinusoidal exposure distributions of differing frequencies, together with a point and a line exposure. A scan through the sinusoidal exposures is also shown. The lower part of the

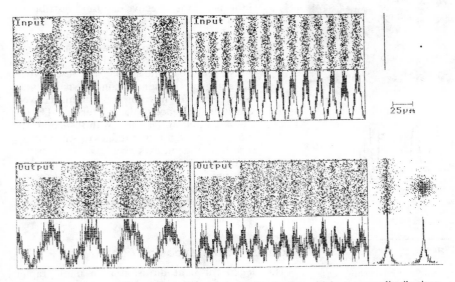

Figure 25.9 Computer simulations of image formation by sinusoidal exposure distributions

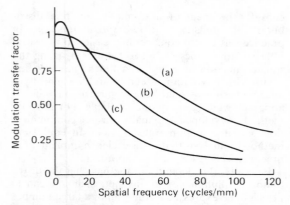

Figure 25.10 MTFs for (a) fine grain film, (b) medium speed film and (c) fast panchromatic film

diagram is an image of the top but with the dots moved a random distance in a random direction, to simulate light diffusion. The much reduced modulation of the higher frequency is clearly shown. The noise is the scans is a result of the small number of dots used in the simulation. The effect is not unlike that produced by photographic granularity.

A complete specification of the light-diffusing properties of the imaging system is possible using this 'sine-wave response', or modulation transfer function (MTF). This represents the output modulation divided by the input modulation, plotted against spatial frequency. Examples are shown in Figure 25.10. Mathematically, the MTF is obtained

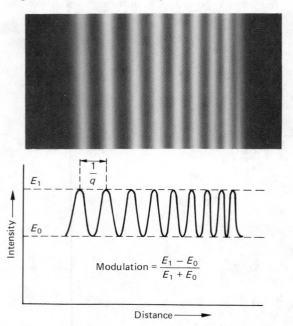

Figure 25.11 Section of sine wave test chart showing spatial frequency w increasing to the right

from the Fourier transform of the line spread function and includes no information not contained in that function.

In practice, the MTF can be determined for photographic materials in a number of ways. Photographing a chart containing spatial sine waves of a range of frequencies is perhaps the simplest in terms of the subsequent analysis (see Figure 25.11) although the production of the chart is difficult.

Another common technique involves photographing an edge and analysing the resulting image. In this way the line spread function is readily obtained and with the appropriate Fourier mathematics the complete MTF can be determined.

A third method of measuring the MTF of an emulsion uses a square-wave chart of the Sayce type (Figure 25.2(a)). The photographic image is subjected to Fourier analysis to obtain the true photographic MTF.

Factors affecting the modulation transfer function

Non-linearities of the photographic process

Strictly speaking, MTF theory is applicable only if the output chosen for measurement bears a linear relationship with the input. The following are two of the most important sources of non-linearities in photographic materials:

(1) The characteristic, or response curve. The commonly-measured output quantities, density and transmittance, are not in general linearly related to the input exposure unless low-contrast images are involved. To overcome this, the output modulation must be measured in terms of the effective exposure distribution inside the emulsion at the exposure stage.

(2) Development edge effects. These are due to exhaustion, diffusion and inhibition processes occuring during development and are an intrinsic feature of the system. Because of their advantageous influence on image sharpness, it is often expedient to promote them. However, in the presence of these effects, MTFs are obtained that are variable with respect to the exposure configuration (edges or sine waves), also to the mean exposure level, composition of the developer and development time. The presence of adjacency effects can be recognized by the increase in modulation of the lower frequencies. Curve (c) of Figure 25.10 illustrates this.

Colour of the exposing light

The degree of light diffusion in a photographic emulsion, and hence its MTF, depend on the

wavelength of the exposing light. There is however no systematic trend.

Halation

This arises when light scattered within the emulsion continues through to the base and its reflected at the base-air interface. The light re-enters the emulsion causing a secondary image. The highest concentration of reflected light appears within a narrow range near the critical angle and gives rise to a characteristic circular halo around small bright points in the image. Extended bright regions tend to form broad fogged patches with severe loss of fine detail.

The effect of halation on the photographic MTF is to reduce the level of the function, and this can be seen in the low frequency region of curve (a) in Figure 25.10.

Noise

The image noise, or granularity, makes the measurement of MTF inaccurate. This is particularly the case with edge methods and can introduce a *systematic error*.

Importance of the MTF

One of the basic advantages of modulation transfer analysis over earlier methods of evaluation lies in its fundamental nature. Although it is not in itself a measure of image quality it does allow an analysis of individual components of an imaging system from the point of view of detail reproduction. What we term 'resolving power' is the spatial frequency at which the MTF falls to some threshold value. This value depends on chart contrast, film contrast and graininess. Thus the MTF is more useful than a mere assessment of resolving power.

The MTF of a combination of components, e.g. a lens and a film, can be determined by multiplying together the MTF's of the individual elements ordinate by ordinate at each abscissa value. Also, the elements of a system can be examined to determine how much each is degrading the image and hence deduce which elements should be improved.

Autocorrelation function and power spectrum

Although the standard deviation of density (i.e. the square root of the mean square density deviation) can be used to describe the amplitude characteristics of photographic noise, a much more informative approach to noise analysis is possible using methods routinely used in communications theory. Instead of evaluating only the mean square density deviation of a noise trace, the mean of the product of density deviations at positions separated by a distance τ is measured for various values of τ. The result, plotted as a function of τ, is known as the autocorrelation function. It includes a measure of the mean square density deviation ($\tau = 0$), but equally important, contains information about the spatial structure of the granularity trace.

The importance of the function is illustrated in Figure 25.12, where a scan across two different (greatly enlarged) photographic images is shown. The granularity traces, produced using a long thin slit, have a characteristic which is clearly related to the average grain clump size in the image. The traces are random, however, so to extract this information the autocorrelation function is used. The two autocorrelation functions shown summarize the structure of the traces, and can therefore be used to describe the underlying random structure of the image.

The autocorrelation function is related mathematically (via the Fourier transform) to another function of great importance in noise analysis, the *Wiener* or *power spectrum*. This function can be obtained from a harmonic analysis of the original granularity trace, and expresses the noise characteristics in terms of spatial frequency components.

The power spectra of the two granularity traces is also shown in Figure 25.12. It will be noticed that the trend in shape is opposite, or reciprocal, to that of the autocorrelation functions. The fine-grain image has a fairly flat spectrum, extending to quite high spatial frequencies. This reflects the fact that the granularity trace contains fluctuations that vary rapidly, as compared with the coarse-grain sample in which the fluctuations are mainly low in frequency.

To measure autocorrelation functions and power spectra in practice requires the use of a precision scanning microdensitometer and computing facilities to handle the large quantities of data necessary (10000 readings may typically be taken from a single trace). Although the two functions are closely related (one may be readily calculated from the other), they have very distinct roles in image evaluation. The autocorrelation function relates well to the causes of granularity while the power spectrum is important in assessing its effects.

Detective quantum efficiency

Photographic materials are not particularly efficient in utilizing exposure photons, which means that for a fixed exposure level the detection quality of the

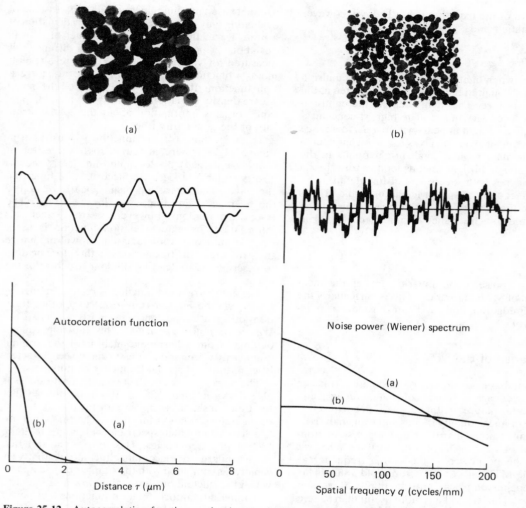

Figure 25.12 Autocorrelation functions and noise-power (Wiener) spectra for two different image structures

image* is very much poorer than the theoretical maximum. This is probably not significant in normal photography where exposure levels are high enough to ensure images of good detection quality on the output side of the photographic process. In situations involving low light levels however, such as may be encountered in astronomical photography, this characteristic is extremely important, and has led to the development of far more efficient image-recording systems to replace or supplement the photographic material. In these situations it is important to appreciate fully the performance capabilities and optimum exposure levels of the image

recorders available in order that they may be used most efficiently. *Detective quantum efficiency (DQE)* assesses the performance capability in this context essentially by measuring the efficiency with which the image recorder utilizes the incident exposure photons. It is defined as follows:

$$\text{DQE} = \left(\frac{(S/N)_{out}}{(S/N)'_{out}}\right)^2 \times 100 \text{ per cent}$$

where $(S/N)_{out}$ denotes the signal-to-noise ratio of the output from the image recording process under consideration, and $(S/N)'_{out}$ denotes the output signal-to noise ratio of an hypothetical 'ideal' image recording system registering every single exposure photon.

Broadly speaking, the signal-to-noise ratio refers to the detection quality of the image, and for a

*We use 'detection quality' instead of the more general, highly subjective term 'quality', as an objective appraisal of the level of discrimination possible between two density levels or two levels of luminance.

(a)

(b)

Figure 25.13 Images of different detection qualities. In (a) the negative has been printed in contact with a noise pattern to simulate excessive graininess. The higher detection quality of (b), printed without the noise pattern, is evident

photographic material depends on the contrast and granularity of the material. Figure 25.13 depicts a subject recorded with two different detection qualities, while Figure 25.14 shows simulated photographic images for a simple star object and demonstrates the concept of signal-to-noise ratio. In this illustration (a) represents the subject, (b) represents

an image formed by a high speed, coarse-grained material, while (c) represents that formed by a slower, finer-grained film.

To understand more fully the implications of the above definition of DQE, it is useful to derive two alternative expressions. First, the output signal-to-noise ratio for an ideal image recording process

Figure 25.14 (a) Simple, low-contrast exposure distribution consisting of a star disc on a uniform background. (b) and (c) Simulated photographic images.

Microdensitometer traces through the star images are also shown. The much higher signal-to-noise ratio of (c) is evident

equals (by definition) the input signal-to-noise ratio (i.e. the S/N ratio of the incident exposure distribution). We can therefore write

$$DQE = \left(\frac{(S/N)_{out}}{(S/N)_{in}}\right)^2 \times 100 \text{ per cent}$$

Further, it can be shown that the signal-to-noise ratio of an exposure distribution (i.e. the input S/N) is proportional to the square root of the exposure level (because the exposure photons have a random distribution in space and time), i.e.

$$(S/N)_{in} = k\sqrt{H}$$

Hence we can imagine comparing the output of our real image-recording process with the output from the 'ideal' process while reducing the exposure level of the latter. At some point the two outputs will match, i.e.

$$(S/N)_{out,\text{exposure level } H} = (S/N)'_{out,\text{exposure level } H'}$$

where H' is less than H. Hence we can write

$$DQE_E = \left(\frac{(S/N)_{in,H'}}{(S/N)_{in,H}}\right)^2 \times 100 \text{ per cent}$$

$$= \left(\frac{k\sqrt{H'}}{k\sqrt{H}}\right)^2 \times 100 \text{ per cent} = \frac{H'}{H} \times 100 \text{ per cent}$$

i.e. the DQE of a real image recording process at an exposure level H is given by the ratio H'/H, where H' is the (lower) exposure level at which the hypothetical 'ideal' process would need to operate in order to produce an output of the same detection quality as that produced by the real process. This idea is demonstrated in Figure 25.15.

Because ideal systems do not exist in reality, this last definition does not help in measuring the DQE for image recorders in practice. Instead it is necessary to use the second definition above and determine an expression for the signal-to-noise ratio of the image in terms of readily-measurable parameters. When this is done for the photographic process we arrive at a surprisingly simple expression

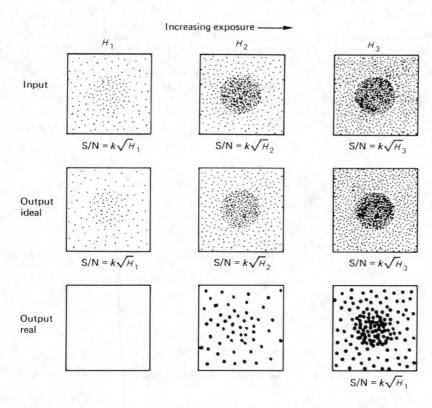

Figure 25.15 Input and output for 'ideal' and real image-recording process. Top row: input exposure distribution (photon distribution) at three different exposure levels. Middle row: output for an ideal detector (identical to the input). Bottom row: output for a real detector. Here,

exposure H_1 is insufficient for any response and the result for exposure H_3 has been drawn with the same S/N ratio as the input at exposure H_1. i.e. DQE for real detector at exposure level $H_3 = H_1/H_3$

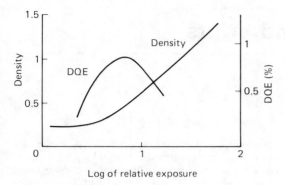

Figure 25.16 Detective quantum efficiency (DQE) as a function of exposure for a typical photographic material. The function peaks at an exposure level near the toe of the characteristic curve

$$\mathrm{DQE}_H = \frac{0.43\,\gamma_H^2}{EG_H} \times 100 \text{ per cent}$$

where γ_H is the slope of the characteristic curve at the exposure level H photons/$\pi \mathrm{m}^2$ and G_H is a measure of the image granularity at this point.

Figure 25.16 shows a DQE vs log-exposure curve for a typical photographic material. It can be seen that the function peaks around the toe of the characteristic curve and has a maximum value of only about 1 per cent at best. The two materials represented in Figure 25.14 would probably have much the same peak DQE values, but these would occur at different exposure levels. The curve for the fast, coarse-grain material would be at the lower exposure level, corresponding to a lower input signal-to-noise ratio.

This last expression is equivalent to writing

$$\mathrm{DQE} = \frac{(\text{contrast})^2 \times \text{speed}}{\text{granularity}}$$

Such a relationship, happily, agrees with conclusions arrived at from a more intuitive commonsense approach to the problem of improving the threshold signal-detecting capabilities of photographic images.

Information capacity

The information capacity of a photographic material is a measure of the maximum amount of information (in a precisely defined form) that can be stored on the material. It is usually evaluated by determining the number of micro-regions, or cells, per unit area, that can be distinguished as separate. The figure obtained depends on the constraints applied: the greater the number of distinct density levels we wish each cell to be capable of exhibiting, the larger the cells must be. The relationship arises as a result of image granularity.

Generally only two density levels are adopted and the cell size is found to be of the same order as the point spread function area. It cannot be less. Using such two-level recording, each cell is said to possess one bit of information and the number of cells per unit area is a measure of the information capacity in bits per unit area. Values range typically from about 5×10^4 bits/cm^2 for high-speed materials to 2×10^8 bits/cm^2 for high resolution material.

Colour images

It is possible to use the techniques of evaluation outlined so far for monochrome (silver) images quite generally for the analysis of colour images. The differences are mainly in interpretation, because the fundamental colour image element is a transparent and spectrally highly-selective dye cloud. Hence it is necessary to specify the appropriate wavelengths for exposure and measurement in order that the results should be meaningful.

If the MTF is evaluated for each layer of a tripack, it is generally found that the layer closest to the film base yields the poorest result, owing to the greater light scatter involved. Threshold graininess originates from differences in perceived intensity; colour differences are not involved. Hence magenta dye contributes most to the observed graininess, and yellow dye the least.

As the location and extent of the dye clouds depend on the distribution and size of the original developed silver grains, it might be expected that the dye-image granularity would be closely related to the silver-image granularity. This is certainly true for low densities, where the granularity of the colour image is proportionally higher than that for the black-and-white image. This arises because the dye clouds are larger and absorb more light than the silver grains from which they are derived. It requires less of them, therefore, to yield the same optical density. At higher densities, however, the dye clouds intersect, and, because of the limited amount of colour former (in incorporated coupler systems at least) the distinction between clouds is lost. The granularity therefore falls. At maximum density the granularity can be very low, depending more on the original coupler distribution than on the pattern of exposed grains.

T-grain technology, mentioned earlier in this chapter and in chapter 12, has been responsible for significant improvements in the quality of colour images. The reduced diffusion of exposing light is especially valuable in multi-layer colour materials, and together with reduced graininess has made it possible to manufacture an ISO 1000/31° colour-negative emulsion.

26 Faults in negatives and prints

Never destroy a faulty negative or transparency until you have ascertained the cause of the fault. You will be wiser as the result of your investigation and may save yourself much trouble and annoyance in the course of further work.

It is, of course, impossible to mention every fault which may occur, but we propose to deal with as many as possible, both usual and unusual. In order to facilitate identification, description of the appearance of the negative is given as a heading, and beneath it are listed the various faults which may be the cause of this appearance.

In arriving at the cause of any particular fault, the first step should be to narrow down the field of investigation by reference to Tables 26.1 to 26.4. By following up the references to text in the tables, it should be possible to classify the fault as one of exposure or of development, and then, from the evidence available it should be a simple matter to identify the cause. The majority of faults can occur in all types of material, but where any faults are peculiar to (or most likely to occur with) one particular type of material or camera this fact is mentioned.

Faults in black-and-white negatives

Unsharp negatives

There are basically two kinds of unsharpness, and they are easily distinguishable by the appearance of the photographic image. The first is caused by the optical image being out of focus; the image appears blurred uniformly in all directions. The second is caused by movement of the optical image during the exposure; the image is blurred in one direction only. Occasionally the image may appear doubled. A third type of unsharpness is somewhat different in nature.

Lack of focus

One type of blur occurs because the image is out of focus, due to misjudgement of distance, incorrect setting of the focusing scale or to approaching the subject too closely when using a fixed-focus camera. More rarely the unsharpness may be due to a faulty focusing scale, incorrect register of the film or to the components of the lens being misplaced. In the case of a camera with coupled rangefinder and focusing scale, unsharpness may be due to the coupling being out of adjustment. This is unusual, but it can happen if the camera is dropped or knocked violently.

With reflex cameras and other cameras focused by means of a viewing screen, unsharpness results if the screen is removed and replaced the wrong way round. Frequently, some part of the subject will be sharp, but not the part which ought to have been in best focus.

Occasionally, when a folding camera has been used, the unsharpness may be more at one edge of the picture than at the other. The fault is due to the front of the camera becoming out of true through wear or damage. If unsharpness is more serious in the centre of the picture than at the sides, then the fault may be due to the camera having been opened too quickly, and the film sucked forward out of the plane of focus by the partial vacuum so formed. This fault can also be caused by an incorrectly-assembled lens unit.

Camera shake

The other kind of unsharpness is caused by unsteady holding of the camera during exposure. If the camera is jerked during the exposure, two or more images will be recorded, each shifted slightly from the others. A magnifier usually shows these separate outlines. Time exposures made with the camera on an unsteady support show the same effect. This can be avoided by using a firm tripod and a cable release.

A more common type of unsharpness resulting from *camera shake* is a directional blurring which does not show a double image. This is caused by a uniform movement of the camera during exposure, and is most common in lightweight 35 mm (or smaller) cameras, as these have a low moment of inertia.* Anyone, no matter how experienced, may have trouble with camera-shake when using long exposures (1/30 second or longer), and this is aggravated with a small format: a degree of camera-shake which would pass unnoticed in a 4 × 5 inch negative

*It is not always appreciated that it is *rotational* movement, not translational movement, that causes camera shake. A rotation at a speed of only 20° per second will produce a picture that is visibly unsharp at a shutter speed as high as 1/500 s.

is a serious fault in a negative measuring only 24 × 36 mm, which must subsequently be considerably enlarged.

Sometimes the blur caused by camera-shake is evident over only a part of the negative. This may be due to one of two causes. In the case of a camera fitted with a focal-plane shutter, the movement may have occurred when the slit in the blind had already travelled across half the width of the film. The alternative explanation, applicable to any type of camera, is that one hand of the photographer moved while the other remained still, thus one side of the camera moved more than the other – usually it is the hand that presses the shutter release that is the more likely to shake.

An unsharpness somewhat similar to camera shake is obtained if the shutter speed is too slow when photographing moving objects: the optical image on the film has time to move while the shutter is open. This occurs chiefly with objects crossing the line of sight and, of course, affects the moving parts of the subject only.

This fault can be prevented in three ways:

(1) By giving a shorter exposure and using a wider lens aperture.
(2) By swinging the camera carefully so that the image of the moving subject remains in the same place in the picture area, and the movement is imparted to the background. This technique termed 'panning' helps to suggest speed and is most effective.
(3) By standing near the line of approach of the subject.

There is no remedy for unsharpness of negatives other than digital image processing, but it can be masked to some extent by printing on a textured print material.

'Soft-focus'

A third, somewhat different, type of unsharpness is the result of a dirty lens, or a badly-corrected lens that is being used at a large aperture. The image is not in itself unsharp, but is surrounded by a soft-edged haze. It is an effect that is sometimes deliberately sought for pictorial reasons.

Thin negatives

Insufficient density of the negative arises from under-exposure or under-development (or both). Some idea of the cause may be obtained by noticing the occurrence of detail and the density of the highlights (sky) relative to the shadows. If there is detail everywhere, though faint in the shadows, and if the shadows are free from veil (almost clear when the negative is laid face down on white paper), the cause is under-development, i.e. development for too short a time, or in a solution that is cold or partially exhausted. The negative is weak and low in contrast, and the rebates are clear. A chromium intensifier may increase the density to give very much the same effect as though development had been continued for the proper time.

If the negative shows detail throughout, including the shadows, but is veiled all over (so that the picture appears to be buried in fog when the negative is laid face down on paper), the cause is over-exposure followed by under-development. It is not easy to remedy an over-exposed and under-developed negative satisfactorily, but intensification often makes a marked improvement. Unless the negative is excessively thin, it is worth reducing it slightly with a subtractive reducer before intensifying. This requires considerable care, but the negative can then be intensified with a better chance of success.

If the negative is thin only in the midtones and shadows, which are badly lacking in detail, but of fair density in the sky or other highlight, the cause is under-exposure. The negative may look contrasty, owing to the highlight density, but the other parts are flat. Most intensifiers only aggravate matters, but the negative may be improved sufficiently to yield passable prints by treatment with a uranium intensifier.

Such after-treatments are rarely practicable on 35 mm or small films. They tend to increase grain size, and the extra handling can frequently damage the film physically.

In the case of negatives that are weak or flat from under-development, satisfactory prints can frequently be obtained simply by using a contrasty paper.

Note: it is often difficult to distinguish between under-exposure and under-development, as emulsion speed depends on development, and under-development of an otherwise correctly-exposed negative often results in a loss of shadow detail. The correct diagnosis can always be made by examining the rebates, which will be transparent and often pinkish in the case of under-development, but pale grey when development was correct.

Dense negatives

Excessive density of negatives results from over-development, but the character of the negative varies very greatly according to whether it was originally over-, under- or correctly-exposed. The means for improvement likewise differ.

In the case of negatives that have had reasonably correct exposure, over-development results in increased contrast. The densities in the highlights

increase relative to those in the shadows. The negative looks contrasty, and may be grainy. If this contrast is excessive, the range of densities is too great to be rendered in the print, which then lacks gradation of either the lightest tones or the darkest ones. The remedy is to reduce the negative with a solution which, so to speak, will undo the action of the developer. No reducer does this exactly, but Farmer's reducer is fairly satisfactory if used very dilute. The permanganate-persulphate reducer, though nearer the ideal in action, is more troublesome to make up.

In the case of over-exposure, continued development gives a negative that is very dense and black all over, yet may be as perfect as one correctly exposed but similarly developed, except that much longer time is required for printing. This arises from the latitude of the emulsion. But if exposure has been grossly excessive, the negative, though dense, will be low in contrast. In either case it is best to treat with Farmer's reducer until density is reduced to a degree suitable for printing. For negatives judged to be of satisfactory contrast, the reducer should be used dilute; if the negative is thought to lack contrast, a stronger solution should be used. (It is a good plan to make certain by making a print before reducing.) Then, if necessary, the negative is brought to satisfactory contrast by intensification.

Over-development of a negative that has been much under-exposed results in excessive density, chiefly in the highlight and heavier densities, which become opaque and almost unprintable. The best reducer is ammonium persulphate, but it is often difficult to remedy a negative of this very hard character.

Fog

Fog, ranging from a thin uniform deposit (called 'veil', which causes the negative to print flat, to a heavy one which obliterates the picture, may be due either to general action of light other than that from the lens, or to chemical action.

The condition of the edges of the film, or other portion protected from the action of light in the camera, provides a clue to the probable cause. If these, or parts of them, are practically free from fog, the cause must be sought among things that can possibly happen to the film in the camera, whereas fog that covers every part of the negative is probably due to action of light before or after exposure, or to chemical action.

Fog in the camera arises from gross over-exposure (e.g. use of a shutter set by accident to 'time'; from the scattering of light caused by a dusty or dirty lens or reflection of light from the camera interior (slight veil); from a scattering of the light which often occurs when the camera is pointed directly against a strong light; or from leakage of light into the camera, in which case the fog often occurs as a band or streak, the position of which gives some indication of the point of leakage (such as a loose-fitting camera back).

Fog or veil over the whole surface may arise from some accidental exposure to white light, or to an unsafe darkroom light. Fog may even occur from exposure of negatives to white light before they are completely fixed, especially if a plain (not acid) fixing bath is used. Apart from improper action of light, wrongly compounded developer or the contamination of developer with fixer may cause the defect. Materials that show persistent fog should be tried with freshly prepared developing solutions. Fog along the edges of roll film is caused by the spool becoming loose, and light penetrating between the spool paper and the metal flanges of the spool. Such fog extends sometimes right across the width of the film.

Light fogging of 35 mm films while in the camera is unusual, but the possibility of light leakage in the cassette should never be overlooked. If a cassette with a velvet-edged light trap has been used several times and the nap flattened, light is likely to leak in and fog the film at the leader end.

As a rule nothing can be done to remove fog.

General stain

Yellowish or brownish discoloration of negatives seldom occurs with modern emulsions and developers. When it does, the cause is almost always stale or oxidized developer, due to the use of a stock solution kept too long, to using a developer for too many films, or to 'forcing' a negtive in the developer. When using hydroquinone developer, a yellow stain is liable to occur if negatives are not well rinsed between development and fixing. An acid stop bath is a good insurance against staining.

A very effective method of removing the heaviest developer stain is by use of the following bleaching solution:

Potassium permanganate	6 g
Sodium chloride	12.5 g
Acetic acid, glacial	50 ml
Water to make	1000 ml

This solution oxidizes the stain to a soluble substance, and at the same time converts the silver image into silver chloride. The negative is immersed in it for ten minutes with constant agitation, rinsed and soaked in a solution of potassium or sodium metabisulphite (50 g in 1000 ml water) until the negative is white when viewed from the back. It is then redeveloped fully with any normal MQ or PQ developer.

Owing to the highly acidic nature of the bleach, it is well to harden the film first by immersion for a few minutes in a solution of chrome alum (10 g in 1000 ml water). Such treatment should be used for 35 mm or smaller films only as a last resort.

Dichroic fog

Dichroic fog is a stain which appears green by reflected light and reddish by transmitted light. It is caused by contamination of developer with fixer, ammonia or other solvent of silver bromide, by keeping films in an impure atmosphere, by the use of alkaline fixer, or by one film lying upon another in the fixing bath. It can be removed by very weak Farmer's reducer.

Transparent spots

The two chief causes are air-bells clinging to the emulsion surface during development, and particles of dust on the emulsion surface during exposure and/or development. Spots of the two kinds may be distinguished by holding up the negative to the light and examining with a pocket magnifier. Spots from air-bells are all almost circular in shape. Air-bells generally arise in the developer. Water drawn from pressure mains is usually highly aerated, and when used for diluting stock solutions is apt to cause a crop of air-bells. Air-bells in the developer can be eliminated by using a one-minute pre-soak in water before development, or by lifting the film out of the developer briefly, shortly after immersion. Air-bells in other solutions are uncommon, though they may occur in the wash water, leading to small unwashed spots which can eventually become discoloured.

Dust spots, under the magnifier, are seen to be all kinds of shapes, much smaller than spots made by air-bells, and sharp in outline. The dust causing this trouble is almost always present in the camera before loading, and occasional cleaning with a blower or vacuum brush is advisable if these blemishes are experienced regularly.

Clear spots on a negative may also be caused by dirty tanks or by impurities in tap water. Clear spots and smudges may be caused by the adherence of scum to the surface of the emulsion during development. This scum is found on the surface of large tank developers that have been used, and should be removed before films are inserted. The formation of scum, and oxidation of the developer, are greatly reduced if a floating lid is used.

Clear spots arising from causes other than the above are seldom met. Developer that has become stale from age or use, or is contaminated with grease, is liable to cause light spots of irregular shape. In tropical countries, similar spots may be formed by bacteria which have found the damp gelatin a suitable culture medium. In temperature climates, cases occasionally occur where the gelatin coatings of negatives have been eaten into minute holes by insects.

Light spots of comet shape on a ground of heavy fog are also rare, and may be a puzzle until their cause is found. They arise from leakage of light from some point which causes rays to graze the emulsion surface. Particles of dust on the latter cast shadows which, in the negative, form the comet-like spots on the ground of fog.

Clear spots on negatives cannot be rectified other than by retouching.

Dark spots

Dark spots may be caused by undissolved particles of developing agent (metol, hydroquinone, etc) in the developing solution; settlement on the emulsion of particles of developing agents suspended in the air of the darkroom from previous weighings of the dry chemicals (spots produced by metol dust are very characteristic: they are clear with dark edges); dark, insoluble particles of oxidized developer formed in old or used developing solutions.

Particles of solid matter in tap water may also settle on the gelatin emulsion and cause spots.

Yellow or brownish spots

The cause of spots of this type is air-bells or dirt clinging to the emulsion surface in the fixing bath and thus obstructing the action of the fixer. If noticed soon after fixing, they can usually be removed by returning the negatives to the fixing bath, and in the case of air-bells (which are usually CO_2 gas, resulting from the acid in the fixing bath reacting with alkali from the developer) this will effect a cure; but specks of dirt will probably have been clinging to the emulsion throughout development as well, and will leave clear spots which will have to be retouched out.

Light bands and patches

Light bands and patches are usually less easy to diagnose than dark ones. Some of these defects are of very obscure origin. The following may be noted:

A light or clear band across one end of the negative usually means that flash has been used at an unsynchronized shutter speed with a focal-plane shutter. On larger-format cameras it might be due to failure to withdraw the darkslide completely or to an overlong camera baseboard.

A clear patch on a roll-film negative, with three straight edges and one irregular edge, may be due to the sealing paper having been torn off and having become lodged in the body of the camera. An irregular shaped patch may be caused by a small, loose fragment of such paper.

A band of lesser density along one side or end of the negative indicates a fixed but unrinsed negative left projecting from the water in the washing tank. Patches of low density may also occur on film negatives left to fix with parts above the surface of the fixing bath. With roll films, the most common cause is insufficient developing solution in the tank.

Areas of lighter density may also be due to uneven flooding of the film with developer, the light areas having remained dry longer than the remainder. This is a common fault when only a very small quantity of developer is used. It can be avoided by using a pre-wash in plain water.

Small, round light patches (finger-tip markings) are produced if the emulsion is touched before development with slightly greasy or chemically-contaminated finger tips. The finger-print pattern usually provides a clue to the cause of this defect. Splashes of fixer on the sensitive material before development will cause clear patches or patches of lighter density.

A light patch surrounded by an edge of greater density is likely to be a drying mark caused by a drop of water remaining on the emulsion after the remainder was dry. Drying marks may also be caused on film negatives by drops of water remaining on the base side. A blank, undefined area at one edge of the negative may be due to part of the picture being cut off by the photographer's finger over part of the lens. Blank areas at the corners of the negative are caused by the lens not covering fully: if only the top corners are affected the fault may be due to the excessive use of rising front. A fault of similar appearance may be caused by a badly-fitting or unsuitable lens hood.

Blank areas or areas of low density may be due to two films having been in contact during development, or incorrect loading into a spiral, one film or coil preventing the solution from reaching the adjacent one.

Dark bands and patches

This type of fog is almost always due to leakage of light into the camera. If the fog in the form of a streak originating at one edge of the film, the cause may be sought in a small point of leakage somewhere in the camera back. In a roll-film camera, looseness of the camera back may be responsible; in the case of a large-format camera, a leakage in the film holder, bad fitting of the holder, or worn condition of the light traps may cause the trouble.

A round or oval patch may be a flare spot, particularly if the picture has been taken against the light. Light reflected from bright metal parts inside the camera or in the lens or shutter may cause similar trouble. Lens flare is comparatively rare, but scattering of light and reflection of the shape of the lens diaphragm are seen fairly frequently when pictures have been taken against the light. Because of the greater number of reflecting surfaces that they incorporate, multi-component lenses are more liable to produce this fault than simpler lenses.

Marks of greater density than the image may be caused by water or developer which has been splashed accidentally on to the emulsion surface before development. Similar markings of rather less density may be caused by water splashing on to the dry negative after processing. If water splashes are discovered before the film is processed, the trouble can be prevented by a pre-soak in plain water before commencing developments.

Dark finger-print patterns occurring on the negative are caused by touching the sensitive material with developer-contaminated finger-tips before development.

Dark or degraded edges of the negative are caused by storage of the sensitive material in a damp place. The fault is usually accompanied by some degradation over other parts of the negative.

Chemically-active substances are also present in some printing inks, and for this reason sensitized materials should never be wrapped in printed paper. The ink used to print lettering and numbers on the backing paper of roll films is made from substances that are inactive in this respect.

Yellowish or reddish patches, usually not occurring until some time (days or weeks) after the negative has been finished, are caused by incomplete fixation. In the case of sheet films, they may be due to part of the negative floating above the surface of the fixing bath or to one film pressing on another. If the patch has a straight edge the latter cause is indicated.

Line markings

Fine, clear lines running the length of a band of roll film are caused by friction of the emulsion surface against rough guide rollers or against dust or grit on the latter; they may also be caused by the guide rollers becoming jammed and failing to revolve as the film is wound across them. Similar 'tram-lines' may occur along the length of a 35 mm film due to the film having been rolled or pulled too tightly, or to the light trap of the cassette picking up grit which causes scratches as the film is drawn through the camera. In general, abrasion marks made before exposure are dark, and abrasion marks made after

exposure are light. Examination of the nature of the marks will often help to identify the precise cause.

Irregular lines may be caused by the film being allowed to touch the working bench almost any form of friction on the sensitive surface is liable to cause such abrasion marks. A tiny 'arrowhead' mark may be caused by the film being allowed to kink.

A dark line round an outline where (in the subject) dark objects come against a light background sometimes occurs in tank development when the solution is allowed to remain without movement for the whole period of development. Solution in contact with a heavy deposit becomes exhausted, while that on an adjoining light deposit (largely unexhausted) runs over to the former, adding further density all along the edge.

So-called 'streamer' lines, i.e. bands of extra density running from the image of a narrow, dark object such as a chimney, flagstaff, etc., result from downward diffusion of largely unexhausted solution in stagnant tank development. The same type of fault can occur when films are developed in spiral tanks, but in this case the streamers run across the width of the film and, with perforated films, are likely to be most intense adjacent to the perforations. Streamers also occur if the agitation of the developer is insufficient or too intense and regular.

The cause of tangle markings, i.e. a tangle of dark lines, sometimes covering the entire negative, is a pinhole in the body or between-lens shutter of the camera. On carrying the latter about in bright sunlight, the pinhole forms an image of the sun on the emulsion surface, and the position of this image changes continuously as the position of the camera changes. The result is a continuous line, running here and there, according to the directions in which the camera was pointed. When lighting is diffused, the indication of a pinhole in the bellows will be small, dark patches on the negative, with heavy centres and undefined edges. A pinhole in the blind of a focal-plane shutter will cause a line of slightly greater density across the negative.

Short hair-line marks occurring all over roll film negatives are called *cinch marks*, and are caused by winding the spool too tightly after removing it from the camera and before sealing.

Halation

Halation takes the form of a spread of density from the image of bright parts of the subject on to surrounding portions, obliterating detail in the latter. Common examples are the blur of fog round the windows in interiors and from the image of the sky onto that of tree branches. It is minimized by the use of anti-halation dyes in the film base or by non-reflective backing of the film.

Light scatter

Light scatter may also occur in such cases. This is due to diffusion of the image of a bright part of the subject within the sensitive emulsion. It is a consequence of the turbidity of the emulsion, and there is no way of preventing it.

Positive instead of negative

At times, the image (when finished in the usual way) appears as a positive instead of a negative; usually a greatly fogged positive. Frequently, part only of the subject is positive and the remainder negative. The reversal is generally caused by forcing an under-exposed film by protracted development under an unsafe darkroom light. The defect is very seldom met with, but cases sometimes occur in which one or two negatives on a spool of film are perfect, while the others are reversed, the exposure to the darkroom light having been greater in the part of the spool affected.

Reticulation

Reticulation takes the form of a fine raised irregular pattern over the whole negative, most pronounced in the heavier densities. It arises from a physical change in the gelatin caused by sudden swelling on transference from a cold to a warm solution, or (rarely) by sudden contraction when transferred from a warm to a cold solution.

Frilling and blisters

These defects are manifestations of poor adhesion of emulsion to the base. Frilling usually occurs at the edges whereas blisters may be found at any point on the surface of the negative. Neither trouble is likely to be met with except perhaps when processing is carried out under the worst tropical conditions and when the various solutions are used at widely-differing temperatures. Frilling may, however, be caused by transference of negatives from a strongly alkaline to a strongly acid bath, and may also result if negatives are held by the edges with warm fingers. Frilling of RC paper may be caused by excessive washing or by washing at too high a temperature.

Mottle

This may be caused by age deterioration of the sensitive material, by deterioration caused by chemical fumes or by exposure to the air, as in the case of a roll film left in a camera for a period of months.

Another form of mottle may be caused by the growth of bacteria or fungus in the gelatin in hot and humid climates. Stagnant developer is the cause of yet another type of mottle.

A mottle that is more or less defined all over the picture arises if a backed film is exposed through the backing; the picture also reversed left to right. Similar mottling occurs if a backed film is left face downward on the bench long enough for the dark-room lamp to fog the emulsion.

Dull image

When the dullness of the image is due to insufficient density of the negative and to a certain amount of veil that extends over the margins, the cause is probably exhausted or contaminated developer. The presence of stain on the negative confirms this. This dullness also may be due to incorrect preparation of the developer. The weakness of the developer is responsible for the weakness of image, and forcing or contamination of the solution is liable to produce chemical fog and stain. Such a negative can be improved by slight reduction followed by chromium intensification.

Dullness of the image of a negative of good density may be due to inadequate fixation. Undissolved silver salts remain in the negative and obscure the clear parts. Re-fixing and washing is usually successful.

Dullness of the image may also be due to dichroic fog, which is dealt with on page 357, or to veiling of the picture by slight general light fog, to scatter from the lens or to chemical fog.

Do not overlook the possibility of dullness being due simply to under-exposure or to under-development, which are explained on page 355. The subject, too, may have been poorly and flatly lit, in which case only a dull reproduction can be expected.

Other faults

The reasons for some photographic failures are obvious. For example, the blurring and mingling of the image that occurs when the emulsion melts is unmistakable and can be attributed only to the use of hot solutions or to drying at too high a temperature.

When pictures overlap on a roll-film the fault is in the film transport mechanism.

Torn and/or cockled edges of a roll film are caused by misalignment in the camera. Often this fault is accompanied by edge fog, due to light entering where the spool paper was torn. The misalignment may be due to a bent or broken spool chamber spring, or to one or both of the small guide rollers being bent or moved out of the true position owing to wear of the bearing ends.

Do not be discouraged by the foregoing formidable list of the failures that may occur in negative making. Our aim has been to provide summarized descriptions of most of the defects that may arise. Many of them are comparatively seldom seen, and when met for the first time may be all the more puzzling on that account.

Index to faults in black-and-white negatives

The index of the following pages is included to assist you in the speedy identification of negative faults. It must, however, be used in conjunction with the general evidence in your possession: type of material, type of camera used, etc. It attempts to sum up,

Table 26.1 Faults in black-and-white negatives

Appearance of negative	Fault	Information (page)
Unsharpness		
Fuzzy definition	Out of focus	354
Blurred directionally	Movement of camera	354
Blurred image of part of subject	Movement of subject	355
Hazy image	Dirty or poor-quality optics	355
Too dense all over		
Flat and much shadow detail	Over-exposure	356
Contrasty	Over-development	355
Too thin all over		
Lacking shadow detail	Under-exposure	355
With some shadow detail but lacking contrast, rebates clear	Under-development	355
Dark markings		
Dark areas with images of lens diaphragm	Light scatter	54, 358, 359
Black 'blobs' with image of lens diaphragm	Lens flare	54, 358

Appearance of negative	Fault	Information (page)
Black splashes	Light leak in camera	358
Splashes of greater density	Water or developer splashes before development	358
Black finger marks	Developer-contaminated fingertips	358
Black edges (roll film)	Edge fog	356
Dark or degraded edges	Damp storage	358
Black streaks, usually from edges	Light leaks in film roll, cassette or camera	358
Fine black lines	Abrasion marks	358
Dark streamers from light parts of negative extending on to dark parts	Tank development – insufficient agitation	359
Black spots	Chemical dust	357
Dark ribbon-like tangle	Sun tracks	359
Tiny dark arrow-shaped mark, accompanied by dimpling of film negative	Kink mark	359
Very short, rather faint parallel hair lines close together all over roll film negative	Cinch marks	359
Light markings		
Clear areas or areas of lower density	Uneven development	358
Sharply defined blank area	Paper in camera	358
Clear finger marks	Greasy or contaminated fingers	358
Sharply defined irregular areas of lesser density	Uneven covering with developer	358
Irregular clear spots	Developer scum	357
Picture fades into transparency at corners	Lens not covering	358
Clear scrape marks – emulsion removed	Abrasion by finger nail or by other negatives	359
Emulsion removed or loosened at edges	Frilling	359
Large spot of lighter density with greater density at edges	Drying mark	358
Line of lighter density	Loose thread on blind of focal plane shutter	
Fine light lines	Abrasion marks	358
Irregular shaped small clear spots	Dust on material during exposure	357
Round spot either clear or of lighter density	Air-bells during development	357
Undefined clear area at one edge of negative	Hand partly covering lens	358
Mottle		
Dappled marking which can be seen also by reflected light	Old material	359
Defined mottle without physical marking of surface	Exposure of fog through backing	360
Defined fine-textured pattern with physical marking of surface	Reticulation	359
Irregular streaky mottle	Insufficient agitation during development	232
Dull image		
Insufficient density with some veil over shadows	Exhausted developer	360
Brownish appearance of back	Inadequate fixation	360
Reddish stain when looked through – greenish stain when looked at	Dichroic fog	357
Obscuration of the picture to a greater or lesser extent	Light fog or chemical fog	356
Distortion		
Converging upright lines	Camera tilt	130
Exaggerated perspective	Short focus lens used too near subject	38
Miscellaneous faults		
Dark halo around highlights	Halation or internal scatter	359
Two images on same negative	Double exposure	360
Blurring and mixing of the image accompanied by irregularities in emulsion surface	Melting of emulsion	360
Positive or partial positive instead of negative (normal density)	Reversal due to fogging by unsafe darkroom lamp during development	359
Positive or partial positive instead of negative (extreme density)	Reversal caused by extreme over-exposure	174
Two images over part of the negative	Over- or under-winding of film spool	360
Torn or cockled edges (roll film)	Misalignment in camera	360

very briefly, the information given in the foregoing pages, and reference should be made to these pages.

Faults in black-and-white prints

Abrasion or stress marks

These defects, in the form of fine lines, hair-like markings or grey patches, sometimes make their appearance when the sensitive paper has been roughly handled before development. The printing apparatus or processing tongs may have some rough edges. To remove the dark markings, pass the prints through a weak reducer such as dilue Farmer's reducer, or rub the surface of the dry prints with a soft cloth dipped in a mixture of equal parts of methylated spirit and ammonia.

Blisters

These may be caused by wide variations in temperature of developer, fixing bath and washing water, by too strong a fixing bath or by too long immersion in it. Blisters on sulphide-toned prints may be caused by too strong a sulphide solution. Hypo-alum toned prints may blister if the prints are put straight from the hot toning bath into cold washing water instead of through an intermediate bath of tepid water. Mechanically produced blisters are caused by creasing or folding the paper, or by use of a fierce jet of water in washing.

Colour of image unsatisfactory

Prints on bromide or contact papers that are greenish in colour indicate under-development following over-exposure, too great a proportion of potassium bromide in the developer, stale developer or too much dilution of the developer. The latter, especially, applies to contact papers.

Contrast excessive or lacking

Excessive contrast generally indicates the use of the wrong grade of paper. Specially soft grades of paper are made for printing from hard or contrasty negatives.

When contrast is lacking, the cause may also be the wrong choice of paper. Thin, flat negatives require printing on hard papers and will give prints of normal contrast in this way. Another cause of poor contrast is the use of a partially-exhausted or improperly-compounded developer, or the use of a developer at too low a temperature. Poor contrast may also be caused by over-exposure, followed by short development.

Deposits on dry prints

When caused by the use of hard water the deposit can usually be removed by wiping the surface of the wet print before drying. Prints that have been insufficiently washed after fixing may show a deposit of white powder or crystals. Prints toned in the hypo-alum bath may dry with a bad surface unless well sponged when removed from the toning solution. Sulphide-toned prints will show patchy alkaline deposits if inadequately washed after toning. Deposits can also be removed mechanically by applying to the surface of the dry print a little metal polish on a piece of soft rag, followed by polishing with a clean rag. Beeswax dissolved in petrol, or one of the waxes sold for treating antique furniture, will often improve a bad surface.

Fading or tarnishing

Incomplete removal of the unused silver salts by the fixing bath or failure to remove all the fixer may cause fading or tarnishing. Impurities in the mount or the use of an acid mountant may also cause fading. Keeping the prints in a polluted atmosphere may cause yellowing or tarnishing.

Fog or degraded whites

A grey veil over the surface of a print may be caused by:

(1) Exposure to light or an unsafe darkroom light before or during printing or developing.
(2) Prolonged development beyond the usual time, or with the developer at too high a temperature.
(3) Using an incorrectly made up developer, or one with insufficient potassium bromide.
(4) Storing the sensitive papere in an unsuitable place.

Mottle or patches

Bad storage of the sensitive paper, or failure to keep the print moving in the developer, fixing or other bath, may cause these defects. In the case of prints on contact papers, patches are usually caused by failure to move the developed prints as soon as they are first placed in the fixing bath, especially if the acid content of the fixer is exhausted.

Spots

White spots, other than those caused by defects on the negative, are the result of air-bells forming on

the surface of the print during development. Particles of chemicals, either as dust or solution, particularly of fixer, falling on the surface of the paper may cause black or white spots. Dark spots are usually caused by air-bells during fixing or by dirt on the negative at the time of exposure or during development.

Stains

Yellow stains may be caused by prolonged development, by too long exposure to the air between development and fixation, by imperfect fixing or by insufficient acid in the fixing bath. A mere trace of fixer in the developer or on the fingers when handling the print bfore development may cause stains.

Faults in colour materials

Because of the complex nature of colour materials and their processing, faults are less easy to assign to single causes. Nevertheless, some of the more general faults listed in Table 26.1 also apply to colour materials. These include: unsharpness, dense negatives, thin negatives, reticulation, distortion, streaks, partial reversal, air bells. In colour materials line markings, spots, stains, etc., have a particular colour associated with them and this colour is often indicative of the cause but tends to be associated with a particular material and process. A fault with similar appearance in different materials may have a different cause. Thus it may be misleading to give an exhaustive list of faults in colour materials. The tables below list some of the more common general faults which may occur in colour materials, but manufacturers generally provide information on possible faults specific to their particular materials and processes.

Unlike black-and-white processing, colour processing is always carried out for a fixed time at a fixed and accurately-maintained temperature. Time-temperature nomograms are not used nor are processing conditions varied from those prescribed unless non-standard results are required. This lack of variation in the processing conditions means tht processing faults are less likely to occur, provided that the processing conditions are accurately complied with. Any faults that do occur can be due only to solution contamination, incorrect preparation or use of solutions, faulty materials, or some other extraneous cause such as fogging, abrasion etc. A number of colour materials appear milky when wet. This is often mistaken for incomplete fixation but is quite normal and disappears on drying. This apparent fault occurs in those colour materials that have the colour couplers incorporated in the emulsion in the form of a solution in oil droplets (see page 320), and is due to refractive index differences in the wet emulsion layer. Some colour-print materials may appear bluish when wet for similar reasons.

Another apparent fault appears in masked colour negatives. These have what looks like an orange/pink stain or fog which is disturbing to those unused to processing colour negatives. This is also quite normal and is the colour of the integral mask used to correct for dye imperfections (see page 208). A knowledge of how dye images are formed and the structure of colour materials is helpful in deciding on the likely causes of faults such as colour casts, fogging or staining. For example a red image on a colour reversal film may be due to the use of a red filter over the camera lens, a magenta coloration of a masked colour-negative film may be due to the exposure of the film to a greenish safelight and so on.

The following tables list some of the more general faults associated with various colour processes, but for the reasons given earlier the list cannot be taken as being exhaustive.

Table 26.2 Faults in colour reversal films

Appearance	Fault
Too dense all over	
Too dark, highlights cloudy	Under-exposure
Almost opaque, overall or patchy	Bleach and/or fixer omitted, too dilute or too exhausted
Too dark and colour cast present	Inadequate first development
Completely black, no image present but edge markings visible	Film unexposed
As above but edge markings not legible	First and colour developers interchanged, or first development grossly inadequate
Somewhat dark and colour cast present	Excessive colour development
Too thin all over	
Image flat and bleached but edges of film black	Over-exposure
Too light and colour cast present	Excessive first development
Completely clear, no image or rebate	Fully fogged before processing
Too light and pronounced colour cast	Contamination of first developer with colour developer or fixer
	Colour developer contaminated with first developer
Colour casts	
Blue/cyan, edges black	Artificial-light-balanced film exposed to daylight
Yellow/red, edges black	Daylight-balanced film exposed to artificial light
Pronounced cast, edges black	Camera filter used (same colour as cast)
Pronounced cast including edges	Use of incorrect safelight, if green may be due to afterglow from fluorescent lamp in darkroom
Markings and spots	
Light streamers from spaces between sprocket holes with 35 mm film	Excessive and regular agitation in colour developer, or insufficient agitation in first developer
Light patches with dark outlines	Drying marks

Table 26.3 Faults in colour negative films

Appearance	Fault
Too dense all over	
Too dark with much shadow detail	Over-exposure
Too dark and contrasty	Over-development
Too dark, no image or little image present	Fogging
Heavy fogging and partial reversal	Exposure to light during development
Opaque or cloudy image	Bleach or fixer omitted
Too thin all over	
Image too light and little shadow detail	Under-exposure
Too light and of low contrast	Under-development
Colour casts and stains	
Orange/pink	Normal
Green	Exposure to red safelight
Patches (may be reddish-brown)	Solution contamination
Markings and spots	
Streaks and spots in uniformly light areas	Excessive and regular agitation in developer, or parts of film incompletely bleached and fixed
Light spots same colour as mask	Air bubbles in developer or splashes of fixer on film before development

Table 26.4 Faults in colour prints

Appearance	Fault
Too dark all over	
Image too dense	Over-exposure or over-development
Too light all over	
Image too light and lacking contrast	Negative and/or print under-exposed, print under-developed
Colour casts and stains	
Colour cast but borders white	Incorrect filtration
Colour cast including borders	Exposure to incorrect safelight
Muddy appearance, especially of yellow	Bleach-fix bath exhausted (incomplete removal of silver)
Pale clearly defined areas	Prints touching in developer
Whites stained, image of low contrast	Exhausted or stale developer
Whites stained image purple	Contamination of developer by bleach-fix
Markings and spots	
Red or blue spots	Iron contamination of wash water
Pale bluish irregular spots	Splashes of water before development
Brown spots or patches	Prints in contact in bleach-fix

Appendix

Processing formulae for black-and-white materials

The formulae given below are grouped under the following headings:

Developers
Stop baths and fixers
Reducers
Intensifiers
Toners
Reversal processing of black-and-white films

Making up solutions

All quantities are given in metric units; conversions between metric and Imperial units are given on page 376.

Dissolve the chemicals in the order given, using about three-quarters of the total volume of water required. This water should be hot, at about 50°C, and then cold water should be added to make up the full amount. In very hard-water areas distilled or de-ionized water should be used. In formulae containing metol add a small amount (a pinch) of sodium sulphite before adding the metol to inhibit atmospheric oxidation, then add the bulk of sodium sulphite after the metol has dissolved completely.

All solutions and chemicals should be regarded as potentially hazardous (page 238) and appropriate precautions taken when preparing solutions. More complete details of precautions to be observed when using the chemicals mentioned can be found in *Hazards in the Chemical Laboratory* by G.D. Muir, published by the Royal Society of Chemistry.

Substitution of chemicals

In formulae containing sodium sulphite, the quantities given are for sodium sulphite, anhydrous. If sodium sulphite, crystalline is used the quantities given must be doubled.

In formulae containing sodium carbonate, the quantities given are for sodium carbonate, anhydrous. If sodium carbonate, crystalline (decahydrate) is used the quantities given must be multiplied by

2.75. If sodium carbonate monohydrate is used the quantities given must be multiplied by 1.25.

In formulae containing sodium thiosulphate (hypo), the quantities given are for sodium thiosulphate, crystalline. With sodium thiosulphate, anhydrous, use 0.625 of the quantities given.

In many chemical formulae it is immaterial whether the sodium or potassium salt is used (e.g. sodium metabisulphite or potassium metabisulphite). As the relative atomic mass of potassium (40) is higher than that of sodium (23) it is necessary to use proportionally more when the potassium salt is used instead of the sodium salt, and proportionally less in the reverse case.

In most PQ formulae, Ilford IBT Restrainer solution is specified. An alternative restrainer may be made by dissolving 10 grams of benzotriazole in 1 litre of 1 per cent sodium carbonate (anhydrous) solution.

Developers

Developer formulae for black-and-white materials have been classified into the following groups:

1 Universal developers
2 Film developers:
 (a) General purpose
 (b) Fine-grain
 (c) Acutance
 (d) High-contrast
 (e) Extreme-contrast (lithographic)
 (f) Low-contrast
 (g) Tropical
 (h) Monobath
3 Paper developers

1 Universal developers (for roll film, sheet film, contact and enlarging papers

ID-36 Metol-hydroquinone developer
A universal MQ developer for films and papers.

STOCK SOLUTION

Water	750 ml
Metol	3 g
Sodium sulphite, anhydrous	50 g
Hydroquinone	12.5 g
Sodium carbonate, anhydrous	72 g
Potassium bromide	0.75 g
Water to make	1000 ml

WORKING STRENGTH

Films
Dish: Dilute 1 part with 3 parts water.
Tank: Dilute 1 part with 7 parts water.

Contact paper
Dilute 1 part with 1 part water.

Enlarging and rollhead papers
Dilute 1 part with 3 parts water.

ID-62 Phenidone-hydroquinone developer
A universal PQ formula for films and papers.

STOCK SOLUTION

Water	750 ml
Sodium sulphite, anhydrous	50 g
Sodium carbonate, anhydrous	60 g
Hydroquinone	12 g
Phenidone	0.5 g
Potassium bromide	2 g
IBT restrainer, solution	20 ml
Water to make	1000 ml

WORKING STRENGTH

Films
Dish: Dilute 1 part stock solution with 3 parts water.
 Time: 1¼–3¾ minutes at 20°C.
Tank: Dilute 1 part stock solution with 7 parts water.
 Time: 3–7½ minutes at 20°C.

Contact papers
Dilute 1 part stock solution with 1 part water.

Enlarging and rollhead papers
Dilute 1 part stock solution with 3 parts water.
 Time: 1½–2 minutes at 20°C.

2 Film developers

(a) General purpose

ID-67 Phenidone-hydroquinone developer
A general-purpose PQ formula for roll films and sheet films.

STOCK SOLUTION

Water	750 ml
Sodium sulphite, anhydrous	75 g
Sodium carbonate, anhydrous	37.5 g

Hydroquinone	8 g
Phenidone	0.25 g
Potassium bromide	2 g
IBT Restrainer, solution	15 ml
Water to make	1000 ml

WORKING STRENGTH
Dish: Dilute 1 part stock solution with 2 parts water.
 Time: 1¼–4½ minutes at 20°C.
Tank: Dilute 1 part stock solution with 5 parts water.
 Time: 2½–10 minutes at 20°C.

D-61A Metol-hydroquinone developer
A general-purpose MQ formula for roll films and sheet films.

STOCK SOLUTION

Water	750 ml
Metol	3 g
Sodium sulphite, anhydrous	90 g
Sodium metabisulphite	2 g
Hydroquinone	6 g
Sodium carbonate, anhydrous	11 g
Potassium bromide	2 g
Water to make	1000 ml

WORKING STRENGTH
Dish: Dilute 1 part stock solution with 1 part water.
 Time: 7 minutes at 20°C.
Tank: Dilute 1 part stock solution with 3 parts water.
 Time: 14 minutes at 20°C.

(b) Fine-grain

D-76 (ID-11) Fine-grain developer
An MQ-borax developer for films. Gives grain fine enough for all normal requirements with minimum loss of emulsion speed.

STOCK SOLUTION

Water	750 ml
Metol	2 g
Sodium sulphite, anhydrous	100 g
Hydroquinone	5 g
Borax	2 g
Water to make	1000 ml

Use without dilution in dish or tank. Time: 6–10 minutes at 20°C. May also be used diluted 1 + 1 or 1 + 3, with appropriate increase in developing time, and discarded after use.

Replenisher for D-76, ID-11 developer
A replenisher designed to maintain the activity of ID-11 developer, and thus prolong its life.

STOCK SOLUTION

Water	750 ml

Metol	3 g
Sodium sulphite, anhydrous	100 g
Hydroquinone	7.5 g
Borax	20 g
Water to make	1000 ml

Add to the developer tank as required to maintain the level of the solution. Under normal working conditions, where the tank is in regular use, a total quantity of replenisher equal to that of the original developer may be added before discarding the developing solution.

ID-68 Fine-grain developer

A PQ-borax formula for films. Gives grain fine enough for all normal requirements without loss of emulsion speed.

STOCK SOLUTION

Water	750 ml
Sodium sulphite, anhydrous	85 g
Hydroquinone	5 g
Borax	7 g
Boric acid	2 g
Potassium bromide	1 g
Phenidone	0.13 g
Water to make	1000 ml

Use without dilution in dish or tank. Time: 3–12 minutes at 20°C.

Replenisher for ID-68 developer

A replenisher formula designed to maintain the activity of ID-68 developer, and thus prolong its life.

STOCK SOLUTION

Water	750 ml
Sodium sulphite, anhydrous	85 g
Hydroquinone	8 g
Borax	10 g
Phenidone	0.22 g
Water to make	1000 ml

Add to the developer tank as required to maintain the level of the solution. Under normal working conditions, where the tank is in regular use, a total quantity of replenisher equal to that of the original developer may be added before discarding the developing solution.

(c) Acutance developers

The following formulae have been designed to give enhanced adjacency effects (acutance).

Beutler developer

STOCK SOLUTION A

Water	750 ml
Metol	10 g

Sodium sulphite, anhydrous	50 g
Water to make	1000 ml

STOCK SOLUTION B

Water	750 ml
Sodium carbonate, anhydrous	50 g
Water to make	1000 ml

WORKING STRENGTH

1 part A, 1 part B and 8 parts water. Time: 8–15 minutes at 20°C. Use once only.

FX-1 High-acutance developer

A variant of the Beutler developer for which enhanced adjacency effects, better contrast control and a speed increase of ½–1 stop are claimed.

STOCK SOLUTION

Water	750 ml
Metol	0.5 g
Sodium sulphite, anhydrous	5 g
Sodium carbonate, anhydrous	2.5 g
Potassium iodide (0.001% solution)	5 ml
Water to make	1000 ml

WORKING STRENGTH

Use without dilution and discard after use. Time: 12–14 minutes at 20°C.

(d) High-contrast developers

D-19b, ID-19 developer

A high-contrast developer for X-ray film, aerial film, industrial and scientific photography.

STOCK SOLUTION

Water	750 ml
Metol	2.2 g
Sodium sulphite, anhydrous	72 g
Hydroquinone	8.8 g
Sodium carbonate, anhydrous	48 g
Potassium bromide	4 g
Water to make	1000 ml

WORKING STRENGTH

Use without dilution in dish or tank. Time: 5 minutes at 20°C.

Replenisher for D-19b developer

STOCK SOLUTION

Water	750 ml
Metol	4 g
Sodium sulphite, anhydrous	72 g
Hydroquinone	16 g
Sodium carbonate, anhydrous	48 g
Sodium hydroxide	7.5 g
Water to make	1000 ml

Add to the developer tank as required to maintain the level of the solution.

(e) Extreme-contrast (lithographic or process) developers

ID-13 Hydroquinone-caustic developer
For the dish development of line films when maximum contrast is required. Also recommended for the development of certain special plates used for scientific purposes, when maximum contrast is required.

STOCK SOLUTION A
Water	750 ml
Hydroquinone	25 g
Potassium metabisulphite	25 g
Potassium bromide	25 g
Water to make	1000 ml

STOCK SOLUTION B
Water	750 ml
Potassium hydroxide	50 g
Water to make	1000 ml

WORKING STRENGTH
Dish: Mix equal parts of A and B immediately before use. Time: 2 minutes at 20°C.

The above hydroquinone-caustic developer is a maximum-contrast developer rather than a lithographic developer and has poor keeping properties when mixed. An example of a true lithographic developer is given below.

AN-79b Lithographic developer
For the development of lithographic materials. A two-solution formulation containing paraformaldehyde as a means of keeping the sulphite concentration low, with hydroquinone as the developing agent.

STOCK SOLUTION A
Water	750 ml
Sodium sulphite, anhydrous	1 g
Paraformaldehyde	30 g
Potassium metabisulphite	10.5 g
Water to make	1000 ml

STOCK SOLUTION B
Water	2500 ml
Sodium sulphite, anhydrous	120 g
Boric acid, crystals	30 g
Hydroquinone	90 g
Potassium bromide	6 g
Water to make	3000 ml

WORKING STRENGTH
1 part A and 3 parts B. Time: 2 minutes at 20°C.

(f) Low-contrast developers

For use with films of high inherent contrast such as Kodak Technical Pan, or for recording scenes of extreme contrast.

POTA developer

STOCK SOLUTION
Water (distilled or de-ionized)	750 ml
Phenidone	1.5 g
Sodium sulphite, anhydrous	30 g
Water (distilled or deionized) to make	1000 ml

WORKING STRENGTH
Use without dilution. Time: 10–20 minutes at 20°C.

D-23 developer

STOCK SOLUTION
Water	750 ml
Metol	7.5 g
Sodium sulphite, anhydrous	100 g
Water to make	1000 ml

WORKING STRENGTH
Use without dilution. Time: 5–10 minutes at 20°C.

(g) Tropical developers

For processing at high temperatures (up to about 35°C).

DK-15 Tropical developer

STOCK SOLUTION
Water	750 ml
Metol	5.7 g
Sodium sulphite, anhydrous	90 g
Borax, crystals	13.5 g
Sodium hydroxide	2.9 g
Potassium bromide	1.9 g
Sodium sulphate, anhydrous	46.5 g
Water to make	1000 ml

WORKING STRENGTH
Use without dilution. Times: 8 minutes at 21°C, 3¾ minutes at 30°C, 2½ minutes at 32°C.

D-76, ID-11 plus sodium sulphate
For temperatures 29–32°C add 100 g of sodium sulphate, anhydrous, per litre of D-76, ID-11 stock solution. For higher temperatures, 32–35°C, also decrease developing time by approximately one third.

(h) Monobath

MM-1 Monobath

STOCK SOLUTION

Water	750 ml
Sodium sulphite, anhydrous	50 g
Phenidone	4 g
Hydroquinone	12 g
Sodium hydroxide	4 g
Sodium thiosulphate, crystals	110 g
Glutaraldehyde (25% solution)	8 ml
Water to make	1000 ml

After the addition of the phenidone add a pinch of hydroquinone followed by the sodium hydroxide. The phenidone will then dissolve completely; the small amount of hydroquinone helps prevent the oxidation of the phenidone. Then add the remainder of the hydroquinone and the other chemicals in the order given. Process films for 7 minutes at 24°C.

Different films respond differently to processing in the monobath. Some give speed and contrast increases. To lower contrast add glacial acetic acid (1–5 ml per litre of solution). If increased contrast is required add sodium hydroxide (2.5 g per litre of solution). For certain films some speed loss may occur (½ to ⅔ stop).

3 Paper developers

ID-20 Metol-hydroquinone

STOCK SOLUTION

Water	750 ml
Metol	3 g
Sodium sulphite, anhydrous	50 g
Hydroquinone	12 g
Sodium carbonate, anhydrous	60 g
Potassium bromide	4 g
Water to make	1000 ml

WORKING STRENGTH
For normal use, dilute 1 part with 3 parts water.

D-163 Metol-hydroquinone

STOCK SOLUTION

Water	750 ml
Metol	2.2 g
Sodium sulphite, anhydrous	75 g
Hydroquinone	17 g
Sodium carbonate, anhydrous	65 g
Potassium bromide	2.8 g
Water to make	1000 ml

WORKING STRENGTH
Dilute 1 part with 3 parts water. Time: 1½–3 minutes at 20°C.

Stop bath and fixers

IS-1 Acetic acid stop bath
For films and papers.

Acetic acid, glacial	17 ml
Water to make	1000 ml

Films and papers should be immersed in the bath for about 5 seconds, and should be kept moving.

Note This top bath should be replaced when its pH reaches 5.8. This may be determined by using pH test papers.

IF-2 Acid-hypo fixer
A non-hardening acid fixing bath for films, plates and papers.

STOCK SOLUTION

Hot water (50°C)	750 ml
Sodium thiosulphate (hypo), crystals	200 g
Potassium metabisulphite	12.5 g
Cold water to make	1000 ml

WORKING STRENGTH

Films
Use undiluted. Fix for 10 to 20 minutes at 20°C.

Papers
Dilute with an equal quantity of water. Fix for 5 to 10 minutes at 20°C.

Note For more rapid fixing of films and plates the quantities of hypo and metabisulphite in this formula may be doubled.

F-5 Acid hardener-fixer
For films and papers.

WORKING SOLUTION

Hot water (50°C)	500 ml
Sodium thiosulphate (hypo), crystals	240 g
Sodium sulphite, anhydrous	15 g
Boric acid, crystals	7.5 g
Acetic acid, glacial (see mixing instructions)	17 ml
Potassium alum, crystals	15 g
Water to make	1000 ml

Dissolve the hypo in 500 ml of hot water and when this solution is cool add the sulphite. Dissolve the boric acid, acetic acid and alum in 150 ml of hot water, allow to cool to below 21°C and slowly pour into the sulphite-hypo solution. Finally, make up to 1000 ml with cold water. To obtain full hardening, films should remain in the bath for 5 to 10 minutes.

Rapid fixer for films and papers

Water	750 ml
Ammonium thiosulphate	175 g
Sodium sulphite, anhydrous	25 g
Acetic acid, glacial	10 ml

Boric acid, crystals	10 g
Water to make	1000 ml

Fixing time 30–90 seconds for films and 30–60 seconds for papers.

Reducers

IR-1 Ferricyanide-hypo (Farmer's) reducer
A subtractive reducer, for clearing shadow areas in negatives, and for brightening highlights of prints.

SOLUTION A

Water (distilled or de-ionized)	700 ml
Potassium ferricyanide (hexacyanoferrate)	100 g
Water to make	1000 ml

SOLUTION B

Hot water (distilled or de-ionized)	700 ml
Sodium thiosulphate (hypo), crystals	200 g
Water to make	1000 ml

For use, add to Solution B just sufficient of Solution A to colour the mixture pale yellow (e.g. 10 ml of A per 200 ml of B). This should be used immediately after mixing. The process of reduction should be carefully watched and the negative washed thoroughly as soon as it has ben reduced sufficiently. The energy of reduction can be controlled by varying the amount of Solution A in the mixture.

IR-2 Persulphate reducer
A superproportional reducer, for great reduction of negative contrast.

Water (distilled or de-ionized)	750 ml
Ammonium persulphate	25 g
Water to make	1000 ml

It is important that the water used for making up this bath should be free from dissolved chlorides; distilled water is recommended. One or two drops of sulphuric acid should be added to induce regularity of action. When reduction has gone nearly but not quite far enough, pour off the reducer and flood the negative with a 1 per cent solution of sodium metabisulphite. Wash the negative thoroughly before drying.

Note This reducer is ineffective with some modern high-speed emulsions. If it fails, IR-3 should be tried.

IR-3 Permanganate-persulphate reducer
A proportional reducer for lowering negative contrast.

SOLUTION A

Water (distilled or de-ionized)	700 ml
Sulphuric acid, concentrated	1.5 ml
Potassium permanganate	0.25 g
Water to make	1000 ml

SOLUTION B

Water (distilled or de-ionized)	700 ml
Ammonium persulphate	25 g
Water to make	1000 ml

Caution When making up solution A, the acid must (be added to the water, slowly, and not the water to the acid. Adding water to sulphuric acid is highly dangerous. The permanganate should be added last.

It is important that the water used for both solutions should be free of dissolved chlorides; distilled water is recommended.

For use, mix 1 part of A with 3 parts of B. When reduction has gone far enough, pour off the reducer and flood the negative with a 1 per cent solution of sodium metabisulphite. Wash the negative thoroughly before drying.

IR-4 Iodine reducer
For local or general reduction of prints.

STOCK SOLUTION

Water	750 ml
Potassium iodide	16 g
Iodine crystals	4 g
Water to make	1000 ml

WORKING STRENGTH
For use, dilute 1 part stock solution with 19 parts water. After reduction, rinse and re-fix in a 20 per cent plain hypo bath. Wash the print thoroughly before drying.

Intensifiers

IIn-3 Chromium intensifier
For controlled intensification of negatives. This intensifier does not stain.

DICHROMATE STOCK SOLUTION

Water	750 ml
Potassium dichromate	100 g
Water to make	1000 ml

This solution keeps indefinitely.

BLEACHING SOLUTION A

Dichromate stock solution (as above)	100 ml
Hydrochloric acid, concentrated	2.5 ml
Water to make	1000 ml

BLEACHING SOLUTION B

Dichromate stock solution (as above)	100 ml
Hydrochloric acid, concentrated	12.5 ml
Water to make	1000 ml

Note Bleaching Solution A gives more intensification than Solution B. Whichever solution is selected should be freshly mixed. Immerse the washed negative in the bleaching solution selected until it is completely bleached, then wash until the yellow stain is removed and redevelop, by white light, or after exposure to light, in an MQ or PQ developer containing a low concentration of sulphite, e.g. D-163. Wash the negative thoroughly before drying.

IIn-5 Uranium intensifer
For considerable intensification of negatives.

STOCK SOLUTION A

Water (distilled or de-ionized)	750 ml
Uranium nitrate	25 g
Water to make	1000 ml

STOCK SOLUTION B

Water (distilled or de-ionized)	750 ml
Potassium ferricyanide (hexacyanoferrate)	25 g
Water to make	1000 ml

For use, mix 4 parts A, 4 parts B and 1 part acetic acid, glacial. After immersing negative in intensifier, remove the yellow stain remaining by rinsing in water containing a trace of acetic acid. Wash the negative thoroughly before drying.

If required, the intensification can be removed with a weak (1%) solution of sodium carbonate.

Intensification by this process is of limited permanence.

Toners

Sulphide toner
For sepia tones.

STOCK BLEACH SOLUTION

Water (distilled or de-ionized)	750 ml
Potassium ferricyanide (hexacyanoferrate)	50 g
Potassium bromide	50 g
Water to make	1000 ml

Use undiluted

STOCK SULPHIDE SOLUTION

Water (distilled or de-ionized)	750 ml
Sodium sulphide	50 g
Water to make	1000 ml

For use, dilute 1 part with 9 parts water. Prints should be fully developed. After the prints have been fixed and very thoroughly washed, immerse them in the ferricyanide solution until the image is bleached. Then wash them for 10 minutes and place them in the sulphide solution, in which they will acquire a rich sepia colour. After darkening, wash prints for half-an-hour. Warmer tones can be produced by reducing the potassium bromide in the

stock ferricyanide solution to one-quarter of the figure given. Colder tones can be obtained by immersing the washed black-and-white prints for 5 minutes in the sulphide bath before bleaching. Prints are then washed, bleached and darkened in the usual way.

Alternatively the following odourless solution of thiourea can be used in place of the sulphide solution:

THIOUREA SOLUTION

Water	750 ml
Thiourea	2 g
Sodium carbonate, anhydrous	100 g
Water to make	1000 ml

IT-2 Hypo-alum toner
For purplish-sepia tones.

Water	750 ml
Sodium thiosulphate (hypo), crystals	150 g
Potassium alum, crystals	25 g
Water to make	1000 ml

First dissolve the hypo in hot water, then add the alum a little at a time.

Until ripened, the bath has a reducing action; ripening is best done by immersing some waste prints or by adding to every 1 litre of the bath 0.14 gram of silver nitrate dissolved in a little water to which is added just sufficient strong ammonia drop by drop, to re-dissolve the precipitate formed. This bath lasts for years and improves on keeping; it should be kept up to bulk by adding freshly-made solution. The prints (which should be developed a little darker than for black-and-white) are toned at about 50°C for about 10 minutes. At lower temperatures toning is unduly prolonged; higher temperatures give colder tones. Finally, wash the prints thoroughly and swab with a tuft of cotton wool. This process is suitable for bulk work. For warmer tones, add 1 gram of potassium iodide to every 1 litre of the toning bath.

IT-6 Ferricyanide-iron toner
For blue tones.

STOCK FERRICYANIDE SOLUTION

Water (distilled or de-ionized)	700 ml
Potassium ferricyanide (hexacyanoferrate)	2 g
Sulphuric acid, concentrated	4 ml
Water to make	1000 ml

First add the acid to the water, slowly; then dissolve the ferricyanide in the diluted acid.

STOCK IRON SOLUTION

Water	700 ml
Sulphuric acid, conc.	4 ml
Ferric ammonium citrate	2 g
Water to make	1000 ml

First add the acid to the water, slowly; then dissolve the ferric ammonium citrate in the diluted acid. For use, mix equal parts of the two solutions just before using.

Caution When making up both solutions the acid must be added to the water, slowly, and not the water to the acid. Adding water to sulphuric acid is highly dangerous.

The prints, which should be a little lighter than they are required to be when finished, must be thoroughly washed before toning. They should be immersed until the desired tone is obtained and then washed until the yellow stain disappears from the whites. Bleaching of the blue image, which may occur on washing, may be prevented by washing in very slightly acid water.

Copper toner
For red tones

STOCK COPPER SOLUTION

Water (distilled or de-ionized)	750 ml
Copper sulphate	25 g
Potassium citrate	110 g
Water to make	1000 ml

STOCK FERRICYANIDE SOLUTION

Water (distilled or de-ionized)	750 ml
Potassium ferricyanide (hexacyanoferrate)	20 g
Potassium citrate	110 g
Water to make	1000 ml

For use mix equal volumes of the above solutions.

Kodak Gold Protective Solution GP-1
For archival permanence of prints.

Gold chloride (1% solution)	10 ml
Sodium thiocyanate	10 g
Water to make	1000 ml

Add the gold chloride solution to 750 ml of water. Separately dissolve the thiocyanate in 125 ml of water, then add to the gold chloride solution slowly with rapid stirring and make up to 1 litre. Immerse the thoroughly-washed prints* in the solution for 10 minutes, or until a slight change in image tone is observed, then wash in running water for 10 minutes.

*Preferably treat with hypo-eliminator HE-1 before toning

Hypo eliminator HE-1

Hydrogen peroxide (3% solution)	125 ml
Ammonia (1 part concentrated ammonia (28%) and 9 parts water)	100 ml
Water to make	1000 ml

Immerse the prints in the above solution for 6 minutes then wash for 20 minutes.

Reversal processing of black-and-white films

Reversal processing procedures and formulae for Kodak and Ilford black-and-white negative films are given below.

Procedure and formulae for Kodak films (e.g. Panatomic-X, rated at 80 ASA)

1 Develop in D-19b developer (page 368) containing 2 g/litre of potassium thiocyanate for 6 minutes at 20°C
2 Wash for 5 minutes
3 Bleach in formula R-21A for 3–5 minutes
4 Wash for 5 minutes
5 Clear in formula R-21B for 2 minutes
6 Rinse for ½ minute
7 Expose for 2½ minutes to artificial white light
8 Develop in D-19b developer for 4 minutes at 20°C
9 Rinse
10 Fix in an acid-hardening fixer (page 370)
11 Wash for 15–20 minutes
12 Dry

Bleach R-21A

Water	750 ml
Potassium dichromate	50 g
Sulphuric acid, concentrated	50 ml
Water to make	1000 ml

Caution Dissolve the dichromate in the water then add the concentrated sulphuric acid slowly with constant stirring to the cold solution.

Clearing solution R-21B

Water	750 ml
Sodium sulphite, anhydrous	50 g
Sodium hydroxide	1 g
Water to make	1000 ml

Procedure and formulae for Ilford films (e.g. FT 4)

1 Develop in ID-36 developer (page 366) diluted 1 + 1 to which 12 g/litre of sodium thiosulphate crystals have been added, for 12 minutes at 20°C
2 Wash for 3 minutes
3 Bleach for 3–5 minutes
4 Wash for 2–5 minutes
5 Clear for 2 minutes
6 Wash for 2 minutes
7 Expose for 1–2 minutes to white light
8 Develop in the same developer as in 1 above for 6 minutes at 20°C

9 Rinse
10 Fix in an acid-hardening fixer (page 370)
11 Wash for 15–30 minutes
12 Dry

Bleach

Water	750 ml
Potassium permanganate	4 g
Sulphuric acid, concentrated	20 ml
Water to make	1000 ml

Caution Add the sulphuric acid slowly with constant stirring to the cold solution.

Clearing solution

Water	750 ml
Sodium metabisulphite	25 g
Water to make	1000 ml

Processing formulae for colour materials

In black-and-white processing there are many universal processing formulae that can be used for processing almost any type of film, and most manufacturers of photographic materials have published suitable formulae, some of which were given in the preceding section. In colour processing the situation is different. Manufacturers of colour photographic materials do not usually publish processing formulae, but market the appropriate pre-packed processing chemicals. Alternatively, some independent companies offer pre-packed chemicals for processing the colour films and papers of various manufacturers. Substitute formulae for various types of colour materials are published. These may give results that are different from those obtained when the material is processed in the manufacturer's pre-packed chemicals, and different batches of the same material may respond differently in substitute processing formulae. Accordingly, these formulae should be treated with caution, and some experimentation may be required in order to achieve satisfactory results.

Some representative examples of substitute formulae are given below, but more exhaustive substitute formulae are published in the *British Journal of Photography Annual* and in *Developing* (see Bibliography page 382).

Colour developers, and especially colour developing agents, should not be allowed to come into contact with the skin. When preparing and using colour-processing chemicals and solutions it is advisable to wear rubber gloves.

Procedure and substitute formulae for the Kodak C-41 process

This process is claimed to be suitable for processing colour-negative films. Equivalent designations for manufacturers other than Kodak are: Agfa AP-70, Fuji CN-16, Konica CNK-4.

1	Colour-develop	3 min 15 s at 37.8 ± 0.15°C
2	Stop	30 s at 38 ± 3°C
3	Rinse	30 s at 38 ± 3°C
4	Bleach-fix	4 min at 38 ± 3°C
5	Wash	3 min 15 s at 38 ± 3°C
6	Stabilize	1 min 5 s at 38 ± 3°C
7	Dry	below 43°C

Agitation and temperature control for colour development are critical, and the following procedure is recommended when developing films in spiral developing tanks: first prepare a water bath at 41°C to act as a thermal reservoir. Warm the colour developer to 38°C, pour into the developing tank and agitate continuously for the first 20 seconds. Place the developing tank in the water bath to approximately 2 cm below the lid, then remove the tank and agitate by inversion for 5 seconds and replace it in the water bath. Repeat this cycle 6 times each minute until 10 seconds before the end of development. Finally drain the tank for 10 seconds.

Agitate continuously when the tank is filled with the stop bath.

Colour developer

Water	750 ml
Calgon	2 g
Sodium sulphite, anhydrous	4.25 g
Potassium bromide	1.5 g
Potassium carbonate, anhydrous	37.5 g
Hydroxylamine sulphate	2 g
CD-4 (*add 6h before use*)	4.75 g
Water to make	1000 ml
pH	10.1–10.2
Shelf-life	1 month
Capacity (number of 135/36 exp films)	5

Stopbath

Glacial acetic acid	10 ml
Water to make	1000 ml

Bleach-fix

Water	750 ml
EDTA sodium ferric (Merck)	40 g
EDTA acid	4 g
Potassium iodide	1 g
Ammonia, 20% solution	10 ml
Ammonium thiosulphate, crystals	100 g
Sodium sulphite, anhydrous	2 g
Sodium thiocyanate, 20% solution	50 ml
Water to make	1000 ml

pH (adjust by addition of ammonia or acetic acid) 5.8–6.2

Stabilizer

Wetting agent, 10% solution	10 ml
Formaldehyde, 35–37% solution	6 ml
Water to make	1000 ml

Procedure and substitute formulae for the Kodak Ektaprint 2 process

This is claimed to be suitable for all negative-positive chromogenic colour-print papers. The table below gives processing times for three temperatures when using a drum processor.

	$31 \pm 0.3°C$	$33 \pm 0.3°C$	$38 \pm 0.3°C$
1 Pre-soak	45 s	45 s	45 s
2 Colour develop	3 min 30 s	3 min	2 min
3 Rinse	45 s	45 s	30 s
4 Bleach-fix	1 min 45 s	1 min 30 s	1 min
5 Wash	2 min	1 min 30 s	1 min
6 Stabilize (optional)	1 min	45 s	30 s
7 Dry below 107°C			

Agitation should be carried out at the rate of approximately 20–30 cycles per minute according to the drum used.

Means of obtaining the correct temperature are usually provided with the drum in the form of a nomogram which takes into account the ambient temperature and a different pre-soak temperature may be required from that given above.

For washing in the drum 4 changes of water may be considered equivalent to 1 minute wash.

Colour developer

Water	750 ml
Calgon	2 g
Hydroxylamine sulphate	3.4 g
Sodium sulphite, anhydrous	2 g
Potassium carbonate, anhydrous	32 g
Potassium bromide	0.4 g
Benzyl alcohol. (50% solution)	30 ml
CD-3	4.4 g
Water to make	1000 ml
pH	10.1–10.2

Bleach-fix

Same formula as that given for the C-41 substitute process, but the pH is adjusted to 6.2–6.5.

Stabilizer

Water	750 ml
Sodium carbonate, anhydrous	2.5 g
Acetic acid, glacial	12.5 ml

Citric acid, crystals	7 g
Water to make	1000 ml
pH	3.6 ± 0.1

Procedure and substitute formulae for the Kodak E-6 process

This is suitable for processing colour-reversal (slide) films with the exception of Kodachrome, certain special-purpose films and some films originating in eastern Europe.

1	Black-and-white develop	7 min at $38 \pm 0.3°C$
2	Rinse	2 min at 33–39°C
3	Reversal bath	2 min at 33–39°C
4	Colour develop	6 min at $38 \pm 0.6°C$
5	Conditioner	2 min at 33–39°C
6	Bleach	7 min at 33–39°C
7	Fix	4 min at 33–39°C
8	Wash	6 min at 33–39°C
9	Stabilize	1 min at 33–39°C
10	Dry	not more than 49°C

See notes under C-41 process for details of temperature control and agitation.

Black-and-white developer

Water	750 ml
Calgon	2 g
Sodium sulphite, anhydrous	15 g
Potassium carbonate, anhydrous	15 g
Hydroquinone	6 g
Phenidone	0.4 g
Sodium thiocyanate (20% solution)	8 ml
Potassium bromide	2 g
Potassium iodide (1% solution)	5 ml
Water to make	1000 ml
pH	9.6 ± 0.1

Reversal bath

Water	750 ml
Propionic acid	12 ml
Stannous chloride anhydrous	1.65 g
4-Aminophenol (p-aminophenol)	0.5 g
BDH calcium complexing agent No 4	15 ml
Water to make	1000 ml
pH	5.8 ± 0.1

Colour developer

Water	750 ml
EDTA tetrasodium salt	3 g
Potassium carbonate, anhydrous	40 g
Potassium bromide	0.5 g
Potassium iodide (1% solution)	3 ml
Citrazinic acid	1.2 g
Hydroxylamine hydrochloride	1.5 g
CD-3	10 g
Water to make	1000 ml
pH	11.6 ± 0.1

Conditioner

Water	750 ml
Sodium sulphite, anhydrous	10 g
EDTA acid	8 g
Thioglycerol	0.5 ml
Water to make	1000 ml
pH	6.1 ± 0.1

Bleach

Water	750 ml
Potassium nitrate, crystals	30 g
Potassium bromide	110 g
EDTA sodium ferric	110 g
Water to make	1000 ml
pH	5.5–5.7

Fix

Water	750 ml
Ammonium thiosulphate, crystals	70 g
Potassium metabisulphite, crystals	12 g
Sodium sulphite, anhydrous	7 g
Water to make	1000 ml
pH	6.6–6.7

Stabilizer

Water	750 ml
Wetting agent (aerosol OT, anionic or similar product) (10% solution)	5 ml
Formaldehyde (35–40%)	6 ml
Water to make	1000 ml

Conversion of units

Mass

Imperial units to SI units

1 oz = 28.35 g
1 lb = 0.4536 kg (453.6 g)

SI units to Imperial units

1 g = 0.0353 oz
1 kg = 2.2025 lb

Length

Imperial units to SI units

1 yd = 0.9144 m
1 ft = 0.3048 m
1 in = 25.4 mm

SI units to Imperial units

1 m = 1.094 yd (3.218 ft)
1 mm = 0.039 in

Area

Imperial units to SI units

$1 \text{ in}^2 = 645.16 \text{ mm}^2$
$1 \text{ ft}^2 = 0.0929 \text{ m}^2$
$1 \text{ yd}^2 = 0.8361 \text{ m}^2$

SI units to Imperial units

$1 \text{ m}^2 = 1.196 \text{ yd}^2 \ (10.764 \text{ ft}^2)$

Volume

Imperial and American units to SI units

1 UK fl oz = 28.41 ml
1 US fl oz = 29.57 ml
1 UK pint = 568 ml
1 US pint = 473 ml
1 UK gal = 4546 ml
1 US gal = 3785 ml

SI units to Imperial and American units

1 cm^3 = 0.035 UK fl oz
 = 0.034 US fl oz
1 litre = 0.220 UK gal
 = 0.264 US gal

Velocity

Imperial units to SI units

1 ft/s = 0.3048 m/s
1 mile/h = 0.44704 m/s

SI units to Imperial units

1 m/s = 3.281 ft/s
1 km/h = 0.621 mile/h

Table A.1 Multiples and submultiples of SI units

Multiplication factor	Scientific notation	Prefix	Symbol
1 000 000 000 000 000 000	10^{18}	exa	E
1 000 000 000 000 000	10^{15}	peta	P
1 000 000 000 000	10^{12}	tera	T
1 000 000 000	10^{9}	giga	G
1 000 000	10^{6}	mega	M
1 000	10^{3}	kilo	k
100	10^{2}	hecto	h
10	10^{1}	deca	da
0.1	10^{-1}	deci	d
0.01	10^{-2}	centi	c
0.001	10^{-3}	milli	m
0.000 001	10^{-6}	micro	μ
0.000 000 001	10^{-9}	nano	n
0.000 000 000 001	10^{-12}	pico	p
0.000 000 000 000 001	10^{-15}	femto	f
0.000 000 000 000 000 001	10^{-18}	atto	a

Logarithms

When a number is multiplied by itself, the result is called the square, or second power of the number. Thus 4 is called the square of 2, since $2 \times 2 = 4$. The square of 2 is usually written 2^2, the small raised figure (called an *index*) indicating how many factors, each equal to the given number, are to be multiplied together. Thus:

$2^3 = 2 \times 2 \times 2 \qquad = 8$
$2^4 = 2 \times 2 \times 2 \times 2 \qquad = 16$
$2^5 = 2 \times 2 \times 2 \times 2 \times 2 \quad = 32$ etc.

8 is called the third power of 2, 16 the fourth power, 32 the fifth power etc.

If we add the indexes of two powers of the same number we obtain the index of their products. In this way, we can perform multiplication by the usually simpler method of addition. Thus:

$$2^2 \times 2^3 = 2^{2+3} = 2^5$$

Similarly, we can divide any power of a number by another power of the same number by subtracting the index of the latter power from the index of the former. Thus:

$$\frac{2^5}{2^3} = 2^{5-3} = 2^2$$

In these examples we have used only powers of 2, but powers of other numbers can be used to perform multiplication and division in the same way. Thus:

$$5^3 \times 5^2 = 5^{3+2} = 5^5$$

and

$$\frac{10^4}{10^2} = 10^{4-2} = 10^2$$

When indexes of powers of 10 are used, as in the last example, the indexes are called *common logarithms*. Every number can be expressed as some power of 10, and tables giving the common logarithms of all numbers have been prepared and their use saves much time in multiplication and division. Common logarithms (usually contracted simply to 'logarithms') are given the prefix 'log'.

The logarithms of most numbers are not whole numbers, but fractions. Thus, the logarithm of 2 is 0.3010. It may not be easy to understand the meaning of this (i.e. that $2 = 10^{0.3010}$), but there need be no difficulty in appreciating that fractional indices can be used to perform multiplication and division in the same way as integral ones. Thus:

$$2 \times 2 = 10^{0.3010+0.3010} = 10^{0.6020}$$

and 0.6020 is the logarithm of 4. (For certain photographic purposes it is convenient to remember that the logarithm of 2 is almost exactly 0.3.)

This example, while illustrating the fact that fractional indexes may be added to perform multiplication, does not well illustrate the convenience

Table A.2 Two-figure logarithms

Logarithm	Number	Logarithm	Number	Logarithm	Number	Logarithm	Number
.00	1.0	.26	1.8	.52	3.3	.78	6.0
.01	1.0	.27	1.9	.53	3.4	.79	6.2
.02	1.0	.28	1.9	.54	3.5	.80	6.3
.03	1.1	.29	2.0	.55	3.5	.81	6.5
.04	1.1	.30	2.0	.56	3.6	.82	6.6
.05	1.1	.31	2.0	.57	3.7	.83	6.8
.06	1.1	.32	2.1	.58	3.8	.84	6.9
.07	1.2	.33	2.1	.59	3.9	.85	7.1
.08	1.2	.34	2.2	.60	4.0	.86	7.2
.09	1.2	.35	2.2	.61	4.1	.87	7.4
.10	1.3	.36	2.3	.62	4.2	.88	7.6
.11	1.3	.37	2.3	.63	4.3	.89	7.8
.12	1.3	.38	2.4	.64	4.4	.90	7.9
.13	1.3	.39	2.5	.65	4.5	.91	8.1
.14	1.4	.40	2.5	.66	4.6	.92	8.3
.15	1.4	.41	2.6	.67	4.7	.93	8.5
.16	1.4	.42	2.6	.68	4.8	.94	8.7
.17	1.5	.43	2.7	.69	4.9	.95	8.9
.18	1.5	.44	2.8	.70	5.0	.96	9.1
.19	1.5	.45	2.8	.71	5.1	.97	9.3
.20	1.6	.46	2.9	.72	5.2	.98	9.6
.21	1.6	.47	3.0	.73	5.4	.99	9.8
.22	1.7	.48	3.0	.74	5.5	1.00	10.0
.23	1.7	.49	3.1	.75	5.6	2.00	100.0
.24	1.7	.50	3.2	.76	5.8	3.00	1000.0
.25	1.8	.51	3.2	.77	5.9		

afforded by logarithms; in this instance they appear, in fact, to complicate the multiplication rather than to simplify it. When, however, we come to a problem such as multiplying 2.863 by 1.586, the value of logarithms is readily apparent. For:

log 2.863 = 0.4569 (from table of
log 1.586 = 0.2004 logarithms)

Sum = 0.6573

and the number whose logarithm is 0.6573 is 4.452, which is the result required. This may seem a tedious method of multiplication in these days of pocket calculators; but for more than two hundred years it was the only way of performing such calculations, and it was the basis of the design of slide rules. Its continuing importance in photography, however, is that almost every aspect of visual perception is on a logarithmic scale, and the whole discipline of sensitometry is based on the relationship between linear and logarithmic measurements.

Tables of logarithms and detailed instructions for their use will be found in a number of textbooks and mathematical tables, as, for instance, *Logarithmic and Other Tables for Schools*, by Frank Castle (Macmillan). In photography four-figure accuracy is seldom necessary, two or three figures usually being sufficient. Accordingly, a table of two-figure logarithms is given (Table A.2).

Logarithmic scales

In photographic sensitometry, a logarithmic (log) exposure scale is almost invariably used, for reasons explained in Chapter 15. The relation between an arithmetic and a logarithmic exposure scale is illustrated in Figure A.1, where the increased space given to low values of exposure by the logarithmic scale will be noted.

Figure A.1 Comparison of (a) arithmetic and (b) logarithmic scales covering the same range

Trigonometrical ratios

Sine, cosine, tangent etc.

ABC in Figure A.2 contains an acute angle θ. From a point P on AB, a line PQ is drawn perpendicular to BC. Then, the ratios PQ/BP, BQ/BP and

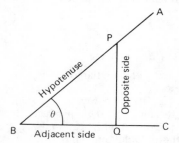

Figure A.2 Right-angle triangle

PQ/BQ are called respectively the *sine*, *cosine* and *tangent* of the angle θ. These terms are usually abbreviated to *sin*, *cos* and *tan*. Thus:

$$\sin \theta = \frac{PQ}{BP} = \frac{\text{opposite side}}{\text{hypotenuse}}$$

$$\cos \theta = \frac{BQ}{BP} = \frac{\text{adjacent side}}{\text{hypotenuse}}$$

$$\tan \theta = \frac{PQ}{BQ} = \frac{\text{opposite side}}{\text{adjacent side}}$$

Three other less widely used ratios are the *cosecant* (*csc*), *secant (sec)* and *cotangent (cot)* of an angle, where:

$$\csc \theta = \frac{1}{\sin \theta} = \frac{BP}{PQ} = \frac{\text{hypotenuse}}{\text{opposite side}}$$

$$\sec \theta = \frac{1}{\cos \theta} = \frac{BP}{BQ} = \frac{\text{hypotenuse}}{\text{adjacent side}}$$

$$\cot \theta = \frac{1}{\tan \theta} = \frac{BQ}{PQ} = \frac{\text{adjacent side}}{\text{opposite side}}$$

The values of the trigonometrical ratios (sine, cosine, tangent, cosecant, secant and cotangent) of angles from 0 to 90° are published in mathematical tables, as, for instance, *Logarithmic and Other Tables for Schools*, by Frank Castle (Macmillan).

Radians

If an arc equal in length to the radius of a circle is measured along the circumference (Figure A.3), the angle subtended at the centre by the arc is said to be one *radian*. This angle, which is equal to about 57° 18′ (180/π), is another unit used in trigonometry. The importance of the radian is that it simplifies

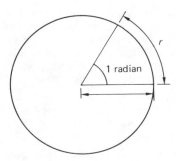

Figure A.3 The radian

many calculations concerned with small angles. This is because for any angle (θ) less than about 20°, sin θ = tan θ = θ (in radians). Also, the resolution of the average human eye is about 1 milliradian, which corresponds to an object of dimension 1 mm seen from a distance of 1 metre. This is the basis on which depth-of-field calculations are made.

The pH scale

Every aqueous solution contains hydrogen (H^+) and hydroxyl (OH^-) ions (charged atoms or groups of atoms). In a neutral solution, such as pure water, the two types of ions are present in equal concentrations of 10^{-7} mol per litre. In an acid solution there is an excess of hydrogen ions over hydroxyl ions, and in an alkaline solution an excess of hydroxyl ions over hydrogen ions, but the product of the two concentrations remains at 10^{-14}, as in pure water.

The degree of acidity or alkalinity of a solution is related to the relative concentrations of the two ions, and for this purpose the pH scale is used.

$$pH = \log_{10} \frac{1}{\text{hydrogen-ion concentration}}$$

On this scale, pure water (a neutral solution) has a pH of 7. An acid solution has a pH below 7, and an alkaline solution a pH above 7. The greater the amount by which the pH of a solution differs from 7, the greater is its acidity or alkalinity. It will be appreciated that, since the pH scale is logarithmic, quite small changes in pH may indicate significant changes in the activity of a solution.

pH can be determined precisely only by electronic means, using an instrument known as a *pH meter*. For many photographic purposes, however, the pH of a solution may be determined with sufficient accuracy by means of *indicator papers*, strips of paper impregnated with substances which change colour according to the degree of acidity or alkalinity of the solution. There are papers suited to most parts of the pH scale.

Some outstanding dates and names in the early history of photography

1725 J.H. Schulze
Established light sensitivity of silver nitrate. Produced images by allowing sun's rays to fall on flask containing a mixture of chalk, silver and nitric acid, around which stencils of opaque paper were pasted.

1777 C.W. Scheele
Noted that blue and violet light is much more active in darkening silver chloride than red or orange.

1802 T.Wedgwood and (Sir) H. Davy
Printing of silhouettes by contact on paper or leather sensitized with silver nitrate. No fixation. First light-sensitive surface attached to a support. Material found to be too slow to record images produced in camera obscura.

1812 W.H. Wollaston
Meniscus lens (landscape lens) for camera obscura. (The camera obscura using a pinhole was known at least as early as the eleventh century, with convex lens in the sixteenth century.)

1819 (Sir) J.F.W. Herschel
Discovery of thiosulphates and their property of dissolving silver halides.

1816 J.N. Niépce
Obtained negative record of camera obscura image on paper sensitized with silver chloride. Partial fixation with nitric acid. Unable to print through negative to obtain a positive.

1822 J.N. Niépce
Permanent copy of engraving by contact printing on to a glass plate sensitized with 'bitumen of Judæa'. The bitumen, normally soluble in lavender oil, became insoluble in this oil on exposure to light. In the following years, Niépce used zinc and pewter plates which, after the image had been perpetuated, were etched in weak acid to form printing plates. Process named 'heliography'.

1826 J.N. Niépce
First permanent photographs from nature. Bitumen process on pewter plate, giving a direct positive picture.

1828 C. and V. Chevalier
Achromatized landscape lens for use on camera obscura.

1829 L.J.M. Daguerre and J.N. Niépce
Joined articles of partnership (J.N. Niépce died in 1833; his son Isidore Niépce then took his place as Daguerre's partner.)

1835 W.H.F. Talbot
Photogenic drawings. Negative prints on print-out paper sensitized with common salt and silver nitrate,

forming silver chloride. Fixation with potassium iodide or by prolonged washing in salt water. Print-out exposure by contact or in the camera obscura. Right-reading positives obtained by contact printing from the negatives.

1837 L.J.M. Daguerre
First successful Daguerrotype. Employed silvered copper plate sensitized with iodine vapour, which formed layer of silver iodide. Development of the latent image by mercury vapour. Fixation with common salt. Image laterally reversed.

1837 J.B. Reade
Photomicrographs with solar microscope. Paper sensitized with solutions of common salt and silver nitrate, producing silver chloride. This was washed over with gallic acid immediately before and during the exposure. Fixation with thiosulphate. (Reade did not realize that he was developing a latent image.)

1839 F.D. Arago
Announced Daguerre's discovery to the Academy of Science, Paris, on 7 January.

1839 M. Faraday
Showed Talbot's photogenic drawings and gave the first public description of the process at a meeting of the Royal Institution, London, on 25 January.

1839 W.H.F. Talbot
Disclosed working details of photogenic drawings to the Royal Society, London, on 21 February.

1839 F.D. Arago
Made public, on the instructions of the French Government, the working details of the Daguerro-type process, at a joint meeting of Academies of Science and Fine Arts, Paris, on 19 August.

1839 (Sir) J.F.W. Herschel
Use of the words *photography, negative* and *positive*. Suggested to Fox Talbot the use of thiosulphate as fixing agent.

1840 J. Petzval
Designed first lens of sufficiently high aperture for portraiture. First lens to be mathematically computed. Manufactured by Voigtländer.

1840 J.W. Goddard
Increased the speed of Daguerrotype plates by exposing the iodized plate to bromine vapour.

1840 H.L. Fizeau
Tones of Daguerrotype images softened and enriched by gold toning.

1840 W.H.F. Talbot
Discovery of the possibility of the development of the latent image by gallic acid.

1841 W.H.F. Talbot
Calotype process (later named Talbotype process).

Negative prints on silver iodide paper bathed in silver nitrate and gallic acid. Development of the latent image by bathing in the same solution. Fixation with potassium bromide; later with thiosulphate. Positives obtained by contact printing from the negatives on to silver chloride paper.

1847 C.F.A. Niépce de Saint Victor
Negatives on glass. Albumen process. Printed more rapidly than paper negatives and gave clearer prints.

1850 L.D. Blanquart-Evrard
Albumen paper for printing of positives from negatives. Recorded more detail than Talbot's salted paper, and became almost universal method of print-making for remainder of century.

1851 F. Scott Archer
Wet collodion process. Glass coated with collodion in which potassium iodide was dissolved, dipped in silver nitrate solution and exposed while wet. Development of latent image with pyrogallic acid or ferrous sulphate. Fixation with thiosulphate or potassium cyanide.

1861 J. Clerk Maxwell
Demonstrated three-colour separation and additive synthesis.

1864 (Sir) J.W. Swan
Introduced carbon-pigmented gelatin paper commercially and thus first made carbon printing really practicable.

1866 J.H. Dallmeyer and H.A. Steinheil
Introduced (independently) the rapid rectilinear lens.

1868 L. Ducos du Hauron
Proposed various methods of three-colour photography, including subtractive colour synthesis.

1871 R.L. Maddox
Introduced gelatin dry plates, at first positive-type plates for physical development only.

1873 H.W. Vogel
Discovered colour-sensitization by dyes.

1880 (Sir) W. de W. Abney
First used hydroquinone as a developer.

1882 J. Clayton and P.A. Attout
First gelatin colour-sensitive plates ('isochromatic').

1883 Howard E. Farmer
Farmer's reducer (ferricyanide-thiosulphate).

1887 H. Goodwin
Applied for patent (granted in 1898) for the manufacture of sensitive material on a cellulose nitrate base.

1888 G. Eastman
First roll-film camera. Employed paper with an

emulsion which could be stripped after processing, for printing purposes.

1890 P. Rudolph and E. Abbé
Anastigmatic lenses manufactured by Zeiss.

1890 F. Hurter and V.C. Driffield
Scientific study of the behaviour of photographic materials (sensitometry).

1891 A. Bogisch
First use of metol as a developer (introduced by Hauff).

1893 H.D. Taylor
Cooke Triplet, an anastigmatic lens with only three elements. Manufactured by Taylor, Taylor and Hobson.

1893 L. Baekeland
Unwashed paper emulsions ('gaslight' paper).

Bibliography

General photographic theory and practice

Attridge, G.G. and Walls, H.J., *Basic Photo Science*, Focal Press, London (1977)

Arnold, C.R., Rolls, P.J. and Stewart, C.J., *Applied Photography*, Focal Press, London (1971)

Carrol, B.H., Higgins, G.C. and James, T.H., *Introduction to Photographic Theory*, Morgan and Morgan, New York (1980)

James, T.H. (editor), *The Theory of the Photographic Process*, Macmillan, New York, 4th edition (1977)

Kodak, *Kodak Handbook for the Professional Photographer*, Vols 1–4, Kodak Ltd, (1979)

Kowaliski, P., *Applied Photographic Theory*, Wiley, New York (1972)

Langford, M.J., *Professional Photography*, Focal Press, London (1975)

Langford, M.J., *Advanced Photography*, Focal Press, London, 5th edition (1989)

Morton, R.A. (editor), *Photography for the Scientist*, Academic Press, London (1984)

Stroebel, L., Compton, J., Current, I., and Zakia, R., *Photographic Materials and Processes*, Focal Press, Boston (1986)

Sturge, J.M. (editor), *Neblette's Handbook of Photography and Reprography Materials and Processes*, Van Nostrand, New York, 7th edition (1977)

Thomas, W. (editor), SPSE Handbook of Photographic Science and Engineering, Wiley-Interscience, New York (1973)

Light, optics and cameras

Brandt, H., *The Photographic Lens*, Focal Press, London (1964)

Cayless, M.A., and Marsden, A.M. (editors), *Lamps and Lighting*, 3rd edition, Edward Arnold, London (1983)

Coe, B., *Cameras*, Marshall Cavendish, London (1978)

Edgerton, H.E., *Electronic Flash, Strobe*, McGraw-Hill, New York (1970)

Franke, G., *Physical Optics in Photography*, Focal Press, London (1964)

Jenkins, F.A. and White, H.E., *Fundamentals of Optics* 4th edition, McGraw-Hill, New York (1981)

Ray, S.F., *The Photographic Lens*, Focal Press, London (1979)

Ray, S.F., *Camera Systems*, Focal Press, London (1983)

Ray, S.F., *The Focal guide to Larger Format Cameras*, Focal Press, London (1979)

Ray, S.F. *Applied Photographic Optics*, Focal Press, London (1988)

Stimson, A., *Photometry and Radiometry for Engineers*, Wiley-Interscience, New York (1974)

Exposure, sensitometry, image evaluation

Brock, G.C., *Image Evaluation for Aerial Photography*, Focal Press, London (1970)

Dainty, J.C. and Shaw, R., *Image Science*, Academic Press, London (1974)

Dunn, J.F. and Wakefield, G., *Exposure Manual*, Fountain Press, London (1974)

Eggleston, J., *Sensitometry for Photographers*, Focal Press, London (1984)

Todd, H.N., *Photographic Sensitometry, a self-teaching text*, Wiley-Interescience, New York (1976)

Todd, H.N. and Zakia, R.D., *Photographic Sensitometry*, Morgan and Morgan, New York, 2nd edition (1974)

Colour theory and practice

Coote, J.H., *Colour Prints*, Focal Press, London, 5th edition (1974)

Evans, R.M., *Eye Film and Camera in Colour Photography*, Wiley, New York (1960)

Evans, R.M., Hanson, W.T. and Brewer, W.L., *Principles of Colour Photography*, Wiley, New York (1953)

Eynard, A.E. (editor), *Colour: Theory and Imaging Systems*, SPSE, Washington DC (1973)

Hunt, R.W.G., *The Reproduction of Colour*, Fountain Press, Tolworth, 4th edition (1987)

Spencer, D.A., *Colour Photography in Practice*, Focal Press, London, revised 3rd edition (1975)

Photographic processing and printing

Attridge, G.G., *Photographic Developing in Practice*, David and Charles, Newton Abbot (1984)

Coote, J.H., *Photofinishing Techniques and Equipment*, Focal Press, London (1971)

Coote, J.H., *Ilford Monochrome Darkroom Practice*, 2nd edition, Focal Press, London (1988)

Crawley, G. (editor), *British Journal of Photography Annual*, Henry Greenwood, London (1988)

Haist, G., *Modern Photographic Processing*, Vols 1 and 2, Wiley, New York (1979)

Jacobson, K.I. and Jacobson, R.E., *Developing*, Focal Press, London, 18th edition (1978)

Kodak, *Preservation of Photographs*, Eastman Kodak Co., Publication F-30, Rochester New York (1979)

Langford, M.J., *The Darkroom Handbook*, Ebury Press, London (1981)

Mason, L.F.A., *Photographic Processing Chemistry*, Focal Press, London (1979)

Ray, S.F. and Taylor, R.J., *Photographic Enlarging in Practice*, David and Charles, Newton Abbot (1985)

Photographic standards

Photographic standards for chemicals, equipment, materials and techniques are issued by the following standards organizations:

American National Standards Institute (ANSI)

American Standards Association (ASA): former name of ANSI

Association Française de Normalisation (AFNOR)

British Standards Institution (BSI)

Deutscher Normenausschuss (DNA)

Gosudarstvenny j Standart (GOST)

International Organization for Standards (ISO): ISO standards are available for National Standards Organizations

Japanese Industrial Standards Committee

Index